Janson's History of Art

THE ANCIENT WORLD

Eighth Edition

Portable Edition | Book 1

PENELOPE J. E. DAVIES

WALIER B. DENNY

FRIMA FOX HOFRICHTER

JOSEPH JACOBS

ANN M. ROBERTS

DAVID L. SIMON

Prentice Hall

Upper Saddle River London Singapore Toronto Tokyo Sydney Hong Kong Mexico City Editorial Director: Leah Jewell Editor in Chief: Sarah Touborg Senior Sponsoring Editor: Helen Ronan Editorial Project Manager: David Nitti Editorial Assistant: Carla Worner Media Director: Brian Hyland Media Editor: Alison Lorber Director of Marketing: Brandy Dawson Senior Marketing Manager: Laura Lee Manley Marketing Assistant: Ashley Fallon Senior Managing Editor: Ann Marie McCarthy Assistant Managing Editor: Melissa Feimer Senior Operations Specialist: Brian Mackey Production Liaisons: Barbara Cappuccio and Marlene Gassler AV Project Manager: Gail Cocker Cartography: Peter Bull Art Studio Senior Art Director: Pat Smythe Site Supervisor, Pearson Imaging Center: Joe Conti Pearson Imaging Center: Corin Skidds, Robert Uibelhoer, and Ron Walko Cover Printer: Lehigh-Phoenix Color

This book was produced by Laurence King Publishing Ltd, London. www.laurenceking.com

Senior Editor: Susie May
Copy Editor: Robert Shore
Proofreader: Lisa Cutmore
Picture Researcher: Amanda Russell
Page and Cover Designers: Nick Newton and Randell Harris
Production Controller: Simon Walsh

Cover image: Octopus Vase, stirrup jar from Palaikastro, Crete. ca. 1500 BCE. Height 11" (28 cm). Archaeological Museum, Iráklion, Crete. © Marie Mauzy, Athens.

Credits and acknowledgements borrowed from other sources and reproduced, with permission, in this textbook appear on the appropriate page within text or on the credit pages in the back of this book.

Copyright © 2012, 2007, 2004 Pearson Education, Inc., publishing as Prentice Hall, 1 Lake St., Upper Saddle River, NJ 07458. All rights reserved. Manufactured in the United States of America. This publication is protected by Copyright, and permission should be obtained from the publisher prior to any prohibited reproduction, storage in a retrieval system, or transmission in any form or by any means, electronic, mechanical, photocopying, recording, or likewise. To obtain permission(s) to use material from this work, please submit a written request to Pearson Education, Inc., Permissions Department, 1 Lake St., Upper Saddle River, NJ 07458

Library of Congress Cataloging-in-Publication Data

Janson, H. W. (Horst Woldemar)
Janson's history of art: the western tradition / Penelope J.E. Davies ... [et. al]. -- 8th ed. p. cm.
Includes bibliographical references and index.
ISBN 978-0-205-68517-2 (hardback)
1. Art--History. I. Davies, Penelope J. E., II. Janson, H. W. (Horst Woldemar), History of art.
III. Title. IV. Title: History of art.
N5300.J29 2009b
709--dc22
2009022617

10 9 8 7 6 5 4 3 2 1

Printer/Binder: Courier/Kendallville

Prentice Hall is an imprint of

ISBN 10: 0-205-16110-3 ISBN 13: 978-0-205-16110-2 Exam Copy ISBN 10: 0-205-16750-0 ISBN 13: 978-0-205-16750-0

Contents

	Preface Faculty and Student Resources for Teaching and Learning	v
	with Janson's History of Art	X
	Introduction	xii
	PART ONE	
	THE ANCIENT WORLD	
Name of the last	Prehistoric Art	. 1
	PALEOLITHIC ART	2
	MATERIALS AND TECHNIQUES: Cave Painting	5
	■ INFORMING ART: Telling Time: Labels and Periods	9
	NEOLITHIC ART	11
	INFORMING ART: Dating Techniques	17
2	Ancient Near Eastern Art	21
	SUMERIAN ART	22
	MATERIALS AND TECHNIQUES: Mud Brick	23
	PRIMARY SOURCE: The Gilgamesh Epic	25
	THE ART HISTORIAN'S LENS: Losses Through Looting	29
	ART OF AKKAD	30
	NEO-SUMERIAN REVIVAL	32
	PRIMARY SOURCE: Texts on Gudea Figures from Lagash and Surrounding	
	Areas, ca. 2100	33
	BABYLONIAN ART	33
	ASSYRIAN ART	34
	■ PRIMARY SOURCE: The Code of Hammurabi	35
	LATE BABYLONIAN ART	37
	REGIONAL NEAR EASTERN ART	38
	IRANIAN ART	41

3	Egyptian Art	49
	PREDYNASTIC AND EARLY DYNASTIC ART	50
	■ INFORMING ART: Egyptian Gods and Goddesses	52
	THE OLD KINGDOM: A GOLDEN AGE	53
	III INFORMING ART: Major Periods in Ancient Egypt	54
	MATERIALS AND TECHNIQUES: Building the Pyramids	56
	■ PRIMARY SOURCE: Excerpt from the Pyramid Text of Unis (r. 2341-2311 BCE)	58
	THE MIDDLE KINGDOM: REASSERTING TRADITION THROUGH THE ARTS	62
	THE NEW KINGDOM: RESTORED GLORY	65
	AKHENATEN AND THE AMARNA STYLE	72
	■ THE ART HISTORIAN'S LENS: Interpreting Ancient Travel Writers	75
	PAPYRUS SCROLLS: THE BOOK OF THE DEAD	77
	■ PRIMARY SOURCE: The Book of the Dead	77
	LATE EGYPT	78
4	Aegean Art	81
	EARLY CYCLADIC ART	82
	MINOAN ART	84
	THE ART HISTORIAN'S LENS: Two Excavators, Legend, and Archaeology	87
	MYCENAEAN ART	93
5	Greek Art	103
9		100
	THE EMERGENCE OF GREEK ART: THE GEOMETRIC STYLE	104
	■ INFORMING ART: Greek Gods and Goddesses	105
	THE ORIENTALIZING STYLE: HORIZONS EXPAND	107
	ARCHAIC ART: ART OF THE CITY-STATE	109
	STONE SCULPTURE	113
	THE CLASSICAL AGE	123
	■ MATERIALS AND TECHNIQUES: <i>The Indirect Lost-Wax Process</i> ■ PRIMARY SOURCE: <i>Aristotle (384–322 BCE)</i>	128 133
	THE ART HISTORIAN'S LENS: Repatriation of Cultural Heritage	133
	■ PRIMARY SOURCE: Plutarch (ca. 46-after 119 ce)	136
	THE LATE CLASSICAL PERIOD	141
	THE AGE OF ALEXANDER AND THE HELLENISTIC PERIOD	147
	THE ART HISTORIAN'S LENS: J.J. Winckelmann and the Apollo Belvedere	157

6	Etruscan Art	165
	FUNERARY ART	165
	MATERIALS AND TECHNIQUES: Etruscan Gold-Working	169
	ARCHITECTURE	173
	SCULPTURE	175
	SCOLPTORE	1/3
7	Roman Art	181
	EARLY ROME AND THE REPUBLIC	181
	■ THE ART HISTORIAN'S LENS: Recognizing Copies: The Case of the Laocoön	183
	NEW DIRECTIONS IN ARCHITECTURE	183
	■ PRIMARY SOURCE: Cicero (106-43 BCE)	192
	MATERIALS AND TECHNIQUES: Copying Greek Sculptures	193
	PRIMARY SOURCE: Polybius (ca. 200-ca. 118 BCE)	194
	THE EARLY EMPIRE	195
	■ THE ART HISTORIAN'S LENS: Two Pantheon Problems	202
	PRIMARY SOURCE: Josephus (37/8-ca. 100 ce)	210
	THE LATE EMPIRE	222
	■ MATERIALS AND TECHNIQUES: Painted Stone in Greece and Rome	223
	Glossary	234
	Books for Further Reading	242
	Index	253
	Credits	261
	Cieuits	201

Preface

officially renamed *Janson's History of Art* in its seventh edition to reflect its relationship to the book that introduced generations of students to art history. For many of us who teach introductory courses in the history of art, the name Janson is synonymous with the subject matter we present.

When Pearson/Prentice Hall first published the *History of Art* in 1962, John F. Kennedy occupied the White House, and Andy Warhol was an emerging artist. Janson offered his readers a strong focus on Western art, an important consideration of technique and style, and a clear point of view. The *History of Art*, said Janson, was not just a stringing together of historically significant objects, but the writing of a story about their interconnections—a history of styles and of stylistic change. Janson's text focused on the visual and technical characteristics of the objects he discussed, often in extraordinarily eloquent language. Janson's *History of Art* helped to establish the canon of art history for many generations of scholars.

Although revised to remain current with new discoveries and scholarship, this new edition continues to follow Janson's lead in important ways: It is limited to the Western tradition, with a chapter on Islamic art and its relationship to Western art. It keeps the focus of the discussion on the object, its manufacture, and its visual character. It considers the contribution of the artist as an important part of the analysis. This edition maintains an organization along the lines established by Janson, with separate chapters on the Northern European Renaissance, the Italian Renaissance, the High Renaissance, and Baroque art, with stylistic divisions for key periods of the modern era. Also embedded in this edition is the narrative of how art has changed over time in the cultures that Europe has claimed as its patrimony.

WHAT'S NEW IN JANSON'S HISTORY OF ART?

"The history of art is too vast a field for anyone to encompass all of it with equal competence."

H. W. JANSON, from the Preface to the first edition of History of Art

Janson's History of Art in its eighth edition is once again the product of careful revision by a team of scholars with different specialties, bringing a readily recognized knowledge and depth to the discussions of works of art. We incorporate new interpretations such as the reidentification of the "Porticus Aemilia" as Rome's Navalia, or ship-shed (p. 186); new documentary evidence, such as that pertaining to Uccello's Battle of San Romano (p. 538); and new interpretive approaches, such as the importance of nationalism in the development of Romanticism (Chapter 24).

Organization and Contextual Emphasis

Most chapters integrate the media into chronological discussions instead of discussing them in isolation from one another, which reflected the more formalistic approach used in earlier editions. Even though we draw connections among works of art, as Janson did, we emphasize the patronage and function of works of art and

the historical circumstances in which they were created. We explore how works of art have been used to shore up political or social power.

Interpreting Cultures

Western art history encompasses a great many distinct chronological and cultural periods, which we wish to treat as distinct entities. So we present Etruscan art as evidence for Etruscan culture, not as a precursor of Roman or a follower of Greek art. Recognizing the limits of our knowledge about certain periods of history, we examine how art historians draw conclusions from works of art. The boxes called The Art Historian's Lens allow students to see how the discipline works. They give students a better understanding of the methods art historians use to develop arthistorical arguments. Primary Sources, a distinguishing feature of Janson for many editions, have been incorporated throughout the chapters to support the analysis provided and to further inform students about the cultures discussed, and additional documents can be found in the online resource, MyArtsLab. (See p. xi for more detail.)

Women in the History of Art

Women continue to be given greater visibility as artists, as patrons, and as an audience for works of art. Inspired by contemporary approaches to art history, we also address the representation of women as expressions of specific cultural notions of femininity or as symbols.

Objects, Media, and Techniques

Many new objects have been incorporated into this edition to reflect the continuous changes in the discipline. The mediums we discuss are broad in scope and include not only modern art forms such as installations and earth art, but also the so-called minor arts of earlier periods—such as tapestries, metalwork, and porcelain. Discussions in the Materials and Techniques boxes illuminate this dimension of art history.

The Images

Along with the new objects that have been introduced, every reproduction in the book has been reexamined for excellence in quality, and when not meeting our standards has been replaced. Whenever possible we obtain our photography directly from the holding institutions to ensure that we have the most accurate and authoritative illustrations. Every image that could be obtained in color has been acquired. To further assist both students and teachers, we have sought permission for electronic educational use so that instructors who adopt Janson's History of Art will have access to an extraordinary archive of high-quality (over 300 dpi) digital images for classroom use. (See p. xi for more detail on the Prentice Hall Digital Art Library.)

New Maps and Timelines

A new map program has been created to both orient students to the locations mentioned in each chapter and to better tell the story of the chapter narrative. Readers now can see the extent of the Eastern and Western Roman Empires, as well as the range of the Justinian's rule (p. 236). They can trace the migration routes of tribes during early medieval times (p. 314) and the Dutch trade routes of the seventeenth century (p. 702). This enriching new feature provides an avenue for greater understanding of the impact of politics, society, and geography on the art of each period. End of chapter timelines recap in summary fashion the art and events of the chapter, as well as showing key contemporaneous works from previous chapters (for example, pp. 345 and 759).

Chapter by Chapter Revisions

The following list includes the major highlights of this new edition:

CHAPTER 1: PREHISTORIC ART

Expands upon the methods scholars (both art historians and anthropologists) use to understand artwork, including, for instance, feminist interpretations. Includes new monuments such as Skara Brae and Mezhirich. A new box explains dating techniques.

CHAPTER 2: ANCIENT NEAR EASTERN ART

This chapter is expanded to include a discussion of Jerusalem.

CHAPTER 3: EGYPTIAN ART

Now includes a tomb painting from the pre-Dynastic age, and a discussion of jewelry. A new box names the major Egyptian gods.

CHAPTER 4: AEGEAN ART

Improved images and a reconstruction of Mycenae enhance the discussion of Aegean art.

CHAPTER 5: GREEK ART

This chapter is tightened to allow space for longer discussion of Greek sanctuaries, and the inclusion of Hellenistic works outside of the Greek mainland, such as the Pharos at Alexandria. The issue of homosexuality in fifth-century Athens is addressed, as well as women's roles in life and art. A new box deals with the issue of repatriation of works of art such as the Elgin marbles.

CHAPTER 6: ETRUSCAN ART

The range of artworks is increased to include, for instance, terracotta revetments and terra-cotta portraits.

CHAPTER 7: ROMAN ART

This chapter includes new interpretations such as the reidentification of the "Porticus Aemilia" as Rome's Navalia or ship-shed. It also has been tightened to allow space for more Republican works (such as the terra cotta pediment from Via di San Gregorio and the Praeneste mosaic) and a wider discussion of life in Pompeii. There is some rearrangement of art works to improve the chronological flow.

CHAPTER 8: EARLY CHRISTIAN AND BYZANTINE ART

A new section on early Jewish art is added, including three images of early synagogue wall paintings and mosaics (Dura Europos and Hammath Tiberias). Coverage of Late Byzantine art is increased, as is discussion of liturgical and social history.

CHAPTER 9: ISLAMIC ART

The relationship of Islamic art to early Jewish and Christian medieval art is accentuated.

CHAPTER 10: EARLY MEDIEVAL ART

Includes an expanded discussion and reorganization of Viking art, which is now placed later in the chapter.

CHAPTER 11: ROMANESQUE ART

Coverage of secular architecture is broadened to include the bridge at Puente la Reina on the pilgrimage route to Santiago de Compostela and a new section on the crusades and castle architecture.

CHAPTER 12: GOTHIC ART

This chapter is tightened to allow space for added focus on secular objects and buildings with the inclusion of a Guillaume de Machaut manuscript illumination and Westminster Hall from the royal palace in London. There is also expanded discussion of courtly art and royal iconography in later Gothic monuments.

CHAPTER 13: ART IN THIRTEENTH-AND FOURTEENTH-CENTURY ITALY

Organization now places less emphasis on religious architecture. Siena's Palazzo Pubblico is added. There is a more focused discussion of Tuscany, and a briefer treatment of Northern Italy and Venice. Images of key works of art, including Nicola and Giovanni Pisano and the Arena chapel are improved. Two maps in the chapter outline Italian trade routes and the spread of the plague in the 1340s.

CHAPTER 14: ARTISTIC INNOVATIONS IN FIFTEENTH-CENTURY NORTHERN EUROPE

Discussion of the Très Riches Heures du Duc de Berry is enlarged, and reproductions contrasting aristocratic "labors" and the images of peasants are added. Treatment of works by Van Eyck, Van der Weyden and Bosch is revised and sharpened. A new map of centers of production and trade routes in Northern Europe illustrates the variety of media produced in the region.

CHAPTER 15: THE EARLY RENAISSANCE IN FIFTEENTH-CENTURY ITALY

Reorganized for better flow and student comprehension, this chapter now begins with the Baptistery competition illustrating reliefs by both Ghiberti and Brunelleschi. It then looks at architectural projects by Brunelleschi and Alberti in Florence as a group, considering their patronage and function as well as their form. New art illustrates Brunelleschi's innovations at the Duomo, while his work at San Lorenzo is expanded to include the

Old Sacristy. Section on domestic life has been revised, but it still offers a contextualized discussion of works such as Donatello's David, Uccello's Battle of San Romano and Botticelli's Birth of Venus. This section now includes the Strozzi cassone at the Metropolitan Museum of Art in New York and Verrocchio's Lady with a Bunch of Flowers. The discussion of Renaissance style throughout Italy is revised for greater clarity.

CHAPTER 16: THE HIGH RENAISSANCE IN ITALY, 1495-1520

A discussion of the portrait of Ginevra de' Benci is now included, permitting a revised discussion of the Mona Lisa. The section on the Stanza della Segnatura is revamped to focus on The School of Athens. Treatment of Giorgione and Titian is reorganized and revised to reflect current discussions of attribution and collaboration. A new Titian portrait, Man with a Blue Sleeve, is included.

CHAPTER 17: THE LATE RENAISSANCE AND MANNERISM IN SIXTEENTH-CENTURY ITALY

Florence in the sixteenth century is reorganized and refreshed with new images, including a view of the architectural context for Pontormo's Pietà. Michelangelo's New Sacristy is treated in terms of architecture as well as sculpture. Ducal Palaces of the Uffizi and the Pitti and of the Boboli Gardens receives a new focus. Cellini's Saltceller of Francis I is discussed in its Florentine context. Treatment of Il Gesù is revamped. New images enliven the Northern Italian art section and Sofonisba Anguissola's Self Portrait is compared to Parmigianino's. There is a revised consideration of Palladio, and a new Titian, The Rape of Europa, exemplifies the artist's work for elite patrons.

CHAPTER 18: RENAISSANCE AND REFORMATION IN SIXTEENTH-CENTURY NORTHERN EUROPE

Discussion of France, as well as Spain, is revised and images are improved. Includes new images and discussions of Cranach and Baldung: Cranach's Judgment of Paris in New York replaces another version of this theme, while Baldung is represented by his woodcut of The Bewitched Groom of 1544. The discussion of Holbein is enlivened by consideration of his Jean de Dinteville and Georges de Selve ("The Ambassadors"), allowing examination of him as an allegorist as well as a portraitist. Gossaert is now represented by the Neptune and Amphitrite of 1516, while a new Patinir, the triptych of The Penitence of Saint Jerome, represents the landscape specialty of that region.

CHAPTER 19: THE BAROQUE IN ITALY AND SPAIN

Chapter content benefits from insights gained through recent exhibitions and from the inclusion of new architectural image components. New illustrations better expand understanding of the Roman Baroque and the role of the Virgin in Spanish art, including a view of the Piazza Navonna that shows Bernini's Four Rivers Fountain and as well as Borromini's church of S. Agnese, a cut-away of Borromini's complex star-hexagon shaped church,

S. Ivo, and one of Murillo's many depictions of the *Immaculate Conception* (St. Petersburg).

CHAPTER 20: THE BAROQUE IN THE NETHERLANDS

The importance of trade, trade routes and interest in the exotic is explored in this chapter. Gender issues—and the relationship between men and women—and local, folk traditions (religious and secular) play a role here in the exploration of the visual culture and social history. New images include: Peter Paul Rubens' The Raising of the Cross—the entire open altarpiece; Peter Paul Rubens' Four Studies of the Head of a Negro; Jacob Jordaens' The King Drinks; Judith Leyster's The Proposition; Rembrandt van Rijn's Bathsheba with King David's Letter, and Vermeer's Officer and Laughing Girl.

CHAPTER 21: THE BAROQUE IN FRANCE AND ENGLAND

New scholarship from the *Poussin and Nature: Arcadian Visions* exhibition in 2008 informs a more developed discussion of this artist's work. A fuller discussion of the role of the 1668 Fire of London and the re-building of St. Paul's Cathedral, in addition to a three-dimensional reconstruction of St. Paul's and a modern reconstruction of Sir Christopher Wren's plan of the city of London drawn just days after the fire, expands the coverage of this architect.

CHAPTER 22: THE ROCOCO

Expresses in greater depth the concept of the Rococo, the role of Madame da Pompadour and the expansion of the Rococo style in Germany. New images include Francois Boucher's *Portrait of Madame de Pompadour* (Munich); Jean-Simeon Chardin's *The Brioche (the Dessert)* and Egid Quirin Asam's interior and altar of the Benedictine Church at Rohr. Sections of this chapter are reorganized to accommodate the removal of Marie-Louise Élisabeth Vigée-Lebrun, Sir Thomas Gainsborough and Sii Joshua Reynolds to Chapter 23.

CHAPTER 23: ART IN THE AGE OF THE ENLIGHTENMENT, 1750-1789

Slightly restructured, the chapter keeps Neoclassicism and early Romanticism separated, thus making them more clearly defined. Joshua Reynolds, Thomas Gainsborough, and Vigée-Lebrun are placed here and into the context of Neoclassicism and Romanticism. Antonio Canova also is moved to this chapter to emphasize his importance in the development of Neoclassicism. Image changes include Joseph Wright's more clearly Romantic *The Old Man and Death*; Ledoux's Custom House with the entrance to the Saltworks at Arc-et-Senans; as well as the addition of Canova's tomb of Archduchess Maria Christina.

CHAPTER 24: ART IN THE AGE OF ROMANTICISM, 1789-1848

This chapter is tightened and has several new images. William Blake is now represented by *Elohim Creating Adam* and Corot by *Souvenir de Montrefontaine (Oise)*. Frederick Church's *Twilight in*

the Wilderness is added. The discussion of architecture is changed by placing the Empire style at the very end, thus keeping the Neoclassical revival together.

CHAPTER 25: THE AGE OF POSITIVISM: REALISM, IMPRESSIONISM, AND THE PRE-RAPHAELITES, 1848-1885

Includes a number of image changes to better focus discussions. These include: Monet's *Gare St. Lazare*; Rossetti's *Proserpine*; Nadar's portrait *Édouard Manet*; and Le Gray's *Brig on the Water*.

CHAPTER 26: PROGRESS AND ITS DISCONTENTS: POST-IMPRESSIONISM, SYMBOLISM, AND ART NOUVEAU, 1880-1905

Now incorporates discussions of vernacular, or amateur, photography, represented by Henri Lartigue's *Avenue du Bois de Bologne; Woman with Furs*, and the advent of film, represented by Thomas Edison's *New Brooklyn to New York via Brooklyn Bridge*.

CHAPTER 27: TOWARD ABSTRACTION: THE MODERNIST REVOLUTION, 1904-1914

Discussion of the formal and stylistic developments between 1904 and 1914 that culminated in abstractionism is tightened and the number of images reduced.

CHAPTER 28: ART BETWEEN THE WARS

More compact discussion structured around the impact of World War I and the need to create utopias and uncover higher realities, especially as seen in Surrealism.

CHAPTER 29: POSTWAR TO POSTMODERN, 1945-1980

Polke is placed here from Chapter 30, thus putting him within the context of an artist influenced by Pop Art. David Hammons is moved to Chapter 30. Betye Saar's *Shield of Quality* adds a woman to the discussion of African-American artists.

CHAPTER 30: THE POSTMODERN ERA: ART SINCE 1980

Architecture is reduced, and fine art is expanded. Neo-Expressionism benefits from the addition of Julian Schnabel's *The Exile*. The multi-culturalism of the period receives greater emphasis, especially feminism. Barbara Kruger is placed in a more feminist context with inclusion of a new image, *Untitled (We Won't Play Nature to Your Culture)*. The discussion of African-American identity is broadened by the placement of David Hammons here, and by the addition of Kara Walker's *Insurrection (Our Tools Were Rudimentary, Yet We Pressed On)*. Fred Wilson's *Mining the Museum* is also included. The discussion of González-Torres now stresses his involvement with the AIDS crisis. The importance of large-scale photography for the period is reinforced by the addition of Andreas Gursky's *Shanghai*. The truly global nature of contemporary art is strengthened by the addition of El Antsui's *Dzesi II*.

Acknowledgments

We are grateful to the following academic reviewers for their numerous insights and suggestions on improving Janson:

Amy Adams, College of Staten Island Susan Benforado Baker, University of Texas Arlington Jennifer Ball, Brooklyn College Dixon Bennett, San Jacinto College - South Diane Boze, Northeastern State University Betty Ann Brown, California State University - Northridge Barbara Bushey, Hillsdale College Mary Hogan Camp, Whatcom Community College Susan P. Casteras, University of Washington Cat Crotchett, Western Michigan University Tim Cruise, Central Texas College Julia K. Dabbs, University of Minnesota - Morris Adrienne DeAngelis, University of Miami Sarah Diebel, University of Wisconsin-Stout Douglas N. Dow, Kansas State University Kim Dramer, Fordham University Brian Fencl, West Liberty State College Monica Fullerton, Kenyon College Laura D. Gelfand, The University of Akron Alyson A. Gill, Arkansas State University Maria de Jesus Gonzalez, University of Central Florida

Bobette Guillory, Carl Albert State College Bertha Steinhardt Gutman, Delaware County Community College Marianne Hogue, University of North Carolina - Wilmington Stephanie Jacobson, St. John's University Ruth Keitz, University of Texas - Brownsville Joanne Kuebler, Manhattan College Adele H. Lewis, Arizona State University Lisa Livingston, Modesto Junior College Diane Chin Lui, American River College B. Susan Maxwell, University of Wisconsin-Oshkosh Paul Miklowski, Cuyahoga Community College Charles R. Morscheck Jr., Drexel University Elaine O'Brien, California State University – Sacramento Matthew Palczynski, Temple University Jason Rosenfeld, Marymount Manhattan College Phyllis Saretta, The Metropolitan Museum of Art Onoyom Ukpong, Southern University and A & M College Kristen Van Ausdall, Kenyon College Marjorie S. Venit, University of Maryland Linda Woodward, Montgomery College Ted M. Wygant, Dayton Beach Community College

The contributors would like to thank John Beldon Scott, Whitney Lynn, and Nicole Veilleux for their advice and assistance in developing this edition. We also would like to thank the editors and staff at Pearson Education including Sarah Touborg, Helen Ronan, Barbara Cappuccio, Marlene Gassler, Cory Skidds, Brian Mackey, David Nitti, and Carla Worner who supported us in our work. At Laurence King Publishing, Susie May, Kara Hattersley-Smith, Julia Ruxton, Amanda Russell, and Simon Walsh oversaw the production of this new edition.

Faculty and Student Resources for Teaching and Learning with Janson's History of Art

an outstanding array of high quality resources for teaching and learning with *Janson's History of Art*. Please contact your local Prentice Hall representative (use our rep locator at www.pearsonhighered.com) for more details on how to obtain these items, or send us an email at art.service@pearson.com.

www.myartslab.com Save time, improve results. MyArtsLab is a robust online learning environment providing you and

your students with the following resources:

Complete and dynamic e-book Illustrated and printable flashcards Unique "Closer Look" tours of over 125 key works of art Pre-and post-tests for every chapter of the book Customized study plan that helps students focus in on key areas Primary Sources with critical thinking questions Writing Tutorials for the most common writing assignments

Available at no additional charge when packaged with the text. Learn more about the power of MyArtsLab and register today at www.myartslab.com

THE PRENTICE HALL DIGITAL ART LIBRARY. Instructors who adopt *Janson's History of Art* are eligible to receive this

unparalleled resource containing every image in *Janson's History of Art* in the highest resolution (over 300 dpi) and pixilation possible for optimal projection and easy download. Developed and endorsed by a panel of visual curators and instructors across the country, this resource features images in jpeg and in PowerPoint, an instant download function for easy import into any presentation software, along with a zoom and a save-detail feature.

COURSESMART ETEXTBOOKS ONLINE is an exciting new choice for students looking to save money. As an alternative to

purchasing the print textbook, students can subscribe to the same content online and save up to 50% off the suggested list price of the print text. With a CourseSmart eTextbook, students can search the text, make notes online, print out reading assignments that incorporate lecture notes, and bookmark important passages for later review. For more information, or to subscribe to the CourseSmart eTextbook, visit www.coursesmart.com.

CLASSROOM RESPONSE SYSTEM (CRS) IN CLASS QUESTIONS (ISBN: 0-205-76375-8). Get instant, classwide responses to beautifully illustrated chapter-specific questions during a lecture to gauge students' comprehension—and keep them engaged. Contact your local Pearson representative for details.

MYTEST (ISBN: 0-205-/6391-X) is a commercial-quality computerized test management program available for both Microsoft Windows and Macintosh environments.

A SHORT GUIDE TO WRITING ABOUT ART, 10/e (ISBN: 0-205-70825-0) by Sylvan Barnet. This best-selling text has guided tens of thousands of art students through the writing process. Students are shown how to analyze pictures (drawings, paintings, photographs), sculptures and architecture, and are prepared with the tools they need to present their ideas through effective writing. Available at a discount when purchased with the text.

INSTRUCTOR'S RESOURCE MANUAL WITH TEST BANK (ISBN: 0-205-76374-X, download only) is an invaluable professional resource and reference for new and experienced faculty, containing sample syllabi, hundreds of sample test questions, and guidance on incorporating media technology into your course.

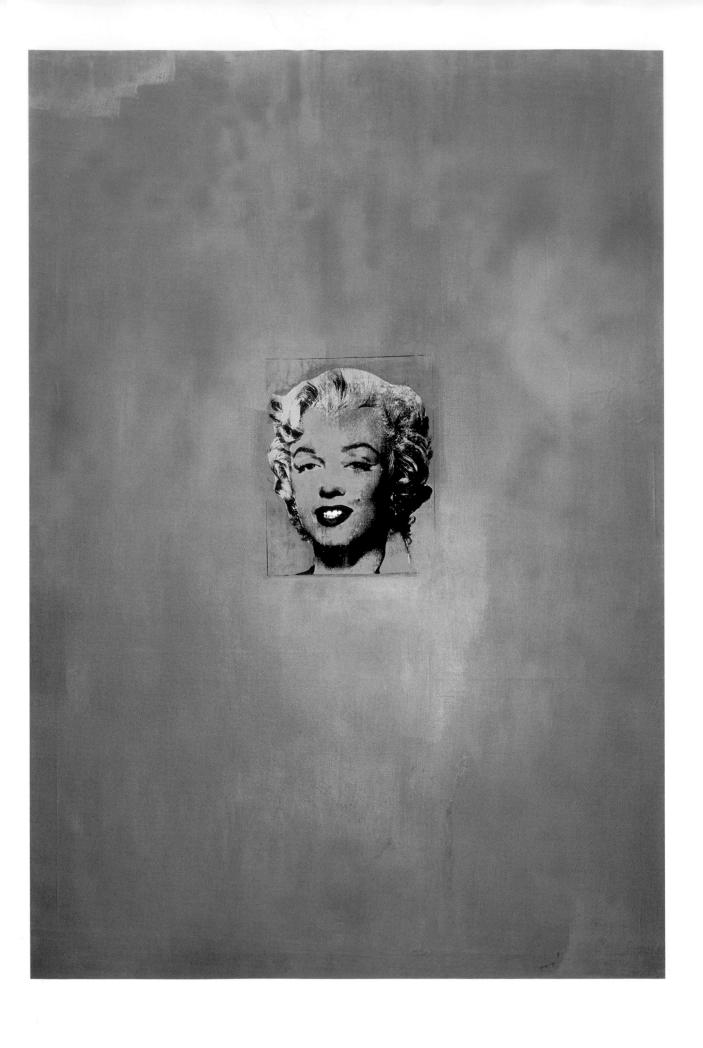

Introduction

Gold Marilyn Monroe (fig. I.1)? This almost 7-foot-high canvas was produced shortly after the death of the Hollywood screen star and sex symbol. It was not commissioned and obviously Monroe never "sat" for it, an activity that we generally associate with portraiture. Instead, Warhol

worked from a press photograph, a still from the 1953 movie *Niagara*, which he cropped to his liking and then transferred onto canvas using **silkscreen**. This process involves mechanically transferring the photograph onto a mesh screen, or in this case several screens, one for each color, and pressing printing ink through them onto canvas. Warhol then surrounded Marilyn's head with a field of broadly brushed gold paint.

Warhol's painting is not a conventional portrait of Monroe but rather a pastiche of the public image of the film star as propagated by the mass media. Warhol imitates the sloppy, gritty look and feel of color newspaper reproductions of the period, when the colors were often misregistered, aligning imperfectly with the image, and the colors themselves were "off," meaning not quite right. The Marilyn we are looking at is the impersonal celebrity of the media, the commodity being pushed by the film industry. She is supposedly glamorous, with her lush red lipstick and bright blond hair, but instead she appears pathetically tacky because of the grimy black ink and the garish color of her blond hair as it becomes bright yellow and her flesh tone turns pink. Her personality is impenetrable, reduced to a sad, lifeless public smile. Prompted by Monroe's suicide, *Gold Marilyn Monroe* presents the real Marilyn—a depressed, often miserable person, who, in

I.1 Andy Warhol, *Gold Marilyn Monroe*. 1962. Synthetic polymer paint, silk-screened, and oil on canvas, $6'11'_4" \times 4'9"$ (2.11 × 1.44 m). Museum of Modern Art, New York. Gift of Philip Johnson 316.1963

this textureless, detailless, unnaturalistic image, is becoming a blur fading into memory. Warhol has brilliantly expressed the indifference of the mass media, whose objective is to promote celebrities by saturating a thirsty public with their likenesses but which tells us nothing meaningful about them and shows no concern for them. Monroc's image is used simply to sell a product, much as the alluring and often jazzy packaging of Brillo soap pads or Campbell's soup cans is designed to make a product alluring without telling us anything about the product itself. The packaging is just camouflage. As a sentimental touch, Warhol floats Marilyn's head in a sea of gold paint, embedding her in an eternal realm previously reserved for use in icons of Christ and the Virgin Mary, which immerse these religious figures in a spiritual aura of golden, heavenly light (see fig. 13.22). But Warhol's revered Marilyn is sadly dwarfed by her celestial gold surrounding, adding to the tragic sense of this powerful portrait, which trenchantly comments on the enormous gulf existing between public image and private reality.

If we turn the clock back some 200 years and look at a portrait by the Boston painter John Singleton Copley, we again see an image of a woman (fig. I.2). But, made as it was in a different time and context, the story surrounding the painting is entirely different. The sitter is Freelove Olney Scott, and she is presented as a refined-looking woman, born, we would guess, into an aristocratic family, used to servants and power. As a matter of fact, we have come to accept Copley's portraits of colonial Bostonians, such as Mrs. Joseph Scott, as accurate depictions of their subjects

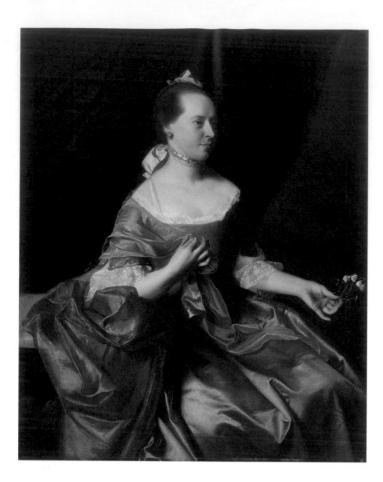

I.2 John Singleton Copley, Mrs. Joseph Scott.
Oil on canvas, 69½ × 39½" (176.5 × 100 cm).
The Newark Museum, Newark, New Jersey. 48.508

and lifestyles. But many, like Mrs. Scott, were not what they appear to be. So, who was Mrs. Scott? Let's take a closer look at the context in which the painting was made.

Copley is recognized as the first great American painter. Working in Boston from about 1754 to 1774, he became the most sought-after portraitist of the period. Copley easily outstripped the meager competition, most of whom actually earned their living painting signs and coaches. After all, no successful British artist had any reason to come to America. The economically struggling colonies were not a strong market for art. Only occasionally was a portrait commissioned, and typically, artists were treated like craftsmen rather than intellectuals. Like most colonial portraitists, Copley was largely self-taught, learning his trade by looking at black-and-white prints of paintings by the European masters.

As we can see in *Mrs. Joseph Scott*, Copley was a master of painting textures, which is all the more astonishing when we remember that he had no one to teach him the tricks of the painter's trade. His pictorial illusions are so convincing, we think we are looking at real silk, ribbons, lace, pearls, skin, hair, and marble, quite the opposite of Warhol's artificial Marilyn. Copley's contemporaries also marveled at his sleight of hand. No other colonial painter attained such a level of realism.

But is Copley just a "face painter," as portraitists were derogatorily called at the time, offering mere resemblances of his sitters and their expensive accourtements? Is this painting just a means to replicate the likeness of an individual in an era before the advent of photography? The answer to both questions is a

resounding "no." Copley's job was not just to make a faithful image of Mrs. Scott, but to portray her as a woman of impeccable character, limitless wealth, and aristocratic status. The flowers she holds are a symbol of fertility, faithfulness, and feminine grace, indicating that she is a good mother and wife, and a charming woman. Her expensive dress was imported from London, as was her necklace. Copley undoubtedly copied her pose from one of the prints he had of portraits of British or French royalty.

Not only is Mrs. Scott's pose borrowed, but most likely her clothing is as well, for her necklace appears on three other women in Copley portraits. In other words, it was a studio prop, as the dress may have been too. In fact, except for Mrs. Scott's face, the entire painting is a fiction designed to aggrandize the wife of a newly wealthy Boston merchant who had made his fortune selling provisions to the occupying British army. The Scotts were *nouveau-riche* commoners, not titled aristocrats. By the middle of the eighteenth century, rich Bostonians wanted to distinguish themselves from the multitude, and so, after a century of trying to escape their British roots, from which many had fled to secure religious freedom, they now sought to imitate the British aristocracy, even to the point of taking tea in the afternoon and owning English Spaniels, a breed that in England only aristocrats were permitted to own.

Joseph Scott commissioned this painting of his wife, as well as a portrait of himself, not just to record their features, but to show off the family's wealth. The pictures were extremely expensive and therefore status symbols, much as a Rolls-Royce or a Tiffany diamond ring are today. The portraits were displayed in the

public spaces of their house so that they could be readily seen by visitors. Most likely they hung on either side of the mantel in the living room, or in the entrance hall. They were not intended as intimate affectionate resemblances destined for the bedroom. If patrons wanted cherished images of their loved ones, they would commission miniature portraits, which captured the likeness of the sitter in amazing detail and were often so small they could be encased in a locket that a woman would wear on a chain around her neck, or a gentleman would place in the inner breastpocket of his coat, close to the heart.

Warhol and Copley worked in very different times, a fact that has tremendous effect on the look and meaning of their portraits. Their paintings were made to serve very different purposes, and consequently they tell very different stories. And because art always serves a purpose, it is impossible for an artist to make a work that does not represent a point of view and tell a story, sometimes many stories. As we will see, great artists tell great and powerful stories. We shall find that an important key to unraveling these stories is understanding the context in which the work was made.

THE POWER OF ART AND THE IMPACT OF CONTEXT

In a sense, art is a form of propaganda, for it represents an individual's or group's point of view, and this view is often presented as truth or fact. For centuries, art was used by church and state to propagate their importance, superiority, and greatness. *The Alba Madonna* (fig. **I.3**), for example, was designed to proclaim the idealized, perfect state of existence attainable through Catholicism in sixteenth-century Italy, while the Arch of Titus (fig. **I.4**) was erected to reinforce in the public's mind the military prowess of the first-century Roman emperor. Even landscape

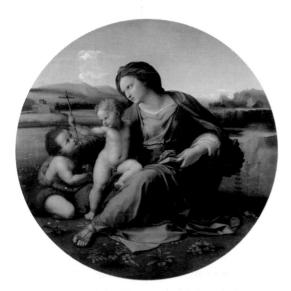

I.3 Raphael, *The Alba Madonna*. ca. 1510. Oil on panel transferred to canvas, diameter 37¼" (94 cm). Image courtesy of the Board of Trustees, National Gallery of Art, Washington, D.C., Andrew W. Mellon Collection, 1937.1.24. (24)

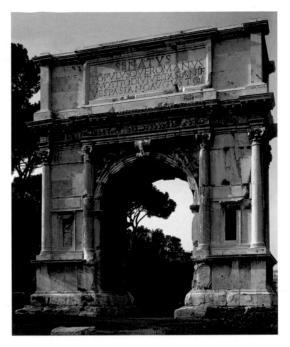

I.4 Arch of Titus, Forum Romanum, Rome. ca. 81 CE (restored)

paintings and still lifes of fruit, dead game, and flowers made in the seventeenth century are loaded with moral messages, and are far from simple attempts to capture the splendor and many moods of nature or show off the painter's finesse at creating a convincing illusionistic image.

Epitomizing the power of art is its ability to evoke entire historical periods. The words "ancient Egypt" will conjure up in most people's minds images of the pyramids, the Sphinx, and flat stiff figures lined up sideways across the face of stone (fig. I.5). Or look at the power of Grant Wood's famous 1930 painting

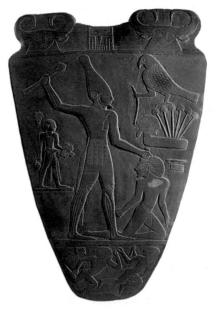

1.5 Palette of King Narmer, from Hierakonpolis. ca. 3150–3125 BCE. Slate, height 25" (63.5 cm). Egyptian Museum, Cairo

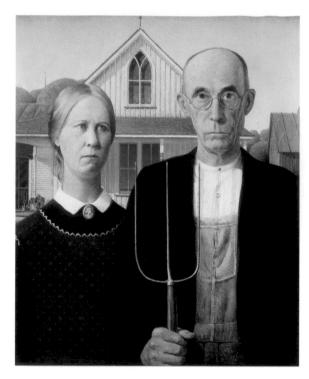

I.6 Grant Wood, American Gothic. 1930. Oil on beaverboard, 30¹¹/₁₆" × 25¹¹/₁₆" (78 × 65.3 cm). Unframed. Friends of American Art Collection. 1930.934. The Art Institute of Chicago

American Gothic (fig. I.6), which has led us to believe that humorless, austere, hardworking farmers dominated the American hinterlands at the time. The painting has virtually become an emblem of rural America for the period.

American Gothic has also become a source of much sarcastic humor for later generations, which have adapted the famous pitchfork-bearing farmer and his sour-faced daughter for all kinds of agendas unrelated to the artist's original message. Works of art are often later appropriated to serve purposes quite different from those initially intended, with context heavily influencing the meaning of a work. The reaction of some New Yorkers to The Holy Virgin Mary (fig. I.7) by Chris Ofili reflects the power of art to provoke and spark debate, even outrage. The work appeared in an exhibition titled Sensation: Young British Artists from the Saatchi Collection, presented at the Brooklyn Museum in late 1999. Ofili, who is a Briton of African descent, made an enormous picture of a black Virgin Mary using tiny dots of paint, glitter, map pins, and collaged images of genitalia from popular magazines. Instead of hanging on the wall, this enormous painting rested on two large wads of elephant dung, which had been a signature feature of the artist's large canvases since 1991. Elephant dung is held sacred in some African cultures, and for Ofili, a devout Catholic who periodically attends Mass, the picture was a modernization of the traditional presentation of the elemental sacredness of the Virgin, with the so-called pornographic images intended to suggest both procreation and hovering naked angels. While intentionally provocative, the picture was not conceived as an attack on the Catholic religion.

Many art historians, critics, and other viewers found the picture remarkably beautiful—glittering and shimmering with a delicate, ephemeral otherworldy aura. Many, especially Catholics, however, were repulsed by Ofili's homage to the Virgin and were infuriated. Instead of viewing the work through Ofili's eyes, they placed the painting within the context of their own experience and beliefs. Consequently, they interpreted the dung and graphic imagery—and perhaps even the black Virgin, although this was never mentioned—as sacrilegious. Within days of the opening of the exhibition, the painting had to be placed behind a large Plexiglas barrier. One artist hurled horse manure at the façade of the Brooklyn Museum, claiming, "I was expressing myself creatively," a defense often offered for Ofili. Another museum visitor sneaked behind the Plexiglas barrier and smeared the Virgin with white paint in order to cover her up. The biggest attack came from New York's mayor, Rudolph Giuliani, a Catholic, who was so outraged that he tried, unsuccessfully, to stop city funding for the museum. The public outrage at Ofili's work is just part of a long tradition that probably goes back to the beginning of image making. Art has consistently provoked anger, just as it has inspired pride, admiration, love, and respect, and the reason is simple: Art is never an empty container but rather a vessel loaded with meaning, subject to multiple interpretations, and always representing someone's point of view.

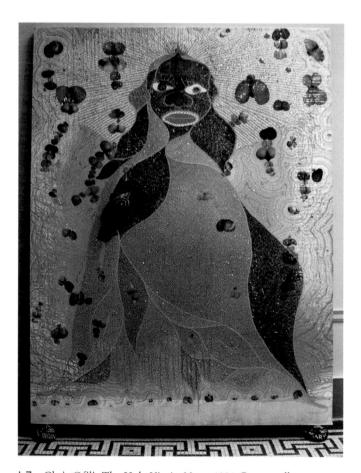

1.7 Chris Ofili, *The Holy Virgin Mary*. 1996. Paper, collage, oil paint, glitter, polyester resin, map pins, and elephant dung on linen, $7'11" \times 5'11\%6"$ (2.44 × 1.83 m). Victoria Miro Gallery, London

Because the context for looking at art constantly changes, our interpretations and insights into art and entire periods evolve as well. For example, when the first edition of this book was published in 1962, women artists were not included, which was typical for textbooks at the time. America, like most of the world, was male-dominated and history was male-centric. Historically, women were expected to be wives and mothers, and to stay in the home and not have careers. They were not supposed to become artists, and the few known exceptions were not taken seriously by historians, who were mostly male. The feminist movement, beginning in the mid-1960s, overturned this restrictive perception of women. As a result, in the last 40 years, art historians—many of them female—have "rediscovered" countless women artists who had attained a degree of success in their day. Many of them were outstanding artists, held in high esteem during their lifetimes, despite the enormous struggle to overcome powerful social and even family resistance against women becoming professional artists.

One of these "lost" women artists is the seventeenth-century Dutch painter Judith Leyster, a follower, if not a student, of the famed Frans Hals. Over the subsequent centuries, Leyster's paintings were either attributed to other artists, including Hals and Gerrit van Honthorst, or they were labeled "artist unknown." At the end of the nineteenth century, however, Leyster was rediscovered in her own right through an analysis of her signature, documents, and style, and her paintings were gradually restored to her name. It was only with the feminist movement that she was elevated from a minor figure to one of the more accomplished painters of her generation, one important enough to be included in basic histories of art. The feminist movement provided a new context for evaluating art, one that had an interest in rather than a denial of women's achievements and a study of issues relating to gender and how they appear in the arts.

A work like Leyster's Self-Portrait (fig. I.8) is especially fascinating from this point of view. Its size and date (ca. 1633) suggest that this may have been the painting the artist submitted as her presentation piece for admission into the local painters' guild, the Guild of St. Luke of Haarlem. Women were not generally encouraged to join the guild, which was a male preserve that reinforced the professional status of men. Nor did women artists generally take on students. Leyster bucked both traditions, however, as she carved out a career for herself in a man's world. In her self-portrait, she presents herself as an artist armed with many brushes, suggesting her deft control of the medium—an idea that the presentation picture itself was meant to demonstrate. On the easel is a segment of a genre scene of which several variations are known. We must remember that at this time artists rarely showed themselves working at their easels, toiling with their hands: They wanted to separate themselves from mere artisans and laborers, presenting themselves as intellectuals belonging to a higher class. As a woman defying male expectations, however, Leyster needed to declare clearly that she was indeed an artist. But she cleverly elevates her status by not dressing as an artist would when painting. Instead, she appears as her patrons do in their portraits, well-dressed and well-off. Her mouth is open, in what is called a

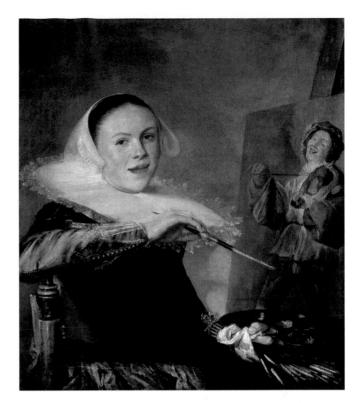

1.8 Judith Leyster, *Self-Portrait*. ca. 1633. Oil on canvas, 293/4 × 255/8" (72.3 × 65.3 cm). National Gallery of Art, Washington, D.C. Gift of Mr. and Mrs. Robert Woods Bliss

"speaking likeness" portrait, giving her a casual but self-assured animated quality, as she appears to converse on equal terms with a visitor, or with us. Leyster, along with Artemisia Gentileschi and Marie-Louise-Élisabeth Vigée-Lebrun, who also appear in this book, was included in a major 1976 exhibition titled *Women Artists* 1550–1950, which was shown in Los Angeles and Brooklyn, and played a major role in establishing the importance of women artists.

WHAT IS ART?

Ask most people "What is art?," and they will respond with the words "an oil painting" or "a marble or bronze sculpture." Their principal criterion is that the object be beautiful—whatever that may be—although generally they will probably define this as the degree to which a painting or sculpture is real looking or adheres to their notion of naturalism. Technical finesse or craft is viewed as the highest attribute of art making, capable of inspiring awe and reverence. Epitomizing these values is Greek and Roman sculpture, such as the fourth-century BCE sculpture the *Apoxyomenos* (Scraper) (fig. I.9), which for centuries was considered the high point of fine art. To debunk the myth that art is only about technique and begin to get at what it is really about, we return to Warhol's Gold Marilyn Monroe. The painting is rich with stories, one of which is how it poses questions about the meaning of art,

how it functions, and how it takes on value, both financial and aesthetic. Warhol even begs the question of the significance of technical finesse in art making, an issue raised by the fact that he wants to give us the impression that he may not have even touched this painting himself. We have already seen how he appropriated someone else's photograph of Monroe, not even taking his own. Warhol then instructed his assistants to make the screens for the printing process. They may also have prepared the canvas, screened the image with the colors Warhol selected, and even painted the gold to Warhol's specifications.

By using assistants to make his work, Warhol is telling us that art is not necessarily about the artist's technical finesse, but about communicating an idea using visual language. The measuring stick for quality in art is the quality of the statement being made, or its philosophy, as well as the quality of the technical means for making this statement, even if not executed by the artist. Looking at Gold Marilyn Monroe in the flesh at New York's Museum of Modern Art is a powerful, even unforgettable experience. Standing in front of this large canvas, we cannot help but feel the

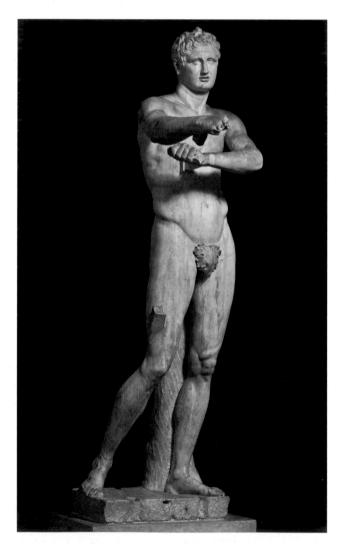

1.9 Apoxyomenos (Scraper). Roman marble copy, probably after a bronze original of ca. 330 BCE by Lysippos. Height 6'9" (2.1 m). Musei Vaticani, Rome

empty glory of America's most famous symbol of female sexuality and stardom. Because the artist's vision, and not his touch, is the relevant issue for the production of this particular work, it is of no consequence that Warhol makes it seem as though he never laid a hand on the canvas except to sign the back. We shall see shortly, however, that the artist's touch is indeed often critical to the success of a work of art, which is especially true for art made before 1900.

Warhol openly declared that his art was not about his technical ability when he named his midtown Manhattan studio "The Factory." By doing so, he told us that art was a commodity, and that he was manufacturing a product, even a mass-produced one. The factory churned out over a thousand paintings and prints of Marilyn based on the same publicity still. All Warhol appeared to do for the most part was sign them, his signature reinforcing the importance people placed on the idea of the artist's signature itself being an essential part of the work. Ironically, most Old Master paintings, dating from the fourteenth through the eighteenth centuries, are not signed; and despite giving the public the impression that he had little involvement in his work, Warhol was a workaholic and very hands-on in the production of his art.

Moreover, artists have been using assistants to help make their pictures for centuries. Peter Paul Rubens, an Antwerp painter working in the first half of the seventeenth century and one of the most famous artists of his day, had an enormous workshop that cranked out many of his paintings, especially the larger works. His assistants often specialized in particular elements such as flowers, animals, or clothing, for example, and many went on to become successful artists in their own right. Rubens would design the painting, and then assistants, trained in his style, would execute individual parts. Rubens would then come in at the end and pull the painting together as needed. The price the client was willing to pay often determined how much Rubens himself participated in the actual painting of the picture: Many of his works were indeed made entirely by him, and therefore commanded the highest prices. Rubens's brilliant flashy brushwork was in many respects critical to the making of the picture. Not only was his handling of paint considered superior to that of his assistants, the very identity of his paintings—their very life, so to speak—was linked to his unique genius in applying paint to canvas, almost as much as it was to the dynamism of his dramatic compositions. His brushwork complemented his subject matter. The two went hand in hand.

Warhol was not the first artist to make art that intentionally raised the issue of what art is and how it functions. This distinction belongs to the humorous and brilliant Parisian Marcel Duchamp, one of the most influential artists of the twentieth century. In 1919, Duchamp took a postcard reproduction of Leonardo da Vinci's Mona Lisa, which hangs in the Louvre Museum in Paris, and drew a moustache on the sitter's face (fig. I.10). Below he wrote the letters, "L.H.O.O.Q.," which when pronounced in French is elle a chaud au cul, or "She's got the hots." Duchamp was poking fun at the public's fascination with the mysterious smile on the Mona Lisa, which had intrigued

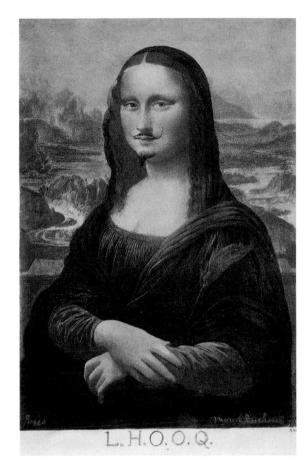

1.10 Marcel Duchamp, *Mona Lisa (L.H.O.O.Q.)*. 1919. Rectified readymade; pencil on a postcard reproduction, $7 \times 4\%$ (17.8 × 12 cm). Private collection

viewers for centuries and eluded suitable explanation. Duchamp irreverently provided one: She is sexually aroused. With the child-ish gesture of affixing a moustache to the image, Duchamp also attacked bourgeois reverence for Old Master painting, as well as the age-old ideal of oil painting representing the pinnacle of art.

Art, Duchamp is saying, can be made by merely drawing on a mass-produced reproduction. Artists can use any imaginable medium in any way in order to express themselves: not just oil on canvas or cast bronze or chiseled marble sculpture He is announcing that art is about ideas that are made visually, and not necessarily about craft. In this deceptively whimsical work, which is actually rich in ideas, Duchamp is telling us that art is anything someone wants to call art—which is not the same as saying it is good art. Furthermore, he is proclaiming that art can be small, since Mona Lisa (L.H.O.O.Q.) is a fraction of the size of its source, the Mona Lisa. By appropriating Leonardo's famous picture and interpreting it very differently from traditional readings (see pages 564-66), Duchamp suggests that the meaning of art is not fixed forever by the artist, that it can change and be reassigned by viewers, writers, collectors, and museum curators, who may use it for their own purposes. Lastly, and this is certainly one of Duchamp's many wonderful contributions to art, he is telling us that art can be fun, that it can defy conventional notions of beauty, and while intellectually engaging us in a most serious manner, it can also provide us with a smile, if not a good belly laugh. Many historians today consider *Mona Lisa* (*L.H.O.O.Q*) as important as Leonardo's *Mona Lisa*, and put the two artists on the same plane of importance.

ART AND AESTHETICS: THE ISSUE OF BEAUTY

Mona Lisa (L.H.O.O.Q.) also raised the issue of aesthetics, which is the study of theories surrounding art, including the definition of beauty and the meaning and purpose of art. Duchamp selected the Mona Lisa for appropriation for many reasons, one of them no doubt being that many people considered it the greatest and therefore the most beautiful painting ever made. Certainly, it was one of the most famous paintings in the world, if not the most famous. In 1919, most of those who held such a view had probably never seen it and only knew if from reproductions, probably no better than the one Duchamp used in Mona Lisa (L.H.O.O.Q.). And yet, they would describe the original painting as beautiful, but not Duchamp's comical version.

Duchamp called altered found objects such as *Mona Lisa* (*L.H.O.O.Q.*) "readymades" (for other examples, see *Bicycle Wheel*, fig. 27.29, and *Fountain*, fig. 28.2), and he was adamant that these works had no aesthetic value whatsoever. They were not to be considered beautiful; they were aesthetically neutral. What interested Duchamp were the ideas that these objects embodied once they were declared art.

Despite his claim, Duchamp's readymades can be perceived as beautiful, in ways, of course that are quite different from Leonardo's *Mona Lisa*, but beautiful all the same. *Mona Lisa* (*L.H.O.O.Q.*) has an aura about it, an aura of wit and ideas that are specific to Duchamp. As a result, this slightly altered cheap color postcard is a compelling work of art. The qualities that attract us to it, which we can describe as its beauty, could not be further from those of Leonardo's *Mona Lisa*, which have more to do with composition, color, and paint handling. Ultimately, beauty, in many respects, can be equated with quality, which to a large degree hinges on the power of the statement, not some pre-conceived notion of visual beauty.

Beauty is not just a pretty colorful picture or a perfectly formed, harmonious nude marble figure such as the *Apoxymenos*. Beauty resides as well in content and how successfully this content is made visual. This book is intended to suggest the many complex ways that quality, and thus beauty, manifests itself in art. Some of the greatest paintings are grotesque, depicting horrific scenes that many people do not find acceptable, but they are nonetheless beautiful—scenes such as beheadings, crucifixions (fig. I.11), death and despair, emotional distress, and the brutal massacre of innocent women and children. Like Duchamp's *Mona Lisa (L.H.O.O.Q.)*, these works possess an aura that makes them riveting, despite the repulsiveness of their subject matter. They have quality, and to those who recognize and feel this quality, this

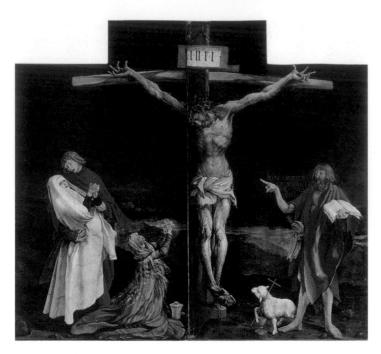

I.11 Matthias Grünewald, *The Crucifixion* (center panel). ca. 1509/10–15. Oil on panel, $9'9\frac{1}{2}" \times 10'9"$ (2.97 × 3.28 m). Musée d'Unterlinden, Colmar, France

makes them beautiful. Others will continue to be repulsed and offended by them, or at best fail to find them interesting.

ILLUSIONISM AND MEANING IN ART

The Roman historian Pliny tells the story about the competition between the Greek painters Zeuxis and Parrhasius to see who could make the most realistic work. Zeuxis painted grapes so real that birds tried to eat them. But it was Parrhasius who won the competition when he made a painting of a curtain covering a painting. So realistic was the work that Zeuxis asked him to pull back the curtain covering his painting only to discover that he was already looking at the painting.

Pliny's story is interesting, because despite a recurring emphasis on illusionism in art, the ability to create illusionistic effects and "fool the eye" is generally not what determines quality in art, and if it were, thousands of relatively unknown artists today would be considered geniuses. As we just discussed, quality in art comes from ideas *and* execution. Just being clever and fooling the eye is not enough.

A look at the sculpture of twentieth-century artist Duane Hanson shows us how illusionism can be put in the service of meaning to create a powerful work of art. Hanson's 1995 sculpture *Man on a Mower* (fig. I.12) is a work that is too often appreciated only for its illusionistic qualities, while the real content goes unnoticed. Yet, it is the content, not the illusionism itself, that makes this sculpture so powerful. Hanson began making his sculptures in the late 1960s, casting his figures in polyester resin, and then meticulously painting them. He then dressed them in

real clothing, used real accessories (including wigs and artificial eyeballs), and placed them with real bits of furniture. Most viewers are startled to discover his sculptures are not real people, and many have tried to interact with his characters, which include museum guards, tourists, shoppers, house painters, and sunbathers.

But Hanson's art is about more than just a visual sleight of hand. He is also a realist and a moralist, and his art is filled with tragic social commentary. By "realist," we mean that his sculpture is not limited to attractive, beautiful, and ennobling people, objects, and situations, but instead focuses on the base, crude, and unseemly. In *Man on a Mower*, which, with the exception of the lawnmower and aluminum can, is painted cast bronze, we see an overweight man clutching a diet soda. He dwarfs the riding mower he sits on. His T-shirt, baseball hat, pants, and sneakers are soiled. He is ordinary, and the entire sculpture is remarkably prosaic.

Man on a Mower is a tragic work. We see disillusionment in the man's eyes as he blankly stares off into space. The diet soda he holds suggests that he is trying to lose weight but is losing the battle. Cutting grass is another metaphor for a losing battle, since the grass is going to grow back. This work also represents the banality of human existence. What is life about? The monotony of cutting grass. In this last work, made when he knew he was dying of cancer, Hanson captured what he perceived to be the emptiness of human existence and contemporary life in the modern world. The illusionism of the sculpture makes this aura of alienation and lack of spirituality all the more palpable. This man is us, and this is our life, too. He embodies no poetry, nobility, or heroism. Our twentieth-century Man on a Mower has no fine causes or beliefs to run to as he confronts the down-to-earth reality of life and death.

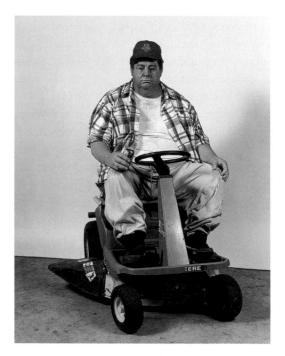

I.12 Duane Hanson, Man on a Mower. 1995.Bronze, polychromed in oil, with mower. Life-size.Courtesy Van de Weghe Fine Art, New York

CAN A MECHANICAL PROCESS BE ART? PHOTOGRAPHY

The first edition of this book did not include photography, reflecting on attitude dating back to the introduction of photography in 1839 that the medium, because it was largely a mechanical process, was not an art form, or certainly not one that had the same merit as painting and sculpture. Within the last 25 years, however, photography has been vindicated. Along with video and film, it has been elevated to the status of one of the most important artistic mediums, perhaps even outstripping painting. Pictures from the nineteenth and twentieth centuries that had interested only a handful of photography insiders suddenly became intensely sought-after, with many museums rushing to establish photography departments and amass significant collections. In other words, it took well over 125 years for people to understand photography and develop an eye for the special qualities and beauties of the medium, which are so radically different from those of the traditional twin peaks of the visual arts, painting and sculpture.

We need only look at a 1972 photograph titled Albuquerque (fig. I.13) by Lee Friedlander to see how photography operates as an artistic medium. In his black-and-white print, called a gelatin silver print since the pre-exposed paper surface consists of silver in a gelatin solution, Friedlander portrays a modern America which, he suggests, has been rendered vacuous and lifeless by modernity and twentieth-century technology. How does he make such a statement? The picture obviously has a haunting emptiness, for it contains no people and is instead filled with strange vacant spaces of walkway and street that appear between the numerous objects, such as a fire hydrant, street signs, and traffic light, that pop up everywhere. A hard, eerie geometry prevails, as seen in the strong verticals of poles, buildings, and wall. Cylinders, rectangles, and circles can be found throughout the composition, even in the background apartment building and the brick driveway in the foreground.

Despite the stillness and sense of absence, the picture is busy and restless. The vertical elements create a vibrant staccato rhythm, which is reinforced by the asymmetrical composition lacking a focus or center, and by the powerful intersecting diagonals of the street and foreground wall. Friedlander crafted his composition so carefully he gets the shadow of the hydrant to parallel the street. Disturbing features appear everywhere. There is a lopsided telephone pole, suggesting collapse. And there is the pole for a street sign, the top of which has been cropped, that visually cuts a dog in two while casting a mysterious shadow on a nearby wall. The fire hydrant appears to be mounted incorrectly, sticking too far out of the ground. The car on the right has been brutally cropped and appears to have a light pole sprouting from its hood. The entire picture is dominated by technology and synthetic, industrial, or mass-produced objects. Nature has been cemented over, reduced to a few straggly trees in the middle ground and distance and the thriving weeds surrounding the

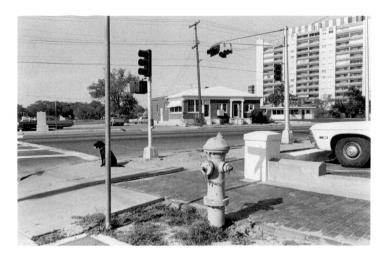

I.13 Lee Friedlander, *Albuquerque*. 1972. Gelatin silver print, 11×14 " (27.9 × 35.6 cm)

hydrant. In this brilliant print, Friedlander powerfully suggests that technology, mass-produced products, and a fast fragmented lifestyle are spawning alienation and a disconnection with nature. Friedlander also suggests that modernization is also making America homogeneous—if it were not for the title, we would have no idea that this photograph was taken in Albuquerque, New Mexico.

Friedlander did not just find this composition. He very carefully made it. He not only wanted a certainly quality of light for his picture, but probably even waited for the sun to cast shadows that aligned perfectly with the street. When framing the composition, he meticulously incorporated a fragment of the utility cover in the lower left foreground, while axing a portion of the car on the right. Nor did the geometry of the picture just happen. He made it happen. Instead of a soft focus that would create an atmospheric blurry picture, he used a deep focus that produces a sharp crisp image filled with detail, allowing, for example, the individual rectangular bricks in the pavement to be clearly seen. The strong white tones of the vertical rectangles of the apartment building, the foreground wall, and the utility box blocking the car on the left edge of the picture were most likely carefully worked up in the darkroom, as was the rectangular columned doorway on the house. Friedlander has exposed the ugliness of modern America in this hard, cold, dry image, and because of the power of its message has made an extraordinarily beautiful work of art, the kind of image that has elevated photography into the pantheon of art.

HOW ARCHITECTURE TELLS STORIES

An art form that is basically abstract and functional might be seen as a poor candidate for telling stories, conveying messages, and disseminating propaganda. And yet it can. We see Gianlorenzo Bernini doing it in 1657 when he was asked by Pope Alexander XVII to design a large open space, or piazza, in front of St. Peter's

Cathedral in Rome. Bernini's solution was to create a plaza that was defined by a colonnade, or row of columns, resembling arms that appear to embrace visitors maternally, welcoming them into the bosom of the church (fig. I.14). He thus anthropomorphized the building by emphasizing the identification of the church with the Virgin Mary. At the same time, the French architect Claude Perrault was commissioned to design the façade of Louis XIV's palace, the Louvre in Paris (fig. I.15). To proclaim the king's grandeur, he made the ground floor, where the day-to-day business of the court was carried out, a squat podium. In contrast, the second floor, where the royal quarters were located and Louis would have held court, was much higher and grander and served as the main floor, clearly supported by the worker-bee floor. Perrault articulated this elevated second story with a design that recalled Roman temples, thus associating Louis XIV with imperial Rome and worldly power. The severe geometry and symmetry of the building reflect the regimented order and tight control of Louis XIV's reign.

At first glance, it seems hard to project any story onto Frank Lloyd Wright's Solomon R. Guggenheim Museum (fig. I.16), a museum that, when it was built between 1956 and 1959, was largely dedicated to abstract art. Located on upper Fifth Avenue in New York and overlooking Central Park, the building resembled for many a flying saucer; it was certainly radically different from the surrounding residential apartment buildings, and for that matter, almost anything built anywhere up to that time. But if we had to guess, we would probably first divine that the building might be a museum, for the exterior resembles a work of art a giant nonobjective sculpture. Made of reinforced concrete, the building even seems as though it were made from an enormous mold that formed its continuous upward spiral, which from any one side appears to consist of enormous, weighty, massive horizontal bands. There is no mistaking this structure for an apartment complex or office building.

Wright conceived the Guggenheim in 1945-46, when he received the commission, and his personal goal was to create an organic structure that deviated from the conventional static rectangular box filled with conventional rectangular rooms. The building is designed around a spiral ramp (fig. I.17), which is meant to evoke a spiral shell, and this ramp is what defines the design of the exterior. Wright also thought of the interior as a ceramic vase, for it is closed at the bottom, widens as it rises, and is "open" at the top since it is capped by a spectacular light-filled, cone-shaped glass roof. Essentially, the museum is a single ramplined space, although there are a handful of galleries off the ramp and separate spaces for offices, auditorium, and bookstore, for example. Wright expected visitors to take an elevator to the top of the ramp, and then slowly amble down its 3 percent gradient, gently pulled along by gravity. Because the ramp was relatively narrow, viewers could not stand too far back from the art, which seemed to float on the curved walls, enhancing the fluid effect of Wright's curved, organic design. As a result, visitors were forced into a more intimate relationship with the art. At the same time, however, they could look back across the open space of the room to see where they had gone, comparing the work in front of them to a segment of the exhibition presented on a sweeping distant arc, Or they could look ahead as well, to get a preview of where they were going.

Not only do visitors see the art, they also see other visitors, sometimes just as distant specks, winding their way down the ramp. The building has a sense of continuity and mobility that Wright viewed as an organic experience, analogous to traveling along the continuous winding paths of the adjacent Central Park, which was designed in the nineteenth century to capture and preserve nature in the encroaching urban environment. Wright's enormous "room" reflects nature not only in its spiral shell design, but also in the organic concave and convex forms that can be seen from the top of ramp and that reflect the subtle eternal movement of nature. Wright even placed a lozenge-shaped pool on the ground floor, directly opposite the light entering from the skylight above, the two architectural touches reinforcing a sense of nature. Art historians have also likened the sense of constant

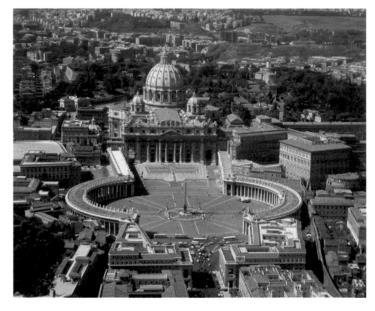

I.14 St. Peter's, Rome. Nave and façade by Carlo Maderno, 1607–15; colonnade by Gianlorenzo Bernini, designed 1657

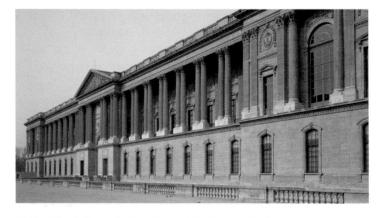

1.15 Claude Perrault. East front of the Louvre, Paris. 1667–70

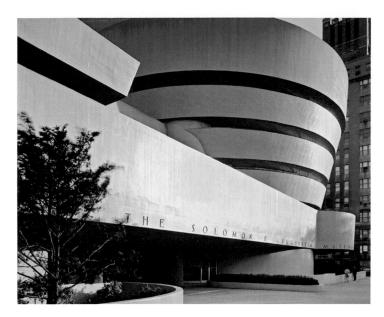

1.16 Frank Lloyd Wright. The Solomon R. Guggenheim Museum, New York. 1956–59

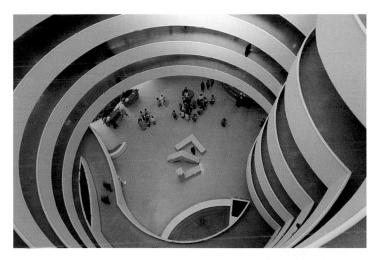

I.17 Frank Lloyd Wright. Interior of the Solomon R. Guggenheim Museum, New York. 1956-59

movement in Wright's seemingly endless ramp—which most people now ascend rather than descend because exhibitions begin at the foot of the ramp—to the American frontier, the ramp embodying "the expansive, directionless response of the frontiersman to limitless space," as expressed by James Fenimore Cooper's Natty Bumppo, Herman Melville's whaling chase, Mark Twain's Mississippi, and Walt Whitman's Open Road. Far-fetched as this may sound, we must remember that Wright was born in the Midwest in the nineteenth century, when it was still rural, and beginning with his earliest mature buildings, his designs, such as the Robie House (see fig. 26.39), were meant to capture the vast spread of the plains and were carefully integrated into the land.

If Wright's austere, abstract sculptural design for both the exterior and interior undermines his attempt to evoke nature, the building still retains a sense of open space and continuous movement. Unlike any other museum, the Guggenheim has a sense of communal spirit, for here everyone is united in one large room and traveling the same path.

EXPERIENCING ART

You will be astonished when you see first-hand much of the art in this book. No matter how accurate the reproductions here, or in any other text, they are no more than stand-ins for the actual objects. We hope you will visit some of the museums where the originals are displayed. But keep in mind that looking at art, absorbing its full impact, takes time and repeated visits. In many respects, looking at art is no different than reading a book or watching a film—it requires extensive, detailed looking, a careful reading of the image or object, perhaps even a questioning of why every motif, mark, or color is used. Ideally, the museum will help you understand the art. Often, there are introductory text panels that tell you why the art has been presented as it is and what it is about, and ideally there will be labels for individual works that provide further information. Major temporary exhibitions gener ally have a catalog, which adds further information and sometimes another layer of interpretation. But text panels, labels, and catalogues generally reflect one person's reading of the art: Keep in mind there are usually many other ways to approach or think about it.

Art museums are relatively new. Before the nineteenth century art was not made to be viewed in museums, so when you are looking at work in a museum, you are often viewing it out of the original context in which it was meant to be seen. Much work can still be seen in its original context—churches, cathedrals, chateaux, public piazzas, and archaeological sites. Ultimately, however, art can be found everywhere—in commercial galleries, corporate lobbies and offices, places of worship, and private homes. It is displayed in public spaces, from subway stations and bus stops to public plazas and civic buildings such as libraries, performing arts centers, and city halls. University and college buildings are often filled with art, and the buildings themselves are art. The chair you are sitting in and the house or building you are reading this book in are also works of art-maybe not great art, but art all the same, as Duchamp explained. Even the clothing you are wearing is in a sense art, and for you it is a way to make a personal statement. Everywhere you find art, it is telling you something, and supporting a point of view.

Art is not a luxury, as many people would have us believe, but an integral part of daily life. It has a major impact on us, even when we are not aware of it, for we feel better about ourselves when we are in environments that are visually enriching and exciting. Most important, art stimulates us to think. Even when it provokes and outrages us, it broadens our experience by making us question our values, attitudes, and worldview. This book is an introduction to this fascinating field that is so intertwined with our lives. After reading it, you will find that the world will no longer look the same.

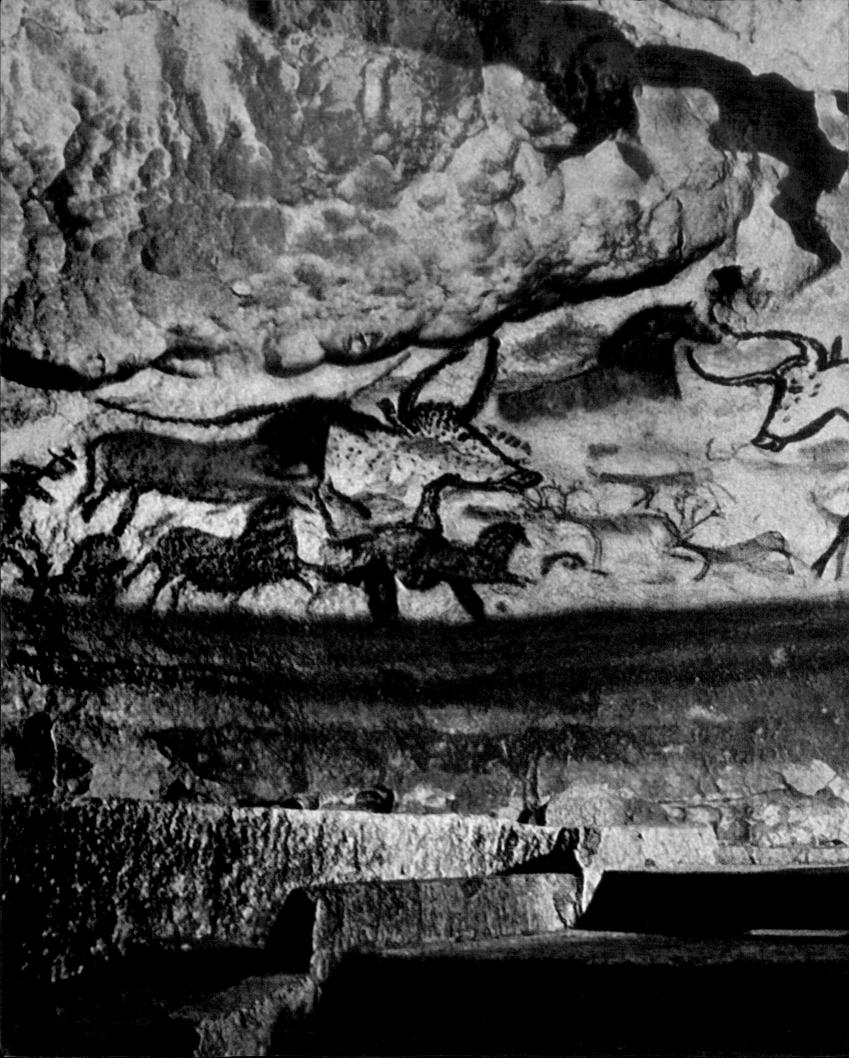

Prehistoric Art

then Modern Humans first encountered prehistoric cave paintings in the 1870s, they literally could not believe their eyes. Although the evidence indicated that the site at Altamira in Spain dated to around 13,000 BCE, the paintings had been executed with such skill and sensitivity that historians initially considered them forgeries

(see fig 1.1). Since then, some 200 similar sites have been discovered all over the world. As recently as 1994, the discovery of a cave in southeastern France (see fig. 1.2) brought hundreds more paintings to light and pushed back the date of prehistoric painting even further, to approximately 30,000 BCE. Carved objects have been discovered that are equally old.

These earliest forms of art raise more questions than they answer: Why did prehistoric humans spend their time and energy making art? What functions did these visual representations serve? What do the images mean? Art historians often use contemporaneous written texts to supplement their understandings of art; prehistoric art, however, dates to a time before writing, for which works of art are among our only evidence. Art historians therefore deploy scientific and anthropological methods in their attempts to interpret them. Archaeologists report new finds with regularity, so the study of prehistoric art continues to develop and refine its interpretations and conclusions.

Fully modern humans have lived on the earth for over 100,000 years. At first they crafted tools out of stone and fragments of bone. About 40,000 years ago, they also began to make detailed representations of forms found in nature. What inspired this change? Some scholars suppose that image making and symbolic

Detail of figure 1.8, Hall of the Bulls, Lascaux Cave, Dordogne, France

language are the result of the new structure of the brain associated with homo sapiens sapiens. Art emerges at about the time that fully modern humans moved out of Africa and into Europe, Asia, and Australia, encountering—and eventually displacing—the earlier Neanderthals (homo neanderthalensis) of western Eurasia. On each of these continents, there is evidence of representational artwork or of body decoration contemporary with homo sapiens sapiens. Tens of thousands of works survive from this time before history, the bulk of which have been discovered in Europe. Many are breathtakingly accomplished.

The skill with which the earliest datable objects are executed may have been the product of a lengthy and lost period of experimentation in the techniques of carving and painting, so the practice of art making may be much older than the surviving objects. All the same, some scholars argue that a neurological mutation related to the structure of the brain opened up the capacity for abstract thought, and that symbolic language and representational art were a sudden development in human evolution. Whatever led to the ability to create art, whether a gradual evolutionary process, or a sudden mutation, it had an enormous impact on the emergence of human culture, including the making of naturalistic images. Such works force us to reevaluate many of our assumptions about art and the creative process, and raise fundamental questions, not least of which is why human beings make art at all.

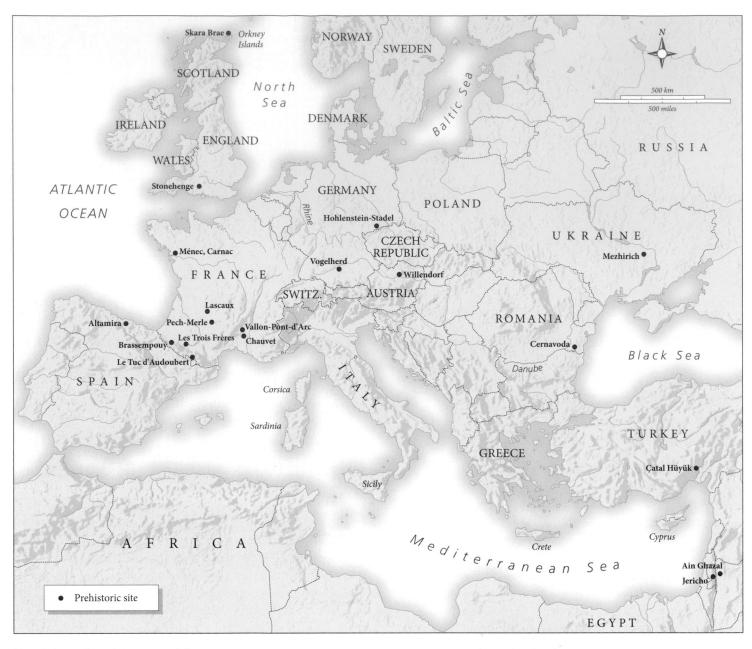

Map 1.1 Prehistoric Europe and the Near East

PALEOLITHIC ART

Upper Paleolithic painting, drawing, and sculpture appeared over a wide swath of Eurasia, Africa, and Australia at roughly the same time, between 10,000 and 40,000 years ago (map 1.1 and *Informing Art*, page 9). This time span falls in the Pleistocene era, more commonly known as the Ice Age, when glaciers (the extended polar ice caps) covered much of the northern hemisphere. The Lower and Middle Paleolithic periods extend back as far as 2 million years ago, when earlier species of the *homo genera* lived. These cultures crafted stone tools, which they sometimes decorated with abstract patterns. The end of the most recent Ice Age corresponded with the movement of fully modern humans out of Africa and into Europe, newly habitable as the warming climate caused the glaciers to recede.

Prehistoric paintings first came to light in 1878 in a cave named Altamira, in the village of Santillana del Mar in northern Spain. As Count Don Marcelino Sanz de Sautuola scoured the ground for flints and animal bones, his 12-year-old daughter, Maria, spied bison, painted in bold black outline and filled with bright earth colors (fig. 1.1), on the ceiling of the cave. There, and in other more recently discovered caves, painted and engraved images predominantly depict animals. The greatest variety known is in the vast cave complex of Chauvet, near Vallon-Pont-d'Arc in southeastern France, named after one of the spelunkers who discovered it in 1994. Here, the 427 animal representations found to date depict 17 species, including lions, bears, and aurochs (prehistoric oxen), in black or red outlines (fig. 1.2), and are sometimes polychromatic (containing several colors). Abstract shapes may accompany the animals, or appear alone, such as those depicted

1.1 Wounded Bison, Altamira, Spain. са. 15,000-10,000 все

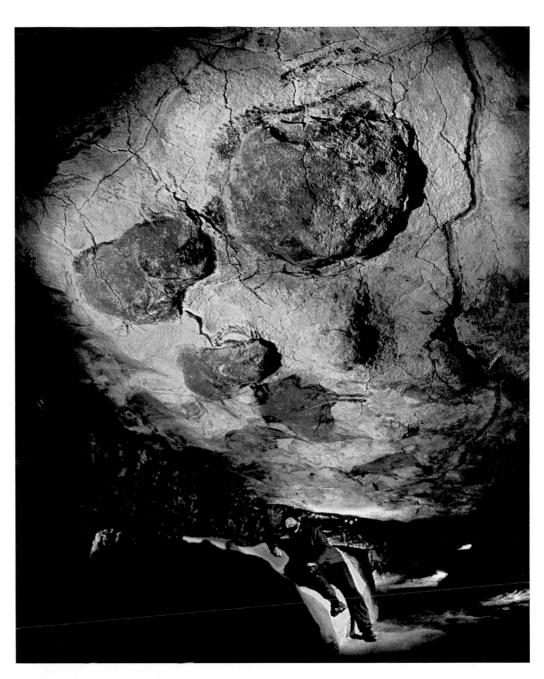

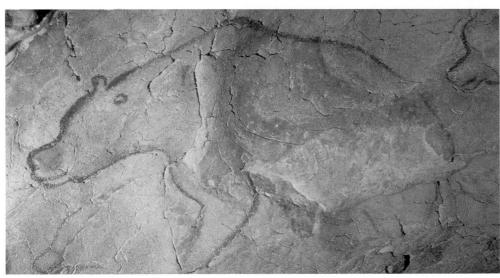

1.2 Bear, Recess of the Bears, Chauvet Cave, Vallon-Pont-d'Arc, Ardèche Gorge, France. ca. 30,000–28,000 BCE

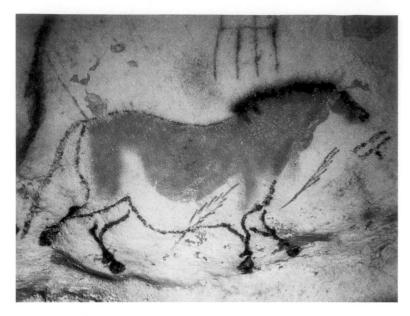

1.3 Chinese Horse, Lascaux Cave, Dordogne, France. ca. 15,000–13,000 BCE

next to the *Chinese Horse* at Lascaux in the Dordogne region of France (fig. 1.3). Scholars have interpreted these as weapons, traps, and even insects. Human hands occasionally feature on the cave walls, stamped in paint or, more usually, in negative

silhouette (see *Materials and Techniques*, page 5). In rare instances, images depict human or partly human forms. At Chauvet, for instance, archaeologists identified the lower half of a woman painted on a projection of rock. At Les Trois Frères, a site in the French Pyrenees, a human body depicted with its interior muscles and anatomy supports an animal head with antlers. At Lascaux, a male stick figure with a birdlike head lies between a woolly rhinoceros and a disemboweled bison, with a bird-headed stick or staff nearby (fig. 1.4).

On first assessing the Altamira paintings toward the end of the nineteenth century, experts declared them too advanced to be authentic and dismissed them as a hoax. Indeed, though cave art may represent the dawn of art as we know it, it is often highly sophisticated. Like their counterparts at Chauvet and elsewhere, the bison of Altamira were painted from memory, yet their forms demonstrate the painters' acute powers of observation and skill in translating memory into image. Standing at rest, or bellowing or rolling on the ground, the bison behave in these paintings as they do in the wild. The painters' careful execution enhances the appearance of nature: Subtle shading (modeling) expresses the volume of a bison's belly or a lioness's head, and the forward contour of an animal's far leg is often rendered with a lighter hue to suggest distance.

Initially, scholars assigned relative dates to cave paintings by using stylistic analysis, dating them according to their degree of **naturalism**, that is, how closely the image resembled the subject

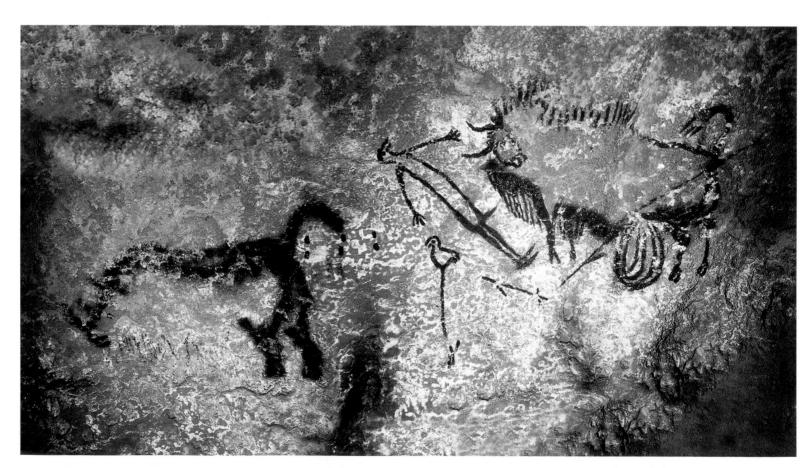

1.4 Rhinoceros, Wounded Man, and Bison, Lascaux Cave, Dordogne, France. ca. 15,000-13,000 BCE

Cave Painting

aleolithic cave artists used a wide variety of techniques to achieve the images that have survived. Often working far from cave entrances, they illuminated the darkness using lamps carved out of stone and filled with fat or marrow. Archaeologists have found several of these lamps at Lascaux and elsewhere. Sometimes, when the area of rock to be painted was high above ground level, they may have built scaffolds of wood, which they stabilized against the wall by driving the poles into the limestone surface.

They prepared the surface by scraping the limestone with stone tools, bringing out its chalky whiteness as a background. They then engraved some images onto the wall, with a finger if the limestone was soft enough, or with a sharp flint. Sometimes they combined this technique with the application of color. They created black using vegetal charcoal and perhaps charred bones. Ocher, a natural iron ore, provided a range of vivid reds, browns, and yellows. For drawing-outlines of animals, for instance—they deployed charcoal and ocher in chunks, like a crayon; to generate paint, they ground the minerals into powder on a large flat stone. By heating them to extremely high temperatures, they could also vary the shades of red and yellow. They could then blow these mineral powders through tubes of animal bone or reed against a hand held up with fingers splayed to the rock surface to make hand silhouettes.

To fill in animal or human outlines with paint, they mixed the powders with blenders, which consisted of cave water, saliva, egg white, vegetal or animal fat, or blood; they then applied the colors to the limestone surface, using pads of moss or fur, and brushes made of fur, feather, or chewed stick. Some scholars understand, by experimentation, that pigment was often chewed up In the mouth and then blown or spat directly onto the walls to form Images. In some cases, like the Spotted Horse of Pech-Merle or at Chauvet, artists applied paint in dots, leading to what some scholars describe as a "pointilliste" effect. They achieved this by covering the palm with ocher before

in nature. As art historians at that time considered naturalism the most advanced form of representation, the more naturalistic the image, the more evolved and, therefore, the more recent it was considered to be. Radiocarbon dating has since exposed the flaws in this approach, however (see Informing Art, page 17). Judged to be more recent in the overall sequence on account of their remarkable naturalism, some of the paintings at Chauvet in fact proved to be among the earliest on record, dating to about 32,000 years ago. It is thus a mistake to assume that naturalism was a Paleolithic artist's—or any artist's—inevitable or only goal. A consistent use of conventions in depicting individual species (bulls at Lascaux shown in profile but with frontal horns, for instance) defies nature; these are not optical images, showing an animal as one would actually see it, but composite ones, offering many of the details that go toward making up the animal portrayed, though not necessarily in anatomically accurate positions. As the "stick man" at Lascaux may illustrate, artists may have judged their success by standards quite removed from naturalism.

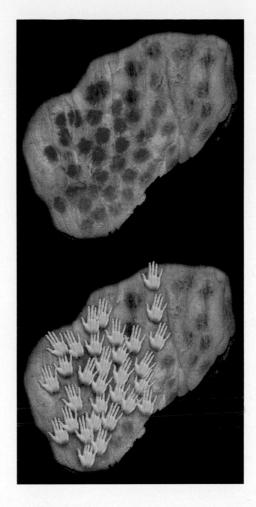

Hand dots in the Brunel Chamber at Chauvet. Large dots were made by covering the palm with paint and applying it to the wall. In places, fingers are just visible.

pressing it against the limestone. Analysis of these marks has yielded rich results: Not only can archaeologists identify individual artists by their handprint, but they have even been able to determine that women and adolescents were at work as well as men.

Interpreting Prehistoric Painting

As majestic as these paintings can be, they are also profoundly enigmatic: What purpose did they serve? The simplest view, that they were merely decorative—"art for art's sake"—is highly unlikely. Most of the existing paintings and engravings are readily accessible, while many more that once embellished caves that open directly to the outside have probably perished. But some, at Lascaux and elsewhere, lie deep inside extended cave systems, remote from habitation areas and difficult to reach (fig. 1.5). In these cases, the power of the image may have resided in its making, rather than in its viewing: the act of painting or incising the image may have served some ritual or religious purpose.

After the images' initial discovery, scholars turned to approaches developed by ethnographers (anthropologists who study cultural behavior) to interpret cave paintings and engravings. Most often, they have attributed the inspiration for these works to magico-religious motives. Thus, early humans may have perceived an image as equivalent to the animal it represented; to

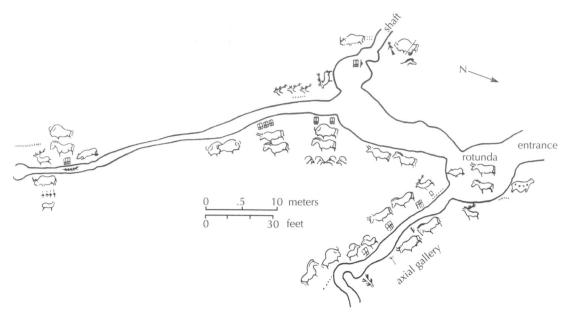

1.5 Schematic plan of Lascaux Cave system (based on a diagram by the Service de l'Architecture, Paris)

create or possess the image was to exert power over its subject, which might improve the success of a hunt. Gouge marks on cave walls indicate that in some cases spears were cast at the images (fig. 1.6). Similarly, artists may have hoped to stimulate fertility in the wild—ensuring a continuous food supply—by depicting pregnant animals. A magico-religious interpretation might explain the choice to make animals appear lifelike, and to control them by fixing them within outlines; conversely, human fear of falling victim to the same magic may account for the decidedly unnaturalistic, abstract quality of the "stick figure" at Lascaux.

More recent theories concerning shamanism—a belief in a parallel spirit world accessed through alternative states of con-

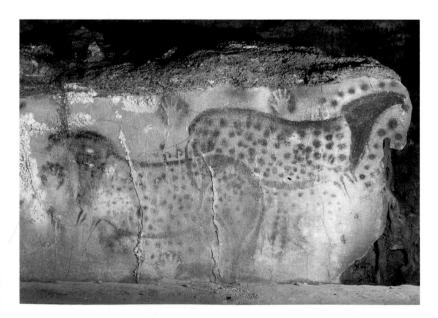

1.6 Spotted Horses and Human Hands, Pech-Merle Cave, Dordogne, France. Horses ca. 16,000 BCE; hands ca. 15,000 BCE. Limestone, approximate length 11'2" (3.4 m)

sciousness—build upon the earlier ethnographic interpretations, arguing that an animal's "spirit" was evident where a bulge in the wall or ceiling suggested its shape, as with the Spotted Horses (see fig. 1.6) at Pech-Merle in southwestern France. The artist's or shaman's power brought that spirit to the surface. Some scholars have cast the paintings in a central role in early religion, as images for worship. Others focus on a painting's physical context—this means examining relationships between figures to determine, in the absence of an artificial frame, a ground-line or a landscape, whether multiple animal images indicate individual specimens or a herd, and whether these images represent a mythical past for early communities. Do Lascaux's Rhinoceros, Wounded Man, and Bison (see fig. 1.4) constitute separate images or the earliest known narrative—the gory tale of a hunt, perhaps, or a shaman's encounter with his spirit creature? Multiple animal engravings, one on top of another, as at Les Trois Frères (fig. 1.7), may have recorded animal migrations throughout the passing seasons.

Assessing physical context also means recognizing that a cave 15 feet deep is a very different kind of space from another over a mile deep, and was possibly used for different purposes. Paintings in the spacious Hall of the Bulls at Lascaux and the stick man at the same site, located at the bottom of a 16-foot well shaft, may have functioned differently. It means factoring in the experiential aspects of caves: In order to reach these images, a prehistoric viewer had to contend with a precarious path, eerie flickering lights, echoing sounds, and the musty smells that permeate subterranean spaces, all of which added texture to the viewing process (fig. 1.8). Most important, recent interpretations acknowledge that one explanation may not suffice for all times and places. For instance, even if sympathetic magic makes sense of the Chinese Horse from Lascaux with its distended belly (see fig. 1.3), it hardly explains the art at Chauvet, where fully 72 percent of the animals represented were not hunted, judging by organic remains found in the cave.

1.7 Overlapping animal engravings, Les Trois Frères, France. ca. 40,000-10,000 BCE. Rubbing of the panel done by Abbé Breuil from Begohen Collection

Paleolithic Carving

Prehistoric artists also carved and modeled sculptures in a variety of materials. At just under a foot high, a carved figure from Hohlenstein-Stadel in Germany (fig. 1.9) represents a standing creature, half human and half feline, crafted out of mammoth ivory. Although it is now in a poor state of preservation, the creation of this figure, with rudimentary stone tools, was clearly an arduous business. It involved splitting the dried mammoth tusk, scraping it into shape, and using a sharp flint blade to incise such features as the striations on the arm and the muzzle. Strenuous polishing followed, using powdered hematite (an iron ore) as an abrasive. Exactly what the figure represents is unclear. Like the hybrid figures painted on cave walls (see fig. 1.4), it may represent a human dressed as an animal, possibly for hunting purposes. Some prehistorians have named these composite creatures shamans or "sorcerers," who could contact the spirit world through ritualistic behavior.

As in cave paintings, animals were frequent subjects for sculpture. A miniature horse from a cave in Vogelherd along the Danube River in Germany, and a pair of interlocked ibexes, date

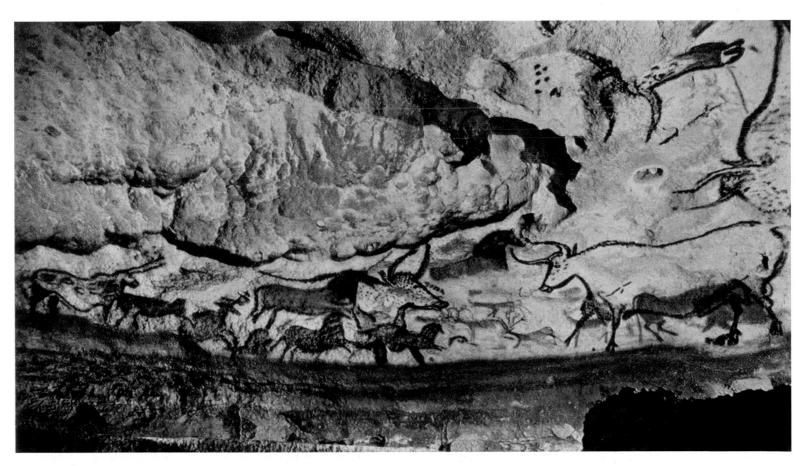

1.8 Hall of the Bulls, Lascaux Cave, Dordogne, France. ca. 15,000–13,000 BCE. Largest bull approximate length 11'6" (3.5 m)

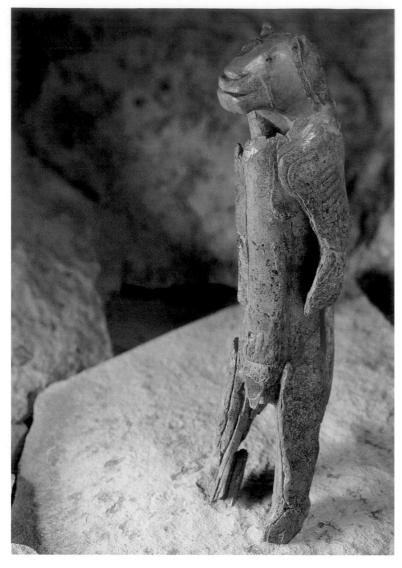

1.9 Hybrid figure with a human body and feline head, from Hohlenstein-Stadel (Baden-Württemberg), Germany. ca. 30,000 BCE. Mammoth ivory, height 11½" (29.6 cm). Ulma Museum, Ulm, Germany

to the beginning and end of the Upper Paleolithic era (figs. 1.10 and 1.11). The horse is one of many portable carvings in woolly mammoth ivory created around 28,000 BCE. A small hole between its front legs suggests that it was a pendant. The ibexes, carved from reindeer antler around 13,000 BCE, functioned as a spearthrower. Once attached to a spear by the hook at the end of its shaft, it allowed a hunter to propel the weapon more effectively. The sculptor had an eye for strong outlines and finished the surface with painstaking care, marking the ibexes' coats with nicks from a stone tool and working up a high polish.

Just as cave artists sometimes transformed bulges in rock walls into painted animals, so, deep within a cave at Le Tuc d'Audoubert in the French Pyrenees, around 13,000 BCE, a sculptor used clay to build up a natural outcropping of rock into two bison (fig. 1.12); a calf originally stood by the front legs of the right-hand figure. Each sculpture is about 2 feet long; their forms

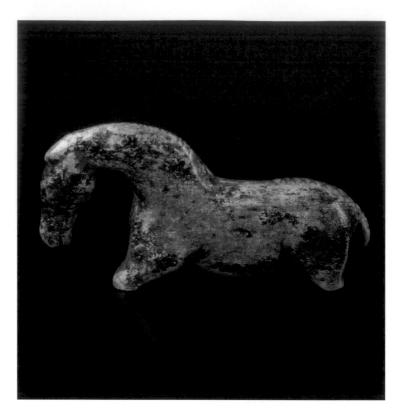

1.10 Horse, from Vogelherd Cave, Germany. ca. 28,000 BCE. Mammoth ivory, height 2" (5 cm). Institut für Urgeschichte, Universität Tübingen

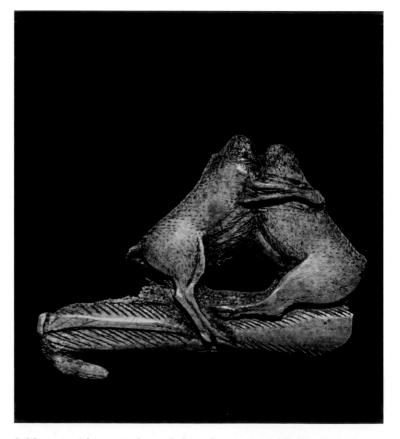

1.11 Spear Thrower with Interlocking Ibexes, Grotte d'Enlène, Ariège, France. ca. 16,000 BCE. Reindeer antler, $3\% \times 2\%$ " (9 × 7 cm). Musée de l'Homme, Paris

Telling Time: Labels and Periods

Ihile geologists have developed methods for dividing time based on the age of the Earth, historians have used the activity of toolmaking as the defining feature when measuring human time. For the era before the written word (prehistory), patterns apparent in stone tools serve as the basis for distinguishing different cultures. The Stone Age stretches from about 2 million years ago to about 2000 BCE.

Prehistorians divide this broad span of time into the Paleolithic or Old Stone Age (from the Greek palaio-, meaning "ancient," and lithos, meaning "stone"), the Mesolithic or Middle (meso-) Stone Age, and the Neolithic or New (neo-) Stone Age. The Paleolithic era reaches from 2 million years ago to about 10,000 BCE and the Mesolithic from about 10,000 to 8000 BCE. The Neolithic era spans from about 8000 to about 2000 BCE. At some time during the third millennium BCE, humans in some parts of the world replaced stone tools with tools made of metal, ushering in the Bronze Age in Europe and Asia.

Specific human cultures reached these phases at different times: The beginning of the Neolithic era appears to start earlier in western Asia than in Europe, for example. Yet the broad span of the Paleolithic era requires further refinement, and excavations of Paleolithic sites provide another framework for dividing time. The oldest material is at the bottom of an excavation, so scholars call the oldest Paleolithic era the Lower Paleolithic (ending about 100,000 years ago). The middle layers of Paleolithic excavations—thus the Middle Paleolithic era—date from 100,000 to about 40,000 years ago. The most recent layers in such excavations are called the Upper Paleolithic, and date from about 40,000 to around 8000 BCE.

Archaeologists have used many sites and different types of tools and tool-making technologies to identify specific culture groups within the Upper Paleolithic period. For example, they name the Aurignacian culture for Aurignac, a site in western France. The objects from this culture date from about 34,000 to 23,000 BCE. The Gravettian culture is named for La Gravette, a site in southwestern France, and dates from about 28,000 to 22,000 BCE. The most recent of these cultures is the Magdalenian, named for a site in southwestern France called La Magdaleine, with dates ranging from around 18,000 to 10,000 BCE. Many of these terms were coined in the nineteenth century, when the study of prehistoric culture first took root.

The Paleolithic Age

ower Paleolithic	2,000,000-100,000 BCE	
Middle Paleolithic	100,000-40,000 все 40,000-10,000 все	
Jpper Paleolithic		
Aurignacian	34,000-23,000 BCE	
Gravettian	28,000-22,000 BCE	
Solutrean	22,000-18,000 BCE	
Maddalenian	18 000-10 000 BCE	

10,000-8000 BCE Mesolithic Neolithic 8000-2000 BCE

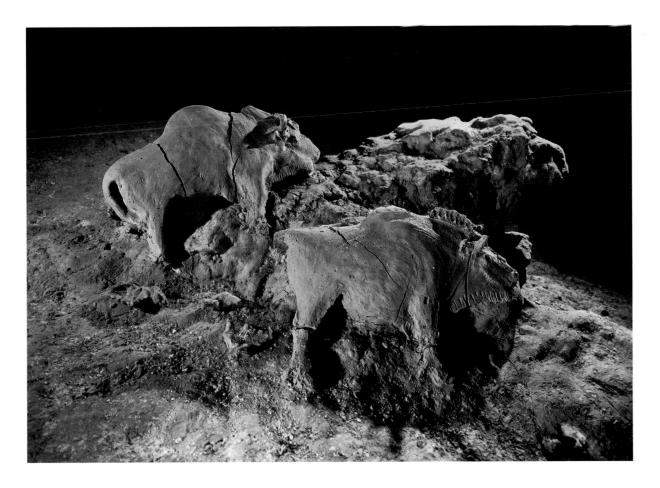

1.12 Two Bison, Le Tuc d'Audoubert Cave, Ariège, France. ca. 13,000 BCE. Clay, length 23%" (60 cm)

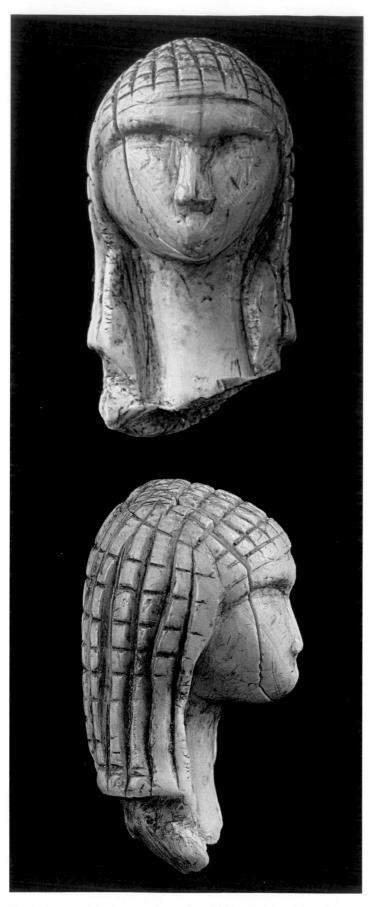

1.13 Woman from Brassempouy, Grotte du Pape, Brassempouy, France. ca. 22,000 BCE. Ivory, height 1½" (3.6 cm). Musée des Antiquités Nationales, Saint-Germain-en-Laye

swell and taper to approximate the mass of a real bison. Despite the three-dimensional character of the representations (notice the fullness of the haunch and shoulder and the shaggy manes), the sculptures share conventions with cave paintings: The artist rendered them in fairly strict profile, so that they are viewable from one side only, but once again the function of the object is unclear to us. Among the human footprints found near this group are those of a two-year-old child. Along with the baby's hand-print in a cave at Bedeilhac in France, and the women's handprints at Chauvet, these caution us against simply reconstructing Paleolithic works of art as the ritual centerpieces of a male-dominated hunting society.

Women were frequent subjects in prehistoric sculpture, especially in the Gravettian period (see Informing Art, page 9). In fact, so far do female images outnumber male images at that time that they may be evidence of a matrilineal social structure. In the late nineteenth century, a group of 12 ivory figurines were found together in the Grotte du Pape at Brassempouy in southern France. Among them was the Woman from Brassempouy (fig. 1.13) of about 22,000 BCE. The sculpture is almost complete, depicting a head and long elegant neck. At a mere 1½ inches long, it rests comfortably in the hand, where it may have been most commonly viewed. Also hand-sized is the limestone carving of the nude Woman of Willendorf of Austria, from about 28,000 to 25,000 BCE (fig. 1.14). Discovered in 1908, her figure still bears traces of ocher rubbed onto the carved surface. Both figurines are highly abstract. Instead of rendering the female form with the naturalism found in the representations of animals, the artist reduced it to basic shapes. In the case of the Woman from Brassempouy, the artist rendered the hair schematically with deep vertical gouges and shallow horizontal cross-lines. There is no mouth and only the suggestion of a nose; hollowed-out, overhanging eye sockets and holes cut on either side of the bridge of the nose evoke eyes. The quiet power and energy of the figure reside in the dramatic way its meticulously polished surface responds to shifting light, suggesting movement and life.

The abstract quality of the Woman of Willendorf appears to stress a potent fertility. This kind of abstraction appears in many other figurines as well; indeed, some incomplete figurines depict only female genitalia. Facial features are not a priority: schematically rendered hair covers the entire head. Emphasis rests on the figure's reproductive qualities: Diminutive arms sit on pendulous breasts, whose rounded forms are echoed in the extended belly and copious buttocks. Genitalia are shown between large thighs.

The terminology applied to figures like the Woman from Brassempouy and the Woman of Willendorf in the past has complicated our interpretations of them. At the time of the first discovery of such female figurines in the mid-nineteenth century, scholars named them "Venus" figures: Venus is the Roman goddess of love (Aphrodite in the Greek world), whom ancient sculptors portrayed as a nude female; nineteenth-century archaeologists believed the prehistoric figures to be similar to the Roman goddess, in function if not in form. Today, we tend to avoid such anachronisms in terminology. We do not know whether the

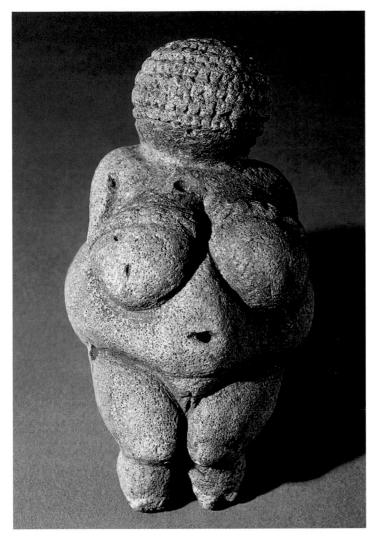

1.14 Woman of Willendorf. ca. 28,000-25,000 BCE. Limestone, height 43/8" (11.1 cm). Naturhistorisches Museum, Vienna

Woman of Willendorf represents a specific woman, or a generic or ideal woman. Indeed, she may not represent the idea of woman at all, but rather the notion of reproduction or, as some have argued, the fertile natural world itself. The emphasis on the reproductive features has suggested to many that she may have been a fertility object; the intention may have been to ensure a successful birth outcome rather than an increase in the number of pregnancies. According to one feminist view, the apparently distorted forms of figures like this specifically reflect a woman's view of her own body as she looked down at it. If so, some of the figures may have served as obstetric aids, documenting different stages of pregnancy to educate women toward healthy births. Moreover, this may indicate that at least some of the artists were women.

Paleolithic Houses

In the Paleolithic period, people generally built small huts and used caves for shelter and ritual purposes. In rare cases, traces of dwellings survive. At Mezhirich, in the Ukraine, a local farmer

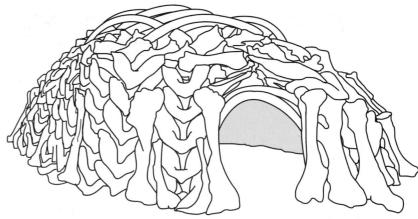

1.15 House at Mezhirich, Ukraine. 16,000-10,000 BCE. Mammoth bone

discovered a series of oval dwellings with central hearths, dating to between 16,000 and 10,000 BCE (fig. 1.15). The distinctive feature of these huts was that they were constructed out of mammoth bones: interlocked pclvis bones, jawbones and shoulder blades provided a framework, and tusks were set across the top. The inhabitants probably covered the frame with animal hides. Archaeological evidence shows that inside these huts they prepared foods, manufactured tools, and processed skins. Since these are cold-weather occupations, archaeologists conclude that the structures were seasonal residences for mobile groups, who returned to them for months at a time over the course of several years.

NEOLITHIC ART

Around 10,000 BCE, the climate began to warm, and the ice that had covered almost a third of the globe started to recede, leaving Europe with more or less the geography it has today. New vegetation and changing animal populations caused human habits to mutate, especially in relation to their environment. In the Neolithic period, or New Stone Age, they began to build more substantial structures, choosing fixed settlement places on the basis of favorable qualities such as a water supply, rather than moving seasonally. Instead of hunting and gathering what nature supplied, they domesticated animals and plants. This gradual change occurred at different moments across the world; in some places, hunting and gathering are still the way of life today.

Settled Societies and Neolithic Art

The earliest evidence of these adjustments to environmental shifts appears in the fertile regions of the eastern Mediterranean and Mesopotamia, between the Euphrates and Tigris rivers. A small settlement developed in the ninth millennium BCE by the Jordan River at the site of Jericho, of biblical fame, in the present West Bank territory. Over time its inhabitants built houses of sun-baked mud brick on stone foundations. They plastered the floors and crafted roofs of branches and earth. Skeletal remains indicate that they buried the bodies of their dead beneath the floors; they displayed the skulls separately above ground, reconstructing them with tinted plaster to resemble flesh, and crafting eyes of seashell fragments (fig. 1.16). The subtlety of their modeling, and the close observation of the interplay between flesh and bone, make these works remarkably lifelike, each as individual as the skulls they encased. Perhaps these funerary practices reflect a concept of an afterlife; at the very least, they suggest a respect for the dead or even ancestor worship. Around 7500 BCE, the people of Jericho, now numbering over 2,000, dug a wide ditch and raised a solid stone wall around their town, which by this time had expanded to cover some 10 acres. Built with only the simplest stone tools, the wall was 5 feet thick and over 13 feet high. Into it they set a massive circular tower, perhaps one of several, 28 feet tall and 33 feet in diameter at the base, with a staircase inside providing access to the summit (fig. 1.17). The wall may have functioned as a fortification system against neighboring settlements, or as a barrier against rising floodwaters. With its construction, monumental architecture was born.

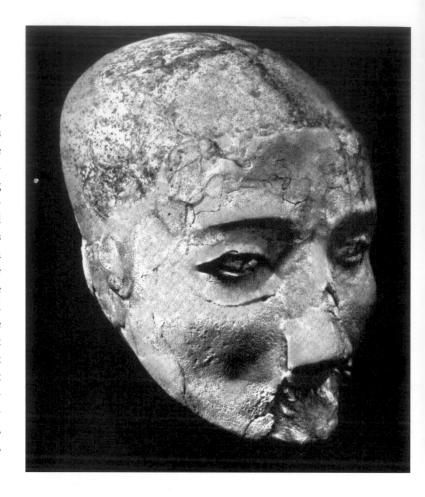

1.17 Jericho, Jordan (aerial view)

At Ain Ghazal, near Amman in Jordan, over 30 fragmentary plaster figures, dating to the mid-seventh millennium BCE, represent a starkly different sculptural tradition from the Jericho heads (fig. 1.18). Some are only bust-size, but the tallest statues, when restored, are 3 feet in height, and constitute the first known largescale sculptures. Conservators have studied the construction technique of these figures, and conclude that large size was the motivating force behind their design, directly resulting in their flat, shallow appearance. These investigations have shown that artists applied plaster to bundles of fresh reeds, bound with cordage, which they kept horizontal during the assembly process. They added the legs separately, then applied paint and added cowrie shells for eyes, darkened with bitumen (a black, tarlike substance) for pupils. Once the plaster was dry, they stood the fragile figures upright and probably added wigs and clothing. Like the Jericho heads, the figures may have represented ancestors. Alternatively, as some of the bodies are two-headed, they may have had a mythical function.

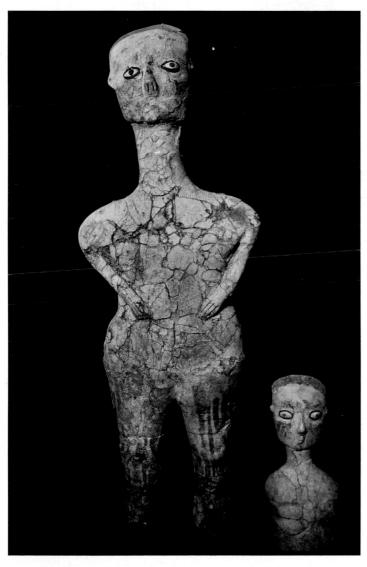

1.18 Human figures, from Ain Ghazal, Jordan. ca. 6750–6250 BCE. Height of larger figure 33" (84 cm). Department of Antiquities, Amman

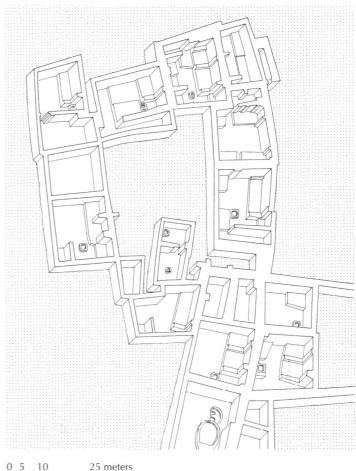

0 5 10 25 meters 0 25 50 75 feet

1.19 Reconstruction of Catal Hüyük, Turkey

ÇATAL HÜYÜK In Anatolia (modern Turkey), excavations since 1961 have revealed a Neolithic town at Catal Hüyük, dating from about 7500 BCE, a thousand years later than Jericho (see map 1.1). Flourishing through trade in ores—principally obsidian, a highly valued glasslike volcanic stone, used to make strong, sharp blades—the town developed rapidly through at least 12 successive building phases between 6500 and 5700 BCE. Its most distinctive feature is that it lacked streets, and the mud-brick and timber houses had no doors at ground level: Each house stood side by side with the next, accessed by ladder through a hole in the roof that doubled as a smoke vent (fig. 1.19). The advantages of this design were structural—each house buttressing the next—and defensive, since any attacker would have to scale the outer walls before facing resistance on the rooftops. The design also made economic use of available building stone and provided thickwalled insulation. The rooms inside accommodated activities ranging from working and cooking to sleeping, on platforms lining the walls. As at Jericho, burials were beneath the floor.

In most of the rooms at Çatal Hüyük, plaster covered the walls; often it was painted. Many of the paintings depict animal hunts, with small human figures running around disproportionately large bulls or stags. The images have a static quality, quite

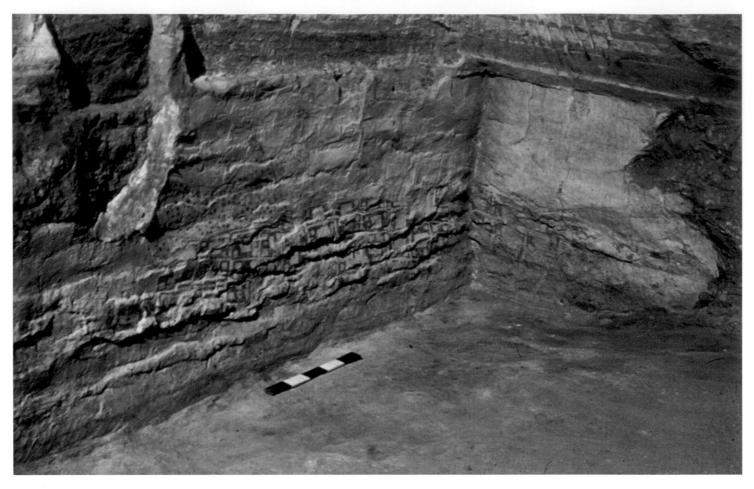

1.20 View of Town and Volcano, Shrine VII.14, Çatal Hüyük. ca. 6000 BCE. Wall painting

unlike the earlier cave paintings that seem to embody motion. One unusual painting in an early room appears to depict rows of irregular blocklike houses, and probably represents Çatal Hüyük itself (fig. 1.20). Above the town, a bright red feature spotted with black and topped with black lines and dots may represent Hasan

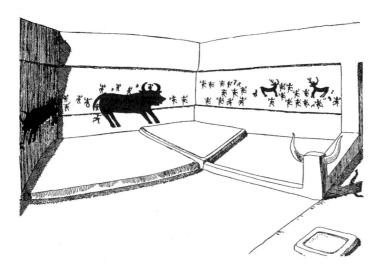

1.21 Animal Hunt. Restoration of Main Room, Shrine A.III.1, Çatal Hüyük. ca. 6000 BCE (after Mellaart)

Dag, a twin-peaked volcano in view of the town. If archaeologists have properly identified this site, the image is the first known landscape painting. It may indicate a sense of community in this early settlement, with inhabitants specifically identifying themselves with place. Some archaeologists speculate that the more ornate rooms at Çatal Hüyük functioned as shrines; in some of them, bulls' horns and plaster breasts may have signified fertility (fig. 1.21).

OVEN-FIRED POTTERY A number of new technologies that developed during the Neolithic period collectively suggest the beginnings of specialization. As the community could count on a regular food supply, some of its members were able to devote time to acquiring special skills. These included pottery, weaving, and the smelting of copper and lead. Oven-fired pottery is extremely durable, and often survives in the form of discarded shards. Though absent from early Jericho, a great variety of clay vessels painted with abstract forms survive in regions stretching from Mesopotamia, where pottery may have originated in the sixth millennium BCE, to Egypt and Anatolia, where it was discovered at Çatal Hüyük (see map 1.1) and other settlements. Archaeologists have found pottery from this period in the Balkans, and by about 3500 BCE the technology of pottery making appeared in western Europe.

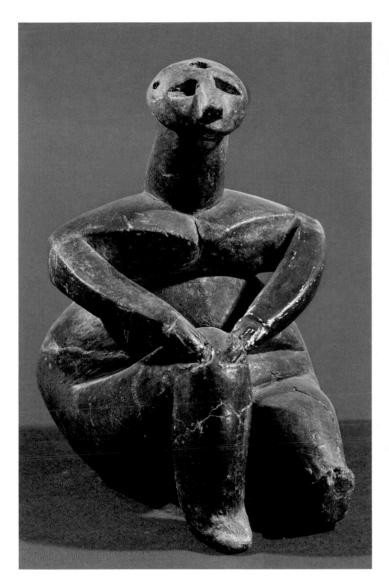

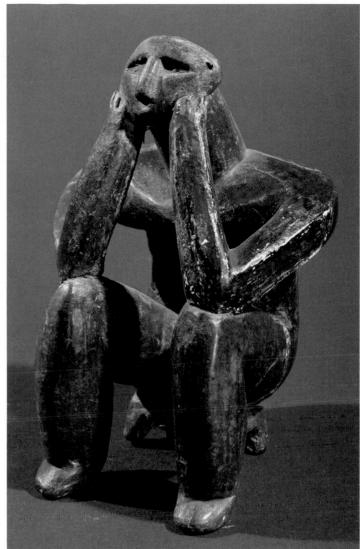

1.22 Female and male figures, from Cernavoda, Romania. ca. 3500 BCE. Ceramic, height 4½" (11.5 cm). National Museum of Antiquities, Bucharest

In Europe, artists also used clay to fashion figurines, such as a woman and man from Cernavoda in Romania, of about 3500 BCE (fig. 1.22). Like the Woman of Willendorf and the Ain Ghazal figurines, they are highly abstract, yet their forms are more linear than rounded: The woman's face is a flattened oval poised on a long, thick neck, and sharp edges articulate her corporeality across her breasts, for instance, and at the fold of her pelvis. Elbowless arms meet where her hands rest on her raised knee, delineating a triangle and enclosing space within the sculptural form. This emphasizes the figurine's three-dimensionality, encouraging a viewer to look at it from several angles, moving around it or shifting it in the hand. The abstraction highlights the pose; yet, tempting as it may be to interpret this, perhaps as coquettishness, we should be cautious about reading meaning into it, since gestures can have dramatically different meanings from one culture to another. Found in a tomb, the couple may represent the deceased, or mourners; perhaps they were gifts that had a separate purpose before burial.

Architecture in Europe: Tombs and Rituals

Neolithic people of western and northern Europe framed their dwellings mostly in wood, with walls of wattle (branches woven into a frame) and daub (mud or earth dried around the wattle) and roofs of thatch, which rarely survive. At Skara Brae, on the island of Orkney just off the northern tip of Scotland, is a group of ten houses built of stone, dating to between 3100 and 2600 BCE. The builders sunk them into mounds for protection against the harsh weather, and connected them by covered passages. A typical house had a square room, with walls of flat unmortared stones (fig. 1.23). Driftwood and whalebone supported a roof of turf thatch. At the center of the room was a hearth for cooking, and the inhabitants built furniture—such as beds and shelving—out of large flat stones.

It was a concern for ceremonial burial and ritual, rather than for protection, that inspired Neolithic people of western and northern Europe to create monumental architecture. They defined spaces for tombs and rituals with huge blocks of stone

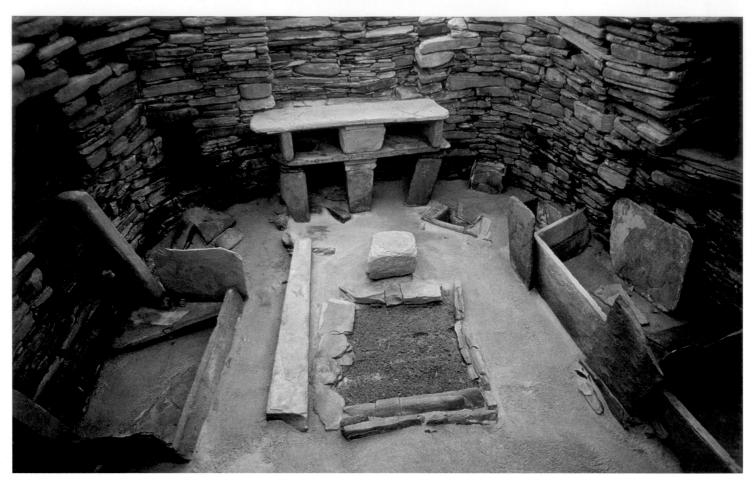

1.23 House at Skara Brae, Orkney, Scotland. ca. 3100–2600 BCE

known as megaliths. Often they mounted the blocks in a trilithic (three-stone) post-and-lintel arrangement (with two upright stones supporting a third horizontal capstone) (see fig. 1.25) to construct tombs for the dead with one or more chambers. Termed dolmen tombs, they were both impressive and durable. At some sites, upright megaliths known as menhirs marked out horizontal space in distinct ways, and perhaps served as ritual centers. Between 4250 and 3750 BCE at Ménec, in the Carnac region on the south coast of Brittany (see map 1.1), over 3,000 megaliths set upright at regular intervals in long, straight rows stretch out over 2 miles (3 km). Typically, the smaller stones of about 3 feet in height stand at the eastern end, and, gradually, the height of the stones increases, reaching over 13 feet at the western end (fig. 1.24). Scholars argue that the lines, with their east-west orientation, gauged the sun's position in the sky at different times of the year, functioning as a calendar for an agrarian people whose sustenance depended on the sun's cycle. Quarrying, shaping, transporting, and erecting these blocks was an extraordinary feat. Quite apart from remarkable engineering expertise, it required a highly efficient organization of manpower. The resulting monument, with its simple repeated forms identical in shape yet diverse in size, static yet cast into motion by the sun's slow and constant passage, has a calm grandeur and majesty that imposes quiet order on the open landscape.

Often, megaliths appear in circles, known as cromlechs. This is the prevalent arrangement in Britain, where the best-known megalithic structure is Stonehenge, on the Salisbury Plain (figs. 1.25 and 1.26). What now appears as a unified design is in fact the result of at least four construction phases, beginning with a huge ditch defining a circle some 330 feet in diameter in the white chalk ground, and an embankment of over 6 feet running around the inside. A wide stone-lined avenue led from the circle to a pointed gray sandstone (sarsen) megalith, known today as the Heel Stone. By about 2100 BCE, Stonehenge had grown into a horseshoe-shaped arrangement of five sarsen triliths, encircled by a ring of upright blocks capped with a lintel; between the rings was a circle of smaller bluestone blocks. Recent excavations exposed remains of a similar monument built of wood 2 miles (3 km) away, as well as remnants of a village. Archaeologists believe the structures are related.

Exactly what Stonehenge—and its nearby counterpart—signified to those who constructed them is a tantalizing mystery. Many prehistorians believe that Stonehenge, like Ménec, marked the passing of time. Given its monumentality, most also concur that it had a ritual function, perhaps associated with burial; its careful circular arrangement supports this conjecture, as circles are central to rituals in many societies. Indeed, these two qualities led medieval observers to believe that King Arthur's magician, Merlin, created Stonehenge, and it continues to draw crowds on

Dating Techniques

One of the chief concerns of archaeologists and art historians, regardless of the period in which they conduct research, is to be able to place works of art in a historical context. This means that dating an object is of paramount importance. Scholars assign two types of date: relative dates and absolutes dates. A relative date indicates that one object is older or more recent than another. To determine these dates, archaeologists tend to use stratigraphy: An object found at a lower layer or *stratum* of an excavation is normally older than an object found above it. The relative chronology of one site can be transferred to another site if objects of a similar kind appear at both. Pottery is a useful indicator of relative date for most ancient cultures because it is so durable that it exists in great profusion, often in an uninterrupted sequence.

Absolute dating assigns a calendar date to an object. In historical cultures (those with written documents), written records might preserve a date. For instance, building inscriptions indicate that the Athenians constructed the Parthenon between 447 and 432 BCE. Researchers have developed numerous other methods for establish-

ing absolute dates. These include radiometric dating, which works well for dating organic materials up to approximately 40,000 years old. Living organisms contain radioactive isotopes (such as carbon-14) that decay at a known rate after its death. By measuring the level of isotopes in organic material, archaeologists can gauge when it lived. Though effective, this method requires destroying part of the object, and can only establish when an organism died, not when an artist turned it into an artifact.

Some other techniques measure radiation levels. For instance, thermoluminescence is an effective dating technique for objects containing crystalline materials that have been exposed to high temperatures—such as pottery, which has been fired. Heat releases electrons trapped in the object's crystalline lattice, resulting in a "zeroing" radiation moment. Thereafter, electrons accumulate again. By measuring the luminescence (light, which is proportional to the number of electrons released) of the object during a second heating, archaeologists can determine the length of time since the zeroing event.

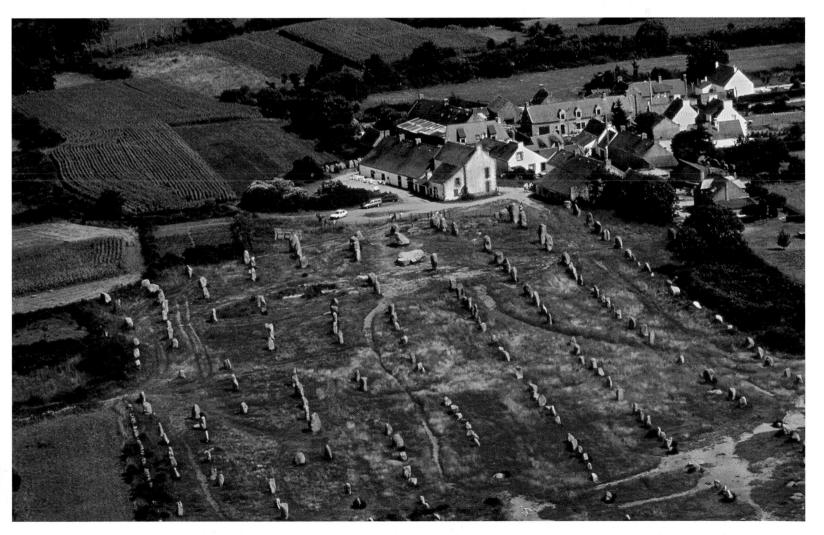

1.24 Menhir alignments at Ménec, Carnac, France. ca. 4250–3750 BCE

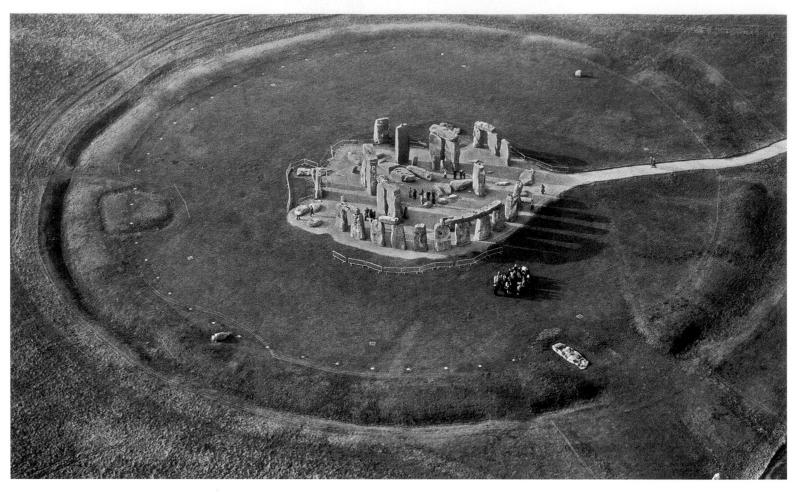

1.25 Stonehenge (aerial view), Salisbury Plain, Wiltshire, England. ca. 2100 BCE. Diameter of circle 97' (29.6 m)

summer solstices. What is certain is that, like Ménec, Stonehenge represents tremendous organization of labor and engineering skill. The largest trilith, at the center of the horseshoe, soars 24 feet, supporting a lintel 15 feet long and 3 feet thick. The sarsen blocks weigh up to 50 tons apiece, and traveled 23 miles (37 km) from the Marlborough Downs; the bluestones originated 200 miles (320 km) away, in the Welsh Preseli mountains. The blocks reveal evidence of meticulous stone working. Holes hollowed out of the capstones fit snugly over projections on the uprights (forming a mortise-and-tenon joint), to make a stable structure. Moreover, upright megaliths taper upward, with a central bulge, visually implying the weight they bear, and capturing an energy that gives life to the stones. The lintels are worked in two directions, their faces inclining outward by about 6 inches to appear vertical from the ground, while at the same time they curve around on the horizontal plane to make a smooth circle. Art historians usually associate this kind of refinement with the Parthenon of Classical Athens (see fig. 5.40).

Prehistoric art raises many questions. While we know humans began to express themselves visually during the prehistoric age, there are no written records to explain their intentions. Even so, by the end of the era, people had established techniques of painting, sculpting, and pottery making, and begun to construct

monumental works of architecture. They developed a strong sense of the power of images and spaces: They recognized how to produce naturalistic and abstract figures, and how to alter space in sophisticated ways.

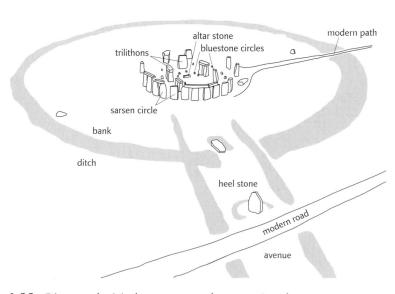

1.26 Diagram of original arrangement of stones at Stonehenge

са. 28,000-25,000 все Woman of Willendorf

Prehistoric Art

40,000 BCE

objects classed as "art"

at Chauvet

30,000

ca. 13,000 BCE Clay sculpture of two bison crafted on a rock outcropping

20,000

to warm

4000 BCE

3000

■ Sixth millennium BCE Pottery may have originated in Mesopotamia

Western Europe

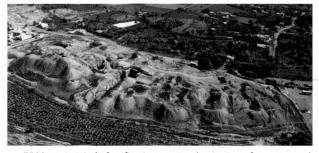

16,000-10,000 BCE Mammoth bone

houses at Mezhirich

ca. 7500 BCE Jericho's fortification system; beginning of monumental architecture

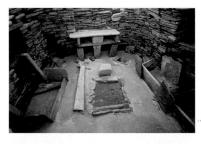

са. 3100-2600 все Stone houses at Skara Brae

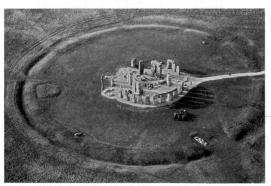

ca. 2100 BCE Final phase of construction at Stonehenge

2000 BCE

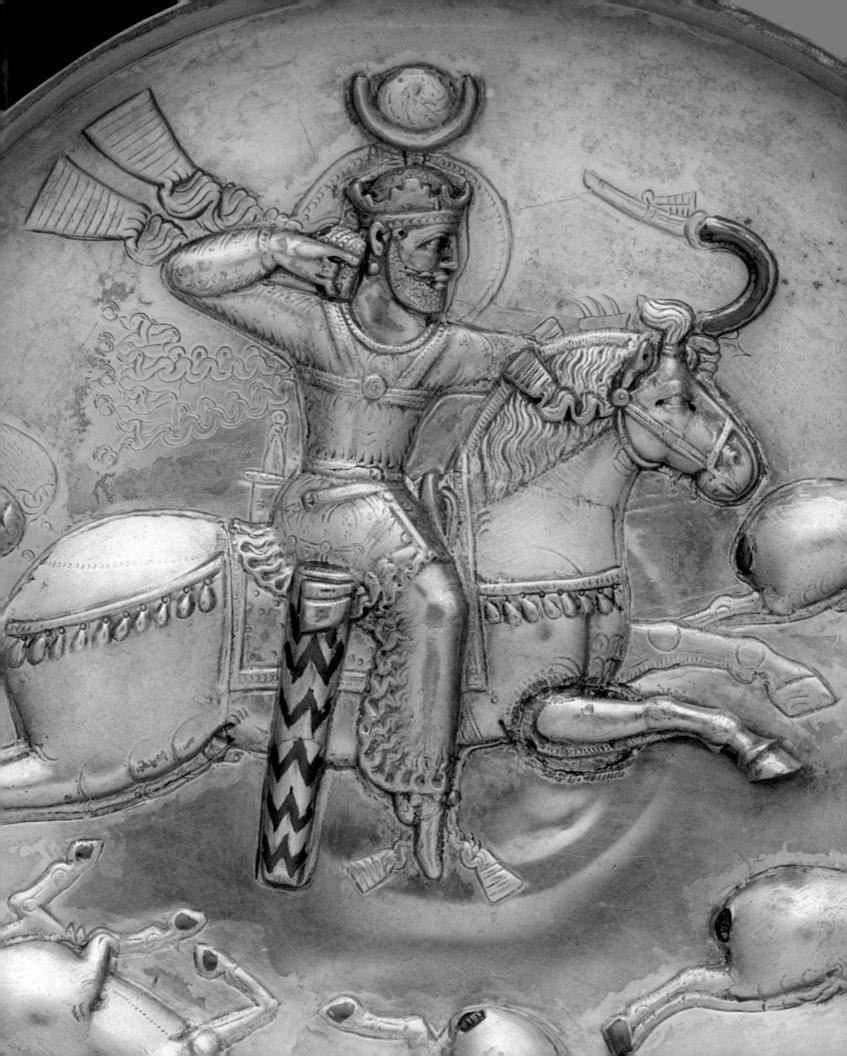

Ancient Near Eastern Art

ROWING AND STORING CROPS AND RAISING ANIMALS FOR FOOD. the signature accomplishments of Neolithic peoples, would gradually change the course of civilization. Not long before they ceased to follow wild animal herds and gather food to survive, people began to form permanent settlements. By the end of the Neolithic era, these settlements grew

beyond the bounds of the village into urban centers. In the fourth millennium bce, large-scale urban communities of as many as 40,000 people began to emerge in Mesopotamia, the land between the Tigris and Euphrates rivers. The development of cities had tremendous ramifications for the development of human life and for works of art.

Although today the region of Mesopotamia is largely an arid plain, written, archaeological, and artistic evidence indicates that at the dawn of civilization lush vegetation covered it. By mastering irrigation techniques, populations there exploited the rivers and their tributaries to enrich the fertile soil even further. New technologies and inventions, including the wheel and the plow, and the casting of tools in copper and bronze, increased food production and facilitated trade. As communities flourished, they grew into city-states with distinct patterns of social organization to address the problems of urban life. Specialization of labor and trade, mechanisms for the resolution of disputes, and construction of defensible walls all required a central authority and government.

It was probably the efficient administration that developed in response to these needs that generated what may have been the earliest writing system, beginning around 3400-3200 BCE, consisting of pictograms pressed into clay with a stylus to create inventories. By around 2900 BCE, the Mesopotamians had refined the pictograms into a series of wedge-shaped signs known as cuneiform (from cuneus, Latin for "wedge"). They used this system for administrative accounts and the Sumerian Epic of Gilgamesh in the late third millennium BCE. Cuneiform writing continued through much of the ancient era in the Near East and formed a cultural link between diverse groups who established power in the region. With the invention of writing, we enter the realm of history.

The geography of Mesopotamia had other profound effects on developing civilizations. Unlike the narrow, fertile strip of the Nile Valley in Egypt, protected by deserts on either side, where urban communities now also began to thrive, Mesopotamia is a wide, shallow trough, crisscrossed by the two rivers and their tributaries and with few natural defenses. People wanting to exploit its fertile soil constantly traversed the region, entering easily from any direction. Indeed, the history of the ancient Near East is a multicultural one; city-states were constantly at war with one another and only sometimes united under a single ruler. Still, Mesopotamian visual culture retains a surprisingly constant character. Two dominant themes emerge: Art enabled and reflected political power; and Mesopotamians used visual narrative, exploring strategies for telling stories through art.

Detail of figure 2.33, Peroz I (457-483) or Kavad I hunting rams.

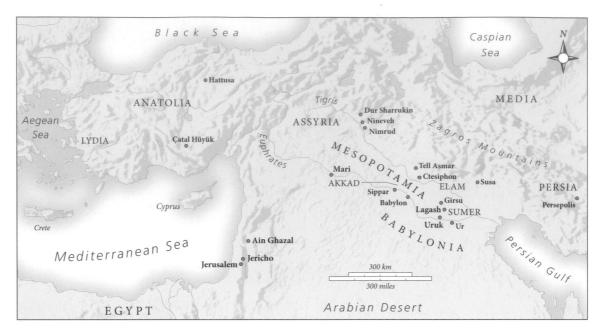

Map 2.1 The Ancient Near East

2.1 Babylonian deed of sale. ca. 1750 BCE. This deed graphically shows the impressions made by the stylus in the soft clay. Department of Western Asiatic Antiques, No. 33236. The British Museum, London

SUMERIAN ART

The first major civilization in Mesopotamia was in the southern region of Sumer, near the junction of the Tigris and Euphrates rivers, where several city-states flourished from before 4000 BCE (map 2.1) until about 2340 BCE. Who the Sumerians were is not clear; often scholars can establish linkages between peoples through common linguistic traditions, but Sumerian is not related to any other known tongue. Archaeological excavations since the middle of the nineteenth century have unearthed many clay tablets with cuneiform writing including inventories and lists of kings, as well as poetry (fig. 2.1). Many of the earliest excavations concentrated on Sumerian cities mentioned in the Bible, such as Ur (the birthplace of Abraham) and Uruk (the biblical Erech). Along with architecture and writing, works of art in the form of sculpture, relief, and pottery inform us about Sumerian society.

For Sumerians, life itself depended on appeasing the gods, who controlled natural forces and phenomena such as weather and water, the fertility of the land, and the movement of heavenly bodies. Each city had a patron deity, to whom residents owed both devotion and sustenance. The god's earthly steward was the city's ruler, who directed an extensive administrative staff based in the temple. As the produce of the city's land belonged to the god, the temple staff took charge of supplying farmers with seed, work animals, and tools. They built irrigation systems, and stored and distributed the harvest. Centralized food production meant that much of the population could specialize in other trades. In turn, they donated a portion of the fruits of their labor to the temple. This system is known as theocratic socialism.

Mud Brick

Mud brick was made primarily from local clay. Raw clay absorbs water, and then cracks after drying. As a binding agent and to provide elasticity and prevent cracking, Sumerian builders would add vegetable matter, such as straw, to the clay. By forcing the mud mixture into wooden frames, the brick makers obtained uniformly rectangular bricks. They then knocked the molded bricks out of the frames and placed them in the sun to bake. To erect walls, they joined the bricks together with wet clay. One disadvantage of mud brick is that it is not durable. The Sumerians would therefore seal important exterior walls with bitumen, a tarlike substance, or they would use glazed bricks. Sometimes they covered interior walls with plaster.

Mud brick is not a material that readily excites the imagination today (in the way that, for instance, marble does), and because it is so highly perishable, it has rarely survived from ancient times to indicate how Sumerian temples might once have looked. However, more recent examples of mud-brick architecture like the kasbahs (citadels) south of Morocco's Atlas mountains, at Aït Ben Haddou and elsewhere, reveal the extraordinary potential of the material. There, the easy pliability of mud brick allows for a dramatic decorative effect that is at once man-made and in total harmony with the natural colors of the earth. Notice, too, the geometric designs echoed In the woodwork of doorways and windows. First constructed in the sixteenth century CE, these buildings undergo constant maintenance (recently funded by UNESCO) to undo the weather's frequent damage. Naturally, Sumerian temples may have looked quite different, but the kasbahs serve as a useful reminder that mud-brick construction can produce magnificent results.

Mud-brick kasbahs at Aït Ben Haddou, Morocco

Mud bricks at Aït Ben Haddou, Morocco

Temple Architecture: Linking Heaven and Earth

The temple was the city's architectural focus. Good stone being scarce, Sumerians built predominantly with mud brick covered with plaster. (See *Materials and Techniques*, above).

Scholars distinguish two different types of Sumerian temple. "Low" temples sat at ground level. Usually their four corners were oriented to the cardinal points of the compass. The temple was tripartite: Rooms serving as offices, priests' quarters, and storage areas lined a rectangular main room, or cella, on its two long sides. The essential characteristics of "high" temples were similar, except that a platform raised the building above ground level; these platforms were gradually transformed into squat, stepped pyramids known as ziggurats. The names of some ziggurats—such as Etemenanki at Babylon ("House temple, bond between heaven and earth")—suggest that they may have been links or portals to the heavens, where priest and god could commune.

At approximately 40 to 50 feet high (at Warka and Ur), ziggurats functioned analogously as mountains, which held a sacred status for Sumerians. A source of water flowing to the valleys, mountains were also a place of refuge during floods, and symbolized the Earth's generative power. Indeed, Sumerians knew their mother goddess as the Lady of the Mountain. Significantly, raised platforms made temples more visible. Mesopotamian texts indicate that the act of seeing was paramount: In seeing an object and finding it pleasing, a god might act favorably toward those who made it. The desired response of a human audience, in turn, was wonder. Finally, there was probably a political dimension to the high platform: It emphasized and maintained the priests' status by visually expressing their separation from the rest of the community.

Around 3500 BCE, the city of Uruk (present-day Warka and the biblical Erech) emerged as a center of Sumerian culture, flourishing from trade in its agricultural surplus. One of its temples, the White Temple, named for its whitewashed brick surfaces, probably honored the sky-god Anu, chief of the Sumerian gods

(fig. 2.2). It sits on a 40-foot mound constructed by filling in the ruins of older temples with brickwork, which suggests that the site itself was sacred (fig. 2.3). Recessed brickwork articulated its

2.2 Plan of the White Temple on its ziggurat (after H. Frankfort)

sloped sides. A system of stairs and ramps led counterclockwise around the mound, culminating at an entrance in the temple's long north side. This indirect approach is characteristic of Mesopotamian temple architecture (in contrast to the direct axial approach favored in Egypt), and the winding ascent mirrored a visitor's metaphorical ascent into a divine realm. From three sides, members of the community could also witness the ceremonial ascent of priests and leaders who had exclusive access to the temple. Enough survives of the superstructure to indicate that thick buttressed walls surrounded a central, rectangular hall (cella) housing a stepped altar. Along the long sides of the cella were smaller rooms, creating an overall tripartite layout typical of the earliest temples.

Uruk was the home of the legendary king Gilgamesh, hero of an epic poem that describes his adventures. Gilgamesh purportedly carved his tale on a stone marker—which suggests the importance of narrative in Sumerian culture. The epic credits Gilgamesh with building the city walls of Uruk and the Eanna, a temple of Inanna (goddess of love and war) or Ishtar. The poem describes the temple's gleaming walls, built with "kiln-fired brick." In the Eanna precinct, archaeologists found several temples whose walls were decorated with colored stone or painted clay cones set into plaster to form mosaic patterns. (See *Primary Source*, page 25.)

2.3 Remains of the White Temple on its ziggurat. ca. 3500-3000 BCE. Uruk (Warka), Iraq

The Gilgamesh Epic

One of the earliest written epics, the Gilgamesh epic survives on cuneiform tablets. Although the earliest texts to survive come from Akkadian tablets written after 2150 BCE, the text itself dates to the Sumerian era, about 2800 BCE. The surviving parts of the epic recount the tale of Gilgamesh, the king of Uruk, who first battles, then befriends the wild man Enkidu. When his friend dies, Gilgamesh goes in search of a way to defeat death, but eventually returns to Uruk, accepting his own mortality. This excerpt from the beginning of the poem describes (with gaps from the sources) Gilgamesh's accomplishments as king.

Anu granted him the totality of knowledge of all.

He saw the Secret, discovered the Hidden,
he brought information of (the time) before the Flood.
He went on a distant journey, pushing himself to exhaustion,
but then was brought to peace.
He carved on a stone stela all of his toils,
and built the wall of Uruk-Haven,
the wall of the sacred Eanna Temple, the holy sanctuary.

Look at its wall which gleams like copper(?), inspect its inner wall, the likes of which no one can equal! Take hold of the threshold stone—it dates from ancient times! Go close to the Eanna Temple, the residence of Ishtar, such as no later king or man ever equaled! Go up on the wall of Uruk and walk around, examine its foundation, inspect its brickwork thoroughly. Is not (even the core of) the brick structure made of kiln-fired brick,

and did not the Seven Sages themselves lay out its plans?

One square mile is devoted to city, one to palm gardens, one to lowlands, the open area(?) of the Ishtar Temple, three leagues and the open area(?) of Uruk it (the wall) encloses. Find the copper tablet box, open the ... of its lock of bronze, undo the fastening of its secret opening.

Take out and read the lapis lazuli tablet how Gilgamesh went through every hardship.

Source: The Epic of Gilgamesh, tr. Maureen Gallery Kovacs (Stanford, CA: Stanford Univ. Press. 1989)

Sculpture and Inlay

The cella of Uruk's White Temple would once have contained a cult statue, which is now lost. Yet a female head dating to about 3100 BCE, found in the Eanna sanctuary of Inanna at Uruk, may indicate what a cult statue looked like (fig. 2.4). The sculptor carved the face of white limestone, and added details in precious

2.4 Female Head, from Uruk (Warka), Iraq. ca. 3200–3000 BCE. Limestone, height 8" (20.3 cm). Iraq Museum, Baghdad

materials: a wig, perhaps of gold or copper, secured by the ridge running down the center of the head, and eyes and eyebrows of colored materials. Despite the absence of these features, the sculpture has not lost its power to impress: The abstraction of its large eyes and dramatic brow contrasts forcefully with the delicate modeling of the cheeks. Flat on the back, the head was once attached to a body, presumably made of wood, and the full figure must have stood near life-size.

TELL ASMAR A group of sculptures excavated in the 1930s at a temple at Tell Asmar illustrates a type of limestone, alabaster, and gypsum figures that artists began to make about 500 years after the carving of the Uruk head (fig. 2.5). Ranging in height from several inches to 2½ feet, these figures probably originally stood in the temple's cella. They were purposely buried near the altar along with other objects, perhaps when the temple was rebuilt or redecorated. All but one of the figures in this group stand in a static pose, with hands clasped between chest and waist level. The style is decidedly abstract: On most of the standing male figures, horizontal or zigzag ridges define long hair and a full beard; the arms hang from wide shoulders; hands are clasped around a cup; narrow chests widen to broad waists; and the legs are cylindrical. The male figures wear fringed skirts hanging from a belt in a stiff cone shape, while the women have full-length drapery. Most scholars identify the two larger figures as cult statues of Abu, god of vegetation, and his consort. The others figures probably represent priests, since the fringed skirt is the dress of the priesthood. Some statues of this kind from elsewhere are inscribed with the name of the god and of the worshiper who dedicated the statue.

The poses and the costumes represent conventions of Sumerian art that later Mesopotamians adopted. Most distinctive are the faces, dominated by wide, almost round eyes. Dark inlays

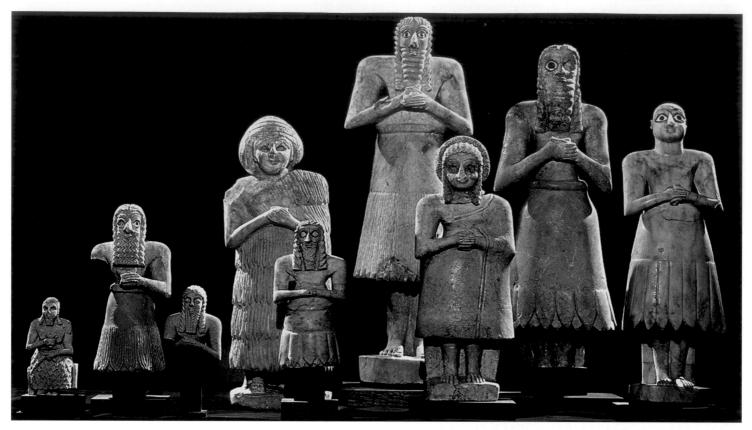

2.5 Statues from the Abu Temple, Tell Asmar, Iraq. ca. 2700–2500 BCE. Limestone, alabaster, and gypsum, height of tallest figure approx. 30" (76.3 cm). Iraq Museum, Baghdad, and The Oriental Institute Museum of the University of Chicago

of lapis lazuli and shells set in bitumen accentuate the eyes, as do powerful eyebrows that meet over the bridge of the nose. As noted above, seeing was a major channel of communication with gods, and the sculptures may have been responding to the god's awe-inspiring nature with eyes wide open in admiration. Enlarged eyes were also a conventional means of warding off evil in Mesopotamia, known today as an apotropaic device. Several of these statues were in the Iraq Museum, and were looted during recent unrest in Baghdad (see *The Art Historian's Lens*, page 29).

THE ROYAL CEMETERY AT UR The Sumerian city of Ur in southern Mesopotamia first attracted archaeologists because of its biblical associations. Its extensive cemetery was well preserved under the walls of King Nebuchadnezzar II's later city, and Leonard Woolley discovered a wide variety of Sumerian objects in excavations there during the 1920s. The cemetery contained some 1,840 burials dating between 2600 and 2000 BCE. Some were humble, but others were substantial subterranean structures and contained magnificent offerings, earning them the designation

2.6 Goat in Thicket (Ram and Tree), one of the pair from the Great Death Pit in the Royal Cemetery of Ur, Muqaiyir, Iraq. ca. 2600 BCE. Wood, gold, lapis lazuli, height 20" (50.8 cm). University Museum, University of Pennsylvania, Philadelphia

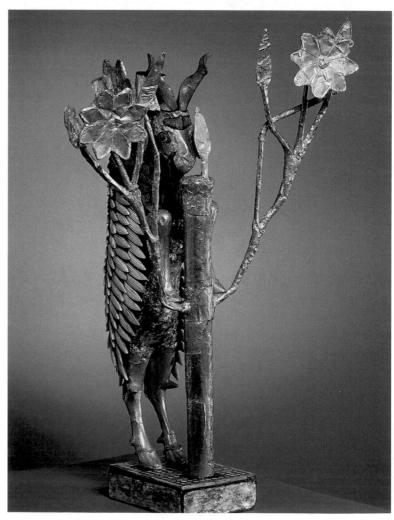

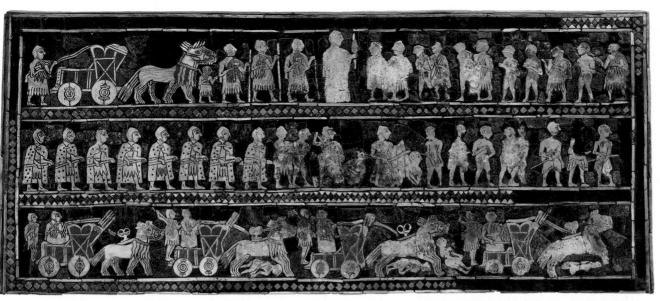

2.7 Royal Standard of Ur, front and back sides. ca. 2600 BCE. Wood inlaid with shell, limestone, and lapis lazuli, height 8" (20.3 cm). The British Museum, London

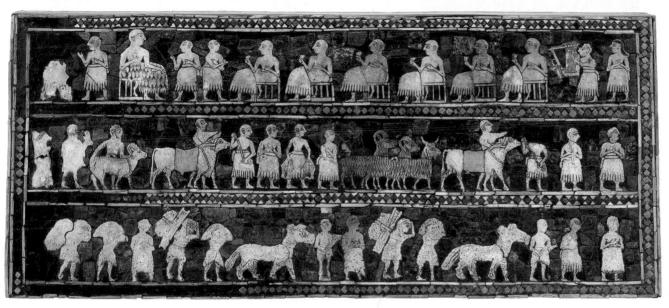

of "royal graves," even though it remains uncertain whether the deceased were royalty, priests, or members of another elite. So-called Death Pits accompanied the wealthiest burials. Foremost among them was the Great Death Pit, in which 74 soldiers, attendants, and musicians were interred, apparently drugged before lying down in the grave as human sacrifices. Even in death, the elite maintained the visible trappings of power and required the services of their retainers. These finds suggest that Sumerians may have believed in an afterlife.

Among the many kinds of grave goods Woolley found in the Royal Cemetery were weapons, jewelry, and vessels. Many of the objects display the great skill of Sumerian artists in representing nature. A pair of wild goats rearing up on their hind legs against a flowering tree probably functioned as stands for offerings to a deity. Gold leaf is the dominant material, used for the goat's head, legs, and genitals, as well as for the tree and a cylindrical support strut rising from the goat's back in the one shown here (fig. 2.6). Lapis lazuli on the horns and neck fleece complements the shell

fragments decorating the body fleece and the ears of copper. The base is an intricately crafted pattern of red limestone, shell, and lapis lazuli. Images on cylinder seals show that a bowl or saucer would have been balanced on the horns and the support cylinder. The combination of the goat (sacred to the god Tammuz) and the carefully arranged flowers (rosettes sacred to Inanna) suggests that the sculpture reflects Sumerian concerns about fertility, both of plants and animals.

Visual Narratives

Two objects from the Royal Cemetery at Ur offer glimpses of the development of visual narrative in Mesopotamia. The *Royal Standard of Ur*, of about 2600 BCE, consists of four panels of red limestone, shell, and lapis lazuli inlay set in bitumen, originally attached to a wooden framework (fig. 2.7). The damaged side panels depicted animal scenes, while the two larger sections show a military victory and a celebration or ritual feast, each unfolding in

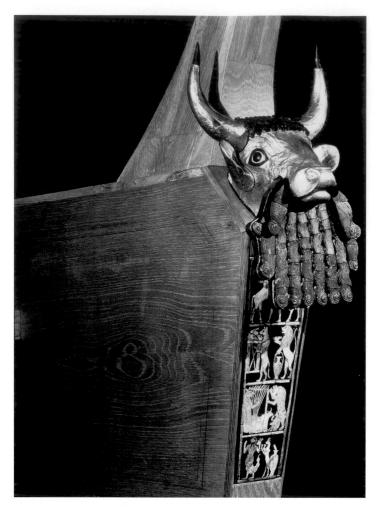

2.8 *Bull Lyre*, from the tomb of Queen Pu-abi, Ur (Muqaiyir), Iraq. ca. 2600 BCE. Wood with gold, lapis lazuli, bitumen, and shell, reassembled in modern wood support. University Museum, University of Pennsylvania, Philadelphia

three superposed registers, or horizontal bands. Reading from the bottom, the "war" panel shows charioteers advancing from the left, pulled by onagers (wild asses), and riding over enemy bodies. In the middle register, infantry soldiers do battle and escort prisoners of war, stripped of armor and clothing. At the top, soldiers present the prisoners to a central figure, whose importance the artist signals through his position and through his larger size, a device known as hieratic scale; his head even breaks through the register's frame to emphasize his importance. In the "banquet" panel, figures burdened with booty accompany onagers and animals for a feast. Their dress identifies them as travelers from northern Sumer and probably Kish, the region later known as Akkad. In the top register, the banquet is already underway. Seated figures raise their cups to the sound of music from a nearby harpist and singer; a larger figure toward the left of the scene is presumably a leader or king, perhaps the same figure as on the "war" side. Together, the panels represent the dual aspects of kingship: the king as warrior, and the king as priest and mediator with the gods. Despite the action in the scenes, the images have a static quality, which the figures' isolation emphasizes (a staccato treatment): Their descriptive forms (half frontal, half

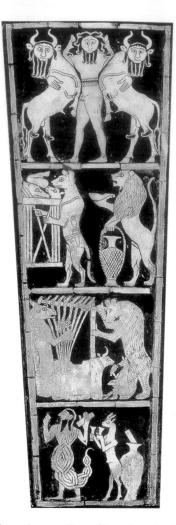

2.9 Inlay panel from the soundbox of lyre, from Ur (Muqaiyir), Iraq. ca. 2600 BCE. Shell and bitumen, 12¼ × 4½" (31.1 × 11.3 cm). University Museum, University of Pennsylvania, Philadelphia

profile) rarely overlap. This, and the contrasting colored materials, give the narrative an easy legibility, even from a distance.

On excavating the Royal Standard of Ur, Woolley envisioned it held aloft on a pole as a military standard, and named it accordingly. In fact, it is unclear how the Sumerians used the object. It may have been the sounding-box for a stringed instrument, an object that was commonly deposited in burials. In one of the cemetery's most lavish graves, the grave of "Queen" Pu-abi, Woolley discovered a lyre decorated with a bull's head of gold gilt and lapis lazuli, dating to ca. 2600 BCE (fig. 2.8), comparable to the lyre on the Standard. On its sounding-box, a panel of shell inlaid in bitumen depicts a male figure in a heraldic composition, embracing two human-faced bulls and facing a viewer with a frontal glare (fig. 2.9). In the lower registers, animals perform human tasks such as carrying foodstuffs and playing music. These scenes may have evoked a myth or fable that contemporary viewers knew either in written or in oral form, and that was perhaps associated with a funerary context. In some cultures, fantastic hybrid creatures, such as the bulls or the man with a braided, snakelike body in the bottom scene, served an apotropaic function.

Losses Through Looting

The archaeologist's greatest nemesis is the looter, who pillages ancient sites to supply the world's second largest illicit business: the illegal trade in antiquities. The problem is worldwide, but recent publicity has focused on Iraq, where thousands of archaeological sites still await proper excavation. Looters are often local people, living in impoverished conditions but supported and organized by more powerful agents; just as frequently, looters work in organized teams, arriving on site with jackhammers and bulldozers, wielding weapons to overcome whatever meager security there might be. Often employing the most sophisticated tools, such as remote-sensing and satellite photography, they move quickly and unscrupulously through a site, careless of what they destroy in their search for treasure. Loot changes hands quickly as it crosses national borders, fetching vast sums on the market. Little or none of this fortune returns to local hands.

Even more is at stake in these transactions than the loss of a nation's heritage. Only a fraction of the value of an archaeological find resides in the object itself. Much more significant is what its findspot—the place where it was found—can tell archaeologists, who use the information to construct a history of the past. An object's location within a city or building reveals how it was used. A figurine, for instance, could be a fertility object, doll, or cult image, depending on its physical context. The exact level, or stratum, at which archaeologists find an object discloses when it was in use. On some sites, stratigraphy (reading levels/strata) yields very precise dates. If an

object comes to light far from its place of manufacture, its findspot can even document interactions between cultures.

A 1970 UNESCO Convention requires member states to prohibit the importation of stolen antiquities from other member states, and offers help in protecting cultural property that is in jeopardy of pillage. To date, 115 countries are party to the convention.

Looters at the archaeological site of Isin, southern Iraq, January 2004

Cylinder Seals

The Mesopotamians also produced vast numbers of cylinder seals, which the administration used to seal jars and secure storerooms. The seals were cylindrical objects usually made of stone, with a hole running through the center from end to end. A sculptor carved a design into the curved surface of the seal, so that when the owner impressed it in soft clay, a raised, reverse image would unfold, repeated as the cylinder rolled along. Great quantities of seals and sealings (seal impressions) have survived. Many are of modest quality, reflecting their primarily administrative purpose,

but the finest examples display a wealth of detail and a high level of sculptural expertise. With subjects ranging from divine and royal scenes to monumental architecture, animals, and daily activities, the seals provide critical information about Mesopotamian existence and values. The sealing illustrated here appears to show the feeding of the temple herd, which provided a significant portion of the temple's wealth (fig. 2.10). The human figure's distinctive costume and hat may identify him as a priest-king; some have seen the large vessels as a reference to sacred offerings, and excavators found one such vase, measuring nearly 3 feet in height, in the Eanna precinct at Uruk, dating to ca. 3200 BCE.

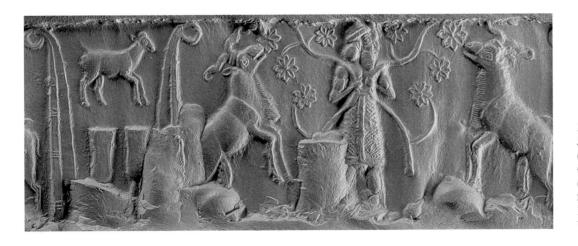

2.10 Priest-King Feeding Sacred Sheep, from vicinity of Uruk (Warka), Iraq. ca. 3300 BCE. Cylinder sealing, height 2½" (5.4 cm), diameter 1¾" (4.5 cm). Staatliche Museen zu Berlin, Preussischer Kulturbesitz, Vorderasiatisches Museum

ART OF AKKAD

Around 2350 BCE, Sumerian city-states began to fight over access to water and fertile land. Gradually, their social organization was transformed as local "stewards of the god" positioned themselves as ruling kings. The more ambitious tried to enlarge their domains through conquest. Semitic-speaking people (those who used languages in the same family as Hebrew and Arabic) from the northern region gradually assumed positions of power in the south. Although they adopted many features of Sumerian civilization, they were less bound to the tradition of the city-state. Sargon (meaning "true king") conquered Sumer, as well as northern Syria and Elam (to the northeast of Sumer) in about 2334 BCE (see map 2.1), basing himself in the city of Akkad (a site unknown today, but probably to the northwest of Sumer, near present-day Baghdad). Akkadian then became the language of authority in Mesopotamia. Sargon's ambitions were both imperial

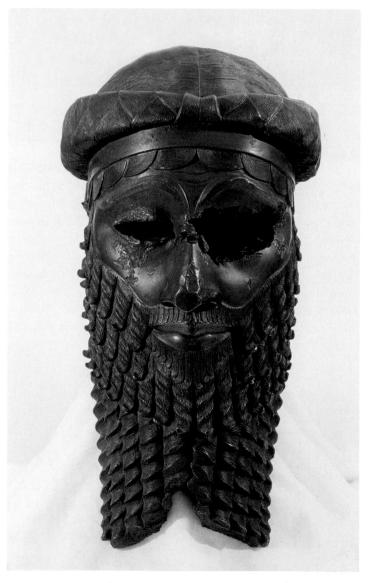

2.11 Head of an Akkadian Ruler, from Nineveh (Kuyunjik), Iraq. ca. 2250–2200 BCE. Copper, height 12" (30.7 cm). Iraq Museum, Baghdad

and dynastic. He combined Sumerian and Akkadian deities in a new pantheon, hoping to break down the traditional link between city-states and their local gods, and thereby to unite the region in loyalty to his absolute rule. Under his grandson, Naram-Sin, who ruled from 2254 to 2218 BCE, the Akkadian Empire stretched from Sumer in the south to Elam in the east, and then to Syria in the west and Nineveh in the north.

Sculpture: Power and Narrative

Akkadian rulers increasingly exploited the visual arts to establish and reflect their power. A magnificent copper portrait head found in a rubbish heap at Nineveh, dated to between 2250 and 2200 BCE and sometimes identified as Naram-Sin himself (fig. 2.11), derives its extraordinary power from a number of factors: The intended view of the portrait was from the front, and this frontality makes it appear unchanging and eternal. The abstract treatment of beard and hair (which is arranged like a Sumerian king's) contrasts with the smooth flesh to give the head a memorable simplicity and strong symmetry, which denote control and order. The intricate, precise patterning of hair and beard testifies to the metalworker's expertise in hollow casting (see Materials and Techniques, page 128). Furthermore, at a time before many people understood the science of metallurgy, the use of cast metal for a portrait demonstrated the patron's control of a technology that most associated primarily with weaponry. In its original form, the portrait probably had eyes inlaid with precious and semiprecious materials, as other surviving figures do. The damage to the portrait was probably incurred during the Medes' invasion of Nineveh in 612 BCE. The enemy gouged out its eyes and hacked off its ears, nose, and lower beard, as if attacking the person represented. Many cultures, even today, practice such acts of ritualized vandalism as symbolic acts of violence or protest.

The themes of power and narrative combine in a 6½-foot stele (upright marker stone) erected in the Akkadian city of Sippar during the rule of Naram-Sin (fig. 2.12). The stele commemorates Naram-Sin's victory over the Lullubi, people of the Zagros mountains in eastern Mesopotamia, in relief. This time the story does not unfold in registers; instead, ranks of soldiers, in composite view, climb the wavy contours of a wooded mountain. Their ordered march contrasts with the enemy's chaotic rout: As the victorious soldiers trample the fallen foe underfoot, the defeated beg for mercy or lie contorted in death. Above them, the king's large scale and central position make his identity clear. He stands isolated against the background, next to a mountain peak that suggests his proximity to the divine. His horned crown, formerly an exclusive accourrement of the gods, marks him as the first Mesopotamian king to deify himself (an act that his people did not unanimously welcome). The bold musculature of his limbs and his powerful stance cast him as a heroic figure. Solar deities shine auspiciously overhead, as if witnessing his victory.

The stele of Naram-Sin still communicated its message of power over a thousand years later. In 1157 BCE, the Elamites of southwestern Iran invaded Mesopotamia and seized it as war

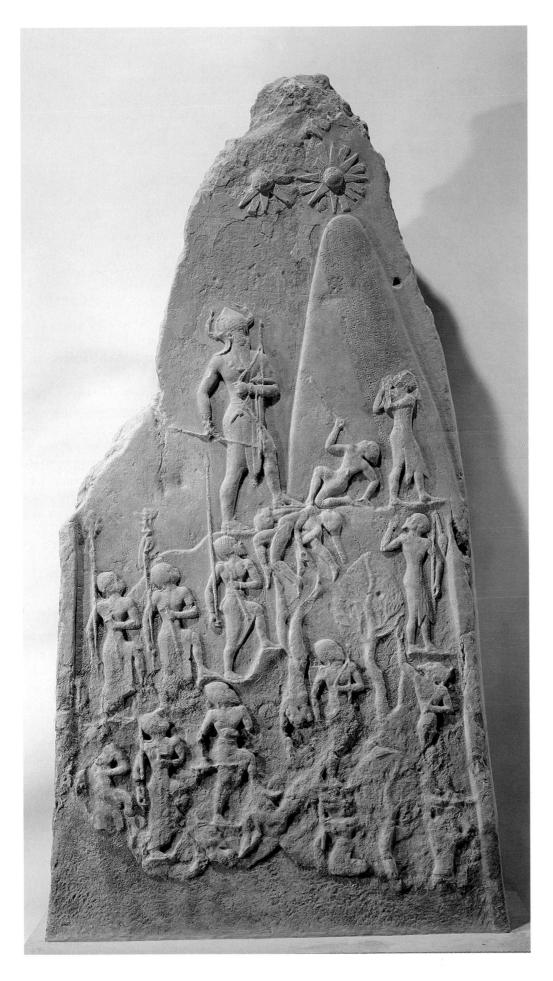

2.12 Stele of Naram-Sin. r. 2254–2218 BCE. Height 6'6" (2 m). Musée du Louvre, Paris

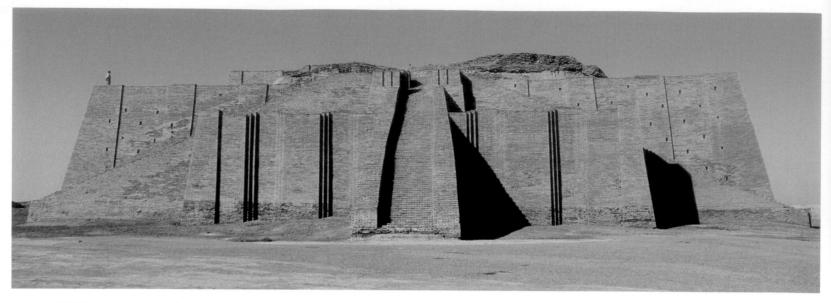

2.13 Great Ziggurat of King Urnammu, Ur, Muqaiyir, Iraq. ca. 2100 BCE

booty. An inscription on the stele records that they then installed it in the city of Susa (see map 2.1). By capturing the defeated city's victory monument, they symbolically stole Naram-Sin's former glory and doubly defeated their foe.

NEO-SUMERIAN REVIVAL

The rule of the Akkadian kings came to an end when a mountain people, the Guti, gained control of the Mesopotamian Plain in about 2230 BCE. The cities of Sumer rose up in retaliation and drove them out in 2112 BCE, under the leadership of King Urnammu of Ur (the present-day city of Muqaiyir, Iraq, and the birthplace of the biblical Abraham), who united a realm that was to last 100 years. As part of his renewal project, he returned to building on a magnificent scale.

Architecture: The Ziggurat of Ur

Part of Urnammu's legacy is the Great Ziggurat at Ur of about 2100 BCE, dedicated to the moon god, Nanna (Sin in Akkadian) (fig. 2.13). Its 190-by-130-foot base soared to a height of 50 feet in three stepped stages. The base consisted of solid mud brick faced with baked bricks set in bitumen, a tarry material used here as mortar. Although not structurally functional, thick buttresses (vertical supporting elements) articulate the walls, giving an impression of strength. Moreover, a multitude of upward lines adds a dynamic energy to the monument's appearance. Three staircases, now reconstructed, converged high up at the fortified gateway. Each consisting of 100 steps, one stood perpendicular to the temple, the other two parallel to the base wall. From the gateway, a fourth staircase, which does not survive, once rose to the temple proper. The stairways may have provided an imposing setting for ceremonial processions.

Sculpture: Figures of Gudea

Contemporary with Urnammu's rule in Ur, Gudea became ruler of neighboring Lagash (in present-day Iraq), a small Sumerian city-state that had retained independence after the collapse of Akkad. Reserving the title of king for Lagash's city-god, Ningirsu, Gudea promoted the god's cult through an ambitious reconstruction of his temple. According to inscriptions, Ningirsu appeared to Gudea in a dream after the Tigris River had failed to rise and instructed him to build the temple.

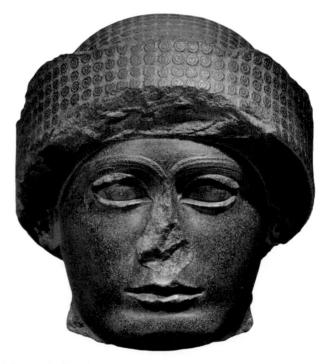

2.14 Head of Gudea, from Lagash (Telloh), Iraq. ca. 2100 BCE. Diorite, height 91/8" (23.2 cm). Museum of Fine Arts, Boston. Francis Bartlett Donation of 1912. 26.289

Texts on Gudea Figures from Lagash and Surrounding Areas, ca. 2100

Gudea, the ruler of Lagash, commissioned numerous temples and many figures of himself to be placed in the temples. Many of these figures (compare figs. 2.14 and 2.15) are inscribed with cuneiform texts that provide insight into the function of each image.

In this excerpt, the god Ningirsu speaks to Gudea, encouraging him to rebuild his temple:

When, O faithful shepherd Gudea,

Thou shalt have started work for me on Eninnu, my royal abode,

I will call up in heaven a humid wind.

It shall bring thee abundance from on high

And the country shall spread its hands upon riches in thy

Prosperity shall accompany the laying of the foundations of my house.

All the great fields will bear for thee;

Dykes and canals will swell for thee;

Where the water is not wont to rise

To high ground it will rise for thee.

Oil will be poured abundantly in Sumer in thy time,

Good weight of wool will be given in thy time.

Source: H. Frankfort, *The Art and Architecture of the Ancient Orient*, 4th ed. (New Haven: Yale University Press, 1970, p. 98).

Of the building itself, nothing now remains. Yet some 20 examples of distinctive statues representing Gudea survive. He had dedicated (or given as an offering) the images at the temple and in other shrines of Lagash and vicinity (figs. 2.14 and 2.15), and they served as a mark of his piety, at the same time as they also extended the Akkadian tradition of exalting the ruler's person. Carved of diorite, a dark stone that was as rare and expensive as it

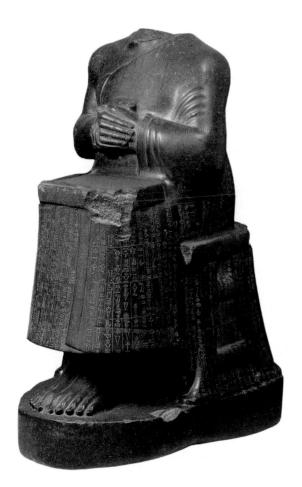

2.15 Seated statue of Gudea holding temple plan, from Girsu (Telloh), Iraq. ca. 2100 BCE. Diorite, height approx. 29" (73.7 cm). Musée du Louvre, Paris

was hard to work, they testify to Gudea's great wealth. Whether standing or seated in pose, the statues are remarkably consistent in appearance: Often wearing a thick woolen cap, Gudea has a long garment draped over one shoulder, and clasps his hands across his front in a pose similar to statues from Tell Asmar of 500 years earlier. Like those figures, Gudea's eyes are wide open, in awe. The highly polished surface and precise modeling allow light to play upon the features, showcasing the sculptors' skills. Rounded forms emphasize the figures' compactness, giving them an impressive monumentality.

In the life-size seated example shown in figure 2.15, Gudea holds the ground plan of Ningirsu's temple on his lap. Inscriptions carved on the statue reveal that the king had to follow the god's instructions meticulously to ensure the temple's sanctity. The inscriptions also provide Gudea's motivation for building the temple, and his personal commitment to the project: By obeying the god, he would bring fortune to his city. (See *Primary Source*, above.) Following Ningirsu's instruction, Gudea purified the city and swept away the soil on the temple's site to expose bedrock. He then laid out the temple according to the design that Ningirsu had revealed to him, and helped manufacture and carry mud bricks.

BABYLONIAN ART

The late third and early second millennia BCE were a time of turmoil and warfare in Mesopotamia. The region was then unified for over 300 years under a Babylonian dynasty. During the reign of its most famous ruler, Hammurabi (r. 1792–1750 BCE), the city of Babylon assumed the dominant role formerly played by Akkad and Ur. Combining military prowess with respect for Sumerian tradition, Hammurabi cast himself as "the favorite shepherd" of the sun-god Shamash, stating his mission "to cause justice to prevail in the land and to destroy the wicked and evil, so that the strong might not oppress the weak nor the weak the strong." Babylon retained its role as cultural center of Sumer for more than 1,000 years after its political power had waned.

The Code of Hammurabi

Posterity remembers Hammurabi best for his law code. It survives as one of the earliest written bodies of law, engraved on a black basalt stele reaching to over 7 feet in height (fig. 2.16). The text consists of 3,500 lines of Akkadian cuneiform, and begins with an account of the temples Hammurabi restored. The largest portion concerns commercial and property law, rulings on domestic issues, and questions of physical assault, detailing penalties for noncompliers (including the renowned Hebrew Bible principle of "an eye for an eye"). (See *Primary Source*, page 35.) The text concludes with a paean to Hammurabi as peacemaker.

At the top of the stele, Hammurabi appears in relief, standing with his arm raised in greeting before the enthroned sun-god Shamash. The god's shoulders emanate sun rays, and he extends his hand, holding the rope ring and the measuring rod of kingship; this single gesture unifies both the scene's composition and the implied purpose of the two protagonists. The image is a variant on the "introduction scene" found on cylinder seals, where a goddess leads a human individual with his hand raised in salute before a seated godlike figure, who bestows his blessing. Hammurabi appears without the benefit—or need—of a divine intercessor, implying an especially close relationship with the sun-god. Still, the smaller scale of Hammurabi compared to the seated god expresses his status as "shepherd" rather than god himself. The symmetrical composition and smooth surfaces result in a legible image of divinely ordained power that is fully in line with Mesopotamian traditions. Like the stele of Naram-Sin, Hammurabi's stele later became war booty, when the Elamites carried it off to Susa.

ASSYRIAN ART

Babylon fell around 1595 BCE to the Hittites, who had established themselves in Anatolia (present-day Turkey). When they departed, they left a weakened Babylonian state vulnerable to other invaders: the Kassites from the northwest and the Elamites from the east. Although a second Babylonian dynasty rose to great heights under Nebuchadnezzar I of Isin (r. 1125–1104 BCE), the Assyrians more or less controlled southern Mesopotamia by the end of the millennium. Their home was the city-state of Assur, sited on the upper course of the Tigris and named for the god Ashur.

Art of Empire: Expressing Royal Power

Under a series of able rulers, beginning with Ashur-uballit (r. 1363–1328? BCE), the Assyrian realm expanded. At its height, in the seventh century BCE, the empire stretched from the Sinai peninsula to Armenia; the Assyrians even invaded Egypt successfully in about 670 BCE (see map 2.1). They drew heavily on the artistic achievements of the Sumerians and Babylonians, but adapted them to their own purpose. The Assyrians' was clearly an

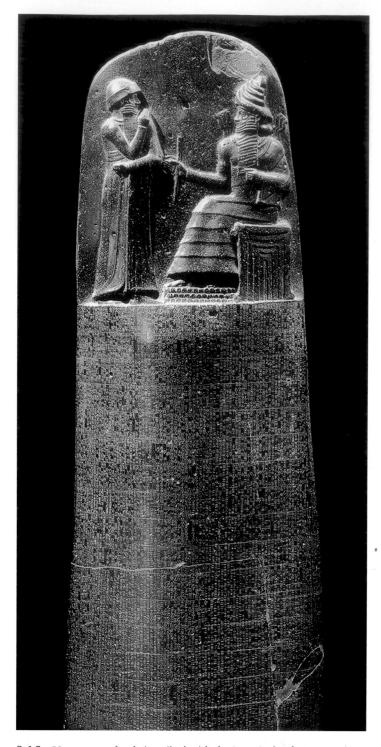

2.16 Upper part of stele inscribed with the Law Code of Hammurabi. ca. 1760 BCE. Diorite, height of stele approx. 7' (2.1 m); height of relief 28" (71 cm). Musée du Louvre, Paris

art of empire: propagandistic and public, designed to proclaim and sustain the supremacy of Assyrian civilization, particularly through representations of military power. The Assyrians continued to build temples and ziggurats based on Sumerian models, but their architectural focus shifted to constructing royal palaces. These grew to unprecedented size and magnificence, blatantly expressing royal presence and domination.

The Code of Hammurabi

Inscribed on the stele of Hammurabi in figure 2.16, the Code of Laws compiled by King Hammurabi offers a glimpse of the lives and values of Babylonians in the second millennium BCE.

Prologue

When Anu the Sublime, King of the Anunaki, and Bel, the lord of Heaven and earth, who decreed the fate of the land, assigned to Marduk, the over-ruling son of Ea, God of righteousness, dominion over earthly man, and made him great among the Igigi, they called Babylon by his illustrious name, made it great on earth, and founded an everlasting kingdom in it, whose foundations are laid so solidly as those of heaven and earth; then Anu and Bel called by name me, Hammurabi, the exalted prince, who feared God, to bring about the rule of righteousness in the land, to destroy the wicked and the evil-doers; so that the strong should not harm the weak; so that I should rule over the black-headed people like Shamash, and enlighten the land, to further the well-being of mankind. ...

The Code of Laws [excerpts]

If any one bring an accusation against a man, and the accused go to the river and leap into the river, if he sink in the river his accuser shall take possession of his house. But if the river prove that the accused is not guilty, and he escape unhurt, then he who had brought the accusation shall be put to death, while he who leaped into the river shall take possession of the house that had belonged to his accuser. ...

If any one bring an accusation of any crime before the elders, and does not prove what he has charged, he shall, if it be a capital offense charged, be put to death. ...

If any one steal the property of a temple or of the court, he shall be put to death, and also the one who receives the stolen thing from him shall be put to death. ...

If any one steal cattle or sheep, or an ass, or a pig or a goat, if it belong to a god or to the court, the thief shall pay thirtyfold; if they

belonged to a freed man of the king he shall pay tenfold; if the thief has nothing with which to pay he shall be put to death ...

If any one break a hole into a house (break in to steal), he shall be put to death before that hole and be buried ...

If any one be too lazy to keep his dam in proper condition, and does not so keep it; if then the dam break and all the fields be flooded, then shall he in whose dam the break occurred be sold for money, and the money shall replace the corn which he has caused to be ruined. ...

If any one be on a journey and entrust silver, gold, precious stones, or any movable property to another, and wish to recover it from him; if the latter do not bring all of the property to the appointed place, but appropriate it to his own use, then shall this man, who did not bring the property to hand it over, be convicted, and he shall pay fivefold for all that had been entrusted to him. ...

If a man wish to separate from a woman who has borne him children, or from his wife who has borne him children: then he shall give that wife her dowry, and a part of the usufruct of field, garden, and property, so that she can rear her children. When she has brought up her children, a portion of all that is given to the children, equal as that of one son, shall be given to her. She may then marry the man of her heart. ...

If a son strike his father, his hands shall be hewn off.

If a man put out the eye of another man, his eye shall be put out.

If he break another man's bone, his bone shall be broken.

If a builder build a house for some one, and does not construct it properly, and the house which he built fall in and kill its owner, then that builder shall be put to death.

If it kill the son of the owner, the son of that builder shall be put to death.

If it kill a slave of the owner, then he shall pay slave for slave to the owner of the house. ...

Source: World Civilizations Online Classroom "The Code of Hammurabi" tr. L. W. King (1910), Edited by Richard Hooker www.wsu.edu:8080/2dee. © 1996.

Note: The Epilogue of The Code of Hammurabi appears at www.myartslab.com.

The proclamation of Assyrian royal power began well outside the palace, as is clear in the plan for the city of Dur Sharrukin (present-day Khorsabad, Iraq), where Sargon II (r. 721–705 BCE) had his royal residence (fig. 2.17). Though much of the city remains unexcavated, archaeologists estimate that it covered an area of nearly a square mile, enclosed within an imposing mudbrick fortification wall. To reach the palace, a visitor had to cross the city, traversing open plazas and climbing broad ramps. On the northwest side, a walled and turreted citadel closed the ziggurat and the palace off from the rest of the town and emphasized their dominant presence. Enclosing temple and palace, the citadel revealed the privileged relationship between the king and the gods. Both structures stood atop a mound 50 feet high, which

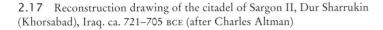

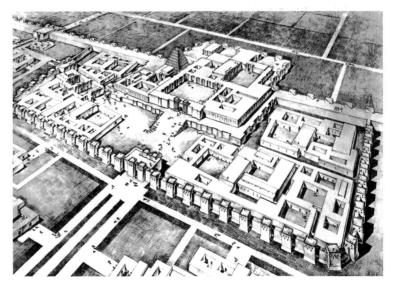

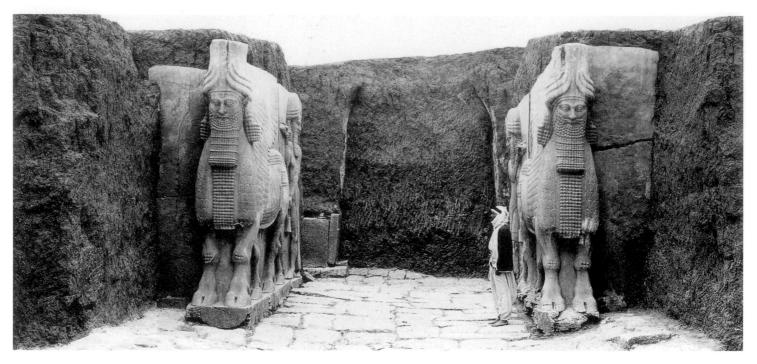

2.18 Gate of the citadel of Sargon II, Dur Sharrukin (Khorsabad), Iraq (photo taken during excavation). 742-706 BCE

raised them above the flood plain and expressed the king's elevated status above the rest of society. The ziggurat had at least four stages, each about 18 feet high and of a different color, and a spiral ramp wound around it to the top.

The palace complex comprised about 30 courtyards and 200 rooms, and monumental imagery complemented this impressive scale. At the gateways stood huge, awe-inspiring guardian figures known as lamassu, in the shape of winged, human-headed bulls (fig. 2.18). The illustration here shows the lamassu of Khorsabad during excavation in the 1840s; masons subsequently sawed up one of the pair for transportation to the Louvre in Paris. The massive creatures are almost in the round (fully three-dimensional

and separate from the background). Carved out of the limestone of the palace wall, they are one with the building. Yet the addition of a fifth leg, visible from the side, reveals that the sculptor conceived of them as deep relief sculptures on two sides of the stone block, so that the figures are legible both frontally and in profile. From the front, the lamassu appear stationary, yet the additional leg sets them in motion when seen from the side. With their tall, horned headdresses and deep-set eyes, and the powerful muscularity of their legs and bodies, all set off by delicate patterning of the beard and feathers, they towered over any approaching visitor, embodying the king's fearful authority. The Assyrians may have believed the hybrid creatures had the power to ward off evil

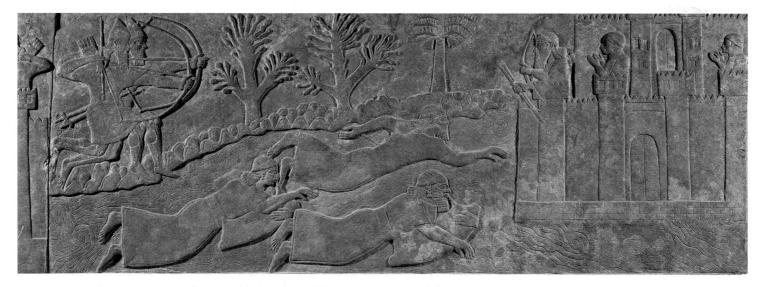

2.19 Fugitives Crossing River, from the Northwest Palace of Ashurnasirpal II, Nimrud (Calah), Iraq. ca. 883–859 BCE. Alabaster, height approx. 39" (98 cm). The British Museum, London

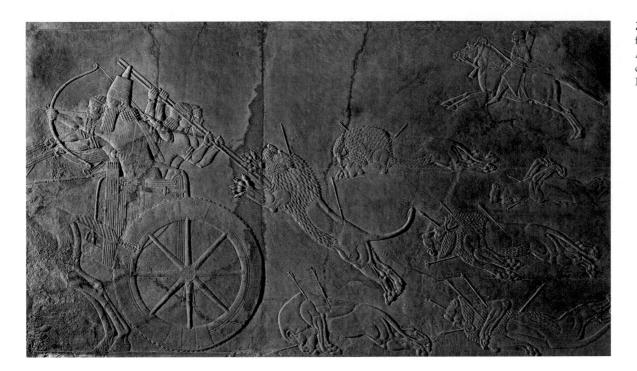

2.20 Lion Hunt relief, from the North Palace of Ashurbanipal, Nineveh. ca. 645 BCE. The British Museum, London

spirits. Contemporary texts indicate that sculptors also cast lamassu in bronze, but because these images were later melted down, none now survives.

Once inside a royal palace, a visitor would confront another distinctive feature of Assyrian architecture: upright gypsum slabs called orthostats, with which builders lined the lower walls. Structurally, the slabs protected the mud brick from moisture and wear, but they served a communicative purpose as well. On their surfaces, narrative images in low relief, painted in places for emphasis, glorified the king with detailed depictions of lion hunts and military conquests (with inscriptions giving supplementary information). In these reliefs, the Assyrian forces march indefatigably onward, meeting the enemy at the empire's frontiers, destroying his strongholds, and carrying away booty and prisoners of war. Actions take place in a continuous band, propelling a viewer from scene to scene, and repetition of key images creates the impression of an inevitable Assyrian triumph. This detail (fig. 2.19), from the Northwest Palace of Ashurnasirpal II (r. 883-859 BCE) at Nimrud (ancient Kalah, biblical Calah, Iraq), shows the enemy fleeing an advance party by swimming across a river on inflatable animal skins. From their fortified city, an archer—possibly the king—and two women look on with hands raised. The artist intersperses landscape elements with humans, yet shows no concern to capture relative scale, or to depict all elements from a single viewpoint. This suggests that the primary purpose of the scenes was to recount specific enemy conquests in descriptive detail; depicting them in a naturalistic way was not critical.

As in Egypt (discussed in Chapter 3), royal lion hunts were staged events that took place in palace grounds. Royal attendants released animals from cages into a square formed by troops with shields. Earlier Mesopotamian rulers hunted lions to protect their subjects, but by the time of the Assyrians, the activity had become

more symbolic, ritually showcasing the king's strength and serving as a metaphor for military prowess. On a section of Assyrian relief from the North Palace of Ashurbanipal (r. 668-627 BCE) at Nineveh, dating to roughly 645 BCE (fig. 2.20), the king races forward in his chariot with bow drawn, leaving wounded and dead lions in his wake. A wounded lion leaps at the chariot as attendants plunge spears into its chest. Its body is hurled flat out in a clean diagonal line, its claws spread and mouth open in what appears to be pain combined with desperate ferocity. To ennoble the victims of the hunt, the sculptor contrasted the limp, contorted bodies of the slain animals with the taut leaping lion and the powerful energy of the king's party. Yet we should not conclude that the artist necessarily hoped to evoke sympathy for the creatures, or to comment on the cruelty of a staged hunt; it is more likely that by ennobling the lions the sculptor intended to glorify their vanquisher, the king, even more intensely.

LATE BABYLONIAN ART

Perpetually under threat, the Assyrian Empire came to an end in 612 BCE, when Nineveh fell to the Medes (an Indo-European-speaking people from western Iran) and the resurgent Babylonians. Under the Chaldean dynasty, the ancient city of Babylon had a final brief flowering between 612 and 539 BCE, before the Persians conquered it. The best known of these Late Babylonian rulers was Nebuchadnezzar II (r. 604–ca. 562 BCE), builder of the biblical Tower of Babel, which soared 270 feet high and came to symbolize overweening pride. He was also responsible for the famous Hanging Gardens of Babylon, numbered among the seven wonders of the ancient world compiled by Greek historians by the second century BCE.

The Royal Palace

The royal palace at Babylon was on almost the same scale as Assyrian palaces, with numerous reception suites framing five huge courtyards. Instead of facing their buildings with carved stone, the Late Babylonians adopted baked and glazed brick, which they molded into individual shapes. Glazing brick involved putting a film of glass over the brick's surface. Late Babylonians used it both for surface ornament and for reliefs on a grand scale. Its vivid coloristic effect appears on the courtyard façade of the Throne Room and the Processional Way leading to the Ishtar Gate and the gate itself, now reassembled in Berlin (fig. 2.21). A framework of brightly colored ornamental bands contains a procession of bulls, dragons, and other animals, set off in molded brick against a deep blue background. The animals portrayed were sacred: White and yellow snake-necked dragons to Marduk, the chief Babylonian god; yellow bulls with blue hair to Adad, god of storms; and white and yellow lions to Ishtar herself, goddess of love and war. Unlike the massive muscularity of the

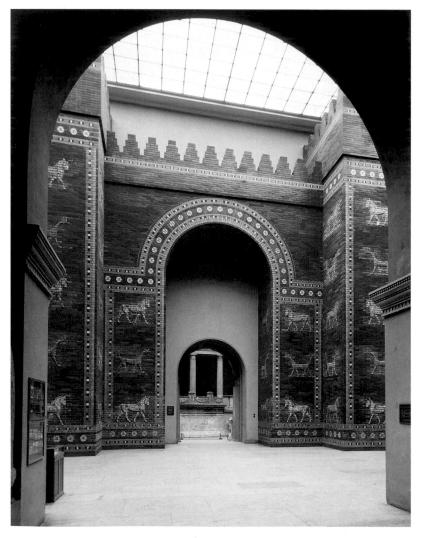

2.21 Ishtar Gate (restored), from Babylon, Iraq. ca. 575 BCE. Glazed brick originally 40' high (12.2 m). Staatliche Museen zu Berlin, Preussischer Kulturbesitz, Vorderasiatisches Museum

lamassu, their forms are light and agile-looking, arrested in a processional stride that slowly accompanies ceremonial processions leading to the archway of the gate.

REGIONAL NEAR EASTERN ART

Alongside the successive cultures of Mesopotamia, a variety of other cultures developed in areas beyond the Tigris and Euphrates. Some of them invaded or conquered contemporaneous city-states in Mesopotamia, as did the Hittites in the north and the Iranians in the east. Others, such as the seagoing Phoenicians on the Mediterranean coast to the west, traded with the people of Mesopotamia and in so doing spread Mesopotamian visual forms to Africa and Europe.

The Hittites

The Hittites were responsible for Babylon's overthrow in 1595 BCE. An Indo-European-speaking people, they had probably entered Anatolia from southern Russia in the late third millennium BCE and settled on its rocky plateau as one of several cultures that developed independently of Mesopotamia. As they came into contact with Mesopotamian traditions, the Hittites adopted cuneiform writing for their language, and preserved details of their history on clay tablets. Emerging as a power around 1800 BCE, they rapidly expanded their territory 150 years later under Hattusilis I. Their empire extended over most of present-day Turkey and Syria, which brought them into conflict with the imperial ambitions of Egypt. The Hittite Empire reached its apogee between 1400 and 1200 BCE. Its capital was Hattusa, near the present-day Turkish village of Bogazköy. Fortification walls protected the city, constructed of huge, irregularly shaped stones that were widely available in the region. At the city gates, massive limestone lions and other guardian figures protruded from the blocks that formed the jambs (fig. 2.22). The Lion Gate is 7 feet high, and though badly weathered, the figures still impress visitors with their ferocity and stark frontality. These powerful guardians probably inspired the later Assyrian lamassu (see fig. 2.18).

The Phoenicians

The Phoenicians, too, contributed a distinctive body of work to Near Eastern art. Living on the eastern coast of the Mediterranean in the first millennium BCE in what is now Lebanon, they developed formidable seafaring skills, which led them to found settlements farther west in the Mediterranean (most notably on the North African coast and in Spain). They became a linchpin in the rapidly growing trade in objects—and ideas—between East and West. The Phoenicians were especially adept in working metal and ivory, and in making colored glass. They readily incorporated motifs from Egypt and the eastern Mediterranean coast, as seen in the open-work ivory plaque illustrated here (fig. 2.23), on which is poised an Egyptian winged sphinx. The plaque dates to the

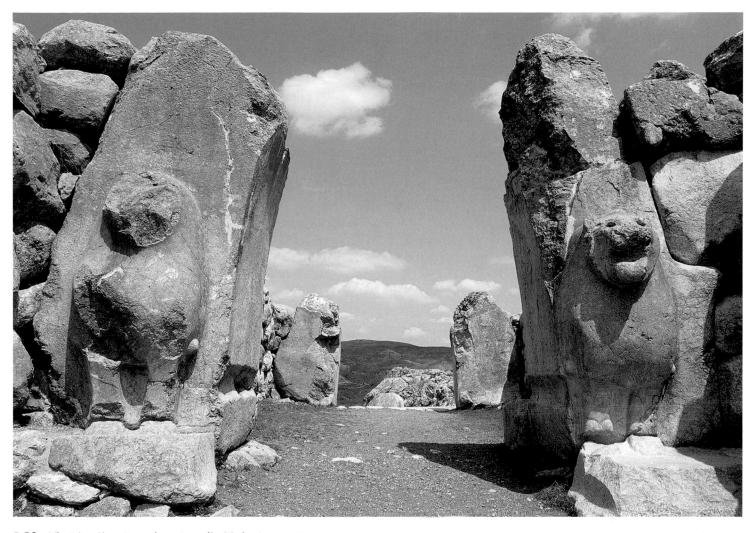

2.22 The Lion Gate, Bogazköy, Anatolia (Turkey). ca. 1400 BCE

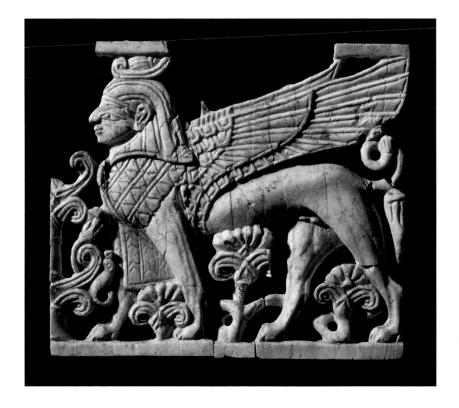

2.23 Phoenician ivory plaque depicting a winged sphinx, found at Fort Shalmaneser, Nimrud (ancient Kalhu), northern Iraq. ca. 8th century BCE. The British Museum, London

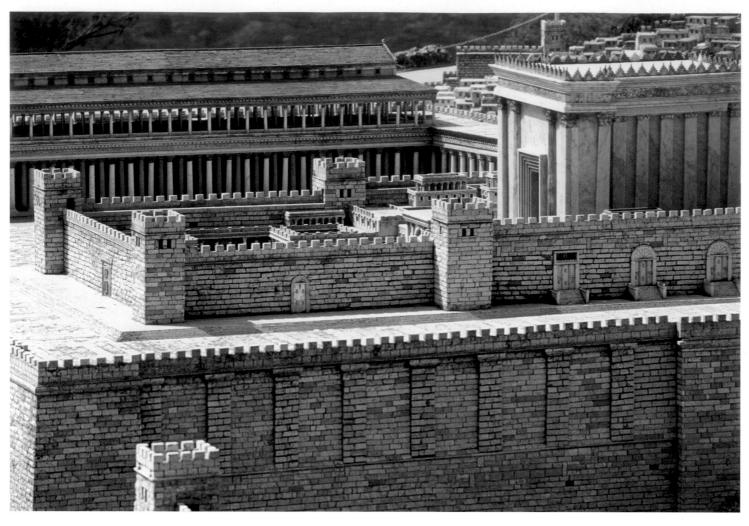

2.24 Temple of Solomon (reconstruction), Jerusalem. ca. 457–450 BCE

eighth century BCE, and came to light in Fort Shalmaneser at Nimrud, the Assyrian capital where the conquering Assyrian kings had probably taken it as booty. Though the details are Egyptian—its wig and apron, the stylized plants—the carver has reduced its double crown to fit neatly within the panel, suggesting that what mattered was a general quality of "Egyptianness" rather than an accurate portrayal of Egyptian motifs. The rounded forms and profile presentation translate the Egyptian motif into a visual form more familiar to Mesopotamian eyes.

The Hebrews

According to later tradition, the Akkadians expelled the Hebrews from Mesopotamia in about 2000 BCE. The latter settled in Canaan, on the eastern Mediterranean, before moving to Egypt in around 1600 BCE. There, they were bound into slavery. Moses led their flight from Egypt into the Sinai desert, where they established the principles of their religion. Unlike other Near Eastern peoples, the Hebrews were monotheistic. Their worship centered on Yahweh, who provided Moses with the Ten Commandments, a set of ethical and moral rules. After 40 years, they returned to Canaan, which they named Israel. King David, who ruled until

961 BCE, seized the city of Jerusalem from the Canaanites, and began to construct buildings there worthy of a political and religious capital for Israel, including a royal palace. His son, Solomon, completed a vast temple for worship, now known as the First Temple (fig. 2.24). The temple stood within a sacred precinct on Mount Moriah (the present-day Temple Mount), where, according to the scriptures, the patriarch Abraham had prepared to sacrifice his son, Isaac. Archaeological evidence for the massive building is controversial, and literary descriptions are incomplete. According to the Hebrew Bible, Solomon covered the entire temple and the altar inside with gold. For the inner sanctuary, which held the Ark of the Covenant (a chest containing the Commandments), sculptors created two monumental cherubim (angels depicted as winged children) out of gilded olive wood. They also covered the walls with carvings of cherubin, palm trees, and flowers. Brass pillars stood at the front of the temple, with pomegranate-shaped capitals. King Hiram of Tyre (Phoenicia) is credited with providing resources for the construction of the temple, such as materials and artisans, which is further evidence of the close connections between Near Eastern cultures.

Babylonian forces under King Nebuchadnezzar II destroyed the temple in 587/86 BCE, forcing the Israelites into exile. Upon

their return in 538, they built the temple anew, and under Herod the Great, king of Judea from 37 BCE to 4 CE, the Second Temple was raised up and substantially enlarged. Roman soldiers razed this rebuilding in the reign of the emperor Vespasian, in the first century CE. The only vestige of the vast complex Herod commissioned is the western wall, known today as the Wailing Wall.

IRANIAN ART

Located to the east of Mesopotamia, Iran was a flourishing agricultural center in Neolithic times, starting in about 7000 BCE. During that period, Iran became a gateway for migrating tribes

2.25 Painted beaker, from Susa. ca. 4000 BCE. Height 111/4" (28.3 cm). Musée du Louvre, Paris

from the Asiatic steppes to the north as well as from India to the east. While it is distinctive, the art of ancient Iran still reflects its intersections with the cultures of Mesopotamia.

Early Iranian Art

The early nomadic tribes left no permanent structures or records, but the items they buried with their dead reveal that they ranged over a vast area—from Siberia to central Europe, from Iran to Scandinavia. They fashioned objects of wood, bone, or metal, and these diverse works share a common decorative vocabulary, including animal motifs used in abstract and ornamental ways. They belong to a distinct kind of portable art known as **nomad's gear**, including weapons, bridles, buckles, **fibulae** (large clasps or brooches), and other articles of adornment, as well as various kinds of vessels.

The handleless beaker in figure 2.25, dating to about 4000 BCE, originates from a pottery-producing center at Susa on the Shaur River. On the surface of its thin shell of pale yellow clay, a brown glaze defines an ibex (mountain goat), whose forms the painter has reduced to a few dramatic sweeping curves. The circles of its horns reflect in two dimensions the cup's three-dimensional roundness. Racing hounds above the ibex stretch out to become horizontal streaks, and vertical lines below the vessel's rim are the elongated necks of a multitude of birds. This early example of Iranian art demonstrates the skill of the potter in both the construction of the cup and its sensitive painted design. It prefigures a later love of animal forms in the nomadic arts of Iran and Central Asia.

The Persian Empire: Cosmopolitan Heirs to the Mesopotamian Tradition

During the mid-sixth century BCE, the small kingdom of Parsa to the east of lower Mesopotamia came to dominate the entire Near East. Under Cyrus the Great (r. 559-530/29 BCE), ruler of the Achaemenid dynasty, the people of Parsa-the Persiansoverthrew the king of the Medes, then conquered major parts of Asia Minor in ca. 547 or 546 BCE, and Babylon in 538 BCE. Cyrus assumed the title "king of Babylon," along with the broader ambitions of Mesopotamian rulers. The empire he founded continued to expand under his successors. Egypt fell in 525 BCE, while Greece only narrowly escaped Persian domination in the early fifth century BCE. At its height, under Darius I (r. 521-486 BCE) and his son Xerxes (r. 485-465 BCE), the territorial reach of the Persian Empire far outstripped the Egyptian and Assyrian empires combined. It endured for two centuries, during which it developed an efficient administration and monumental art forms.

Persian religious beliefs related to the prophecies of Zoroaster (Zarathustra) and took as their basis the dualism of good and evil, embodied in Ahuramazda (Light) and Ahriman (Darkness). The cult of Ahuramazda focused its rituals on fire altars in the open air; consequently, Persian kings did not construct monumental

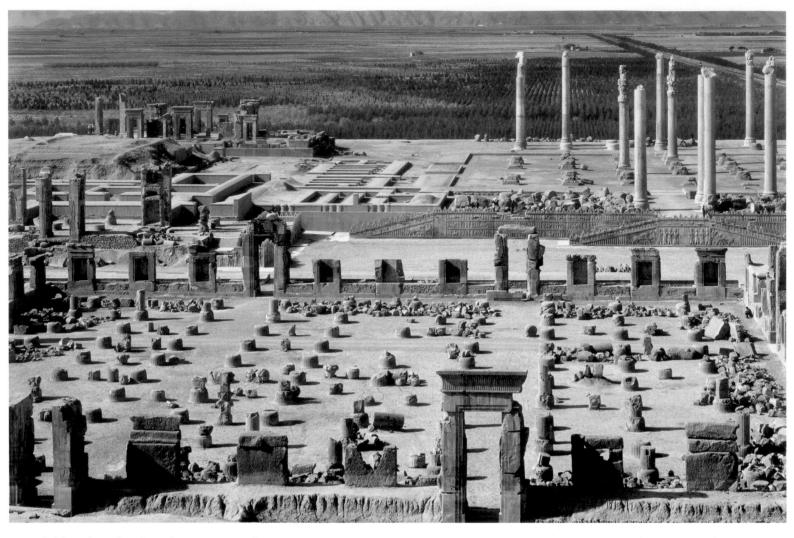

2.26 Palace of Darius and Xerxes, Persepolis. 518-460 BCE

religious architecture. Instead they concentrated their attention and resources on royal palaces, which were at once vast and impressive.

PERSEPOLIS Darius I began construction on the most ambitious of the palaces, on a plateau in the Zagros highlands at Parsa or Persepolis, in 518 BCE. Subsequent rulers enlarged it (fig. 2.26). Fortified and raised on a platform, it consisted of a great number of rooms, halls, and courts laid out in a grid plan. The palace is a synthesis of materials and design traditions from all parts of the far-flung empire; brought together, they result in a clear statement of internationalism. Darius boasts in his inscriptions that the palace timber came from Lebanon (cedar), Gandhara and Carmania (yaka wood), and its bricks from Babylon. Items for palace use (such as the golden **rhyton**, or ritual cup, in fig. 2.27), were of Sardian and Bactrian gold, Egyptian silver, and ebony, and Sagdianan lapis lazuli and carnelian. To work these materials, the Achaemenids brought in craftsmen from all over the empire, who

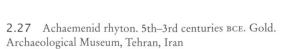

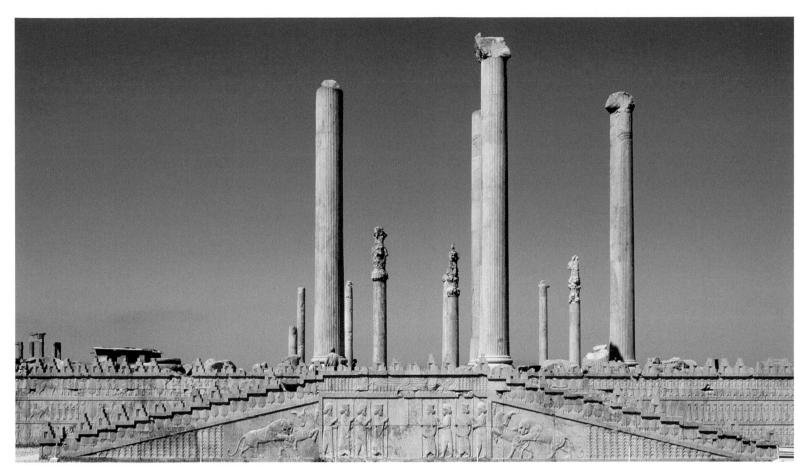

2.28 Audience Hall of Darius and Xerxes, Persepolis, Iran. ca. 500 BCE

then took this international style away with them on returning to their respective homes. The gold-worker responsible for the rhyton shaped it as a senmury, a mythical creature with the body of a lion sprouting griffin's wings and a peacock's tail. It belongs firmly to the tradition of Mesopotamian hybrid creatures.

Visitors to the palace were constantly reminded of the theme of empire, beginning at the entrance. There, at the massive "Gate of All the Lands," stood colossal winged, human-headed bulls, like the Assyrian lamassu (see fig. 2.18). Inside the palace, architects employed columns on a magnificent scale. Entering the 217foot-square Audience Hall, or apadana, of Darius and Xerxes, a visitor would stand amid 36 columns, which soared 40 feet up to support a wooden ceiling. A few still stand today (fig. 2.28). The concept of massing columns in this way may come from Egypt; certainly Egyptian elements are present in the vegetal (plantlike) detail of their bases and capitals. The form of the shaft, however, echoes the slender, fluted column shafts of Ionian Greece (see fig. 5.8). Crowning the column capitals are "cradles" for ceiling beams composed of the front parts of two bulls or similar creatures (fig. 2.29). The animals recall Assyrian sculptures, yet their truncated, back-to-back arrangement evokes animal motifs of Iranian art, as seen in the form of the rhyton.

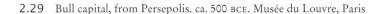

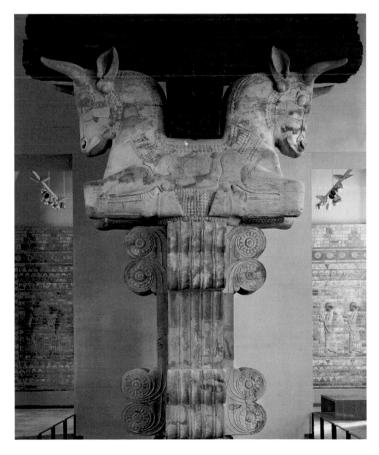

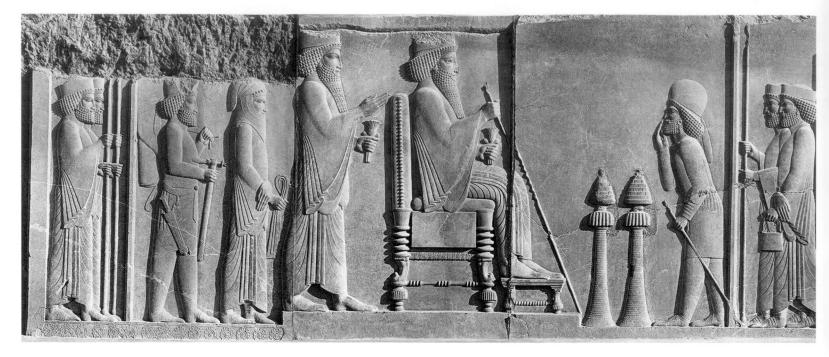

2.30 Darius and Xerxes Giving Audience. ca. 490 BCE. Limestone, height 8'4" (2.5 m). Archaeological Museum, Tehran, Iran

In marked contrast to the military narratives of the Assyrians, reliefs embellishing the platform of the Audience Hall and its double stairway proclaim a theme of harmony and integration across the multicultural empire (fig. 2.30). Long rows of marching figures, sometimes superposed in registers, represent the empire's 23 subject nations, as well as royal guards and Persian dignitaries. Each of the nations' representatives wears indigenous dress and brings a regional gift—precious vessels, textiles—as tribute to the

Persian king. Colored stone and metals applied to the relief added richness to a wealth of carved detail. The relief is remarkably shallow, yet by reserving the figures' roundness for the edge of their bodies (so that they cast a shadow), and by cutting the background away to a level field, the sculptors created an impression of greater depth. Where earlier Mesopotamian reliefs depict figures in mixed profile and frontal views, most of these figures are in full profile, even though some figures turn their heads back to

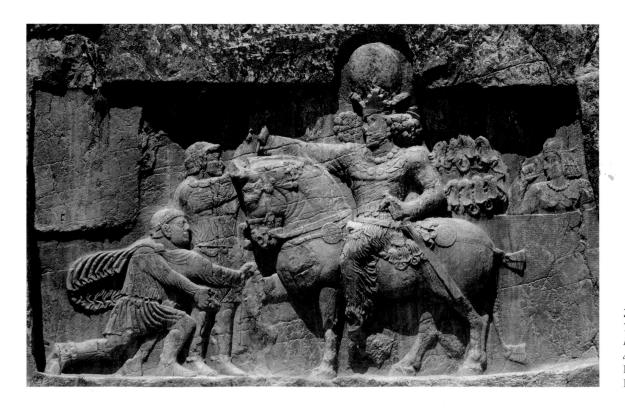

2.31 Shapur I Triumphing over the Roman Emperors Philip the Arab and Valerian, Naksh-i-Rustam (near Persepolis), Iran. 260–272 CE

address those who follow. Through repetition of the walking human form, the artists generated a powerful dynamic quality that guides a visitor's path through the enormous space. The repetition also lends the reliefs an eternal quality, as if preserving the action in perpetual time. If, as some believe, the relief represents the recurring celebration of the New Year Festival, this timeless quality would be especially apt.

The Achaemenid synthesis of traditions at Persepolis demonstrates the longevity and flexibility of the Near Eastern language of rulership. The palace provides a dramatic and powerful setting for imperial court ritual on a grand scale.

Mesopotamia Between Persian and Islamic Dominion

Rebuffed in its attempts to conquer Greece, the Persian Empire eventually came under Greek and then Roman domination, but like many parts of the Greek and Roman empires, it retained numerous aspects of its own culture. The process began in 331 BCE with Alexander the Great's (356-323 BCE) victory over the Persians, when his troops burnt the palace at Persepolis in an act of symbolic defiance. After his death eight years later, his generals divided his realm among themselves, and Seleukas (r. 305-281 BCE) inherited much of the Near East. The Parthians, who were Iranian nomads, gained control over the region in 238 BCE. Despite fairly constant conflict, they fended off Roman advances until a brief Roman success under Trajan in the early second century CE, after which Parthian power declined. The last Parthian king was overthrown by one of his governors, Ardashir or Artaxerxes, in 224 ce. This Ardashir (d. 240 ce) founded the Sasanian dynasty, named for a mythical ancestor, Sasan, who claimed to be a direct descendent of the Achaemenids, and this dynasty controlled the area until the Arab conquest in the midseventh century CE.

Ardashir's son, Shapur I (r. 240–272 ce), proved to be Darius' equal in ambition, and he linked himself directly to the Persian king. He expanded the empire greatly, and even succeeded in defeating three Roman emperors in the middle of the third century CE. Two of these victories Shapur commemorated in numerous reliefs, including an immense panel carved into rock at Naksh-i-Rustam, near Persepolis, where Darius I and his successors had previously located their rock-cut tombs (fig. 2.31). The victor, on horseback, raises his hand in a gesture of mercy to the defeated "barbarian," who kneels before him in submission. This was a stock Roman scene, recognizable to Roman viewers, and this quotation gives the relief an ironic dimension, for the victorious Shapur here expropriates his enemy's own iconography of triumph. Elements of style are typical of late or provincial Roman sculpture, such as the linear folds of the emperor's billowing cloak. However, Shapur's elaborate headdress and clothing, his heavily caparisoned horse, and his composite pose are all distinctly Near Eastern.

Roman and Near Eastern elements are combined again in Shapur I's palace (242–272 CE) at Ctesiphon, near Baghdad, with its magnificent brick, barrel-vaulted audience hall, or iwan (fig. 2.32). It was a Roman practice to exploit the arch to span huge spaces (see fig. 7.61), and the architect used it here to enclose a space 90 feet high, typical of the Near Eastern tradition of large-scale royal building. The registers of arched blank windows or blind arcades may derive from Roman façades, such as those in the stage buildings of theaters or ornamental fountains (see fig. 7.7). Yet the shallowness of the arcades creates a distinctly

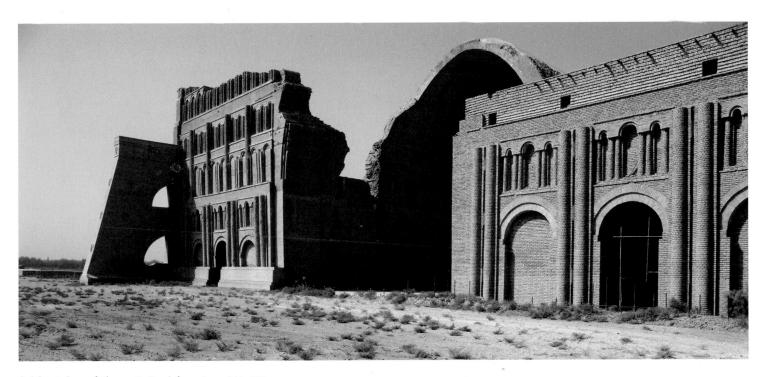

2.32 Palace of Shapur I, Ctesiphon, Iraq. 242-272 CE

eastern surface pattern, in turn subordinated to an awe-inspiring entryway.

Metalwork continued to flourish in the Sasanian period, using a wide variety of techniques. Hunting scenes were a popular subject, as seen in figure 2.33, a late fifth-century CE silver bowl that probably represents King Peroz I hunting gazelles. A metalworker turned the bowl on a lathe, and hammered out the king and his prey from behind (a technique known as repoussé), before applying gilt and inlaying details such as the horns of the

animals and the pattern on the quiver, with niello, a compound of sulphur. The hunting subject continues a tradition known to Assyrians, as well as to Egyptians and Romans. Sasanians exported many of their wares to Constantinople (see map 8.1) and to the Christian West, where they had a strong impact on the art of the Middle Ages. Artists would manufacture similar vessels again after the Sasanian realm fell to the Arabs in the mid-seventh century CE, and these served as a source of design motifs for Islamic art as well (see Chapter 9).

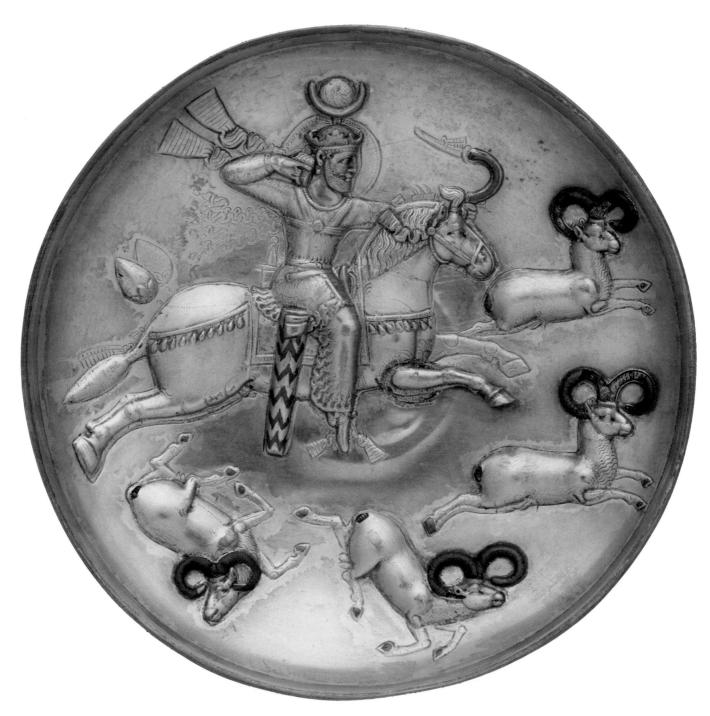

2.33 Peroz I (457–483) or Kavad I hunting rams. 5th–6th century CE. Silver, mercury gilding, niello inlay, diameter 85/8" (21.9 cm), height 17/8" (4.6 cm). Metropolitan Museum of Art, New York, Fletcher Fund, 1934 (34.33)

ca. 4000 BCE Handleless beaker from Susa

AGGATATA MAMATATA

ca. 2600 BCE The Royal Standard of Ur

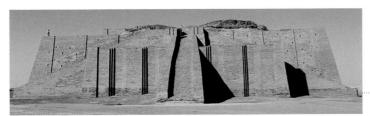

ca. 2100 BCE King Urnammu commissions the Great Ziggurat at Ur

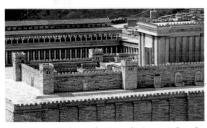

ca. 957 BCE Solomon's Temple is completed in Jerusalem

ca. 668-627 BCE Assyrians construct the North Palace of Ashurbanipal

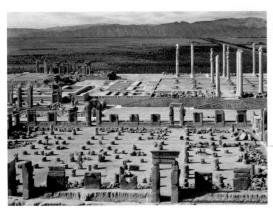

ca. 518 BCE Construction of the Persian palace at Persepolis begins

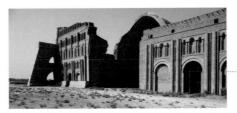

242-272 ce Shapur I's palace at Ctesiphon built

Ancient Near Eastern Art

	100	W.	707	
	題品	8 W 68	98	
85	25,6	PAS	P E N	w)
	.00	dib.	ക്ക	iid
		80 P.4	ϵ	

3500

ca. 3500 BCE Pottery manufacturing appears in western Europe

3000 BCE ca. 3100-2600 BCE Neolithic stone houses at Skara Brae

 ca. 2900 BCE Mesopotamians begin using cuneiform writing

2500 BCE

2000

1500

- ca. 2350 BCE Conflict begins among Sumerian citystates over access to water and fertile land
- after 2150 BCE Earliest surviving Akkadian tablets of the Epic of Gilgamesh

ca. 2100 ncr Final phase of construction at Stonehenge

■ 1400-1200 BCE Apogee of the Hittite Empire

1000 BCE

> 500 BCE

> > 0

■ 612 BCE Nineveh falls to the Medes and resurgent Babylonians; end of the Assyrian Empire ca. 604–562 BCE Reign of the Late Babylonian ruler Nebuchadnezzar II ca. 559–530/29 BCE Rule of Cyrus the Great, who leads Persians to overthrow the Medes

■ 331 BCE Alexander the Great defeats the Persians

■ 224 cE Ardashir founds the Sasanian dynasty

500 CE

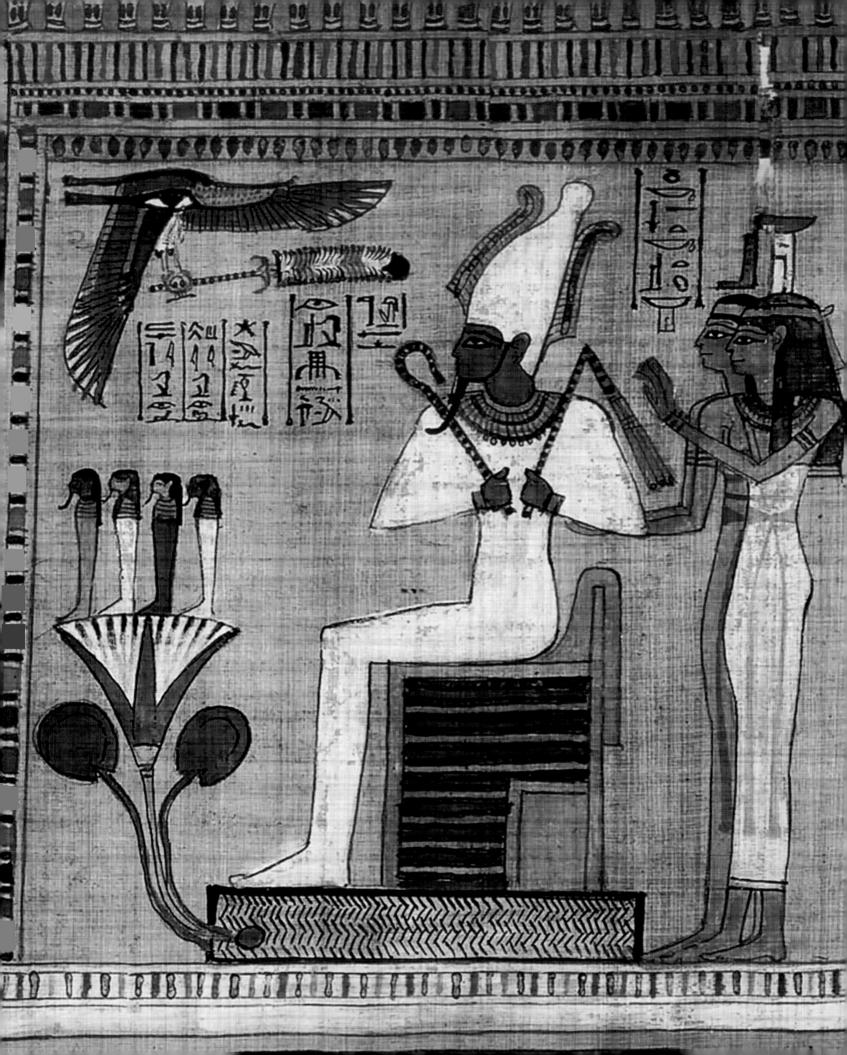

Egyptian Art

the Romans knew and admired Egypt, and Renaissance collectors and scholars took up their esteem. Napoleon's incursions into Egypt in the late eighteenth century brought artifacts and knowledge back to France and stimulated interest throughout Europe. European-sponsored excavations have been

going on in Egypt since the nineteenth century, sometimes, as in the case of the discovery in 1922 of the tomb of King Tutankhamun, with spectacular results.

One reason that ancient Egypt enthralls us is the exceptional technique and monumental character of its works of art. Most surviving objects come from tombs, which Egyptians built to assure an afterlife for the deceased. They intended the paintings, sculptures, and other objects they placed in the tombs to accompany the deceased into eternity. Thus, Egyptian art is an art of permanence. In fact, the fourth-century BCE Greek philosopher Plato claimed that Egyptian art had not changed in 10,000 years. The reality is more complex, but it is fair to say that most Egyptian artists did not strive for innovation or originality, but adhered instead to traditional formulations that expressed specific ideas. Continuity of form and subject is a characteristic of ancient Egyptian art.

Egyptian artists executed works of art mainly for the elite patrons of a society that was extremely hierarchical. Contemporary with the Egyptian development of writing around 3000 BCE there emerged a political and religious system that placed a god-king (called a pharaoh from the New Kingdom on) in charge of the physical and spiritual well-being of the land and its people. Many of the best-known works of Egyptian art exalted

Detail of figure 3.41, The Weighing of the Heart and Judgment by Osiris

these powerful rulers, and express the multifaceted ways that Egyptians envisioned their king: as a human manifestation of the gods, as a god in his own right, as a beneficent ruler, and as an emblem of life itself. Royal projects for the afterlife dominated the landscape and provided the model for elite burials. These two categories of art—royal commissions and funerary objects—constitute a large proportion of surviving Egyptian art. Religion accounts for the predominance of both types of art.

Egyptian geography also played a formative role in the development of art. The land was established on the course of the Nile River in North Africa, exploiting the natural protection of the surrounding desert, or "red land." The river floods annually, inundating the land on either side. As it recedes, the water leaves a dark strip of soil fertilized by silt. The Egyptians called this rich soil the "black land." They irrigated and farmed it, and regularly produced surplus food. This allowed them to diversify and develop a complex culture. Egypt's agrarian society depended on the annual flooding of the Nile to survive. The king had to assure continuity of life through intercession with the gods, who often represented natural forces. (See Informing Art, page 52.) The chief deity was the sun, whom they worshiped as Ra-Horakhty. In matters concerning the afterlife, the deities Osiris, Isis, and Horus played key roles. Osiris was the mythical founder of Egypt, and Isis was his consort. Osiris's brother Seth (god of chaos) murdered him, and having dismembered him, scattered his remains far and wide. Isis eventually recovered them, and reassembled them

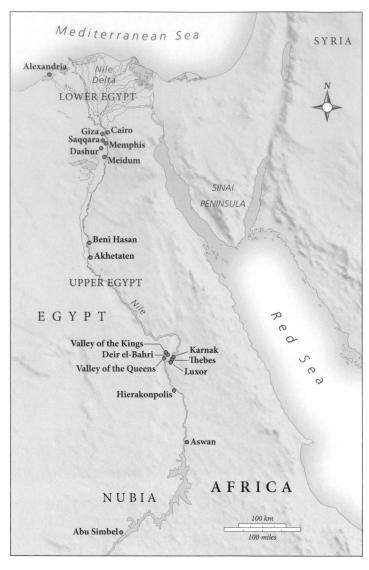

Map 3.1 Ancient Egypt

to create the first mummy (an embalmed and wrapped body). From it she conceived her son, Horus, who avenged his father's death by besting Seth in a series of contests. Gods took many forms: Ra might appear as a falcon-headed man; Osiris as a mummy. Egyptians called the king himself the son of Ra and saw him as the human embodiment of Horus. As an equal to the gods, he controlled the land, the future, and the afterlife. A large priesthood, an administrative bureaucracy, and a strong military assisted him.

PREDYNASTIC AND EARLY DYNASTIC ART

The origins of Egyptian culture stretch back into the Neolithic period. By at least 5000 BCE, humans were growing crops and domesticating animals in the Nile Valley. Settlements there gradually transformed into urban centers.

According to tradition, Egypt initially consisted of two regions. Upper Egypt, in the south, includes the Nile Valley

between present-day Aswan and the point where the river fans out into the Delta, near present-day Cairo. Lower Egypt, in the north, consists mainly of the vast Delta, from ancient Memphis to the Mediterranean. In Upper Egypt, independent cities shared a rich culture that archaeologists know as Nagada II/III (from the location where they first discovered it). One of those cities was Hierakonpolis, where a number of well-constructed tombs contained valuable furnishings. In one, known as Tomb 100 and probably built for a ruler, paintings embellished the walls (fig. 3.1). Human figures with rectangular torsoes, stick limbs, and simple round heads ride in boats, and engage in battle with one another. Unlike later Egyptian tomb paintings, the design is not arranged in registers (rows). A group of animals at the top sit on a ground-line, but the painter dispersed most of the figures freely against the background. In the lower left corner, a figure raises a stick against three smaller figures, who may be prisoners. This scheme will reappear in later Egyptian art (see fig. 3.2).

With time, the culture of Upper Egypt spread northward, ultimately dominating the centers of Lower Egypt. Tradition maintained that the first king of the first dynasty founded the city of Memphis, at the mouth of the Nile Delta, uniting Upper and Lower Egypt (map 3.1). The traditional division of Egypt into two distinct regions arises from the Egyptian worldview, which saw the world as a set of dualities in opposition: Upper and Lower Egypt; the red land of the desert and the black land of cultivation; the god of the earth (Geb) balanced by the sky (Nut); Osiris (god of civilization) opposed to Seth (god of chaos). The king had to balance the forces of chaos and order, and bring ma'at (harmony or order) to the world. Recognizing this worldview has led some scholars to question the traditional explanation that Upper and Lower Egypt were independent regions unified by King Narmer. Instead, they argue that this division was an imaginative reconstruction of the past.

The Palette of King Narmer

The Palette of King Narmer (fig. 3.2), dated to around 3000 BCE, visually expressed the concept of the king as unifier. A palette is a stone tablet with a central depression for grinding the protective paint that Egyptians applied around their eyes to protect them from ailments and the sun's glare. Its size—more than 2 feet high—suggests that it was not for ordinary use, but was probably reserved for a ceremony to ornament a cult statue. This ritual function may explain its findspot (where it was found) in the temple of Hierakonpolis, where it had been buried along with other offerings to the god Horus.

Shallow relief carvings in registers decorate both sides of the *Palette*. At the top of each side, in the center, **hieroglyphs** spell out Narmer's name, within an abstract rendering of the king's palace. The Egyptians developed hieroglyphs as a writing system at about the same time as the Mesopotamians were inventing cuneiform, and used them in both religious and administrative contexts. They called them "god's words"; the Greeks later saw them as sacred carvings, and their name for them, derived from

3.1 *People, boats, and animals.* First example of an Egyptian decorated tomb chamber showing people, boats and animals in the late predynastic Tomb 100 at Hierakonpolis. ca. 3000 BCE. Height 43.3" (110 cm). Egyptian Museum, Cairo

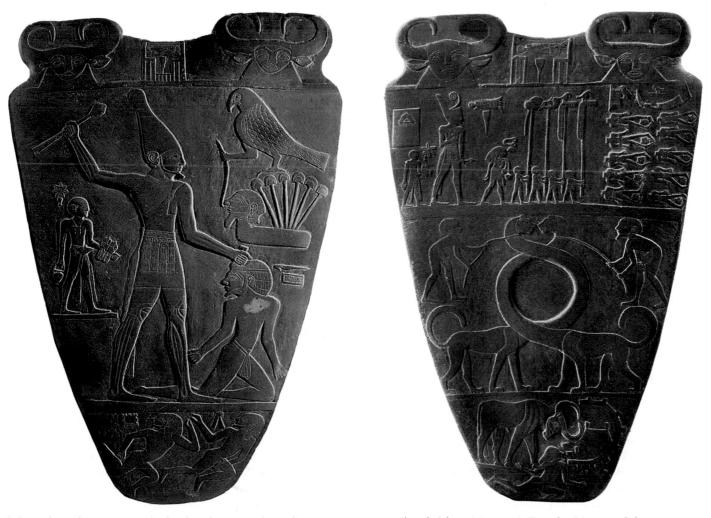

3.2 Palette of King Narmer (both sides), from Hierakonpolis. ca. 3150-3125 BCE. Slate, height 25" (63.5 cm). Egyptian Museum, Cairo

Egyptian Gods and Goddesses

Religion permeated every aspect of Egyptian life. According to Egyptian belief, the gods not only created the world, but remained involved in its existence. From artistic and textual evidence, we know the names of over 1,500 deities, some of whom are named below. The Egyptians conceived of their gods in myriad human, animal, and hybrid forms, and assigned numerous functions to them, which evolved over the course of time.

AMUN: One of Egypt's most important gods, associated with the sun, creation, and fertility. When combined with Ra as Amun-Ra in the Middle and New Kingdoms, he became the supreme Egyptian god. Usually represented as a man with a double plumed crown, a ram, or a human with a ram's head.

ANUBIS: God of the dead and embalming. Usually depicted as a jackal or another canine, or as a man with a jackal's head.

ATEN: A manifestation of the sun-god, supreme and only god under Akhenaten. Represented by the disk of the sun, emanating rays ending in hands.

HAPY: God of the inundation of the Nile, associated with life-giving and creation. Usually represented as a man with a swollen belly.

HATHOR: One of Egypt's most important goddesses. Mother or wife of Horus, wife or daughter and "Eye" of Ra, mother or wife of the king. Goddess of the sky, of women, female sexuality, and motherhood, of foreign lands, of the afterlife, and of joy, music, and happiness, and cow-goddess. Shown as a woman in a long wig or in a vulture cap with cow horns and a sun-disk, or as a cow.

HORUS: God of the sky, of the sun, and of kingship, with whom the living king was associated. Son of Isis and Osiris. Represented as a falcon or hawk, or as a man with a falcon's head.

ISIS: Egypt's most important goddess. Sister and wife of Osiris, mother and protector of Horus, and mother of the king. Cosmic goddess, goddess of magic, and protector of the dead. Usually represented as a woman crowned with the hieroglyphic throne sign, or with horns and a sun-disk.

MA'AT: Personification of truth, justice, and order. Represented as a woman with a tall feather headdress, or as a feather.

NEPHTHYS: Sister of Isis, funerary goddess. Represented as a woman. NUT: Personification of the heavens, associated with thunder, rain, and stars, and with resurrection. Mother of Isis, Osiris, Nephthys, and Seth. Usually shown as a woman, often with limbs or body extended across the sky.

OSIRIS: One of Egypt's chief deities. Ruler of the underworld, god of death, resurrection, and fertility, and associated with the king. Murdered and dismembered by his brother, Seth, he was reassembled by his consort Isis and sister Nephthys, and brought back to life. Represented as a white or black mummy, often wearing the white crown of Upper Egypt.

RA: The most important Egyptian deity. Creator, king and father of the king. Combined with Ra-Horakhty as the morning sun. Often shown as a sun-disk surrounded by a cobra, or as a man with a hawk's head and headdress with a sun-disk.

SETH: Brother of Osiris and Isis, who murdered Osiris; brother and husband of Nephthys. Desert deity, associated chiefly with chaos, violence, and destruction. Represented as an animal with a curved head, or as a man with a curved animal head.

THOTH: Moon-god, associated with writing and knowledge. Represented as an ibis, a baboon, or an ibis-headed man with a writing palette.

the Greek words hieros (sacred) and gluphein (to carve), has endured. Flanking the hieroglyphs, heads of cows represent the sky goddess, locating the king in the sky. On one side of the Palette (shown on the left), King Narmer holds a fallen enemy by the hair, as he raises his mace—an emblem of kingship—with the other hand. The king appears in the composite view that will be the hallmark of Egyptian two-dimensional art: with a frontal view of eye, shoulders, and arms, but a profile of head and legs. He wears the white crown of Upper Egypt and from the belt of his kilt hangs the tail of a bull, a symbol of power that Egyptian kings would wear as part of their ceremonial dress for 3,000 years. The large scale of his figure compared with others immediately establishes his authority. For his part, the enemy, like those in the bottom register, is stripped of clothing as an act of humiliation. Behind the king, and standing on his own ground-line, an attendant carries the king's sandals. Hieroglyphs identify both the sandal-carrier and the enemy. To the right of Narmer appears a falcon resting on a papyrus stand, which grows from a humanheaded strip of land; the falcon holds a rope tethered to the face.

On the other side of the *Palette* (on the right in fig. 3.2), Narmer appears in the highest register, now wearing the red crown of Lower Egypt. Flanked by the sandal-carrier and a long-haired figure, he follows four standard-bearers to inspect the decapitated bodies of prisoners, arranged with their heads between their legs. In the larger central register are two animals, each roped in by a male figure. They twist their long necks to frame a circle in the composition. The symmetrical, balanced motif may represent *ma'at*. Similar beasts occur on contemporary Mesopotamian cylinder seals, and may have influenced this design. In the lowest register, a bull representing the king attacks a city and tramples down the enemy.

The *Palette* communicates its message by combining several different types of signs on one object. Some of these signs—the king, attendants, and prisoners—are literal representations. Others are symbolic, such as the depiction of the king as a bull, denoting his strength. **Pictographs**, small symbols based on abstract representations of concepts, encode further information: In the falcon and papyrus group, the falcon represents Horus,

whom the Egyptians believed the king incarnated, while the human-headed papyrus stand represents Lower Egypt, where papyrus grew abundantly. A possible interpretation is that this pictograph expresses Narmer's control of that region. Finally, the artist included identifying texts in the form of hieroglyphs. Together, the different signs on the *Palette of King Narmer* drive home important messages about the nature of Egyptian kingship: The king embodied the unified Upper and Lower Egypt, and though human, he occupied a divine office, as shown by the placement of his name in the sky, the realm of Horus.

As Horus's manifestation on earth, the king provided a physical body for the royal life force (ka) that passed from monarch to succeeding monarch. Positioned at the pinnacle of a highly stratified human hierarchy (indicated by his scale), the king was between mortals and gods, a kind of lesser god. His role was to enforce order over its opposing force, chaos, which he does on the *Palette* by overcoming foreign foes and establishing visible authority over them.

THE OLD KINGDOM: A GOLDEN AGE

The *Palette of King Narmer* offers an image of kingship that transcends earthly power, representing the king as a divinity as well as a ruler. The kings of the Old Kingdom (Dynasty Three to Dynasty Six, ca. 2649–2150 BCE) found more monumental ways to express this notion. Other dynasties would emulate their works of art for the following two millennia. (See *Informing Art*, page 54.)

Old Kingdom Funerary Complexes

During the Old Kingdom, Egyptians fashioned buildings to house the day-to-day activities of the living mainly out of perishable materials, with the result that little now survives. The bulk of archaeological evidence comes instead from tombs. The great majority of the population probably buried their dead in shallow desert graves, but the elite had the resources to build elaborate funerary monuments with luxury provisions for the afterlife. The survival of these tombs is no accident; they were purposely constructed to endure.

These structures had several important functions. As in many cultures, tombs gave the deceased a permanent marker on the landscape. They expressed the status of the dead and perpetuated their memory. Generally a rectangular mud-brick or stone edifice marked an early elite or royal burial (fig. 3.3), known today as a mastaba, from the Arabic word for "bench." Plaster covered its exterior sloping walls, which were painted to evoke a niched palace façade. Often this superstructure was solid mud brick or filled with rubble, but sometimes it housed a funerary chapel or storerooms for equipment needed in funerary rituals. These monuments also served a critical function in ensuring the preservation of a deceased individual's life force, or ka. Egyptians considered the ka to live on in the grave, and in order to do so, it required a

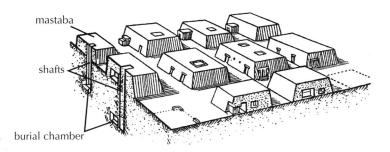

3.3 Group of mastabas, 4th Dynasty (after A. Badawy)

place to reside for eternity. This need led embalmers to go to great lengths to preserve the body through mummification (a process that they only perfected in the Eleventh and Twelfth Dynasties). The mummified body was usually placed within a **sarcophagus** (a stone coffin) and buried in a chamber at some depth below the mastaba, surrounded by subsidiary chambers for funerary apparatus. Egyptians believed that a statue could serve as a surrogate home for the *ka* in the event that the embalmers' efforts failed and the body decayed, so they set a sculpture within the burial chamber. They also equipped their tombs with objects of daily life for the *ka*'s enjoyment.

THE FUNERARY COMPLEX OF KING DJOSER Out of this tradition emerges the first known major funerary complex, that of the Third Dynasty King Djoser (Netjerikhet), at Saqqara (figs. 3.4, 3.5, and 3.6), who ruled between 2630 and 2611 BCE. On the west side of the Nile, Saqqara was the necropolis (cemetery or city of the dead) of the capital city of Memphis in Lower Egypt. Encircling the entire complex is a rectangular stone wall stretching over a mile in length and 33 feet high. The dominant feature of the complex is a stepped pyramid, oriented to the

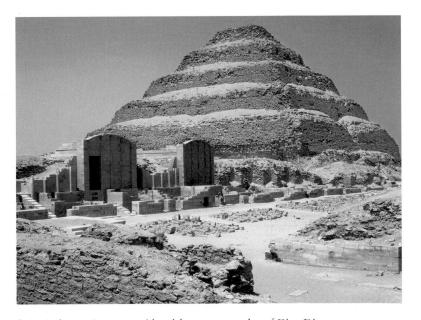

3.4 Imhotep. Step pyramid and funerary complex of King Djoser, Saqqara. 3rd Dynasty. ca. 2681–2662 BCE

Major Periods in Ancient Egypt

n Egyptian society, a king's life was the measure of time. To organize the millennia of Egyptian culture, scholars use a chronology devised in the third century BCE by the priest-historian Manetho, who wrote a history of Egypt in Greek for Ptolemy I, based on Egyptian sources. He divided the list of Egyptian kings into 31 dynasties, beginning with the First Dynasty shortly after 3000 BCE. Modern scholars have organized the dynasties into kingdoms, beginning with the Old Kingdom, which covers from ca. 2649 BCE to 2150 BCE. The period before this, between prehistory and the First Dynasty, is known as the Predynastic period. Further subdivisions include the Middle Kingdom (ca. 2040–1640 BCE) and the New Kingdom (ca. 1550–1070 BCE).

Scholars still debate the actual dates for these broad periods and even for the reigns of kings, as Manetho's list offered only a relative chronology (that is, the order in which kings succeeded one another) rather than absolute dates.

Major Periods in Ancient Egypt

ca. 5450-2960 BCE-Predynastic

ca. 2960-2649 BCE-Early Dynastic (Dynasties 1, 2)

ca. 2649-2150 BCE-Old Kingdom (Dynasties 3-6)

ca. 2040-1640 BCE-Middle Kingdom (Dynasties 11-13)

ca. 1550-1070 BCE-New Kingdom (Dynasties 18-20)

cardinal points of the compass (figs. 3.4 and 3.5). It began as a 26-foot-high mastaba, which the enclosure wall would originally have concealed. Over the course of years it rose to its towering 204-foot height as builders added progressively diminishing layers of masonry to its form. These layers resulted in the emergence of a kind of a staircase, perhaps the means by which the king could ascend to the gods after death. The treads of the "steps" incline downwards and the uprights outwards, giving the structure an impressively stable appearance. A chamber cut into the rock about 90 feet beneath the pyramid and lined with Aswan granite contained the burial, and additional chambers held funerary provisions. North of the pyramid was a labyrinthine funerary temple, where the living performed offering rituals for the dead king.

The buildings in the burial complex reproduce the palace architecture inhabited by the king while alive. The niched enclosure wall evokes a palace façade. In the palace, large courts accommodated rituals of kingship; similarly, a large court to the south of the pyramid may have housed rituals for receiving tribute or asserting royal dominion. Shrines of Upper and Lower Egypt flanked a smaller oblong court to the east, which may have been the site of the *sed*-festival, a ceremony that celebrated the king's 30-year jubilee and rejuvenated his power. Unlike palace structures, however, many of the buildings in the funerary complex are nonfunctional: Of 14 gateways indicated in the enclosure wall, only one (on the southeast corner) allows entrance, while the rest are false doors. Likewise, chapels dedicated to local gods were simply façades with false doors, behind which was a fill of rubble, sand, or gravel. Furthermore, while architects chose perishable materials for palaces—primarily mud brick—they constructed the funerary complex entirely in limestone: It was built to last. All the

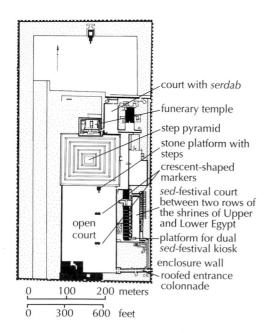

3.5 Plan of the funerary district of King Djoser, Saqqara (Claire Thorne, after Lloyd and Müller)

3.6 Papyrus-shaped half-columns, North Palace, funerary complex of King Djoser, Saqqara

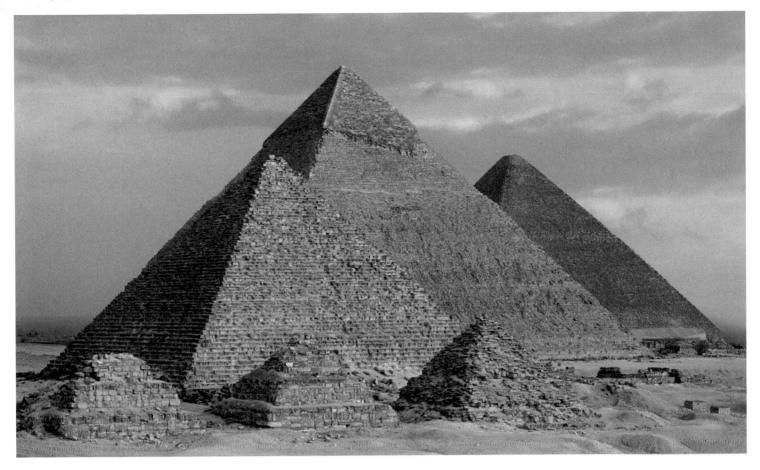

3.7 The pyramids of Menkaure, ca. 2533–2515 BCE, Khafra, ca. 2570–2544 BCE, and Khufu, ca. 2601–2528 BCE, Giza

same, masons treated the durable limestone to mimick the perishable fabrics of the palace: They dressed the limestone blocks of the enclosure wall to resemble the niched façades of mud-brick architecture. Additionally, the now reconstructed façade of a shrine echoes the form of an Upper Egyptian tent building, with tall poles supporting a mat roof that billows in the wind. Engaged columns imitate the papyrus stems or bundled reeds that Egyptian builders used to support mud-brick walls, with capitals shaped to resemble blossoms (fig. 3.6). Paint over the stone lintels disguised them as wood, and inside the tomb chamber, blue and green tiles covered false doors to imitate rolled-up reed matting.

Many elements of the complex served as permanent settings for the dead king to perpetually enact rituals of kingship—rituals that maintained order among the living. The installation of a life-sized seated statue of the king in a **serdab** (an enclosed room without an entrance) to the east of the funerary temple assured his presence in the complex. Two holes in the serdab's front wall enabled his ka, residing in the statue, to observe rituals in his honor and draw sustenance from offerings of food and incense. The entire complex was oriented north–south, and the king's statue looked out toward the circumpolar stars in the northern sky. With these provisions, his ka would remain eternally alive and vigilant.

Inscriptions on statue fragments found within the complex preserve the name of the mastermind behind its construction, a high official at Djoser's court and high priest of Ra named Imhotep. Egyptians in Imhotep's own time and beyond credited him with advancing Egyptian culture through his wisdom and knowledge of astronomy, architecture, and medicine; they regarded him so highly that they deified him. This complex, the first large-scale building constructed entirely in stone, preserves at least one of his legacies. Scholars often identify him as the first named architect in history.

The Pyramids at Giza: Reflecting a New Royal Role

Other kings followed Djoser's lead, but during the Fourth Dynasty, ca. 2575–2465 BCE, funerary architecture changed dramatically. To the modern eye, the most obvious change is the shift from a step pyramid to a smooth-sided one. A pyramid at Meidum attributed to Sneferu, the founder of the Fourth Dynasty, underlines the deliberateness of the transformation. It was originally built as a step pyramid, but its steps were later filled in to produce smooth sides.

The best-known pyramids are the three Great Pyramids at Giza (fig. 3.7), commemorating Sneferu's son, Khufu (the first and largest pyramid), Khafra (r. 2520–2494) (a somewhat smaller one), and Menkaure (r. 2490–2472) (the smallest pyramid). (See *Materials and Techniques*, page 56.) Throughout the ages since

Building the Pyramids

n spite of much research, many aspects of pyramid design remain a mystery to Egyptologists. Elevations of other types of building—palaces and pylons, for instance—are preserved on the walls of New Kingdom tombs and temples, and a few plans survive. Pyramid architects may have worked from similar guidelines. Orienting the pyramids to the cardinal points of the compass appears to have been critical, and the architects probably achieved this by observing the stars. The greatest deviation is a meager 3 degrees east of north, in the pyramid of Djoser.

During the Old and Middle Kingdoms, builders constructed a pyramid's core out of local limestone. Quarries are still visible around the Great Pyramids and the Great Sphinx (fig. a and see fig. 3.9). For the casing (the outer surface), they must have brought Tura limestone and Aswan granite from quarries some distance away, as these are not local materials. Using copper tools, levers, and rope, workers cut channels in the rock and pried out blocks averaging 1½ to 5' in length but sometimes much larger. Somehow they hauled these blocks overland, on hard-packed causeways built for that purpose. Some scholars believe teams of men or oxen pulled them on sleds, basing this view primarily upon a tomb painting showing 172 men dragging a huge statue of the Twelfth Dynasty king Djehutihopte on a sled. When documentary filmmakers tried to replicate the process using blocks of stone, it proved extraordinarily slow and cumbersome. Yet estimates of 2.3 million stone blocks in the pyramid of Khufu, constructed within 23 years, suggest that quarries must have moved stone at tremendous rates: approximately 1,500 men had to produce at least 300 blocks a day. In Hatshepsut's mortuary temple, late nineteenth century archaeologist William Flinders Petrie discovered models of wooden cradles in the shape of a quarter-circle. If four cradles were fitted to the four sides of a block of stone, these frames would have allowed a small team of men to roll a block relatively quickly.

Archaeological remains of pyramids indicate that methods of construction evolved over time. In early pyramids, builders used a buttressing technique, with inclined layers around a central core, diminishing in height from inside out (fig. b). They then set a smooth outer casing of cut stones at an angle to the ground. When this technique proved unstable at the beginning of the Fourth Dynasty, architects turned to courses of stone, built up layer by layer. They designed outer casing blocks as right-angled trapezoids and set them level to the ground as the pyramid rose (fig. c). Scholars believe that workers constructed ramps to raise blocks into place as the monument grew, but still debate the ramps' design; since builders dismantled them after use, they have left little trace in the archaeological record. The simplest solution would be a linear ramp leading up to one face of the pyramid, made out of debris left over from building. As the pyramid grew, however, the slope would have become so steep that workers would have needed steps to haul the blocks up. At this point, they could only have maneuvered the blocks with levers. A spiraling ramp, which worked its way around the pyramid at a shallower incline, would have concealed the base corners of the pyramid, making calculations difficult for surveyors, and it would have been hard to construct at the highest levels. Another alternative is a ramp zigzagging up one side of the monument. One scholar proposes that workers used sand and rubble ramps for roughly the lowest sixth of the Great Pyramid, followed by stone ramps at the higher levels, resting on the untrimmed outer steps. As they removed the ramps, the builders would have smoothed out the outer casing blocks to form a slope.

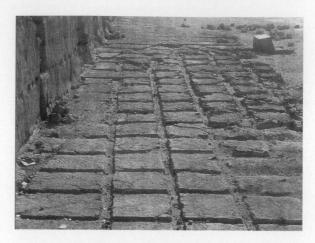

(a) Limestone quarry to the north of the Pyramid of Khafra

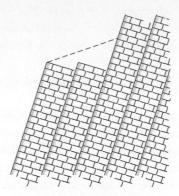

Buttressing Technique
Third Dynasty

(b) Buttressing technique

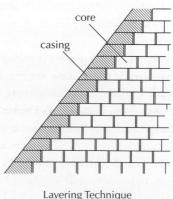

Layering Technique Fourth Dynasty?

(c) Layering technique

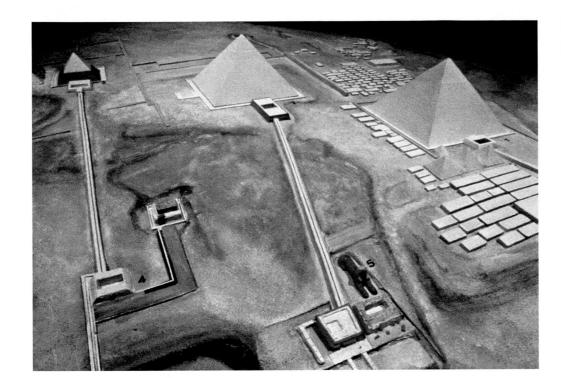

3.8 Model of the Great Pyramids, Giza: Menkaure (left), Khafra (middle), Khufu (right)

their construction, the pyramids have continued to fascinate and impress (see The Art Historian's Lens, page 75.) Their lasting grandeur derives both from their sheer monumentality (Khafra's covers 13 acres at the base, and still rises to a height of about 450 feet) and from their extraordinary simplicity. On a square plan, their four surfaces, shaped as equilateral triangles, taper up from the desert sand toward the sky. At any time of day, one side will hold the sun's full glare, while another is cast into shadow. Before Islamic builders plundered their stone, each pyramid was dressed with white limestone, preserved now only on the pinnacle of the pyramid of Khafra; at the tip of each, moreover, was a thin layer of gold. On Khafra's pyramid, a course of red granite set off the limestone's whiteness at ground level. The entrance to each pyramid was on its north face, and somewhere within the solid stone mass, rather than below ground, the architect concealed a burial chamber in the hopes of foiling tomb robbers (see fig. 3.3). Encircling each pyramid was an enclosure wall, and clustered all around were smaller pyramids and mastabas for members of the royal family and high officials.

Like Djoser's complex at Saqqara and most subsequent royal burials, Fourth Dynasty burials took place on the Nile's west bank, the side of the setting sun, across from living habitations on the east bank (fig. 3.8). Yet in contrast to Djoser's complex, where the compact arrangement was laid out on a north–south axis, the architects at Giza set out the monuments on an extended east—west axis. At the start of the funeral ceremony, attendants transported the body westward across the Nile. Once beyond the land under cultivation, the procession reached the valley temple, connected to the Nile by a canal. In the valley temple of Khafra is a central T-shaped hallway, where floors of white calcite set off walls and pillars of costly red Aswan granite. Light cascaded in through slits in the upper walls and the red granite roof.

Beyond the valley temple, a raised and covered causeway led westward into the desert for about a third of a mile (0.2 km) to the funerary temple, adjoined to the pyramid's east face. Here an embalmer preserved the dead king's body, and the living perpetuated the cult for his ka. Again, a rich variety of hard stone made for a vivid coloristic effect; relief sculptures probably added to the funerary temple's decoration, but most have perished over time. Next to the valley temple of Khafra stands the Great Sphinx, carved from an outcropping of rock left after quarrying stone (fig. 3.9). (Like pyramid, sphinx is originally a Greek term.) Uncomfortable with human representation in art, later Islamic residents of Giza damaged the massive sculpture, obscuring details of its face, and the top of the head is also missing. Still, scholars believe that the sculptors combined a portrait of Khafra (or possibly Khufu) with the crouching body (and thus strength) of a lion. Its vast scale also proclaims the king's power.

The change in funerary architecture suggests a shift in the way Egyptians perceived their ruler. The smooth-sided pyramid was the shape of the ben-ben, a sacred stone relic in Heliopolis, center of the sun cult. These monumental tombs may therefore have emphasized the solar aspect of the king's person; indeed, the change in building practice coincides more or less with the king's adoption of the title "son of Ra." The change in orientation for the complexes also meant that the king's funerary temple did not face the northern stars, as before, but the rising sun in the east, which signified eternity through its daily rising and setting. In contrast to the funerary complex for Djoser (see figs. 3.4 and 3.5), the Giza complex contains no buildings for reenacting rituals of kingship. This suggests that the perpetual performance of these rituals was no longer the dead king's task. Now, his role was to rise to the sun-god on the sun's rays, perhaps symbolized by the pyramid's sloping sides, and to accompany him on his

Excerpt from the Pyramid Text of Unis (r. 2341–2311 BCE)

King Unis of the Fifth Dynasty built a pyramid at Saqqara on the walls of which were inscribed a series of incantations and prayers for the afterlife of the pharaoh. So-called Pyramid Texts such as these were placed in tombs throughout Egyptian history for both royal and nonroyal burials. Some of their formulas were adapted for different versions of the Book of the Dead. Though the earliest text to survive dates from about 2320 BCE, the prayers may have been composed much earlier.

The Resurrection of King Unis

A pale sky darken, stars hide away,
Nations of heavenly bowmen are shaken,
Bones of the earth gods tremble—
All cease motion, are still, for they have looked upon Unis,
the King,

Whose soul rises in glory, transfigured, a god,
Alive among his fathers of old time, nourished by ancient mothers.

The King, this is he! Lord of the twisty ways of wisdom (whose very mother knew not his name),

His magnificence lights the black sky,

His power flames in the Land of the Risen—

Like Atum his father, who bore him;

And once having born him, strong was the Son more than the Father!

The Kas of the King hover about him;
Feminine spirits steady his feet;
Familiar gods hang over him;
Uraei (cobras) rear from his brow;
And his guiding Serpent precedes:
"Watch over the Soul! Be helpful, O Fiery One!"

All the mighty companions are guarding the King!

Source: Ancient Egyptian Literature: An Anthology, tr. John I. Foster (Austin, TX: University of Texas Press, 2001)

endless cycle of regeneration. Texts in the form of chants or prayers inscribed on the interior walls of some later Old Kingdom pyramids express this conception of the role of the king vividly.

The *Primary Source* text reproduced above, from the pyramid of Unis in Saqqara, dates to about 2320 BCE and describes the king's resurrection and ascension.

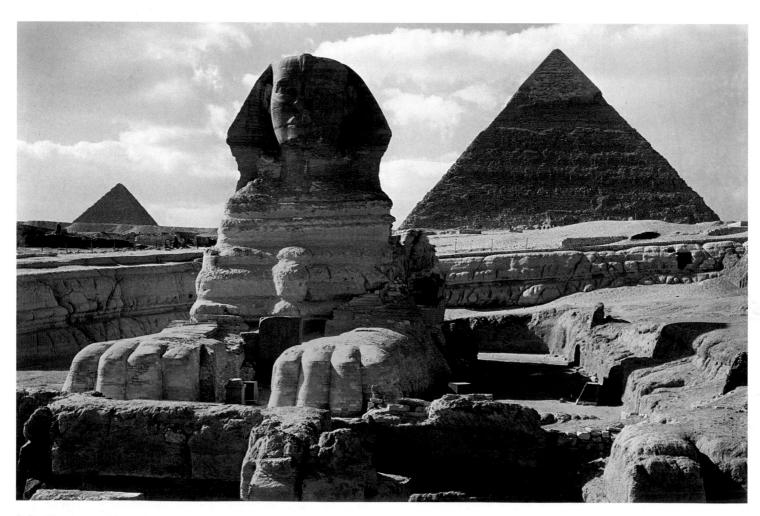

3.9 The Great Sphinx, Giza. ca. 2570-2544 BCE. Sandstone, height 65' (19.8 m)

Representing the Human Figure

In the hall in the valley temple of Khafra, a series of indentations in the paving show that 23 seated statues of the king once lined its walls. Archaeologists discovered one of these almost intact and six in poorer condition, interred in the temple floor. The best-preserved statue represents the seated king in a rigidly upright and frontal pose (fig. 3.10). This pose allowed him to watch—and thus take part in—rituals enacted in his honor; frontality gave him presence. Behind him, the falcon Horus spreads his wings protectively around his head. Like the *Palette of King Narmer*, this sculpture neatly expresses qualities of kingship. Horus declares the king his earthly manifestation and protégé, and the king's muscular form indicates his power. The smooth agelessness of the latter's face bespeaks his eternal nature, while the sculpture's compact form gives it a solidity that suggests permanence. The intertwined plants—papyrus and perhaps sedge—carved between the legs of his chair

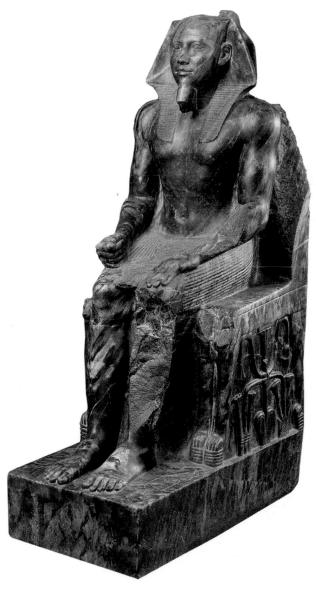

3.10 Khafra, from Giza. ca. 2500 BCE. Diorite, height 66" (167.7 cm). Egyptian Museum, Cairo

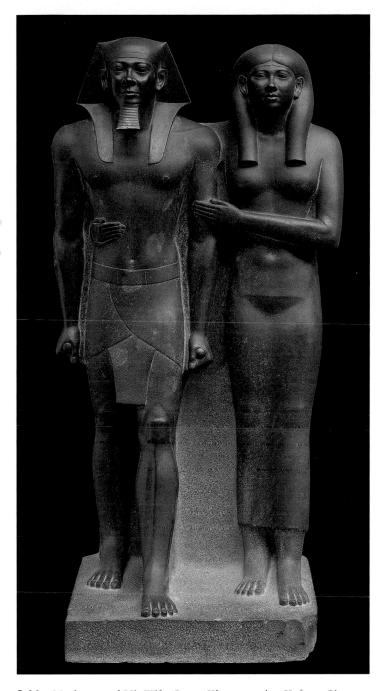

3.11 Menkaure and His Wife, Queen Khamerernebty II, from Giza. ca. 2515 BCE. Slate, height 54½" (138.4 cm). Museum of Fine Arts, Boston. Harvard University—Boston Museum of Fine Arts Expedition

are indigenous to both Lower and Upper Egypt, indicating the territorial reach of royal authority and the unity of the land. Even the stone used for his image expresses the king's control of distant lands: Diorite came from the deserts of Nubia. A hard stone, it lends itself to fine detail and a high polish, and the strong Egyptian light pouring in through the temple's louvered ceiling and reflected off the white calcite pavement must have made the figure glisten.

A slightly later, three-quarter-life-size group in schist represents King Menkaure and his chief wife Khamerernebty II (fig. 3.11). It shares important features with the statue of Khafra. Carved in one piece with an upright back slab, it exhibits a similar

rigid frontality. One reason for this may have been the sculpture's intended location and function. This group, too, may have come from the king's valley temple.

The artist depicted Menkaure and his queen with several characteristics in common. Of almost identical height, both are frozen in a motionless stride with the left foot forward. Though the king is more muscular than Khamerernebty, and though she is draped in a thin dress hemmed at her ankles while he is half nude, smooth surfaces and a high polish characterize both bodies. Menkaure's headdress even echoes the form of Khamerernebty's hair. These common qualities establish an appearance of unity, and the queen's embrace further unifies the pair.

In some cases, traces of paint show that sculptors added details to their work in color, though whether they always painted statues carved in high-quality hard stone is hard to assess. A pair of Fourth Dynasty sculptures from a mastaba tomb at Meidum are carved from limestone, which is softer than diorite and does not yield such fine surface detail (fig. 3.12). Here, the artist painted

skin tones, hair, garments, and jewelry, using the standard convention of a darker tone for a male, a lighter tone for a female. Rock-crystal pupils so animate the eyes that, in later years, fearful robbers gouged the eyes out of similar figures before looting the tombs they occupied. Inscriptions identify this pair as Rahotep and his wife Nofret, and describe their social status: He is a government official and she is a "dependent of the king." Like the royal portraits, these figures are represented with ritualized gestures and in full frontality.

This rigid frontality is the norm for royal and elite sculptures in the round. In relief and painting, there is also a remarkable consistency in stance among royal and elite subjects. The standard pose, as illustrated on the *Palette of King Narmer* (see fig. 3.2) and on a wooden stele found in the mastaba of a court official of Djoser, Hesy-ra, at Saqqara (fig. 3.13), is altogether nonnaturalistic. In the case of the latter, frontal shoulders and arms and a frontal kilt combine with a profile head (with a frontal eye) and legs; the figure has two left feet, with high arches and a single toe.

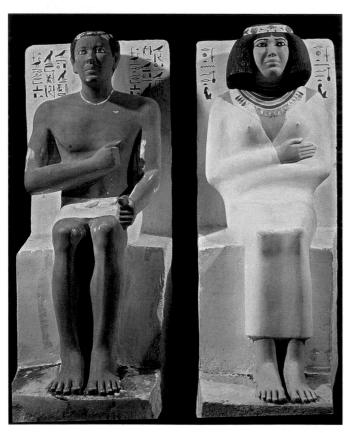

3.12 Prince Rahotep and His Wife, Nofret. ca. 2580 BCE. Painted limestone, height 47¼" (120 cm). Egyptian Museum, Cairo

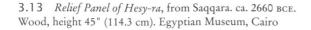

3.14 Grid showing proportional guidelines for relief panel of Hesy-ra.

The representation is conceptual or intellectual rather than visual: The artist depicts what the mind knows, not what the eye sees. This artificial stance contributes to the legibility of the image, but it also makes the figure static.

THE CANON Body proportions are also consistent enough in royal and elite sculpture in the round and in relief and painting to suggest that artists relied on guidelines for designing the human image. In fact, traces of such guidelines are still visible on reliefs and paintings. This canon (set of rules) began in the Fifth Dynasty with a grid superimposed over the human image: One vertical line ran through the body at the point of the ear, and as many as seven horizontal lines divided the body according to a standard module. Over time, the guidelines changed, but the principle of the canon remained: Although body-part measurements might vary from person to person, the relationship between parts remained constant. With that relationship established, an artist could make a human portrait at any scale, taking the proportions of body parts from copybooks. Unlike later systems of perspective, where a figure's size suggests its distance from a viewer, in the Egyptian canon size signaled social status.

For elite male officials, there were two kinds of ideal image, each representing a different life stage. One is a youthful, physically fit image, like that of Hesy-ra (see fig. 3.13). In the other, a paunch, rolls of fat, or slack muscles, and signs of age on the face indicate maturity. A painted limestone figure of a scribe, perhaps

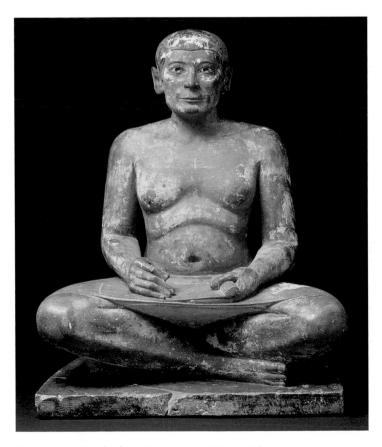

3.15 Seated Scribe, from Saqqara. ca. 2400 BCE. Limestone, height 21" (53.3 cm). Musée du Louvre, Paris

3.16 *Ti Watching a Hippopotamus Hunt*, Tomb of Ti, Saqqara. ca. 2510–2460 BCE. Painted limestone relief, height approx. 45" (114.3 cm)

named Kay, from his mastaba at Saqqara, is an example of the second type (fig. 3.15). He is depicted rigidly upright and frontal but, unlike Hesy-ra, his body shows signs of slackening, in the sallow cheeks, sagging jaw, and loose stomach. Since Egyptian society was mostly illiterate, a scribe had high status; indeed, the artist depicted the figure seated on the floor in the act of writing, the very skill in which his status resided. The image reinforces his social status: It shows an official who has succeeded in his career, eats well, and relies on subordinates to do physical work on his behalf.

These conventions of pose, proportion, and appearance applied only to the highest echelons of society—royalty and courtiers. By contrast, the lower the status of the subject, the more relaxed and naturalistic their pose. Once the conventions were established, ignoring them could even result in a change of meaning for a figure, especially a change of status, from king or official to servant or captive. Fine low-relief paintings in the tomb chapel of Ti, a high official during the Fifth Dynasty, at Saqqara encapsulate the correlation between rank and degree of naturalism neatly (fig. 3.16). In one section, Ti stands on a boat in a thicket of papyrus, observing a hippopotamus hunt. He stands

rigidly in the traditional composite view, legs and head in profile, torso and eye frontal, while hunters, shown on a smaller scale, attack their prey from a second boat in a variety of active poses that more closely resemble nature. Zigzagging blue lines beneath the boats denote the river, where hippopotami and fish—on the lowest rung of the natural world—swim about in naturalistic poses. Similarly, nesting birds and predatory foxes freely inhabit the papyrus blossoms overhead.

PAINTINGS AND RELIEFS Like statues in tombs, paintings and reliefs played a role in the Egyptian belief system. Images such as Ti Watching a Hippopotamus Hunt (see fig. 3.16) allowed the deceased to continue activities he or she had enjoyed while alive. They also functioned on metaphorical levels. The conquest of nature, for instance, served as a metaphor for triumph over death. Death was the realm of Osiris, as god of the underworld, and so were the life-giving waters of the Nile, because of his regeneration after Seth had murdered him. Osiris was the god of fertility and resurrection, to whom Egyptians could liken the deceased. And, because Isis hid Horus in a papyrus thicket to protect him from Seth, they saw a papyrus stand as a place of rebirth, much like the tomb itself. Traditionally, too, a boat was the vehicle that carried the ka through its eternal journey in the afterlife. By contrast, Egyptians viewed the crop-destroying hippopotamus as an animal of evil and chaos, and so as the embodiment of the destructive Seth, lord of the deserts. Thus, meanings specific to its funerary context may have encoded the entire painting. Other Old Kingdom tomb paintings depict family members buried alongside the principal tomb owner, or as company for the ka in the afterlife. Some scenes depict rituals of the cult of the dead (that is, rituals in honor of the dead), or portray offerings and agricultural activities designed to provide the ka with an eternal food supply. In these scenes, the deceased typically looks on, but does not participate.

THE MIDDLE KINGDOM: REASSERTING TRADITION THROUGH THE ARTS

The central government of the Old Kingdom disintegrated with the death of the Sixth Dynasty king Pepy II in around 2152 BCE. This led to the turbulent First Intermediate Period, which lasted over a century and when local or regional overlords fostered antagonisms between Upper and Lower Egypt. The two regions reunited in the Eleventh Dynasty, as King Nebhepetra Mentuhotep or Mentuhotep II (ca. 2061–2010 BCE) gradually reasserted regal authority over all of Egypt. The late Eleventh, Twelfth and Thirteenth Dynasties make up the Middle Kingdom (ca. 2040–1640 BCE), when much of the art deliberately echoed Old Kingdom forms, especially in the funerary realm. The art asserted continuity with the golden days of the past. Sculptures of some members of the royal family, however, also show breaks with tradition.

Royal Portraiture: Changing Expressions and Proportions

A fragmentary quartzite sculpture of Senwosret III (r. 1878–1841 BCE) indicates a rupture with convention in the representation of royalty (fig. 3.17). Rather than sculpting a smooth-skinned, idealized face, untouched by time—as had been done for over 1,000 years—the artist depicted a man scarred by signs of age. His brow creases, his eyelids droop, and lines score the flesh beneath his eyes. Scholars have described the image as "introspective," and reading it against the background of Senwosret III's troubled campaign of military expansion in Nubia to the south, they see the portrait's physical imperfections as reflections of the king's stress. Facial expressions or signs of age, however, can signify different things to different societies, and it is equally likely that the tight-lipped expression reflects a new face of regal authority, projecting firm resolve. Sculptors of this time tended to combine the aged face with a body that was still youthful and powerful.

As facial expressions became more naturalistic in royal images of this time, so the canon of proportions changed too. This is clear if we compare the Old Kingdom sculpture of Queen Khamerernebty (see fig. 3.11) with a sculpture of Lady Sennuwy (fig. 3.18), the wife of a provincial governor, found at Kerma in Upper Nubia. Depictions of women during the Middle Kingdom

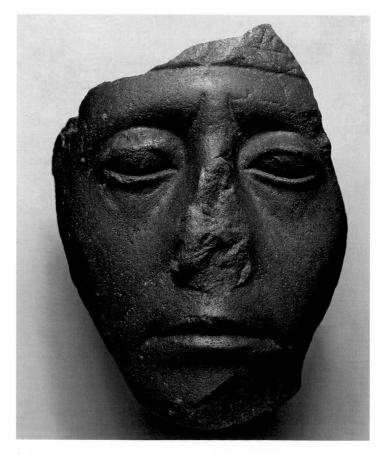

3.17 Senwosret III. ca. 1850 BCE. Quartzite, height 6½" (16.5 cm). Metropolitan Museum of Art, New York. Purchase, Edward S. Harkness Gift, 1926 (26.7.1394)

have increasingly narrower shoulders and waists, and slimmer limbs. Males have proportionally smaller heads, and lack the tight musculature of their Old Kingdom counterparts. Though subtle, these changes distinguish representations of the human body from period to period.

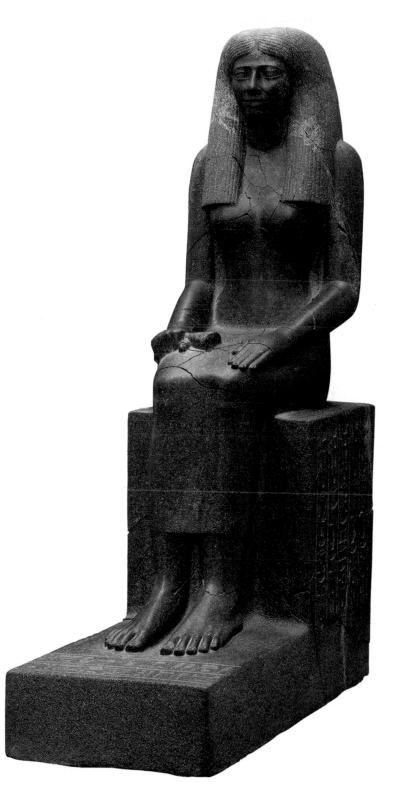

3.18 Lady Sennuwy. ca. 1920 BCE. Granite, height 67¾" (172 cm), depth 45¾" (116.5 cm). Museum of Fine Arts, Boston. Harvard University—Boston Museum of Fine Arts Expedition. 14.720

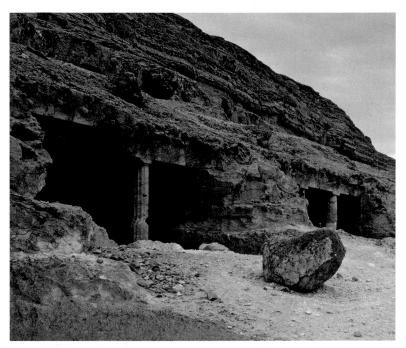

3.19 Rock-cut tombs, Beni Hasan, B-H 3-5, 11th and 12th Dynasties. ca. 1950–1900 BCE

Funerary Architecture

Burial patterns among court officials and other members of the elite stayed relatively constant during the Middle Kingdom, with most choosing interment in sunken tombs and mastabas. Already known in the Old Kingdom, rock-cut tombs were especially popular at this time. Fine examples still exist at Beni Hasan, the burial place of a powerful ruling family of Middle Egypt in the Eleventh and Twelfth Dynasties (fig. 3.19). The tombs were hollowed out of a terrace of rock on the east bank of the Nile and offered stunning views across the river. Inside, a vestibule led to a columned hall and burial chamber, where a niche framed a statue of the deceased (fig. 3.20). As in Old Kingdom tombs, paintings and painted relief decorated the walls. The section illustrated in figure 3.21, from the restored tomb of Khnum-hotep, shows workers restraining and feeding oryxes (a type of antelope trapped in the desert and raised in captivity as a pet).

As in the Old Kingdom, tomb owners believed the paintings provided nourishment, company, and pastimes for the dead. The living placed a wide variety of objects in tombs along with the dead, including objects made of faience, a glass paste fired to a shiny opaque finish. The figurine shown in figure 3.22 came from a tomb in Thebes, and represents a schematized woman. Her legs stop at the knees, possibly to restrict her mobility, or because legs were not essential to her function. The artist delineated her breasts and pubic area, and painted a cowrie-shell girdle to emphasize her belly and hips. Her function may have been as a fertility object, to enhance family continuity among the living and regeneration of the dead into a new life in the beyond. Egyptians associated the blue-green color of the faience with fertility, regeneration, and the goddess Hathor.

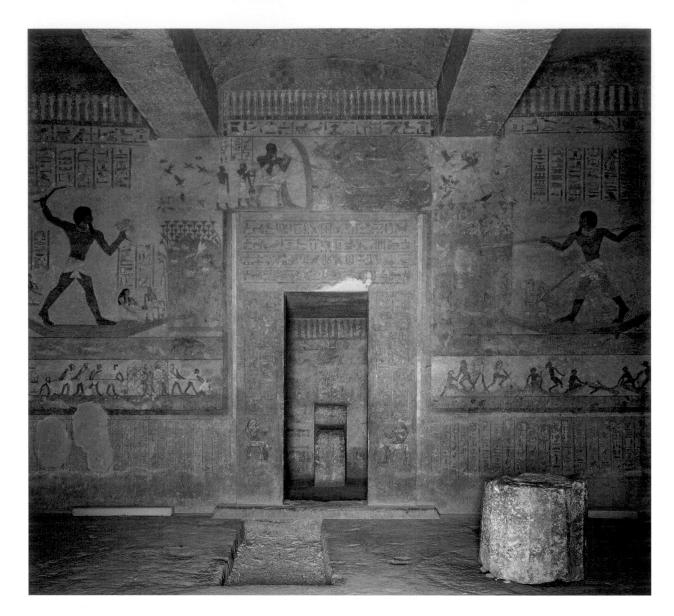

3.20 Interior hall of rock-cut tomb, Beni Hasan, B-H 2. 12th Dynasty. ca. 1950–1900 BCE

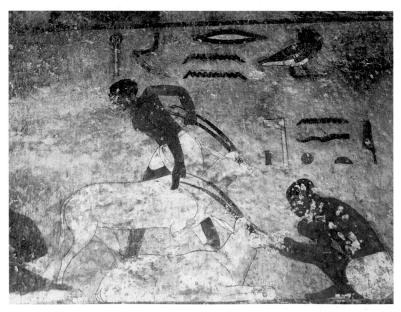

3.21 Feeding the Oryxes. Tomb of Khnum-hotep, Beni Hasan. ca. 1928–1895 BCE. Wall painting (detail)

Often, the living buried jewelry with the deceased. Egyptians used jewelry widely, for daily personal adornment, for formal occasions such as court audiences, to bedeck cult statues, and to protect mummies. Many of the surviving pieces show extraordinary technological skill on the part of the jewelers. In the pyramid complex at Dahshur, the tomb of Mereret, a royal woman at the court of Senwosret III, contained two valuable pectorals, or large pendants. One is designed as a shrine with lotus-capital columns, within which two sphinxes trample enemies underfoot. With one raised forepaw, they support a cartouche of the king's name (fig. 3.23). A vulture spreads its wings overhead. In wearing the pectoral, Mereret broadcast Senwosret's power to overcome foes and assert order. At the same time, the pectoral expressed royal wealth: The jeweler fashioned it in cloisonné (a metalworking technique often used for enamel), using a gold framework for valuable stones brought from afar: carnelian from the eastern desert, turquoise from Sinai, and lapis lazuli from present-day Afghanistan. As a mummy ornament, the pectoral may have offered protection against malevolent forces.

3.22 Female Figurine, from Thebes. 12th–13th Dynasties. Faience, height 3½" (8.5 cm). The British Museum, London. Courtesy of the Trustees

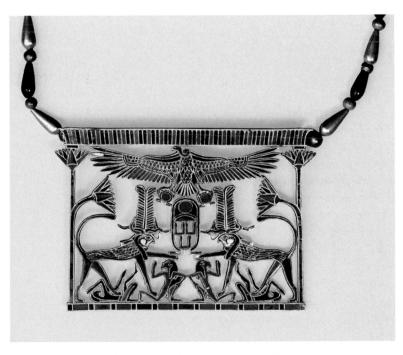

3.23 Pectoral of Mereret, from tomb in pyramid complex of Senwosret III at Dahshur. 12th Dynasty. Gold, carnelian, lapis lazuli, and turquoise, height 2½" (6.1 cm). Egyptian Museum, Cairo

The stability of the Middle Kingdom was not to last. As central authority weakened after about 1785 BCE, local governors usurped power. During the Twelfth Dynasty, immigrants from Palestine known as the Hyksos (a Greek rendering of the Egyptian for "rulers of foreign lands") moved into the Nile Delta, gaining control of the area and forcing the king southward to Thebes. The era of their control is known as the Second Intermediate Period.

THE NEW KINGDOM: RESTORED GLORY

The first king of the Eighteenth Dynasty, Ahmose (r. 1550–1525 BCE), finally expelled the Hyksos from Egypt. The 500 years after their expulsion—covering the Eighteenth, Nineteenth, and Twentieth Dynasties—are designated the New Kingdom. They constitute a time of renewed territorial expansion and tremendous prosperity for Egypt, and a time when the arts flourished. Tremendous architectural projects were accomplished along the full length of the Nile, centering on the region of Thebes (present-day Luxor). Of these projects, many of the secular buildings, including palaces and forts, were made of mud brick and have perished. Stone tombs and temples, however, retain a measure of their former glory.

Royal Burials in the Valley of the Kings

Changes in burial practices expose a major difference between the Old Kingdom and the New. Having witnessed the loss of order that allowed plundering of royal burials, Eighteenth Dynasty kings abandoned the practice of marking their tombs with pyramids. Instead, they excavated tombs out of the rock face in the Valley of the Kings west of Thebes, and their entrances were concealed after burial. Excavations have revealed that in these tombs a corridor led deep into the rock to a burial chamber flanked by storage rooms. Decorating the burial chamber were paintings of the king with Osiris, Anubis, and Hathor, funerary deities who assured his passage from this world to the next. Rituals of the funerary cult took place away from the tomb, over a rocky outcropping to the east, at a temple on the edge of the land under cultivation.

HATSHEPSUT'S TEMPLE The best-preserved example of a New Kingdom funerary temple is that of the female king Hatshepsut (ca. 1478–1458 BCE) (fig. 3.24). Hatshepsut was the chief wife—and half-sister—of Thutmose II. On his death in 1479 BCE, power passed to Thutmose III, his young son by a minor wife. Designated regent for the young king, Hatshepsut ruled with him as female king until her death in 1458 BCE. She justified her unusual rule by claiming that her father, Thutmose I, had intended her to be his successor.

Nestled in the cliffside at Deir el-Bahri, Hatshepsut's temple sat beside the spectacular Eleventh Dynasty temple of

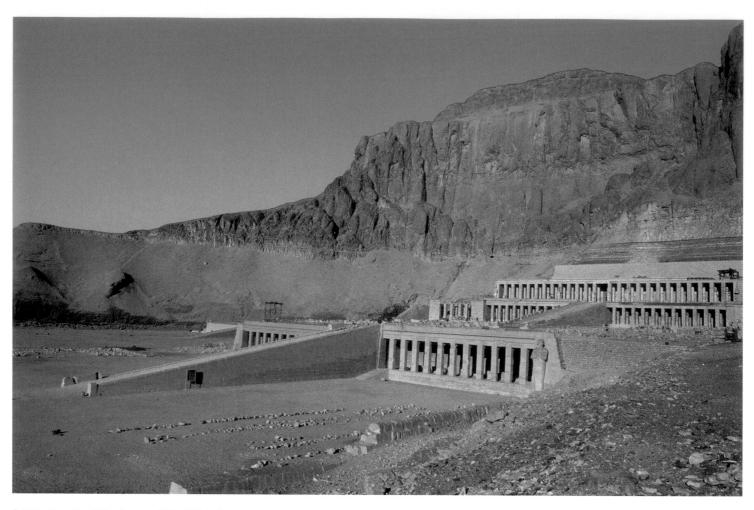

3.24 Temple of Hatshepsut, Deir el-Bahri. ca. 1478–1458 BCE

Mentuhotep II (fig. 3.25), who had reunited Egypt over 500 years earlier during the Middle Kingdom. Senenmut, the architect who designed Hatshepsut's temple, may have modeled some of its features after this earlier temple, with its crowning pyramid or mastaba and terraces extending into the cliff face. Hatshepsut's temple is a striking response to its physical setting. Its ascending white limestone courts, linked by wide ramps on a central axis, echo the desert's strong horizontal ground-line and the clifftop above. Meanwhile, the bright light and shadows of the colonnades create a multitude of vertical lines that harmonize with the fissures of the cliff. With its clean contours, the royal structure imposes order on the less regularized forms of nature, just as the king's role was to impose order on chaos. At the time of its construction, a causeway led from a valley temple by the Nile to the funerary temple. Trees lined the entrance way, and paired sphinxes faced each other. Cut into the rock at the farthest reach of the temple was the principal sanctuary, dedicated to Amun-Ra, god of the evening sun. Smaller chapels honored Anubis, god of embalming, and Hathor, goddess of the west. An altar dedicated to Ra-Horakhty stood on the upper terrace.

Throughout the complex, painted relief sculptures brought the walls to life, describing battles, a royal expedition to the land of Punt in search of myrrh trees for the terraces, and scenes of

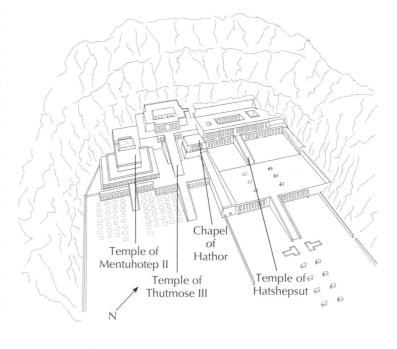

3.25 Reconstruction of Temples, Deir el-Bahri, with temples of Mentuhotep II, Thutmose III, and Hatshepsut (after a drawing by Andrea Mazzei, Archivio White Star, Vercelli, Italy)

3.26 Kneeling Figure of King Hatshepsut, from Deir el-Bahri. ca. 1473–1458 BCE. Red granite, height approx. 8'6" (2.59 m). Metropolitan Museum of Art, New York. Rogers Fund, 1929 (29.3.1)

Thutmose I legitimizing his daughter's rule. Sculptures of the king and deities abounded. One of eight colossal red-granite statues from the third court (fig. 3.26) depicts Hatshepsut kneeling as she makes an offering of two spherical jars. An inscription on the base records that the king is presenting *ma'at* (order) to Amun. Since kingship was a male office, she wears the regalia of a male king: a kilt, a false beard, and the **nemes headdress**, the striped cloth worn by kings. Although she is visibly female in some images, in this and many others she is depicted without breasts.

Sometime after Hatshepsut's demise, Thutmose III (r. 1479–1425) constructed his own temple between his mother's and Mentuhotep's, with the purpose of eclipsing Hatshepsut's. He designated his own temple as the destination of the divine boat carrying the statue of Amun in the Festival of the Wadi, held at

Deir el-Bahri. At some point after Hatshepsut's death, the uraeus cobras were meticulously removed from the granite sphinxes and seated statues at her mortuary complex. Perhaps the intention was to repudiate her royal descent. By the forty-second year of Thutmose III's reign, a more systematic elimination of her images and removal of her name from inscriptions was underway. Workmen smashed her statues and buried the fragments in two pits in front of the temple complex. Still, Hatshepshut's temple remains a monument to her memory. Archaeologists have recently identified an obese mummified body in an unmarked tomb in the Valley of the Kings as her mortal remains.

Temples to the Gods

Besides building their own funerary temples, Eighteenth Dynasty kings expended considerable resources on temples to the gods, such as the Theban divine triad: Amun, his consort Mut, and their son Khons. At Karnak and nearby Luxor, successive kings built two vast temple complexes to honor this triad, and on special festivals divine boats conveyed the gods' images along waterways between the temples.

THE TEMPLE OF AMUN-RA At the Temple of Amun-Ra (a manifestation of the god Amun) at Karnak, a vast wall encircled the temple buildings (fig. 3.27). Entering the complex, a visitor walked through massive pylons, or gateways built as monuments to individual kings (and sometimes dismantled as building proceeded over the years). As a ceremonial procession moved within the buildings, these pylons marked its progress deeper and deeper into sacred space. Within the complex, a vast hypostyle hall (room with many columns) was the farthest point of access for all but priests and royalty (fig. 3.28). Here, a forest of columns would awe the mind, their sheer mass rendering the human form almost insignificant. The architect placed the columns close to one another to support a ceiling of stone lintels which had to be shorter than wooden lintels to prevent them from breaking under their own weight. Nevertheless, the columns are far heavier than they needed to be, with the effect that a viewer senses the overwhelming presence of stone all around—heavy, solid, and permanent. Beyond the hall, a sacred lake allowed the king and priests to purify themselves before entering the temple proper. They proceeded through smaller halls, sun-drenched courts, and processional ways decorated with obelisks, tall stone markers topped by pyramid-shaped points, and chapels where they would pause to enact ceremonies. Every day the priests would cleanse and robe the images of the gods, and offer sacred meals to nourish them. The king and the priests conducted these rituals away from the public eye, with the result that they gained power for being shrouded in mystery.

Essential to the temple's ritual functioning was its metaphorical value: It symbolized the world at its inception. The columns of the hypostyle hall represented marsh plants in stylized form: Their capitals emulated the shape of papyrus flowers and buds—so that the building evoked the watery swamp of chaos out of

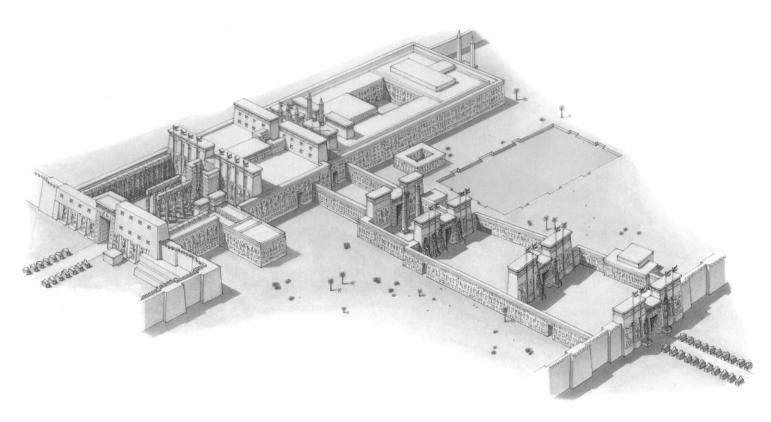

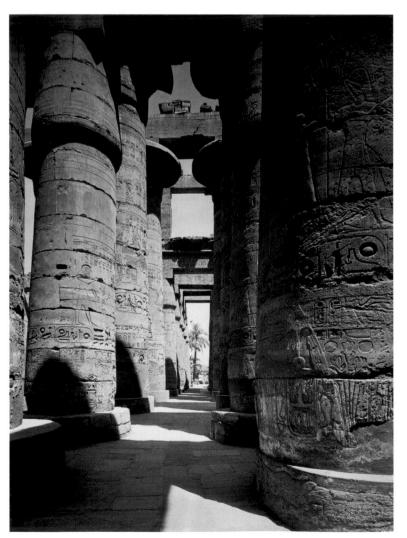

3.27 Reconstruction drawing of Temple of Amun-Ra, Karnak, Thebes

which the mound of creation emerged. The temple was thus the king's exhortation in stone to the gods to maintain cosmic order.

Throughout the complex, a distinctively Egyptian form of decoration covered the pylons and hall and enclosure walls: sunken relief. In this technique, the sculptor cut sharp outlines into the stone's face, and modeled the figures within the outlines, below the level of the background, rather than carving away the surface around figures to allow them to emerge from the stone. Light shining onto the stone's surface then cast shadows into the outlines, animating the figures without compromising the solid planar appearance of the wall. This type of relief was especially popular for decorating hard stone, since it required less carving away.

The subject of the reliefs at Karnak was the king's relationship with the gods. In one section, from the north exterior wall of the hypostyle hall, an upper register shows Seti I sacking the Hittite city of Kadesh on the Orontes River, and, in a lower register, his Libyan campaign (fig. 3.29). Following convention, the king and his horse-drawn chariot are frozen against a background filled with hieroglyphs and soldiers, whose smaller scale glorifies the king's presence. The figures of the king and his horse are also cut more deeply than surrounding figures, resulting in a bolder outline. The king's might and the ruthless efficiency of his forces seem to assure victory, although neither battle was, in fact, decisive. Through his conquest of foreign forces, the king established order, ma'at.

3.28 $\,$ Hypostyle hall of Temple of Amun-Ra, Karnak, Thebes. ca. 1290–1224 $_{\rm BCE}$

3.29 Seti I's Campaigns, Temple of Amun-Ra, Karnak, Thebes (exterior wall, north side of hypostyle hall). ca. 1280 BCE. Sandstone

ABU SIMBEL Seti I's son, Ramesses II, ruled for 67 years during the Nineteenth Dynasty (ca. 1290-1224 BCE). He commissioned more architectural projects than any other Egyptian king, including a monumental temple dedicated to himself and Amun, Ra-Horakhty, and Ptah, carved into the sandstone at Abu Simbel on the west bank of the Nile (fig. 3.30). Location alone made an eloquent statement: With the temple, the king marked his claim to the land of Kush in Lower Nubia, which was the origin of precious resources of gold, ivory, and animal pelts. A massive rock façade substitutes for a pylon, where four huge seated statues of the king almost 70 feet high flank the doorway, dwarfing any approaching visitor. Between the statues' legs, small figures represent members of the royal family. A niche above the entrance holds an image of Amun, who is shown as a falcon-headed figure crowned by a sun disk. Flanking this deeply carved sculpture are sunk-relief depictions of Ramesses holding out a statue of the

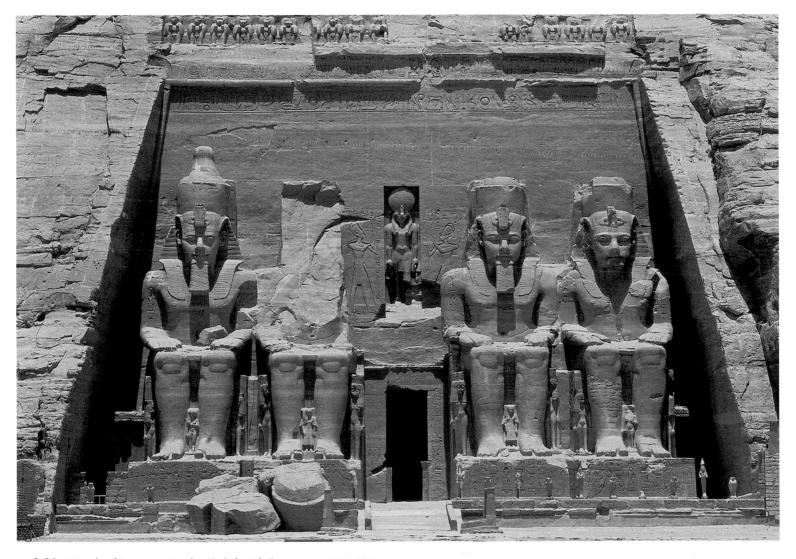

3.30 Temple of Ramesses II, Abu Simbel. 19th Dynasty. ca. 1279–1213 BCE

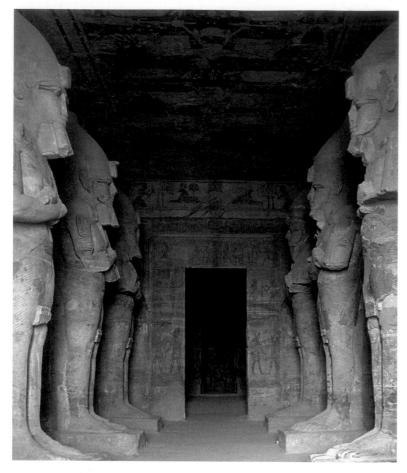

3.31 Interior of Temple of Ramesses II, Abu Simbel. 19th Dynasty. ca. 1279–1213 BCE

goddess of order, Ma'at, to the god. The image thus demonstrates the king's role as keeper of terrestrial order at the gods' request. On the interior of the temple are more colossal figures of Ramesses, shaped from the same rock as the columns behind them. Their size (32 feet high) and frontality presented an aweinspiring sight to priests who conducted rituals inside (fig. 3.31).

Ramesses commissioned a second, complementary temple about 500 feet away from his own, in honor of his wife, Nefertari, and Hathor. Here, too, sculptors cut figures into the rock as a façade for the temple, which, though colossal in scale, was significantly smaller than Ramesses' temple. The topographical relationship between the two temples may be significant. Their central axes, when extended forward, intersected in the Nile's life-giving waters, so their locations may express the generative force embodied in the royal couple. This relationship has hardly been visible since the 1960s, when engineers moved the temple of Ramesses upward nearly 700 feet to raise it above flood levels resulting from the construction of the Aswan Dam.

Block Statues

In the New Kingdom, a type of sculpture known since the late Old Kingdom experienced fresh popularity. This was the block statue, where the artist reduced the body, shown seated on the

ground with knees drawn up to the chest and wrapped in a cloak, to a cubic abstraction. Above the block is a portrait head, and feet protrude at the bottom; sometimes arms are folded across the knees. Like the more conventional full-body sculptures, these images functioned as seats for the ka in tombs. When they first appear in the Sixth Dynasty, the figures are found in model funerary boats, transporting the dead to the cult center of Osiris at Abydos. They may, therefore, represent the deceased as a being sanctified by this journey in the afterlife. The example illustrated in figure 3.32 may come from the temple at Karnak. It presents two portraits. Above is the head of Senenmut, a high official at the court of Hatshepsut and Thutmose III and master of works for the temple at Deir el-Bahri. Below Senenmut's head is a very small head, portraying Nefrua, daughter of Hatshepsut and Thutmose II. Featuring the sidelock of hair that identifies her as a child, her head emerges from the block in front of Senenmut's face, as if held in an embrace, perhaps reflecting his protective role as her tutor. Omitting anatomical features in favor of the block form left an ample surface for a hieroglyphic text of prayers or dedications.

3.32 Senenmut with Nefrua, from Thebes. ca. 1470–1460 BCE. Granite, height approx. 31½" (107 cm). Ägyptisches Museum, Berlin

Images in New Kingdom Tombs

New Kingdom artists continued to paint tomb chapels with scenes similar to those in Old and Middle Kingdom tombs. In the New Kingdom, however, additional images showed the deceased worshiping deities whose interventions could ease their transition to the next world—most typically, Osiris and Anubis. In the tomb chapel that featured in the annual festival of the Wadi at Thebes, when the living crossed to the west bank of the Nile and feasted with the dead, artists also painted banquet scenes. Music, dance, and wine were sacred to Hathor, who could lead the dead through the dangerous liminal phase between death and the afterlife. A fragment of painting from the Tomb of Nebamun at Thebes (ca. 1350 BCE) shows that painters still employed hierarchical conventions established in the Old Kingdom 1,000 years previously (fig. 3.33). While elite diners sit in rigid composite view (half profile, half frontal) in an upper register, musicians and dancers below move freely in pursuit of their crafts. A flute player and a clapper have fully frontal faces, and they even turn the soles of their feet to face a viewer—an extreme relaxation of elite behavior. The nude dancers twist and turn, and the loosened, separated strands of the entertainers' long hair further animate their painted images. The freedom of movement inherent in these figures has suggested to some that works from contemporary Crete may have been available for these painters to study. Art historians have gone so far as actually to attribute paintings elsewhere to artists from this Aegean island culture.

New Kingdom artists and patrons also followed Middle and Old Kingdom precedents in designing sculpted tomb images. Some reliefs executed for an unfinished tomb in Thebes belonging to Ramose, vizier for Amenhotep III (ca. 1375 BCE), depict Ramose's brother, Mai, and his wife, Urel (fig. 3.34). The relief is shallow, but the carving distinguishes different textures with great mastery. The composite postures and the gestures of the wife embracing her husband reflect conventions going back at least to the Old Kingdom; all the same, the canon of proportions differs from earlier representations, and some of the naturalism seen in other New Kingdom works informs the profiles of this couple. The united front that husband and wife present through eternity may be compared to a New Kingdom love song that extols the joy of spending "unhurried days" in the presence of one's beloved. (See www.myartslab.com.)

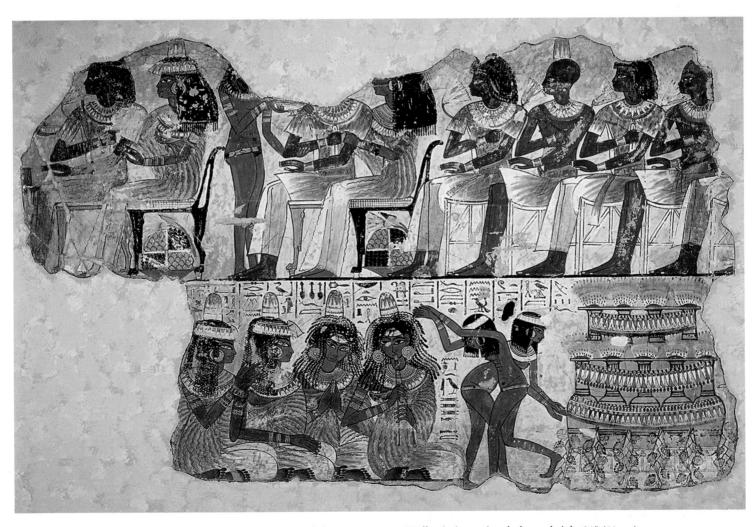

3.33 Musicians and Dancers, from the Tomb of Nebamun, Thebes. ca. 1350 BCE. Wall painting, painted plaster, height 24" (61 cm). The British Museum, London

3.34 *Mai and His Wife, Urel*, Tomb of Ramose, Thebes. ca. 1375 BCE. Limestone relief detail

AKHENATEN AND THE AMARNA STYLE

Amenhotep III, whom Ramose served as vizier, raised the level of devotion to the sun-god during his reign (1391–1353 BCE). In temple complexes at Karnak and elsewhere, the king established wide open-air courtyards where Egyptians could worship the sun in its manifestation as a disk (or Aten) in the sky. Aten worship increased dramatically under his son, Amenhotep IV, who stressed the sun's life-giving force and began to visualize the god not in the traditional guise of a falcon-headed figure, but as a disk that radiated beams terminating in hands. Enraged by the young king's monotheistic vision of Aten, a powerful conservative priesthood thwarted his attempts to introduce this new cult to traditional religious centers such as Thebes. In response, Amenhotep IV established a new city devoted entirely to Aten on the Nile's east bank in central Egypt. He named his new city Akhetaten (now known as Amarna), meaning "horizon of Aten," and changed his own name to Akhenaten, "beneficial to Aten." Akhenaten's belief in Aten as the source of life found expression in the "Hymn to Aten" which is sometimes attributed to the king. This text (see www.myartslab.com) expresses joy in the daily rising of the sun by describing the world coming back to life at its appearance. Akhenaten's new cult and fledgling city lasted only as long as its founder; after his death, his opponents razed the city to the ground. Still, archaeological remains suggest that Akhenaten built temples in the contemporary style, using massive pylons and obelisks, as at Karnak, but with an emphasis on open-air courts directly exposed to the sun's glare.

The Amarna Style

Sculptures of Akhenaten and his family break dramatically with long-established conventions for depicting royal subjects. In numerous depictions, the figure of Akhenaten exhibits radically different proportions from those of previous kings. A colossal figure of Akhenaten installed at the temple of Amun-Ra in Karnak between 1353 and 1335 represents the king with narrow shoulders lacking in musculature, and with a marked pot belly, wide hips, and generous thighs (fig. 3.35). His large lips, distinctive nose and chin, and narrow eyes make his face readily recognizable. The Amarna style, which was not reserved for the king's image but influenced representations of court officials and others as well, specifically emphasized naturalism in the body. Still, these unusual portraits of Akhenaten have puzzled scholars. Some dismiss them as caricatures, yet such expensive and prominent images must have had the king's approval. There have also been attempts to diagnose a medical condition from these representations, by reading the king's features as symptoms of Frolich's Syndrome, a hormonal deficiency that produces androgynous (both male and female) characteristics. Possibly he simply intended his "feminized" appearance to capture the androgynous fertile character of Aten as life-giver.

Group representations of Akhenaten with his family—his consort Nefertiti and three oldest daughters—are equally remarkable for the apparent intimacy among the figures. This is clear on a sunk-relief scene on an altar stele, of the kind that Egyptians would erect in small shrines in their homes and gardens (fig. 3.36). Beneath the disk of the sun, its life-giving beams radiate downward with hands at their terminals. Attenuated reed columns

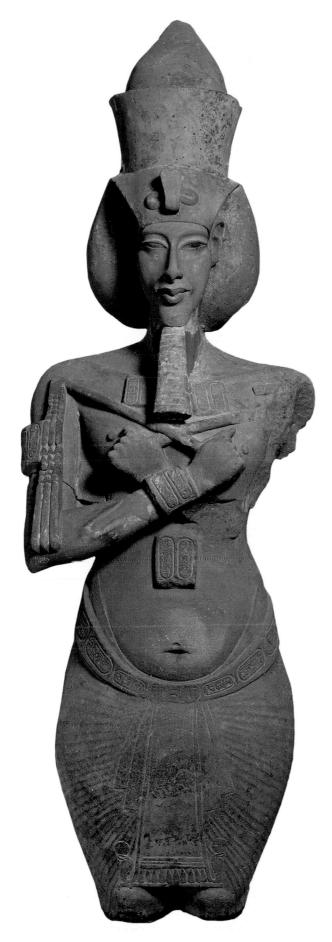

3.35 Akhenaten, from Karnak, Thebes. 1353–1335 BCE. Sandstone, height approx. 13' (3.96 m). Egyptian Museum, Cairo

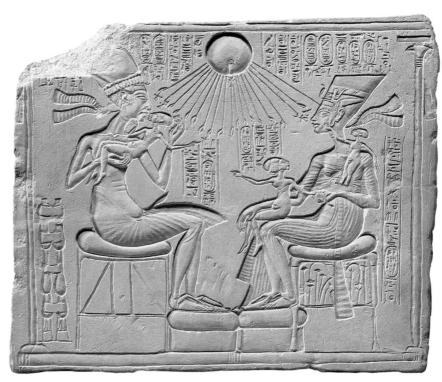

3.36 Akhenaten and His Family. ca. 1355 BCE. Limestone, $12^34 \times 15^14''$ (31.1 × 38.7 cm). Staatliche Museen zu Berlin, Preussischer Kulturbesitz, Ägyptisches Museum

suggest that the scene takes place within a garden pavilion, which is stocked with wine jars. The king and his consort sit facing each other on stools. They hold three lively daughters, who clamber on their laps and in their arms, uniting the composition with animated gestures that reach across the relief in marked contrast to the static quality of scenes of other times. The deliberate emphasis on the daughters' childishness marks a change: In the past, artists had represented children with a hieroglyphic pictograph of an adult in miniature, sucking a finger. The emphasis on children epitomizes the regeneration that the royal couple represent, and especially the king as manifestation of Aten.

QUEEN TIY The surprising transience implicit in the children's youthfulness and animated gestures on the altar also characterizes a one-third-life-size portrait of Akhenaten's mother Queen Tiy, chief wife of Amenhotep III (fig. 3.37). Using the dark wood of the yew tree, with precious metals and semiprecious stones for details, the artist achieved a delicate balance between idealized features and signs of age. Smooth planes form the cheeks and abstract contours mark the eyebrows, which arch over striking eyes inlaid with ebony and alabaster. Yet the downturned mouth and the modeled lines running from the sides of the nose to the mouth offer careful hints of the queen's advancing years.

The sculpture went through two stages of design: Initially, the queen wore gold jewelry and a silver headdress ornamented with golden cobras, which identified her with the funerary goddesses Isis and Nephthys. A wig embellished with glass beads and topped with a plumed crown (the attachment for which is still

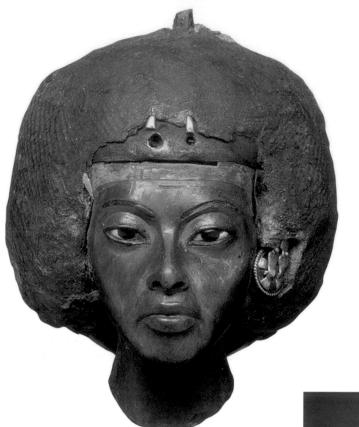

3.37 *Queen Tiy*, from Kom Medinet el-Ghurab. ca. 1352 BCE. Yew, ebony, glass, silver, gold, lapis lazuli, cloth, clay, and wax, height 3¾" (9.4 cm). Staatliche Museen zu Berlin, Preussischer Kulturbesitz, Ägyptisches Museum

extant) later concealed this headdress. Although excavators discovered the sculpture with funerary paraphernalia for her husband, Amenhotep III, these changes indicate that it was adapted to suit the beliefs of Akhenaten's new monotheistic religion.

PORTRAITS OF NEFERTITI As with Akhenaten's images, early depictions of Nefertiti emphasize her reproductive capacity by contrasting a slender waist with large thighs and buttocks. Sculptures from the second half of Akhenaten's reign, however, are less extreme. At Amarna, archaeologists discovered the studio of the king's chief sculptor, Tuthmosis, whom court records call "the king's favorite and master of the works." This yielded sculptures at every stage of production: heads and limbs of quartzite and jasper, and torsos of royal statues to which they could be affixed. Plaster casts were found, modeled from clay or wax studies taken from life. The most famous of these sculptures is a bust of Nefertiti, plastered over a limestone core and painted—a master portrait, perhaps, from which artists could copy other images (fig. 3.38). The sculpture's left eye lacks the inlay of the right, showing that

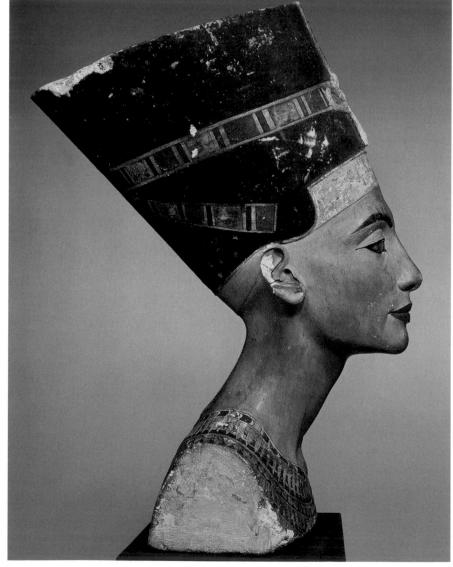

3.38 *Queen Nefertiti.* ca. 1348–1336/35 BCE. Limestone, height 19" (48.3 cm). Staatliche Museen zu Berlin, Preussischer Kulturbesitz, Ägyptisches Museum

Interpreting Ancient Travel Writers

A great many Greeks went to Egypt; some, as might be expected, for business, some to serve in the army, but also some just to see the country itself.

-Herodotus

ne of the primary sources available to art historians is the writing of ancient travelers. Despite the dangers of travel in antiquity, from shipwrecks to thievery, Egypt became a prime destination for curiosity-seekers, beginning around 1500 BCE, and peaking during the first and second centuries CE. Locals did what they could to entice travelers. In Roman times, men from Busiris, near Giza, would climb the pyramids' slippery slopes as a tourist attraction. Some early travelers painted or scratched their names on works of art, among them Hadrian's wife, Sabina. Others made a crucial-if complex-contribution to our knowledge of ancient monuments by writing about their journeys. Born in the early fifth century BCE in Halicarnassos (presentday Bodrum, Turkey), Herodotus spent the best part of his adulthood traveling throughout the Mediterranean and the Near East. His account of his Egyptian travels still survives. In the late first century BCE, the Greek geographer Strabo also wrote a valuable description of his experiences in Egypt and elsewhere.

These authors saw the "great wonders" at first hand, at a time when much more survived of them than is the case today. Often, their accounts supply vital information for reconstructions, or other details, such as the names of artists, architects, or patrons; but it is a mistake to accept the writers' words uncritically. These ancient travelers had different priorities from the modern art historian, and this fact would certainly have affected the accuracy of their accounts. Herodotus, for instance, was much more interested in religion than in works of art or architecture. This results in him giving considerably less detailed or precise information about artistic monuments than we might desire. It is also all too easy to forget that even ancient travelers visited Egypt at least a millennium after the pyramids and other monuments had been built. Furthermore, they relied on traditions handed down by guides and other locals, who, research shows, were often misinformed. Herodotus insists that the blocks of Khufu's pyramid were all at least 30 feet long, when 3 feet would have been more accurate. He also attributes the work to slaves, thus denigrating Khufu as a tyrant. Local priests may have broadcast this view in the fifth century BCE to please their Persian rulers. A long tradition among scholars of giving greater credence to classical texts than other types of evidence has led, in many instances, to an undue acceptance of ancient authors' words as "truth," even when archaeological evidence paints a different picture.

the bust remained unfinished, but an extraordinary elegance still derives from the sculptor's command of geometry, which is at once precise—the face is completely symmetrical—and subtle. The sculptor abandoned this piece and another similar head in the workshop when he moved from Amarna to Memphis after Akhenaten's death in 1335 BCE and the subsequent razing of his city.

Tutankhamun and the Aftermath of Amarna

Shortly after Akhenaten's death, a young king ascended the throne. Married to Akhenaten's daughter, even perhaps himself one of Akhenaten's sons, Tutankhaten was only nine or ten when he became king. Possibly under the influence of the priests of Amun, he restored the royal residence to Memphis and resurrected the orthodox religion of Egypt that Akhenaten had rejected. He changed his name to Tutankhamun to reflect the monarchy's renewed alliance with Amun, before dying unexpectedly at the age of 19. His sudden death has inspired numerous murder and conspiracy theories, but recent scientific studies of his mummy point to natural causes.

Tutankhamun's greatest fame results not from his life, but from his death and the discovery of his tomb in 1922 by the British archaeologist Howard Carter. Although robbers had entered the tomb twice, much of it remained untouched when Carter found it (fig. 3.39). With a stairway, corridor, and four chambers, the tomb is uncharacteristically small for a royal burial, leading scholars to suppose that a nonroyal tomb might have

been hastily coopted for the king at the time of his unanticipated death. All the same, offerings buried with him lacked nothing in volume or quality. Indeed, the immense value of the objects makes it easy to understand why grave robbers have been active in Egypt ever since the Old Kingdom. The tomb contained

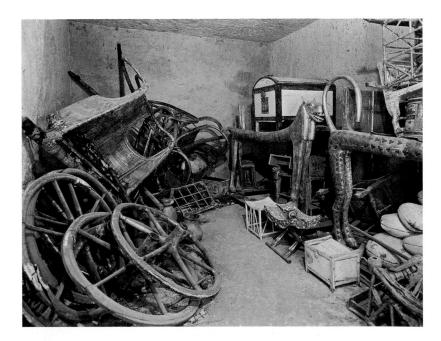

3.39 Tomb of Tutankhamun. 18th Dynasty

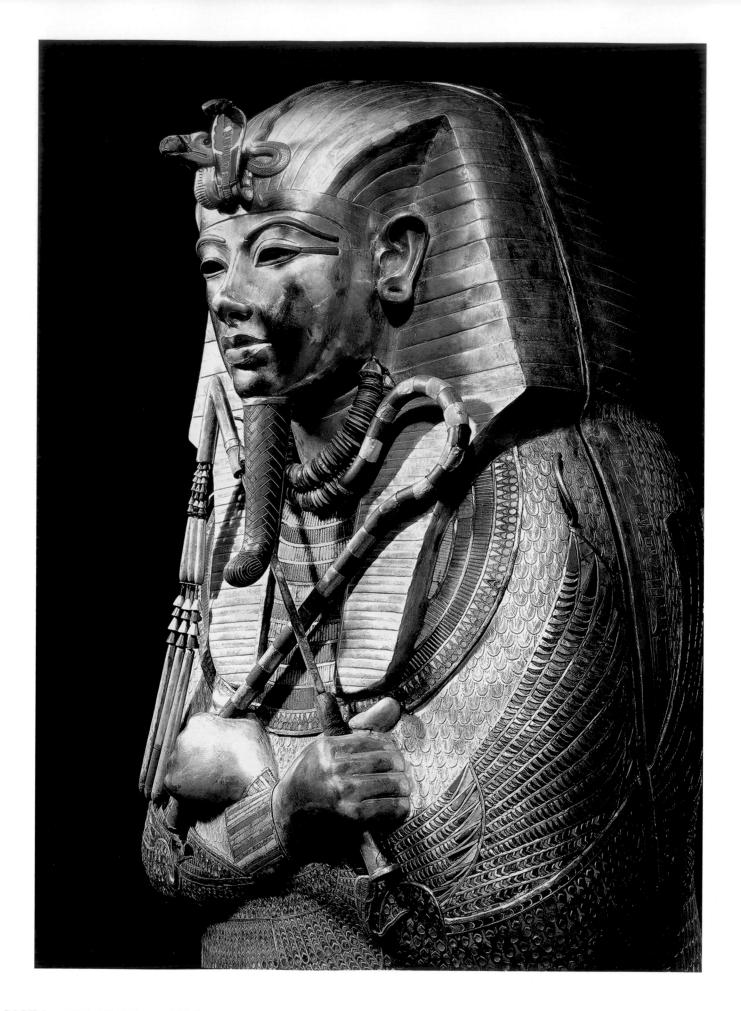

The Book of the Dead

This text is an incantation from Plate III of the Papyrus of Ani in the British Museum, from the latter half of the Eighteenth Dynasty. It accompanies the weighing of the soul illustrated in the closely related The Book of the Dead of Hunefer (see fig. 3.40).

Saith Thoth the righteous judge of the cycle of the gods great who are in the presence of Osiris: Hear ye decision this. In very truth is weighed the heart of Osiris, is his soul standing as a witness for him; his sentence is right upon the scales great. Not hath been found

wickedness [in] him any; not hath he wasted food offering in the temples; not hath he done harm in deed; not hath he let go with his mouth evil things while he was upon earth.

Saith the cycle of the gods great to Thoth [dwelling] in Hermopolis [the god's cult-center along the Nile in Upper Egypt]: Decreed is it that which cometh forth from thy mouth. Truth [and] rightcous [is] Osiris, the scribe Ani triumphant. Not hath he sinned, not hath he done evil in respect of us. Let not be allowed to prevail Amemet [Ammut, the devourer of souls] over him. Let there be given to him cakes, and a coming forth in the presence of Osiris, and a field abiding in Sekhet-hetepu [Field of Peace] like the followers of Horus.

funerary equipment, such as coffins, statues, and masks, as well as items used during the king's lifetime, such as furniture, clothing, and chariots. Many of the objects feature images of Tutankhamun battling and overcoming foreign enemies, as part of his kingly duty to maintain order amid chaos. Three coffins preserved the king's mummified corpse, the innermost of which is gold and weighs over 250 pounds. Most impressive is the exquisite workmanship of its cover, with its rich play of colored inlays against polished gold surfaces (fig. 3.40). The number and splendor of the objects in the burial of a minor king like Tutankhamun make the loss of the burial finery of powerful and long-lived kings all the more lamentable.

Tutankhamun's short-lived successor, the aged Ay, continued the process of restoring the old religion. He married Tutankhamun's widow, perhaps to preserve, rather than usurp, succession to the throne. Head of the army under Tutankhamun and last king of the Eighteenth Dynasty, Horemheb completed the restoration process: He set out to erase all traces of the Amarna revolution, repairing shattered images of the traditional gods and rebuilding their temples; but the effects of Akhenaten's rule lived on in Egyptian art for some time to come.

PAPYRUS SCROLLS: THE BOOK OF THE DEAD

Inscriptions on walls and furnishings accompanied royal burials like Tutankhamun's. Yet in the Middle Kingdom, the desire to include the prayers and incantations that accompanied kings to the afterlife spread to other classes of patrons. By the New Kingdom, these patrons commissioned scribes to make illustrated funerary texts such as *The Book of the Dead* which first appeared in the Eighteenth Dynasty. This is a collection of over 200 incantations or spells that ultimately derived from the Coffin Texts of the Middle Kingdom, which scribes copied onto scrolls made of papyrus reeds. The popularity of *The Book of the Dead* in the

3.40 Cover of the coffin of Tutankhamun. 18th Dynasty. Gold, height 72" (182.9 cm). Egyptian Museum, Cairo

New Kingdom signals a change in Egyptian beliefs about the afterlife: Any member of the elite could enjoy an afterlife, as long as the deceased had lived in accordance with *ma'at* and could pass tests imposed by the gods of the underworld. In order to ensure that the deceased had the knowledge required to do this and progress to the hereafter, relatives generally placed a version of *The Book of the Dead* inside the coffin or wrapped within the mummy bandaging itself. Among the scenes illustrating the book are the funeral procession, the weighing of the heart, and the provision of nourishment for the dead.

One of the finest surviving examples is The Book of the Dead of Hunefer, dating from about 1285 BCE. The seene representing the weighing of the heart and Osiris' judgment of the dead in Chapter 125 (see Primary Source, above) conforms to a welldefined type that many workshops shared (fig. 3.41). Derived from traditional tomb painting, its imagery has been adapted to the format of the scroll to be a continuous narrative, repeating protagonists in one scene after another without a dividing framework. At the left, Anubis, the jackal-faced guardian of the underworld, leads Hunefer into the Hall of the Two Truths. Anubis then weighs Hunefer's heart, contained in a miniature vase, against the ostrich feather of Ma'at, who symbolized divine order and governed ethical behavior. Ma'at's head appears on the top of the scales. Thoth, the ibis-headed scribe, records the outcome. Looking on with keen interest is Ammut. Made up of the parts of various ferocious beasts-the head of a crocodile, the body and forelegs of a lion, and the hindquarters of a hippopotamus—she was the devourer of those whose unjust life left them unworthy of an afterlife.

The deceased had to swear to each of the deities seen overhead that he or she had lived according to ma'at. When he had been declared "true of voice," Horus presented him to his father, Osiris, shown with emblems of kingship, wrapped in a white mummy-like shroud, and seated in a pavilion floating above a lake of natron, a salt used for preserving the body. With him are Isis and her sister Nephthys, mother of Anubis and protector of the dead. In front of the throne, the four sons of Horus stand on a white lotus blossom, symbol of rebirth. Also considered the gods of the cardinal points, they protected the internal organs that were removed as part of the embalming process and placed in containers known

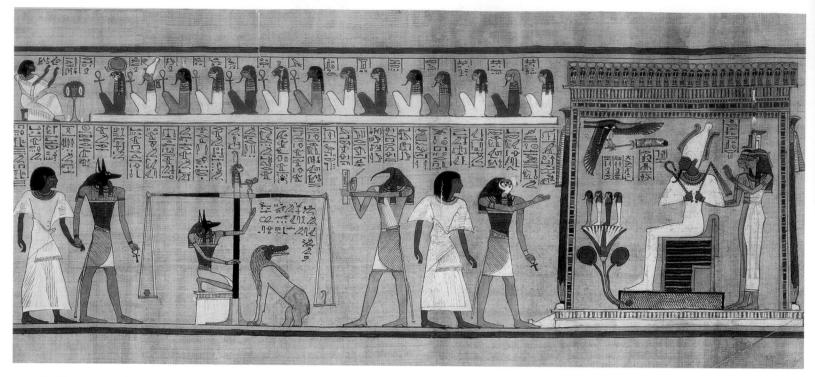

3.41 The Weighing of the Heart and Judgment by Osiris, from The Book of the Dead of Hunefer. 1285 BCE. Painted papyrus, height 15%" (39.5 cm). The British Museum, London

as canopic jars. Above, Horus, identified by the eye he lost in his struggle with Seth, called the udjat eye, bears an ostrich feather, representing the favorable judgment of Ma'at. In the afterlife, as on earth, the desire for order was paramount.

LATE EGYPT

Tutankhamun's revival of the cult of Amun and the ancient sources of *The Book of the Dead* demonstrate that New Kingdom Egyptians deeply venerated the traditions of the past. Even as Ramesses II extended the borders of his realm to the south and the east, the cult centers at Luxor and Karnak absorbed great wealth and developed great influence. About 1076 BCE, barely 70 years after the end of the reign of Ramesses III, priests began to exert more and more power, until during the Twenty-first Dynasty the cult of Amun dominated Egypt. Thereafter, successive groups of foreigners controlled the area, including Nubians, Persians, and Macedonians, and the era known as the New Kingdom comes to an end.

The final phase of ancient Egypt belongs to the history of Greece and Rome. Alexander the Great conquered Egypt and founded the city of Alexandria before his death in 323 BCE. His general, Ptolemy (d. 284 BCE), became king of the region, and established a dynasty that lasted nearly 300 years, until the death of Ptolemy XIV or Caesarion, Cleopatra's son by the Roman dictator Julius Caesar. In 30 BCE, the Roman general Octavian, soon to be the emperor Augustus, claimed Egypt as a Roman province. Despite its lack of autonomy, Egypt flourished economically

under the Greeks and Romans. In the Ptolemaic period, Alexandria became one of the most vibrant centers of culture and learning in the Hellenistic world, and its port ensured a lively trade that reached as far as China and India. In Roman times, the Nile's life-giving waters made Egypt the chief source of grain in the empire, earning it the title of Rome's granary. But in addition to this commercial function, Egypt provided Rome and its successors with inspiring models of kingly power and imagery that lasted through the ages.

For some 3,000 years, from the era of the pyramids down to the time of the Ptolemies, Egyptian kings built magnificent structures that expressed their wealth and their control over the land and its resources. All aspects of royal patronage demonstrated the intimate link between the king and the gods. Building in stone and on a grand scale, Egyptian kings sought to impress a viewer with the necessity and inevitability of their rule. The formulas for representing the power of the king are as old as Egypt itself.

Egyptian kings and other elite patrons built structures for both the living and the dead. The objects and images placed in their tombs for the afterlife offer a modern viewer a glimpse of the material goods that they enjoyed in their lifetimes. The tombs provided a safe haven for the body and the soul (ka) of the deceased. They were built to endure, and they were equipped with numerous representations of the dead. These representations were also designed to last by virtue of being made of the most permanent of materials. Permanence was also sought through the consistent use of conventions for representing the patron. The longevity of Egyptian art forms testifies to the longevity of Egyptian social structures, political organization, and beliefs.

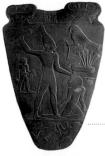

ca. 3150–3125 BCE The *Palette of King Narmer*

ca. 3500-3200 BCE Predynastic painting at Hierakonpolis

2630-2611 BCE Rule of King Djoser, and construction of his mortuary complex at Saqqara

ca. 2575-2465 BCE The Fourth Dynasty, and construction of the three Great Pyramids at Giza

ca. 1870s-1840s BCE Naturalistic sculpture of King Senwosret III

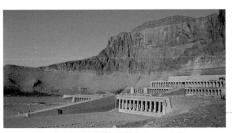

ca. 1458 BCE King Hatshepsut dies; her mortuary temple was designed by Senenmut

ca. 1348-1336/35 BCE Plaster and limestone portrait bust of Akhenaten's wife, Nefertiti

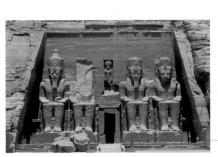

ca. 1290-1224 BCE Rule of King Ramesses II, who commissioned a monumental temple at Abu Simbel

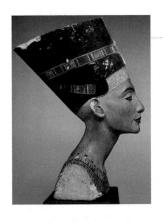

Egyptian Art

000	\triangleleft	ca.	5000	BCE	Human	settlements	along	the	Nile
BCE		Val	ley						

ca. 4250-3750 BCE Neolithic menhirs at Ménec

4500

4000

3000

2500

2000

1500

1000

500

0

ca. 3500 BCE Pottery manufacturing appears in western Europe

 ca. 2900 BCE Mesopotamians begin using cuneiform writing

· ca. 2100 BCE Final phase of construction at Stonehenge

 1792-1750 BCE Hammurabi rules Babylon after 1785 BCE The Hyksos gain control of the Nile Delta

■ ca. 1595 BCE The Hittites conquer Babylon ca. 1550–1525 BCE Rule of King Ahmose; expulsion of the Hyksos from Egypt

 ca. 1353-1335 BCE Rule of King Akhenaten; new religious center at Amarna

......ca. 957 BCE Solomon's Temple is completed in Jerusalem

323 BCE Alexander the Great dies, leading to Ptolemy's kingdom of Egypt

 30 BCE Roman general Octavian proclaims Egypt a Roman province

Aegean Art

connected the cultures of antiquity. With North Africa on the south, Asia on the east, and Europe on the west and north, this body of water brought disparate cultures into contact for both trade and conflict. The Greeks named one branch of the Mediterranean, between Greece and Turkey, the

Aegean Sea, and on islands and peninsulas there several closely related but distinct cultures developed in the third and second millennia BCE. The Cycladic culture emerged on the islands forming an irregular circle between the Greek mainland and the island of Crete. The British archaeologist Sir Arthur Evans named the culture on the island of Crete Minoan, because the later Greeks associated Crete with the legendary King Minos, son of the Greek god Zeus, and a mortal princess, Europa. The culture on the mainland is called Helladic, from the Greek *Hellas*. Together, these separate cultures formed a civilization we know today as Aegean, after the sea that both separates and unites them.

Until the second half of the nineteenth century, Aegean civilization was known principally from *The Iliad* and *The Odyssey*, epic tales of gods, kings, and heroes attributed to the eighth-century BCE Greek poet (or group of poets) known as Homer. His story of the siege of Troy and its aftermath still excites the modern imagination. Prompted by these stories, and curious to determine whether they had a factual basis, German archaeologist Heinrich Schliemann excavated sites in Asia Minor and Greece during the 1870s. Following his lead, Arthur Evans began excavations in Crete in 1900. Since then, a great deal of archaeological evidence has come to light, some consistent with, but much contradicting, Homer's tales. Although writing has been found in

Minoan and Mycenaean contexts, it is not bountiful and scholars are still working on its decipherment. (Note the absence of *Primary Source* boxes in this chapter.) Consequently, we understand less about Aegean civilization than we do about the cultures of Egypt or the ancient Near East.

There is evidence of human habitation throughout the Aegean as early as the Paleolithic period, though settlements spread and grew mainly in the Neolithic and Early Bronze ages. Scholars divide the Aegean Bronze Age into three phases: Early, Middle, and Late, each of which is further subdivided into three phases, I, II, and III. Archaeologists often prefer these relative dates to absolute dates, because the chronology of the Aegean Bronze Age is so open to debate. The Early phase (ca. 3000-2000 BCE) corresponds roughly to the Predynastic and Old Kingdom period of Egypt, and Sumerian and Akkadian culture in Mesopotamia. The Middle phase (ca. 2000-1600 BCE) is contemporaneous with the Middle Kingdom in Egypt and the rise of Babylon in Mesopotamia. And the Late phase (ca. 1600-1100 BCE) is contemporaneous with the Second Intermediate Period and the New Kingdom in Egypt, the Hittite overthrow of Babylon, and the rise of the Assyrians in Mesopotamia. A mass destruction of Aegean sites, from a cause still unknown to us, led to significant depopulation in about 1200 BCE, and, despite a slight resurgence, by 1100 BCE the Aegean Bronze Age had come to an end.

The different cultures of the Aegean produced distinct art forms. Stylized marble representations of the human figure and

CHAPTER 4

Detail of figure 4.20, Corbeled casemate at Tiryns, Greece

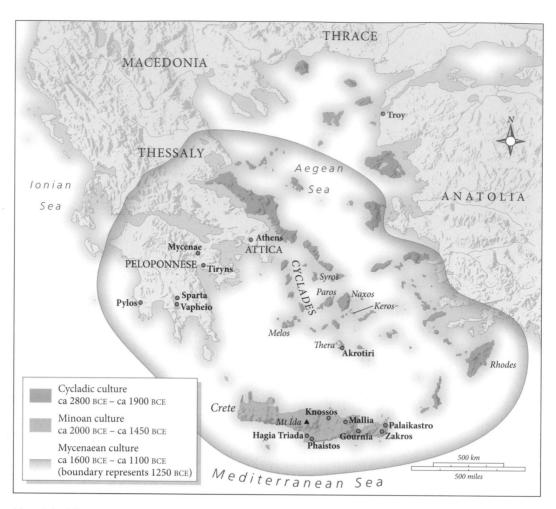

Map 4.1 The Bronze Age Aegean

frescoes are paramount in the Cyclades. Large palaces with elaborate adornments on their walls dominate on Crete. Citadels and grave goods remain from the Greek mainland. In the absence of extensive writing, these works of art provide valuable insights into Aegean practices and ideals. The fact that the tales of Homer and Greek myths look back to these cultures testifies to their importance in the development of later Greek culture.

EARLY CYCLADIC ART

Information about the culture of the Cyclades comes entirely from the archaeological record, which indicates that wealth accumulated there early in the Bronze Age as trade developed, especially in obsidian, a dark volcanic stone. Funerary practice reflects this prosperity. At the beginning of the Early Bronze Age, around 2800 BCE, the islanders started to bury their dead in stone-lined pits sealed with stone slabs, known today as cist graves. Although they lacked large-scale markers, some of these graves contained offerings, such as weapons, jewelry, and pottery. Potters crafted their wares by hand in the Early Cycladic period, and in addition to drinking and eating vessels, they produced flat round objects with handles, decorated with incised or stamped spirals and circles, and sometimes with abstract renderings of ships (fig. 4.1).

Archaeologists nickname them "frying pans" because of their shape, but they may in fact have been **palettes** for mixing cosmetics, or, once polished, served as an early kind of mirror.

Some Cycladic burials included striking figures, usually female, carved from the local white marble. The Early Cycladic II example illustrated here represents the prevalent type (fig. 4.2). The figure is nude, with arms folded across the waist, and toes extended. The flat body has a straight back, and a long, thick neck supports a shield-shaped face at a slight angle. The artist used abrasives, probably emery from the island of Naxos, to distinguish details on the figure, such as a ridgelike nose, small pointed breasts, a triangular pubic area, and eight toes. Traces of pigments on a few figures indicate that the artist painted on other details, including eyes, hair, jewelry, and body markings similar to tattoos.

Female figures of this type are always standing (or reclining). They come in many sizes (the largest reaching 5 feet long and the smallest only a few inches), but their form is consistent enough to indicate a governing canon of proportions, as with Egyptian sculptures (see Chapter 3). All the same, a number of figures clearly stand outside this canon. For instance, some appear to be pregnant. There are also some male figures. These are usually seated and play a musical instrument, such as a flute or a harp, like the player illustrated in figure 4.3.

4.1 "Frying pan," from Chalandriani, Syros. Early Cycladic II. ca. 2500-2200 BCE. Terra cotta, diameter 11" (28 cm), depth 2\%" (6 cm). National Archaeological Museum, Athens

For many years, archaeologists called these figures Cycladic "idols," and pictured them playing a central role in a religion focusing on a mother goddess. More recently scholars have offered two other plausible explanations for their functions. Perhaps sculptors crafted them purely for funerary purposes, to represent servants or surrogates for human sacrifices, or even for the body of the deceased. Alternatively, they may have served a different function before burial, possibly within household shrines. Although most have come to light in a reclining position, they may once have been propped upright. Some examples show signs of repair with wire, which is a strong indication that people used—and valued—them before depositing them in graves.

Most likely, no single explanation applies to all of them. The greatest obstacle to determining their function is our general ignorance about their provenance, that is, where and how they were found and their subsequent history. The simplicity and clear geometry of the figures appeals to a twentieth- and twenty-firstcentury aesthetic that favors understated and clean geometric forms. Those qualities and the luscious white marble used to form the figures have led to their widespread appearance on the art market, often without any record of archaeological context. In

4.3 Harpist, from Amorgos, Cyclades. Latter part of the 3rd millennium BCE. Marble. Height 81/2" (21.5 cm). Museum of Cycladic Art, Athens

4.2 Figure, from the Cyclades. ca. 2500 BCE. Marble. Height 15¾" (40 cm). Nicholas P. Goulandris Foundation. Museum of Cycladic Arts, Athens. N.P. Goulandris Collection, No. 206

order to better interpret these figures, archaeologists need to know their exact findspots, whether in a burial context or in living quarters.

The carved figures of women and musicians that survive from these Aegean islands seem to look back to Paleolithic and Neolithic figures, such as the *Woman of Willendorf* (see fig. 1.14). Yet the characteristic pattern of these figures—the canon that they followed—is distinct to these islands (and to Crete, where some examples have surfaced). The tradition of making figural imagery in the marble native to these islands would become a dominant feature of later Greek art.

MINOAN ART

Archaeologists have found a wider range of objects and structures on the island of Crete than on the Cyclades. This large island, south of the Cyclades, and about 400 miles (640 km) northwest of Egypt, stretches over 124 miles (200 km) from east to west, divided by mountain ranges, and with few extensive areas of flat, arable land (map 4.1). This geography, along with continuous migration throughout the Bronze Age, encouraged diversity and independence among the population: Minoan communities tended to be small and scattered. All the same, as a result of inhabiting an island that is centrally placed in the Mediterranean, Minoans became skilled seafarers and developed a powerful fleet of ships.

The major flowering of Minoan art occurred about 2000 BCE, when Crete's urban civilizations constructed great "palaces" at Knossos, Phaistos, and Mallia. At this time, the first Aegean script, known as Linear A, appeared. This is known as the First Palace period, comprising Middle Minoan I and II. Little evidence of this sudden spurt of large-scale building remains, as all three early centers suffered heavy damage, probably from an earth-quake, in about 1700 BCE. A short time later, the Minoans built new and even larger structures on the same sites. This phase constitutes the Second Palace period, which includes Middle Minoan III and Late Minoan IA and IB. An earthquake demolished these centers, too, in about 1450 BCE. After that, the Minoans abandoned the palaces at Phaistos and Mallia, but the Mycenaeans, who gained control of the island almost immediately, occupied Knossos.

The "Palace" at Knossos

The buildings of the Second Palace period are our chief source of information for Minoan architecture. The largest is the structure at Knossos, which its excavator, Arthur Evans, dubbed the Palace of Minos (figs. 4.4 and 4.5). In fact, the city of Knossos may have been the most powerful Cretan center of the Middle and Late Bronze Age, with its most impressive structures dating from between 1700 and 1400 BCE. These included courts, halls, shrines, workshops, storerooms (housing vast clay jars for oil and other provisions), and perhaps residential quarters, linked by corridors,

staircases, and porticoes. Frequent **light wells** (open spaces reaching down through several floors) illuminated and ventilated interior spaces (as seen in fig. **4.6**). Other amenities in the buildings included a system of clay pipes for drainage. Conspicuously lacking are exterior fortifications to protect the complex. Given their strength at sea, the Minoans may have had little fear of invasion.

As well-preserved as it appears, the present complex is a little deceptive: Evans reconceived and reconstructed much of it in concrete when he worked there between 1900 and 1932 (see *The Art Historian's Lens*, page 87). The original builders at Knossos framed the walls with timbers and constructed them out of rubble masonry or mud brick. Some they built of **ashlar masonry** (cut and dressed stone), which gave them a more ornamental appearance. Columns, often made of wood with a stone base, supported the porticoes. Their form was unusual: A smooth shaft tapered downward from a generous cushionlike capital. Often the shaft was oval in cross section rather than round. Wall paintings suggest that capitals were painted black and the shaft red or white. The origin of this type of column remains a mystery.

At first glance, the plan of the complex (see fig. 4.4) may appear confusing and haphazard. This probably explains why later Greek legend referred to it as the labyrinth, home of the Minotaur, a half-human, half-bull creature who devoured the youths the Athenians offered him in tribute, and whom the hero Theseus killed after penetrating the maze. Coupled with the natural defenses of the island's geography, this mazelike arrangement of rooms, and a general lack of emphasis on entrances, may have been part of a moderate internal defensive strategy. The small size of the rooms and the careful control of the sun's penetration into living spaces through light wells may also have been deliberate decisions to keep the buildings cool in hot weather.

Moreover, the design does have an underlying logic. At its core is a large central court, onto which important rooms opened. The court divides the plan on an approximately north-south axis. On the west, a corridor running north-south separates long, narrow storerooms from rooms of less uniform shapes close to the court; the latter rooms may have performed a ceremonial role. An east-west corridor divides the east wing into (perhaps) a workshop area on the north side, and grander halls on the south. The complex appears to grow outward from the court, and using flat (rather than pitched) roofs would have greatly facilitated the building of additional structures. Compared to Assyrian and Persian palaces, such as the citadel of Sargon II at Dur Sharrukin (fig. 2.17) or the palace of Darius and Xerxes at Persepolis (fig. 2.26), the overall effect at Knossos is modest; individual units are relatively small and the ceilings low. Still, the rich decoration of some of the interior walls made for a set of elegant spaces. We should also remember that much of what remains belongs to subterranean or ground-floor levels, and archaeologists have long believed that grander rooms existed on a lost upper level.

Exactly how the grand structures of Crete functioned, and who lived in them, is still a subject of debate. As noted above, Arthur Evans described the complex at Knossos as a "palace" when he first excavated it (assigning royal names to various

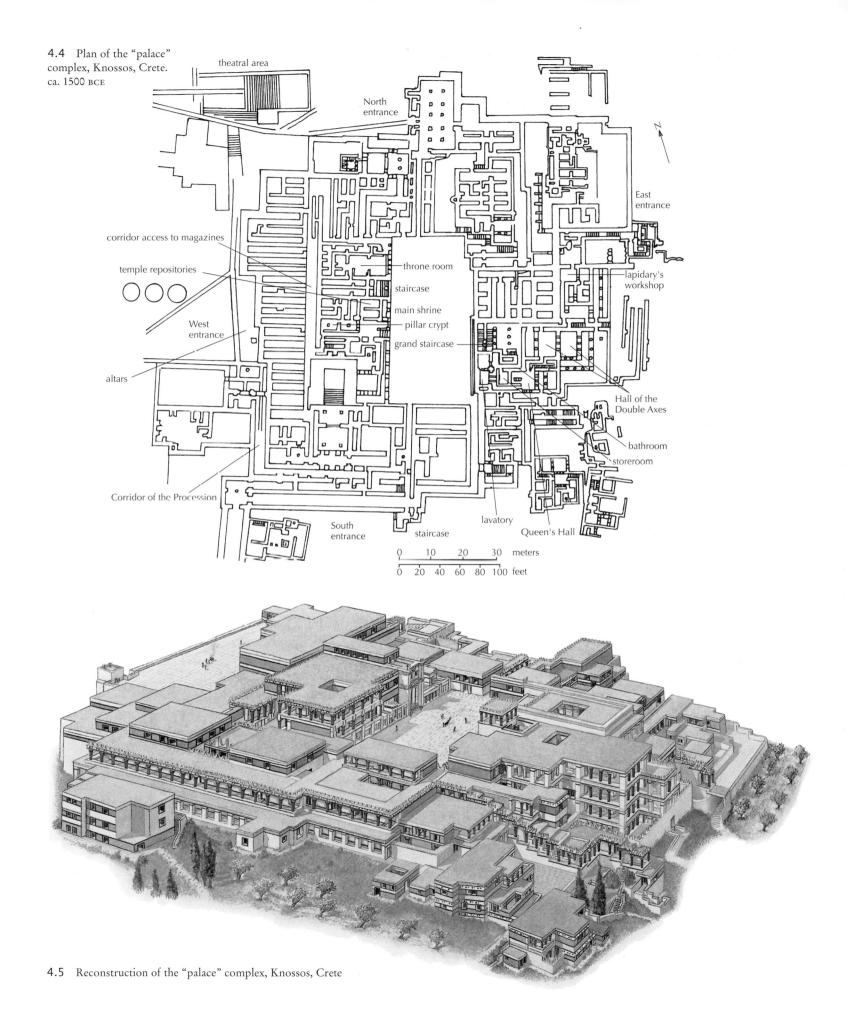

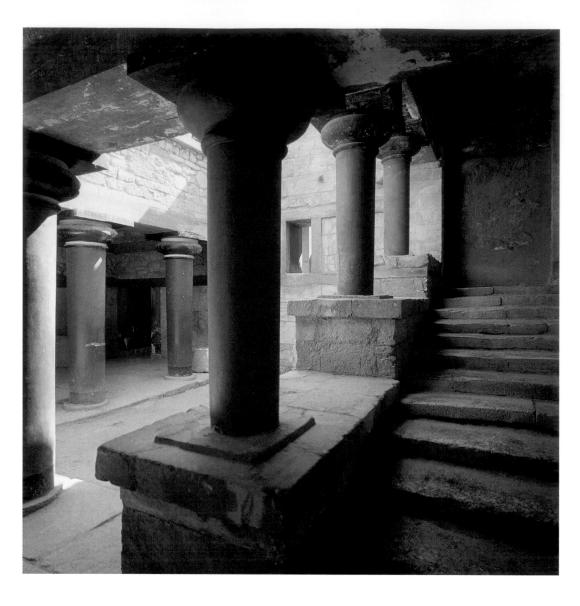

4.6 Staircase, east wing, "palace" complex, Knossos, Crete

rooms), and the term stuck, regardless of its accuracy. Evans conceived of the complex as a palace or an elite residence for several reasons. He was reacting partly to recent discoveries on the Mycenaean mainland, described below, and partly to the presence of a grand room with a throne. But the social and political realities of Evans's own homeland may have been even more influential in his thinking: He would have been familiar with the large palaces that the extended royal family occupied in late Victorian England. In fact, excavation of the complex at Knossos suggests that a variety of activities went on there. Extensive storage areas support a hypothesis that the palace was a center of manufacturing, administration, and commerce. Additionally, some spaces that seem ceremonial, such as the great court with its triangular raised causeway, and small shrine-like rooms with apparently religious paraphernalia, suggest that political and sacred activities occurred there too. There is no reason to believe that the Minoans segregated these activities as neatly as we often do today. Moreover, there is no evidence to suggest that the functions of the various complexes, at Knossos and elsewhere, were identical, or that they remained constant over time.

Wall Paintings: Representing Rituals and Nature

Grand rooms within the complexes at Knossos and elsewhere were decorated with paintings. Archaeologists found most of them in extremely fragmentary condition, so that what we see today is the result of extensive restoration, which may not always be entirely reliable. Vibrant mineral colors characterize the frescoes, applied to wet or dry plaster in broad washes without shading, in a technique known as buon fresco; wide bands of geometric patterns serve as elaborate frames. The prevalent subjects of paintings at Knossos go a long way toward supporting a hypothesis of ritual activity there. For instance, a miniature Second Palace period painting, dating to around 1500 BCE, depicts a crowd of spectators attending an event—a ritual or a game perhaps (fig. 4.7). Art historians know it as the Grandstand Fresco. A tripartite building features at the center, which scholars identify as a shrine because of the stylized bulls' horns on its roof and in front of its façade. On either side sit two groups of animated women, bare-breasted and dressed in flounced skirts. Above and

Two Excavators, Legend, and Archaeology

n the mid-nineteenth century, most scholars believed that Homer's epic tales of the Trojan War and its aftermath, The Iliad and The Odyssey, were merely the stuff of legend. But just a few decades later, that view had radically changed. Two extraordinary men were key figures in bringing about that change. One of them was Heinrich Schliemann (1822-1890). The German-born son of a minister, Schliemann became wealthy through a succession of business ventures and retired at the age of 41. From a young age, he had been fascinated by Homer's world of gods and heroes, vowing to learn ancient Greek (one of about 15 languages he would eventually master). He became convinced that a historical framework supported Homer's poetry, and during his extensive travels, he learned that a handful of archaeologists believed the Turkish site of Hissarlik to be the site of Homer's Troy. After gaining permission from the Turkish government to excavate there, he began working officially in 1871. Among the spectacular finds he described in print was "Priam's Treasure," a hoard of vessels, jewelry, and weapons made of precious metals, which he named after Homer's king of Troy. Then, turning his attention to Mycenae, Schliemann discovered the shaft graves of Circle A, some of which contained magnificent objects, such as the gold mask in figure 4.27.

Schliemann was also intrigued by the site of Knossos on Crete, but he was unable to purchase the land. The opportunity fell instead to Arthur Evans (1851–1941), the son of a renowned British naturalist, and himself Keeper of the Ashmolean Museum in Oxford. By 1900, he had begun excavating the so-called Palace of Minos at Knossos with extraordinary results. In 1911, in recognition of his contribution to the field of archaeology, Evans received a knighthood.

Until recently, scholars judged these two early archaeologists very differently. They deemed Schliemann's excavation technique destructive and considered Schliemann himself little more than a treasure hunter. Some scholars questioned whether he actually discovered "Priam's Treasure" as a hoard, or whether he assembled sporadic finds to make more of a news splash. Tales of his excavations have been embellished into myth in their own right. By some accounts, Schliemann had his Greek wife, Sofia, model ancient jewelry. Of late, scholars have recognized the unfairness of assessing Schliemann by modern scientific standards, and they have acknowledged his critical role in igniting scholarly and popular interest in the pre-Hellenic world.

Evans's reputation has fared better than Schliemann's, largely because of his close attention to stratigraphy, that is, using layers of deposit in excavations to gauge relative time. Geologists had developed this technique in the seventeenth and eighteenth centuries and archaeologists still use it today in a refined form. Evans employed it to assess the relative positions of walls and other features, and it led him to establish a relative chronology for the entire site. His designations of Early, Middle, and Late Minoan periods defined an essential historical framework for the Aegean world as a whole in the Bronze Age. Evans's work at Knossos included a considerable amount of reconstruction. His interventions help to make the site comprehensible to laypeople, but can also mislead an unknowing viewer. In fact, it was Evans, not the Minoans, who built much of what a visitor now sees at Knossos. One significant consequence of Evans's restorations at Knossos is that they have kindled debate among conservators about how much to restore and how to differentiate visually between ancient ruin and modern reconstruction.

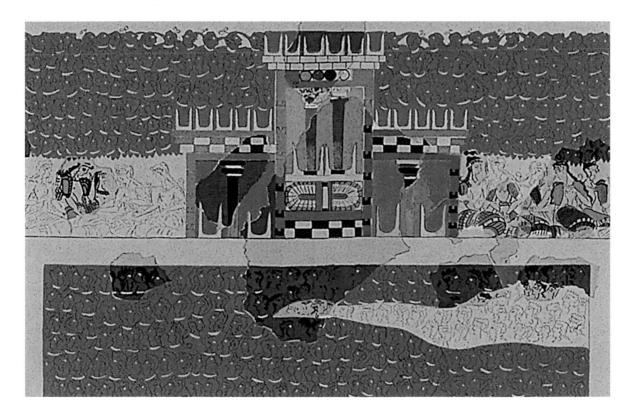

4.7 Grandstand Fresco, from Knossos, Crete. ca. 1500 BCE. Archaeological Museum, Iráklion, Crete

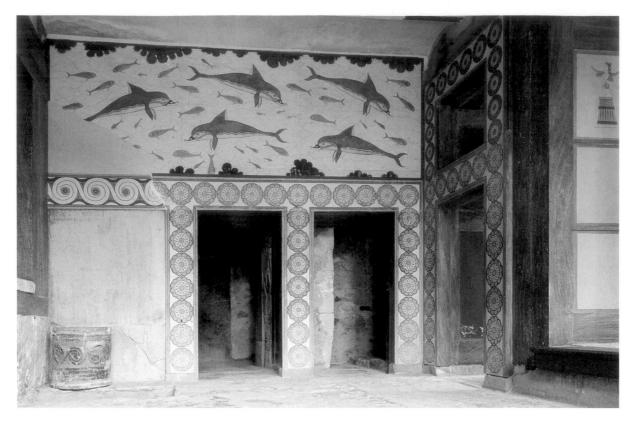

4.8 The "Queen's Megaron," from Knossos, Crete. ca. 1700–1300 BCE. Archaeological Museum, Iráklion, Crete

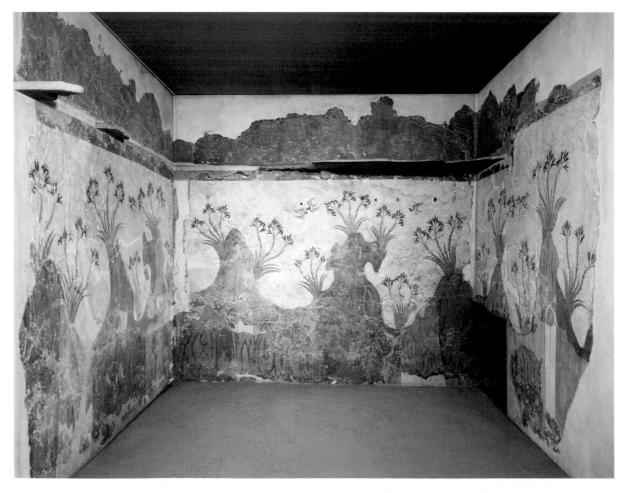

4.9 Spring Fresco, from Akrotiri, Thera. ca. 1600–1500 BCE. National Archaeological Museum, Athens

below, the painter used countless disembodied heads as a short-hand technique to denote the crowd, rendered with simple, impressionistic black strokes, on a swath of brown for males and white for females. The crowd figures are smaller in scale than the central women, suggesting that they are of lesser importance. The fresco may represent an event that took place in the palace's central court, as archaeologists have unearthed remains of a tripartite room on the west side of the court.

In many other Minoan paintings, nature is the primary subject. A painting found in fragments in a light well has been restored to a wall in the room Evans called the "Queen's Megaron" in Knossos' east wing (fig. 4.8), though some have contended that it actually belongs on the floor. Blue and yellow dolphins swim against a blue-streaked cream background, cavorting with small fish. Within the upper and lower frames, multilobed green forms represent plants and rocks. Sinuous outlines suggest the creatures' forms, while the curving, organic elements throughout the composition animate the painting. Such lively representations of nature occur frequently in Minoan art in a variety of mediums, and the many images of sea creatures probably reflect the Minoans' keen awareness of and respect for the sea. The casual quality of Minoan images contrasts forcefully with the rigidity and timelessness of many Egyptian representations, even though there is good evidence for contact between Minoan artists and Egypt.

PAINTED LANDSCAPES IN A SEASIDE TOWN In the mid-second millennium BCE, a volcano erupted on the Cycladic island of Thera (present-day Santorini), about 60 miles (96 km) north of Crete. The eruption covered the town of Akrotiri in a deep layer of volcanic ash and pumice. Beginning in 1967, excavations directed by Spyridon Marinatos and then Christos Doumas uncovered houses dating from the Middle Minoan III phase (approximately 1670–1620 BCE) preserved up to a height of two stories. On their walls was an extraordinary series of paintings.

Landscapes dominate. In a small ground-floor room, a rocky landscape known as the *Spring Fresco* occupies almost the entire wall surface (fig. **4.9**). The craggy terrain undulates dramatically, its dark outline filled with rich washes of red, blue, and ocher—colors that were probably present in the island's volcanic soils—with swirling black lines to add texture within. Sprouting from its surface, lilies flower in vivid red trios, while swallows dart between them, painted in a few graceful black lines.

In other rooms at Akrotiri, painters inserted humans into the landscape. Often they are life-size, but sometimes smaller, as in a painting on the upper section of at least three walls in a large second-floor room (fig. 4.10). The scene reflects the town's role as a harbor: A fleet of ships ferries passengers between islands, set within a sea full of leaping dolphins. The ships vary, some being under sail and some rowed by oarsmen, but the painter's brush describes them all carefully. The same is true of the islands, each of which features a port city with detailed stone architecture. Crowds of people watch the spectacle from streets, rooftops, and windows. The painting may represent an actual event—a memorable expedition to a foreign land, perhaps, or an annual festival.

Minoan Pottery

Like the wall paintings, Minoan painted pottery was inspired by the natural world of the Aegean. Minoan potters painted their vessels sensitively with lively organic forms that enhance the curving shapes of the vases. By the Middle and Late Minoan periods, they manufactured pottery on the wheel, allowing for a variety of rounded forms and many sizes. Minoans used large and rough vessels for storage, while inhabitants of the "palaces" used the finest wares, which were often very thin-walled. Minoans also exported these "eggshell" ceramics in great quantities to markets all around the Mediterranean, creating one of the first major international industries.

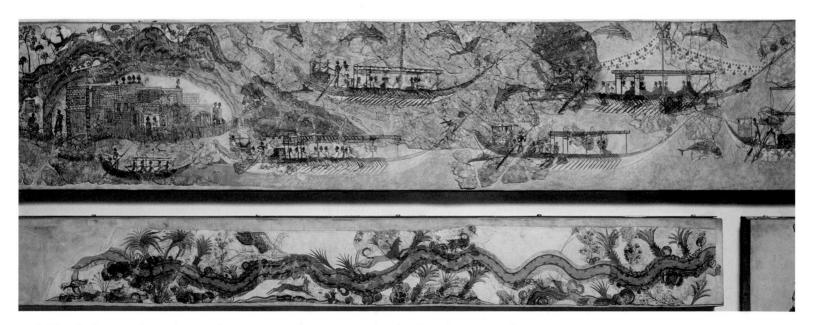

4.10 Flotilla Fresco, from Akrotiri, Thera. ca. 1600-1500 BCE. National Archaeological Museum, Athens

KAMARES WARE The shape of a vase from Phaistos in southern Crete, dating to the Middle Minoan II period (about 1800 BCE), illustrates the organic approach of many Minoan potters to their wares (fig. 4.11). Its neck curves upward into a beak shape, which the vase painter has emphasized by giving it an eye. Bold curvilinear forms in white, red, orange, and yellow stand out against a black background to form abstracted sea horses, which endow the vessel with life and movement. This style, known today as Kamares ware, first appears at the beginning of the Middle Minoan phase and took its name from the cave on Mount Ida where it originally came to light.

MARINE MOTIFS Marine motifs gained prevalence in the pottery of the slightly more recent Late Minoan IB phase. A stirrup jar, with two round handles flanking its narrow spout, makes a vivid example of this "marine style." A wide-eyed black octopus swirls its tentacles around the body, contrasting with the light eggshell-colored clay (fig. 4.12). Clumps of algae float between the tentacles. As with Minoan wall paintings, an extraordinarily dynamic and naturalistic quality energizes the painting. Moreover, the painting's forms express the shape of the vessel they decorate: The sea creature's rounded contours emphasize the jar's swollen belly, while the curves of its tentacles echo the curved

4.11 Beaked jug (Kamares ware), from Phaistos. ca. 1800 BCE. Height 105/8" (27 cm). Archaeological Museum, Iráklion, Crete

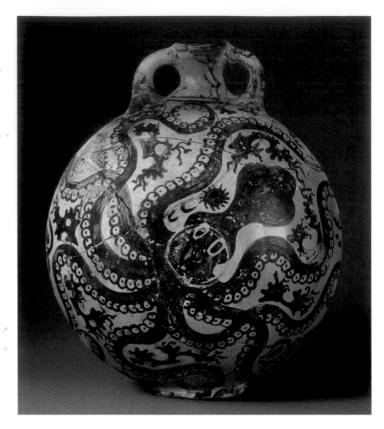

4.12 Octopus Vase, from Palaikastro, Crete. ca. 1500 BCE. Height 11" (28 cm). Archaeological Museum, Iráklion, Crete

handles. Exactly beneath the spout, the end of a tentacle curls to define a circle of the same size as the jar's opening.

Carved Minoan Stone Vessels

From an early date, Minoan artists also crafted vessels of soft stone, either from black steatite (soapstone), which was locally available, or from stones imported from other Aegean islands. They carved it with tools of a harder stone, hollowing out the interior with a bow-driven drill before finishing surfaces with an abrasive, probably emery. Traces of gold on some pieces reveal that the stone was often gilded. Fragments of such works were discovered at Hagia Triada on the southern side of Crete, including a black steatite vessel known as the *Harvester Vase*, with a large hole at the top and a smaller hole at the base (fig. **4.13**). This type of vessel was used for pouring liquid offerings or drinking. Later Greeks called it a rhyton (plural rhyta), and archaeologists suppose that, like many stone vessels, it had a ceremonial use.

Only the upper part of the rhyton survives. Twenty-seven slim, muscular men, mostly nude to the waist and clad in flat caps and pants, seem to move around the vessel in a lively rhythm and with raucous energy. Their dynamic movement is a counterpart to the animated imagery on Minoan pots and wall paintings. Hoisting long-handled tools over their shoulders, four bare-headed singers bellow with all their might. Their leader's chest is so distended that his ribs press through his skin. A single long-haired

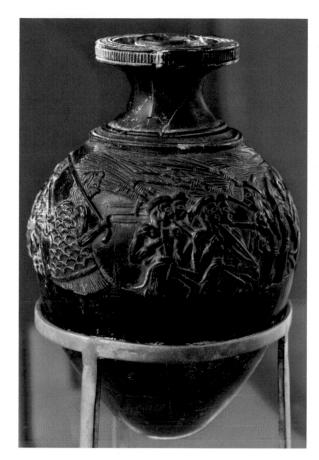

4.13 Harvester Vase, from Hagia Triada. ca. 1500–1450 BCE. Steatite (soapstone), width 4½" (11.3 cm). Archaeological Museum, Iráklion, Crete

male in a scaly cloak, holding a staff, seems to head the procession. The leader of the singers holds a sistrum, a rattle that originated in Egypt. This detail and the composite depiction of the men's bodies provide evidence of contact between Crete and Egypt.

Interpretations of the scene depend partly on identifying the tools carried by the crowd and the objects suspended from their belts. If they are hoes and bags of seed corn, then the subject may be a sowing festival; if, instead, they are winnowing forks and whetstones, it is more likely a harvest festival. Alternatively, some see the scene as a warriors' triumph, while still others see a representation of forced labor. In the absence of further evidence, either archaeological or written, debate about the meaning of the image will certainly continue.

Another magnificent rhyton in the shape of a bull's head comes from Knossos, and dates to the Second Palace period (about 1500–1450 BCE) (fig. 4.14). Like the *Harvester Vase*, it is carved from steatite, with white shell inlaid around the muzzle. For the eyes, the artist inserted a piece of rock crystal, painted on the underside with a red pupil, black iris, and white cornea, so that it has a startlingly lifelike appearance. The horns, now restored, were once of gilded wood. Light incisions in the steatite, dusted with white powder, evoke a shaggy texture and variegated color in the animal's fur. The vessel was filled through a hole in the neck, and a second hole below the mouth served as a spout.

Excavators have discovered similar vessels elsewhere in Crete, for instance at the palace at Zakros, on the east coast of Crete, and contemporaneous Egyptian tomb paintings depict Cretans carrying bull-headed rhyta, suggesting that the civilizations with which Minoans traded identified them with these distinctive vessels. The prevalence of the bull motif, coupled with evidence of altars decorated with horns, suggest that bulls played a part in Minoan religious ritual. Rhyta are often found smashed to pieces. Although later vandalism or earthquakes might account for the damage, their smashed state suggests that ceremonial vessels were ritually destroyed after use.

Religious life on Minoan Crete centered on shrines and on natural places deemed sacred, such as caves, mountain peaks, or groves. No temples or large cult statues have been discovered. Archaeologists did find two small-scale faience statuettes from

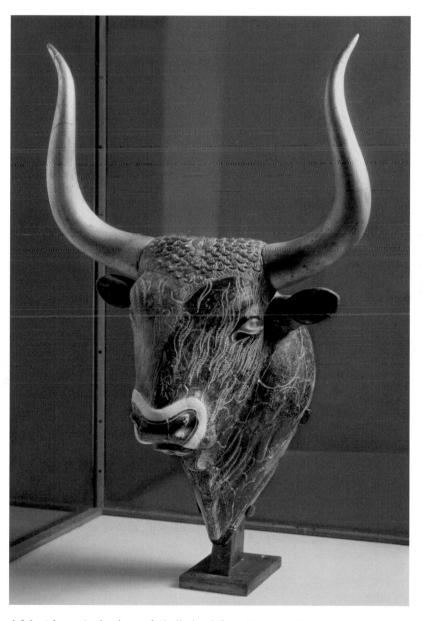

4.14 Rhyton in the shape of a bull's head, from Knossos, Crete. ca. 1500–1450 BCE. Serpentine, steatite, crystal, and shell inlay (horns restored), height 81/8" (20.6 cm). Archaeological Museum, Iráklion, Crete

91

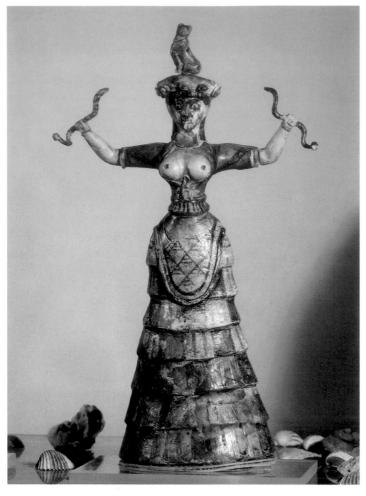

4.15 Snake Goddess, from the palace complex, Knossos, Crete. ca. 1650 BCE. Faience, height 115/8" (29.5 cm). Archaeological Museum, Iráklion, Crete

the Middle Minoan III phase (about 1650 BCE) at Knossos. One shows a female figure raising a snake in each hand and wearing a headdress topped by a feline creature (fig. 4.15). She is clad in a flounced skirt similar to those worn by women in the *Grandstand Fresco* (see fig. 4.7), and bares her breasts. Her tiny waist is another consistent feature of Minoan representations of humans, like the men on the *Harvester Vase* (see fig. 4.13). These statuettes came to light along with remnants of furniture in pits sunk in the floor of a room on the west side of the central court. Because some ancient religions associated snakes with earth deities and male fertility, and because of this statuette's bared breasts, some scholars have associated them with a mother goddess or ritual attendants, and identified the room as a shrine.

Late Minoan Art

It is unclear what brought Minoan civilization to an end. In the past, scholars argued that the eruption of the volcano on the island of Thera may have hastened its decline. Recent discoveries and dating of the volcanic ash from the eruption, however, indicate that the civilization on Crete survived this natural disaster, though perhaps in a weakened state. About 1450 BCE (Late Minoan II), invaders from the Greek mainland, whom archaeologists call Mycenaeans, took over the complexes on Crete. They established themselves in the center at Knossos until around 1375 BCE, when Knossos was destroyed and the Mycenaeans abandoned most of the island's sites. During the period of Mycenaean control, however, artists at Knossos worked in Minoan styles.

The fragmentary *Toreador Fresco* dates from the Mycenaean occupation of Knossos (Late Minoan II-IIIA), and appears to

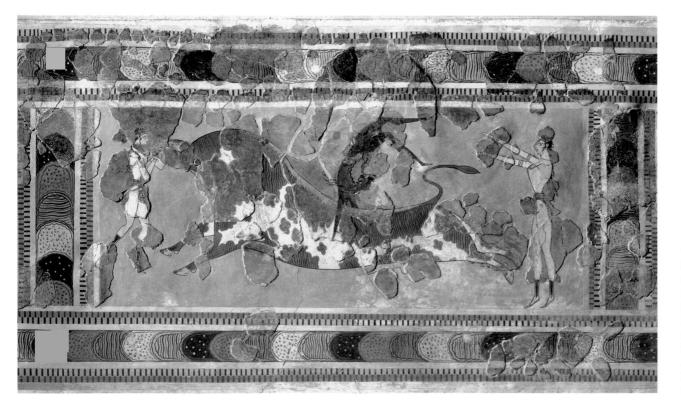

4.16 Toreador Fresco, from the palace complex, Knossos, Crete. ca. 1550–1450 BCE (restored). Fresco. Height including upper border approx. 24½" (62.3 cm). Archaeological Museum, Iráklion, Crete

have been one of a series that decorated an upper room in the northeast part of the palace (fig. 4.16). Against a deep-blue background, a white-skinned figure clad in a kilt clasps the horns of a huge curvaceous bull, painted at a full gallop. Behind the bull, a similar white-skinned figure stands on tiptoe with arms outstretched, while above the bull's back, a dark-skinned figure performs a backward somersault. The figures have long limbs and small waists, and they are painted in profile. The strong washes of color, and animated though somewhat stylized poses, demonstrate the continuity of Minoan practice into the Late period.

Scholars continue to debate the meaning of this scene. Although most agree that such bull-leaping performances had a ritual function, the purpose of the activity and the identity of the participants remain unclear. Following the widespread Mediterranean convention for distinguishing gender by skin tone, Arthur Evans identified the light-skinned figures as female and the darker one as male. In this case, the presence of women in such a prominent role in Minoan imagery may serve as evidence of their importance in ritual activities. Others have seen the three figures as sequential representations of the same person, taking part in a coming-of-age initiation ceremony in which boys cast off their earlier "feminine" guise and emerge as fully masculine.

MYCENAEAN ART

By the time the Mycenaeans conquered Crete in about 1450 BCE, they had been building cities of their own on the Greek mainland since the start of the Late Helladic period, ca. 1600 BCE. They

probably made early contact with Minoan Crete, which exerted important influences on their own culture. From the dating of Mycenaean sites and the objects discovered in them, archaeologists place the height of the culture between about 1500 and 1200 BCE (Late Helladic III). The most imposing remains are the citadels at sites that Homer named: Mycenae, Pylos, and Tiryns. The culture takes its name from the first of these, the legendary home of King Agamemnon, who led the Greek forces in Homer's account of the Trojan War.

Architecture: Citadels

At the beginning of the Second Palace period on Crete, growing settlements throughout the Greek mainland, including at Mycenae itself (figs. 4.17 and 4.18), centered around large structures known as citadels (when fortified) or palaces. In some of them, most particularly Pylos on the southern coast of the

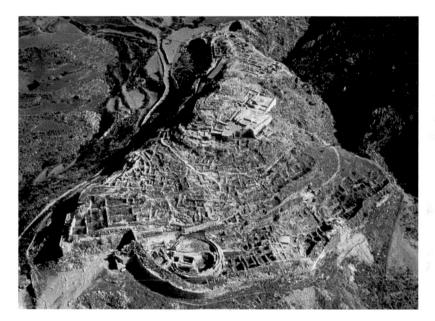

4.17 Aerial view of Mycenae, Greece. ca. 1600–1200 BCE

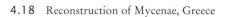

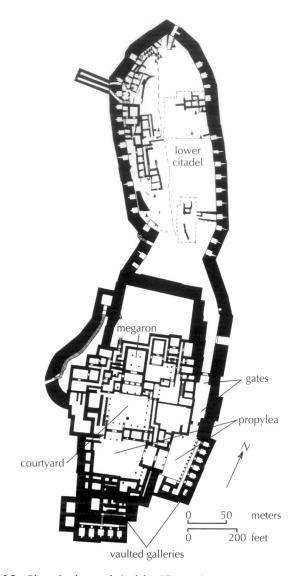

4.19 Plan of palace and citadel at Tiryns, Greece. ca. 1400-1200 BCE

Peloponnesian region (see map 4.1), archaeologists found clay tablets inscribed with a second early writing system, which they dubbed Linear B because of its linear character and because it derived, in part, from earlier Minoan Linear A. Architect and classical scholar Michael Ventris decoded the system in 1952. The tablets proved to have been inventories and archival documents, and the language of Linear B was an early form of Greek. The inhabitants of these Late Bronze Age sites, therefore, were the precursors of the Greeks of more recent times.

The Linear B tablets refer to a *wanax* ("lord" or "king"), suggesting something of a Mycenaean social order, so it is reasonable to suppose that Mycenaean citadels and palaces may have incorporated royal residences. The inhabitants of many of these sites gradually enclosed them with imposing exterior walls. They exploited the sites' topography for defense purposes, and often expanded and improved their walls in several building phases. They constructed these fortifications of large stone blocks laid on top of each other, creating walls that were at times 20 feet thick. These walls, and tunnels leading from them to wells that would

provide water during a siege, have led scholars to regard the Mycenaeans as quite different from the Minoans, with a culture focused primarily on warfare. The contrast is often stated in terms that imply an essential character difference between nature-loving Minoans and warmongering Mycenaeans. Homer's characterizations of the kings of this era and, in fact, his entire narrative of the Trojan War, only reinforce modern ideas about the Mycenaeans as warlike. The poet describes the city of Tiryns, set on a rocky outcropping in the plain of Argos in the northeastern Peloponnesus, as "Tiryns of the Great Walls." We should note, however, that Mycenaean fortifications date to after the destruction of Minoan centers, so the Mycenaeans may have been responding to a new set of political and social circumstances.

The inhabitants at Tiryns fortified their citadel in several stages around 1365 BCE (fig. 4.19). Like the slightly later walls at Mycenae, those at Tiryns consist of massive blocks of limestone, weighing as much as 5 tons. For most of the wall, the blocks were irregularly shaped (or polygonal), wedged together with smaller stones and fragments of pottery. At entrances or other highly visible places, the stones might be saw-cut and dressed, or smoothed with a hammer. In its final form, the outer wall at Tiryns was a full 20 feet thick, and a second inner wall was just as impressive. Centuries later, the massiveness of these walls so awed the Greeks that they declared them the work of the Cyclopes, a mythical race of one-eyed giants. Even today, archaeologists term such walls "Cyclopean."

Builders designed the fortifications at Tiryns carefully to manipulate any visitor's approach to the residents' military advantage, just as the slightly earlier Hittite fortifications did (see fig. 2.22). A narrow fortified ramp circled the walls, so that an aggressor approaching in a clockwise direction would have his nonshield-bearing side vulnerable to attack by defenders on the walls. If an aggressor reached the entrance, two sets of fortified propylons (gateways) presented further obstacles: Inhabitants could trap the aggressor between the propylons and attack from above. Within the walls, rooms and passages known as casemates provided storage for weapons (fig. 4.20). They also offered safety for townspeople or soldiers during an assault. The gallery passage was built using a corbel technique: Each course of masonry projects slightly beyond the course below it, until the walls meet in an irregular arch to cover the span (fig. 4.21). When a corbel roofs an entire space, as it does here, it is called a corbel vault.

A corbel arch served effectively to create the Lioness Gate at Mycenae of about 1250 BCE. When the inhabitants enlarged the city walls to improve its defenses, they built this gate as a principal entrance into the citadel (fig. 4.22). Two massive stone posts support a huge lintel to form the opening. Above the lintel, a corbel arch directs the weight of the heavy wall to the strong posts below it. The corbel thus relieves the weight resting on the vast stone lintel, which itself weighs 25 tons; this form of construction is known as a relieving triangle. To seal the resulting gap, the builders inserted a triangular gray limestone slab above the lintel, carved with a huge pair of animals, probably lionesses. They stand in a heraldic pose (as mirror images of each other), with their

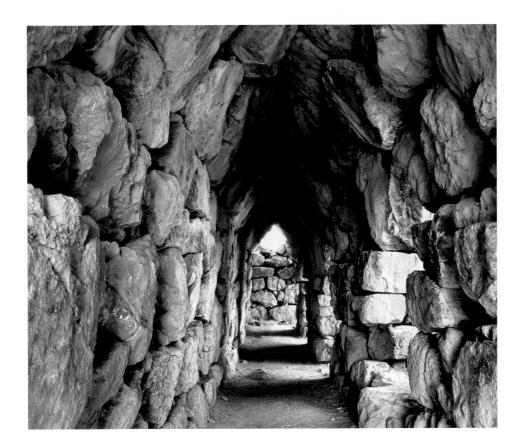

4.20 Corbeled casemate at Tiryns, Greece. ca. 1400–1200 BCE

4.21 Drawing: corbel arch

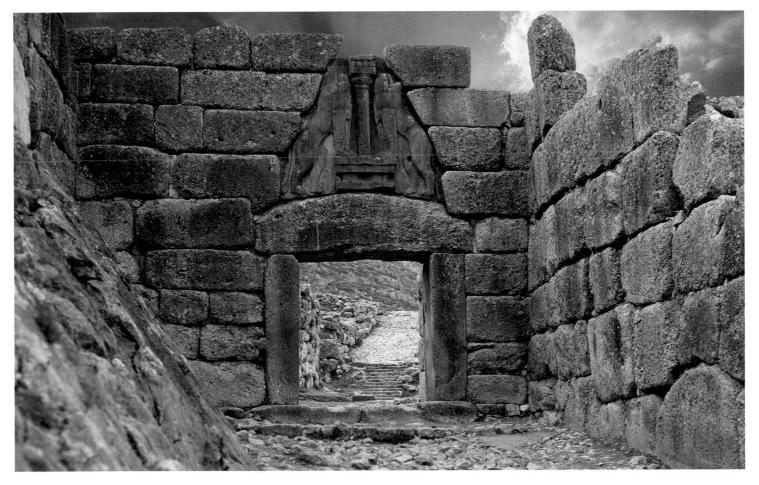

4.22 The Lioness Gate, Mycenae, Greece. ca. 1250 BCE

front paws on a pair of altars of a Minoan type, and flanking a tapering Minoan-style column, which may have supported another element of some kind. Dowel holes in their necks suggest that their heads were added separately, in wood or a different stone. At almost 10 feet high, this relief is the first large-scale sculpture known on the Greek mainland. The lionesses function as guardians, and their tense, muscular bodies and symmetrical design suggest an influence from the Near East. Mycenaeans ventured all over the Mediterranean, including Egypt and Anatolia, and Hittite records suggest contact with a people who may have been Mycenaean. Similar structures such as the Hittite Lion Gate at Bogazköy in Anatolia (fig. 2.22) may have suggested the concept of animal guardians at the gate of a palace.

The fortifications of Mycenaean citadels protected a variety of buildings (see figs. 4.17 and 4.18). These interior structures were built of rubble in a timber framework, as in Minoan palaces, sometimes faced with limestone. The dominant building was a megaron, a large rectangular audience hall. At Tiryns (see fig. 4.19) the megaron lay adjacent to an open courtyard. Two columns defined a deep porch that led into a vestibule and then into the hall. The hall contained a throne and a large central hearth of stuccoed clay, surrounded by four columns supporting the roof beams. Above the hearth, the ceiling may have been left open to the sky or covered by a raised roof, allowing smoke to escape and light to enter.

The design of a megaron is essentially an enlarged version of simple houses of earlier generations; its ancestry goes back at least to Troy in 3000 BCE. A particularly well-preserved example survives at the southern Peloponnesian palace of Pylos of about 1300 BCE. There, the hearth is set into a plastered floor decorated to resemble flagstones of varied ornamental stone (fig. 4.23). A rich decorative scheme of wall paintings and ornamental carvings enhanced the megaron's appearance. The throne stands against the northeast wall, and painted griffins flank it on either side, similar

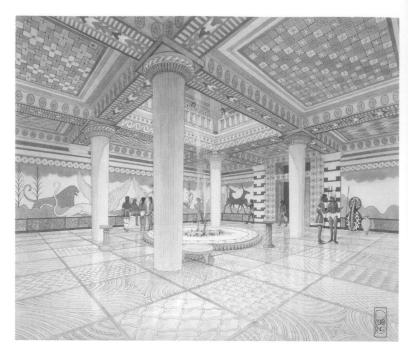

4.23 Reconstruction of megaron at Pylos. ca. 1300–1200 BCE

to those decorating the throne room at Knossos, elaborated under Mycenaean rule. Other elements of the decoration, such as the shape of the columns and the ornament around the doorways, reveal further Minoan influence at Pylos.

Mycenaean Tombs and Their Contents

At the end of the Middle Helladic period at Mycenae, ca. 1600 BCE, the ruling elite began to bury their dead in deep rectangular shafts, marking them at ground level with stones shaped like stelai. The burials were distributed in two groups (known as

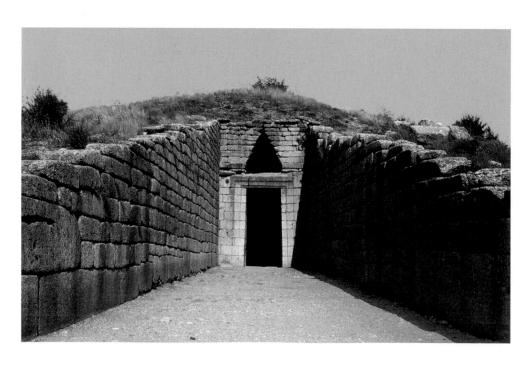

4.24 "Treasury of Atreus," Mycenae, Greece. ca. 1300–1250 BCE

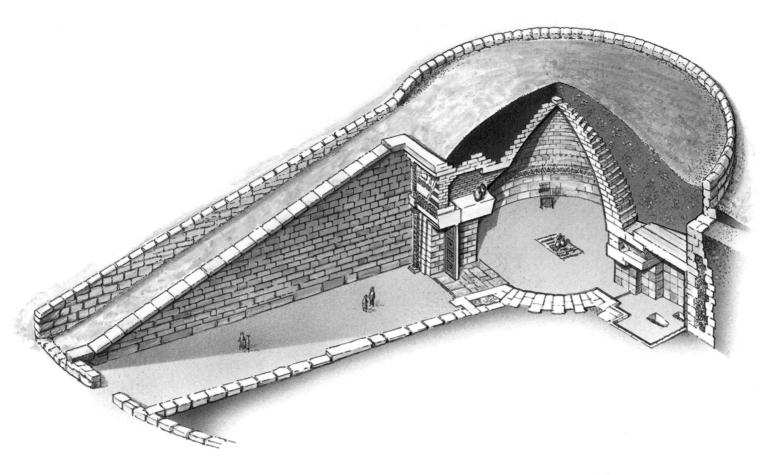

4.25 Reconstruction of "Treasury of Atreus," Mycenae, Greece

Grave Circles A and B), which later generations eventually set off and monumentalized with a low circular wall. As time passed, the elite built more dramatic tombs, in a round form known as a tholos. Over 100 tholoi are known on the mainland, nine of them near Mycenae.

One of the best-preserved and largest of these tombs is at Mycenae. Dubbed the "Treasury of Atreus" after the head of the clan that Homer placed at Mycenae, it dates to about 1250 BCE (Late Helladic III B). A great pathway, or **dromos**, lined with carefully cut and fitted ashlar masonry, led to a spectacular entrance (figs. **4.24** and **4.25**). The door slopes inward, in a style associated with Egyptian construction. Flanking the opening were columns of Egyptian green marble, carved with spirals and zigzags. Above the doorway, small columns framed decorative marble bands that concealed a relieving triangle.

The tomb itself consisted of a large circular chamber dug into sloping ground and then built up from ground level with a corbel vault: Courses of ashlar blocks protruded inward beyond one another up to a capstone (fig. 4.26). When built in rings rather than parallel walls (as at Tiryns, see fig. 4.20), the corbel vault

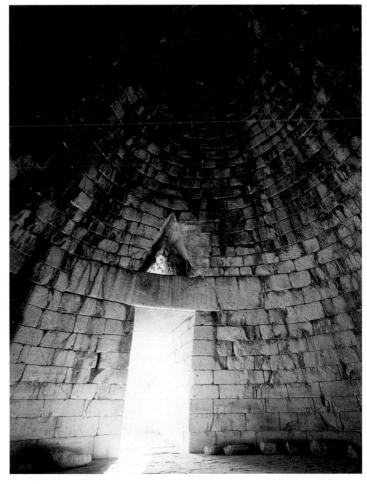

4.26 Interior of "Treasury of Atreus," Mycenae, Greece

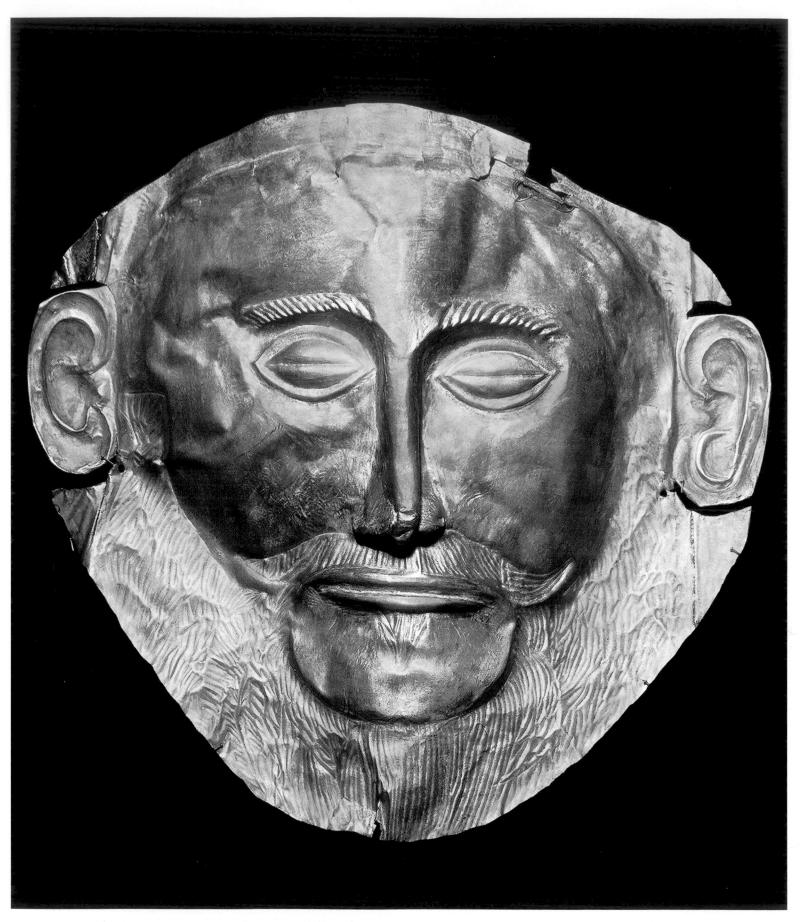

4.27 *Mask of Agamemnon*, from shaft grave, Grave Circle A, Mycenae, Greece. ca. 1600–1500 BCE. Gold, height 12" (35 cm). National Archaeological Museum, Athens

4.28 Inlaid dagger blade, from shaft grave IV, Grave Circle A, Mycenae, Greece. ca. 1600–1550 BCE. Length 93/8" (23.8 cm). National Archaeological Museum, Athens

results in a beehive profile for the roof. Gilded rosettes may once have decorated the ashlar blocks of the vault to resemble a starry sky. The vault rose 43 feet over a space 48 feet in diameter. Architects would not dare such a large unsupported span again until the Pantheon of Roman times (see Chapter 7). To one side of the main room, a small rectangular chamber contained subsidiary burials. Earth covered the entire structure, helping to stabilize the layers of stone and creating a small hill, which was encircled with stones.

METALWORK Like the Great Pyramids of Egypt, these monumental tholos tombs exalted the dead by drawing attention to themselves. As a result, they also attracted robbers throughout the ages, and the grave goods that once filled them have long been dispersed. Many of the earlier shaft graves also contained lavish burial goods, ranging from luxurious clothing and furniture to fine weaponry. On excavating Grave Circle A, Heinrich Schliemann discovered five extraordinary death masks of hammered gold, covering the faces of dead males. Although far from naturalistic, each mask displays a distinct treatment of physiognomy: Some faces are bearded while others are clean-shaven. This suggests that the goldsmiths individualized the masks somewhat to correspond to the deceased's appearance. On finding one of them in 1876 (fig. 4.27), Schliemann telegraphed a Greek newspaper, "I have gazed on the face of Agamemnon." Since modern archaeology places the mask between 1600 and 1500 BCE, and the Trojan War—if it happened—would date to about 1300–1200 BCE, this could not in fact be a mask of Agamemnon, despite its title. But it may represent a Mycenaean king of some stature, given the expense of the materials and the other objects found near it. Among the weapons in the graves were finely made ornamental bronze dagger blades, some of them inlaid with spirals or figural scenes in gold, silver, and niello (a sulfur alloy that bonds with silver when heated to produce a shiny black metallic finish). The example in figure 4.28 depicts a lion preying on gazelles; the dagger's owner claims the lion's predatory strength.

THE VAPHIO CUPS While the burial method used in the shaft graves is distinctively Mycenaean, the treasures found within them raise an interesting question about the interactions between Minoans and Mycenaeans. Many objects show Minoan influence, while others appear so Minoan that they must have come from Crete or been created by Cretan craftsmen. Two gold cups from a Mycenaean tomb at Vaphio near Sparta, in the southern Peloponnesus, are particularly intriguing (fig. 4.29). Probably crafted between 1500 and 1450 BCE, they are made of two skins of gold: The outer layer was embossed with scenes of bullcatching—a theme with Minoan roots—while the inner lining is smooth. A cylindrical handle was riveted to one side. On one cup, bull-trappers try to capture the animal with nets, while on the other, a cow is set out to pasture to entice a bull into captivity. The subject matter of the cups suggests that they refer to one another, yet they are not, strictly speaking, a pair. One cup has an upper border framing the scene, but the other does not, and stylistic analyses suggest that different artists crafted them. Where the cups or the artists originated is a matter for debate. For some, the "finer" cup (with the pasture scene) must be Minoan on account of its peaceful quality, and the other a more violent Mycenaean complement made by a Mycenaean—or a Minoan—artist. What the cups underline is how little we understand about the interplay between, and the movements of, Minoan and Mycenaean artists, and, indeed, how arbitrary and subjective our attempts to distinguish between them may be.

Sculpture

Mycenaean religious architecture apparently consisted of modest structures set apart from the palaces. At these small shrines, Mycenaeans worshiped a wide variety of gods. Names recorded on Linear B tablets indicate that some of them, such as Poseidon, are the predecessors of the later Olympian gods of Greece. The Greek Poseidon was the god of the sea, and was probably of some importance to the seafaring Mycenaeans.

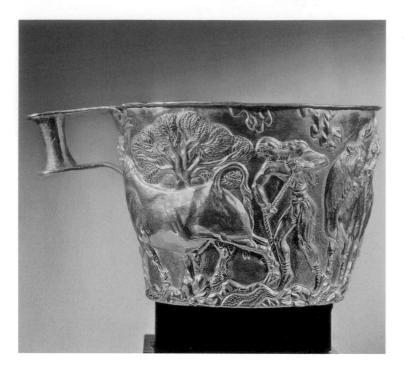

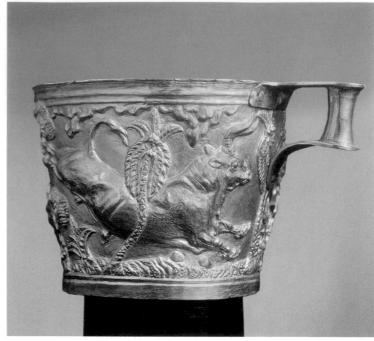

4.29 Vaphio Cups. ca. 1500-1450 BCE. Gold, height 31/2" (3.9 cm). National Archaeological Museum, Athens

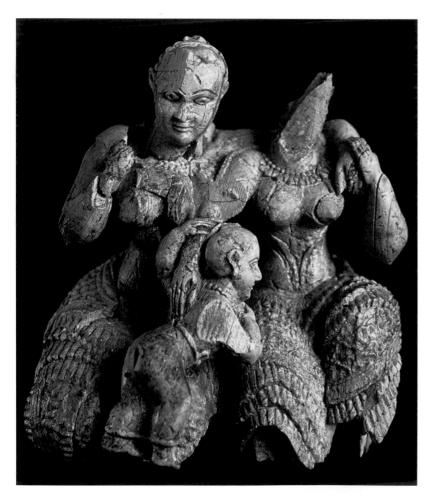

4.30 *Three Deities*, from Mycenae, Greece. 14th–13th century BCE. Ivory, height 3" (7.5 cm). National Archaeological Museum, Athens. Ministry of Culture Archaeological Receipts Fund. 7711

Free-standing sculptures are rare, but one small, finely carved ivory group depicting two kneeling women with a young child came to light in a shrine next to the palace at Mycenae in 1939 (fig. 4.30). The women wear flounced skirts similar to the one worn by the Minoan *Snake Goddess* (see fig. 4.15), suggesting that the work came from Crete or was carved by an artist from Crete working on the Greek mainland for Mycenaean patrons. Yet the material is ivory, and probably originated in Syria or Egypt, documenting Mycenaean trade links. The figures' intertwined limbs and the child's unsettled pose describe a transient moment. For some scholars, the close physical interaction among the figures suggests that this small object is a rendering of a family group, including grandmother, mother, and child. Others argue that it represents three separate divinities, one of whom takes the form of a child.

Along with the "Treasury of Atreus," with its echoes of Egypt, and the Lioness Gate, which is a blend of Minoan and Near Eastern influences, this sculpture and others that survive from Bronze Age Greece reveal a culture with contacts throughout the Mediterranean. Whether those contacts came as a result of war or trade, the culture of Mycenaean Greece was receptive to the ideas and forms of other regions. Despite its warlike and dynamic character, Mycenaean civilization collapsed around 1200 or 1100 BCE, probably in the chaos caused by the arrival of new peoples on the Greek mainland. Whether or not the inhabitants of these powerful citadels actually took part in a legendary ten-yearlong siege of Troy in Asia Minor, their descendants believed they did. For the Greeks, the Mycenaean Age was an age of heroes.

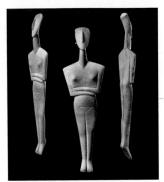

ca. 2500 BCE White marble Cycladic figurines

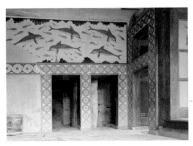

ca. 1700-1300 BCE Minoans construct the Second "Palace" at Knossos

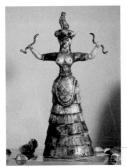

ca. 1650 BCE Snake Goddess from Knossos

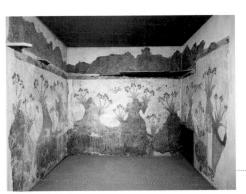

ca. 1600-1500 BCE *Spring Frescu* at Akrotiri, Thera

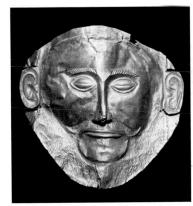

ca. 1600-1500 BCE Mycenaean death masks of hammered gold

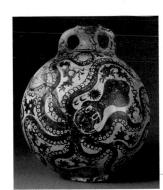

ca. 1500 BCE

Octopus Vase, an
example of Minoan
"marine style" pottery

ca. 1250 BCE Construction of the Lioness Gate at Mycenae

Aegean Art

3000 BCE

2750

 ca. 2800 BCE Cycladic Islanders start to bury their dead in stone-lined pits

> .. ca. 2575–2465 все Egypt's 4th Dynasty; construction of the three Great Pyramids at Giza

2500 BCE

2250

2000

1750 BCE

1500 BCE

1250 BCE

1000 BCE

- ca. 2100 BCE King Urnammu commissions the Great Ziggurat at Ur ca. 2100 BCE Final phase of construction at
- Stonehenge

 ca. 2000 BCE Minoans build the first "palaces" on Crete, and develop Linear A

- ca. 1450 BCE Earthquake demolishes Knossos and other Minoan centers; Mycenaeans invade Crete
 - ca. 1290-1224 BCE King Ramesses II rules Egypt, and commissions a monumental temple at Abu Simbel

8th century BCE The Iliad and The Odyssey, attributed to Homer

Greek Art

immediately recognizable as ancestors of Western civilization. A Greek temple recalls countless government buildings, banks, and college campuses, and a Greek statue evokes countless statues of our own day. This is neither coincidental nor inevitable: Western civilization has carefully

constructed itself in the image of the Greek and Roman worlds. Through the centuries, these worlds have represented a height of cultural achievement for Western civilization, which looked to them for artistic ideals as well as for philosophical models such as democracy.

The great flowering of ancient Greck art was just one manifestation of a wide-ranging exploration of humanistic and religious issues. Artists, writers, and philosophers struggled with common questions, preserved in a huge body of works. Their inquiries cut to the very core of human existence, and form the backbone of much of Western philosophy. For the most part, they accepted a pantheon of gods, whom they worshiped in human form. (See Informing Art, page 105.) Yet they debated the nature of those gods, and the relationship between divinities and humankind. Did fate control human actions, or was there free will? What was the nature of virtue? Greek thinkers conceived of many aspects of life in dualistic terms. Order (cosmos in Greek) was opposed to disorder (chaos), and both poles permeated existence. Civilization which was, by definition, Greek-stood in opposition to an uncivilized world beyond Greek borders; non-Greeks were "barbarians," named for the nonsensical sound of their languages to Greek ears ("bar-bar-bar-bar"). Reason, too, had its opposite: the

Detail of figure 5.6, Griffin-head protome from a bronze tripod-cauldron, from Kameiros, Rhodes

irrational, mirrored in light and darkness, in man and woman. In their art as in their literature, the ancient Greeks addressed the tension between these polar opposites.

Trying to understand the visual culture of the worlds on which Western civilization so deliberately modeled itself presents a special challenge for the art historian: It is tempting to believe that something familiar on the surface holds the same significance for us today as it did for Greeks or Romans. Yet scholars have discovered time and time again that this is a dangerous fallacy.

A further complication in studying Greek art is that there are three separate, and sometimes conflicting, sources of information on the subject. First, there are the works themselves—reliable, but only a fraction of what once existed. Secondly, there are Roman copies of Greek originals, especially sculptures. These works tell us something about important pieces that would otherwise be lost to us, but pose their own problems. Without the original, we cannot determine how faithful a copy is, and sometimes multiple copies present several different versions of a single original. This is explained by the fact that a Roman copyist's notion of a copy was quite different from ours: It was not necessarily a strict imitation, but allowed for interpreting or adapting the work according to the copyist's taste or skill or the patron's wishes. Moreover, the quality of some Greek sculpture owed much to surface finish, which, in a copy, is entirely up to the copyist. If the original was bronze and the copy marble, not only would the finish differ dramatically, but the copyist might alter the very composition to

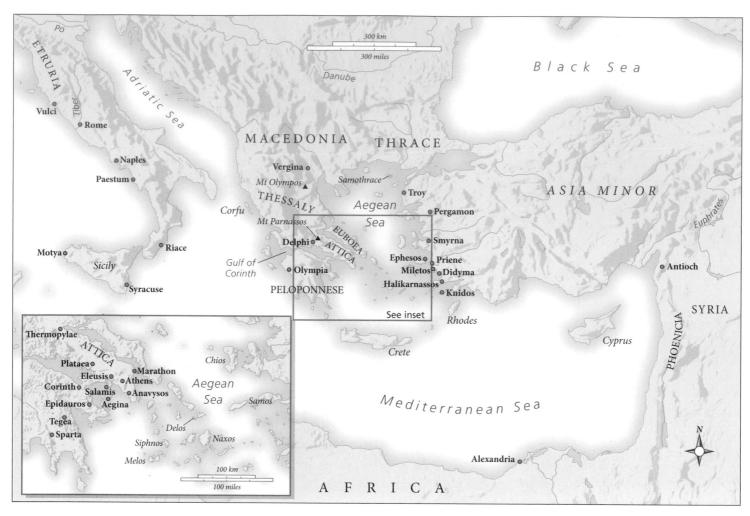

Map 5.1 Greece in the Archaic and Classical periods

accommodate the different strengths of stone and bronze. In rare cases, works that appear to be copies because of their general style or subject matter are of such high quality that we cannot be sure that they really are copies. Lastly, Roman copies tend to come to light in Roman contexts, which allows archaeologists to glean information about Roman collectors but not about the contexts in which Greeks displayed the originals.

The third source of information about Greek works is literature. The Greeks were the first Western people to write at length about their artists. Roman writers incorporated Greek accounts into their own; many of these survive, although often in fragmentary condition. These written sources offer a glimpse of what the Greeks considered their significant achievements in architecture, sculpture, and painting. They name celebrated artists and monuments, but often deal with lost works and fail to mention surviving Greek works that we number among the greatest masterpieces of their time. Weaving these strands of information into a coherent picture of Greek art has been the difficult task of archaeologists and art historians for several centuries.

THE EMERGENCE OF GREEK ART: THE GEOMETRIC STYLE

The first Greek-speaking groups came to Greece about 2000 BCE, bringing a culture that soon encompassed most of mainland Greece, the Aegean Islands, and Crete. By the first millennium BCE, they had colonized the west coast of Asia Minor and Cyprus. In this period we distinguish three main subgroups: the Dorians, centered in the Peloponnese; the Ionians, inhabiting Attica, Euboea, the Cyclades, and the central coast of Asia Minor; and the Aeolians, who ended up in the northeast Aegean (map 5.1). Despite cultural differences, Greeks of different regions had a strong sense of kinship, based on language and common beliefs. From the mid-eighth through the mid-sixth centuries BCE, Greeks spread across the Mediterranean and as far as the Black Sea in a wave of colonization. At this time, they founded settlements in Sicily and southern Italy, collectively known as Magna Graecia, and in North Africa.

After the collapse of Mycenaean civilization described in the last chapter, art became largely nonfigural for several centuries. In the ninth century BCE, the oldest surviving style of Greek art

Greek Gods and Goddesses

All early civilizations and preliterate cultures had creation myths to explain the origin of the universe and humanity's place in it. Over time, these myths evolved into complex cycles that represent a comprehensive attempt to understand the world. Greek gods and goddesses, though immortal, behaved in human ways. They quarreled, and had offspring with one another's spouses and often with mortals as well. Their own children sometimes threatened and even overthrew them. The principal Greek gods and goddesses, with their Roman counterparts in parentheses, are given below.

ZEUS (Jupiter): son of Kronos and Rhea; god of sky and weather, and chief Olympian deity. After killing Kronos, Zeus married his sister HERA (Juno) and divided the universe by lot with his brothers: POSEIDON (Neptune) was allotted the sea, and HADES (Pluto) received the underworld, which he ruled with his queen, PERSEPHONE (Proserpina).

Zeus and Hera had several children:

ARES (Mars), the god of war

HEBE, the goddess of youth

HEPHAISTOS (Vulcan), the lame god of metalwork and the forge

Zeus also had numerous children through his love affairs with other goddesses and with mortal women, including:

ATHENA (Minerva), goddess of crafts, war, intelligence, and wisdom. A protector of heroes, she became the patron goddess of Athens, an honor she won in a contest with Poseidon. Her gift to the city was an olive tree, which she caused to sprout on the Akropolis.

APHRODITE (Venus), the goddess of love, beauty, and female fertility. She married Hephaistos, but had many other liaisons. Her children were HARMONIA, EROS, and ANTEROS (with Ares); HERMAPHRODITOS (with Hermes); PRIAPOS (with Dionysos); and AENEAS (with the Trojan prince Anchises).

APOLLO (Apollo), god of the stringed lyre and bow, who therefore both presided over the civilized pursuits of music and poetry, and shot down transgressors; a paragon of male beauty, he was also the god of prophecy and medicine.

ARTEMIS (Diana), twin sister of APOLLO, virgin goddess of the hunt and the protector of young girls. She was also sometimes considered a moon-goddess with SELENE.

DIONYSOS (Bacchus), the god of altered states, particularly that induced by wine. Opposite in temperament to Apollo, Dionysos was raised on Mount Nysa, where he invented winemaking; he married the princess Ariadne after the hero Theseus abandoned her on Naxos. His followers, the goatish satyrs and their female companions, the nymphs and humans who were known as maenads (bacchantes), were given to orgiastic excess. Yet there was another, more temperate side to Dionysos' character. As the god of fertility, he was also a god of vegetation, as well as of peace, hospitality, and the theater.

HERMES (Mercury), the messenger of the gods, conductor of souls to Hades, and the god of travelers and commerce.

developed, known today as the Geometric Style because of the predominance of linear designs. Artists created works of painted pottery and small-scale clay and bronze sculpture in this style. The forms are closely related: the types of figures found in sculpture often adorned the pottery.

Geometric Style Pottery

As quickly as pottery became an art form, Greek potters began to develop an extensive, but fairly standardized, repertoire of vessel shapes (fig. 5.1), and adapted each type to its function. Making and decorating vases were complex processes, usually performed

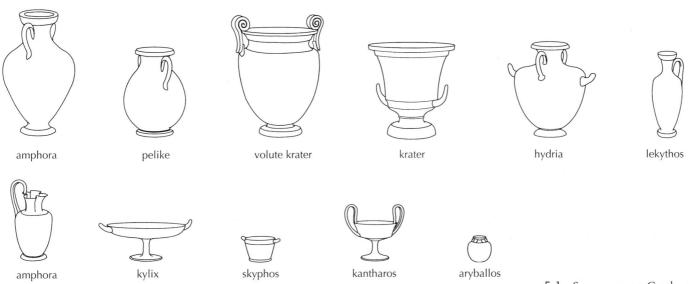

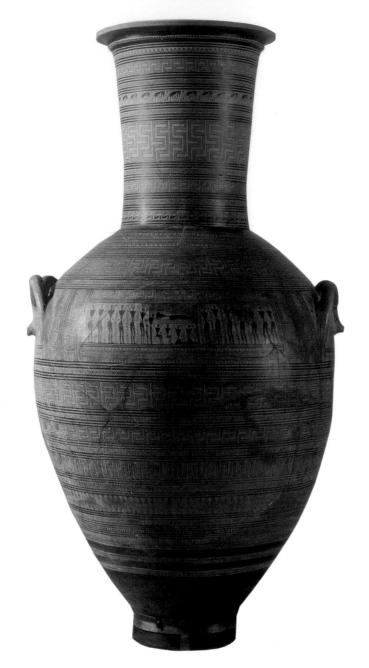

5.2 Dipylon Vase. Late Geometric belly-handled amphora, from the Dipylon Cemetery, Athens. ca. 750 BCE. Height 5'1" (1.55 m). National Archaeological Museum, Athens

by different artisans. Each pottery shape presented its own challenges to the painter, and some became specialists at decorating certain types of vases. Large pots often attracted the most ambitious craftsmen because they provided a generous field on which to work. At first painters decorated their wares with abstract designs, such as triangles, "checkerboards," and concentric circles. Toward 800 BCE, human and animal figures began to appear within the geometric framework, and in elaborate examples these figures interact in narrative scenes. This development occurred at about the time the alphabet was introduced (under strong Near Eastern influence), and contemporaneous, too, with the compositions of the poet (or group of poets) known as Homer, who wrote

the lasting epic poems *The Iliad* and *The Odyssey*, tales of the Trojan War and the return home of one of its heroes, Odysseus, to Ithaka.

The vase shown here, from a cemetery near the later Dipylon gate in northwestern Athens, dates to around 750 BCE (fig. 5.2; see fig. 5.37). Known as the Dipylon Vase, it was one of a group of large vessels Athenians used as funerary markers over burials. Holes in its base allowed mourners to pour liquid offerings (libations) during funerary rituals; the libations filtered down to the dead buried below. In earlier centuries, Athenians had placed the ashes of their dead inside vases, choosing the vase's shape according to the sex of the deceased: They placed a woman's remains in a belly-handled amphora, a type of vase they used more commonly for storing wine or oil; a man's ashes were stored in a neck-amphora (a wine jar with a long neck). Since the early first millennium, Athenians had also used kraters as burial markers, large bowl-like vessels in which they normally mixed wine with water (see fig. 5.1). The shape of the vase illustrated here shows that the person buried beneath was a woman; its monumentality indicates that she was a woman of considerable means.

The amphora is a masterpiece of the potter's craft. At over 5 feet tall, it was too large to be thrown in one piece. Instead, the potter built it up in sections, joined with a clay slip (clay mixed with water or another liquid). A careful proportional scheme governed the vessel's form: Its width measures half of its height and the neck measures half the height of the body. The potter placed the handles so as to emphasize the widest point of the body. Most of the decoration is given over to geometric patterns dominated by a meander pattern, also known as a maze or Greek key pattern (fig. 5.3), a band of rectangular scrolls, punctuated with bands of lustrous black paint at the neck, shoulder, and base. The geometric design reflects the proportional system of the vase's shape. Single meander patterns run in bands toward the top and bottom

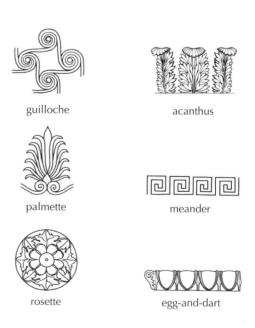

5.3 Common Greek ornamental motifs

of the neck; the triple meander encircling the neck at the center emphasizes its length. The double and single meanders on the amphora's body appear stocky by contrast, complementing the body's rounder form. On the neck, deer graze, one after the other, in an identical pattern circling the vase. At the base of the neck, they recline, with their heads turned back over their bodies, like an animate version of the meander pattern itself, which moves forward while turning back upon itself. These animal **friezes** prefigure the widespread use of the motif in the seventh century BCE.

In the center of the amphora, framed between its handles, is a narrative scene. The deceased lies on a bier, beneath a checkered shroud. Standing figures flank her with their arms raised above their heads in a gesture of lamentation; four additional figures kneel or sit beneath the bier. Rather than striving for naturalism, the painter used solid black geometric forms to construct human bodies. A triangle represents the torso, and the raised arms extend the triangle beyond the shoulders. The scene represents the *prothesis*, part of the Athenian funerary ritual, when the dead person lay in state and public mourning took place. For the living, a lavish funeral was an occasion to display wealth and status, and crowds of mourners were so desirable that families would hire professionals for the event. Thus the depiction of a funeral on the vase is not simply journalistic reportage but a visual record of the deceased person's high standing in society.

Archaeologists have found Geometric pottery in Italy and the Near East as well as in Greece. This wide distribution reflects the important role of not only the Greeks but also the Phoenicians, North Syrians, and other Near Eastern peoples as agents of diffusion around the Mediterranean. What is more, from the second half of the eighth century onward, inscriptions on these vases show that the Greeks had already adapted the Phoenician alphabet to their own use.

Geometric Style Sculpture

A small, bronze sculptural group representing a man and a centaur dates to about the same time as the funerary amphora, and there are similarities in the way the artist depicted living forms in both works of art (fig. 5.4). Thin arms and flat, triangular chests contrast with rounded buttocks and legs. The heads are spherical shapes, with beards and noses added. The metalworker cast the sculptural group in one piece, uniting the figures with a common base and through their entwined pose. Indeed, the figures obviously interact, revealing the artist's interest in narrative, a theme that persists throughout the history of Greek art. The figures' helmets suggest that their encounter is martial, and the larger scale of the man may indicate that he will prevail in the struggle. It is hard to say whether the artist was referring to a story known to the audience. Many scholars believe the male figure represents the hero Herakles, son of Zeus and a mortal woman, who fought centaurs many times in the course of his mythical travails. The group probably came to light in the great Panhellenic (all-Greek) sanctuary at Olympia, home of the Olympic games. This sanctuary, like the Panhellenic sanctuary at Delphi, home of the

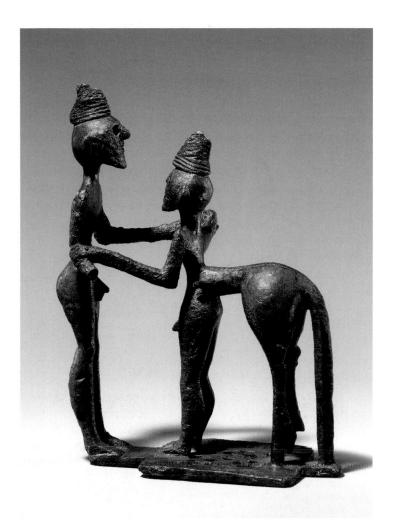

5.4 Man and Centaur, perhaps from Olympia. ca. 750 BCE. Bronze, height 43/8" (11.1 cm). Metropolitan Museum of Art, New York. Gift of J. Pierpont Morgan, 1917. 17.190.2072

Panhellenic games (see fig. 5.19), was not specific to one city-state: People from cities all over the Greek world routinely visited it for festivals and to make dedications to the gods, which accounts for its gradual monumentalization. There was a distinct rise in dedications there and at Delphi in the eighth century BCE, especially of small metal objects. Judging by the figurative quality of the sculptural group, by the costliness of the material, and the complexity of the technique, it was probably a sumptuous votive offering.

THE ORIENTALIZING STYLE: HORIZONS EXPAND

Between about 725 and 650 BCE, a new style of art emerged in Greece that reflects strong influences from the Near East and Egypt. Scholars call this the Orientalizing period, when Greek art and culture rapidly absorbed Eastern motifs and ideas, including hybrid creatures such as griffins and sphinxes. This movement led to a vital period of experimentation, as artists strove to master new forms.

Miniature Vessels

The Orientalizing style replaced the Geometric in many Greek city-states, including Athens. One of the foremost centers of its production, though, was Corinth, at the northeastern gateway to the Peloponnese. During this period, Corinth came to dominate colonizing ventures to the west, as well as the trade in pottery exports. Its workshops had a long history of pottery production, and at this time vase painters learned to refine a black gloss slip, which they used to create silhouette or outline images. By incising the slip, they could add fine detail and vivacity to their work. They particularly specialized in crafting miniature vessels like the vase shown here, which is a Proto-Corinthian aryballos or perfume jar, dating to about 680 BCE (fig. 5.5). Despite its small size, intricate decoration covers the vase's surface. Around the shoulder stalks a frieze of animals, reminiscent of Near Eastern motifs and of the frieze on the Dipylon Vase (see figs. 2.21 and 5.2). Bands of real and imaginary animals are a hallmark of Corinthian and other Orientalizing wares: They cover later vases from top to bottom. A guilloche pattern ornaments the handle, and meander patterns enliven the edge of the mouth and the handle (see fig. 5.3). The principal figural frieze offers another early example of pictorial narrative, but the daily-life scenes that are characteristic of Geometric pottery yield here to the fantastic world of myth.

5.5 The Ajax Painter. Aryballos (perfume jar). Middle Proto-Corinthian I A, 690–675 BCE. Ceramic, height 2½" (7.3 cm), diameter 1¾" (4.4 cm). Museum of Fine Arts, Boston. Catharine Page Perkins Fund. 95.12

5.6 Griffin-head protome from a bronze tripod cauldron, from Kameiros, Rhodes. ca. 650 BCE. Cast bronze. The British Museum, London

On one side, a stocky nude male wielding a sword runs toward a vase on a stand. On the side shown here, a bearded male struggles to wrest a scepter or staff from a centaur. According to one theory, the frieze represents a moment in Herakles' conflict with a band of centaurs on Mount Pholoë. In Greek mythology, centaurs were notoriously susceptible to alcohol, and the mixing bowl for wine represented on the other side may indicate the reason for their rowdiness. Others interpret the "Herakles" figure

as Zeus, brandishing his thunderbolt or lightning. No matter how one reads this scene, it was clearly meant to evoke a myth. Greeks buried vessels like this aryballos in tombs as offerings for the dead, and dedicated them in sanctuaries throughout the Greek world.

BRONZE TRIPODS Among the costliest dedications in Greek sanctuaries during the Geometric and Orientalizing periods were bronze tripod cauldrons, large vessels mounted on three legs. Some of them reached truly monumental proportions, and the dedication was not only an act of piety, but also a way to display status through wealth. From the early seventh century BCE, bronze-workers producing these vessels in the Orientalizing style attached protomes around the edge of the bowl—images of sirens (winged female creatures) and griffins, which were fantasy creatures known in the Near East. The cast protome shown here, from the island of Rhodes, is a magnificently ominous creature, standing watch over the dedication (fig. 5.6). The boldly upright ears and the vertical knob on top of the head contrast starkly with the strong curves of the neck, head, eyes, and mouth, while its menacing tongue is silhouetted in countercurve against the beak. The straight lines appear to animate the curves, so that the dangerous hybrid seems about to spring.

ARCHAIC ART: ART OF THE CITY-STATE

During the course of the seventh and sixth centuries BCE, the Greeks refined their notion of a polis, or city-state. Once merely a citadel, a place of refuge in times of trouble, the city came to represent a community and an identity. They governed these citystates in various ways, including monarchy (from monarches, "sole ruler"), aristocracy (from aristoi and kratia, "rule of the best"), tyranny (from tyrannos, "king"), and oligarchy (from oligoi, "the few," a small ruling elite). The citizens of Athens ruled their city-state by democracy (from demos, "the people"). The path to democracy was a slow one, starting with the reforms of Solon, a statesman of the late sixth century. Even after Perikles' radical democratic reforms of 462 BCE, women played no direct role in civic life, and slavery was an accepted practice, as it was throughout the Greek world. With the changing ideal of the citystate came transformations in its physical appearance. Scholars know the artistic style of this time as Archaic (from archaios, Greek for "old"). Architects began to design monumental buildings in canonical styles, while artists started to explore human movement and emotion.

The Rise of Monumental Temple Architecture

Early Greeks worshiped their gods in open-air sanctuaries. The indispensable installation for cult (religious practice) rituals was an altar, where priests performed sacrifices standing before the worshiping community of the Greek polis. Increasingly, though,

Greeks built temples to accompany these altars. Usually the entrance of the temple faced east, toward the rising sun, and the altar stood to the east of the temple. The chief function of a temple was not so much to house rituals, most of which occurred outside the building, but to provide safe shelter for the cult image of the god to whom the temple was dedicated, and to store valuable dedications. At some point in the seventh century BCE, they began to design temples in stone rather than wood. Corinthian architects were probably the first to make the change, designing in a style known as Doric, named for the region where it originated. From there, the concept spread across the isthmus of Corinth to the mainland and up to Delphi and the island of Corfu, then rapidly throughout the Hellenic world. A second style, the Ionic, soon developed on the Aegean Islands and the coast of Asia Minor. The style known as Corinthian did not develop until the late fifth century BCE (see page 142).

Greeks recognized the importance of this architectural revolution even as it happened: Architects wrote treatises on their buildings—the first we know of—and the fame they achieved through their work has lasted to this day. Writing in the first century BCE, the Roman architect Vitruvius described the Greek styles of architecture, and his work has been central to our understanding of Greek building. However, our readings of his text have been mediated through early modern commentators and illustrators, who wrote of Doric and Ionic "orders" rather than "types," which is a better translation of Vitruvius' "genera." The distinction is important: "Order" suggests an immutable quality, a rigid building code, when in fact there is a subtle but rich variation in surviving Greek architecture.

The essential, functioning elements of Doric and Ionic temples are very similar, though they vary according to the building's size or regional preferences (fig. 5.7). The nucleus of the building—its very reason for existing—is its main chamber, its cella or naos. This chamber housed the god's image. Often, interior columns lined the cella walls and helped to support the roof, as well as visually framing the cult statue. Approaching the cella is a porch or pronaos, and in some cases architects added a second porch behind the cella, making the design symmetrical and providing

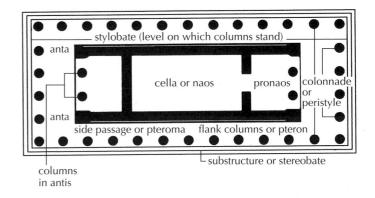

5.7 Ground plan of a typical Greek peripteral temple (after Grinnell)

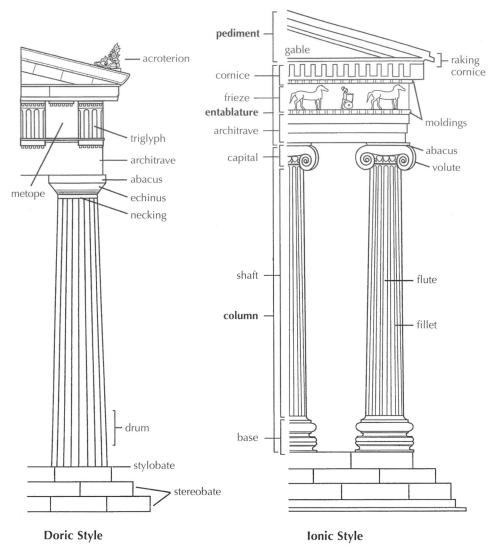

5.8 Doric and Ionic styles in elevation

space for apparatus used in rituals and religious dedications. In large temples, a colonnade or **peristyle** surrounds the cella and porches; Vitruvius called this type a **peripteral temple**. The peristyle commonly consists of 6 to 8 columns at front and back, and usually 12 to 17 along the sides, counting the corner columns twice; the largest temples of Ionian Greece had a double colonnade. The peristyle added more than grandeur: It offered worshipers shelter from the elements. Being neither entirely exterior nor entirely interior space, it also functioned as a transitional zone, between the profane world outside and the sanctity of the cella. Some temples stood in sacred groves, and the strong vertical form of the columns integrated the building with the environment of trees. Echoed again by columns inside the cella, the peristyle also unified the exterior and interior of the building.

Differences between the Doric and Ionic styles are apparent in a head-on view, or elevation. Many terms that Greeks used to describe the parts of their buildings, shown in figure 5.8, are still in common usage. The building proper rests on an elevated level (the stylobate), normally approached by three steps, known as the stereobate. A Doric column consists of a shaft, usually

marked by shallow vertical grooves, known as flutes, and a capital, made up of a flaring, cushionlike echinus and a square tablet called the abacus. The entablature includes all the horizontal elements that rest on the columns: the architrave (a row of stone blocks directly supported by the columns); the frieze, made up of alternating triple-grooved triglyphs and smooth or sculpted metopes; and a projecting horizontal cornice, or geison. The architrave in turn supports the triangular pediment and the roof elements.

An Ionic column differs from a Doric column in having an ornate base, perhaps designed initially to protect the bottom from rain. Its shaft is more slender, less tapered, and the capital has a double scroll or volute below the abacus. Masons left a sharp angle where the flutes met, instead of flattening it as on Doric columns. The Ionic column lacks the muscular quality of its mainland cousin. Instead, it evokes a growing plant, like a formalized palm tree, a characteristic it shares with its Egyptian predecessors, though it may not have come directly from Egypt. Above the architrave, the frieze is continuous, not broken up visually into triglyphs and metopes.

Greek builders created temples, whether Doric or Ionic, out of stone blocks fitted together without mortar. This required them to shape the blocks precisely to achieve smooth joints. Where necessary, metal dowels or clamps fastened the blocks together. With rare exceptions, they constructed columns out of sections called **drums**, and stonemasons fluted the entire shaft once it was in position. They used wooden beams for the ceiling, and terra-cotta tiles over wooden rafters for the roof. Fire was a constant threat.

Why and how either style came to emerge in Greece, and why they came together into succinct systems so quickly, are questions that still puzzle scholars. Remains of the oldest surviving temples show that the main features of the Doric style were already established soon after 600 BCE. It is possible that the temple's central unit, the cella and porch, derived from the plan of the Mycenaean megaron (see fig. 4.23), either through continuous tradition or by way of revival. If this is true, this relationship may reflect the revered place of Mycenaean culture in later Greek mythology. Still, a Doric column shaft tapers upward, not downward like the Minoan-Mycenaean column. This recalls fluted half-columns in the funerary precinct of Djoser at Saggara of over 2,000 years earlier (see fig. 3.6). In fact, the very notion that temples should be built of stone and have large numbers of columns was an Egyptian one, even if Egyptian architects designed temples for greater internal traffic. Scholars believe that the rise of monumental stone architecture and sculpture must have been based on careful, onthe-spot study of Egyptian works and the techniques used to produce them. The opportunity for just such a study was available to Greek merchants living in trading camps in the western Nile Delta, by permission of the Egyptian king Psammetichus I (r. 664–610 BCE).

Some scholars see Doric architecture as a petrification (or turning to stone) of existing wooden forms, so that stone form follows wooden function. Accordingly, triglyphs once masked the ends of wooden beams, and the droplike shapes below, called **guttae**, mimick the wooden pegs that held them in place. Metopes evolved from boards that filled gaps between triglyphs to guard against moisture. Some derivations are more convincing than others, however. The vertical subdivisions of triglyphs hardly seem to reflect the forms of three half-round logs, as some have suggested, and column flutings need not have developed out of tool marks on a tree trunk, since Egyptian builders also fluted their columns and yet rarely used timber for supporting members. The question of how well function explains stylistic features faces the architectural historian repeatedly.

DORIC TEMPLES AT PAESTUM Whatever the reason for the emergence of the Doric and Ionic styles, architects continued to refine them throughout Greek times. The early evolution of Doric temples is evident in two unusually well-preserved examples located in the southern Italian polis of Paestum (ancient Poseidonia), where a Greek colony flourished during the Archaic period. The residents dedicated both temples to the goddess Hera, wife of Zeus, however, they built the Temple of Hera II almost a century after the Temple of Hera I (fig. 5.9). The differences in their proportions are striking. The Temple of Hera I (on the left

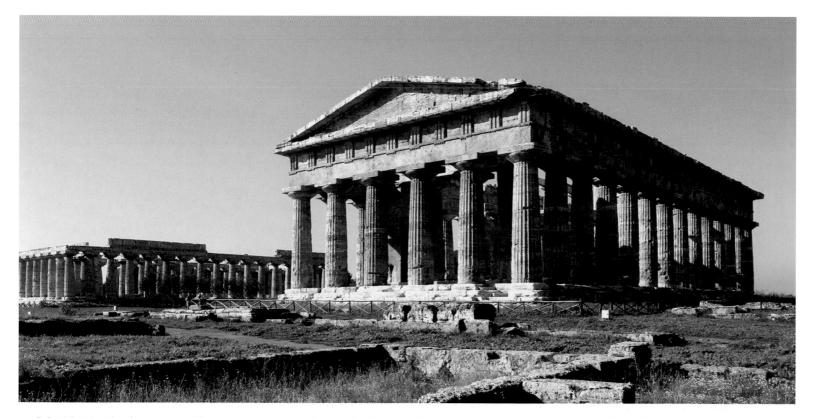

5.9 The Temple of Hera I ("Basilica"), ca. 550 BCE, and the Temple of Hera II ("Temple of Poseidon"), Paestum. ca. 460 BCE

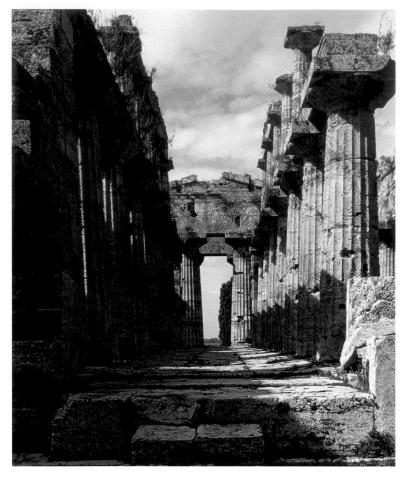

5.10 Interior of Temple of Hera II. ca. 500 BCE

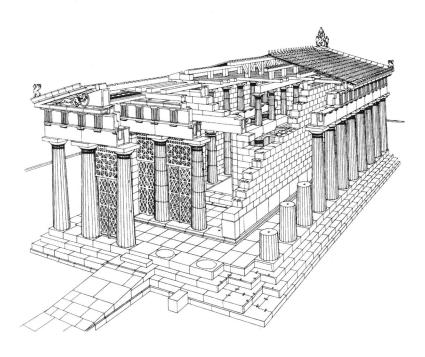

5.11 Sectional view (restored) of Temple of Aphaia, Aegina. ca. 500–480 BCE

of fig. 5.9) appears low and sprawling—and not just because so much of the entablature is missing—whereas the Temple of Hera II looks tall and compact. One reason is that the Temple of Hera I is enneastyle (with nine columns across the front and rear), while the later temple is only hexastyle (six columns). Yet the difference in appearance is also the result of changes to the outline of the columns. On neither temple are the column shafts straight from bottom to top. About a third of the way up, they bulge outward slightly, receding again at about two-thirds of their height. This swelling effect, known as entasis, is much stronger on the earlier Temple of Hera I. It gives the impression that the columns bulge with the strain of supporting the superstructure and that the slender tops, although aided by the widely flaring capitals, can barely withstand the crushing weight. The device, seen also in the monoliths at Stonehenge, adds an extraordinary vitality to the building—a sense of compressed energy awaiting release.

Being so well preserved, the Temple of Hera II shows how the architect supported the ceiling in a large Doric temple (fig. 5.10). Inside the cella, the two rows of columns each support a smaller set of columns scaled in such a way that the tapering seems continuous despite the intervening architrave. Such a two-story interior is first found at the Temple of Aphaia at Aegina around the beginning of the fifth century BCE. A reconstruction drawing of that temple (fig. 5.11) illustrates the structural system in detail.

EARLY IONIC TEMPLES The Ionic style first appeared about a half-century after the Doric. With its vegetal decoration, it seems to have been strongly inspired by Near Eastern forms. The closest known parallel to the Ionic capital is the **Aeolic** capital, found in the region of Old Smyrna, in eastern Greece, and in the northeast Aegean, itself apparently derived from North Syrian and Phoenician designs. Leading cities of Ionian Greece commissioned the earliest Ionic temples in open rivalry with one another. Little survives of these vast, ornate buildings. One of them, the Temple of Artemis at Ephesos, gained tremendous

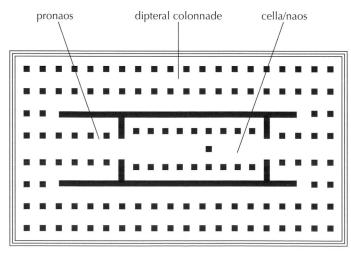

5.12 Restored plan of Temple of Artemis at Ephesos, Turkey. ca. 560 BCE

fame in antiquity, and earned a place among the seven wonders of the ancient world. The Ephesians hired Theodoros of Samos to work on its foundations in about 560 BCE, shortly after he and another architect, Rhoikos, had designed a vast temple to Hera on the island of Samos. The temple's subsequent architects, Chersiphron of Knossos and his son Metagenes, wrote a treatise on it. The temple was dipteral (with two rows of columns surrounding it) (fig. 5.12), and this feature emphasized the forestlike quality of the building, as did its vegetal capitals. In this much, it resembled the temple on Samos. Yet in other respects the Temple of Artemis clearly outshone Hera's: It was larger, and it was the first monumental building constructed mostly of marble. These Ionic colossi had blatant symbolic value: They represented their respective city's bid for regional leadership.

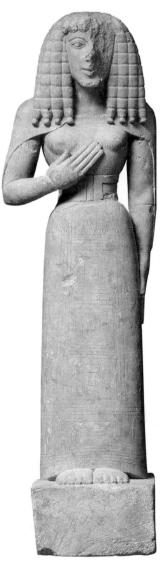

5.13 Kore (Maiden). ca. 630 BCE. Limestone, height 24½" (62.3 cm). Musée du Louvre, Paris. Fletcher Fund, 1932. (32.11.1)

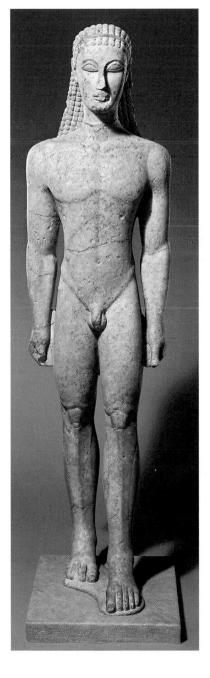

STONE SCULPTURE

According to literary sources, in the eighth century BCE Greeks erected simple wooden sculptures of their gods for worship in sanctuaries; but since wood deteriorates, none of them now survives. In about 650 BCE, sculptors, like architects, made the transition to working in stone, and so began one of the great traditions of Greek art.

KORE AND KOUROS Early Greek statues clearly show affinities with the techniques and proportional systems used by Egyptian sculptors, whose work Greek artists could observe first hand in the Nile Delta. Two are illustrated here: one a small female figure of about 630 BCE, probably from Crete (fig. 5.13); the other a life-size nude male youth of about 600 BCE (fig. 5.14), known as the New York Kouros because it is displayed in the Metropolitan Museum of Art. Like their Egyptian forerunners (see figs. 3.10 and 3.11), the statues are rigidly frontal, and conceived as four distinct sides, reflecting the form of the block from which the sculptor carved them. Like Menkaure, the Greek male youth is slim and broad-shouldered; he stands with his left leg forward, and his arms by his sides, terminating in clenched fists. His shoulders, hips, and knees are all level. Both figures have stylized, wiglike hair like their Egyptian counterparts, and like some Near Eastern sculptures (see fig. 2.11). All the same, there are significant differences. First, the Greek sculptures are truly freestanding, without the back slab that supports Egyptian stone figures. In fact, they are the earliest large stone images of the human figure that can stand on their own. Moreover, Greek sculptures incorporated empty space (between the legs, for instance, or between arms and torso), whereas Egyptian figures remained embedded in stone, with the spaces between forms partly filled. Early Greek sculptures are also more stylized than their Egyptian forebears. This is most evident in the large staring eyes, emphasized by bold arching eyebrows, and in the linear treatment of the anatomy: The sculptor appears almost to have etched the male youth's pectoral muscles and rib-cage onto the surface of the stone, whereas the Egyptian sculptor modeled Menkaure's musculature. Unlike Menkaure, the male youth is nude. Earlier cultures, like the Egyptians, forced nudity on slaves, whereas ancient Greeks considered public nudity acceptable for males, but not for females. Accordingly, like most early Greek female sculptures, this one is draped, in a close-fitting garment that reveals her breasts but conceals her hips and legs.

Dozens of Archaic sculptures of this kind survive throughout the Greek world. Some have come to light in sanctuaries and cemeteries, but most were found in reused contexts, which complicates any attempt to understand their function. Scholars describe them by the Greek terms for maiden (kore, plural korai) and youth (kouros, plural kouroi), terms that gloss over the

5.14 New York Kouros (Youth). ca. 600–590 BCE. Marble, height 6'1½" (1.88 m). Metropolitan Museum of Art, New York difficulty of identifying their function. Some bear inscriptions, such as the names of artists ("'So-and-so' made me") or dedications to various deities, chiefly Apollo. The latter, then, were votive offerings. But in most cases we do not know whether the sculptures represent the donor, a deity, or a person deemed divinely favored, such as a victor in the athletic games that were so central to ancient Greek life. Those placed on graves probably represent the person buried beneath.

Sculptors made no clear effort to give the statues portrait features, so the images can represent an individual only in a general way. It might make sense to think of them as ideals of physical perfection and vitality shared by mortals and immortals alike, given meaning by their physical context. What is clear is that only the wealthy could afford them, since many were well over lifesize and carved from high-quality marble. Indeed, the very stylistic cohesion of the sculptures may reveal their social function: By

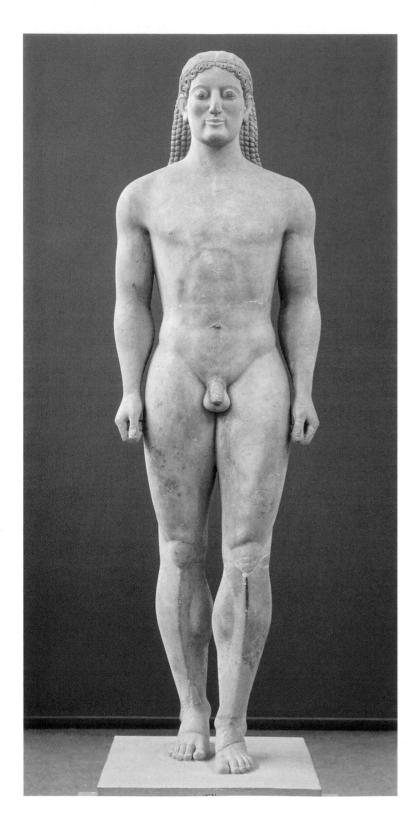

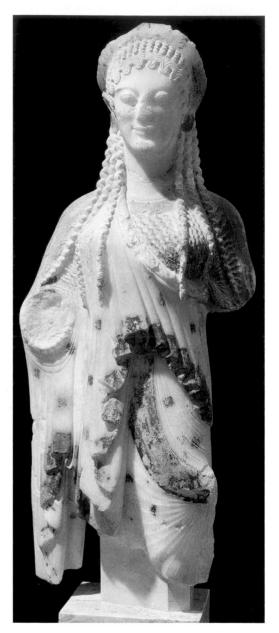

5.16 Kore, from Chios (?). ca. 520 BCE. Marble, height 21%" (55.3 cm). Akropolis Museum, Athens

5.15 Kroisos (Kouros from Anavysos). ca. 540–525 BCE. Marble, height 6'4" (1.9 m). National Museum, Athens

erecting a sculpture of this kind, a wealthy patron declared his or her status and claimed membership in ruling elite circles.

DATING AND NATURALISM The Archaic period stretches from the mid-seventh century to about 480 BCE. Within this time frame, there are few secure dates for free-standing sculptures. Scholars have therefore established a dating system based upon the level of naturalism in a given sculpture. According to this system, the more stylized the figure, the earlier it must be. Comparing figures 5.14 and 5.15 illustrates how this model works. An inscription on the base of the latter identifies it as the funerary statue of Kroisos, who died a hero's death in battle. Like all such figures, it was painted, and traces of color are still discernible in the hair and the pupils of the eyes. Instead of the sharp planes and linear treatment of the New York Kouros (see fig. 5.14), the sculptor of the kouros from Anavysos modeled its anatomy with swelling curves; a viewer can imagine flesh and sinew and bones in the carved stone. A greater plasticity gives the impression that the body could actually function. The proportions of the facial features are more naturalistic as well. The face has a less masklike quality than the New York Kouros, though the lips are drawn up in an artificial smile, known as the Archaic smile, that is not reflected in the eyes. Based on these differences, scholars judge the Kroisos more "advanced" than the New York Knuros, and date it some 75 years later. Given the later trajectory of Greek sculpture, there is every reason to believe that this way of dating Archaic sculpture is more or less accurate (accounting for regional differences and the like). All the same, it is worth emphasizing that it is based on an assumption—that sculptors, or their patrons, were striving toward naturalism-rather than on factual data.

There is more variation in types of kore than in types of kouros. This is partly because a kore is a clothed figure and therefore presents the problem of how to relate body and drapery. It is also likely to reflect changing habits or local styles of dress. The kore in figure 5.16, from about 520 BCE, was a dedication on the Akropolis of Athens, though she probably came from Chios, an island of Ionian Greece. She has none of the severity of the earlier kore from Crete. She wears the light Ionian chiton (a rectangle of fabric draped and fastened at the shoulder by pins) under the heavier diagonally shaped himation, which replaced the earlier peplos (plain woolen garment) in fashion. The layers of the garment still loop around the body in soft curves, but the play of richly differentiated folds, pleats, and textures has almost become an end in itself. Color played an important role in such works, and is unusually well preserved in this example.

Architectural Sculpture: The Building Comes Alive

Soon after the Greeks began to dedicate stone temples, they also started to use architectural sculpture to articulate their buildings and bring them to life. Indeed, early Greek architects such as Theodoros of Samos were often sculptors as well. Traces of pigment show that these sculptures were normally vividly painted. (See *Materials and Techniques*, page 223.)

The Egyptians had been covering walls and columns with reliefs since the Old Kingdom. Their carvings were so shallow (see fig. 3.28) that they did not break the continuity of the surface and had no volume of their own. Thus, like the reliefs on Assyrian, Babylonian, and Persian buildings, they related to their architectural setting in the same way as wall paintings (see figs. 2.19 and 2.20). Another kind of architectural sculpture in the Near East, however, seems to have begun with the Hittites: the lamassu protruding from stone blocks that framed the gateways of fortresses or palaces (see fig. 2.22). Directly or indirectly, this tradition may have inspired the carving over the Lioness Gate at Mycenae (see fig. 4.22).

THE TEMPLE OF ARTEMIS, CORFU The façade of the early Archaic Temple of Artemis on the island of Corfu, built soon after 600 BCE, suggests that the Lioness Gate relief, which was still visible in the sixth century, is a conceptual ancestor of later Greek architectural sculpture (figs. 5.17 and 5.18). Sculpture on the temple is confined to the pediment, a triangle between the ceiling and the roof that serves as a screen to protect the wooden rafters behind it from moisture. Technically, the pedimental sculptures are in high relief, like the guardian lionesses at Mycenae. However, the sculptor undercut the figures so strongly that they are nearly detached from the background, and appear to be almost independent of their architectural setting. Indeed, the head of the central figure actually overlaps the frame; she seems to emerge out of the pediment toward a viewer. This choice on the sculptor's part heightens the impact of the figure and strengthens her function.

Although the Greeks of Corfu dedicated their temple to Artemis, the figure represents the snake-haired Medusa, one of

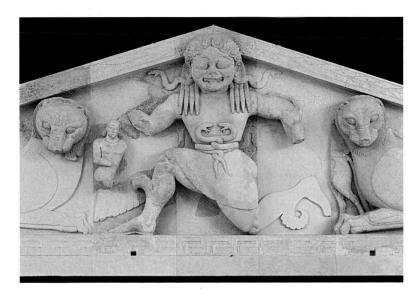

5.17 Central portion of west pediment of Temple of Artemis, Corfu, Greece. ca. 600–580 BCE. Limestone, height 9'2" (2.8 m). Archaeological Museum, Corfu

5.18 Reconstruction drawing of west front of Temple of Artemis, Corfu (after Rodenwaldt)

the Gorgon sisters of Greek mythology. Medusa's appearance was so monstrous, the story went, that anyone who beheld her would turn to stone. With the aid of the gods, the hero Perseus managed to behead her using her reflection in his shield to guide his sword. Traditionally, art historians have interpreted the figure of Medusa as a protective device, used to ward evil spirits away from the temple. However, scholars now argue that she served as a visual commentary on the power of the divinity: As a mistress of animals, she exemplifies the goddess' power and dominance over Nature. To emphasize this, two large feline creatures flank Medusa, in a heraldic arrangement known from the Lioness Gate and from earlier Near Eastern examples.

To strengthen the sculptures' message, the designer included narrative elements in the pediment as well. In the spaces between and behind the main group, the sculptor inserted subsidiary figures. On either side of Medusa are her children, the winged horse Pegasus, and Chrysaor, who will be born from drops of the blood she sheds when Perseus decapitates her. Pegasus was a symbol of Corinth. Since Corfu was Corinth's colony, the winged horse reminded residents of Corinth's control. Logically speaking, Pegasus and Chrysaor cannot yet exist, since Medusa's head is still on her shoulders; and yet their presence in the heraldic arrangment alludes to the future, when Perseus will have claimed the Gorgon's power as his own—just as the sculptor has here, in the service of Artemis. To bring the story to life, the sculptor fused two separate moments from a single story, in what is known as a synoptic narrative. Two additional groups filled the pediment's corners. They may depict Zeus and Poseidon battling the giants (a gigantomachy), a mortal race who tried to overthrow the gods. If so, they strike a cautionary note for a viewer, warning mortals not to aim higher than their natural place in the order of things, since the gods destroyed the giants for their overreaching ambitions.

With their reclining pose, the felines fit the shape of the pediment comfortably. Yet in order to fit Pegasus and Chrysaor between Medusa and the felines, and the groups into the corners,

the sculptor carved them at a significantly smaller scale than the dominant figures. Later solutions to the pediment's awkward shape suggest that this one, which lacks unity of scale, was not wholly satisfactory.

Aside from filling the pediment with sculpture, Greeks often affixed free-standing figures, known as acroteria, above the corners and center of the pediment, to soften the severity of its outline (see fig. 5.20). In Ionic buildings, female statues or caryatids might substitute for columns to support the roof of a porch (see figs. 5.20 and 5.51). Sculptors also decorated the frieze. In Doric temples, they would often embellish the metopes with figural scenes. In Ionic temples, they treated the frieze with a continuous band of painted or sculpted decoration. For the frieze as for the pediment, the designer frequently selected mythological subjects with a topical relevance.

THE SIPHNIAN TREASURY, DELPHI These Ionic features came together in a building constructed at Delphi shortly before 525 BCE by the people of the Ionian island of Siphnos. Delphi was the site of an important Panhellenic sanctuary to Apollo, to which people traveled from all over Greece to consult its oracle (fig. 5.19). The sanctuary gradually came to incorporate a theater and a stadium as well as several temples. Individuals and cities made dedications there, such as statues and spoils of war, and many cities built treasuries on the course of the principal thoroughfare, the Processional Way, to store their votive offerings. Treasuries resembled miniature temples, and typically had an ornate quality. Although the Treasury of the Siphnians no longer stands, archaeologists can reconstruct its appearance from surviving blocks (figs. 5.20 and 5.21). Two carvatids supported the architrave of the porch. Above the architrave was a magnificent sculptural frieze (see fig. 5.21), part of which depicts the mythical battle of the gods against the giants, possibly also seen at Corfu. At the far left, the two lions pull the chariot of Themis, and tear apart an anguished giant. In front of them, Apollo and Artemis advance

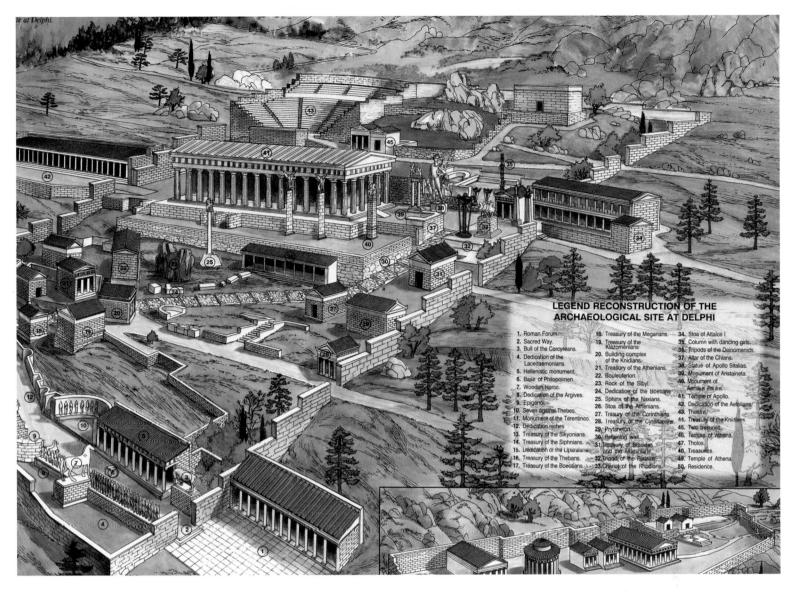

5.19 Plan of Sanctuary of Apollo in ancient times, Delphi

together, shooting arrows, originally added in metal, into a phalanx of giants. Stripped of his armor, a dead giant lies at their feet. Though the subject is mythical, its depiction provides historians with a wealth of detail on contemporary weaponry and military tactics.

Astonishingly, the relief is only a few inches deep from front to back. Within that shallow space, the sculptors (scholars discern more than one hand) created several planes. They carved the arms and legs of those nearest a viewer in the round. In the second and third layers, the forms become shallower, yet even those farthest from a viewer do not merge into the background. The resulting relationships between figures give a dramatic sense of the turmoil of battle and an intensity of action not seen before in narrative reliefs. As at Corfu, the protagonists fill the sculptural field from top to bottom, and this compositional choice enhances the frieze's power. It is a dominant characteristic of Archaic and Classical Greek art, and in time sculptors sought ways to fill the triangular field of the pediment, too, while retaining a unity of scale. Taking

5.20 Reconstruction drawing of Treasury of the Siphnians, Sanctuary of Apollo, Delphi. ca. 525 BCE

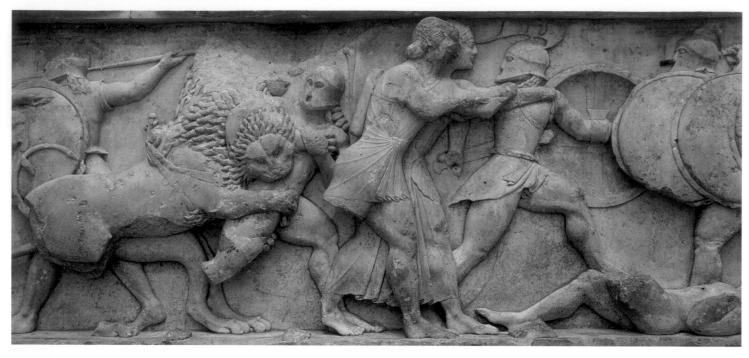

5.21 Battle of the Gods and Giants, from the north frieze of the Treasury of the Siphnians, Delphi. ca. 530 BCE. Marble, height 26" (66 cm). Archaeological Museum, Delphi

their cue, perhaps, from friezes such as that found on the Siphnian Treasury, they introduced a variety of poses for figures, and made great strides in depicting the human body in naturalistic motion. The pediments of the Temple of Aphaia at Aegina illustrate this well (see fig. 5.11).

PEDIMENTS OF THE TEMPLE OF APHAIA AT AEGINA

In ca. 480 BCE, the Aeginetans replaced the sculptures in the east pediment of their Temple of Aphaia. Scholars hypothesize that the Persian invasion of Greece may have caused damage to the earlier sculptures. The new pediment (fig. 5.22) depicts the first sack of Troy, by Herakles and Telamon, king of Salamis. The west pediment, which was not replaced at the time and dates from about 500–490 BCE, shows the second siege of Troy (recounted in *The Iliad*) by the Greek king Agamemnon, who was related to Herakles. The pairing of subjects commemorates the important role the heroes of Aegina played in both legendary battles—and, by extension, at Salamis, where their navy helped to overcome the Persians in 480. The use of allegory to elevate historical events to a universal plane is a frequent strategy in Greek art.

The figures of both pediments are fully in the round, independent of the stone background. For centuries, those of the east pediment lay in pieces on the ground, and scholars now debate their exact arrangement. All the same, they can determine the relative position of each figure within the pediment with reasonable accuracy, since the designer introduced a range of action poses for the figures, so their height, *but not their scale*, varies to suit the gently sloping sides of the pedimental field. In the center stands the goddess Athena, presiding over the battle between Greeks and Trojans that rages on either side of her. Kneeling

5.22 Reconstruction of the east pediment of the Temple of Aphaia, Aegina. Greek, ca. 500–480 BCE. Glyptothek, Staatliche Antikensammlungen, Munich, Germany

archers shoot across the pediment to unite its action. The symmetrical arrangement of poses on the two halves of the pediment creates a balanced design, so that while each figure has a clear autonomy, it also exists within a governing ornamental pattern.

A comparison of a fallen warrior from the west pediment (fig. 5.23) with its counterpart from the later east pediment (fig. 5.24) exposes the extraordinary advances sculptors made toward naturalism during the decades that separate them. As they sink to the ground in death, both figures present a clever solution to filling the difficult corner space. Yet while the earlier figure props himself up on one arm, only a precariously balanced shield supports the later warrior, whose full weight seems to pull him irresistibly to the ground. Both sculptors contorted their subjects' bodies in the agonies of death: The earlier sculptor crosses the warrior's legs in an awkward pose, while the later sculptor twists the body from the waist, so that the left shoulder moves into a new plane. Although the later warrior's anatomy still does not fully respond to his pose (note, for instance, how little the pectorals stretch to accommodate the strenuous motion of the right arm, and the misplaced navel), his body is more modeled and organic than the earlier warrior's. He also breaks from the head-on stare of his predecessor, turning his gaze to the ground that confronts him. The effect suggests introspection: The inscrutable smiling mask of the earlier warrior yields to the suffering and emotion of a warrior in his final moments of life. Depictions of suffering, and how humans respond to it, are among the most dramatic developments of late Archaic art.

Vase Painting: Art of the Symposium

A similar experimentation with figural poses and emotion occurred in Archaic vase painting, which replaced the Orientalizing style as workshops in Athens and other centers began to produce extremely fine wares, painted with scenes from mythology, legend, and everyday life. The difference between Orientalizing and Archaic vase painting is largely one of technique. On the aryballos from Corinth (see fig. 5.5), the figures appear partly as solid silhouettes, partly in outline, or as a combination of the two. Toward the end of the seventh century BCE, influenced by Corinthian products, Attic vase painters began to work in the black-figured technique: They painted the entire design in black silhouette against the reddish clay, and then incised internal details into the design with a needle. Next, they painted white and purple over the black to make chosen areas

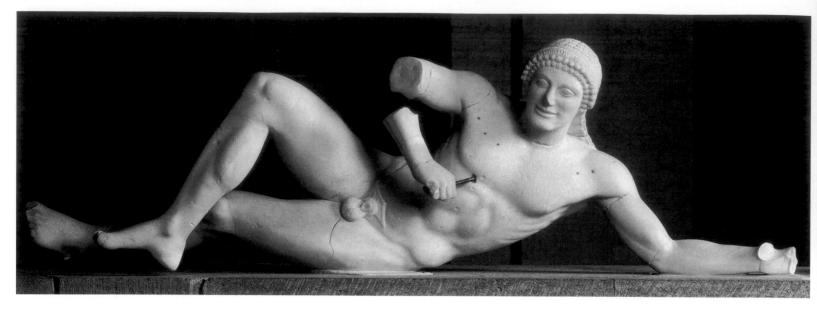

5.23 Dying Warrior, from west pediment of the Temple of Aphaia. ca. 500–490 BCE. Marble, length 5'2½" (1.59 m). Staatliche Antikensammlungen und Glyptothek, Munich

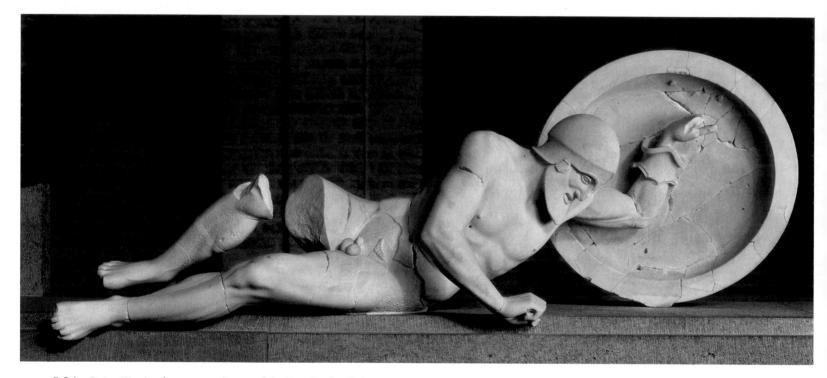

5.24 Dying Warrior, from east pediment of the Temple of Aphaia. ca. 480 BCE. Marble, length 6' (1.83 m). Staatliche Antikensammlungen und Glyptothek, Munich

stand out. The technique lent itself to a two-dimensional and highly decorative effect. This development marks the beginning of an aggressive export industry, the main consumers of which were the Etruscans. Vast numbers of black-figured vases were found in Etruscan tombs. Thus, although in terms of conception these vases (and later red-figured vessels) represent a major chapter in Greek (and specifically Athenian) art, with regard to their actual use, painted vases are a major component of Etruscan culture, both visual and funerary.

Greeks used the vases illustrated in these pages to hold wine. For everyday use, they generally poured wine from plainer, unadorned vases. They reserved decorated vases for special occasions, like the **symposium** (*symposion*), an exclusive drinking party that was a central feature of Greek life. Symposia were exclusively for men and courtesans; wives and other respectable citizen women did not attend. Participants reclined on couches around the edges of a room, and a master of ceremonies filled their cups from a large painted mixing bowl (a krater) at the

center. Music, poetry, storytelling, and word games accompanied the festivities. Often the event ended in lovemaking, which is frequently depicted on drinking cups. Sometimes this was homosexual in orientation, since it was not unusual in the fifth century BCE for a mature Greek man to have a younger male lover, for whom he acted as a social and political mentor. There was also a serious side to symposia, as described by Plato and Xenophon, which centered on debates about politics, ethics, and morality. The great issues that Greeks pondered in their philosophy, literature, and theater—the nature of virtue, the value of an individual man's life, or mortal relations with the gods, to name a few—were mirrored in, and prompted by, the images with which they surrounded themselves.

After the middle of the sixth century BCE, many of the finest vessels bear the signatures of the artists who made them, indicating the pride that potters and painters alike took in their work. In many cases, vase painters had such distinctive styles that scholars can recognize their work even without a signature, and use modern names to identify them. Dozens of vases (in one instance, over 200) might survive by the same hand, allowing scholars to trace a single painter's development over many years.

A fine example of the black-figured technique is an Athenian amphora signed by Exekias as both potter and painter, dating to the third quarter of the sixth century BCE (fig. 5.25). The painting shows the Homeric heroes Achilles and Ajax playing dice. The episode does not exist in surviving literary sources, and its appearance here hints at a wide field of lost traditions that may have inspired Exekias. The two figures lean on their spears; their shields are stacked behind them against the inside of a campaign tent. The black silhouettes create a rhythmical composition, symmetrical around the table in the center. Within the black paint, Exekias incised a wealth of detail, focusing especially upon the warriors' cloaks; their intricately woven texture contrasts with the lustrous blackness of their weapons.

The extraordinary power of this scene derives from the tension within it. The warriors have stolen a moment of relaxation during a fierce war; even so, poised on the edge of their stools, one heel raised as if to spring into action, their poses are edgy. An inscription on the right reads "three," as if Ajax is calling out his throw. Achilles, who in his helmet slightly dominates the scene, answers with "four," making him the winner. Yet many Greek viewers would have understood the irony of the scene, for when they return to battle, Achilles will die, and Ajax will be left to bear his friend's lifeless body back to the Greek camp, before falling on his own sword in despair. Indeed, Exekias himself would paint representations of the heroes' tragic deaths. This amphora is the first known representation of the gaming scene, which subsequently became popular, suggesting that vase paintings did not exist in artistic isolation; painters responded to one another's work in a close and often clever dialogue.

Athenian vase painters seem to have intended most of the scenes on their vessels for a male audience. There are cases, however, when vases reflect female life and appear to be intended for a female audience. A black-figured hydria (water jar) by the

Priam Painter is one such vase (fig. 5.26). The belly of the water jug shows a scene in a columned fountain house, where three women collect water into hydriai from animal-headed spigots, and a fourth supports a hydria on her head. Their poses, with knees and arms raised, allow the painter to experiment with figural movement. The animated gesture of a fifth woman reflects the fact that, for Athenian women, the daily outing to the public fountain house was the only opportunity to leave the confines of the home; the fountain house represented a rare chance to socialize outside the immediate family.

Despite its decorative potential, the silhouettelike black-figured technique limited artists to incision for detail, leading them to develop the reverse procedure of leaving the figures red and filling in the background. This **red-figured** technique gradually replaced the older method between 520 and 500 BCE. The effects of the change would become increasingly evident in the decades to come, but they are already discernible on an amphora of about

5.25 Exekias. *Achilles and Ajax Playing Dice.* Black-figured amphora. ca. 540–530 BCE. Height 2' (61 cm). Vatican Museums

5.26 Priam Painter. Women at a fountain house. 520–510 BCE. Black-figured hydria. Ceramic. Height 201/8" (53 cm). Museum of Fine Arts, Boston, William Francis Warden Fund, 1961. 61.195

510–500 BCE, signed by Euthymides (fig. 5.27). No longer is the scene so dependent on profiles. The painter's new freedom with the brush translates into a freedom of movement in the dancing revelers he represents. They cavort in a range of poses, twisting their bodies and showing off Euthymides' confidence in rendering human anatomy. The shoulder blades of the central figure, for instance, one higher than the other, reflect the motion of his raised arm. The turning poses allow Euthymides to tackle foreshortening, as he portrays the different planes of the body (the turning shoulders, for instance) on a single surface. This was an age of intensive and self-conscious experimentation; indeed, so pleased was Euthymides with his painting that he inscribed a taunting challenge to a fellow painter: "As never Euphronios."

On a slightly later kylix (wine cup) by Douris, dating to 490–480 BCE, Eos, the goddess of dawn, tenderly lifts the limp body of her dead son, Memnon, whom Achilles killed after their mothers sought the intervention of Zeus (fig. 5.28). Douris traces the contours of limbs beneath the drapery, and balances vigorous outlines with more delicate secondary strokes, such as those indicating the anatomical details of Memnon's body. The dead weight of Memnon's body contrasts with the lift of Eos' wings, an ironic commentary, perhaps, on how Zeus decided between the two warriors by weighing their souls on a scale that tipped against

5.27 Euthymides. *Dancing Revelers*. Red-figured amphora. ca. 510–500 BCE. Height 2' (60 cm). Museum Antiker Kleinkunst, Munich

5.28 Douris. Eos and Memnon. Interior of an Attic red-figured kylix. ca. 490–480 BCE. Ceramic. Diameter 10½" (26.7 cm). Musée du Louvre, Paris

Memnon. After killing him, Achilles stripped off Memnon's armor as an act of humiliation, and where the figures overlap in the image, the gentle folds of Eos' flowing chiton set off Memnon's nudity. His vulnerability in turn underlines his mother's desperate grief at being unable to help her son.

At the core of the image is raw emotion. Douris tenderly exposes the suffering caused by intransigent fate, and the callousness of the gods who intervene in mortal lives. In this mythological scene, Athenians may have seen a reflection of themselves during the horrors of the Persian Wars of 490–479 BCE. Indeed, an inscription brings the vase into the realm of everyday life, with the signatures of both painter and potter, as well as a dedication typical of Greek vases: "Hermogenes is beautiful."

THE CLASSICAL AGE

The beginning of the fifth century BCE brought crisis. A number of Ionian cities rebelled against their Persian overlords, and after Athens came to their support, the Persians invaded the Greek mainland, under the leadership of Darius I. At the Battle of Marathon in 490 BCE, a contingent of about 10,000 Athenians, with a battalion from nearby Plataea, repulsed a force of about 90,000 Persians. Ten years later, an even larger force of Persians returned under Darius' son, Xerxes I. Defeating a Spartan force at Thermopylae, they took control of Athens, burning and pillaging temples and statues. The Greeks fought them again at Salamis and Plataea in 480-479 BCE, and finally defeated them. These battles were defining moments for the Greeks, who first faced destruction in their cities, and then emerged triumphant and confident after the horrors of invasion. At least in Athens, Persian destruction of public monuments and space is visible in the archaeological record, and, for archaeologists and art historians, signals the end of the Archaic period. The period stretching from the end of the Persian Wars to the death of Alexander the Great in the late fourth century BCE is known as the Classical Age. During this time, architects and sculptors alike sought visual harmony in proportional systems, and artists achieved a heightened naturalism in depicting the human form.

The struggle against the Persians tested the recently established Athenian democracy. Athens emerged from the war as the leader of the Delian League, a defensive alliance against the Persians, which quickly evolved into a political and economic empire that facilitated many architectural and artistic projects. The Classical era was when the playwrights whose names are still so familiar—Aristophanes, Aeschylus, Sophocles, and Euripides—were penning comedies and tragedies for performance at religious festivals, and thinkers like Socrates and Plato, and then Aristotle, engaged in their philosophical quests. Perhaps the most influential political leader of the day was Perikles, who came to the forefront of Athenian public life in the mid-fifth century BCE, and played a critical role in the city's history until his death in 429 BCE. An avid patron of the arts, he focused much of his attention on beautifying the city's highest point or Akropolis.

Classical Sculpture

The Persian sack of 480 BCE left the Athenian Akropolis in ruins. Among many statues that were once dedications there and were later excavated from the debris, one kouros stands apart (fig. 5.29). Archaeologists sometimes attribute it to the Athenian sculptor Kritios, and know it as the *Kritios Boy*. On account of its

5.29 Kritios Boy. ca. 480 BCE. Marble, height 46" (116.7 cm). Akropolis Museum, Athens

5.30 *Charioteer from Motya*, Sicily. ca. 450–440 BCE. Marble, height 6'3" (1.9 m). Museo Giuseppe Whitaker, Motya

findspot, they date it to shortly before the Persian attack. It differs significantly from earlier, Archaic kouroi (see figs. 5.14 and 5.15), not least because it is the first surviving statue that stands in the full sense of the word. Although the earlier figures are in an upright position—instead of reclining, sitting, kneeling, or running—their stance is really an arrested walk, with the body's weight resting evenly on both legs. This pose is nonnaturalistic

and rigid. The Kritios Boy has one leg forward like earlier kouroi, yet an important change has occurred. The sculptor has shifted the youth's weight, creating a calculated asymmetry in the two sides of his body. The knee of the forward leg is lower than the other, the right hip is thrust down and in, and the left hip up and out. The axis of the body is not a straight vertical line, but a reversed S-curve. Taken together, these small departures from symmetry indicate that the youth's weight rests mainly on the left leg, while the right leg acts as a prop to help balance the body.

The Kritios Boy not only stands; he stands at ease. The artist masterfully observed the balanced asymmetry of this relaxed natural stance, which is known to ancient art historians as a chiastic pose (from "\chi," the Greek letter chi), and to Renaissance art historians as contrapposto (Italian for "counterpoise"). The leg that carries the main weight is called the engaged leg, the other, the free leg. This simple observation led to radical results, for with it came a recognition that if one part of the body is engaged in a task, other parts respond. Bending the free knee results in a slight swiveling of the pelvis, a compensating curvature of the spine, and an adjusting tilt of the shoulders. This unified approach to the body led artists to represent movement with a new naturalism. Indeed, even though the Kritios Boy is at rest, his muscles suggest motion, and the sculpture has life; he seems capable of action. At the same time, the artist recognized that strict adherence to nature would not always yield the desired result. So, as in the later Parthenon (see pages 131-37), refinements are at work. The sculptor exaggerated the line of muscles over the pelvis to create a greater unity between thighs and torso, and a more fluid transition from front to back. This emphasized the sculpture's three-dimensionality, and encouraged a viewer to move around it.

The innovative movement in the musculature gives a viewer the sense, for the first time, that muscles lie beneath the surface of the marble skin, and that a skeleton articulates the whole as a real organism. A new treatment of the flesh and the marble's surface adds to this impression: The flesh has a soft sensuousness that is quite alien to earlier kouroi, and the sculptor has worked the surface of the marble to a gentle polish. Gone, also, is the Archaic smile. The face has a soft fleshiness to it, especially marked around the chin, which is characteristic of sculpture in the early Classical period. The head is turned slightly away from the front, removing the direct gaze of earlier kouroi and casting the figure into his own world of thought.

A sculpture discovered in the Graeco-Punic settlement of Motya in western Sicily exhibits a similar sensuousness (see map 5.1 and fig. 5.30). Like the *Kritios Boy*, it represents a youth standing in a sinuous chiastic pose, his head turned from a frontal axis. The sculptor has used the fine fabric of a charioteer's tunic to "mask" the full curves of the body, revealing the flesh while simultaneously concealing it. Athletic contests were a prominent component of male life in Greece and its colonies. Greeks viewed physical prowess as a virtue, and victors in games won a measure of fame. Sculptures like this one, set up in public places, commemorated their success.

5.31 Zeus. ca. 460–450 BCE. Bronze, height 6'10" (1.9 m). National Archaeological Museum, Athens. Ministry of Culture Archaeological Receipts Fund. 15161

The Kritios Boy marks a critical point in Greek art. One of the changes it engendered was a wholehearted exploration of the representation of movement, another hallmark of early Classical sculpture. A magnificent nude bronze dating to about 460–450 BCE recovered from the sea near the Greek coast (fig. 5.31) was probably in the cargo of a Roman vessel that sank on its voyage to Italy. At almost 7 feet tall, it depicts a spread-eagled male figure in the act of throwing—probably Zeus casting a thunderbolt,

or Poseidon throwing his trident. In a single figure, the sculptor captures and contrasts vigorous action and firm stability. The result is a work of outright grandeur, expressing the god's aweinspiring power. The piece shows off not only the artist's understanding of bodies in motion, but also an expert knowledge of the strengths of bronze, which allowed the god's arms to stretch out without support. (See *Materials and Techniques*, page 128.) Some ten years later, in about 450 BCE, a sculptor named Myron created a

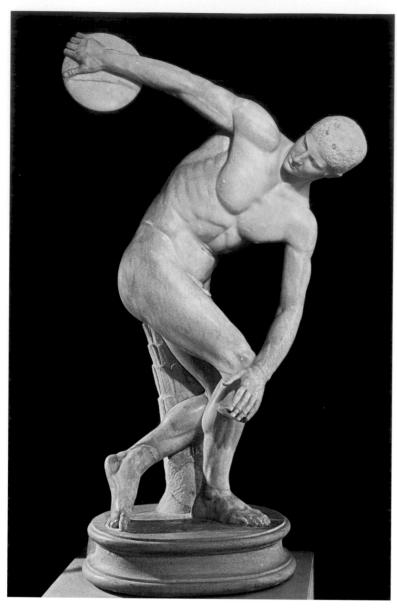

5.32 Diskobolos (Discus Thrower). Roman copy after a bronze original of ca. 450 BCE by Myron. Marble, life-size. Museo delle Terme, Rome

bronze statue of another athlete, a discus thrower, the *Diskobolos*, which earned great renown in its own time. Like most Greek sculptures in bronze, it is known to us only from Roman copies (fig. 5.32). (See www.myartslab.com.) If the bronze Zeus suggested impending motion by portraying the moment before it occurred, Myron condensed a sequence of movements into a single pose, achieved through a violent twist of the torso that brings the arms into the same plane as the legs. The pose conveys the essence of the action by presenting the coiled figure in perfect balance.

THE DORYPHOROS: IDEALS OF PROPORTION AND HARMONY Within half a century of the innovations witnessed in the Kritios Boy, sculptors were avidly exploring the body's articulation. One of those sculptors was Polykleitos of Argos, whose most famous work, the Doryphoros (Spear Bearer) (fig.

5.33 *Doryphoros (Spear Bearer)*. Roman copy after an original of ca. 450–440 BCE by Polykleitos. Marble, height 6'6" (2 m). Museo Archaeologico Nazionale, Naples

5.33), is known to us through numerous Roman copies. In this sculpture, the chiastic pose is much more emphatic than in the Kritios Boy, the turn of the head more pronounced. Polykleitos seems to delight in the possibilities the pose offers, examining how the anatomy on the two sides of the body responds to it. The "working" left arm balances the engaged right leg in the forward position, and the relaxed right arm balances the free left leg. Yet, in this sculpture, Polykleitos did more than study anatomy. He explored principles of commensurability, symmetria, where part related to part, and all the parts to the whole: He proposed an ideal system of proportions, not just for individual elements of the body but for their relation to one another and to the body as a whole. He also addressed rhythmos (composition and movement). According to one ancient writer, Greeks knew this work as his kanon (canon, meaning "rule" or "measure"). (See www.mvartslab.com.) Egyptian artists had earlier aimed to establish guidelines for depiction based on proportion. Yet for Polykleitos, the search for an ideal system of proportions was more than an artist's aid: It was rooted in a philosophical quest for illumination, and in a belief that harmony (harmonia)-in the universe, as in music and in all things-could be expressed in mathematical terms. Only slightly later than this sculpture, Plato would root his doctrine of ideal forms in numbers, and acknowledge that beauty was commonly based on proportion. Philosophers even referred to works of art to illustrate their theories. Morcover, beauty was more than an idle conceit for Classical Athenians; it also had a moral dimension. Pose and expression reflected character and feeling, which revealed the inner person and, with it, arete (excellence or virtue). Thus contemplation of harmonious proportions could be equated with the contemplation of virtue. (See Primary Source, page 133.)

Much of the Doryphoros' original appearance may have been lost in the copy-making process: Bronze and marble differ greatly in both texture and presence. Surviving Greek bronzes are extremely rare, and when a pair of over-life-size figures was found in the sea near Riace, Italy, in 1972, they created a sensation (fig. 5.34). Their state of preservation is outstanding, and shows off to advantage the extraordinarily fine workmanship. Greek sculptors used a refined version of the lost-wax technique familiar to Near Eastern artists. The process differs radically from cutting away stone, since the technique is additive (the artist builds the clay model in the first phase of the process). Further, where marble absorbs light, a bronze surface reflects it, and this led sculptors to explore a variety of surface textures—for hair and skin, for instance. They could add different materials for details: These statues have ivory and glass-paste eyes, bronze eyelashes, and copper lips and nipples. Statue A (or Riace Warrior A), shown here, has silver teeth. Who these figures represented is still unknown: a pair of heroes, perhaps, or warriors. They may have formed part of a single monument. Though they strike similar poses, the men have differing body types, which has led some scholars to date them apart and attribute them to two separate sculptors. They could equally be the work of a single artist exploring the representation of character and age.

5.34 Riace Warrior A, found in the sea off Riace, Italy. ca. 450 BCE. Bronze, height 6'8" (2.03 m). Museo Archaeologico, Reggio Calabria, Italy

THE SCULPTURES OF THE TEMPLE OF ZEUS, OLYMPIA

The Riace bronzes may once have stood in a sanctuary, where Greeks customarily celebrated great men. There, they were in the presence of the gods, whose temples featured additional sculpture

The Indirect Lost-Wax Process

Zeus (see fig. 5.31) is one of the earliest surviving Greek statues that was made by the indirect lost-wax process. This technique enables sculptors to create spatially freer forms than they can in stone. They make projecting limbs separately and solder them onto the torso, and no longer need to support them using unsightly struts. Compare, for example, the freely outstretched arms of the Zeus with the strut extending from hip to drapery on the Aphrodite of Knidos (see fig. 5.56).

The Egyptians, Minoans, and early Greeks had often made statuettes of solid bronze using the *direct* lost-wax process. The technique was simple. The sculptor modeled his figure in wax; covered it with clay to form a mold; heated out the wax; melted copper and tin in the ratio of nine parts to one in a crucible; and poured this alloy into the space left by the "lost wax" in the clay mold. Yet, because figures made in this way were solid, the method had severe limitations. A solid-cast life-size statue would have been prohibitively expensive, incredibly heavy, and prone to developing bubbles and cracks as the alloy cooled. So from the eighth through the sixth centuries BCE, the Greeks developed the *indirect* lost-wax method, which allowed them to cast statues hollow and at any scale.

First, the sculptor shaped a core of clay into the basic form of the intended metal statue, before covering this core with a layer of wax to the thickness of the final metal casting, and carving the details of the statue carefully in the wax. The figure was then sectioned into its component parts—head, torso, limbs, and so on. For each part, the artist applied a heavy outer layer of clay over the wax and secured it to the

inner core with metal pegs. The package was then heated to melt the wax, which ran out. Molten metal—usually bronze, but sometimes silver or gold—was then poured into the space left by this "lost wax." When the molten metal cooled, the outer and inner molds were broken away, leaving a metal casting—the statue's head, torso, or arm—and these individual sections were then soldered together to create the statue. The sculptor completed the work by polishing the surface, chiseling details such as strands of hair and skin folds, and inlaying features such as eyes, teeth, lips, nipples, and dress patterns in ivory, stone, glass, copper, or precious metal.

The indirect lost-wax process

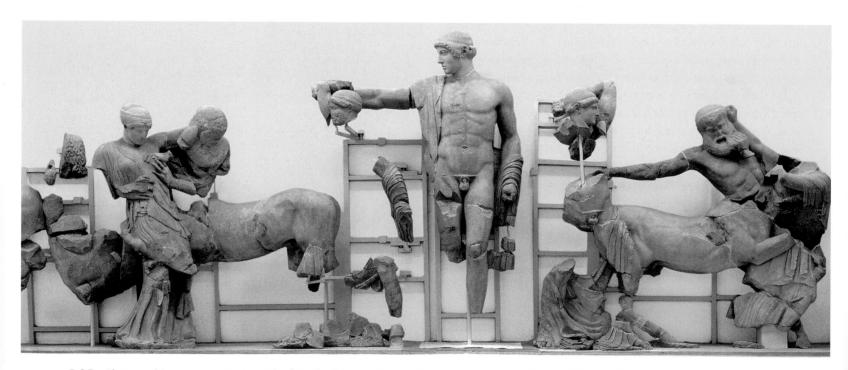

5.35 Photographic reconstruction (partial) of *Battle of the Lapiths and Centaurs*, from west pediment of Temple of Zeus at Olympia. ca. 460 BCE. Marble, slightly over-life-size. Archaeological Museum, Olympia

as ornamentation. The chief temple in the sanctuary at Olympia honored Zeus. Spoils from a victory of Elis over its neighbor Pisa in 470 BCE provided funds for the temple's construction, to a design by the architect Libon from Elis. Its fragmentary pediments, perhaps the work of Ageladas from nearby Argos in about 460 BCE, are highpoints of the early Classical style, and are reassembled in the Archaeological Museum at Olympia. In the east pediment, mythology provides an analogy for the recent victory, as at Aegina. The subject is the triumph of Pelops over Oinomaos, king of Pisa, in a chariot race, for which the prize was the hand of the king's daughter, Hippodameia. Pelops (for whom the Peloponnesos is named) was an important figure for Greeks, for they credited him with founding the athletic games at Olympia. Yet he prevailed in the race by trickery, with the result that he and his descendants, including Agamemnon, king of Mycenae, lived under a curse. Thus, the myth was topical in a second way: Pelops' example served as a warning against foul play to Olympic contestants as they paraded past the temple.

The west pediment represents the struggle of the Lapiths, a tribe from Thessaly, with the centaurs (a centauromachy) (fig. 5.35). Centaurs were the offspring of Ixion, king of the Lapiths, and Hera, whom he tried to seduce while in Olympos (with the result that Ixion was chained forever to a fiery wheel in Tartarus). As half-brothers of the Lapiths, the centaurs were guests at the wedding of the Lapith king Peirithoös and Deidameia. Unable to tolerate alcohol, they got into a drunken brawl with the Lapiths, who subdued them with the aid of Peirithoös' friend Theseus.

At the center of the composition stands the commanding figure of Apollo. His outstretched right arm, the strong turn of his head, and his powerful gaze show his engagement in the drama, as he wills the Lapiths to victory. At the same time, his calm, static pose removes him from the action unfolding around him; he does not help physically. To the left of Apollo, the centaur king, Eurytion, has seized Hippodamcia. Both figures are massive and simple in form, with soft contours and undulating surfaces. The artist entangled them in a compact interlocking group, which is quite different from the individual conflicts of the Aegina figures. Moreover, the artist expressed their struggle in more than action and gesture: The centaur's face mirrors his anguish, and his pain and desperate effort contrast vividly with the calm on the young bride's face. In setting the centaurs' evident suffering against the emotionlessness of the Lapiths, the pediment draws a moral distinction between the bestial centaurs and the civilized humans, who share in Apollo's remote nobility. Apollo, god of music and poetry but also of light and reason, epitomizes rational behavior in the face of adversity. By partaking in divine reason, humans triumph over animal nature. This conflict between the rational and the irrational, order and chaos, lay at the heart of Greek art, both in its subject matter and in its very forms. It exposes the Greeks' sense of themselves, representing civilization in the face of barbarianism—always neatly encapsulated in the Persians.

Like the west pediment, the east pediment may have had a local relevance, encouraging fair play among Olympic competitors.

The metopes were certainly topical: They depict the labors of Herakles, Pelops' great-grandson, who according to legend laid out the stadium at Olympia. Narrative scenes had been a feature of metopes since the early sixth century BCE, but at Olympia the designer exploited the pictorial and dramatic possibilities fully for the first time. The metope illustrated here, which was inserted prominently over the entrance on the temple's east side, shows Atlas returning to Herakles with the apples of the Hesperides (fig. 5.36). Atlas was one of the Titans, the race of gods before the Olympians, and it was his charge to support the Earth on his shoulders. Herakles agreed to hold the world for him, and thus persuaded Atlas to go to the gardens of the Hesperides to fetch the apples in fulfillment of his final labor. On returning, Atlas refused to accept his burden back, until Herakles cheated him into doing so. In the metope, Herakles supports a cushion (which held the globe) on his shoulders, with the seemingly effortless assistance of a young Athena. He eyes the apples as he tries to conceive of a way to trick Atlas into giving them up. This is not the grim combat so characteristic of Archaic Greek art (see figs. 5.23 and 5.24); the burly Herakles has assumed the thoughtful air that is central to the Classical spirit. The figures have all the characteristics of early Classical sculpture: fleshy faces (often described as "doughy"), an economy of pose and expression, and simple, solemn drapery.

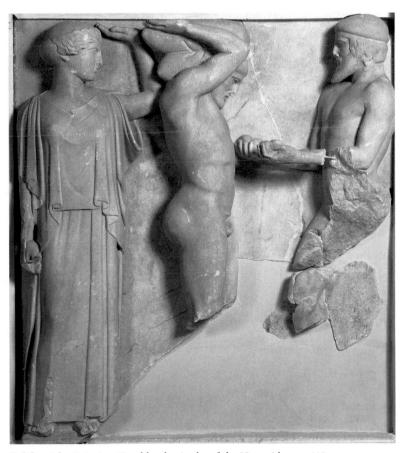

5.36 Atlas Bringing Herakles the Apples of the Hesperides. ca. 460 BCE. Marble, height 63" (160 cm). Archaeological Museum, Olympia

5.38 Akropolis (view from west), Athens. Propylaia, 437–432 BCE; with Temple of Athena Nike, 427–424 BCE

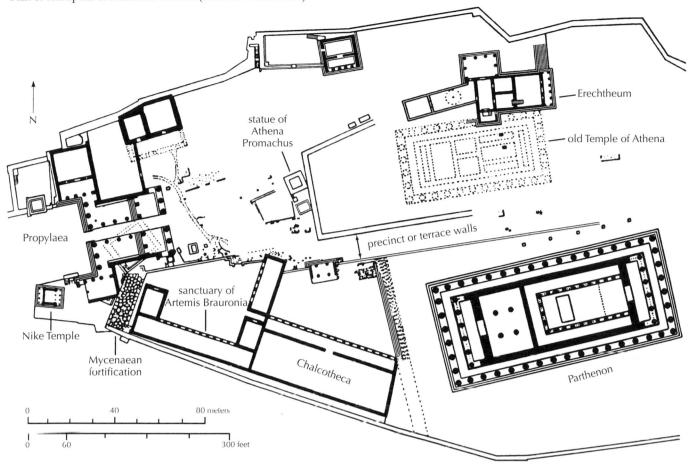

Architecture and Sculpture on the Athenian Akropolis

As in many Greek cities, the principal centers of Athenian public life were the agora and the Akropolis. The agora (fig. 5.37) was primarily a marketplace, but as time passed Athenians dedicated temples and civic buildings such as stoas (colonnaded porticoes) there, and the space took on a monumental character. The Akropolis had been a fortified site since Mycenaean times, around 1250 BCE (figs. 5.38 and 5.39). During the Archaic period, it was home to at least one sizeable temple dedicated to the city's patron goddess, Athena, as well as several smaller temples or treasuries, and votive statues. For over 30 years after the Persian sack of 480 BCE, the Athenians left the sacred monuments on the Akropolis in ruins, as a solemn reminder of the enemy's ruthlessness. This changed in the mid-fifth century BCE, with the emergence of Perikles into political life. Perikles' ambitions for Athens included transforming the city—with its population of about 150,000 into the envy of the Mediterranean world. His projects, which the democratic assembly approved, began on the Akropolis. Individually and collectively, the structures there expressed the ideals of the Athenian city-state, and have come to exemplify Classical Greek art at its height. (See www.myartslab.com.)

THE PARTHENON The dominant temple on the Akropolis is the Parthenon (fig. 5.40). Perikles conceived it to play a focal role in the cult of Athena, though there is no evidence that Athenians used it directly for cult practices; there is no altar to the east, and the chief center of cult practice remained on the site of the Erechtheion, north of the Parthenon (see fig. 5.51). Built of gleaming white marble from nearby Mount Pentelikon, the Parthenon occupies a prominent site on the southern flank of the Akropolis. From there it dominates the city and the surrounding countryside, a brilliant landmark against the backdrop of mountains to the north, east, and west. Contemporary building records, and a biography of Perikles written by the Greek historian Plutarch, indicate that two architects named Iktinos and Kallikrates oversaw its construction between 447 and 432 BCE. To meet the expense of building the largest and most lavish temple of its time on the Greek mainland, Perikles resorted in part to funds collected from the Delian League, its allies against the Persians. Perhaps the Persian danger no longer seemed real; still, the use of these funds weakened Athens' position in relation to its allies. Centuries later, Plutarch still remembered accusations against Perikles for adorning the city "like a harlot with precious stones, statues, and temples costing a thousand talents."

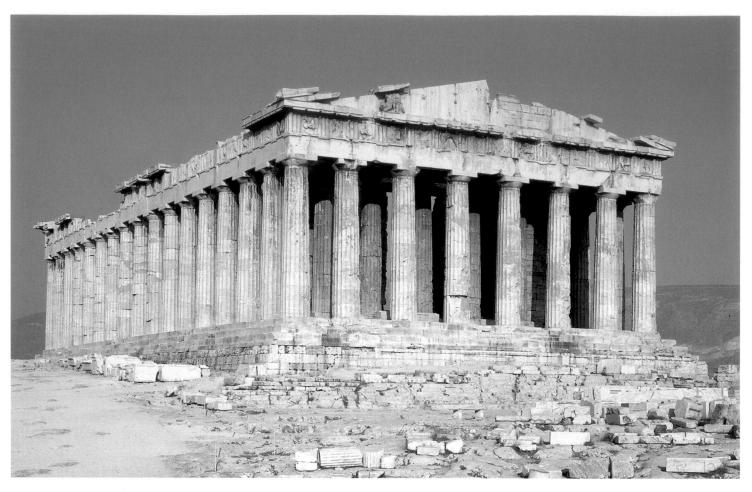

5.40 Iktinos and Kallikrates. The Parthenon (view from the west). Akropolis, Athens. 447–432 BCE

When read against the architectural vocabulary of Classical Greece, the Parthenon emerges as an extraordinarily sophisticated building. Its parts integrate fully with one another, so that its spaces do not seem to be separate, but to melt into one another. Likewise, architecture and sculpture are so intertwined that discussion of the two cannot be disentangled. The temple stood near the culminating point of a grand procession that wound its way through the agora and onto the Akropolis during the Panathenaic festival in Athena's honor; as magnificent as it was to observe from a distance, it was also a building to experience from within. Imitating the grandiose temples of Archaic Ionia, the Parthenon featured an octastyle (eight-column) arrangement of its narrow ends. This was unusually wide, offering a generous embrace and enough space for an arrangement of a U-shaped colonnade in the cella and an enormous statue of Athena by the famed sculptor Pheidias. She stood with one hand supporting a personification of Victory, and a shield resting against her side. Pheidias fashioned the figure out of ivory and gold (a combination known as chryselephantine), supported on a wooden armature (fig. 5.41). It was extraordinarily valuable, and the building's forms drew visitors in to view it. Like all peripteral temples, the encircling colonnade gave the impression that a visitor could approach the temple from all sides. In fact, a prostyle porch of six columns (where the columns stand in front of the side walls, rather than between

them) mediated entry to the cella at the east end, and to an **opisthonaos** (rear room), on the west, containing four tall, slender Ionic columns. The porches are unusually shallow. This allowed light into the cella, which otherwise came in through two large windows on either side of the cella's main entrance. In its combination of a well-lit interior and the rational articulation of the interior space with a colonnade, the Parthenon initiated a new interest in the embellishment of interior space.

Compared with the Temple of Hera II at Paestum (see fig. 5.9, right), the Parthenon appears far less massive, despite its greater size. One of the reasons for this is a lightening and an adjusting of proportions since the Archaic period. The columns are more slender, their tapering and entasis less pronounced, and the capitals are smaller and less flaring. Practical necessity partly determined the diameter of the columns: For convenience and economy, the architects reused many drums from the earlier Parthenon, still unfinished at the time of the Persian sack. Yet how these columns would relate to the rest of the building was a matter for new design. Their spacing, for instance, is wider than in earlier buildings. The entablature is lower in relation to their height and to the temple's width, and the cornice (protruding horizontal element) projects less. The load the columns carry seems to have decreased, and as a result the supports appear able to fulfill their task with a new ease.

Aristotle (384–322) BCE

The Politics, from Book VIII

The Politics is a counterpart to Plato's Republic, a treatment of the constitution of the state. Books VII and VIII discuss the education prescribed for good citizens. Drawing is included as a liberal art—that is, a skill not only useful but also conducive to higher activities. Yet painting and sculpture are said to have only limited power to move the soul.

There is a sort of education in which parents should train their sons, not as being useful or necessary, but because it is liberal or noble. ... Further, it is clear that children should be instructed in some useful things—for example, in reading and writing—not only for their usefulness, but also because many other sorts of knowledge are acquired through them. With a like view they may be taught drawing, not to prevent their making mistakes in their own purchases, or in order that they may not be imposed upon in the buying or selling of

articles [works of art], but perhaps rather because it makes them judges of the beauty of the human form. To be always seeking after the useful does not become free and exalted souls. ...

The habit of feeling pleasure or pain at mere representations is not far removed from the same feeling about realities; for example, if any one delights in the sight of a statue for its beauty only, it necessarily follows that the sight of the original will be pleasant to him. The objects of no other sense, such as taste or touch, have any resemblance to moral qualities; in visible objects there is only a little, for there are figures which are of a moral character, but only to a slight extent, and all do not participate in the feeling about them. Again, figures and colors are not imitations, but signs, of character, indications which the body gives of states of feeling. The connexion of them with morals is slight, but in so far as there is any, young men should be taught to look ... at [the works] of Polygnotus, or any other painter or sculptor who expresses character.

Source: Aristotle, *The Politics*, ed. Stephen Everson (NY: Cambridge University Press, 1988)

Like Polykleitos, Iktinos and Kallikrates grappled with issues of commensurability. The governing principle behind their design was a ratio of 9:4 or 2x + 1:x. Thus, for instance, the 8 (x) columns across the façades answer seventeen (x + 1) columns along the sides. Additionally, the ratio of the spacing between two columns (the intercolumniation) to the diameter at the lowest point of the

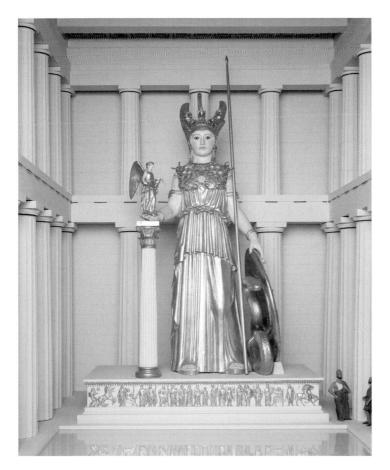

column was 9:4. It was not just a matter of design convenience, but an attempt to produce harmony through numerical relationships. Libon of Elis first used this proportional scheme in the Temple of Zeus at Olympia. Iktinos and Kallikrates employed it pervasively in the Parthenon, though never dogmatically. In fact, despite the relative precision the formula dictated, they built intentional departures from the design's strict geometric regularity into the Parthenon (as architects did in other temples). For instance, the columns are not vertical, but lean in toward the cella (the corner columns in two directions), and the space between the corner column and its neighbors is smaller than the standard intercolumniation of the colonnade as a whole. Moreover, the stepped platform on which the temple rests is not fully horizontal, but bows upward, so that the center of the long sides is about 4 inches higher than the corners. This curvature reflects up through the temple's entablature, and every column capital is slightly distorted to fit the bowed architrave. That these irregularities were intentional is beyond doubt, as masons tailormade individual blocks to accommodate them. Why they were desirable is less clear.

When architects first introduced irregularities into temple architecture, some 100 years earlier, they may have intended to solve drainage problems. Yet in the Parthenon, they are so exaggerated that scholars consider them to be corrections of optical illusions. For instance, when viewed from a distance, straight horizontals appear to sag, but if the horizontals curve upward, they look straight. When seen close up, a long straight line seems to curve like the horizon; by exaggerating the curve, the architects could make the temple appear even larger than it was. These two apparently contradictory theories could work in tandem, since different optical distortions would prevail depending on a viewer's vantage point. What is certain is that these refinements

5.41 Model of *Athena Parthenos* by Pheidias. ca. 438 BCE. Royal Ontario Museum, Toronto

Repatriation of Cultural Heritage

n 2008, a new Acropolis Museum in Athens opened for preliminary viewing. Swiss-French architect Bernard Tschumi designed the museum to hold finds from the Akropolis; but it also incorporates a hall to house the Elgin Marbles from the Parthenon, a move designed to put pressure on the British Museum in London to send them home. Ever since 1978, when UNESCO established a department entitled the Intergovernmental Committee for Promoting the Return of Cultural Property to its Countries of Origin or its Restitution in Case of Illicit Appropriation, the Elgin Marbles have stood at the center of a heated debate on the repatriation of antiquities: Should museums around the world be required to return objects of cultural value to their countries of origin? And should museums purchase works of art that have been illegally trafficked? Recently, the Italian government made headlines by publicly requesting the return of objects illegally looted from Italy and purchased (generally in good faith) by museums in the United States. And to celebrate the successful outcome of negotiations with museums such as the Metropolitan Museum of Art in New York, the Boston Museum of Fine Arts, and the Getty, it mounted a free exhibition of works of art that had "come home," in the Italian president's Quirinal Palace.

The issues might seem straightforward, but repatriation and museum acquisition of illegally trafficked objects are actually complex questions. It is understandable that a country should want to retain its cultural heritage. Moreover, for archaeologists, objects removed by looting lose much of their value (see *The Art Historian's Lens*, page 29). Yet the grand-scale return of works of art to their home countries would cut the heart out of many established museums with valuable educational functions. Should all objects be returned, or just the more outstanding works of art—in which case, who should make such a

qualitative judgment? If repatriation were to apply only to recent acquisitions, how long must an object's pedigree be to make it legal? If looting is inevitable, is it better that a museum purchase illegal objects and display them publicly, or that they should disappear into private collections? Is it better for a work of art to decay in its home country if conditions there prevent adequate preservation, or to be maintained elsewhere? And what if an individual or museum purchased antiquities legally from an invading force (such as the Ottoman authorities, who controlled Greece in Lord Elgin's day)? Such issues are not easily resolved.

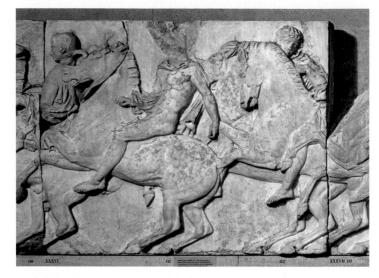

North frieze of the Parthenon

give the temple a dynamic quality that it might otherwise lack. Rather than sitting quietly on its platform, the building derives energy from its swelling forms as if it were about to burst out of its own skin; through the refinements, the temple comes alive.

THE PARTHENON SCULPTURES The largest group of surviving Classical sculptures comes from the Parthenon, which had a more extensive decorative program than any previous temple. The sculptures have a vivid and often unfortunate history.

Christians converted the temple into a church, probably in the sixth century CE, and much of the decoration on the east side was destroyed or vandalized. In 1687, Venetian cannon fire ignited ammunition that the Turkish forces were storing in the temple. The west pediment figures survived the explosion, but not the war's aftermath. They shattered when a crane dropped them while removing them so that the Venetian commander could take them to Venice. Over 100 years later, Lord Elgin, British ambassador to Constantinople, purchased what he could of the temple's

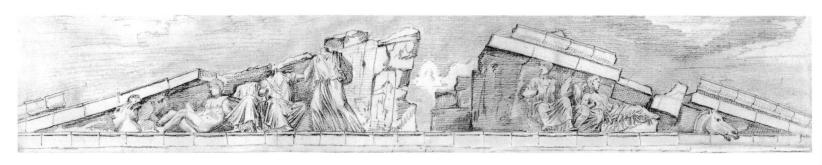

5.42 Jacques Carrey. Drawings of east pediment of the Parthenon. 1674 CE. Bibliothèque Nationale, Paris

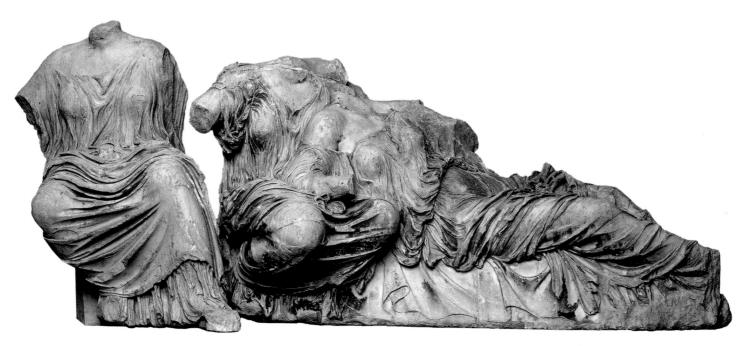

5.43 Three goddesses, from east pediment of the Parthenon. ca. 438–432 BCE. Marble, over-life-size. The British Museum, London

decoration from the Turks and shipped it to England. In 1816, needing money, he sold it to the British Museum. Today, the Elgin Marbles, as they are known, stand at the center of a heated debate on the repatriation of national treasures. (See The Art Historian's Lens, page 134.)

Thirteen years before the explosion in the Parthenon, an artist named Jacques Carrey was traveling in Athens as part of the retinue of the French ambassador to the Ottoman court. He executed a series of drawings of surviving Parthenon sculptures, which, along with literary sources, have become invaluable resources for understanding the decorative program as a whole (fig. 5.42). Like the sculptures on the Temple of Zeus at Olympia, the Parthenon sculptures had topical relevance. The west pediment portrayed the struggle between Athena and Poseidon to be Athens' patron deity. The east pediment represented the birth of Athena from the head of Zeus, in the presence of other gods. All but the central figures survive, and Carrey's drawing allows for a confident reconstruction of their arrangement. Bursting from the left corner is the upper body of Helios, the sun-god, whose rearing horses draw him into view. Balancing him in the right corner, Selene, the moon-goddess, or Nyx, the night, sinks away with her horses. These celestial gods define the day's passing, and place the scene in an eternal cosmic realm. To the right of Helios, a nude male figure in a semireclining position is probably Dionysos. On the other side of the pediment, a closely knit group of three female deities was long identified as Hestia, Dione, and Aphrodite. A recent analysis of the group sees them instead as Leto, Artemis, and Aphrodite (fig. 5.43).

As a group, the pediment figures are strikingly impressive. Like the building in which they are embedded, their forms are strong and solid, yet their implied power contrasts with their languid poses and gains strength from the contrast. The female group is a masterpiece of swirling drapery, which disguises the sheer bulk of the marble. The garments cling to the bodies beneath as if wet, both concealing and revealing flesh. Yet the drapery does not follow the lines of the body, as it does on the Charioteer of Motya (see fig. 5.30), so much as struggle with them, twisting around the legs in massive folds. The effect is extraordinary: Although a viewer can only see the deities from a frontal vantage point, as if the figures were two-dimensional, the curves of the deeply cut folds echo their forms in section (i.e., along a plane made by an imaginary vertical slice from front to back), and thereby broadcast their three-dimensionality. The effect goes against nature; yet the sculptor, possibly Pheidias himself, could better express nature through the appearance of truth than through truth itself. This optical device is a sculptural equivalent of the deliberate distortions in the temple's architecture.

Running the whole way around the building (rather than just at the ends, as at Olympia) was a full program of metopes, numbering 92 in all, depicting scenes of violent action. On the west side, sculptors described the battle of the Greeks against the Amazons (an Amazonomachy), a mythical race ruled by their warrior women. Metopes on the north side portrayed the Sack of Troy (the *Ilioupersis*), the conclusion of the Trojan War, when Greek forces fought the Trojans over Paris' abduction of Helen, wife of Menelaus, brother of King Agamemnon. On the east side, the gods fought the giants. The metopes of the south side mostly depict the Battle of the Lapiths and the Centaurs, already seen at Olympia. The four cycles come together to form a thematic whole: All depict the tension between the civilized and uncivilized worlds, between order and chaos; and all are therefore allegories for the Athenian victory over the Persians. Historical events are cloaked again in the guise of myth; myth elevates life so that the triumph of order over chaos has a preordained inevitability. Little survives of the metope cycles except for those on the south side, which are relatively well preserved. Their quality

Plutarch (ca. 46-after 119 CE)

Parallel Lives of Greeks and Romans, from the lives of Perikles and Fabius Maximus

A Greek author of the Roman period, Plutarch wrote Parallel Lives to show that ancient Greece matched or exceeded Rome in its great leaders. Comparing Perikles (d. 429 BCE) with Fabius Maximus (d. 203 BCE), he concludes that Perikles' buildings surpass all the architecture of the Romans. Plutarch is the only ancient source to say that Pheidias was the overseer of Perikles' works.

B ut that which brought most delightful adornment to Athens, and the greatest amazement to the rest of mankind; that which alone now testifies for Hellas that her ancient power and splendour, of which so much is told, was no idle fiction—I mean his construction of sacred edifices. ... For this reason are the works of Perikles all the more to be wondered at; they were created in a short time for all time.

Each one of them, in its beauty, was even then and at once antique; but in the freshness of its vigour it is, even to the present day, recent and newly wrought. Such is the bloom of perpetual newness, as it were, upon these works of his, which makes them ever to look untouched by time, as though the unfaltering breath of an ageless spirit had been infused into them.

His general manager and general overseer was Pheidias, although the several works had great architects and artists besides. Of the Parthenon, for instance, with its cella of a hundred feet in length, Kallicrates and Iktinus were the architects....

By the side of the great public works, the temples, and the stately edifices, with which Perikles adorned Athens, all Rome's attempts at splendour down to the times of the Caesars, taken together, are not worthy to be considered, nay, the one had a towering preeminence above the other, both in grandeur of design, and grandeur of execution, which precludes comparison.

Source: *Plutarch's Lives*, vol. 3, tr. Bernadotte Perrin (Cambridge: Harvard University Press, 1916)

varies dramatically: Not all of them are as successful as the ballet-like choreography of figure **5.44**, which reminds us that a vast crew of workers must have been engaged in completing the Parthenon in such a short period: They executed two pediments and the frieze in under ten years (ca. 440–432 BCE).

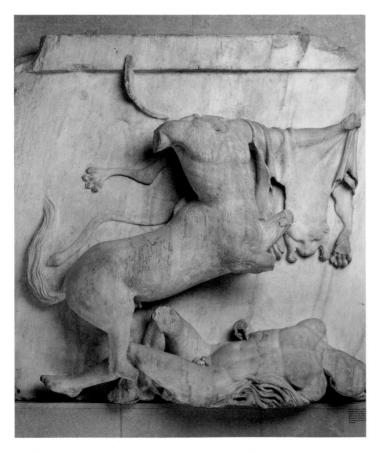

5.44 Lapith and Centaur, metope from south side of the Parthenon. ca. 440 BCE. Marble, height 56" (142.2 cm). The British Museum, London

The Parthenon is often viewed as the perfect embodiment of the Classical Doric style. Although this may be the impression from the outside, it is far from accurate. At architrave level within the peristyle, a continuous sculpted frieze runs around all sides of the building, in a variation of the Ionic style (see fig. 5.8). In a continuous sculpted band, some 525 feet long (fig. 5.45), the frieze depicts a procession, moving from west to east, propelling the viewer around the temple, drawn close to the building to read the images. Horsemen jostle with musicians, water-carriers, and sacrificial beasts. Figures overlap to create the illusion of a crowd, even though the relief is only inches deep. Frenzied animals underline the calm demeanor of the human figures (see *The Art Historian's Lens*, page 134), who have the ideal proportions of the *Doryphoros*.

According to the traditional view, the procession depicted in the frieze is the Panathenaic procession, part of a festival held annually to honor Athena in the presence of the other Olympian gods, and on a grander scale every four years. The figures and their groupings are typical of the participants in these processions, and the frieze represents an idealized event, rather than a specific moment. If this view is correct, the frieze is remarkable in that for the first time it exalts mortal Greeks by depicting them in a space usually reserved for divine and mythological scenes. The most problematic aspect of the relief is the detail in figure 5.46, from the center of the east end of the temple, where there are five unidentified figures, three of them young. Two of the young figures carry stools on their heads, while the third, in a group with one of the adults, handles a piece of cloth. According to the traditional view, the cloth is a new robe for Athena, woven by Athenian girls and women and depicting Athena's triumph against the giants in the gigantomachy. An alternative and controversial theory, however, places the entire frieze in the realm of myth, interpreting this scene as the three daughters of Erechtheus, a legendary king of Athens. According to Athenian myth, the oracle at Delphi

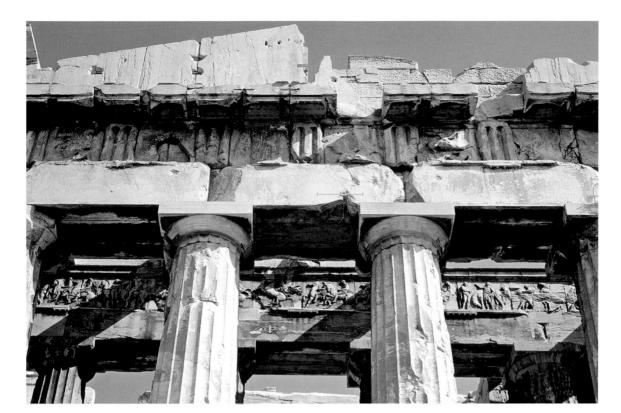

5.45 Frieze above western entrance of the cella of the Parthenon, Akropolis, Athens. ca. 440-432 BCE. Marble, height 43" (109.3 cm)

demanded the death of one of Erechtheus' daughters if Athons was to be saved from its enemies. Here, one of the daughters calmly receives the garment in which she will be sacrificed. The myth had obvious resonance for Athens after its victory over the Persians, and the playwright Euripides made it the subject of a tragedy.

Whatever the meaning of the frieze, its iconography integrated Athenians and divine space, time, and ritual practice in a unity that reflected the Athenians' sense of superiority and self-confi dence. The problem of the frieze is exacerbated by the discovery, during the building's recent preservation and reconstruction, that the pronaos featured another frieze in its upper well. Nothing survives of this frieze, but if it was thematically con nected with the frieze around the cella, we lack a crucial piece of evidence for a secure identification and interpretation of the iconography.

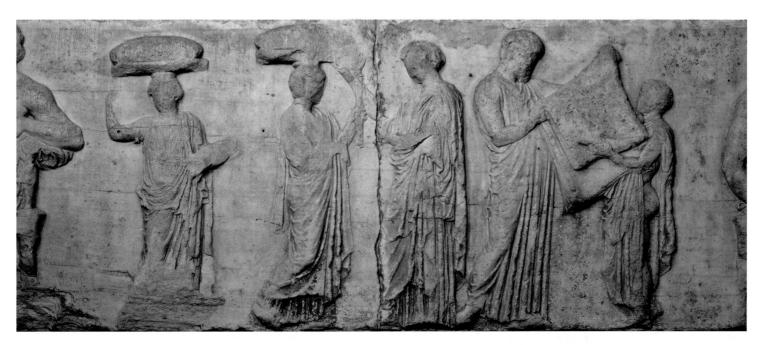

5.46 East frieze of the Parthenon. ca. 440 BCE. Marble, height 43" (109.3 cm). The British Museum, London

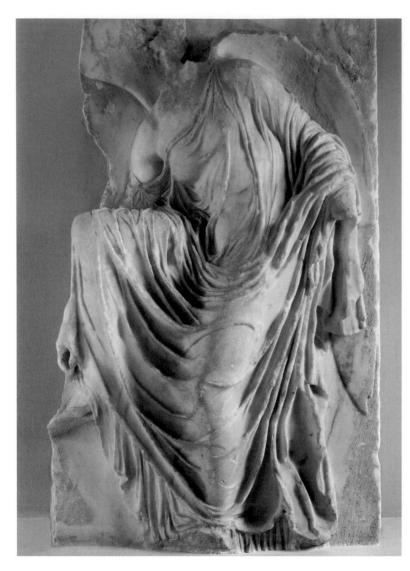

5.47~Nike, from balustrade of Temple of Athena Nike. ca. 410–407 BCE. Marble, height 42" (106.7 cm). Akropolis Museum, Athens

THE PHEIDIAN STYLE According to Plutarch, the sculptor Pheidias was chief overseer of all the artistic projects that Perikles sponsored. (See Primary Source, page 136.) Ancient literary sources attribute few works directly to his hand: His huge sculpture of Athena Parthenos, and a second chryselephantine colossus of a seated Zeus in the Temple of Zeus at Olympia, aroused extreme admiration, not only due to their religious roles, but also because of their vast size and the sheer value of the materials employed. An equally large bronze sculpture of Athena that stood on the Akropolis facing the Propylaia was also by the master sculptor. None of these works survives, and small-scale copies made in later times convey little of their original majesty. He may have worked personally on the Parthenon's architectural sculpture, which undoubtedly involved a large number of masters, but equally he may have simply been a very able supervisor. We can therefore know little for certain about his artistic style. Nevertheless, Pheidias has come to be associated with the Parthenon style, which is often synonymous with the "Pheidian style." The term conveys an ideal that was not merely artistic but also philosophical: The idealized faces and proportions of the Athenians elevate them above the uncivilized world in which they operate. They share the calmness of the gods, who are aware of, yet aloof from, human affairs as they fulfill their cosmic roles.

Given the prominence of the Parthenon, it is hardly surprising that the Pheidian style should have dominated Athenian sculpture until the end of the fifth century BCE and beyond, even though large-scale sculptural enterprises gradually dwindled with the onset of the Peloponnesian War. The style is clear in one of the last of these projects, a balustrade built around the small Temple of Athena Nike on the Akropolis in about 410–407 BCE (see fig. 5.50). Like the Parthenon frieze, it shows a festive procession, but the participants are not Athenians but winged personifications of Victory (Nike, plural Nikai). One Nike is taking off her sandals,

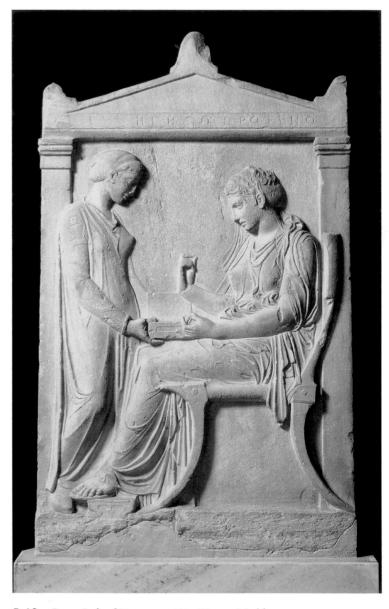

5.48 Grave Stele of Hegeso. ca. 410–400 BCE. Marble, height 59" (150 cm). National Archaeological Museum, Athens

indicating that she is about to step on holy ground (fig. 5.47). Her wings keep her stable, so that she performs this normally awkward act with elegance and ease. The Pheidian style is most evident in the deeply cut folds of her "wet look" garments, which cling to her body and fall in deep swags between her legs.

On the Grave Stele of Hegeso (fig. 5.48), also from the last years of the fifth century BCE, the Pheidian style is again recognizable in the drapery, but also in the smooth planes of the idealized faces, and the quiet mood of the scene. The artist represented the deceased woman seated on an elegant chair, in a simple domestic scene that became standard for funerary markers for young women, whose realm was almost exclusively within the home. She has picked a piece of jewelry from a box held by a girl servant and seems to contemplate it. The delicacy of the carving is especially clear in the forms farthest away from a viewer, such as the servant's left arm, or the veil behind Hegeso's right shoulder. Here, the relief merges with the background, strengthening the illusion that the background is empty space rather than a solid surface. This stele is a fine example of a type of memorial that Athenian sculptors produced in large numbers from about 425 BCE onward, perhaps following a relaxation of earlier sumptuary laws that had curbed expenditure on funerary commemoration. Their export must have helped to spread the Pheidian style throughout the Greek world.

THE PROPYLAIA In the year of the Parthenon's dedication, 437 BCE, Perikles commissioned another costly project: the monumental gate at the western end of the Akropolis, called the Propylaia (see fig. 5.38). Mnesikles was the architect in charge, and he completed the main section in five years; the remainder was abandoned with the onset of the Peloponnesian War in 431 BCE. He designed the entire structure in marble, and incorporated refinements similar to those in the Parthenon. In fact, Mnesikles cleverly adapted elements of traditional temple design to a totally different task, and to a site that rose steeply and irregularly. Conceived on two levels, the design transforms a rough passage among rocks into a magnificent entrance to the sacred precinct. Only the eastern porch (or façade) is in fair condition today. It resembles a Classical Doric temple façade, except for the wide opening between the third and fourth columns, which allowed traffic to pass onto the Akropolis; this feature is common in Ionian architecture. Placed along this central passageway through the Propylaia were two rows of slender Ionic columns, echoing the Ionic columns in the Parthenon. Flanking the western porch (fig. 5.49) were two wings, of unequal size because of constraints imposed by the terrain (figs. 5.38 and 5.39). The larger one to the north contained a picture gallery (pinakotheke), the first known instance of a public room specially designed for the display of paintings. The southern wing may have held a library.

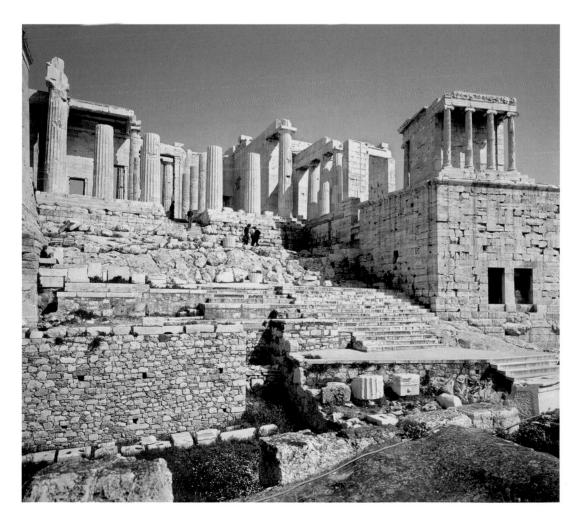

5.49 Mnesikles. The Propylaia, 437–432 BCE (view from west). Akropolis, Athens

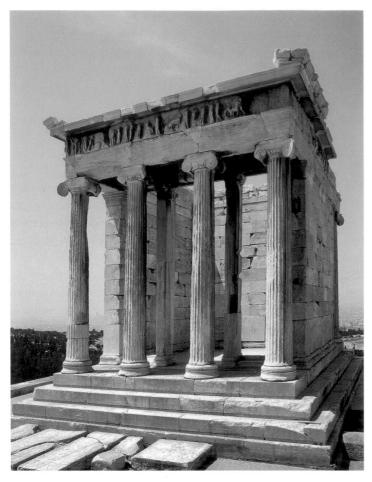

5.50 Temple of Athena Nike. 427–424 BCE (view from east). Akropolis, Athens

THE TEMPLE OF ATHENA NIKE The architects who designed the Parthenon and the Propylaia incorporated Ionic elements into essentially Doric buildings for a reason that may have had as much to do with politics as with design. In pre-Classical times, the only Ionic structures on the Greek mainland were small treasuries, like the Siphnian Treasury (fig. 5.20), which eastern Greek states erected at Delphi in their regional styles. When Athenian architects used the Ionic style, Perikles may have been making a deliberate symbolic gesture, uniting the disparate regions of Greece in an international style. The Akropolis, in fact, houses the finest surviving examples of Ionic architecture. One is the small Temple of Athena Nike, to the south of the Propylaia (fig. 5.50). Kallikrates may have designed it 20 years earlier to celebrate the Athenian victory over the Persians, but building probably only occurred between 427 and 424 BCE. The decorative quality of the Ionic style, with finer proportions than those found in the Doric style, made it a natural choice for the jewel-like building. Standing on a projecting bastion, it was the first structure to greet a visitor to the Akropolis.

THE ERECHTHEION A second, larger Ionic temple stood alongside the Parthenon. The Erechtheion was built between 421 and 405 BCE, and was probably another of Mnesikles' projects

(fig. 5.51 and plan in fig. 5.39). As with the Propylaia, the architect had to deal with difficult terrain: Not only did the site slope, but it already accommodated various shrines associated with the mythical founding of Athens that could not be moved. Beneath it, for instance, was the spot where, so Athenians believed, Poseidon and Athena competed for custody of Athens. In addition to the olive tree that Athena gave the city in the contest, the temple enclosed a saltwater pool that supposedly sprang up where Poseidon threw his trident. The architect therefore designed the Erechtheion to serve several religious functions simultaneously. Its highly irregular plan included four rooms, as well as a basement on the western side. The main, eastern room was dedicated to Athena Polias (Athena as the City Goddess) and contained the old cult image, an amorphous piece of olive wood that was the most sacred cult object in Athens; the western room was sacred to Poseidon. Another room held a cult of King Erechtheus, who promoted the worship of Athena and for whom the building is named.

Instead of a west façade, the Erechtheion has two porches attached to its flanks. A very large one dedicated to Poseidon faces north and served as the main entrance, while a smaller one juts out toward the Parthenon. The latter is the famous Porch of the Maidens (see fig. 5.51), so named because six caryatids, instead

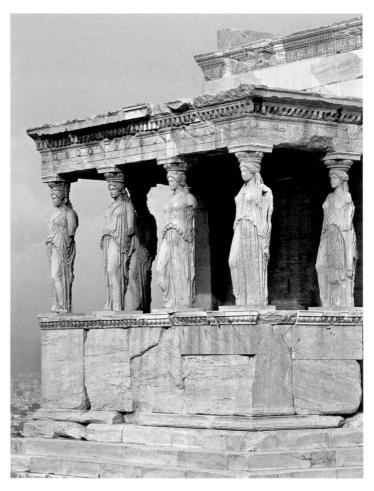

5.51 The Erechtheion. 421–405 BCE (view from the southeast). Akropolis, Athens

of columns, support its roof on a high parapet. The Roman architect Vitruvius wrote that these figural columns represented the women of Carvae, a city-state in the Peloponnese that formed an alliance with the Persians in the Persian Wars. When the war was over, the triumphant Greeks killed the men of Caryae, and took the women as slaves, forcing them nonetheless to retain their fine clothing and other marks of their former status as visible reminders of their shame. Thus, Vitruvius continues, architects designed images of these women to bear the burden of their state's dishonor in perpetuity. Vitruvius' explanation for the origin of caryatids is inconsistent with the fact that they appear on the Siphnian Treasury well before the Persian Wars (see fig. 5.20); but it may reveal the special significance of caryatids for Athenians after the war. Even beyond the caryatids, the Erechtheion was a highly decorative temple. Its pediments remained bare, perhaps for lack of funds at the end of the Peloponnesian War, and little survives of the sculptural frieze. However, the carving on the bases and capitals of the columns, and on the frames of doorways and windows, is extraordinarily delicate and rich. Indeed, according to stone inscriptions detailing construction expenses for the building, it cost more than the temple's figural sculpture.

Although the Akropolis buildings arose over the course of several decades, Perikles clearly intended them as a programmatic unit. The solid, stately forms of the Doric Parthenon and Propylaia complemented the lighter, more decorative style of the Temple of Athena Nike and Ercchtheion, and together they honored Athens' protective goddess, and expressed the ideals and grandeur of the city-state and its place in the wider Greek world.

THE LATE CLASSICAL PERIOD

By the end of the fifth century BCE, Athens' supremacy was on the wane. Conflict between Athens and the Peloponnesian cities of Corinth and Sparta, which had been smoldering since about 460 BCE, gradually escalated into the great Peloponnesian War in 431. By the time this ended in 404, Athens had lost. During the following century, the Greek city-states were constantly at odds with one another. In 338 BCE, Philip II, who had acceded to power in the kingdom of Macedon, to the north, exploited their disunity by invading Greece, and decisively defeated the Athenians and Thebans at the Battle of Chaironeia. The change in Greece's fortune finds its reflection in the art and architecture of the time, as artists and architects start to move away from traditional forms and subjects.

Late Classical Architecture: Civic and Sacred

Two notable changes occurred in monumental architecture in the late fifth and fourth centuries BCE. One was a shift in emphasis: As

5.52 Reconstruction drawing of the Mausoleum at Halikarnassos. ca. 359–351 BCE (from H. Colvin)

well as constructing temples, architects explored a range of other building types. Many of these—stoas, meeting houses for the governing council, and the like—had long existed, but now took on grander form. The other was the development of a new style: the Corinthian.

THE MAUSOLEUM AT HALIKARNASSOS In Halikarnassos (present-day Bodrum, in southwest Turkey; see map 5.1), the tendency toward monumentalization resulted in a vast tomb for Mausolos, who ruled Caria from 377 to 353 BCE as satrap for the Persians. His wife and sister, Artemisia, commissioned Pytheos of Priene to design the sepulcher to commemorate Mausolos as hero-founder of Halikarnassos. Such was its renown in antiquity that the ancients counted it among the seven wonders of the ancient world and by Roman imperial times its title, the Mausoleum, was used to describe any monumental tomb. It stood reasonably intact until the thirteenth century CE, when an earthquake brought down the upper sections. Then, in the late fifteenth and early sixteenth centuries, the Knights of St. John used the site as a source of squared stone to refortify their castle. In 1857, the British archaeologist Charles Newton removed many sculptural fragments to the British Museum. Danish excavations continue to yield information at the site. When coupled with literary evidence, archaeological data permits reconstructions, though none has met with universal approval (see www.myartslab.com). One hypothesis appears in figure 5.52. The tomb was rectangular in plan, and soared 140 feet high in at

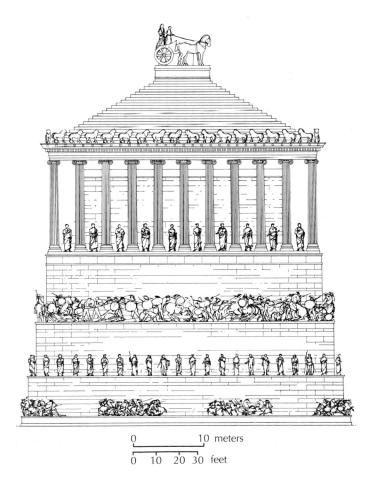

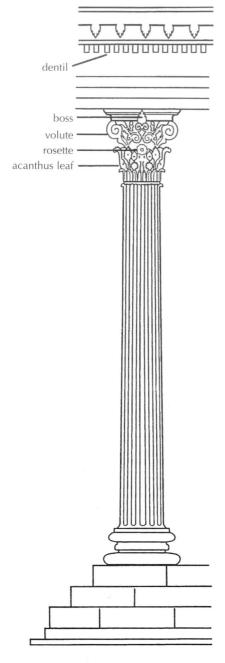

5.53 Corinthian style in elevation

least three sections, covered with sculpture: A high podium, an Ionic colonnade, and a pyramidal roof, where steps climbed to a platform supporting a statue of Mausolos or one of his ancestors in a chariot.

The Mausoleum combined the monumental tomb-building tradition of the region, Lycia, with a Greek peristyle and sculpture, and an Egyptian pyramid. The grouping of these elements in a single monument is evidence of a growing diversity in architecture. It may also have had a propagandistic function: It may have expressed Carian supremacy in the region and the symbiosis of Greek and non-Greek civilizations that might be achieved through founding a Carian empire headed by Halikarnassos.

CORINTHIAN CAPITAL The other major change in architecture that took place in the late fifth century BCE was the development of the Corinthian capital (fig. 5.53) as an elaborate substitute for the Ionic. Its shape is an inverted bell covered with the curly shoots and leaves of an acanthus plant, which seem to sprout from the top of the column shaft. Writing about four centuries later in Italy, Vitruvius ascribed its invention to the metalworker Kallimachos. At first, Greek builders only used Corinthian capitals in temple interiors, perhaps because of the conservative nature of Greek architecture, or because of the perceived sanctity of its vegetal forms. It was not until the second century BCE that Corinthian columns appeared on the exteriors of buildings. The capital in figure 5.54 belongs to a circular shrine, or tholos at Epidauros designed by Polykleitos the Younger. The circular form of the shrine is further evidence of the preoccupation with new types of building, and its elaborate interior continues the tradition, begun with the Parthenon, of stressing the articulation of interior space.

Late Classical Sculpture

The Pheidian style, with its apparent confidence in the transcendence of the Athenian city-state, did not survive Athens' devastating defeat in the Peloponnesian War. At the end of the fifth century, a shift in mood is perceptible in sculpture, which seems to reflect a different—and less optimistic—view of man's place in the universe.

Scholars attempt to match surviving sculptures with fourth-century BCE sculptors named in literary sources. Among these is Skopas of Paros. According to the Roman writer Pliny the Elder, he was one of four masters chosen to work on the Mausoleum of Halikarnassos, and art historians recognize his dynamic style in some parts of a frieze from the tomb depicting the battle of the Greeks and the Amazons. His greatest fame, though, derives from

5.54 Polykleitos the Younger. Corinthian capital, from tholos at Epidauros. ca. 350 BCE. Museum, Epidauros, Greece

5.55 Head of Herakles or Telephos, from west pediment of Temple of Athena Alea, Tegea. ca. 340 BCE. Marble, height 121/2" (31.75 cm). Stolen from the Archaeological Museum, Tegea

the way he infused emotion into the faces he sculpted. A fragmentary head from a pediment of the Temple of Athena Alea at Tegea of about 340 BCE is either by Skopas, or an artist deeply influenced by his work (fig. 5.55). A lion skin covering the head identifies it as either Herakles or his son Telephos. The smooth planes and fleshy treatment of the face are characteristic of Classical art, as seen on the Parthenon. What is new, however, is how the sculptor cut the marble away sharply over the eyes toward the bridge of the nose to create a dark shadow. At the outer edge, the eyelid bulges to overhang the eye. This simple change charges the face with a depth of emotion not seen before. The slightly parted lips and the sharp turn of the head enhance the effect.

PRAXITELES If the Greeks were less confident of their place in the world in the Late Classical period, they were also less certain of their relationship to fate and the gods. This is reflected in the work of Praxiteles, who was at work at roughly the same time as Skopas. Choosing to work in marble rather than bronze, he executed several statues of divinities. Where fifth-century BCE artists had stressed the gods' majesty, Praxiteles gave them a youthful sensuousness that suggests their willful capriciousness toward humans. His most famous work is a sculpture of Aphrodite, dating to about 340-330 BCE (fig. 5.56). Pliny records that the people of Kos commissioned a cult statue of Aphrodite from

5.56 Aphrodite of Knidos. Roman copy after an original of ca. 340-330 BCE by Praxiteles. Marble, height 6'8" (2 m). Musei Vaticani, Rome

Praxiteles, but rejected the nude statue he offered them in favor of a draped version. But the inhabitants of Knidos purchased the nude statue, and profited from the risk: Her fame spread fast, and visitors came to the island from far and wide to see her. (See www.myartslab.com.) Perhaps it was her nudity that drew so much attention: She was the first nude monumental statue of a

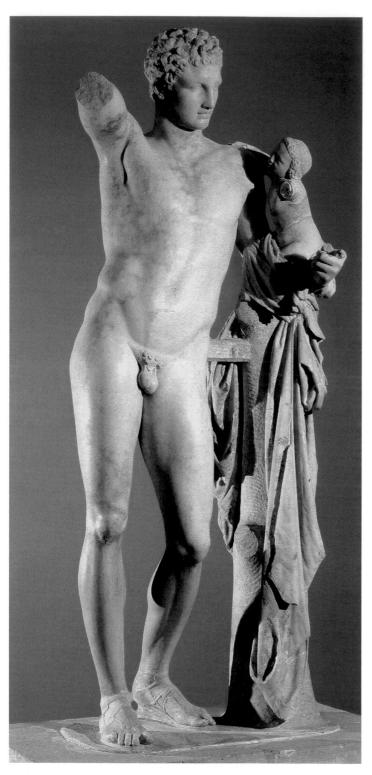

5.57 Hermes. Roman copy after an original of ca. 320–310 BCE by Praxiteles. Marble, height 7'1" (2.16 m). Archaeological Museum, Olympia

goddess in the Greek world. Yet even if artists had previously reserved female nudity principally for representations of slaves or courtesans, the clinging drapery of the fifth century BCE had exposed almost as much of the female anatomy as it concealed. Her appeal may have resided just as much in the blatant eroticism of the image. A viewer catches Aphrodite either as she is about to bathe or as she is rising from her bath. With her right hand, she covers her nudity in a gesture of modesty, while grasping for a robe with her left. Her head is slightly turned, so she does not engage a viewer's gaze directly, but a viewer is made complicit with the sculpture, willingly or not, by having inappropriately witnessed her in her nudity. Perhaps, in her capriciousness, Aphrodite intended to be surprised as she bathed; the uncertainty for a viewer augments the erotic quality of the image. By some accounts, the Knidians displayed Praxiteles' sculpture in a circular shrine with entrances at front and back, so visitors could view the cult statue from all sides. A viewer's role is more complex here than in the Classical period: The sculpture invites physical and emotional engagement, not merely respect.

Praxiteles' Aphrodite is known to us only through Roman copies. In this respect, a group representing Hermes holding the infant Dionysos poses complicated questions (fig. 5.57). The Roman writer Pausanias mentions seeing such a statue by Praxiteles in the Temple of Hera at Olympia, where this marble was found in 1877. It is of such high quality that art historians have long regarded it as a late work by Praxiteles himself. Now, however, most scholars believe it to be a fine copy of the first century BCE because of the strut support and unfinished back; analysis of the tool marks on the surface of the marble support this date, as do the sandals, which are distinctly Roman in style. Still, the group has all the characteristics of Praxitelean sculpture. Hermes is more slender in proportion than Polykleitos' Doryphoros (see fig. 5.33), and the chiastic pose is so exaggerated as to have become a fully relaxed and languid curve of the torso. The anatomy, so clearly defined on the Doryphoros, blurs to suggest a youthful sensuousness rather than athletic prowess. The surface treatment of the marble is masterful, contrasting highly polished skin with rough, almost expressionistic hair. The group has a humorous quality typical of Praxiteles' work as well: The messenger god originally dangled a bunch of grapes in front of Dionysos, whose attempts to reach for them foreshadow his eventual role as the god of wine. Yet, depending upon a viewer's mood (or worldview), Hermes' distant gaze may also hold a callous disregard for the child's efforts.

LYSIPPOS A third great name in fourth-century BCE sculpture is Lysippos, who had an extremely long career. He may have begun sculpting as early as about 370 BCE and continued almost to the end of the century. Known from Roman copies, his *Apoxyomenos* (a youth scraping oil from his skin with a strigil) dates to about 330 BCE (fig. **5.58**) and is in dialogue with Polykleitos' *Doryphoros* (see fig. 5.33). Lysippos preferred more slender proportions for his athlete, calculating the length of the head as one-eighth of the body's length, rather than one-seventh as Polykleitos had. (See

www.myartslab.com.) The Apoxyomenos leans further back into his chiastic pose, too—a sign of Praxiteles' influence—and the diagonal line of the free leg suggests freedom of movement. Most innovative, however, is the positioning of the athlete's arms. The outstretched arm reaches forward into a viewer's space. Since a frontal view foreshortens the arm, it entices a viewer to move around the sculpture to understand the full range of the action;

like Praxiteles, Lysippos breaks the primacy of the frontal view for a standing figure. The athlete's left arm bends around to meet the right at chest height, so the sculpture deliberately contains space within its composition. Lysippos challenges the stark opposition between sculpture and its environment; the two begin to merge. This device is symptomatic of a new interest in illusionism in the Late Classical and Hellenistic ages.

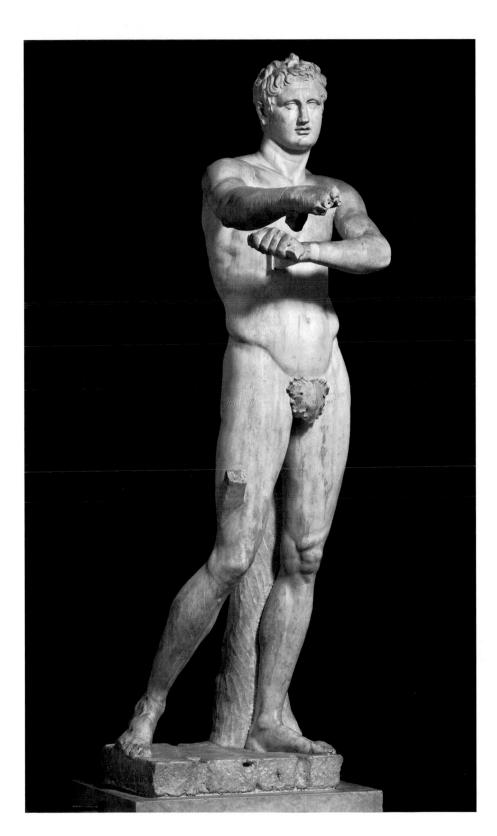

5.58 *Apoxyomenos (Scraper)*. Roman marble copy, probably after a bronze original of ca. 330 BCE by Lysippos. Height 6'9" (2.1 m). Musei Vaticani, Rome

Painting in the Late Classical Age

Written sources name some of the famous painters of the Classical age, and reveal a good deal about how painting evolved, but they rarely include details of what it actually looked like. The great age of Greek painting began early in the Classical period with Polygnotos of Thasos and his collaborator, Mikon of Athens, who both worked as sculptors as well. Polygnotos was known for paintings depicting the aftermath of the Trojan War in Delphi, and mythological paintings coupled with a depiction of the Battle of Marathon decorating the Stoa Poikile (Painted Stoa) in the Athenian agora (see fig. 5.37). He introduced several innovations in painting, including the depiction of emotion and character, which became as central to Classical painting as they were to sculpture. He was also first to depict women in transparent drapery, and to forgo the notion of a single ground-line, placing figures instead at varying levels in a landscape setting.

The placement of figures at different levels of terrain seems to have influenced a contemporary vase painter, known today as the Niobid Painter. His name vase (the vase for which scholars name him) is a calyx krater (a wine-mixing bowl), which shows the outcome of Niobe's foolish boast that she had more—and more beautiful—children than Leto, mother of Apollo and Artemis: The sibling gods of hunting shoot down Niobe's sons and daughters (fig. 5.59). Each of the figures has his or her own ground-line, which undulates to suggest a rocky landscape. Artemis and Apollo stand above two of their victims, who are sprawled over boulders, but we should probably understand the terrain to recede into the distance.

5.59 Niobid Painter. Red-figured calyx krater, from Orvieto. ca. 460–450 BCE. Musée du Louvre, Paris

5.60 Reed Painter. White-ground lekythos. ca. 425–400 BCE. National Archaeological Museum, Athens

Significant technical differences separated wall painting from red-figured vase painting. Much closer to wall painting was a technique reserved almost exclusively for the vases Greeks deposited with burials: white-ground vase painting. Artists working in this technique painted a range of colors onto a white slip background, and favored a type of oil flask used in funerary rituals, known as a lekythos. On a lekythos from the last quarter of the fifth century BCE, attributed to the Reed Painter (fig. 5.60),

a disconsolate young man sits on the steps of a tomb. A woman on the right holds his helmet, while a second man stands to the left with one arm raised in a gesture of farewell. Black outlines define the scene, filled with washes of vivid color. Some blue still survives on parts of the tomb and the seated man's cloak, and brown in the figures' hair, but most of the colors have long vanished, since fugitive paints sufficed for a vessel that did not have to withstand prolonged or repeated use. The freedom of the technique allowed the painter to explore foreshortening and depth, and to achieve a remarkably expressionistic effect with a few fluid lines. The deceased man's deep-set brooding eyes give some indication of the emotion painters could capture. Despite the artistic advantages of the white-ground technique, from the mid-fifth century BCE on monumental painting gradually eclipsed vase painting, though in some cases vase painters tried to reproduce large-scale compositions.

THE AGE OF ALEXANDER AND THE HELLENISTIC PERIOD

In 336 BCE, Philip II of Macedon died, and his kingdom passed to his son Alexander. Alexander the Great is one of the romantic figures of history, renowned for his military genius and personal charm. He embarked upon a great campaign of conquest, overcoming Egypt and the Persians, then continuing on to Mesopotamia and present-day Afghanistan. In 323 BCE, having founded over 70 cities, he died at the age of 33. His conquests changed the face of the Greek world dramatically, expanding it into unknown spheres, creating new political alignments, and breaking down cultural boundaries (see map 5.2).

The years following Alexander's death were fraught with struggles between members of his family and his generals, as each tried to establish himself as his sole successor; none succeeded. By about 275 BCE, Alexander's lands had coalesced into three main kingdoms, which would dominate the Mediterranean until the Romans gradually assumed control. Ptolemy founded a dynasty in Egypt that reigned until Octavian (later the Roman emperor Augustus) defeated Cleopatra VII in 31 BCE. In the east, the Seleucid family captured Babylon in 312 BCE. From Syria they ruled a kingdom which, at its largest, extended from present-day western Turkey to Afghanistan. They lost control of a small pocket of territory around Pergamon to the Attalids, who bequeathed their city to the Romans in 133 BCE. In 64 BCE, the Seleucid kingdom came under Roman control. Most coveted was Alexander's ancestral Macedon, which the Antigonids controlled until the Roman conquest in 168 BCE. Within these kingdoms, powerful cities grew-among them, Alexandria, Antioch, and

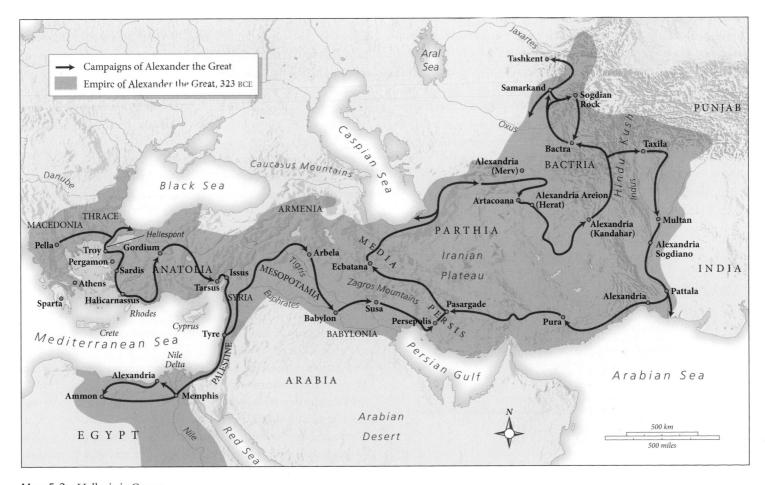

Map 5.2 Hellenistic Greece

Pergamon—with teeming populations drawn from all over the new Greek world. They vied for cultural preeminence, and art played a large part in the rivalry. Scholars call the period from the death of Alexander until Roman rule the Hellenistic period, and Hellenistic culture was radically different from that of Classical times. The expansion of Greek dominance meant that Greek cultural institutions prevailed over a vast territory; those institutions commingled with the strong cultural traditions of the indigenous peoples. The result was a rich and diverse society, in which an individual's identity was more complex than before: the kings of Pergamon, for instance, were not Greek but strove for Greekness and identified themselves as Greek. All the same, over a wide region, people were united by a common cultural vocabulary, known as a koine (Greek for "common thing"). The art of the time reflects this richness: diverse styles coexisted, and artists drew inspiration from indigenous forms as well as the Greek heritage.

Architecture: The Scholarly Tradition and Theatricality

Within the cultural centers of the Hellenistic world, academies emerged, which fostered avid debate among scholars in a range of fields. They engaged, among other things, in a close analysis of the arts, and developed canons by which they could judge works of literature, art, and architecture. In architecture, this led, predictably, to a heightened interest in systems of proportions, recorded in architectural treatises by practitioners of the day. Vitruvius asserts that the leading protagonist in this movement was Pytheos of Priene, one of the architects of the Mausoleum at Halikarnassos (see fig. 5.52). Like most, his treatise does not survive, but Vitruvius notes that he was dismissive of the Doric style because problems with the spacing of corner triglyphs made it impossible to impose the style without compromise. Pytheos worked instead in the Ionic style (in which the volutes of corner capitals could be angled), as seen in his temple to Athena at Priene, dedicated in 334 BCE (fig. 5.61).

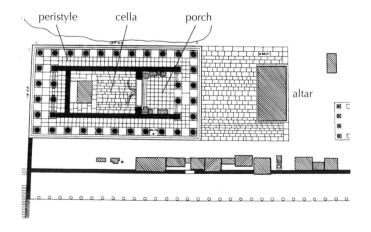

5.61 Plan of Pytheos. Temple of Athena, Priene. 334 BCE

The temple's colonnade had 6 columns by 11, and a grid of squares, each 6 by 6 Attic feet (the Attic foot is slightly longer than the English foot), that dictated the proportions of all of its elements. Proportions controlled the elevation as well: For instance, the columns were 43 feet high and the entablature was 7 feet high —a total of 50 feet, half the external length of the cella. Unlike the Parthenon and other Classical temples, there were no deviations from the rule, and no refinements. The temple is a work of the intellect, the product of a didactic tradition, rather than a compromise between theory and practice. In fact, Vitruvius faults Pytheos precisely for his inability to differentiate between the two.

While this scholarly tradition flourished, the relaxation of architectural guidelines and the combination of architectural types that had occurred in the Late Classical period heralded another development. This was a penchant for dramatic siting, impressive vistas, and surprise revelations. Scholars have termed this movement "theatricality," and it balanced and complemented the scholarly tradition. As the glory of Athens declined, the Athenians and other Greeks came to think of themselves less as members of a city-state and more as individuals; architecture, in turn, began to cater more and more to personal experience, often manipulating visitors toward a meaningful revelation.

THE TEMPLE OF APOLLO, DIDYMA Begun in about 300 BCE and still unfinished by the end of the Roman period, the Temple of Apollo at Didyma is a good example of architectural theatricality (figs. 5.62 and 5.63). Its ground plan and design appear to have been established by the renowned architects Paionios of Ephesos and Daphnis of Miletos, on the site and at the scale of an Archaic temple destroyed by the Persians in 494 BCE.

From the outside, the temple appeared similar to other largescale dipteral Ionic buildings of the area. A visitor would naturally expect the interior to repeat the format of canonical Greek temples such as the Parthenon; but, in fact, the architects constantly defied these expectations, leading visitors instead to dramatic vistas, perhaps intending to heighten their religious experience. Although the temple appeared to be accessible from all sides, its seven massive steps were on a divine, not a mortal scale, and far too high to climb comfortably. Instead, visitors climbed a set of shallower steps at the front, and entered the porch between its vast columns, set to mimic the grove of sacred trees around the building. As expected, an opening led to the cella—but this cella stood approximately 5 feet off the ground, so access was impossible. From this raised threshold, scholars believe, the oracular priestess may have uttered her prophecies to those standing below in the porch. The path further into the building led to the right or left of the threshold, where dark barrel-vaulted tunnels led downward. For a Greek visitor, a barrel-vaulted tunnel evoked a dark interior such as a cave. Yet these passages did not lead to a covered cella, but a vast open courtyard drenched with bright sunshine: A revelation, it must have seemed.

At the end of the courtyard was the shrine itself, a small Ionic building dedicated to Apollo. Near the shrine were sacred laurel bushes and a spring of holy water. Turning back from the shrine, a visitor faced another astonishing sight: A wide, steep staircase dwarfed the tunnels through which he or she had entered the courtyard, and led up to a pair of towering engaged Corinthian columns (joined to the wall). These may have signaled that the room that lay beyond them was the priestess' innermost sanctuary. We know little of the goings-on inside Greek temples, yet

the processional quality of this staircase and the large scale of the courtyard suggest that large crowds of worshipers could have gathered there to witness ritual ceremonies. Also unknown is the function of small staircases leading off from the sanctuary and up to the roof over the colonnades. Building inscriptions describe them as "labyrinths," and the ceiling above them is

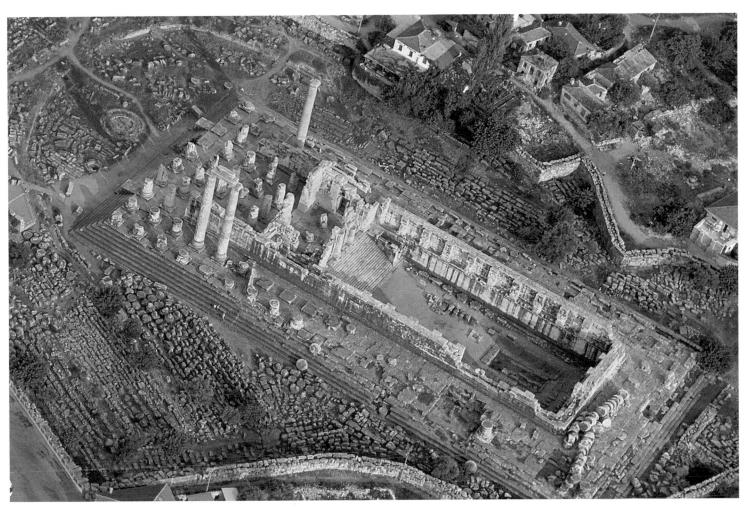

5.62 Paionios of Ephesos and Daphnis of Miletos. Temple of Apollo, Didyma, Turkey. Begun 313 BCE

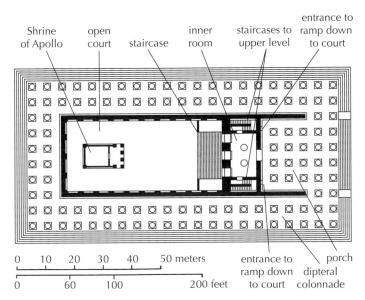

5.63 Plan of Temple of Apollo, Didyma, Turkey

carved with a brightly painted meander pattern (see fig. 5.3), the Egyptian hieroglyphic sign for a maze. They may have provided maintenance workers with access to the roof, but they may equally have accommodated revelatory dramas in honor of Apollo.

As a whole, the temple's design manipulated visitors along unexpected paths, and offered constant surprises. Yet the temple is remarkable for another reason besides. Inside the courtyard, archaeologists unexpectedly discovered diagrams incised (so lightly that they are visible only under a strong raking light) upon its walls. These etchings are scale drawings for aspects of the building's design, ranging from capital decoration to column entasis. They provide a rare insight into the design process in Greek building. They suggest that architects drew a building's design onto its surfaces as it rose, and workers then polished them off as they finished those surfaces. This temple's incompletion preserved the design drawings in place.

City Planning

Early Greek cities such as Athens grew organically, transforming gradually from small settlements into larger urban developments.

Streets were typically winding, and building blocks were irregular. From the seventh century BCE onward, colonization offered Greeks an opportunity to conceive cities as a whole, and to assess different types of city planning, while from the Late Classical period, philosophers debated the structure of ideal cities. Hippodamos of Miletos was the first to write a treatise on city design, advocating grid planning—that is, laying out city streets in intersecting horizontals and verticals. In the mid-fifth century BCE, he designed the Piraeus, near Athens, as a grid, and the pattern is still used in many Western cities today. The design offered many advantages: For an architect, it provided regularity; for colonists, it simplified the distribution of allotments; and for inhabitants, it meant a new ease of orientation. When the inhabitants of Priene relocated their city to avoid flooding, in approximately 350 BCE, they opted for the efficiency of a grid plan (fig. 5.64). As the model demonstrates, the city planners applied the grid to the sloping terrain uncompromisingly. On some longitudinal axes, they inserted staircases to climb straight, steep inclines. Useful for pedestrians, the stairs must have been impassable by wheeled vehicles. Though perhaps a misjudgment, this may equally have been a form of traffic control.

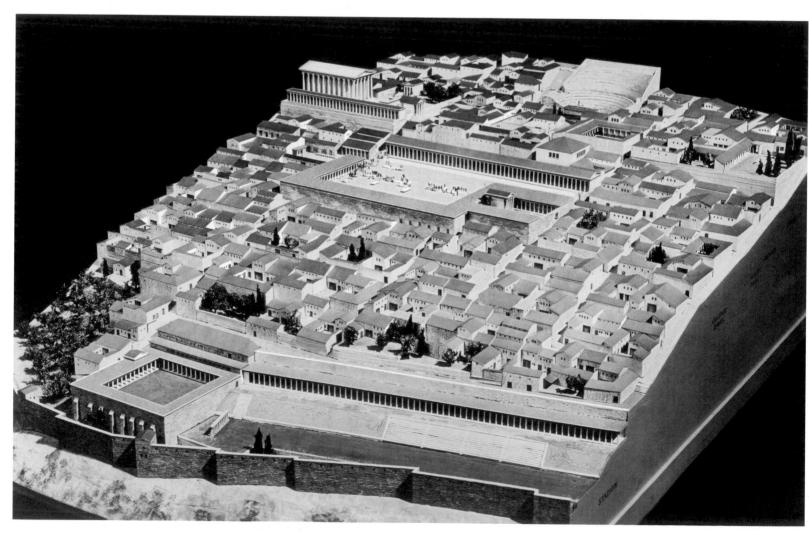

5.64 Model of the city of Priene. 4th century BCE and later. Staatliche Museen, Berlin

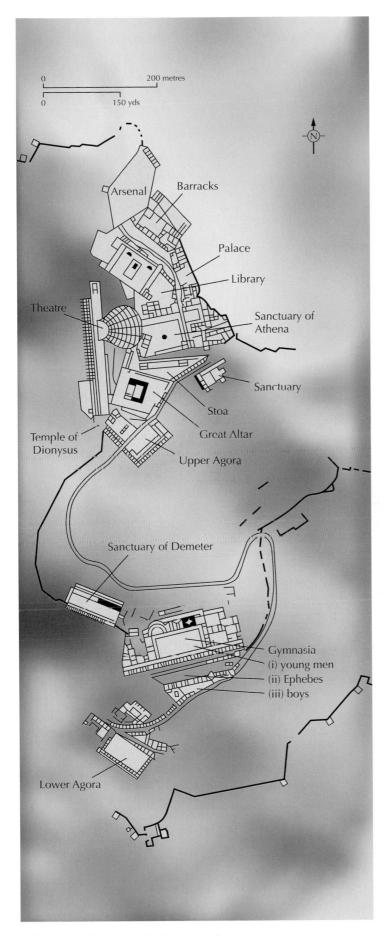

5.65 Plan of Pergamon, Turkey. ca. 2nd century BCE

PERGAMON: A THEATRICAL PLAN A visitor to the city of Pergamon would have had a dramatically different experience. There, in the early second century BCE, King Eumenes II and his architects eschewed a grid as they planned an expansion of the city (fig. 5.65). Residential areas lay mainly on the plain of the Kaikos River; nearby was the towering Akropolis. The new design exploited the dramatic rise in terrain from one to the other, apparently assigning symbolic meaning to the ascent as well. On the lower levels were amenities of everyday life, such as the agora. As the road climbed the southern slope of the Akropolis, it passed through vaulted entrance tunnels to emerge at three gymnasia (schools); the first was for boys, the second for ephebes (adolescents aged 15–17), and the third and highest for young men. Farther up the road were sanctuaries to Hera and Demeter.

The road followed the terrain, snaking past an earlier agora, now chiefly used for legal and political purposes, to the Akropolis proper, where Eumenes II, or perhaps his successor Attalos II, dedicated a magnificent altar court to Zeus (see fig. 5.72). Further up and to the east was a shrine for the hero cult, a heroön. A long portico temporarily obscured any view of the journey's great crescendo; passing through it, a visitor entered the sanctuary of Athena, patron goddess of Pergamon, where the city's oldest temple stood, alongside Eumenes' celebrated library, with an over-life-size marble version of Pheidias' Athena Parthenos (see fig. 5.41). This sanctuary marked the privileged place of learning in Pergamene culture. On its own, the temple was not remarkable. Yet it acquired meaning from the symbolic journey required to reach it. From the sanctuary, a visitor could look out over the steep cavea (or seating area) of the Theater of Dionysos across the plain's breathtaking panorama. Beyond the sanctuary, to the northeast, were the royal residence and barracks for the guard. Like the sanctuary, the residence offered magnificent views of the river and the receding countryside, and cool breezes blowing through the valley and up to the Akropolis must have provided relief from the fierce summer heat. At every turn, the city's designer considered a visitor's experience. The impressive vistas and sudden surprises are hallmarks of Hellenistic theatricality.

THE THEATER AT EPIDAUROS Within these cities, architects continued the Late Classical trend toward formalizing a variety of types of architecture. Given the propensity for theatricality, it is no surprise that they paid close attention to theater buildings. Theaters had long been part of the religious landscape of Greek cities, since Greeks gathered in their communities for the choral performances and plays that were central to festivals of Dionysos. The basic prerequisites for a theater were a hillside, on which an audience could sit (the cavea), and a level area for the performance (the orchestra). In the Late Classical and Hellenistic periods, however, theaters became more formalized as their essential components took on architectural form.

In the sanctuary of the healing god Asklepios at Epidauros on the Peloponnese, a magnificent stone theater was constructed in

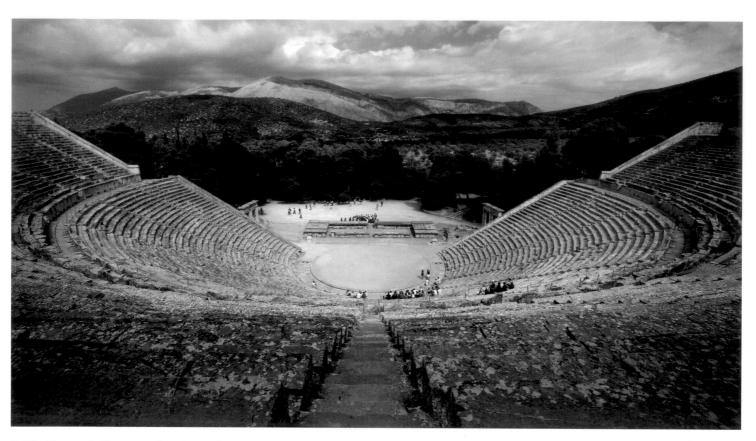

5.66 Theater, Epidauros. Early 3rd to 2nd centuries BCE

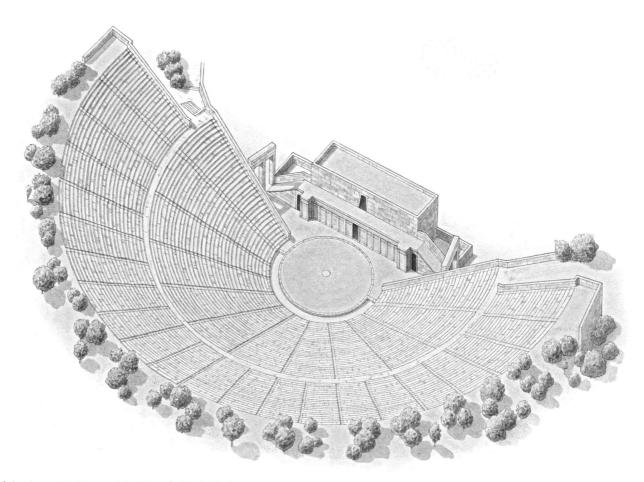

5.67 Plan of the theater, Epidauros (after Picard-Cambridge)

the early third century BCE; its upper tier was completed in the second century BCE (figs. 5.66 and 5.67). Row upon row of stone seats lined the sloping hillside, covering slightly more than a semicircle. To facilitate the audience's circulation, the architect grouped the seats in wedgelike sections (cunei), separated by staircases; a wide horizontal corridor divides the upper and lower sections. Actors performed in the level circle at the center, with a stage building (skene) behind as a backdrop, containing utility rooms for storage and dressing. Because it was open to the sky, no roof supports obstructed the audience's view of the performance, and many of the seats offered spectacular vistas across the landscape as well. Yet perhaps the most astonishing feature of the theater is its acoustics, which visitors can still experience: Its funnel shape carries the slightest whisper up to the highest points of the auditorium. This form is familiar to theatergoers today, a testament to its success.

THE PHAROS AT ALEXANDRIA In Alexandria, on the northwest coast of the Nile Delta, a vast and innovative lighthouse was a testament to the city's cosmopolitan nature and the vitality of shipping and commerce throughout the Hellenistic Mediterranean (fig. 5.68). Alexander the Great founded the city to a grid design by Dinocrites of Rhodes, but the famed lighthouse, or Pharos, was not begun until the reign of Ptolemy I, in ca. 279 BCE, and was completed under his son, Ptolemy II Philadelphos. Some sources attribute it to an architect named Sostratus. The building has long collapsed, but a French team has recently recovered some of its blocks in underwater excavations. Together with mosaic depictions and medieval descriptions, archaeological evidence suggests a building with a square, slightly tapering base, an octagonal central drum, and a tholos-like element, crowned by a huge bronze statue at the dizzying height of about 400 feet. Ancient sources describe a fire at the summit,

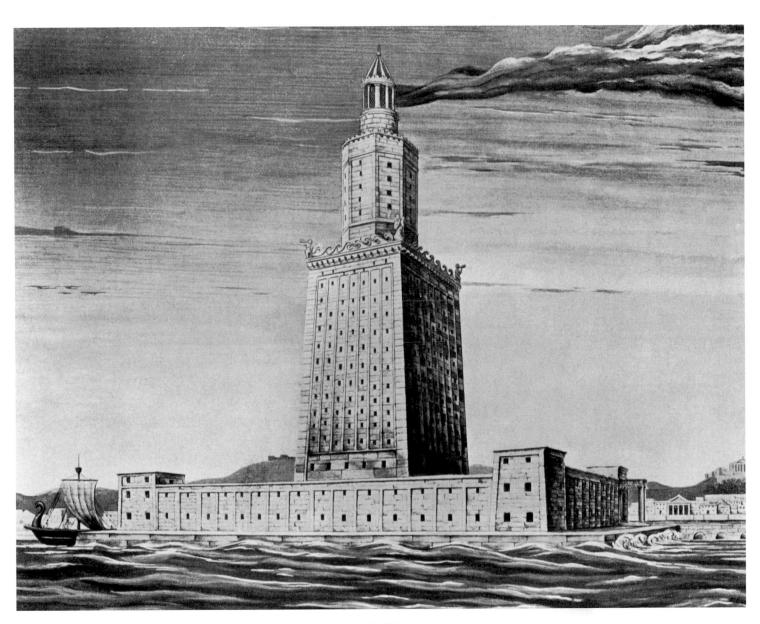

5.68 Alexandria (Egypt), Pharos (lighthouse) completed under Ptolemy II Philadelphos 280–79 BCE, height over 394 ft (120 m); one of the Seven Wonders of the World

and an annular corridor circled up through the tower, wide enough for mules to climb to the top with fuel—a type of petroleum called naphtha, perhaps, that is found in ponds. Yet archaeologists are uncertain how to reconcile a fire with a stone tholos, which would have cracked if exposed to intense heat. The building became an icon for the city. Its monumentality earned it a place among the seven wonders of the ancient world, and it was widely imitated by other cities.

Hellenistic Sculpture: Expression and Movement

Hellenistic sculptors also responded to the cultural changes of the Hellenistic world. Fourth-century BCE sculptors had explored the portrayal of emotion and three-dimensional movement, and their Hellenistic successors made further radical strides in these directions. Both resulted in heightened drama and viewer involvement. That said, one can make only broad generalizations about Hellenistic sculpture, as it is notoriously difficult to date and to attribute to a firm place of origin. Often it is style alone that leads scholars to ascribe a sculpture to this period, and even that is not always straightforward: Although there is good evidence of a dialogue between sculptors, they were working throughout a vast territory where numerous local influences were at play, making the body of material much less homogeneous than Classical sculpture.

PORTRAITURE A chief development in sculpture in this period was portraiture. If Archaic artists depicted individuals at all, they represented them with the all-purpose figures of kouroi and

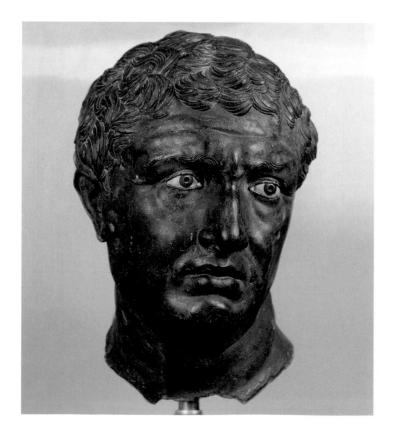

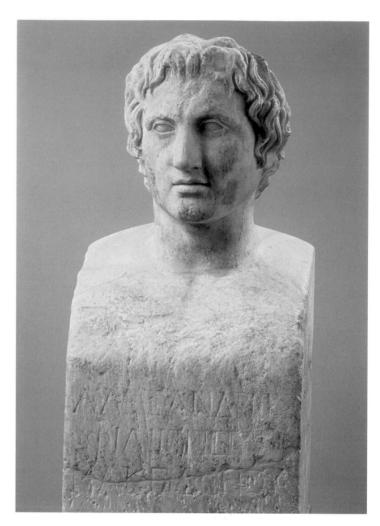

5.69 Lysippos. Portrait of Alexander the Great, the "Azara Herm." Roman copy after an original of the late 4th century BCE. Marble, height 27" (68 cm). Musée du Louvre, Paris

korai. Individual likenesses were unknown in art of the Classical period, which sought a timeless ideal. A copy of a famous sculpture of Perikles dating from about 425 BCE, for instance, differs from the idealized youths of the Parthenon frieze only in that the Perikles wears a beard and a helmet. Later, in the mid-fourth century BCE, portraiture became a major branch of Greek sculpture, and it continued to flourish in Hellenistic times. One of the catalysts for this change was Alexander the Great himself. Recognizing the power of a consistent visual image, he retained Lysippos as the exclusive creator of his sculpted portraits. No surviving original preserves Lysippos' touch, but scholars consider the so-called "Azara Herm" to be relatively faithful to its model (fig. 5.69). To be sure, the face has an idealized quality: Its planes are smooth, especially around the brow. Yet individuality emerges in the unruly hair, raised at the front in Alexander the Great's characteristic cowlick (or anastole), and in the twist of the head, which removes the portrait from a timeless realm and animates it

5.70 *Portrait Head*, from Delos. ca. 80 BCE. Bronze, height 12³/₄" (32.4 cm). National Archaeological Museum, Athens. Ministry of Culture Archaeological Receipts Fund. 14612

with action. Moreover, Alexander does not engage with a viewer, but has a distant gaze. These characteristics would become emblematic of Alexander, and Hellenistic and Roman generals would adopt them as attributes in their own portraiture. With this image, the individual came to inhabit the sculpture, and portraiture began to flourish as a genre.

As with so many Greek sculptures, original Hellenistic portraits are extremely rare. One is an early first-century BCE bronze head from Delos (fig. 5.70), which may portray a trader: The island of Delos was a lively trading port, and many merchants there became extremely wealthy. Unlike the Romans, the Greeks did not isolate an individual's personality in portrait busts, but considered it to animate the full body. Thus this head is just a fragment of a full-length statue. The artist fused the heroic qualities of Alexander's likeness—the whimsical turn of the head, for instance, and the full head of hair—with modeled surfaces. The fleshy features, the uncertain mouth, and the furrowed brows capture an individual likeness. If they also suggest character traits, it is hard to read them with any precision at such a cultural distance.

Like architects, Hellenistic sculptors engaged their audience in the experience of their work, and favored dramatic subjects infused with emotion. The Dying Trumpeter, preserved in a Roman copy (fig. 5.71), probably belonged on one of two statue bases found in the Sanctuary of Athena on the Akropolis of Pergamon, and commemorated Attalos I's defeat of the Gauls in about 233 BCE. Gone is the Classical tradition of referring to the enemy through mythological analogy (see figs. 5.35 and 5.44). Instead, the sculptor specifically identifies the enemy as a Gaul through his bushy hair and moustache, and by the torque, or braided gold band, that he wears around his neck. Gone, too, is any suggestion of the inferiority of the vanquished. The Gaul dies nobly, sinking quietly to the ground or struggling to prop himself up, as blood pours from a wound in his chest. His body is powerful, his strength palpable. He faces his agonies alone, mindless of any viewer. A viewer, in turn, is drawn in by the privateness of the moment, and drawn around the sculpture by the pyramidal composition and the foreshortening witnessed from every angle. The Dying Trumpeter was probably one sculpture in a group, but the victor, always present in Classical battle scenes, was absent. The monument celebrates the conqueror's valor by exalting the enemy he overcame; the greater the enemy, the greater the victory. Pliny records a famous sculpture by Epigonos of a trumpet player, and this Roman copy may reflect that work.

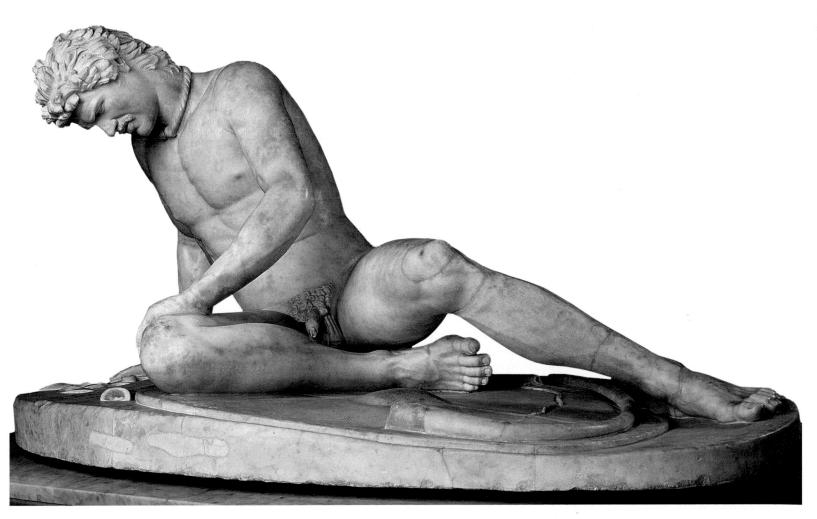

5.71 Epigonos of Pergamon (?). Dying Trumpeter. Perhaps a Roman copy after a bronze original of ca. 230-220 BCE, from Pergamon, Turkey. Marble, life-size. Museo Capitolino, Rome

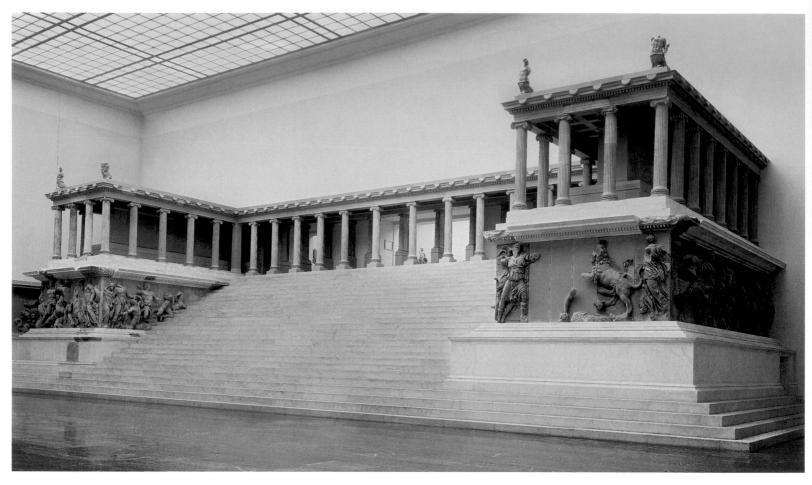

5.72 West front of Great Altar of Zeus at Pergamon (restored). Staatliche Museen zu Berlin, Preussischer Kulturbesitz, Antikensammlung

DRAMATIC VICTORY MONUMENTS Sculptures decorating the Great Altar of Zeus at Pergamon exemplify the highly emotional, dramatic style at its height (figs. 5.72 and 5.73). The monument dates to the second quarter of the second century BCE, when Eumenes II, or Attalos II, built it to commemorate territorial victories over Pontos and Bithynia and the establishment of a grand victory festival, the Nikephoria. The altar stood high on a podium within a large rectangular enclosure defined by an Ionic colonnade. A wide staircase at the front provided access. The altar and its enclosure, which both go by the name of the Great Altar, stood on a terrace on the Pergamene Akropolis. A German team excavated the monument from 1878 to 1886, and its entire west front, with the great flight of stairs leading to its entrance, has been reconstructed in Berlin (see fig. 5.72). The vast enclosure belongs to a long Ionian tradition of massive altars, but this is by far the most elaborate extant example. Its boldest feature is a frieze encircling the base, which extends over 400 feet in length and over 7 feet in height. Its subject, the Battle of the Gods and Giants, was a familiar theme in architectural sculpture. Here, as before, it worked allegorically, symbolizing Eumenes' victories. Never before, however, had artists treated the subject so extensively or so dramatically. About 84 figures crowd the composition, interspersed with numerous animals. This was no mean feat: The designer must have relied upon research by scholars

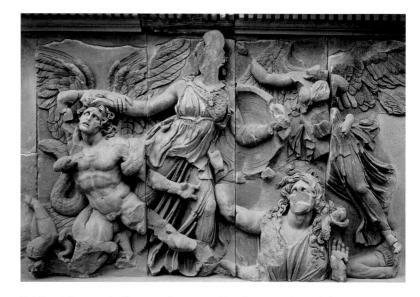

5.73 Athena and Alkyoneus, from east side of Great Frieze of the Great Altar of Zeus at Pergamon, second quarter of the 2nd century BCE. Marble, height 7'6" (2.29 m). Staatliche Museen zu Berlin, Preussischer Kulturbesitz, Antikensammlung

working in the Pergamene library (such as Krates of Mallos, a renowned Stoic theoretician and literary critic) to identify protagonists for this great battle. The scholars may also have assisted

J. J. Winckelmann and the Apollo Belvedere

espite the best efforts of contemporary art historians, many assessments of art today are deeply informed by a notion of beauty rooted in Greek Classicism. This bias has been present through the ages since antiquity; but its abiding power is also the legacy of a pioneering German antiquarian, Johann Joachim Winckelmann, who is often called the father of art history. Born in Stendal in Prussia in 1717, Winckelmann studied in Halle and Jena before becoming librarian for Count Heinrich von Bünau near Dresden. It was in von Bünau's library that he gained an education in the visual arts, which led to his first publication, Reflections on the Imitation of Greek Works of Art in Painting and Sculpture, in 1755. In that same year he moved to Rome, and was soon appointed librarian and advisor to Cardinal Alessandro Albani. In 1764, after the publication of his seminal History of Art of Antiquity, he became papal antiquary and director of antiquities in Rome. Unpublished Antiquities, of 1767, was his last work before his rather ignominious death a year later at the hands of a petty criminal.

The impact of his published works has been enormous. He was first, for instance, to determine that most Greek sculptures (which he often conflated with their Roman copies) represented not historical figures but mythological characters. Even more significant was his contention that Greek art captured an ideal beauty that transcended nature. He established a model for the development of art that divided art history into periods that coincided with political events. The Older Style was the precursor to the High or Sublime Style. Next came the Beautiful Style, and finally the Style of the Imitators. In ancient art, these correspond to the Archaic, fifth-century BCE Classical, Late Classical, and Hellenistic and Roman periods. This progression from rise to eventual decline still lies at the heart of most studies of art history, regardless of the era. When it came to assigning works of art to these phases, Winckelmann was, in a sense, trapped by his own scheme. Reluctant to allot works he admired to the "decline" phase of Hellenistic and Roman art, he often dated sculptures much too early; such was the case with the Laocoon (see The Art Historian's Lens, page 183), which he placed in the fourth century BCE, and the Apollo Belvedere, which he considered a Greek original.

The Apollo Belvedere first came to light again in the fifteenth century CE, and quickly made its way into the collection of Pope Julius II. It represents the god in an open pose, with his left arm outstretched, perhaps to hold a bow. Winckelmann was one of many antiquarians to be profoundly moved by the statue. Combined in its form he perceived both power and desirability, and he penned a rhapsodic description of it that is tinged with eroticizing overtones. "I forget all else at the sight of this miracle of art," he wrote. "My breast seems to enlarge and swell with reverence." Few scholars share his enthusiasm for the piece today. Its significance for art historians resides more in its modern reception—the role it played for admiring Renaissance artists, for instance—than in its place in ancient culture. As for its date, most scholars now identify it as a second-century CE copy or interpretation of a Greek original; the latter is sometimes attributed to Leochares, who worked at the end of the fourth century BCE.

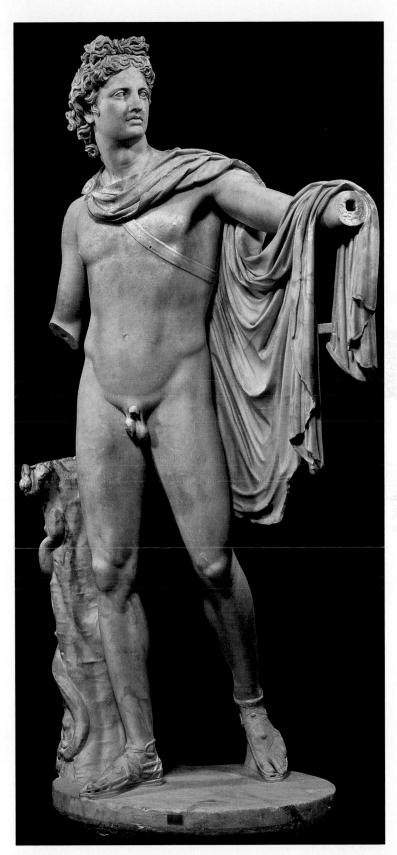

Apollo Belvedere. Roman marble copy, probably of a Greek original of the late 4th century BCE. Height 7'4" (2.3 m). Musei Vaticani, Rome

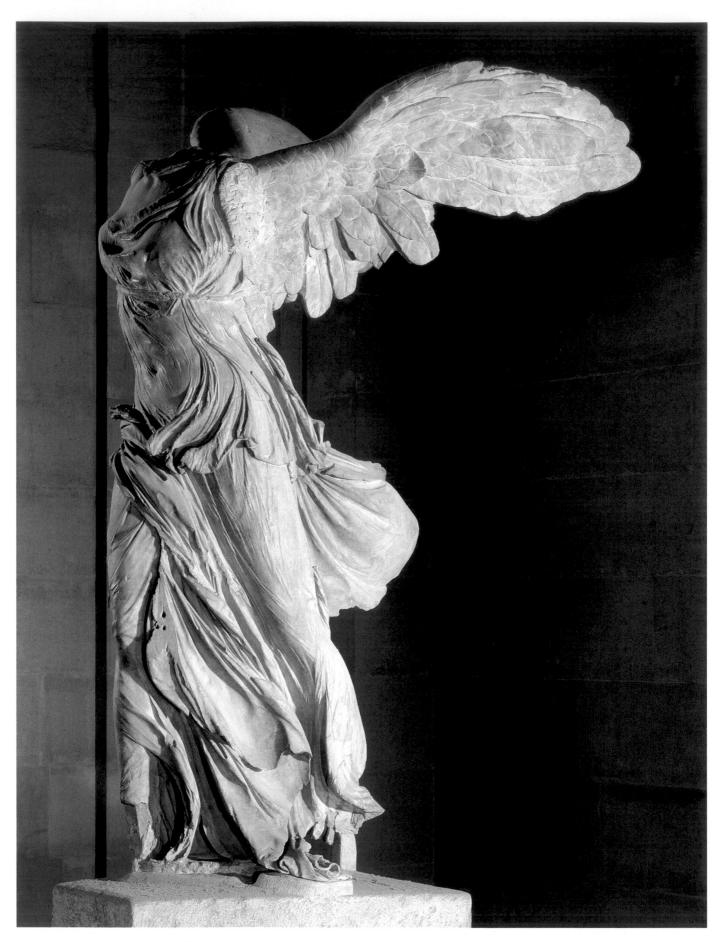

5.74 Pythokritos of Rhodes (?). Nike of Samothrace. ca. 190 BCE. Marble, height 8' (2.44 m). Musée du Louvre, Paris

with creating a balanced and resonant composition, for despite the chaotic appearance of the mêlée, guiding principles lurk behind it. Modern scholars still struggle to understand these principles fully, even with the help of inscriptions naming some of the gods on the molding in the entablature and giants on the base molding. On the eastern frieze, facing the sanctuary's great propylon and the rising sun, were the Olympian gods. The most prominent position belonged to Athena. On the south, drenched in sun, were heavenly lights such as Helios; on the shadowy north were divinities of the night. Deities of the earth and sea were on the west. Compositional parallels unified the four sides. The frieze is direct evidence of the Hellenistic scholarly tradition at work.

On the other hand, it is also deeply imbued with Hellenistic theatricality. Sculptors carved the figures so deeply, and undercut them in places so forcefully, that they are almost in the round. The high relief creates a vivid interplay of light and dark, and on the staircase, the figures seem to spill out onto the steps and climb alongside an ascending visitor. Muscular bodies rush at each other, overlapping and entwining (see fig. 5.73). The giants' snaky extremities twist and curl, echoed in their deeply drilled tendrils of ropelike hair. Wings beat and garments blow furiously in the wind or twist around those they robe, not to reveal the anatomy beneath but to create motion; they have a life of their own and their texture contrasts with the smoothness of the giants' flesh. The giants' emotion is palpable: They agonize in the torment of their defeat, their brows creased in pain, their eyes deep-set in an exaggerated style reminiscent of Skopas. A writhing motion pervades the entire design, and links the figures in a single continuous rhythm. This rhythm, and the quiet Classicism of the gods' faces, so starkly opposed to the giants' faces, create a unity that keeps the violence of the struggle from exploding its architectural frame—but only just. For the first time in the long tradition of its depiction, a viewer has a visceral sense of what a terrible cosmic crisis this battle would be.

The weight and solidity of the great gigantomachy make it a fitting frieze for its place on the building's platform. A second, lighter frieze encircled the inside of the colonnade, and may be slightly later. This frieze portrays the life of Telephos, son of Herakles and legendary founder of Mysia, the region of Pergamon.

Though an altar first and foremost, the Great Altar of Zeus also commemorates Eumenes' victory. Its magnificence underscores the precariousness of the Hellenistic world, and the importance of conquest to a ruler's image. Dramatic location and style combine in another victory monument of the early second century BCE, the *Nike of Samothrace* (fig. 5.74). The sculpture probably celebrates the naval victories—*nike* means "victory"—of Eudamos, an admiral in command of the fleet at Rhodes, over Antiochos the Great and the Seleucid forces in 190 BCE. The Rhodian marble of the sculpture's base, and evidence from inscriptions, suggest that the sculpture comes from Rhodes, and may be the work of the renowned artist Pythokritos from that island. The victory goddess seems to be landing on the prow of a

ship, as if to bestow a crown of victory upon Eudamos. Alternatively, she could be about to take flight. Her massive wings soar out behind her, stretching the limits of the marble's tensile strength. The lift of the wings makes the whole statue appear weightless, despite the great mass of stone: In a new variant of the chiastic stance, neither leg holds the body's full weight. The wings and the drapery give the sculpture its energy. The drapery swirls around the goddess's body, exposing her anatomy and stressing the sensuous curves of her form. Yet it has its own function as well: Its swirling motion suggests the headwind she struggles against, which, in turn, balances the rushing forward thrust of her arrival. The drapery creates the environment around the figure.

This sculpture is a rare instance of a monument coming to light, in 1863, in its original location—in the Sanctuary of the Great Gods at Samothrace, where it must have been a dedication. The stone prow stood high on a terrace overlooking the theater and the sea, within a pool of water that must have reflected the Nike's white marble forms. The pool was raised above a second water basin filled with rocks, to evoke a coastline.

PLAYFULNESS IN SCULPTURE Scholars use the term baroque to describe the extreme emotions, extravagant gestures, and theatrical locations that characterize the Great Altar of Zeus and the Nike of Samothrace. Art historians first used the word to describe seventeenth-century CE art, but the scholars of Hellenistic art borrowed it on recognizing similarities between the two styles. With its dramatic qualities, the Hellenistic baroque style has tended to eclipse the many other contemporary movements in sculpture. One of these is a penchant for works of a light-hearted and sometimes faintly erotic quality. These appear to be a reaction to the weightiness of the baroque style, and sometimes they have an element of parody to them, suggesting that the sculptor hoped to reduce the grand themes of the classical and baroque styles to a comical level. Scholars describe these works somewhat inadequately by the term Rococo, which they also borrow from scholarship on later European art. Some of them represent amorous interactions between divine or semidivine and human figures. In the example shown here, dating to about 100 BCE, Aphrodite wields a slipper to fend off the advances of a lecherous Pan, the half-man, half-goat god of the forests (fig. 5.75). Eros hovers mischievously between them. With her sensuous roundness and her modest hand gesture, the goddess recalls Praxiteles' bathing Aphrodite of Knidos (see fig. 5.56). Here, the erotic possibilities that Praxiteles dangled provocatively in the air are unambiguously answered, and by a humorously undesirable partner. Rather than grasping for her drapery to preserve her dignity, the majestic Aphrodite is reduced to grabbing a slipper in self-defense. This sculpture is another rare example of a Greek original found in the location in which it was used in antiquity. Archaeologists unearthed it in the clubhouse of a group of merchants from Berytus (Beirut) on Delos. Still, it is unclear whether the sculptural group was a cult image or a decorative piece.

159

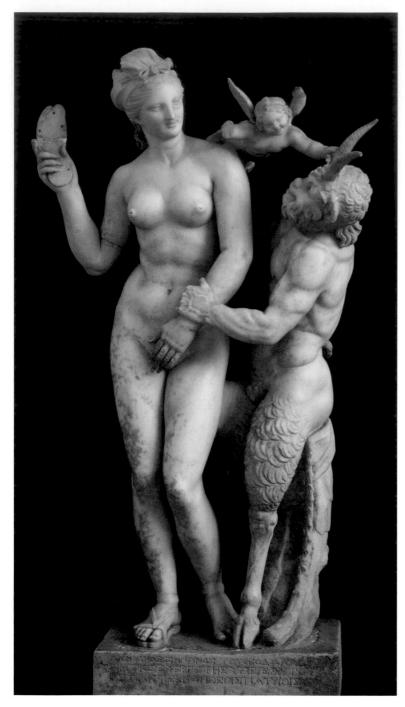

5.75 Aphrodite, Pan, and Eros. ca. 100 BCE. Marble, height 51" (132 cm). National Archaeological Museum, Athens

HELLENISTIC REALISM Scholars sometimes group these light-hearted sculptures together with a series of works depicting unidealized and realistic everyday life. Their genre is known as Hellenistic realism, and a sculpture of a drunken old woman illustrates it well (fig. 5.76). Known from Roman copies, this piece has at times been ascribed to Myron of Thebes, who may have worked at Pergamon. The evidence is slim, and the figure may fit better with the cultural context of Alexandria, where realism seems to have been particularly prevalent. The woman crouches on the ground, clasping a wine bottle, her head flung far back.

Wrinkles cover her face, and the skin on her exposed shoulder and chest sags with age. She wears a buckled tunic, which identifies her as a member of an affluent social class. Other sculptures of this kind focus on the ravaging effects of a rustic life on the poor—an old shepherdess, for instance; yet in this sculpture, the artist explores drunkenness and old age. With her wine jar and her garment slipping from her shoulder, she may even be in ironic dialogue with figures of Aphrodite with her water vessel (see fig. 5.56). Without further insights into the cultural context for the image, it is hard to know if the sculptor intended to offer a sympathetic view of his subject, exalting her nobility, or to engage in hard social commentary.

5.76 Drunken Old Woman. Roman copy of an original of the late 3rd or late 2nd century BCE. Marble, height 36" (92 cm). Staatliche Antikensammlungen und Glyptothek, Munich

5.77 The Abduction of Persephone, Tomb I, Vergina, Macedonia (detail). ca. 340-330 BCE

Hellenistic Painting

It was in the fourth century BCE that Greek wall painting came into its own. Pliny names a number of leading painters, but no surviving work can be attributed to them to give proof of his words. (See www.myartslab.com.) All the same, paintings are preserved in Macedonian tombs, several of which have recently come—and keep coming—to light in northern Greece (in the region of Macedonia). These tombs are of great importance because they contain the only surviving relatively complete Greek wall paintings, and offer a tantalizing glimpse of what painters

could accomplish. The section shown here (fig. 5.77) comes from a small tomb at Vergina, dating to about 340–330 BCE. The subject, the abduction of Persephone, is appropriate to the funereal setting. Pluto, ruler of the underworld, carries away Persephone to be his queen. Thanks to Zeus' intervention, Persephone would be allowed to return to the world of the living for six months of every year. Here, the artist has chosen the moment when Pluto seizes Persephone into his speeding chariot, her handmaiden rearing back in fright and horror. This is the most harrowing moment, before Persephone knows that Zeus will find a compromise, when

5.78 The Battle of Issos or Battle of Alexander and the Persians. Mosaic copy from Pompeii of a Hellenistic painting of ca. 315 BCE. ca. 100 BCE. 8'11" × 16'9½" (2.7 × 5.1 m). Museo Archaeologico Nazionale, Naples

her futile struggle seems the only possible escape from the underworld. The painting captures all of the myth's drama. Persephone flings her body backward, while the chariot rushes onward with her captor; their bodies cross as a sign of conflict. The chariot plunges toward a viewer, its wheel sharply foreshortened. Masterful brushwork animates the scene. With swift flourishes, the artist sends hair and drapery flying, and lends plasticity to the garments. Hatchwork rounds out the bodies' flesh, as on the arms and shoulders. The colors are brilliant washes, with shading for texture. Literary sources attribute the discovery of shading (the modulation of volume by means of contrasting light and shade), known as skiagraphia, to a painter named Apollodorus, who used the technique perhaps as early as the fifth century BCE. They also associate spatial perspective (rendering recession of space) with Agatharchos and the art of stage scenery during the heyday of Athenian drama. The exploration and perfection of both devices during the course of the fourth century BCE illustrate the fascination with illusionism at this time.

Roman copies and imitations may also provide a general impression of Greek wall painting. According to Pliny, at the end of the fourth century BCE, Philoxenos of Eretria painted Alexander the Great's victory over Darius III at Issos. This is the subject of a large and masterful floor mosaic from a Pompeian house of about 100 BCE (fig. 5.78), which could be a copy of Philoxenos' painting. Yet a female painter named Helen, from

Alexandria, also painted the subject, and most scholars believe the mosaic copies her work. It depicts Darius and the fleeing Persians on the right and, in the badly damaged left-hand portion, the figure of Alexander. The mosaic follows a four-color scheme (yellow, red, black, and white) that is known to have been widely used in the late fourth century BCE. (See www.myartslab.com.) The crowding, the air of frantic excitement, the powerfully modeled and foreshortened forms, and the precise shadows also place the scene in the fourth century BCE, as does the minimal treatment of landscape, suggested by a single barren tree to the left of center.

The abundance of surviving Greek art from a period of over seven centuries is a testimony to great intellectual fervor and political change. Devastating wars with their own and neighboring peoples continually shaped Greek culture and art. In the course of those centuries, Greek art changed almost unrecognizably. From the abstract forms of the Geometric period, it transformed itself into the myriad styles of the Hellenistic period. To be sure, the quest for naturalism in sculpture and painting was a driving force in this change. Yet that quest in art was merely part of a more pervasive philosophical outlook, which led to a fascination with proportions and with scholarly analysis of the arts. If the Persian and Peloponnesian Wars, and the Macedonian conquests took their toll, they also fueled the urge to express emotion in the visual arts, and to appeal to an individual's personal experience of the world.

ca. 750 BCE Dipylon Vase

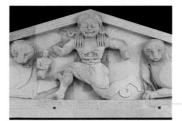

600 BCE Temple of Artemis, Corfu

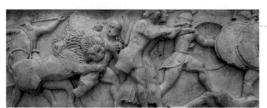

ca. 525 BCE Siphnian Treasury at Delphi

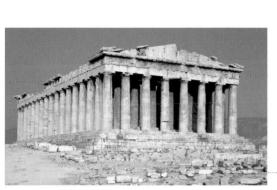

ca. 447 BCE Perikles orders the construction of the Parthenon

ca 480 BCE Kritios Boy

340-330 BCE The Abduction of Persephone at Vergina

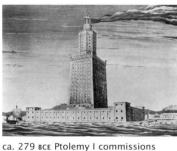

the Pharos at Alexandria

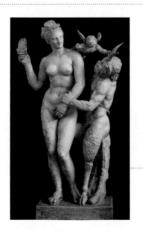

Greek Art

800

- The Odyssey
- 776 BCE First Olympic Games

700 BCE

- mid-7th century BCE Black-figured vase-painting technique develops
- 7th century BCE Doric and Ionic styles develop

600

ca. 518 BCE Construction of the Persian palace at Persepolis begins

500

becomes prevalent in Athens

490 BCE Greeks defeat the Persians at the Battle of Marathon 478 BCE Greek city-states found the Delian League

against the Persians 458 BCE Aeschylus writes the Oresteia trilogy

■ 431-404 BCE Peloponnesian War

400

■ 387 BCE Plato founds the Academy in Athens

■ 338 BCE Philip II of Macedon invades Greece 336-323 BCE Reign of Alexander the Great

300

200

■ 168 BCE Romans conquer Macedon

100

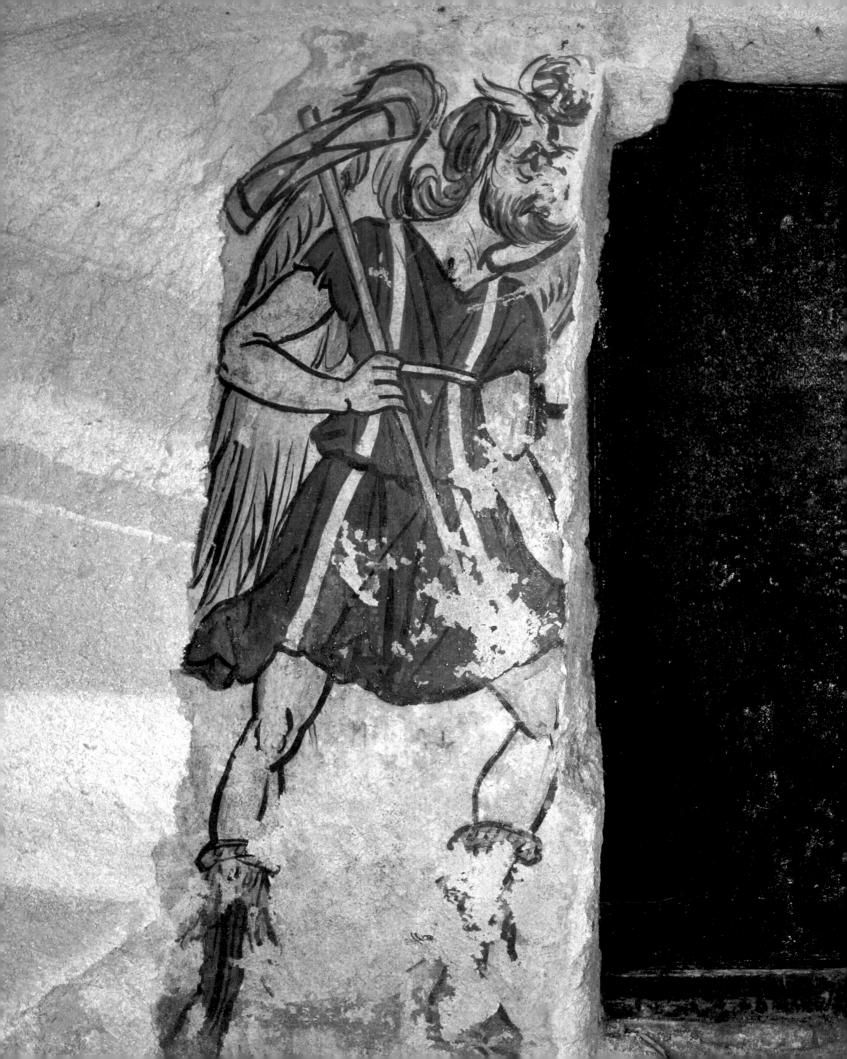

Etruscan Art

the Italian peninsula in the tenth century BCE. Who the Etruscans were remains a mystery; even in antiquity, writers disputed their origins. The Greek historian Herodotus believed that they had left their homeland of Lydia in Asia Minor in about 1200 BCE, and settled in what are now the Italian

regions of Tuscany, Umbria, and Lazio (map 6.1). Recent DNA sampling may support his view. Others claimed they were indigenous. Wherever they came from, the Etruscans had strong cultural links with Asia Minor and the ancient Near East. In fact, their visual culture is a rich blend of distinctly Etruscan traits with influences from the East and from Greece. Since Greek city-states had established colonies in Italy from the eighth century BCE, contact between the two cultures was inevitable. The close relationship between Etruscan and Greek art forms has led scholars to define the stylistic periods of Etruscan art with terms that are similar to those used for Greece. Toward the end of the eighth century BCE the Etruscans began to use the Greek alphabet, and this makes it possible to read their inscriptions, which survive in the thousands; but since their language is unrelated to any other, we cannot always understand their meaning.

The Etruscans reached the height of their power in the seventh and sixth centuries BCE, coinciding with the Archaic period in Greece. They amassed great wealth from mining metals, and their cities rivaled those of the Greeks; their fleet dominated the western Mediterranean and protected a vast commercial network that competed with the Greeks and Phoenicians; and their territory extended from the lower Po Valley in the north to Naples in the south. But, like the Greeks, the Etruscans never formed a unified

Detail of figure 6.6, Charun from the Tomb of the Anina Family

nation. They remained a loose federation of individual city-states, united by a common language and religion, but given to conflict and slow to unite against a common enemy. This may have been one cause of their gradual downfall. In 474 BCE, the Etruscans' archrival, Syracuse, defeated the Etruscan fleet. And during the later fifth and fourth centuries BCE, one Etruscan city after another fell to the Romans. By 270 BCE, all the Etruscan city-states had lost their independence to Rome, although if we are to judge by the splendor of their tombs during this period of political struggle, many still prospered.

The bulk of our knowledge about Etruscan culture comes from art, and especially from their monumental tombs. These structures provide information about Etruscan building practices, and artists often painted them with scenes that reveal a glimpse of Etruscan life. Objects found within them attest to the Etruscans' reputation as fine sculptors and metalworkers. Large numbers of painted vases from Athens have also come to light in tombs, demonstrating the Etruscans' close trade ties with Greece.

FUNERARY ART

As with burials elsewhere in prehistoric Europe, early burials on the Italian peninsula were modest. The living either buried the deceased in shallow graves or cremated them, and placed the ashes, in a pottery vessel or cinerary urn, in a simple pit.

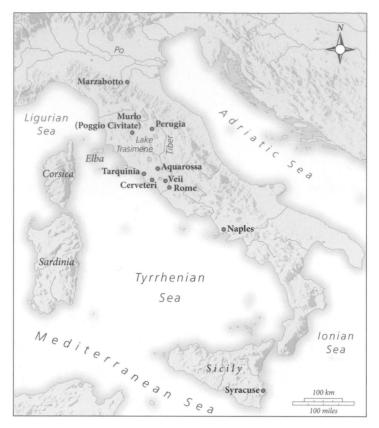

Map 6.1 Italian Peninsula in Etruscan times

Sometimes they buried offerings with the dead—weapons for men, and jewelry and weaving implements for women. Early in the seventh century BCE, as Etruscans began to bury their dead in family groups, funerary customs for men and women became more elaborate, and the tombs of the wealthy gradually transformed into monumental structures.

Tombs and Their Contents

Named for the amateur archaeologists who excavated it, the Regolini-Galassi Tomb at Cerveteri is an early example of this more elaborate burial practice, dating to the so-called Orientalizing phase of the mid-seventh century BCE, when Etruscan arts show a marked influence from Eastern motifs. Etruscans formed tombs in the shape of mounds called **tumuli**, which were grouped together outside the living spaces of Etruscan towns to create a city of the dead, or necropolis. In this example, builders roofed the long dromos (plural, dromoi) or pathway leading into the tomb with corbeled vaults built of horizontal, overlapping courses of stone blocks, similar to the casemates at Tiryns (see fig. 4.20). Among the grave goods was a spectacular fibula (fig. 6.1). A fibula resembled a brooch or a

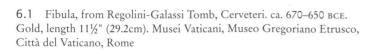

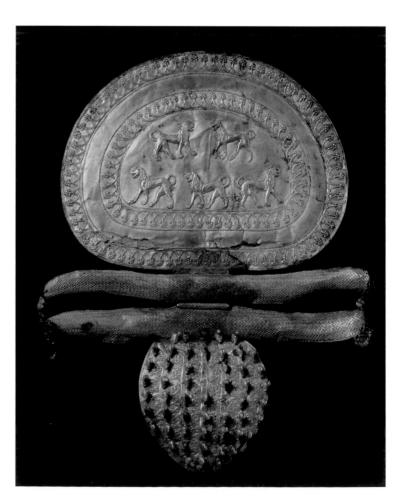

6.2 Aerial view of part of Banditaccia Cemetery, Cerveteri. 7th–2nd centuries BCE

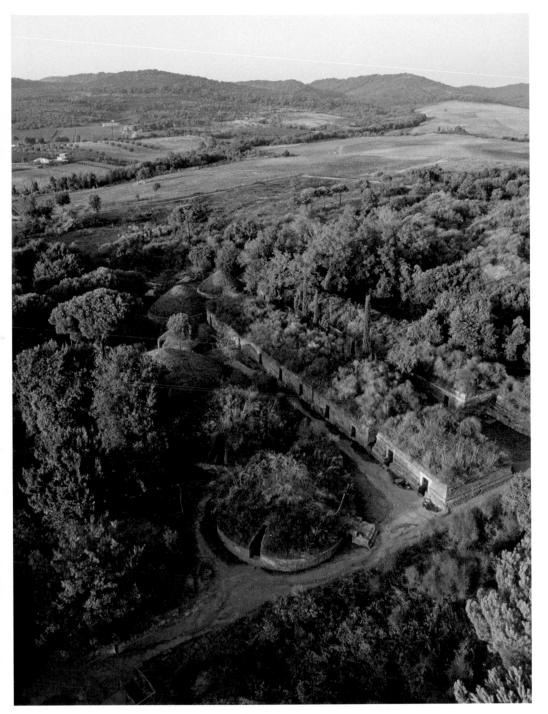

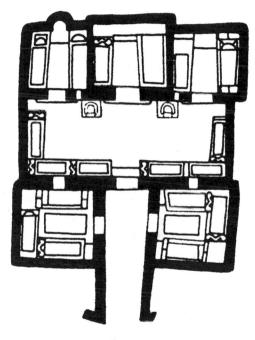

6.3 Plan of Tomb of the Shields and Chairs, Cerveteri. ca. 550–500 BCE

decorative safety pin, and often served to hold a garment together at the neck. At 11½ inches in length, this magnificent example is a tour de force of the goldsmith's art (see Materials and Techniques, page 169), and justifies the fame Etruscan goldsmiths enjoyed in antiquity. Covering the lower leaflike portion are 55 gold ducks in the round. On the upper portion, shaped like a three-quarter-moon, repoussé work defines pacing lions, whose profile pose and erect stance may derive from Phoenician precedents. Indeed, though the workmanship is probably Etruscan, the animal motifs suggest familiarity with the artworks of Near Eastern cultures (see fig. 2.10). Also buried in tombs of this time were precious objects imported from the ancient Near East, such as ivories.

The Regolini-Galassi Tomb is but one of many tumulus tombs built at necropoleis near Cerveteri over the course of several centuries until about 100 BCE (fig. 6.2). The local stone is a soft volcanic rock known as *tuff*, which is easy to cut and hardens after prolonged exposure to the air. Those who created the tumuli excavated into bedrock, cutting away a path and burial chambers. They used excavated stone to build a circular retaining wall around the chambers, and piled up soil above it. Often several dromoi led to independent networks of chambers within a single mound. The layout of the burial chambers varies (fig. 6.3), and scholars have supposed that these dwellings of the dead mimicked contemporary houses, often complete with chairs or beds carved

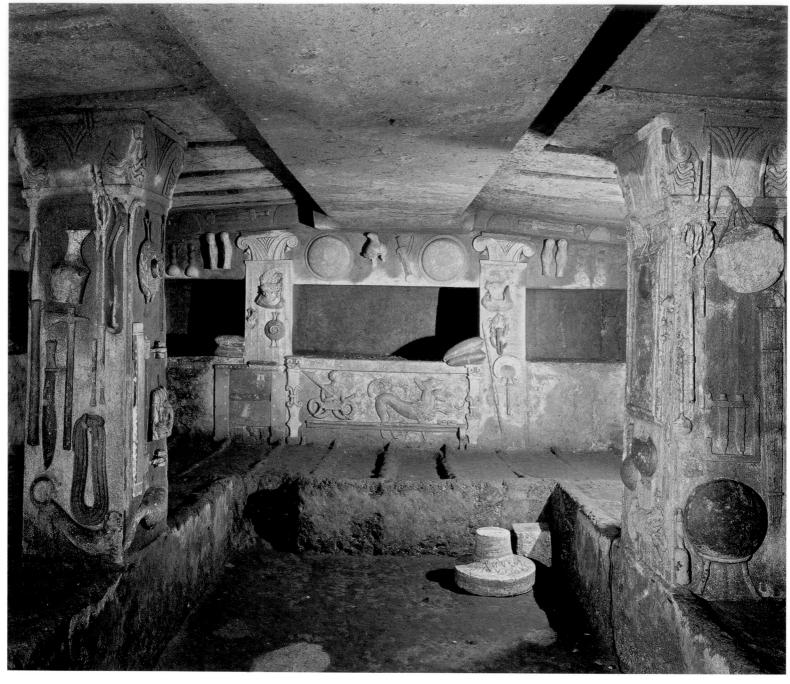

6.4 Burial chamber, Tomb of the Reliefs, Cerveteri. 3rd century BCE

out of the rock as furnishing. This may be true, but it is hard to confirm given the scant evidence for Etruscan residences. In a late example, the Tomb of the Reliefs at Cerveteri, an artist applied everything the dead might want in the afterlife onto the walls in stucco (fig. 6.4). Reproductions of weapons, armor, household implements, and domestic animals cover the piers and the walls between the niches. Two damaged busts may have represented the dead or underworld deities. The concept of burying items that would be of service in the afterlife is reminiscent of Egyptian funerary practice, though replicas of actual items differ markedly between the two cultures.

Farther north, at Tarquinia, tombs consist of chambers sunk into the earth with a steep underground dromos. Vibrant paintings cover the walls, executed while the plaster was wet. At one end of the low chamber in the Tomb of Hunting and Fishing is a marine panorama, dating to about 530–520 BCE (fig. 6.5) during the Archaic period. In the vast expanse of water and sky, fishermen cast lines from a boat, as brightly colored dolphins leap through the waves. A figure on a rocky promontory aims his slingshot at large birds in bright red, blue, and yellow that swoop through the sky. Unlike Greek landscape scenes, where humans dominate their surroundings, here the figures are just one part of

Etruscan Gold-Working

Larly in their history, the Etruscans became talented metalworkers, with special proficiency in gold-working. The goldsmith responsible for the fibula in figure 6.1 was a master of two complex techniques: filigree and granulation.

Filigree is the art of soldering fine gold wires—singly or twisted together into a rope—onto a gold background. The goldsmith used this process to outline the ornamental decoration and two-dimensional animals on the fibula's surface. Etruscan artists were so expert that they could even create openwork designs independent of a backplate.

Granulation describes the process of soldering tiny gold balls or grains onto a background. Skilled Etruscan artists worked with grains as small as χ_{50} ", using them to decorate large areas, or to define linear or geometric patterns. Alternatively, they might employ them in conjunction with embossed designs, or in a mass to create a silhouette against the background. Finally, they might cover the background with grains, leaving a design in silhouette.

Mastery of granulation was lost in early medieval Europe, as tastes changed and different gold-working techniques came to be preferred. Goldsmiths use various methods today, but scholars do not know how Etruscan artists prepared the grains. They may have placed fragments of gold in a crucible, separating them with charcoal. When heated, the gold would melt into separate balls. Goldsmiths would then remove the charcoal that kept the balls apart. Alternatively, they may have poured molten gold into water from a height, to ensure that tiny grains would form into small balls. When the liquid metal reached the water, it would cool into solid form. For all but the simplest designs (which

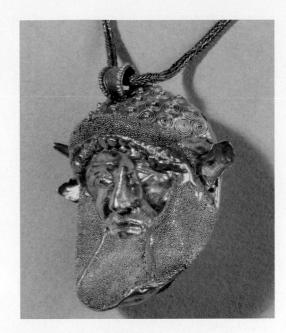

Pendant representing the head of Acheloos, decorated with granulation. 6th century BCE. Musée du Louvre, Paris

were applied straight to the background), the artist probably arranged the grains in a design engraved on a stone or metal plate, and lowered a plece of adhesive-covered papyrus or leather, fixed to the end of a tube, over the design, to pick up the grains. They could then be treated with solder and transferred to the gold backplate.

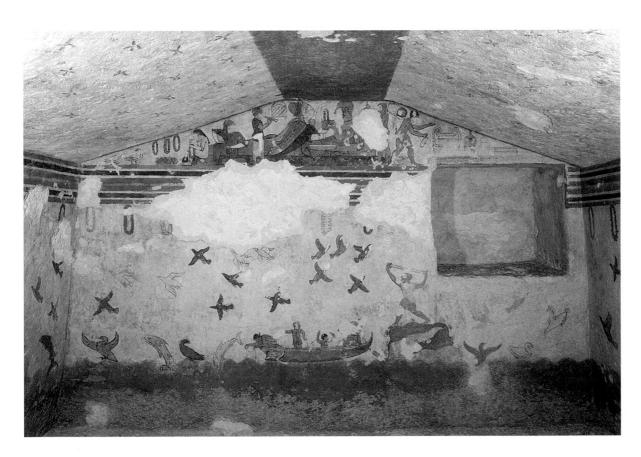

6.5 Tomb of Hunting and Fishing, Tarquinia. ca. 530–520 BCE

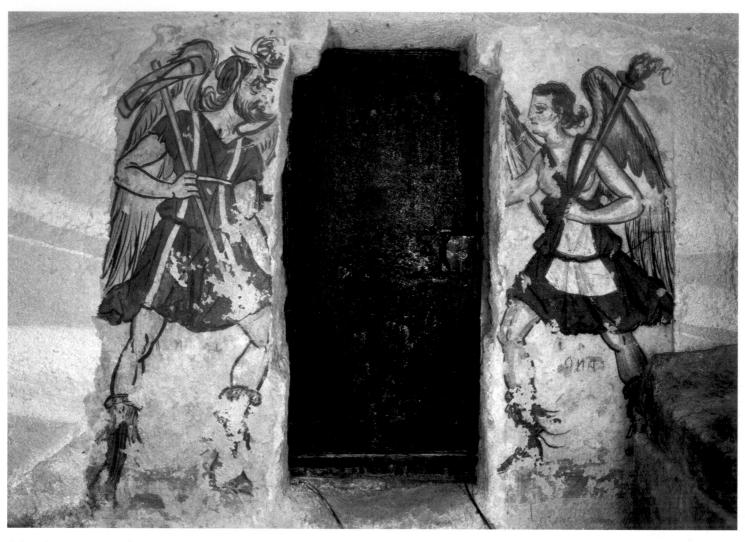

6.6 Charun and Vanth from the Tomb of the Anina Family, Tarquinia. 3rd century BCE

a larger scheme. The exuberance of the colors and gestures, too, is characteristically Etruscan. All the same, here as in most tombs, the treatment of drapery and anatomy reveals that developing Greek painting influenced Etruscan tomb painters.

The artist seems to have conceived of the scene as a view from a tent or hut, defined by wide bands of color at cornice level and roofed with a light tapestry. Hanging from the cornice are festive garlands of the kind probably used during funerary rituals. In many tombs, images of animals fill the gable—leopards, sometimes, or fantastic hybrids—perhaps used as guardian figures to ward off evil. Above the fishing scene, a man and woman recline together at a banquet, where musicians entertain them and servants attend to their needs. One draws wine from a large mixing bowl, or krater, while another makes wreaths. In contrast to Greek drinking parties (symposia), which were reserved for men and courtesans, Etruscan banquet scenes include respectable women reclining alongside men. Banquet paintings appear frequently in Etruscan tombs; athletic games were another common subject, as were scenes that focused on musicians and dancers.

The purpose of these paintings is hard to determine. They may record and perpetuate activities the deceased once enjoyed, or depict rituals observed at the funeral (the games, in fact, are probably the forerunners of Roman gladiatorial contests). Or, like Egyptian tomb paintings, they may have served as provisions for the afterlife of the deceased. At the heart of the problem of interpretation lies our general ignorance about Etruscan beliefs concerning death and the afterlife. Roman writers describe them as a highly religious people, and their priests are known to have read meaning into the flight of birds in different sectors of the sky; beyond that, as enigmatic as they are, these paintings actually constitute a large part of our evidence for understanding Etruscan beliefs. In a few tombs, paintings seem to reflect Greek myths, but these images merely compound the problem, since we cannot be sure that the Etruscans intended the same meaning as Greek artists.

However we interpret these Archaic and Classical images, it is clear that a distinct change in the content of tomb paintings begins in the Late Classical period during the fourth century BCE. An overwhelming sense of sadness replaces the energetic mood of the foregoing periods. The exuberant palette of the earlier phases, with its bright reds and yellows, gives way to a somber range of darker colors. At this time, funerary images often depict

processions taking the deceased to a world of the dead, or they are set in a shadowy underworld. In the Tomb of the Anina Family at Tarquinia, dating to about the end of the fourth century BCE, two winged demons flank a door to another world (fig. 6.6). A hook-nosed male demon Charun, on the left, is the soul's guide to the underworld. He holds the hammer with which he will open the door, while Vanth, a female demon on the right, bears a torch to light the darkness. It is possible that the gloomy subjects reflected difficult times, as they coincide with the Roman conquest and subordination of Etruscan cities.

Containers used for the remains of the dead manifest similar changes. In the Orientalizing period, the pottery urns traditionally used for ashes gradually took on human characteristics (fig. 6.7). The lid became a head, perhaps intended to represent the deceased, and body markings appeared on the vessel itself. Hair and jewelry may have been attached where holes appear in the terra-cotta surface. Sometimes the urn was placed on a sort of throne in the tomb, which may have indicated a high status for the deceased.

In Cerveteri, two monumental sarcophagi of the Archaic period have come to light, molded in terra cotta in two separate lialves. One of them, dating to about 520 BCE, is shown here (fig. 6.8). The artist shaped the lid to resemble a couch, and reclining side by side on top are full-length sculptures of a man and woman, presumably a married couple. A wineskin (a soft canteen made from an animal skin) cushions the woman's left elbow, and the man has his arm around her shoulders. Both figures once held

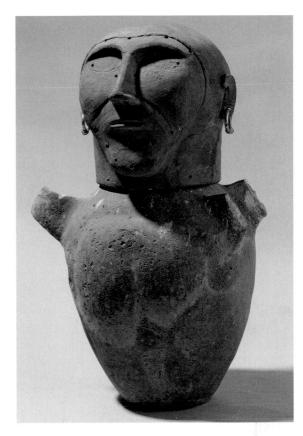

6.7 Human-headed cinerary urn. ca. 675–650 BCE. Terra cotta, height 25½" (64.7 cm). Museo Etrusco, Chiusi, Italy

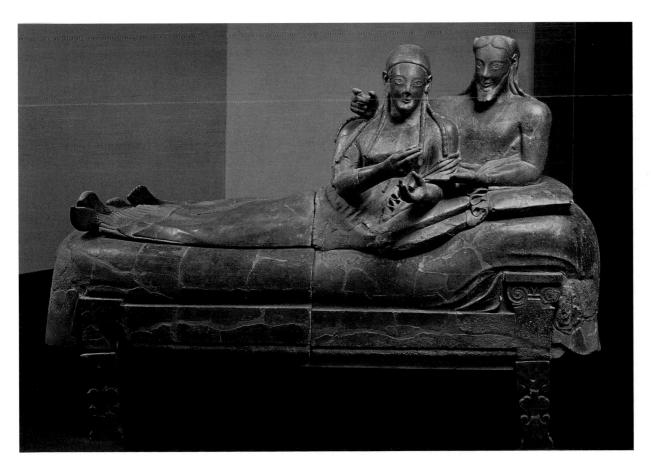

6.8 Sarcophagus, from Cerveteri. ca. 520 BCE.
Terra cotta, length 6'7" (2 m).
Museo Nazionale di Villa Giulia, Rome

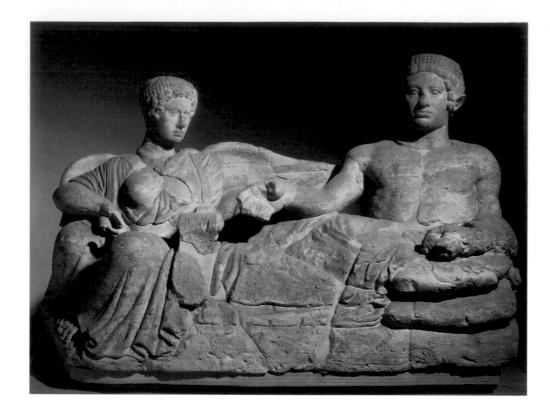

6.9 Youth and Female Demon. Cinerary container. Early 4th century BCE. Stone (pietra fetida), length 47" (119.4 cm). Museo Archaeologico Nazionale, Florence

out objects in their hands—a cup or an **alabastron** (a perfume container), perhaps, or an egg, symbol of eternity. Despite the abstract forms and rigid poses of the Archaic style, the soft material allows the sculptor to model rounded forms and capture an extraordinary directness and vivacity. The artist painted the entire work in bright colors, which conservators have revealed more clearly in a recent cleaning.

The change in mood, from optimistic to somber, that characterizes tomb paintings between the fifth and fourth centuries BCE

also becomes apparent if we compare the sarcophagus in figure 6.8 with a cinerary container made of soft stone soon after 400 BCE (fig. 6.9). At one end reclines a young man wearing his mantle pulled down around his waist, in the Etruscan style. As in wall paintings of this period, a woman sits at the foot of the couch. Yet she is not his wife. Her wings identify her as a demon from the world of the dead, and the scroll in her left hand may record his fate. The two figures set at either end of the couch create a balanced composition, but their separation marks a new mood of

6.10 Funerary urns in the Inghirami Tomb, Volterra. Hellenistic period, ca. 2nd century BCE

6.11 Sarcophagus lid of Larth Tetnies and Thanchvil Tarnai. ca. 350-300 BCE. Marble, length 7' (2.13 m). Museum of Fine Arts, Boston. Gift of Mrs. Gardner Brewer, 86.145 a-b

melancholy associated with death, which each individual must face alone. Still, wealthy Etruscans continued to bury their dead together in family tombs, and the familial context for cinerary urns like this one must have gone some way toward mitigating the isolation of death (fig. 6.10). Moreover, while cinerary urns of this kind were typical, usually with a single figure reclining on the lid, a few grand sarcophagi survive. On the lid of one are carved a man and woman in a tender embrace, lying under a sheet as if in their marital bed (fig. 6.11). The coiffures and beard reflect Greek fashion, and the sides of the chest feature battle scenes influenced by Greek iconography, yet the finished product is definitively Etruscan.

ARCHITECTURE

According to Roman writers, the Etruscans were masters of engineering, town planning, and surveying. Almost certainly, the Romans learned from them, especially in water management (drainage systems and aqueducts) and bridge building. Exactly what they learned is hard to determine, however. Since it was built predominantly of wood or mud brick, relatively little Etruscan and early Roman architecture survives. Additionally, many Etruscan towns lie beneath existing Italian towns, and any permanent materials employed in their construction have often been reused.

Etruscan cities generally sat on hilltops close to a navigable river or the sea. From the seventh century BCE on, in some places the inhabitants added massive defensive walls. A late example of civic architecture survives in the city of Perugia, where sections of a fortification wall and some of its gates still stand. The bestknown of these is the Porta Marzia (Gate of Mars) of the second century BCE, the upper portion of which the Renaissance architect Antonio da Sangallo encased in a later wall (fig. 6.12). The gate is an early example of a voussoir arch, built out of a series of truncated wedge-shaped stones called voussoirs set in a semicircle against a wooden framework, which was removed after construction. Once the voussoirs were in place, they were remarkably strong; any downward thrust from above (the weight of the wall over the void, for instance) merely strengthened their bond by pressing them more tightly against one another. Above the arch, and separated from one another by engaged pilasters, sculpted figures of Tinia (the Etruscan equivalent of Zeus or Jupiter) and his sons (equivalent to Castor and Pollux) with their horses look out over a balustrade. The arch is visual evidence of the confluence of

6.12 Porta Marzia, Perugia. 2nd century BCE

cultures so prevalent in the Mediterranean in the last centuries before the Common Era.

City Planning

The hilltops of Etruria did not lend themselves to grid planning, yet there is good evidence at sites like Marzabotto that when the Etruscans colonized the flatlands of the Po Valley in northern Italy, from the sixth century BCE on, they laid out newly founded cities as a network of streets. These centered on the intersection of two main thoroughfares, one running north—south (known in Latin as the *cardo*) and one running east—west (the *decumanus*). The resulting four quarters could be further subdivided or expanded, according to need. This system seems consistent with religious beliefs that led the Etruscans to divide the sky into regions according to the points of the compass. The Romans also adopted it for the new colonies they founded throughout Italy, Western Europe, and North Africa, and for military camps.

Little survives of the houses that composed Etruscan towns. Unlike tombs, they were built with a packed-earth technique (pisé) similar to wattle and daub or adobe, with only the base made of stone. Even these stone footprints are hard to discern, since the hilltops favored by the Etruscans have been inhabited more or less continually since their days. In a few places, however, archaeologists have unearthed the remains of monumental building complexes that may have been palaces or large villas. An especially fine example existed at Poggio Civitate (present-day Murlo) in the sixth century BCE, where numerous rooms framed a large central courtyard (fig. 6.13). This kind of architecture is conceptually linked to typically Roman atrium houses (see fig. 7.50). In order to protect the wooden fabric of their monumental buildings, Etruscans nailed terra-cotta revetment plaques over exposed parts of beams. A mid-sixth-century BCE monumental residential building at Acquarossa yielded a fine set of molded and painted

6.13 Plan of residential complex, Murlo (Poggio Civitate). 6th century BCE

revetments. One of them shows a banquet scene, with diners on couches amid musicians (fig. 6.14), and others depicted Herakles accomplishing his labors. With their bright colors, the revetments enlivened the building, but they may also have aligned the elite property owners with the Greek hero.

Etruscans built their temples of mud brick and wood, so once again only the stone foundations survive. Early temples consisted of little more than modest rectangular cellas (rooms for holding cult figures). Later temples seem to have fallen heavily under the influence of the innovative design of the massive Temple of Jupiter Optimus Maximus on the Capitoline Hill in Rome (see fig. 7.1). As a result, they are characterized by a tall base, or podium, with steps only on the front (fig. 6.15). The steps lead to a deep porch with rows of columns, and to the cella beyond,

6.14 Revetment plaque, from Acquarossa. ca. 575–550 BCE. Painted terra cotta, height 8.3" (21 cm). Museo Archaeologico Nazionale, Viterbo

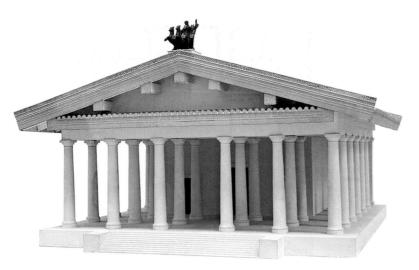

6.15 Reconstruction of an Etruscan temple, as described by Vitruvius. Museo delle Antichità Etrusche e Italiche, Università di Roma "La Sapienza"

which was often subdivided into three compartments. The terracotta tile roof hung well over the walls in wide eaves, to protect the mud bricks from rain, and terra-cotta revetments sheathed the beams.

SCULPTURE

As with their Greek counterparts, Etruscan temples were highly ornate, but where Greeks used marble to adorn their temples, Etruscans had little access to this material. The decoration on Etruscan temples usually consisted of the brightly painted terra-cotta revetments that protected the architrave and the edges of the roof. After about 400 BCE, Etruscan artists sometimes designed large-scale terra-cotta groups to fill the pediment above the porch. The most dramatic use of sculpture, however, was on the ridgepole—the horizontal beam at the crest of a gabled roof. Terra-cotta figures at this height depicted not only single figures but narratives.

Dynamism in Terra Cotta and Bronze

One of the most famous surviving temple sculptures comes from Veii, a site some 14 miles (22 km) north of Rome. Both Roman texts and archaeological evidence indicate that Veii was an important sculptural center by the end of the sixth century BCE.

The late sixth-century BCE temple at Veii was probably devoted to the Etruscan gods Menrva, Aritimi, and Turan. Four life-size terra-cotta statues crowned the ridge of the roof. (Similar examples appear in the reconstruction model, see fig. 6.15.) They formed a dynamic and interactive group representing the contest of Hercle (equivalent to Hercules) and Aplu (Apollo) for the sacred hind (female deer) in the presence of other deities. The best-preserved of the figures is Aplu (fig. 6.16). He wears a mantle with curved hem later known to Romans as a toga. The drapery falls across his form in ornamental patterns and exposes his

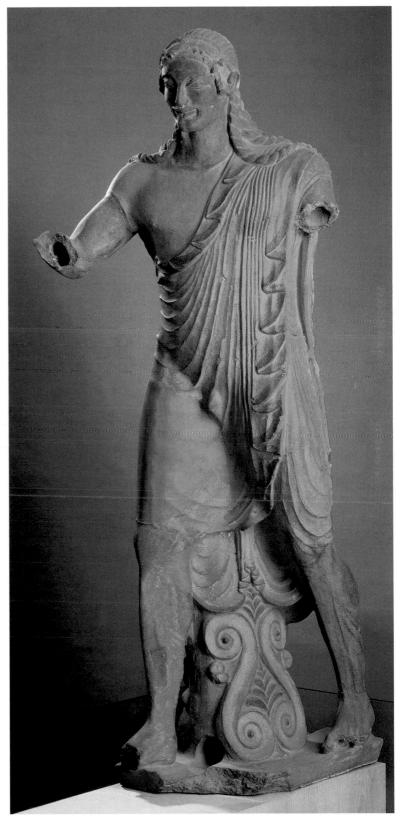

6.16 Vulca of Veii (?). *Aplu (Apollo)*, from Veii. ca. 510 BCE. Terra cotta, height 5'9" (1.75 m). Museo Nazionale di Villa Giulia, Rome

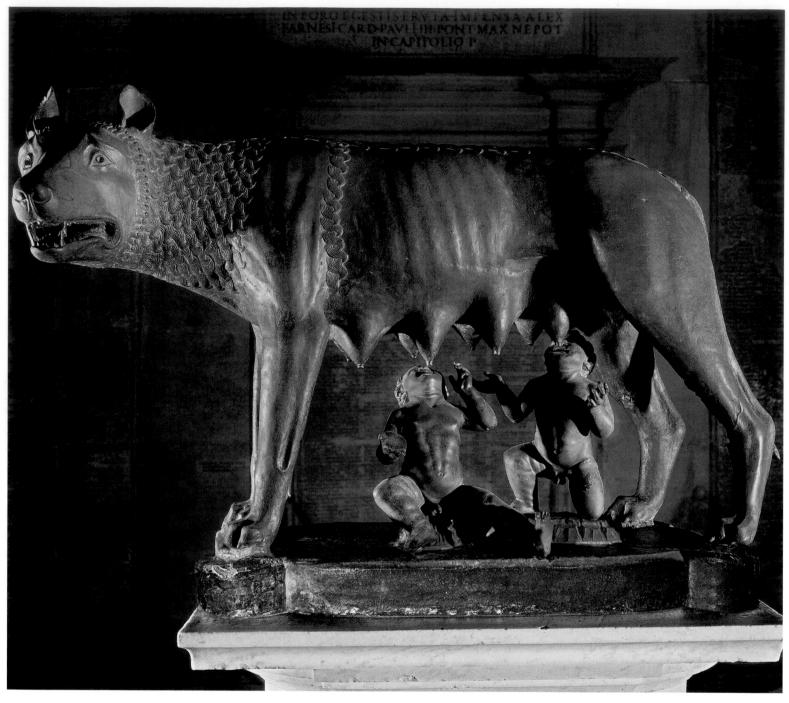

6.17 She-Wolf. ca. 500 BCE. Bronze, height 331/2" (85 cm). Museo Capitolino, Rome

massive body, with its sinewy, muscular legs. The stylistic similarity to contemporary Greek kouroi and korai signals the influence Greek sculpture must have had on the Etruscans. Yet this god moves in a hurried, purposeful stride that has no equivalent in free-standing Greek statues of the same date. Rendered in terra cotta, which allowed the sculptor greater freedom than stone to experiment with poses, this is a purely Etruscan energy. These sculptures have been attributed to a famous Etruscan sculptor, Vulca of Veii, celebrated in Latin literary sources.

Etruscan sculptors also demonstrated extraordinary skill as bronze-casters. One of the most renowned works of Etruscan sculpture is the bronze *She-Wolf* now housed in the Capitoline Museums in Rome (fig. 6.17). Its most likely date is the fifth century BCE, and, judging by its workmanship, it is probably by the hand of an Etruscan artist. The stylized, patterned treatment of the wolf's mane and hackles sets off the bold but smoothly modeled muscularity of her body, tensed for attack. Simple lines augment her power: The straight back and neck contrast with the sharp turn of the head toward a viewer, highlighting her ferocity. So polished is the metal's surface that it almost seems wet; her fangs seem to glisten. The early history and subject matter of this statue is unknown. However, evidence suggests that it was highly

valued in later antiquity, particularly by the Romans. According to Roman legend, the twin brothers Romulus and Remus, descendants of refugees from Troy in Asia Minor, founded Rome in 753/52 BCE. Abandoned as babies, they were nourished by a shewolf in the wild. Romans may have seen in this Etruscan bronze a representation of their legendary mother wolf. In fact, the early fourth-century CE emperor Maxentius built a grand palace in Rome, where, in a large exedra (alcove) framed by a walkway, archaeologists found a statue base with fittings that exactly match the footprints of the she-wolf. A later sculptor—probably Antonio Polaiuolo—added the twins Romulus and Remus beneath her between 1471 and 1473, to resemble Roman coin images of the lactating she-wolf with the babies.

The Etruscan concern with images of the dead might lead us to expect an early interest in portraiture. Yet the features of funerary images such as those in figures 6.8 and 6.9 are stylized rather than individualized. Not until a century later, toward 300 BCE, did individual likenesses begin to appear in Etruscan sculpture. Greek portraiture may have influenced the change, but terra cotta, the material of so much Etruscan sculpture, lent itself to easy modeling of distinctive facial features and a sensitive treatment of flesh, and must have facilitated the development of the genre. The artist individualized an example from Cerveteri by giving it protruding

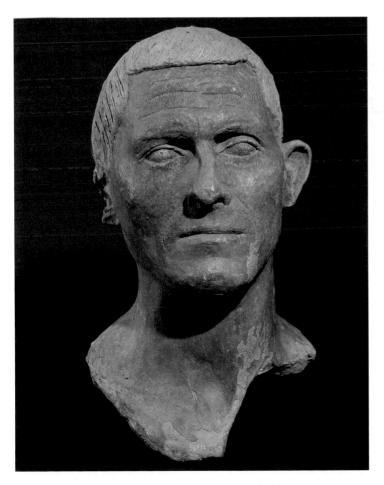

6.18 Portrait of a Man, from Manganello. 1st century BCE. Terra cotta, height 12" (30.5 cm). Museo Nazionale di Villa Giulia, Rome

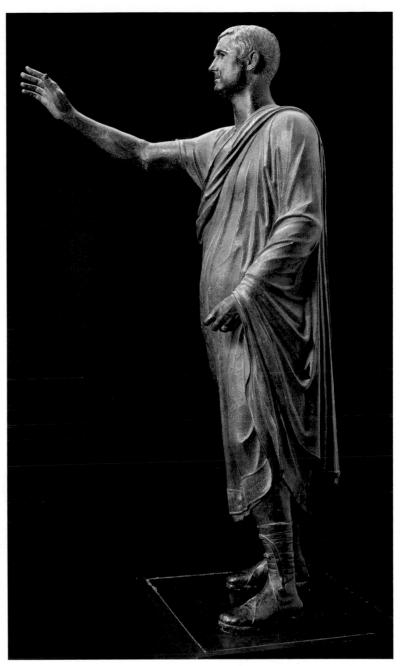

6.19 L'Arringatore (the Orator). Early 1st century BCE. Bronze, height 5'11" (2.80 m). Museo Archaeologico Nazionale, Florence

ears, a crooked nose, and blond hair. Many Etruscan portraits, like this one, come from votive deposits, where Etruscans left them as offerings to the gods (fig. 6.18).

Etruscan artists also produced fine portraits in bronze. A lifesize sculpture of an orator known today as *L'Arringatore* (the Orator) shows how impressive their full-length sculptures were (fig. 6.19). Most scholars place this sculpture in the early years of the first century BCE. It comes from Lake Trasimene, in the central Etruscan territory, and bears an Etruscan inscription that includes the name Aule Meteli (Aulus Metellus in Latin), presumably the name of the person it represents. The inscription shows that the workmanship is Etruscan, yet the high boots mark the

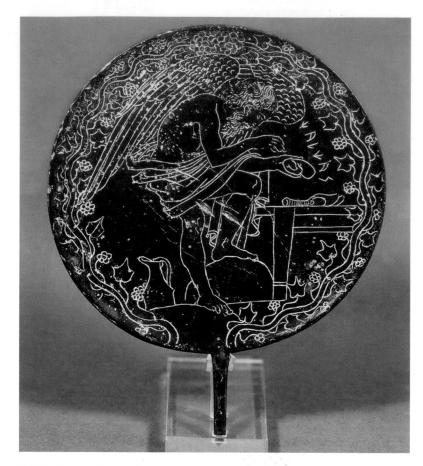

6.20 Engraved back of a mirror. ca. 400 BCE. Bronze, diameter 6" (15.3 cm). Musei Vaticani, Museo Gregoriano Etrusco, Città del Vaticano, Rome

subject as Roman, or at least an official appointed by the Romans. The raised arm, a gesture that denotes both address and salutation, is common to hundreds of Roman statues. The sculpture raises questions about the roles of artist and patron in the conquered Etruscan territories. The high quality of the casting and finishing of Etruscan bronze works bears out their fame as metalworkers. Their skill is hardly surprising in a land whose wealth was founded on the exploitation of copper, iron, and silver deposits.

From the sixth century BCE on, Etruscans produced large numbers of bronze statuettes, mirrors, and other objects for domestic use and for export. They often engraved the backs of mirrors with scenes from Etruscan versions of Greek myths devoted to the loves of the gods. Such amorous subjects were appropriate for objects used for self-admiration. The design on the back of a mirror created soon after 400 BCE (fig. 6.20) is of a different genre, and shows how the Etruscans adapted Greek traditions to their own ends. Within an undulating wreath of vines stands a winged old man, one foot raised upon a rock. An inscription identifies him as the seer Chalchas, an Etruscan version of the Greek figure known from Homer's Iliad. Yet this is the full extent of the borrowing, for the wings make the figure entirely Etruscan, and he is engaged in haruspicy, a pursuit that was central to Etruscan ritual: He is gazing intently at the liver of a sacrificial animal, searching for omens or portents. The Etruscans believed

that signs in the natural world, such as thunderstorms or, as we have seen, the flight of birds, or even the entrails of sacrificed animals, expressed the will of the gods. In fact, they viewed the liver as a sort of microcosm, divided into sections that corresponded to the 16 regions of the sky. By reading natural signs, those priests who were skilled in the arts of augury, as this practice was also called, could determine whether the gods approved or disapproved of their acts. These priests enjoyed great prestige and power, and they continued to thrive long after the Romans had subordinated Etruscan culture. The Romans themselves consulted them before any major public or private event. As the Roman philosopher and statesman Seneca wrote: "This is the difference between us and the Etruscans...Since they attribute everything to divine agency, they are of the opinion that things do not reveal the future because they have occurred, but that they occur because they are meant to reveal the future." Mirrors, too, were valued for their ability to reveal the future, which is probably why the artist represented this scene here.

Etruscan artists and architects show immense skill and versatility when working in many different mediums. Their work is a true product of the Mediterranean crossroads. Their Greek counterparts exerted some influence on them, and they exchanged inspiration with the Romans. Still, Etruscan works stand distinctly apart.

6th century BCE Monumental building complex at Murlo

ca. 670-650 BCE Regolini-Galassi gold fibula

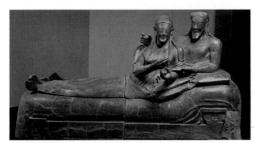

ca. 520 BCE Etruscan terra-cotta sarcophagus from Cerveteri

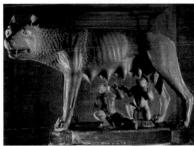

ca. 500 BCE The Capitoline She-Wolf

end of 4th century BCE Tomb of the Anina Family at Tarquinia

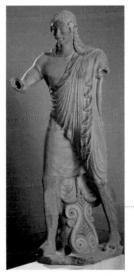

ca. 400 BCE Aplu (Apollo) of Veii

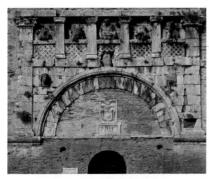

2nd century BCE The Porta Marzia in Perugia

Etruscan Art

\triangleleft	ca. 1000	BCE	Etruscan	culture	appears	on	the
	Italian pe	enin	sula				

1000

900 BCE

800

700 BCE

600

500

BCE

400 BCE

300

200 BCE

100

0

ca.	750	BCE	Greek	sculptural	group,	Man	and
Cer	ntaur	, po	ssibly	from Olyn	ipia		

mid-7th century BCE Black-figured vase-painting
technique develops in Athens
ca. 668-627 BCE Assyrian construction of the
North Palace of Ashurbanipal

ca. 575 BCE Babylonians construct the Ishtar Gate

■ 500s BCE Etruscans begin colonizing the flatlands south of Rome

447-432 BCE Construction of the Parthenon in Athens

ca. 396 BCE The Romans besiege and conquer Veil

ca. 380-330 BCE The Mausoleum at Halikarnassos

■ 331 BCE Alexander the Great defeats the Persians

ca. 300 BCE Construction begins on the Temple of Apollo at Didyma

270 BCE All Etruscan city-states had lost their independence to Rome

ca. 175 BCE Great Altar of Zeus at Pergamon

ca. 80 BCE Greek portrait head from Delos

ca. 100 BCE L'Arringatore (the Orator)

Roman Art

accessible to modern scholars is that of ancient Rome. Romans built countless monuments throughout their empire, many of which are extraordinarily well preserved. A vast literary legacy, ranging from poetry and histories to inscriptions that recorded everyday events, also reveals

a great deal about Roman culture. Yet few questions are more difficult to address than "What is Roman art?"

Rome was a significant power in the Mediterranean from the fifth century BCE until the fourth century CE. At the Empire's height, its borders stretched from present-day Morocco to Iran, and from Egypt to Scotland (map 7.1). Greece was a relatively early addition to Roman territory, and much of Roman public art draws heavily on Greek styles, both Classical and Hellenistic. In the nineteenth and early twentieth centuries, influenced by early art historians like Winckelmann (see The Art Historian's Lens, page 157), art connoisseurs exalted Greek Classicism as the height of stylistic achievement, and considered Roman art derivative, the last chapter, so to speak, of Greek art history. This view changed radically in the ensuing years, especially as pure connoisseurship (an assessment of quality and authenticity) began to yield to other branches of art history. Scholars now focus, for instance, on the roles of a work of art in its social and political contexts. Yet regardless of how one assesses Roman artists for drawing on Greek styles, these were by no means the only styles at play in the Roman world. Works of art created in the provinces or for the nonelite have their own style, as do those of late antiquity. There were also phases of distinct "Egyptianizing" in Rome.

Detail of figure 7.15, Nile Mosaic, from Sanctuary of Fortuna Primigenia

Roman art was the art of both Republic and Empire, the art of a small city that became a vast empire. It was created by Roman artists, but not exclusively; the greatest architect of Trajan's time may have been from Damascus. Perhaps the most useful way to think of Roman art is to see it as an art of syncretism —an art that brings diverse elements together to produce something entirely new, with a powerful message-bearing potential. Syncretism was a profoundly Roman attitude, and was probably the secret to Rome's extraordinarily successful expansion. From the very start, Roman society was unusually tolerant of non-Roman traditions, as long as they did not undermine the state. Romans did not, on the whole, subordinate the populations of newly conquered regions, eventually according many the rights of citizenship and receiving non-Roman gods hospitably in the capital. This Roman propensity for integrating other cultures led to a remarkably diverse world.

EARLY ROME AND THE REPUBLIC

According to Roman legend, Romulus founded the city of Rome in 753/52 BCE, in the region known as Latium, on a site near the Tiber River. The sons of Mars and Rhea Silvia, who later became a Vestal Virgin, Romulus and his twin, Remus, were abandoned at birth, and raised by a she-wolf (see fig. 6.17). Yet archaeological

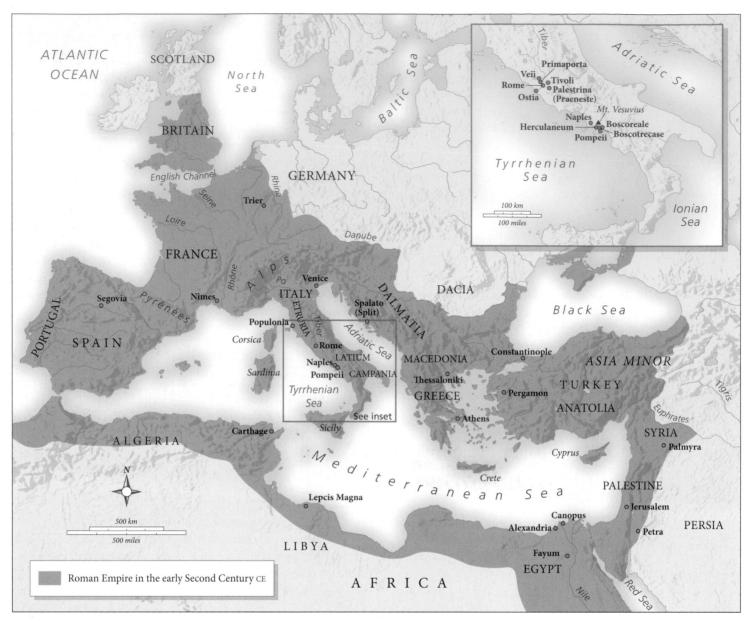

Map 7.1 Roman Empire in the early 2nd century CE

evidence shows that people had actually lived on the site since about 1000 BCE. From the eighth to the sixth centuries BCE, a series of kings built the first defensive wall around the settlement, drained and filled the swampy plain of the Forum, and built a vast temple on the Capitoline Hill, making an urban center out of what had been little more than a group of villages. The kings established many of Rome's lasting institutions, such as priest-hoods and techniques of warfare. In about 509 BCE, the Roman elite expelled the last king, and gradually established a republic, with an unwritten constitution.

Under the Republic, a group of elected magistrates managed the affairs of the growing state. Two consuls headed them, and a Senate served as an advisory council. Popular uprisings led to greater rights and representation for the nonelite over the next 200 years. Rome gained most of its territorial empire during the course of the republic. First Rome and its allies, the Latin League, destroyed the southern Etruscan city of Veii in 396 BCE. The Gauls, from the north, sacked Rome in 390 BCE, but this seems only to have spurred Rome on to greater conquest. By 275 BCE, Rome controlled all of Italy, including the Greek colonies of the south. Three Punic (from the Latin for "Phoenician") Wars against the North African city of Carthage ended with the decisive razing of Carthage in 146 BCE, and during the second century BCE all of Greece and Asia Minor also came under Roman control. Yet despite its successes, from about 133 BCE to 31 BCE, the Late Republic was in turmoil. Factional politics, mob violence, assassination, and competition among aristocratic families led to the breakdown of the constitution and to civil war. Julius Caesar became perpetual dictator in 46 BCE, a position that other senators were unable to tolerate. Two years later, they assassinated him.

During the course of the Republic, magistrates commissioned works of architecture and sculpture to embellish the city as well

Recognizing Copies: The Case of the Laocoon

n one of the most powerful passages of *The Aeneid*, Vergil describes the punishment of Laocoön, who, according to legend, was a priest at the time of the Trojan War. He warned the Trojans against accepting the wooden horse, the famous gift that hid invading Greeks withIn. The goddess Minerva, on the side of the Greeks, punished Laocoön by sending two giant serpents to devour him and his sons. Vergil describes the twin snakes gliding out of the sea to the altar where Laocoön was conducting a sacrifice, strangling him in their terrible coils, turning sacrificer into sacrificed. (See www.myartslab.com.)

In January 1506, a sculptural group depicting Laocoön and his sons writhing in the coils of snakes was unearthed on the Esquiline Hill in Rome. Renaissance humanists immediately hailed the group as an original Greek sculpture describing this brutal scene. It was, they thought, a sculpture that Pliny the Elder praised in his Natural History (completed in 77 cE). Pliny believed the Laocoön group that stood in Titus' palace to be the work of three sculptors from Rhodes: Hagesandros, Polydorus, and Athenodorus. Within a year of its rediscovery, the group had become the property of Pope Julius II, who installed it in his sculpture gallery, the Belvedere Courtyard in the Vatican. The sculpture quickly became a focus for contemporary artists, who both used it as a model and struggled to restore Laocoön's missing right arm (now bent behind him in what art historians consider the correct position). Its instant fame derived in part from the tidy convergence of the rediscovered sculpture with ancient literary sources: The masterpiece represented a dramatic moment in Rome's greatest epic and was described by a reputable Roman author.

The Laocoon group caught the rapt attention of the eighteenthcentury art historian J. J. Winckelmann (see The Art Historian's Lens, page 157). He recognized a powerful tension between the subjects' agonizing death throes and a viewer's pleasure at the work's extraordinary quality. Such was his admiration that he could only see the piece as a Classical work, and dated it to the fourth century BCE; any later and it would be Hellenistic, a period that he characterized as a time of artistic decline. So began a wide debate on not only the date of the sculpture, but also its originality. For many scholars, the writhing agony of the Trojan priest and his sons bears all the hallmarks of the Hellenistic baroque style, as seen in the gigantomachy (the war between gods and giants) of the Great Altar of Zeus at Pergamon (see figs. 5.72 and 5.73). A masterpiece of the Hellenistic style, it should accordingly date to the third or second century BCE. On the other hand, evidence from inscriptions links the three artists named by Pliny to sculptors at work in the mid-first century BCE. making the sculpture considerably later and removing it from the apogee of the Hellenistic age. Yet there are cases of artists' names being passed down through several generations, and it is not at all clear that the group is in fact the sculpture Pliny admired.

Pliny specified that Laocoön was sculpted from a single piece of marble, and this sculpture is not; even more telling is the fact that a slab of Carrara marble—which was not exploited until the reign of Augustus (r. 27 BCE-14 CE)—is incorporated into the altar at the back. Is the sculpture then an early imperial work? Or is this much-lauded masterpiece a Roman copy of a Hellenistic work? If so, does that reduce its status? As if this were not debate enough, one contention takes Laocoön out of the realm of antiquity altogether, and identifies it instead as a Renaissance work by none other than Michelangelo. Evidence cited includes a pen study by the artist depicting a male torso resembling Laocoön's, dating to 1501. At this point, all that can be said with certainty about Laocoön is that the tidy picture imagined by sixteenth-century admirers has become considerably murkier.

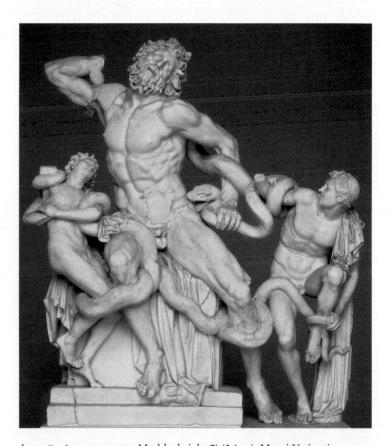

Laocoön, 1st century CE. Marble, height 7' (2.1 m). Musei Vaticani, Museo Pio Clementino, Cortile Ottagono, Città del Vaticano, Rome

as to enhance their own careers. Roman conquests abroad brought new artistic forms to the city, especially from Greece, which merged with Italic (i.e., typical of people of the Italian peninsula) forms to create a Roman artistic vocabulary, and the development of new building technologies such as concrete strongly influenced architectural designs.

NEW DIRECTIONS IN ARCHITECTURE

Roman architecture has had a more lasting impact on Western building through the ages than any other ancient tradition. It is an architecture of power, mediated through the solidity of its forms, and through the experience of those forms. Roman builders were indebted to Greek traditions, especially in their use of the Doric, Ionic, and Corinthian styles, yet these traditions inspired buildings that were decidedly Roman.

THE DEVELOPMENT OF FORMS The Temple of Jupiter Optimus Maximus on the Capitoline Hill was the first truly monumental building of Rome (fig. 7.1). Romans worshiped a wide range of gods, some of them indigenous, but many others adopted from other cultures; in fact, their pantheon of state gods was roughly equivalent to the Greek pantheon. The Capitoline temple honored the chief god, Jupiter, roughly equivalent to the Greek Zeus. Its construction began under two sixth-century BCE kings, Tarquinius the Ancient and Tarquinius the Proud, but it was one of Rome's first consuls who actually dedicated the finished temple. Its scale was unprecedented on the Italian peninsula, evoking the massive Ionic temples of eastern Greece (see fig. 5.12). It stood on a high masonry platform, with steps leading up to the façade. Six wooden columns marked the front, and six columns flanked each side. Two rows of columns supported the roof over a deep porch. An Etruscan artist, Vulca of Veii, crafted a vast terra-cotta acroterion for the peak of the pediment, representing Jupiter in a four-horse chariot. A triple cella with walls of wood-framed mud brick accommodated cult statues of Jupiter, Juno, and Minerva, and recent excavations suggest that two additional rooms were arranged across the rear, accessed from the lateral colonnades. The rectilinear forms, the use of columns, and a gabled roof echo Greek design; yet the high podium and the emphatic frontal

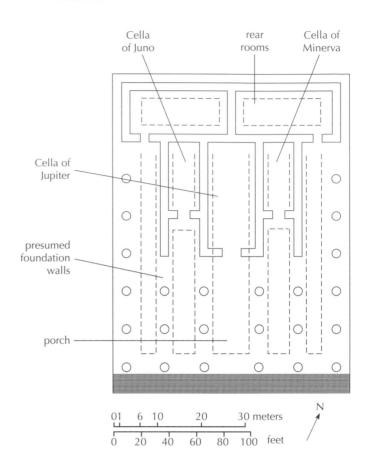

7.1 Restored plan of Temple of Jupiter Optimus Maximus, Capitoline Hill, Rome. Dedicated ca. 509 BCE

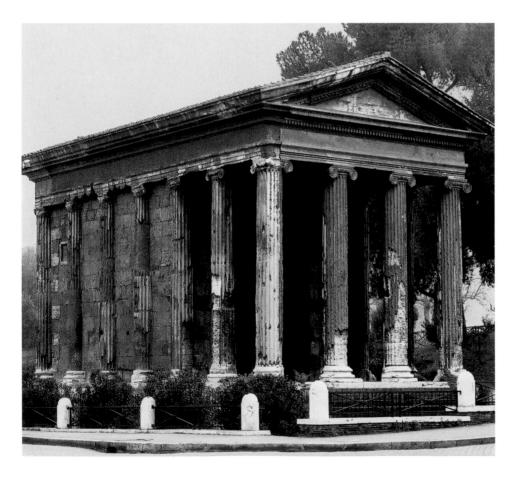

7.2 Temple of Portunus, Rome. ca. 80-70 BCE

access set it apart. Scholars call these features Etrusco-Italic, and they characterize most Roman temples in centuries to come.

Although the practice of borrowing Greek forms began early in the Republic, it was particularly marked during the period of Rome's conquest of Greece, when architects used Greek building materials as well as essential building forms. After celebrating a triumph over Macedonia in 146 BCE, the general Metellus commissioned Rome's first all-marble temple and hired a Greek architect, Hermodorus, for the job. It no longer survives, but was probably close in form to the remarkably well-preserved temple to the harbor-god Portunus near the Tiber (fig. 7.2). Dating from 80 to 70 BCE, the temple is in the Italic style: It stands on a podium, and engaged lateral columns (instead of a true peristyle)

emphasize the frontal approach. All the same, the Ionic columns have the slender proportions of Classical Greek temples, and a white marble stucco covering their travertine and tufa shafts, bases, and capitals deliberately evoked the translucent marbles of Greek architecture.

Roman architects quickly combined the rectilinear designs of Greek architecture with the curved form of the arch (fig. 7.3). An arch could be a free-standing monument in its own right, or be applied to a building, often to frame an entrance. To construct arches, builders assembled wedge-shaped voussoirs, as seen in the Etruscan Porta Marzia at Perugia (see fig. 6.12). These arches are extremely strong, in contrast to corbeled arches (see fig. 4.21). Voussoir arches were not a Roman or an Etruscan invention: Near

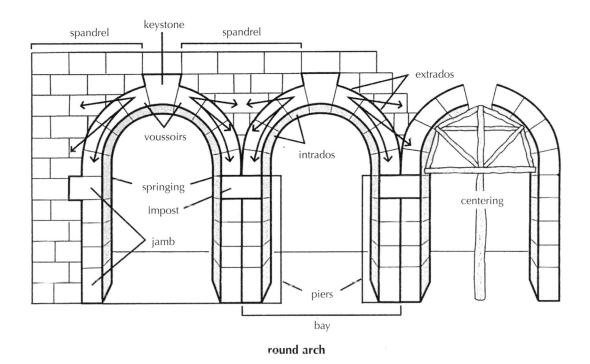

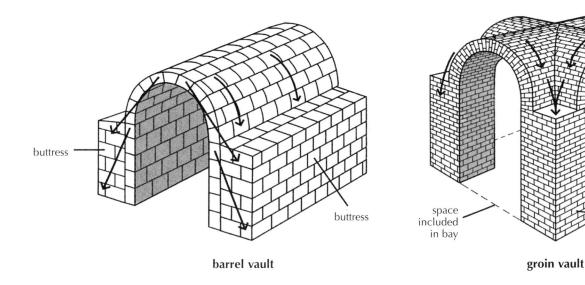

7.3 Arch, barrel vault, and groin vault

piers

Eastern architects used them in ziggurat foundations and in city gates, and Egyptian builders employed them, as well as their extension, the **barrel vault**, as early as about 1250 BCE, mainly in underground tombs and utilitarian buildings, rather than for monumental public buildings; Greeks architects constructed underground structures or simple gateways with arches. The Romans, however, put them to widespread use in public architecture, making them one of the hallmarks of Roman building.

THE CONCRETE REVOLUTION It was the development of concrete, however, that was a catalyst for the most dramatic changes in Roman architecture. Concrete is a mixture of mortar and pieces of aggregate such as tufa, limestone, or brick. At first, Roman architects used it as fill, between walls or in podiums. Yet on adding pozzolana sand to the mortar, they discovered a material of remarkable durability—which would even cure (or set) under water—and they used it with growing confidence from the second century BCE onward. Despite its strength, it was not attractive to the eye, and builders concealed it with cosmetic facings of stone, brick, and plaster, which changed with the passing years and therefore provide archaeologists with an invaluable tool for dating Roman buildings. The advantages of concrete were quickly evident: It was strong and inexpensive, and could be worked by relatively unskilled laborers. It was also extraordinarily adaptable. By constructing wooden frameworks into which they poured the concrete, builders could mold it to shapes that would have been impossible or prohibitively time-consuming to make using cut stone, wood, or mud brick. In terms of design, the history of Roman architecture is a dialogue between the traditional rectilinear forms of Greek and early Italic post-and-lintel traditions (construction using vertical posts to support horizontal elements) on the one hand, and the freedoms afforded by this malleable material on the other.

Two quite different Republican structures demonstrate concrete's advantages. A building of the second century BCE, long identified as the Porticus Aemilia, but almost certainly the Navalia, or ship shed for the Roman fleet, is the earliest known building in Rome constructed entirely of concrete. Its dimensions were simply staggering: It stretched 1,600 Roman feet (a little shorter than modern feet) along the Tiber and was 300 feet deep. As the partial reconstruction in figure 7.4 illustrates, the architects took advantage of the new material to create a remarkably open interior space. Soaring barrel vaults roofed 50 transverse corridors, built in four rising sections to accommodate the sloping terrain. Arches pierced the walls supporting the vaults, so that air could circulate freely. Roman sailors could pull the ships into these spaces for easy maintenance in the winter months.

East of Rome, in the Apennine foothills, the town of Palestrina (ancient Praeneste) is home to another masterpiece of concrete construction (figs. 7.5 and 7.6). The spectacular sanctuary to the goddess Fortuna Primigenia, dated to the late second century BCE, was an oracular center where priests interpreted divine will by drawing lots. Architects used concrete to mold structures over the entire surface of the hillside and to craft spaces

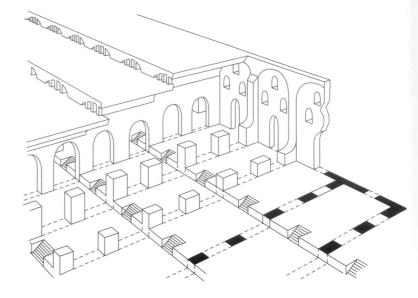

7.4 Navalia, Rome. First half of the 2nd century BCE. Partial reconstruction drawing

that controlled and heightened a visitor's experience. The sanctuary ascended in seven levels. At the bottom stood an early temple, a basilica (see page 225), and a senate house. The upper terraces rose in a grand crescendo around a central axis, established by a series of statue niches and staircases. A visitor climbed lateral staircases to the third terrace, where steep ramps, roofed with sloping barrel vaults, led upward. A bright shaft of daylight beckoned from the end of the ramp, where an open landing provided the first of several stunning views across the countryside.

On the fourth level, colonnaded exedrae (semicircular recesses) framed the altars. Barrel vaults roofed the colonnades, inscribing a half-circle both horizontally and vertically (annular barrel vaults). Their curved forms animate the straight lines, since columns set in a semicircle shift their relationship to the environment with every step a visitor takes. A wide central staircase leads upward to the next level. After the confinement of the ramps, its steps were exposed, engendering a sense of vulnerability in the visitor. On this level, shops probably sold souvenirs and votive objects. Standing on this terrace, a visitor was directly above the voids of the barrel vaults below, evidence of the architects' confidence in the structure. The next terrace was a huge open court, with double colonnades on three sides. The visitor climbed to a small theater topped by a double annular colonnade. Here religious performances took place against the magnificent backdrop of the countryside beyond, and in full sight of Fortuna, the goddess whose circular temple crowned the complex. Its diminutive size drew grandeur from the vast scale of the whole—all accomplished with concrete. The hugely versatile material plays easily with the landscape, transforming nature to heighten a visitor's religious experience.

The first century BCE was a turning point in the use of architecture for political purposes. One of the most magnificent buildings of this time was the vast theater complex of Pompey, which would remain Rome's most important theater throughout antiquity.

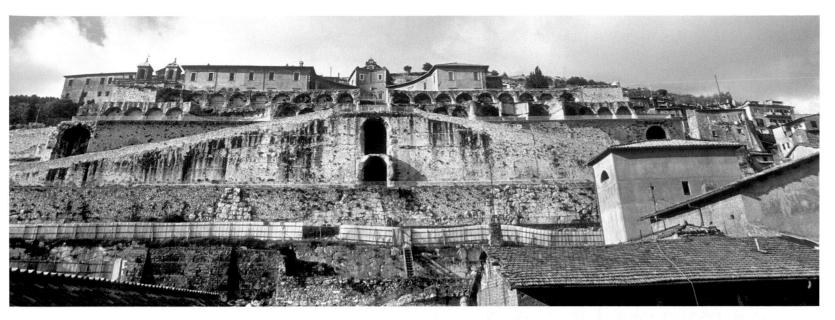

7.5 Sanctuary of Fortuna Primigenia, Praeneste (Palestrina). Late 2nd century BCE

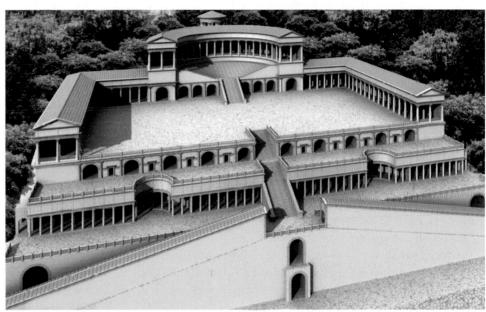

7.6 Reconstruction of Sanctuary of Fortuna Primigenia, Praeneste

Like Julius Caesar after him, Pompey (active in Roman politics in the 70s and 60s BCE) maneuvered his way into a position of sole authority in Rome and used architecture to express and justify his aconstitutional power. To commemorate his conquests, he conceived of a theater on the Field of Mars, just outside the northern city boundary, dedicated to his patron goddess Venus Victrix (the Conqueror) (fig. 7.7). Later buildings on the site incorporate traces of its superstructure, and the street plan still reflects its curved form. Moreover, its ground plan is inscribed on an ancient marble map of the city, carved in the early third century CE, and new excavations may uncover more of its vaulted substructure. The reconstruction in figure 7.7 is therefore provisional, a combination of archaeological evidence and conjecture; it is likely to change as new evidence emerges. In some respects, Pompey's theater resembled its Greek forebears, with sloping banks of seats in a semicircular arrangement, a ground-level orchestra area, and

a raised stage for scenery. In other ways, however, it was radically different. It was not, for instance, nestled into a preexisting hillside. Instead, the architect created an artificial slope out of concrete, rising on radially disposed barrel vaults, which buttressed one another for a strong structure. Concrete, in other words, gave the designer freedom to build independent of the landscape. The curved cavea (seating area), moreover, was a true half-circle, rather than the extended half-circle of Greek theaters. At the summit of the cavea were three shrines and a temple dedicated to Venus. The curved façade held statues personifying the nations Pompey had subdued. Beyond the theater, and adjoining it behind the stage building, porticoes defined a vast garden, where Romans could admire valuable works of art, such as sculptures, paintings, and tapestries, many of which had been brought from Greece. These public gardens were Pompey's gift to the people of Rome-an implicit way of winning political favor.

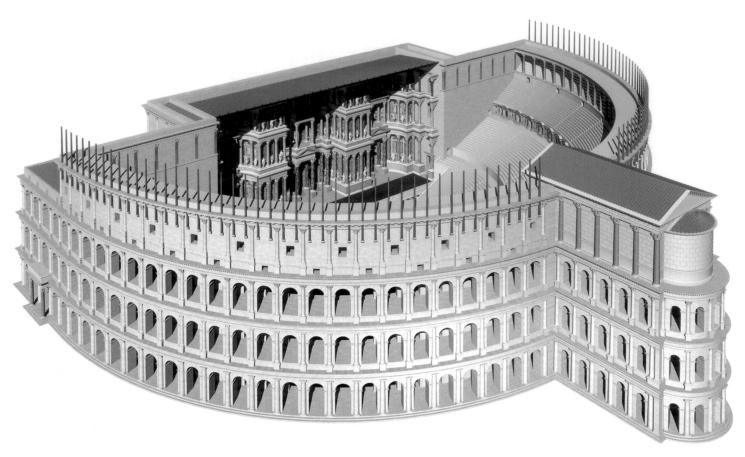

7.7 Theater complex of Pompey, Rome. Dedicated in 55 BCE. Provisional reconstruction by James E. Packer and John Burge

Pompey's theater complex dwarfed the smaller, scattered buildings that individual magistrates had commissioned up to that point. It was also Rome's first permanent theater. As in Greece, plays were an essential component of religious ceremonies, and Romans had always constructed the buildings that accommodated them out of wood, assembling them for the occasion and then dismantling them. In fact, some elite Romans spoke out against the construction of permanent theaters—ostensibly on moral grounds, but also because they were places for the nonelite to meet. Pompey circumvented such objections by describing his theater as a mere appendage to the temple of Venus at its summit, and in building the complex he set the precedent for the great forum project of Julius Caesar, and the imperial fora that would follow (see page 196).

Sculpture

FREE-STANDING SCULPTURE In early Rome, as elsewhere in Italy, sculptors worked primarily in terra cotta and in bronze. Countless terra-cotta votive objects survive from sanctuaries, where visitors dedicated them in hope of divine favor. The gradual conquest of Greece in the second century BCE had led to a fascination with Greek works of art, which flooded into Rome as booty. So intense was the fascination, in fact, that in the late first century BCE, the poet Horace commented ironically, "Greece, having been conquered, conquered her wild conqueror, and brought the arts into rustic Latium." Paraded through the streets

of Rome as part of the triumphal procession, the works of art ended their journey by decorating public spaces, such as the theater complex of Pompey (see fig. 7.7).

These glistening bronze and marble works provoked reaction. For most, it seems, they were a welcome sign of Rome's cultural advance, more visually pleasing than indigenous sculptures in terra cotta. Elite Romans assembled magnificent collections of Greek art in their homes; through their display they could give visual expression to their erudition. The Villa of the Papyri in Herculaneum, a city built on the slopes of Vesuvius in southwest Italy, preserved an extensive collection in situ when the volcano erupted. The villa and its collection are partially reconstructed in the Getty Museum in Malibu, California. When Greek originals were not available, copyists provided alternatives in the styles of known Greek artists. (See Materials and Techniques, page 193, and The Art Historian's Lens, page 183.) A series of letters from Cicero, a lawyer and writer of the mid-first century BCE, to his friend Atticus in Athens shows the process at work: he asks Atticus to send him sculptures to decorate the various parts of his villa. (See Primary Source, page 192.) The stylistic borrowings also had a bold political dimension, showing that Rome had bested the great cultures of Greece.

RELIEF SCULPTURE A few strident voices spoke out against the invasion of Greek art. Most vociferous was Cato ("The Moralist"), for whom traditional Roman art forms symbolized the staunch moral and religious values that had led to, and justified,

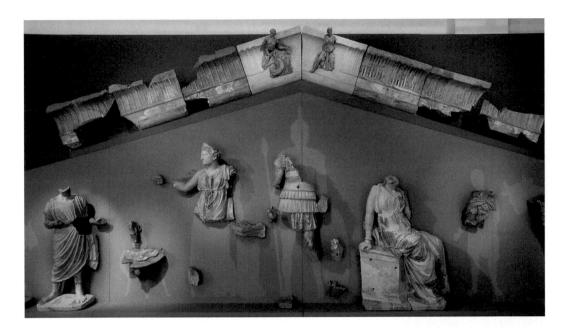

7.8 Reconstruction of pedimental sculptures from Via di San Gregorio. ca. 150–100 BCE

Rome's political ascent. A set of magnificent terra-cotta pediment sculptures discovered on Via di San Gregorio in Rome during sewer repairs in 1878 gives an impression of the art form he was intent on defending (figs. 7.8 and 7.9). The subject of the pediment appears to be a *suovetaurilia*, a sacrifice of a pig, a sheep, and a bull. The larger-scale figures probably represent divinities—perhaps Mars in the center, with breastplate and spear, and two flanking goddesses. Smaller figures include a male in a toga, perhaps the presiding magistrate; a male in tunic and mantle; and several *victimarii* (attendants to the sacrificial animals). The artists sculpted the figures in such high relief that they are almost fully in the round, and applied them to a smooth background, painted black; they protrude emphatically toward the top, in order to be legible from below. As in Egypt, color conventions distinguish the female figures, with their cream skin tones, from the deeper red males.

The pediment may have belonged to a temple to Mars on the Caelian Hill. Scholars date it to the third quarter of the second century BCE, which places it at the height of Greek influence in Rome. This is clearly evident in Mars' Hellenistic breastplate, the classicizing treatment of the drapery and faces, and the musculature. All the same, the material and technique are distinctly Italic, and the refined modeling and high polish demonstrate how striking terra-cotta works could be.

Sometimes Roman sculpture commemorated specific events, as it did in the ancient Near East (see figs. 2.12 and 2.19). Classical Greek sculptors disguised historical events in mythical clothing—a combat of Lapiths and Centaurs, for instance, or Greeks and Amazons (see figs. 5.35, and 5.44)—and this convention broke down only slightly in the Classical period. The Romans, by contrast, represented actual events, developing a form of sculpture known as historical relief—although many were not historically accurate. The reliefs shown in figure 7.10, sometimes called the

7.9 Victimarius from the Via di San Gregorio pediment. Painted terra cotta, height 41½" (106 cm). Museo Capitolino, Rome

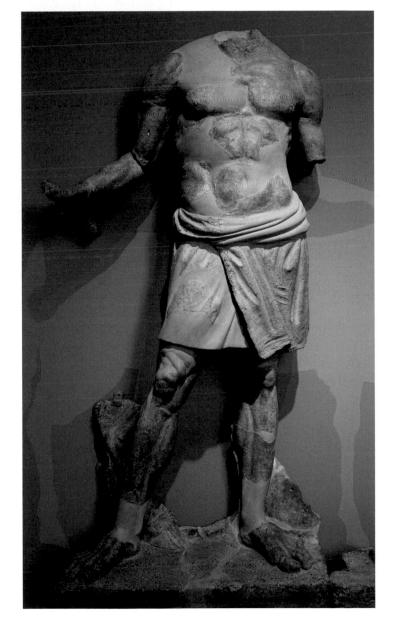

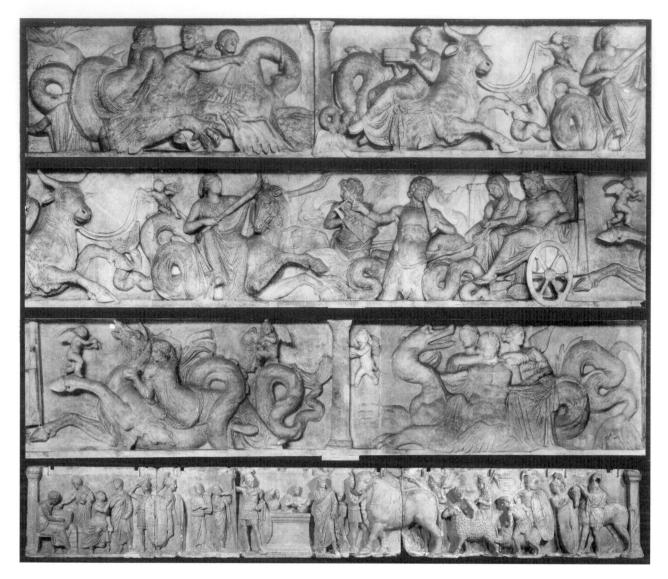

7.10 Sculptural reliefs from statue base, showing sea thiasos and census, from the so-called Altar of Domitius Ahenobarbus or Base of Marcus Antonius. Late 2nd to early 1st century BCE. Marble. Musée du Louvre, Paris, and Glyptothek, Staatliche Antikensammlungen, Munich

Base of Marcus Antonius, probably decorated a base for a statuary group, which scholars place near the route used for triumphal processions through Rome. One long section shows a census, a ceremony during which individuals recorded their property holdings with the state to qualify for military service (which was a prerequisite for public office). On the left side, soldiers and civilians line up to be entered into the census. Two large figures flanking an altar represent a statue of Mars, god of war, and the officiating censor, who probably commissioned the monument. Attendants escort a bull, a sheep, and a pig for sacrifice at an altar, marking the closing ceremony of the census.

On the same monument, the remaining reliefs depict a marine thiasos (procession) for the marriage of the sea-god Neptune and a sea-nymph, Amphitrite. But these reliefs are in an entirely different style. The swirling motion of the marriage procession and its Hellenistic forms contrast dramatically with the static composition of the census relief and the stocky proportions of its figures. Moreover, the panels are carved from different types of marble. Scholars suppose that the sea-thiasos sections were not original to this context, but that a triumphant general brought them back as

spoils from Greece to grace a triumphal monument—proof, as it were, of his conquest. By contrast, artists carved the census relief in Rome to complement the thiasos. Together, the reliefs may represent the patron's military and political achievements.

PORTRAIT SCULPTURE Literary sources reveal that the Senate and People (the governing bodies of the Republic) of Rome honored political or military figures by putting their statues on public display, often in the Roman Forum, the civic heart of the city (see page 196). The custom began in the early Republic and continued until the end of the Empire. Many of the early portraits were bronze and were melted down in later years for coinage or weaponry. A magnificent bronze male head dating to the late first century BCE, a mere fragment of a full-length figure, gives a tantalizing sense of how these statues once looked (fig. 7.11). Sixteenth-century antiquarians dubbed it "Brutus," after the founder and first consul of the Republic. Strong features characterize the over-life-size portrait: a solid neck, a square jaw accentuated by a short beard, high cheekbones, and a firm brow. The image derives its power not from classical idealization or the

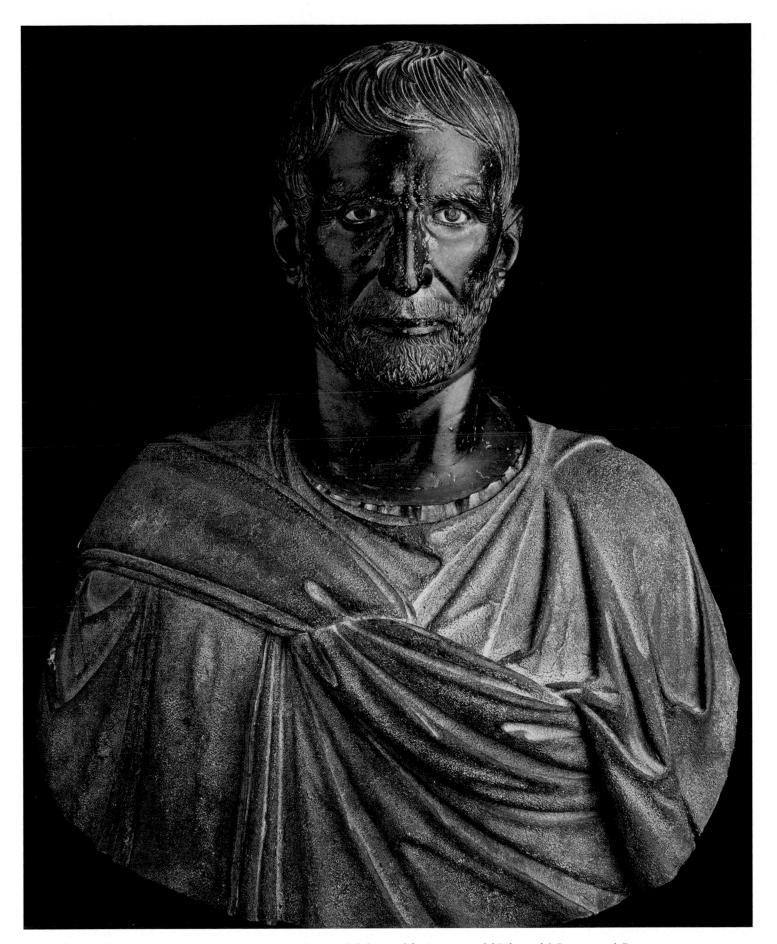

7.11 "Brutus." Late 1st-century BCE head, modern bust. Bronze, slightly over-life-size. Museo del Palazzo dei Conservatori, Rome

Cicero (106-43 BCE)

Letters to Atticus I. 9-10 (67 BCE, Rome)

Marcus Tullius Cicero was a leading politician and orator in Rome during the turbulent days of the late Republic. He is known through his extensive writings, which include orations, rhetorical and philosophical treatises, and letters. Like many other Roman statesmen, he filled his many houses and villas with works of Greek art, either original or copied. Atticus was his childhood friend, who maintained communication with Cicero after moving to Athens and served as his purchasing agent for works of art.

IX

Cicero to Atticus, Greeting

Y our letters are much too few and far between, considering that it is much easier for you to find someone coming to Rome than for me to find anyone going to Athens. Besides, you can be surer that

I am at Rome than I can be that you are in Athens. The shortness of this letter is due to my doubts as to your whereabouts. Not knowing for certain where you are, I don't want private correspondence to fall into a stranger's hands.

I am awaiting impatiently the statues of Megaric marble and those of Hermes, which you mentioned in your letter. Don't hesitate to send anything else of the same kind that you have, if it is fit for my Academy. My purse is long enough. This is my little weakness; and what I want especially are those that are fit for a Gymnasium. Lentulus promises his ships. Please bestir yourself about it. Thyillus asks you, or rather has got me to ask you, for some books on the ritual of the Eumolpidae.

Source: Cicero, Letters to Atticus, 3 vols., tr. E.O. Winstedt (1912-18)

stylized qualities of, for instance, the portrait of an Akkadian ruler (see fig. 2.11), but from the creases and furrows that record a life of engagement. The slight downward turn of the head may indicate that it once belonged to an equestrian portrait, originally displayed raised above a viewer.

The majority of Republican portraits were stone and date to the end of the second century and the first century BCE. Most represent men at an advanced age (fig. 7.12). Wrinkles cover their faces, etching deep crags into their cheeks and brows. Artists played up distinguishing marks—like warts, a hooked nose, or a receding hairline—rather than smoothing over them. In the example illustrated here, remnants of a veil suggest that the subject was represented as a priest. Although there is no way of knowing what the sitter looked like, the images appear realistic, so that scholars term the style veristic, from the Latin verus, meaning "true." Cultures construct different ideals, and to Romans, responsibility and experience came with seniority. Military service was a prerequisite for office, and most magistracies had minimum-age requirements. An image marked by age therefore conveyed the necessary qualities for winning votes for political office, and the veristic style became the hallmark of Late Republican portraiture.

Where the impetus to produce likenesses came from is a mystery that scholars have struggled to solve. For some, its roots lie in an Italic practice of storing ancestral masks in the home to provide a visual genealogy—in this society, a good pedigree was a reliable steppingstone to political success. Polybius, a Greek historian of the mid-second century BCE, recounts that before burying a family member, living relatives would wear these ancestral masks in a funerary procession, parading the family's history in front of bystanders. (See *Primary Source*, page 194.) Other scholars trace it to a Greek custom of placing votive statues of athletes and other important individuals in sacred precincts, and indeed some Roman portraits were executed in Greek styles.

7.12 Veristic male portrait. Early 1st century BCE. Marble, life-size. Musei Vaticani, Rome

Copying Greek Sculptures

n order to satisfy a growing demand for Greek sculptures, artists set up copying workshops in Athens and Rome, where they produced copies of famous "masterpieces." Some of these copies may have been relatively close replicas of the originals; others were adaptations, where the copyist's own creativity came freely into play. Given the paucity of surviving Greek originals, it is often difficult for scholars to determine the appearance of the original, and thus to distinguish replica from adaptation. One clue to recognizing a marble copy (whether a true replica or a free adaptation) of a bronze original is to look for the use of struts to strengthen the stone, since marble has a different tensile strength from bronze (see the tree trunk and the strut at the hip in fig. 5.33).

Scholars have long believed that Roman copyists used a pointing machine (a duplicating device that takes one to one measurements), similar to a kind that was used in the early nineteenth century, but evidence from unfinished sculptures now suggests a different technique using calipers, known as triangulation. By establishing three points on the model, and the same three points on a new block of stone, an artist can calculate and transfer any other point on the model sculpture to a new place on the copy. The sculptor takes measurements from each of the three points on the original to a fourth new point, and, using those measurements, makes arcs with the calipers from each of the three points on the new block of stone. Where the

arcs intersect is the fourth point (see fig. 4) on the copy. In order to alter the scale from original to copy, the artist simply multiplies or divides the measurements. Having taken a number of points in this way, the sculptor uses a chisel to cut away the stone between the points. The accuracy of the resultant copy depends upon how many points the sculptor takes.

The triangulation process

Aspiring politicians probably commissioned many of these Republican portraits, but scholars can rarely give a name to the individuals portrayed. Inscriptions identifying the subject are scarce, and the coin portraits that help to identify later public figures only appear from the mid-first century BCE on. By contrast, we can readily identify individuals represented in a related class of monument. In the Late Republican and Augustan periods, emancipated slaves commissioned group portraits in relief, which they mounted on roadside funerary monuments (fig. 7.13). Usually, a

long rectangular frame surrounds shoulder-length truncated busts of the subjects. The very fact that the ex-slaves are depicted visually reflects their freed status; other visual cues reinforce it, such as a ring, either painted or carved on a man's hand, or the joined right hands of a man and woman, symbolizing marriage, which was not legal among slaves. An inscription records their names and status. In this example, the freed slaves' one-time owner appears in the center of the relief.

7.13 Funerary relief of the Gessii. ca. 50 BCE. Marble, $25\%_6 \times 80\% \times 13\%$ " (65 × 204.5 × 34 cm). Museum of Fine Arts, Boston, Archibald Cary Coolidge Fund. 37.100

Polybius (ca. 200-ca. 118 BCE)

Histories, from Book VI

Polybius was a Greek historian active during the Roman conquest of his homeland. His Histories recount the rise of Rome from the third century BCE to the destruction of Corinth in 146 BCE. In Book VI he considers cultural and other factors explaining Rome's success.

Whenever any illustrious man dies ... they place the image of the departed in the most conspicuous position in the house, enclosed in a wooden shrine. This image is a mask reproducing with remarkable fidelity both the features and complexion of the deceased. On the occasion of public sacrifices they display these images, and decorate them with much care, and when any distinguished member of the family dies they take them to the funeral, putting them on men who seem to them to bear the closest resemblance to the original in

stature and carriage. These representatives wear togas, with a purple border if the deceased was a consul or praetor, whole purple if he was a censor, and embroidered with gold if he had celebrated a triumph or achieved anything similar. They all ride in chariots preceded by the fasces, axes, and other insignia ... and when they arrive at the rostra they all seat themselves in a row on ivory chairs. There could not easily be a more ennobling spectacle for a young man who aspires to fame and virtue. For who would not be inspired by the sight of the images of men renowned for their excellence, all together and as if alive and breathing? ... By this means, by this constant renewal of the good report of brave men, the celebrity of those who performed noble deeds is rendered immortal.... But the most important result is that young men are thus inspired to endure every suffering for the public welfare in the hope of winning the glory that attends on brave men.

Source: Polybius: The Histories, Vol. 3, tr. W.R. Paton (Cambridge, MA: Harvard University Press, 1923)

Painting and Mosaic

Lamentably few free-standing portraits come from known archaeological contexts. Romans appear to have displayed them in tombs as well as in homes and public places. Tombs were more than just lodging places for the dead. They were the focus of routine funerary rituals, and during the course of the Republic they became stages for displaying the feats of ancestors in order to elevate family status. Paintings, both inside and out, served this purpose well.

A tomb on the Esquiline Hill in Rome yielded a fragmentary painting of the late fourth or early third century BCE, depicting scenes from a conflict between the Romans and a neighboring tribe, the Samnites (fig. 7.14). A label identifies a toga-clad figure on the upper right as Quintus Fabius, a renowned general who may have been the tomb's owner. He holds out a spear to a figure identified as Fannius on the left, who wears golden greaves and loincloth. Behind Fannius is a crenelated city wall, and in the lower registers are scenes of battle and parlay. The labels suggest that the images record specific events, relating the subject matter to the relief sculptures discussed previously. Literary sources state that Roman generals also made a practice of commissioning panel paintings of their military achievements, which they displayed in triumphal processions before installing them in a public building such as a temple.

As well as ornamenting walls with narrative paintings, Roman artists also decorated floors with mosaics. They fitted together minute colored stones called **tesserae** to create a pattern or a figured image. An extraordinary example survives from an apsidal room opening onto the forum at Praeneste (Palestrina) (fig. **7.15**; see figs. 7.5 and 7.6), probably dating to the end of the second century BCE. The mosaic is a large visual map of Egypt, perhaps inspired by an Alexandrian work. The Nile dominates. In the foreground is Alexandria, with its monumental buildings, lush vegetation, and cosmopolitan lifestyle. A vignette at the lower right may show a Roman general's visit to Egypt. The mosaicist

7.14 Esquiline tomb painting. Late 4th or early 3rd century BCE. Painted on plaster, 34½ × 17¾" (87.6 × 45 cm). Museo Montemartini, Rome

depicted different buildings from different perspectives to accommodate a viewer's movement across the floor, and suggested recession by placing distant scenes at the top of the mosaic: the river winds away into the distance toward Ethiopia where hunters

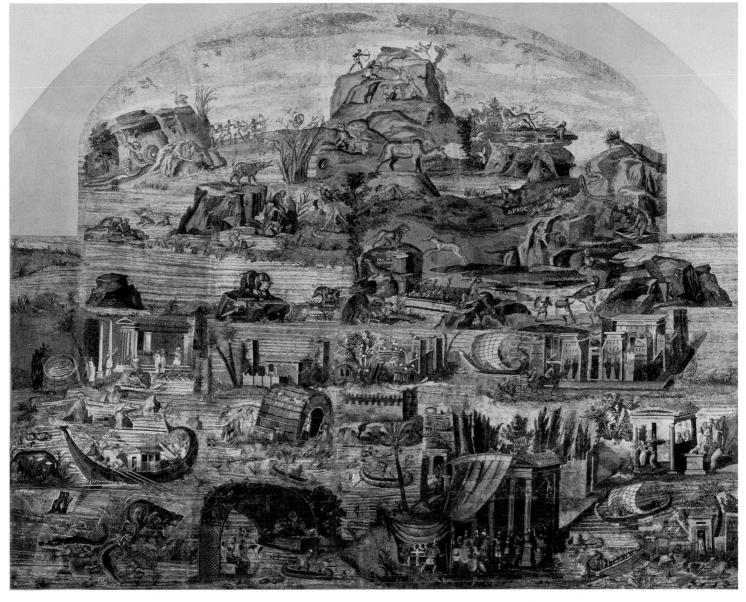

7.15 Nile Mosaic, from Sanctuary of Fortuna Primigenia, Praeneste (Palestrina). First century BCE. Height approx. 16' (4.88 III), width approx. 20' (6.10 m). Museo Archaeologico Nazionale, Palestrina

pursue wild animals—such as crocodiles and hippopotami—labeled with Greek names. Colors also become less vibrant in the faraway scenes, a device known as **atmospheric perspective**. Remarkable for its fine execution and the richness of its colors, the mosaic is a testament to a fascination with far-off lands during a phase of Rome's rapid expansion.

THE EARLY EMPIRE

The last century of the Republic witnessed a gradual breakdown of order in Rome, as ambitious men vied for sole authority in the city. Julius Caesar's assassination on the Ides of March of 44 BCE was a last-ditch effort to safeguard the constitution. His heir, Octavian, took revenge on the principal assassins, Brutus and Cassius, and then eliminated his own rival for power, Mark

Antony, who had made an alliance with the Egyptian queen Cleopatra. In 27 BCE, the Senate named Octavian as Augustus Caesar, and he became *princeps*, or first citizen. History recognizes him as the first Roman emperor. The arts flourished in the Augustan age. Artists took a new interest in classicism, while Virgil penned *The Aeneid* as a Latin response to Homer's epics, and Horace and Ovid wrote poetry of lasting renown.

The birth of the Roman Empire brought a period of greater stability to the Mediterranean region than had previously been known. Roman domination continued to spread, and at its largest extent, in the time of Trajan (98–117 CE), the Empire stretched through most of Europe, as far north as northern England, through much of the Middle East including Armenia and Assyria, and throughout coastal North Africa. Romanization spread through these regions. Roman institutions—political, social, and religious—mingled with indigenous ones, leading to a degree of

homogenization through much of the Roman world. Increasingly, the emperor and his family became the principal patrons of public art and architecture in Rome. Often, their public monuments stressed the legitimacy of the imperial family.

Architecture

THE IMPERIAL FORA During the Republic, the Roman Forum was the bustling center of civic life (figs. 7.16 and 7.17). It was there, in markets and basilicas, that people shopped and attended court cases and schools. The Senate deliberated in the Forum's Senate House, and temples to the state gods housed cult statues as well as the state treasury. Gladiators fought in the open space in the center of the Forum, where temporary wooden bleachers were erected for spectators. The Forum continued to accommodate many essential Roman functions during the Empire, but some moved to new imperial complexes. Pompey's theater complex was the first of a series of huge urban interventions through which Rome's autocrats curried favor with the populace. Julius Caesar and Augustus each commissioned a forum, separate from but close to the Roman Forum, establishing a tradition that Vespasian, Domitian, and Trajan followed. As the plan in figure 7.17 reveals, these for were closely connected to each other topographically and drew significance from their proximity. A visitor entered the Forum of Augustus directly from that of his divinized ancestor Caesar, cementing the connection through physical experience. Augustus' Forum was a large open plaza

with porticoes lining the long sides. At the end of the plaza was a temple to Mars the Avenger, which Augustus had vowed to erect after Caesar's assassination. When compared with the free forms of the Sanctuary of Fortuna Primigenia at Praeneste, this complex is overwhelmingly rectilinear and Classically inspired, as was most Augustan architecture. This deliberate choice evoked the pinnacle of Greek achievement in fifth-century BCE Athens, and the pervasive use of marble, available from newly opened quarries at Carrara, underlined the effect. Sculpture filled the Forum. The porticoes housed full-length, labeled portraits of great men from Rome's legendary past and recent history, suggesting a link between the past and the Augustan present. In the attic (upper level) of the porticoes, engaged caryatids (supporting columns in the shape of draped female figures) flanked shields decorated with heads of Jupiter Ammon (god of the Sahara, sometimes described as Alexander the Great's father). The carved women replicated the figures on the south porch of the Erechtheion on the Athenian Akropolis (see fig. 5.51), where Augustus' architects were engaged in restoration work. Many of the rituals once accommodated by Rome's historic buildings such as the Temple of Capitoline Jupiter now moved to Augustus' Forum, and by diverting these state activities to an arena associated with his name, Augustus placed himself explicitly at the head of Roman public life.

The largest of all the imperial fora was Trajan's, financed with the spoils of his wars against the Dacians. Reconstructions of the complex give a sense of its former magnificence (fig. 7.18). Located alongside Augustus' Forum, it adapted many of that

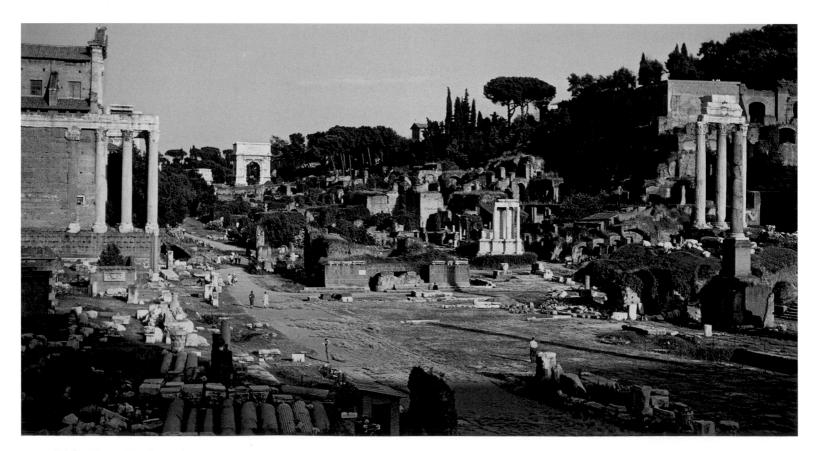

7.16 View of the Forum in Rome

7.17 Plan of the Fora, Rome

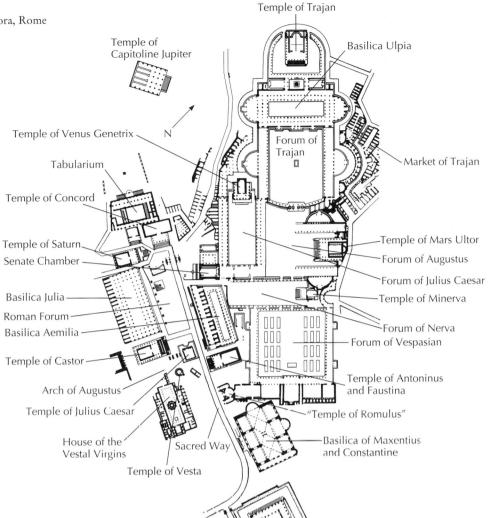

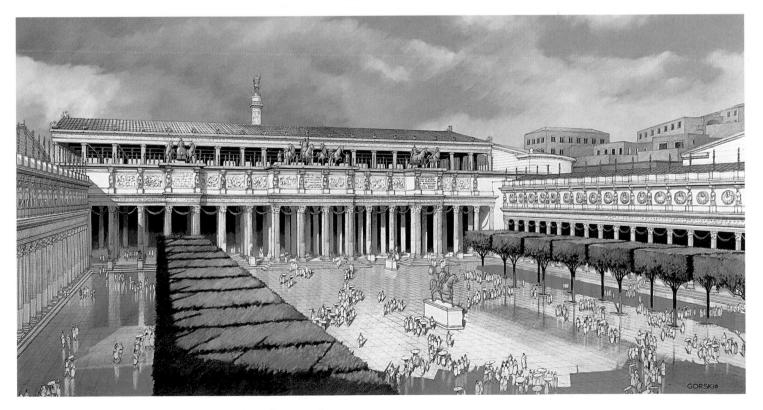

7.18 Forum of Trajan, Rome. Restored view by Gilbert Gorski

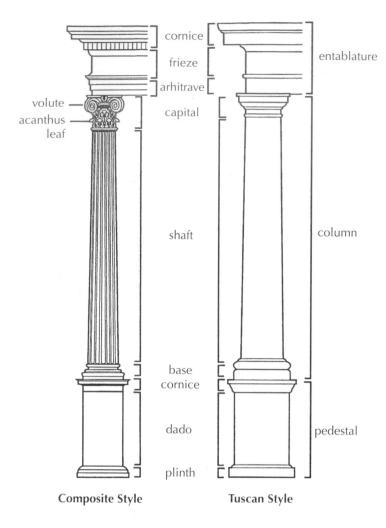

7.19 Tuscan and composite styles

forum's features to new effect. In place of the caryatids in the portico attics, for instance, were statues of captive Dacians carved from exotic marbles. Beyond a basilica at the far end, two libraries and a temple defined a small courtyard, where Trajan's Column stood (see figs. 7.39 and 7.40). The Forum's message is clear: The Dacian Wars brought Rome great financial benefit. As in many societies, the ruling elite hoped to dispel the starker realities of war through visual propaganda.

The change in patronage from magistrates to emperor is one of the major developments in architecture during the Empire. Another is the invention of the composite capital. To the building styles that they borrowed from Greece, Roman architects added two more (fig. 7.19). One was the Tuscan style, which resembled the Doric style except that the shaft stood on a base. This style was in use throughout the Roman period. The composite capital was an imperial phenomenon: Architects used it as a substitute for the Ionic capital on secular buildings, especially from the reign of the first Flavian emperor, Vespasian (69–79 CE). It combined the volutes of an Ionic capital with the acanthus leaves of the Corinthian capital, to rich decorative effect.

THE COLOSSEUM Tuscan columns frequently appear in a decorative capacity on entertainment buildings. Vespasian was the first to construct a permanent amphitheater for the gladiatorial games and mock sea battles that were so central to Roman entertainment and to Rome's penal system (figs. 7.20, 7.21, and 7.22). Putting on shows for the populace was a crucial form of favorgaining benefaction, and the audience assembled for diversion but also to see their emperor and to receive the free handouts that he would make on these occasions. Vespasian died before completing the Colosseum, and his son Titus inaugurated it in 80 CE with over 100 days of games, at a cost of over 9,000 animal lives.

In terms of sheer mass, the Colosseum was one of the largest single buildings anywhere: It stood 159 feet high, 616 feet 9 inches long, and 511 feet 11 inches wide, and held well over 50,000 spectators. Concrete—faced with travertine—was the secret of its success. In plan, 80 radial barrel-vaulted wedges ringed an oval arena. Each barrel vault buttressed the next, making the ring remarkably stable (see fig. 7.22). The wedges sloped down from the outside to the ringside to support seating, as in Pompey's theater, and the architects accommodated countless stairways and corridors within the wedges to ensure the smooth flow of traffic between the entrances and the seating areas and the arena. During the performances, Romans took their seats strictly according to social rank, and the distinctive clothing of each order visually set off one

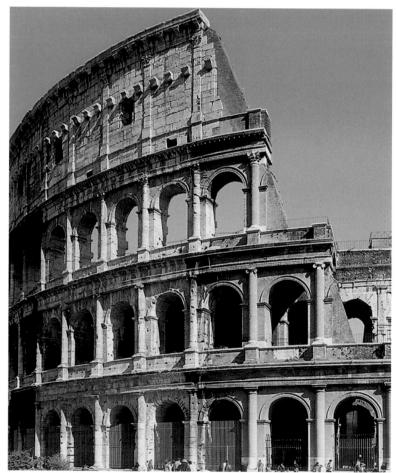

7.20 Exterior of Colosseum

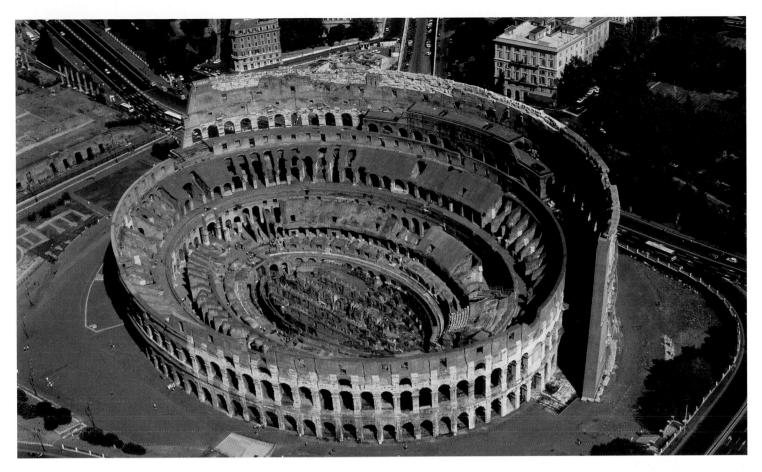

7.21 Colosseum, Rome. 72-80 CE

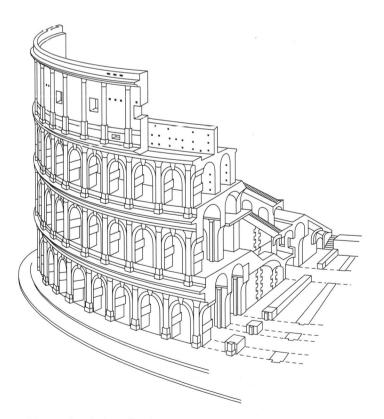

7.22 Sectional view of Colosseum

group from another. On the hottest days, sailors stationed nearby rigged a *velarium*, huge canvas sheets, over the seating areas to provide shade. Dignified and monumental, the exterior reflects the structure's interior organization. Eighty arched entrances led into the building, framed with engaged Tuscan columns. On the second story, Ionic columns framed a second set of arches, and on the third are engaged Corinthian columns. Engaged Corinthian pilasters embellish the wall on the fourth.

THE PANTHEON But of all the masterpieces Roman architects accomplished with concrete, the Pantheon is perhaps the most remarkable (fig. 7.23). Augustus' right-hand man, Agrippa, built the first Pantheon on the site. Its name suggests that he intended it as a temple to all the gods. This was a Hellenistic concept, and it included living and deceased members of the ruling family among the gods. When a fire destroyed this temple in 80 CE, Domitian built a reconstruction, which perished after a lightning strike. The Pantheon we see today, which has a substantially different design, is probably the work of Trajan's architect, perhaps Apollodorus. The temple was completed in Hadrian's reign, and as an act of piety, Hadrian left Agrippa's name in the inscription (see The Art Historian's Lens, page 202). It owes its status as one of the best-preserved temples of Rome to its transformation into a church in the early seventh century CE. All the same, its surroundings have changed sufficiently through the ages to alter a visitor's experience of it quite profoundly.

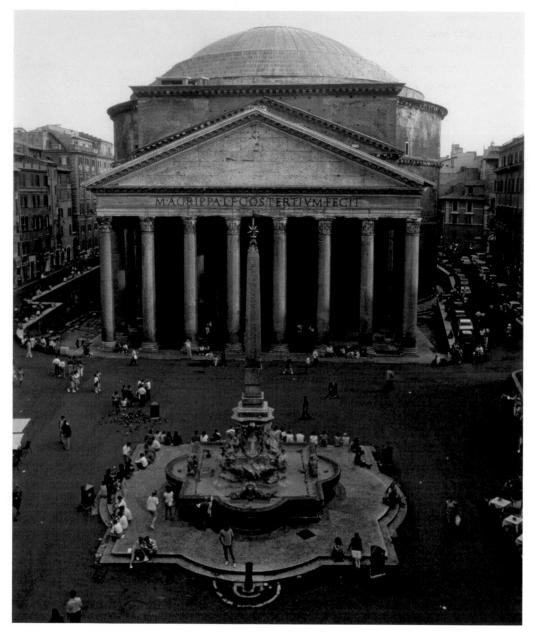

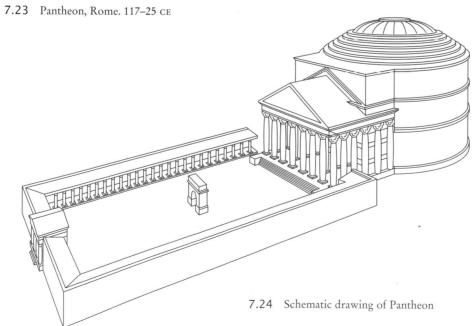

In Roman times, the Pantheon stood, raised on a podium, at the south end of a large rectangular court (fig. 7.24). Porticoes framed the three remaining sides of the court and extended on the south up to the sides of the temple's pedimented porch, hiding the temple's circular drum from view. A visitor approaching the temple's broad octastyle façade would have been struck by the forest of massive monolithic gray and pink granite columns soaring upward; but in most other respects, the temple's form would have been familiar, evoking an expectation of a rectangular cella beyond the huge bronze doors, and a large cult statue. Yet a surprise was in store. On stepping across the threshold (figs. 7.25 and 7.26), a visitor faced a vast circular hall, with seven large niches at

ground level at the cardinal points. Engaged pilasters and bronze grilles decorated an attic level, and high above soared an enormous dome, pierced with a 27-foot hole, or oculus, open to the sky. Through the oculus came a glowing shaft of light, slicing through the shadows from high overhead. Dome and drum are of equal height, and the total interior height, 143 feet, is also the dome's diameter (fig. 7.27). For many ancient viewers, the resultant sphere would have symbolized eternity and perfection, and the dome's surface, once emblazoned with bronze rosettes in its coffers (recessed panels), must have evoked a starry night sky.

For a visitor entering the cella, there was no obvious cue to point out where to go, except toward the light at the center. In

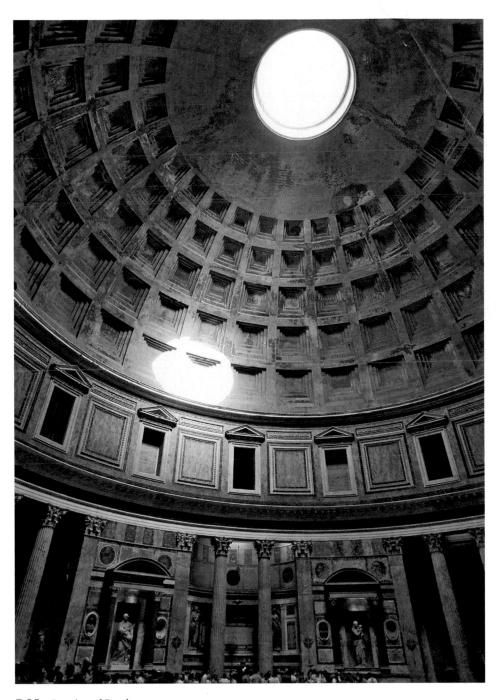

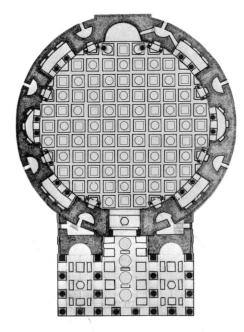

7.26 Plan of Pantheon

7.25 Interior of Pantheon

Two Pantheon Problems

Intil the early twentieth century, most scholars believed that the existing Pantheon was an Augustan building, partially because its inscription attributes it to Agrippa, Augustus' right-hand man. In 1936-38, archaeologist Herbert Bloch produced a masterly analysis of Roman brick-stamps—stamps that manufacturers impressed on bricks while they were wet. Often, these incorporated the names of consuls, especially in the second century CE, which allows scholars to date bricks to a span of years, and sometimes even to a precise year. Bloch's assessment of bricks used in the Pantheon led him to confirm what archaeologists had begun to suspect on the basis of excavations: that the Pantheon was not Agrippa's temple but a later rebuilding of it. Bloch assigned it to the reign of Hadrian. However, Lise Hetland's new reading of the Pantheon brick-stamps stresses the presence of Trajanic bricks in early stages of the temple's construction. This suggests that building began in Trajan's reign, and ended under Hadrian. The Pantheon may be the work of Apollodorus, designer of Trajan's Forum, who also constructed an imperial bath building with similar design features. If true, as many believe, this redating will engender new interpretations of the building's significance and new assessments of the emperors' respective building programs.

Since the fifteenth century, architects studying the Pantheon have struggled with a paradox: Despite the building's profound impact on Western architecture from the moment of its construction, irregularities in its design suggest that it is seriously flawed. These irregularities include an inexplicable second pediment, above and behind the first; the fact that the exterior cornices are at different levels on circular drum and porch; and unaccountable misalignments in the floor plan. To explain these irregularities, scholars initially concluded that the present building is the result of several different building campaigns—a theory that Bloch's brick analysis roundly disproved.

In 1987, while doodling on a napkin over a beer at a pub, three British scholars, Paul Davies, David Hemsoll and Mark Wilson Jones, recognized that if the 40-foot column shafts of the Pantheon's porch were replaced with 50-foot shafts, the irregularities would disappear. The taller shafts would raise the pediment to the level of the "ghost" pediment; the cornices would align around the entire building; and because the shafts would be thicker, the imperfections in the floor plan would be resolved. Gray and pink granite shafts come from Aswan in Egypt. Fifty-foot shafts are relatively rare; in the event that they were—for instance—lost at sea, 40-foot replacements would have been more readily available to keep construction on schedule. The British scholars' contention—which is now widely accepted—is that an unforeseen circumstance forced the builders to deviate from the design mid-construction. One of the most admired buildings of antiguity, in other words, is probably a brilliant compromise between design and necessity.

fact, the dome's coffers only make sense perspectivally from directly beneath the oculus. Once a visitor reached the center, molded space and applied decoration combined to provide a stunning effect. Beginning in the Renaissance, scholars have found fault with the Pantheon's architect for neglecting to align the ribs between the dome coffers with the pilasters in the attic zone and the ground-floor columns. The design is not without logic: a void or a row of coffers aligns exactly over each central intercolumniation (space between columns) on the ground floor. All the same,

7.27 Transverse section of Pantheon

the absence of a systemic network of continuous vertical lines between top and bottom means that, visually speaking, the dome is not anchored. The optical effect is that it hovers unfettered above the visitor-who feels, paradoxically, both sheltered and exposed. The dome seems to be in perpetual motion, spinning overhead in the same way as the heavens it imitates. An all-butimperceptible rise in the floor at the center exaggerates this sensation, which can incite an unnerving feeling similar to vertigo. A visitor's instinct, in response, is to take refuge in the safety of the curved wall. The building is all experience, and photographs do it no justice. This is the place, so literary sources relate, where Hadrian preferred to hold court, greeting foreign embassies and adjudicating disputes here. The temple's form cast the emperor in an authoritative position as controller of his revolving universe. He must have appeared like a divine revelation before his guests, who were already awed and completely manipulated by the building that enclosed them.

The Pantheon is the extraordinary result of an increased confidence in the potential and strength of concrete. The architect calibrated the aggregate as the building rose, from travertine to tufa, then brick, and finally pumice, to reduce its weight. The dome's weight is concentrated on eight wide pillars between the interior alcoves, rather than resting uniformly on the drum (the circular cella wall) (see fig. 7.26). The alcoves, in turn, with their screens of columns, visually reduce the solidity of the walls, and colored marbles on the interior surfaces add energy to the whole.

As in Trajan's Forum, the marbles were symbolic. They underlined the vast reach of imperial authority, assuming trade with or control over Egypt (gray and rose-pink granite, porphyry), Phrygia (Phrygian purple and white stone), the island of Teos (Lucullan red and black stone), and Chemtou in Tunisia (Numidian yellow stone).

HADRIAN'S VILLA AT TIVOLI As well as commissioning public architecture, emperors also built magnificent residences for themselves. From the start of the Empire, the emperor's principal home was on the Palatine Hill in Rome (from which the term "palace" derives). Yet, like many members of the elite, he had several properties, many of which were outside of Rome. The most famous is the Villa of Hadrian at Tibur (present-day Tivoli). Built on the site of a Republican villa, this residence was a vast sprawling complex of buildings, some or all of which Hadrian may have designed himself. The villa's forms appear to follow the natural line of the landscape, but in fact massive earthworks rearranged the terrain to accommodate the architecture and to allow for impressive vistas, cool retreats, and surprise revelations. Water was a common feature, in pools and running channels, adding sound and motion, reflecting light, and offering coolness in the summer heat. Throughout the villa were mosaics, paintings, and sculptures. The emperor may have collected some of these works

of art during his extensive travels, especially in Egypt and Greece. A desire to evoke the far-flung regions of the Empire may also have inspired some of the buildings: A fourth-century CE biographer claims that Hadrian "built up his villa at Tibur in an extraordinary way, applying to parts of it the renowned names of provinces and places, such as the Lyceum, the Academy, the prytaneum, the Canopus, the Poecile, and Tempe. And so as to omit nothing, he even fashioned 'infernal regions.'" This statement has led modern scholars to give fanciful names to many parts of the villa. Few of them are based on archaeological evidence, and they lead visitors to faulty conclusions about the buildings' functions. The canal shown in figure 7.28 has long been known as the Canopus, after a town in Egypt. Only recently have scholars proposed more neutral terms for the villa's components, in this case the "Scenic Canal."

Portrait Sculpture

By the time Augustus had effectively become emperor, he was no more than 36. With its stress on maturity, the veristic portrait style so characteristic of the Republic might have served to underline his unusual, not to say aconstitutional, status in Rome. Perhaps as a consequence, Augustus turned instead to a more Hellenizing style. Portraits made right up to his death in his late

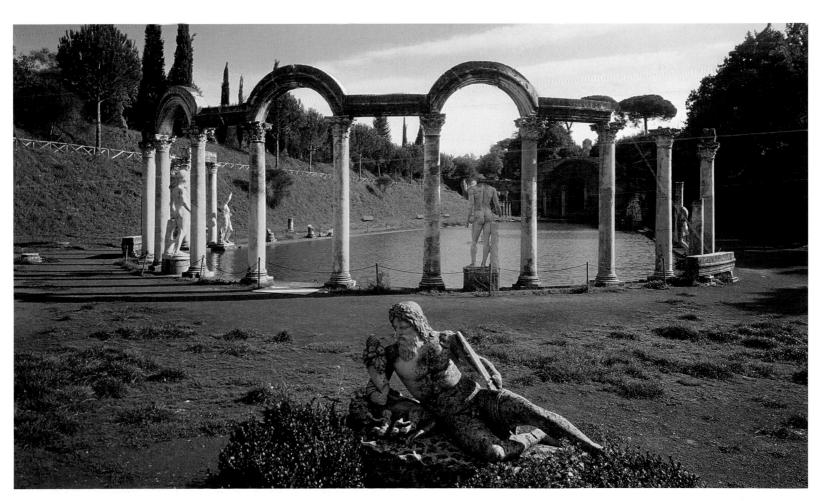

7.28 Scenic Canal, Hadrian's Villa, Tivoli, ca. 130-38 CE

seventies depict him as an ageless youth, as seen in a statue discovered in the house of his wife Livia at Primaporta (fig. 7.29). The emperor appears in battledress with his arm raised in a gesture of address. The portrait seems to combine a series of references to previous works of art and historical events in order to strengthen Augustus' claim to authority.

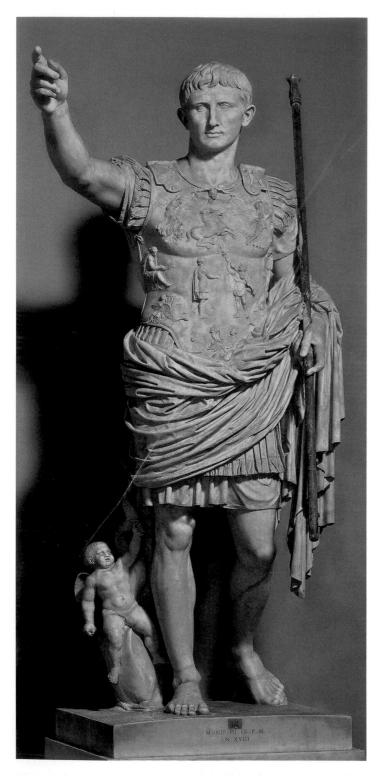

7.29 Augustus of Primaporta. Possibly Roman copy of a statue of ca. 20 CE. Marble, height 6'8" (2.03 m). Musei Vaticani, Braccio Nuovo, Rome

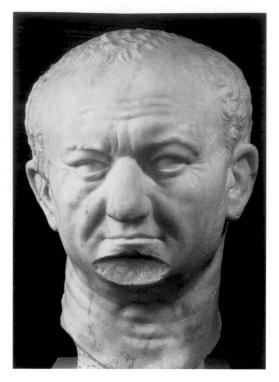

7.30 Portrait of Vespasian. ca. 75 CE. Marble, life-size. Museo Nazionale Romano, Rome

The chiastic stance, and the smooth features of Augustus' face, are so reminiscent of Polykleitos' *Doryphoros* (see fig. 5.33) that scholars assume that Augustus turned deliberately to this well-known image. There was good reason for this kind of imitation: The Classical Greek style evoked the apogee of Athenian culture, casting Augustan Rome as Greece's successor (and conqueror) in cultural supremacy. Even Augustus' hair is similar to that of the Doryphoros—except, that is, at the front, where the locks part slightly over the center of the brow, a subtle reference to Alexander the Great, another youthful general, whose cowlick was such a distinctive feature of his portraits (see fig. 5.69).

Next to Augustus' right ankle, a cupid playfully rides a dolphin, serving as a strut to strengthen the marble. Most Romans would have recognized that Cupid, or Eros, the son of Venus, symbolized Augustus' claim of descent from the goddess of love through his Trojan ancestor Aeneas. The dolphin evoked the sea, and specifically the site off the coast of Actium where Augustus had prevailed over Mark Antony and Cleopatra in a celebrated naval battle in 31 BCE. By associating Augustus with historical or divine figures, these references projected an image of earthly and divinely ordained power, thereby elevating the emperor above other politicians.

The iconography of Augustus' breastplate serves a similar purpose by calling attention to an important event in 20 BCE, when the Parthians returned standards that they had captured, to Roman shame, in 53 BCE. A figure usually identified as Tiberius, Augustus' eventual successor, or the god Mars, accepts the standards from a Parthian soldier, possibly King Phraates IV. Celestial gods and terrestrial personifications frame the scene, giving the event a

cosmic and eternal significance. This diplomatic victory took on momentous proportions in Augustan propaganda. The scene suggests that the portrait dates to about 19 BCE. The emperor is barefoot, which usually denotes divine status. Later in the Roman period, or in the Eastern Empire, emperors might be depicted as gods while still alive, but with Caesar's legacy still fresh in Roman minds, it is unlikely that Augustus would have been so presumptuous. Some scholars therefore conclude that the statue is a posthumous copy of a bronze original dating to about 20 BCE.

The Primaporta Augustus offers a good example of a tendency in Roman art to express a message through references to earlier works. Naturally, not all Romans would have understood all the references in any given work, but the frequency of visual "quotations" suggests that Romans, like many other ancient peoples, were extremely visually astute. In fact, the history of Roman portraiture, as with many other branches of Roman art, is one of constant association with, and negation of (or conscious turning away from), past images. In their portraits, Augustus' dynastic successors, for instance, look very much like the first emperor from whom they drew their authority, even though they were rarely (or at best distantly) related by blood. But then, with the emperor Vespasian, founder of the Flavian dynasty, there was a return to a more veristic style of portrait (fig. 7.30). Scholars reason that this maneuver was part of a deliberate attempt to restore social order when he came into power in 69 CE, after a year of civil war. A soldier by background, Vespasian justified his authority through his military success, and appealed to the rank and file through this harshly matter-of-fact image. However,

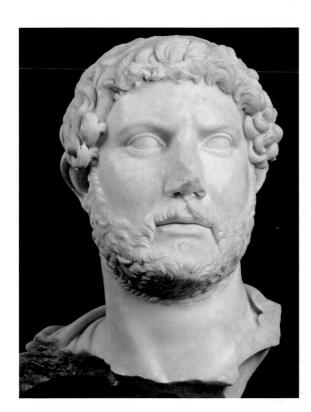

7.31 Portrait of Hadrian. After 117 CE. Marble, height 16.7" (42.5 cm). Museo Nazionale Romano, Rome

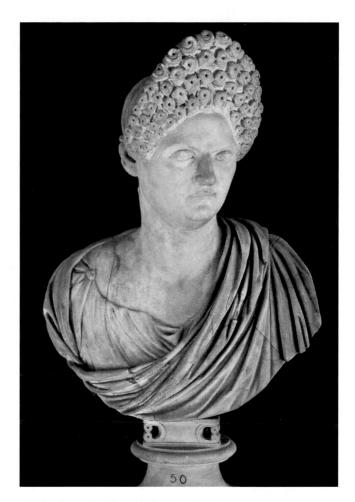

7.32 Portrait of Domitia Longina. Late 1st century CE. Marble, height 24" (60.8 cm). Courtesy of San Antonio Museum of Art, San Antonio, Texas. Gift of Gilbert M. Denman, Jr.

several years later, Hadrian's portraits revived the classicism associated with Augustus, taking the Greek style even further. Nicknamed "The Greekling" by the ancients for his admiration of Greek culture, he adopted the full beard that was characteristic of Greek philosophers (fig. 7.31); ancient reports that he was trying to conceal scars from acne are unlikely to be true. It was in his reign that sculptors began to carve the pupils and irises of eyes, rather than painting them.

Imperial portraits survive in great multitudes. They fall into a number of types, suggesting that there was a master portrait, often executed for a specific occasion, which sculptors would copy for dissemination within and outside of Rome; other sculptors would copy these copies, in turn, leading to a ripple effect around the empire. Thousands of portraits of nonimperial subjects also survive. Scholars can rarely identify them, but date them on the basis of similarities with members of the imperial family. When dealing with female portraits, hairstyles are especially useful since they change relatively rapidly. Livia's simple coiffure, with a roll, or *nodus*, at the front is a far cry from the towering hairstyle of Domitia Longina, wife of Domitian, one of Vespasian's sons (fig. 7.32). Built around a framework (often of wicker), her coiffure was a masterpiece in itself, and its representation in

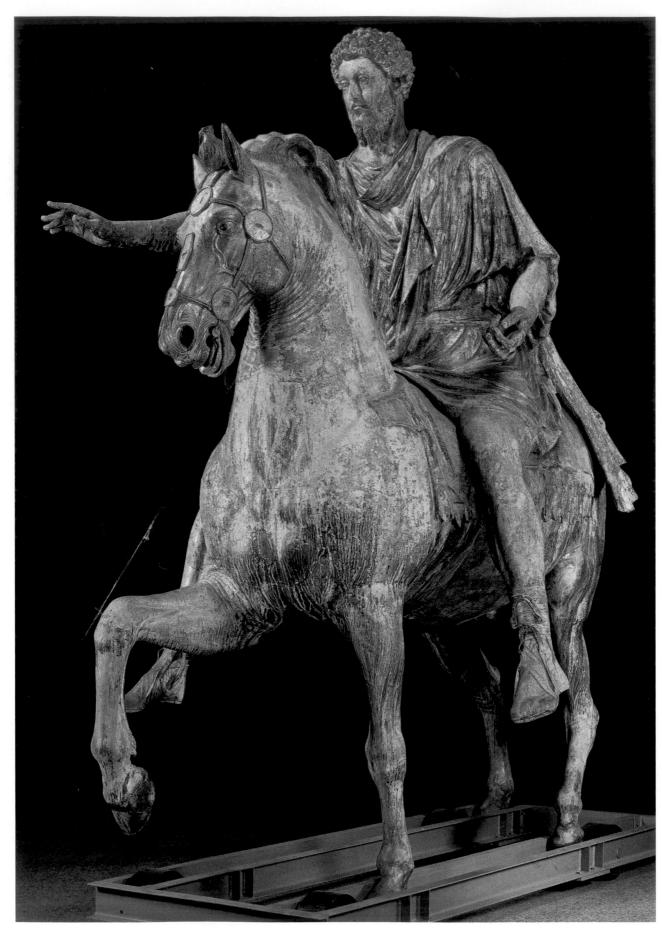

7.33 Equestrian Statue of Marcus Aurelius. 161–80 CE. Bronze, over-life-size. Museo del Palazzo dei Conservatori, Rome

sculpture reflected her status, as well as affording the sculptor an opportunity to explore contrasts of texture between skin and hair, and to drill deep into the marble for a strong play of light and shadow.

Beginning in the second half of the second century CE, Roman portraits gradually take on a more abstract quality. This is perceptible in a spectacular gilded bronze portrait of Marcus Aurelius, which was spared the melting pot in the medieval period because Christians misidentified the subject as Constantine the Great, champion of Christianity (fig. 7.33). With one arm outstretched in a gesture of mercy, the emperor sits calmly astride a spirited horse, whose raised front leg once rested on a conquered barbarian. As in the portrait of Hadrian and the vast majority of second- and third-century CE male portraits, Marcus Aurelius is bearded. He was interested in philosophy, and his Stoic musings still survive as the "Meditations." Sculpture of the time reflects such abstract concerns. For example, his eyelids fall in languid fashion over his pupils, lending them a remote quality.

Relief Sculpture

The Republican practice of commissioning narrative reliefs to record specific events continued well into the Empire. The reliefs were mounted on public buildings and monuments, such as the *Ara Pacis Augustae*, or Altar of Augustan Peace, as well as commemorative columns and arches.

THE ARA PACIS AUGUSTAE ALTAR OF AUGUSTAN

PEACE The Senate and People of Rome vowed the *Ara Pacis Augustae* (fig. **7.34**) in 13 BCE when Augustus returned safely from Spain and Gaul, and it was dedicated in 9 BCE. It stood inside a marble enclosure, which was open to the sky and richly sculpted over its entire surface. On east and west sides, flanking two entrances, relief panels represent allegorical figures, or personifications, and figures from Rome's legendary past. On the west end, a fragmentary panel shows a she-wolf suckling the infants Romulus and Remus, under the watchful eyes of the shepherd

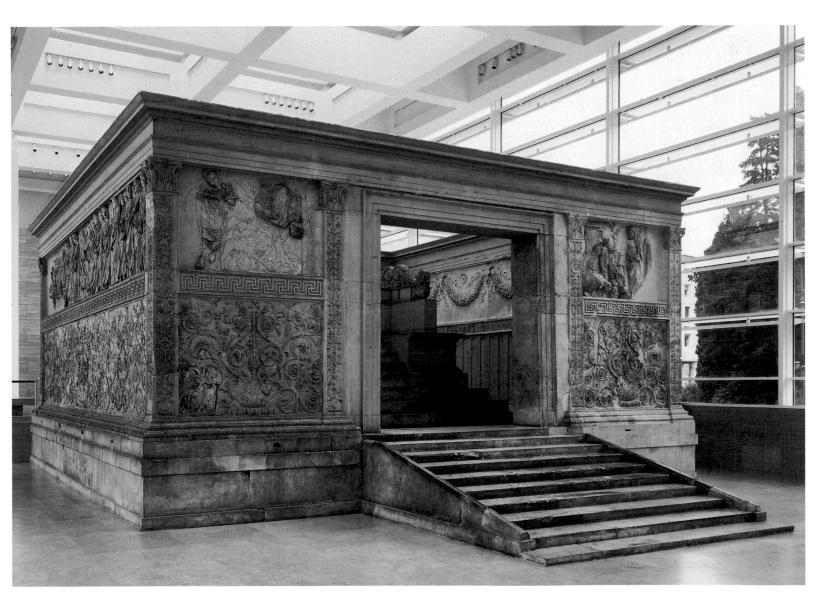

7.34 West façade of Ara Pacis Augustae. 13-9 BCE. Marble, width of altar approx. 35' (10.7 m). Museum of the Ara Pacis, Rome

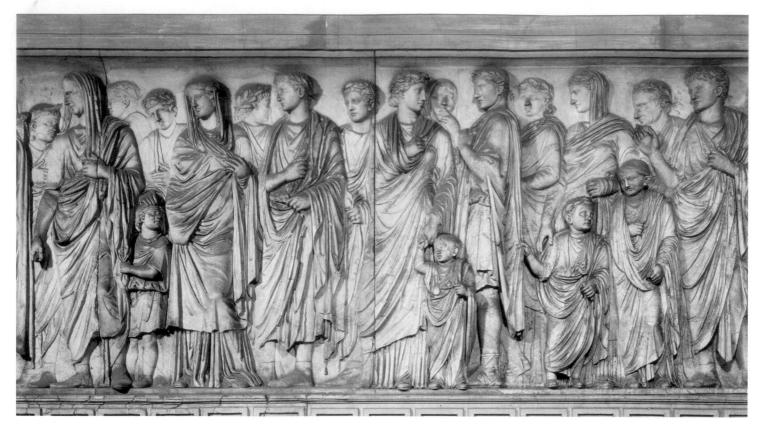

7.35 Imperial Procession south frieze, Ara Pacis Augustae. 13-9 BCE. Marble, height 5'3" (1.6 m). Rome

Faustulus, who discovered and adopted them. In a second relief, Aeneas (or perhaps, according to a recent interpretation, Numa, second king of Rome) makes a sacrifice at an altar of roughly hewn stones. At the east end, a relief depicting the goddess Roma seated on her weapons balances a panel with a female figure (the goddess Venus or Ceres, perhaps, or Peace, Italia, or Mother Earth) embodying the notion of peace. Together, the panels express the message of peace that Augustus was intent on promoting, in contrast with the bleakness of the preceding civil wars. The same message was implicit in the acanthus relief that encircles the enclosure in a lower register. Vegetation unfurls in rich abundance, populated with small creatures such as lizards and frogs.

On north and south sides, the upper register contains continuous procession friezes that portray members of the imperial family interspersed with the college of priests and senators (fig. 7.35). The friezes record a particular event on the day of the altar's dedication. A large gap in the relief falls exactly on Augustus, whose action remains unidentified. Still, the friezes are significant for a number of reasons. In their superficial resemblance to the Greek Parthenon frieze (see figs. 5.45 and 5.46), they bear witness, once again, to a preference for Greek styles in the Augustan age. They also include a number of women from the imperial family, including Livia, and small children. Their inclusion probably denotes the importance of dynasty, as well as referring to moral legislation Augustus enacted to curb adultery and promote child-birth among the elite.

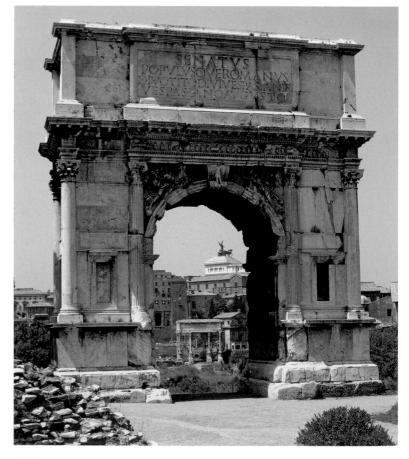

7.36 Arch of Titus, Rome. ca. 81 CE. Marble

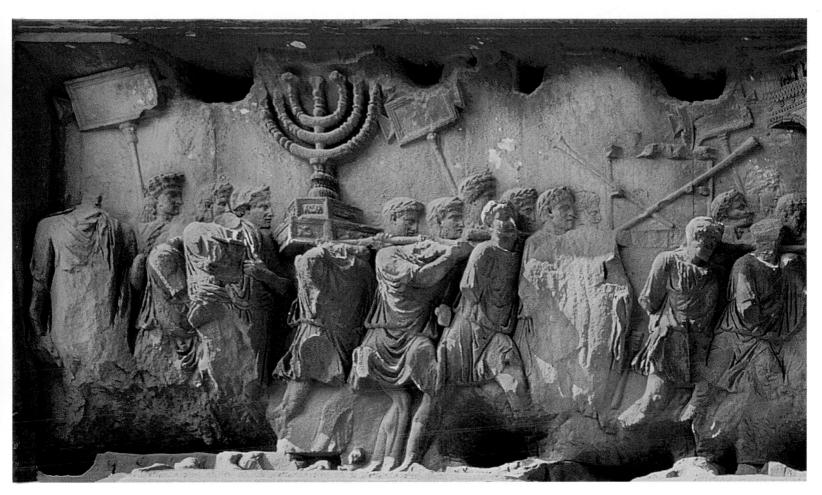

7.37 Relief in bay of Arch of Titus, showing procession of spoils from the Temple in Jerusalem. ca. 81 CE, Marble, height 7'10" (2.39 m)

THE ARCH OF TITUS Reliefs also decorated free-standing arches. Members of the elite first erected arches during the Republic, though no early examples survive. During the Empire, many arches celebrated triumphs, but they also served as commemorative monuments for the dead. Their enduring impact on Western architecture is readily understandable: As with free-standing columns, their chief raison d'être was to express a visual message. Often they stood at or near an entrance to a public area, and framed the transition, or liminal space (from limen, Latin for "threshold"), between one place and another. Many societies consider liminal spaces unsettling and in need of protection; the lamassu of Mesopotamia, one might note, guarded doorways (see fig. 2.18). The Arch of Titus, son and successor of Vespasian, stands at the far eastern end of the Roman Forum. It is the earliest surviving free-standing arch in Rome, though much of it is the product of architect Giuseppe Valadier's restoration from 1822 to 1824 (fig. 7.36). It may have been a triumphal monument, but given that its inscription and a small relief panel describe Titus as a god, it is more likely that it commemorates his apotheosis (or divinization) after his death in 81 CE. Its principal sculptural relief panels are within the bay, and both refer to the triumph after the destruction of the Second Temple in Jerusalem in 70 ce. In one of them, soldiers carry booty through the streets, including a seven-branched menorah (a Jewish candelabra) and other sacred furniture looted from the Temple (fig. 7.37). The panel marks an important move toward spatial illusionism. Two ranks of figures appear, carved in different levels of relief. The background figures are in such shallow relief that they seem to fade into the distance. The procession breaks away abruptly at the sides, so that it appears to continue beyond a viewer's line of sight. On the right, it disappears through a triumphal arch, placed at an angle to the background so that only the nearer half emerges in relief, giving the illusion of spatial depth. The panel even bulges out slightly at the center, so that it seems to turn right in front of a viewer standing inside the arch's bay, making the viewer a part of the action. In the other panel, Titus rides in a triumphal chariot, high above a teeming crowd, signified through differing levels of relief (fig. 7.38). The horses appear in profile, but the chariot is frontal, giving the illusion that the procession is approaching a viewer before turning sharply. Behind the emperor, a personification of victory crowns him for his success. Additional personifications—Honor and Virtue, perhaps, or Roma-accompany the chariot. Their presence, and the absence of Vespasian, whom the Jewish historian Josephus places in the scene, sound a cautionary note for those who

Josephus (37/8-ca. 100 CE)

The Jewish War, from Book VII

The Jewish soldier and historian Josephus Flavius was born Joseph Ben Matthias in Jerusalem. He was named commander of Galilee during the uprising of 66–70 CE against the Romans in the reign of Nero. After surrendering, he won the favor of the general Titus Flavius Sabinus Vespasian and took the name Flavius as his own. Josephus moved to Rome, where he wrote an account of the war (75–79 CE) and Antiquities of the Jews (93 CE). The following passage from his history of the rebellion describes the triumphal procession into Rome following the Sack of Jerusalem in 70 CE, which is depicted on the Arch of Titus (figs. 7.38 and 7.39).

It is impossible to give a worthy description of the great number of splendid sights and of the magnificence which occurred in every conceivable form, be it works of art, varieties of wealth, or natural objects of great rarity. For almost all the wondrous and expensive objects which had ever been collected, piece by piece, from one land and another, by prosperous men—all this, being brought together for exhibition on a single day, gave a true indication of the greatness of the Roman Empire. For a vast amount of silver and gold and ivory, wrought into every sort of form, was to be seen, giving not so much the impression of being borne along in a procession as, one might say, of flowing by like a river. Woven tapestries were carried along, some

dyed purple and of great rarity, others having varied representations of living figures embroidered on them with great exactness, the handiwork of Babylonians. Transparent stones, some set into gold crowns, some displayed in other ways, were borne by in such great numbers that the conception which we had formed of their rarity seemed pointless. Images of the Roman gods, of wondrous size and made with no inconsiderable workmanship, were also exhibited, and of these there was not one which was not made of some expensive material. ...

The rest of the spoils were borne along in random heaps. The most interesting of all were the spoils seized from the temple of Jerusalem: a gold table weighing many talents, and a lampstand, also made of gold, which was made in a form different from that which we usually employ. For there was a central shaft fastened to the base; then spandrels extended from this in an arrangement which rather resembled the shape of a trident, and on the end of each of these spandrels a lamp was forged. There were seven of these, emphasizing the honor accorded to the number seven among the Jews. The law of the Jews was borne along after these as the last of the spoils. In the next section a good many images of Victory were paraded by. The workmanship of all of these was in ivory and gold. Vespasian drove along behind these and Titus followed him; Domitian rode beside them, dressed in a dazzling fashion and riding a horse which was worth seeing.

Source: J.J. Pollitt, The Art in Rome, c. 753 B.C.-A.D. 337: Sources and Documents (NI: Cambridge University Press. 1983)

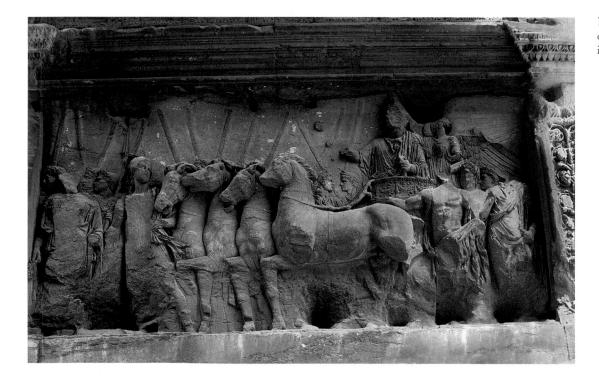

7.38 Relief in bay of Arch of Titus, showing Titus riding in triumph

would read Roman visual narratives as accurate accounts of historical events. (See *Primary Source*, above.) Artists constructed these narratives to express a version of events that served the patron's ideology.

THE COLUMN OF TRAJAN The exploration of space and narrative strategies comes into full bloom in the Column of Trajan (fig. **7.39**), erected between 106 and 113 CE in a small court to the west of Trajan's Forum (see figs. **7.17** and **7.18**). Soaring about 150

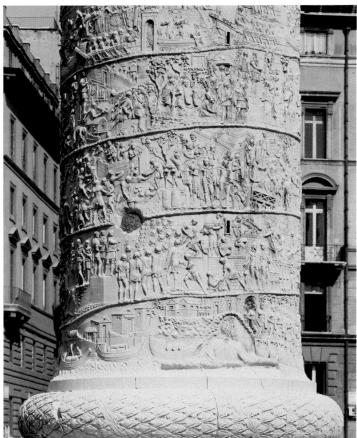

7.40 Lower portion of Column of Trajan, Rome. 106–13 CE. Marble, height of relief band approx. 50" (127 cm)

Roman feet high, this supported a gilded statue of the emperor, lost in medieval times. Winding through the interior of its shaft was a spiral staircase leading to a viewing platform, from which a visitor could look out over Trajan's extraordinary building complex. Free-standing columns had been used as commemorative monuments in Greece from Hellenistic times, but the sheer scale of Trajan's Column, usually credited as the work of Apollodorus, along with its role as **belvedere** (or viewing station), makes it nothing short of a world wonder. However, art historians have tended to focus not on the engineering feat the column represents, but on the 656-foot-long continuous narrative relief that winds around its shaft in a counterclockwise direction, celebrating the emperor's victorious campaigns against the people of Dacia (in present-day Romania).

The narrative begins with the Roman army's crossing of the Danube to reach Dacian territory (fig. 7.40). The river appears as a large personification. To the left are riverboats loaded with supplies and a Roman town on a rocky bank. The second band shows Trajan speaking to his soldiers, and soldiers building fortifications. In the third, soldiers construct a garrison camp and bridge as the cavalry sets out on a reconnaissance mission; and in the

7.39 Column of Trajan, Rome. 106–13 CE. Marble, height 125' (38 m)

fourth, foot soldiers cross a stream while, to the right, the emperor addresses his troops in front of a Dacian fortress. These scenes are a fair sampling of events shown on the column. Among the more than 150 episodes, combat occurs only rarely. The geographic, logistic, and political aspects of the campaign receive more attention, much as they do in Julius Caesar's literary account of his conquest of Gaul.

Individual scenes are not distinctly separate from one another. Sculptors placed trees and buildings in such a way as to suggest divisions, but the scenes still merge into a continuous whole, with important protagonists, such as Trajan, appearing multiple times. Thus, they preserved visual continuity without sacrificing the coherence of each scene. Although Assyrian and Egyptian artists created visual narratives of military conquests, this relief is by far the most ambitious composition so far in terms of the number of figures and the density of the narrative, and understanding it is a complicated matter. Continuous illustrated **rotuli** (scrolls) are a likely inspiration for the composition, if such things existed before the column's construction.

Also problematic is the fact that in order to follow the narrative sequence, a viewer has to keep turning around the column, head inclined upward. Above the fourth or fifth turn, details become hard to make out with the naked eye, even if the addition of paint made the sculpture more vivid. It might have been possible to view the upper spirals from balconies on surrounding

buildings in antiquity, but the format would still have required an encircling motion. These problems have led scholars to propose viewing strategies. They have long noted that the relief is formulaic; that is, the sculptors repeated a fairly limited number of stock scenes again and again. These include, for instance, sacrifice scenes, the emperor addressing his troops, or soldiers constructing forts and dismantling enemy cities. Though these are not identical, they are similar enough to be recognized at a distance, which helps make the upper spirals more legible. The designer may also have aligned important and representative scenes on the cardinal axes of the column, so that a viewer could grasp an abbreviated version of the whole from a single standpoint. Yet there is always the possibility that the designer intended viewers to have to turn around the column in order to read its narrative. The column's base would serve as a burial chamber for Trajan's ashes after his death in 117 CE, and an encircling motion would be entirely consistent with a widespread Roman funerary ritual known as the decursio, in which visitors to a tomb walked around it to protect the dead buried within, to keep harmful spirits in the grave, and to pay perpetual homage to the deceased.

THE COLUMN BASE OF ANTONINUS PIUS The point at which the classicizing phase of Roman sculpture, still so evident on the Column of Trajan, starts to yield to the more abstract style of late antiquity—with its less naturalistic, more linear treatment

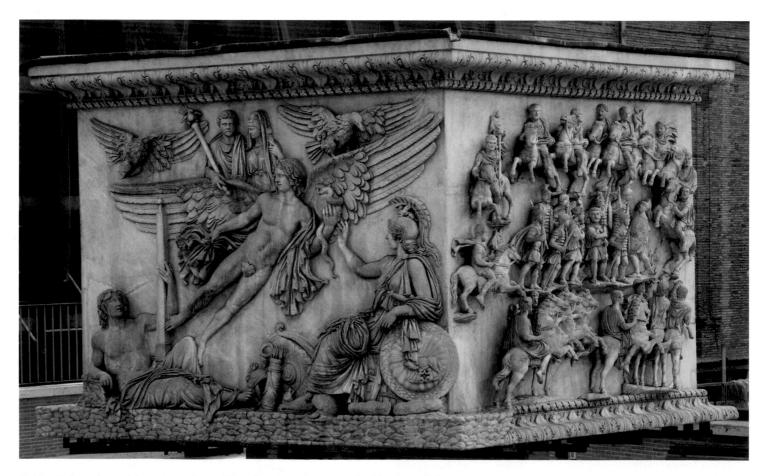

7.41 Column base of Antoninus Pius and Faustina. "Apotheosis" and "decursio" reliefs. ca. 161 CE. Marble. Musei Vaticani, Rome

7.42 Funerary relief of a butcher and a woman. Mid-2nd century CE. Marble, $13\frac{1}{2}\times26\frac{1}{2}$ " (34.5 × 67.3 cm). Staatliche Kunstsammlungen, Dresden

of the body—is a matter of some debate. A critical shift may have taken place with the column base of Antoninus Pius and his wife, Faustina the Elder. Antoninus died in 161 ce. His successors, Marcus Aurelius and Lucius Verus, erected a 50-foot porphyry column in his honor, surmounted by his statue. Its white marble base is all that survives. One side bears an inscription. On another is an apotheosis scene, where a winged figure bears the emperor and his wife to the heavens, while personifications of the Field of Mars (where the cremation took place) and Rome look on (fig. 7.41). The figures have lithe, Classical proportions, and idealized faces, with smooth, even planes and ageless features. On the two remaining sides of the base, Roman cavalrymen ride in a counterclockwise circle around a group of infantrymen, in nearly identical scenes that probably represent the decursio around the funeral pyre. The sculptural style of these scenes is unlike the apotheosis scene. The soldiers have stocky, squat proportions, and the action unfolds in a bird's-eye perspective, while the soldiers are viewed from the side. Both of these factors find parallels in sculpture commissioned in the provinces and in nonelite circles. Figure 7.42 shows a nonelite style, in a funerary relief commemorating a butcher and a woman. The image has a flatness that is different from the illusionistic treatment of space on the panels of the Arch of Titus (see figs. 7.37 and 7.38) The figures are stocky, and the butcher's head is large in proportion to his body. The artist's priority was probably legibility: The patron would have mounted the panel on the façade of a tomb, so that viewers could see it from a distance. The linear treatment of the image and the boldness of the forms served this goal well. The introduction of these qualities into imperial commissions in Rome signals a change in the way state art expressed messages.

Art and Architecture in the Provinces

The spread of Rome's authority over a wide geographical reach had a profound impact on artistic and architectural production in those areas. As Rome's political and cultural institutions reached the provinces, so did the architectural and artistic forms that accommodated them. Sometimes provincial monuments are all but indistinguishable from those in the city of Rome; but more often the syncretism of Roman forms and indigenous styles and materials led to works that were at once recognizably Roman and yet distinctive to their locale.

The principal written sources on the provinces tend to be works by Romans. For this reason, it is hard to assess how provincial peoples reacted to Roman rule. But it certainly brought them some benefits. For instance, Roman engineers had mastered the art of moving water efficiently, and the new aqueducts that sprang up in urban centers around the Empire must have improved local standards of living immeasurably. A striking aqueduct still stands at Segovia in Spain, dating to the first or early second century CE (fig. 7.43). It brought water from Riofrío, about

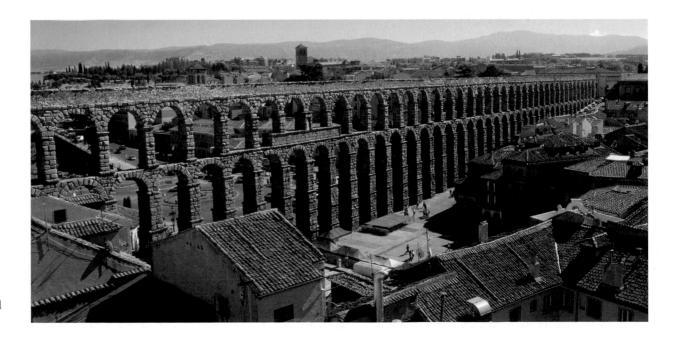

7.43 Aqueduct, Segovia. 1st or early 2nd century CE

10½ miles (17 km) away, flowing for most of its length through an underground channel. Approaching the town, however, architects built a massive bridge stretching 2,666 feet long and up to 98 feet high to span a valley. One hundred and eighteen arches support the water channel, superimposed in two registers at the highest point. Like most provincial builders, the architects used a local stone, in this case granite, which they assembled without mortar and left unfinished to give it an air of strength. Despite the obvious practical advantages the aqueduct provided, the design also illustrates how Roman architecture could effect dominion. The arches—such a quintessentially Roman form—march relentlessly across the terrain, symbolically conquering it with their step. Even the act of moving water was a conquest of a kind, a conquest of Nature.

THE MAISON CARÉE, NÎMES Romans carried their way of life with them across the Empire, constructing theaters and amphitheaters in a Roman style, and temples to accommodate their rituals. A well-preserved temple (fig. 7.44) known as the Maison Carrée (Square House) survives in the French town of Nîmes (ancient Nemausus). Typically Roman, it stands on a high podium, with a frontal staircase. Six Corinthian columns across the front lead into a deep porch and to the cella; engaged columns decorate the cella's exterior walls. Reconstructing an inscription

in bronze letters on its architrave from the evidence of dowel holes, scholars long thought the temple to have been dedicated to Rome and Augustus during the Augustan age. Acanthus scrolls in the frieze appeared to be reminiscent of the *Ara Pacis*, and the masonry style showed similarities to that of the Temple of Mars the Avenger in Augustus' Forum. Indeed, scholars once considered the temple evidence for traveling workshops. Recent research has cast doubt on this view, though, and illustrates the danger that historians may construct the very history they are looking for by interpreting evidence to fit preconceived theories. As it turns out, the dowel holes could support any number of different inscriptions; and the **module** (construction measure) employed throughout the building only came into use under Trajan. The building could be a temple dedicated to Trajan's wife, Plotina, as attested in literary sources.

EL KHASNEH, PETRA In some cases, the syncretism of indigenous building traditions with Roman styles resulted in powerful new effects. This appears to be the case with the extraordinary rock-cut façade known as El Khasneh, or the Treasury, at the site of Petra in present-day Jordan (fig. **7.45**). This façade is the first sight to greet a visitor who wanders through the long, twisting gorge known as the Siq, leading to the town center. The Nabataeans, a nomadic people who settled this area before the

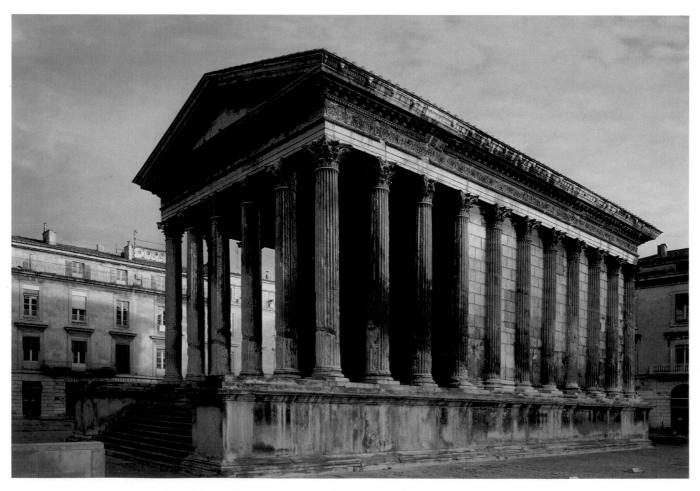

7.44 Maison Carrée, Nîmes. Early 2nd century CE (?)

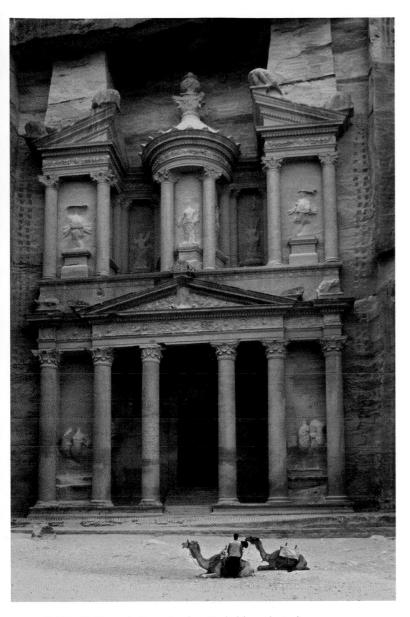

7.45 El Khasneh, Petra, Jordan. Probably early 2nd century CE

Romans took control in 106 CE, buried their wealthy dead in tombs cut out of the pink sandstone cliffs, and some have seen El Khasneh as one of their monuments. Most now agree, however, that it belongs to the Trajanic or Hadrianic period. Carved from the living rock, the monument resembles a temple façade, with six columns beneath an architrave decorated with floral designs and a pediment. In a second story, lateral columns support the angles of a broken pediment. Between them is a tholos with a conical roof, surmounted by an ornamental finial. In modern times, locals imagined that pirates had stored their treasure in the finial, lending the monument its name; bullet holes show how they tried to knock it down. The façade is a striking amalgamation of a Nabataean concept with Roman decorative features—the Corinthian column capitals, for instance, and the vegetal designs. The architectural elements are not structural, and this allows for a freedom and quality of fantasy in the design, not unlike the fantasy vistas of Second Style wall paintings (see page 221). This playful treatment of once-structural elements became popular in the provinces and in Rome in the second century CE, and scholars sometimes describe it as a "baroque" phase, for its similarities to Italian Baroque architecture. The monument's function may have changed for Roman usage as well: Relief sculptures between the columns seem to represent figures from the cult of Isis, suggesting that it was a temple. In some cases, inscriptions and other written documents indicate who commissioned monuments in the provinces; the patron might be local, a Roman official, or even the emperor himself. More often, as in this case, there is no such evidence, which makes it hard to determine meaning in a particular choice of design.

provinces also has a distinctive look—the result, generally, of a merging of different traditions. A limestone funerary relief from Palmyra in Syria from the second half of the second century CE (fig. 7.46) once sealed the opening to a burial within a characteristically Palmyrene monument, a tower tomb. An Aramaic inscription identifies the subject as Tibnan, an elite woman, who holds a small child in one arm. The language bespeaks her origin, and the strict frontality, large staring eyes, and local dress and headband set her apart from elite women of Rome (see fig. 7.32). All the same, the portrait has distinctly Roman qualities: Tibnan

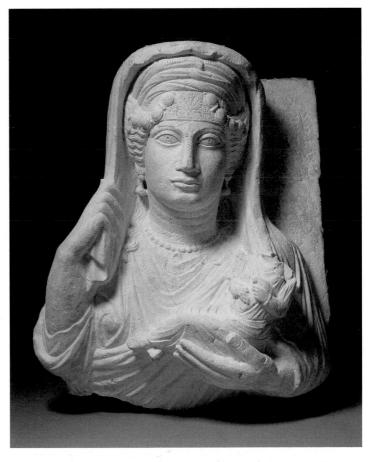

7.46 Funerary relief of Tibnan, from Palmyra, Syria. ca. 150–200 CE. Painted limestone. Musée du Louvre, Paris

raises her right hand, for instance, to hold her veil, in a Roman gesture that signified chastity (or *pudicitia*, defined as loyalty to one's husband) (see fig. 7.13). The portrait neatly encapsulates the dual identity of this provincial woman, who is both Palmyrene and Roman.

The largest body of painting to survive from the Roman world is wall painting (see page 218). Yet the sands of Fayum, in Lower Egypt, preserved a magnificent group of painted portraits, once attached over the faces of embalmed, mummified corpses (fig. 7.47). The earliest of them appear to date from the second century

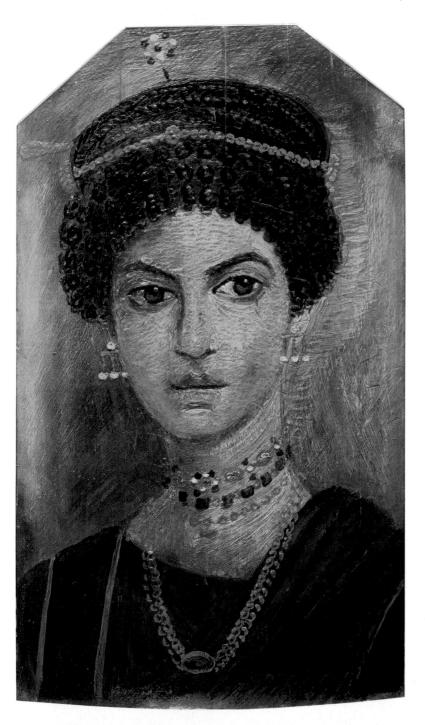

7.47 Portrait of a Woman, from Hawara in the Fayum, Lower Egypt. ca. 110–30 CE. Encaustic on wooden panel. Royal Museum of Scotland. © Trustees of the National Museum of Scotland

ce. Artists painted them on wooden panels in the encaustic technique, which involves suspending pigments in hot wax. The mixture can be opaque and creamy, like oil paint, or thin and translucent. The medium is extremely durable, and the panels retain an extraordinary freshness; the wax also gives them a lustrous vitality. The quality of the portraits varies dramatically. At their best, they have a haunting immediacy, largely the result of the need to work quickly before the hot wax set. The woman pictured here wears a crimson tunic and a wealth of jewelry. Rows of black circles denote the ringlets of her hair, bound with a golden diadem. Her appearance is Roman, yet the portrait itself speaks of her local identity, since she was buried in the Egyptian, not the Roman, fashion. As a result, these portraits belong rightly in the history of both Roman art and Egyptian art.

Domestic Art and Architecture

The Romans are one of the few ancient peoples to have left abundant evidence of domestic architecture and its decoration. This is largely due to the catastrophic eruption of Vesuvius in 79 CE, which left the nearby cities of Pompeii and Herculaneum buried under a thick blanket of ash and lava. When excavations began in Pompeii in the eighteenth century, archaeologists discovered a city frozen in time. Utensils and remnants of furniture were still in place in houses, inns, and bath buildings, allowing historians to reconstruct the rituals of daily life in extraordinary detail.

POMPEII AND HERCULANEUM In its early days, the Oscans inhabited Pompeii. Another early Italic tribe, the Samnites, took control in the late fifth century BCE, and the city's monumentalization began under their aegis, and under the influence of nearby Greek cities. After the Social War of 90-89 BCE, the Roman dictator Sulla refounded Pompeii as a Roman colony. Like other colonies, which took their design from Roman army camps, Pompeii had two main streets, the cardo and the decumanus (fig. 7.48). At their intersection stood the forum, the civic heart of the city, near which the Pompeiians built the principal temples and two theaters. Interspersed among surrounding streets were houses and the other buildings that accommodated everyday Roman life: baths for daily bathing and socializing, taverns and fast-food kitchens, launderers with their great vats of urine for washing clothes, and brothels. A state-of-the-art amphitheater on the outskirts of the city, which was a prototype for the Colosseum, provided gladiatorial entertainments, and outside the city gates the wealthy buried their dead in monumental tombs. In the Augustan period, an aqueduct brought fresh water to the public fountains that flowed continuously throughout the city. Water flushed the basalt-paved streets to keep them clean, and raised steppingstones allowed pedestrians to cross from sidewalk to sidewalk without getting wet.

The unusually good state of preservation of the houses of Pompeii and Herculaneum means that they dominate scholarly discussion, as they will here; yet such was the durability of Roman domestic construction that houses survive elsewhere as

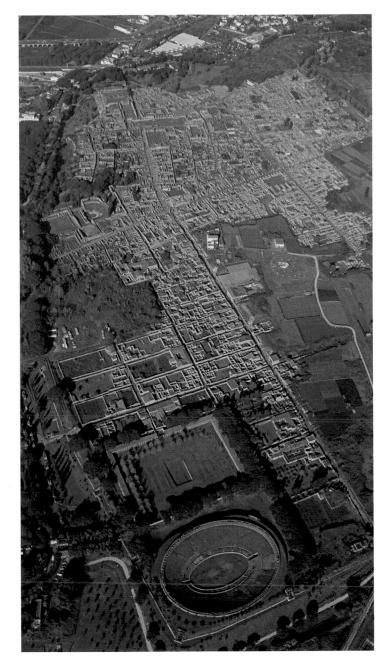

7.48 Aerial view of Pompeii

well, as far afield as Morocco and Jordan, and although Roman houses have many common qualities, they also differ from one region to the next, to cater, for instance, to local climates. One should be cautious, therefore, about conceiving of a "typical" Roman house.

Scholars describe elite Roman houses by their Latin name, domus, known from Vitruvius and other ancient writing (fig. 7.49). (See www.myartslab.com.) Its most distinctive feature is an atrium, a square or oblong central hall lit by an opening in the roof, answered by a shallow pool, or impluvium, in the ground to collect rainwater. The airy quality of the atrium confers an element of grandeur upon the house, visible here in the House of the Silver Wedding (fig. 7.50), and by tradition it was where Romans kept portraits of ancestors. Other rooms, such as bedrooms

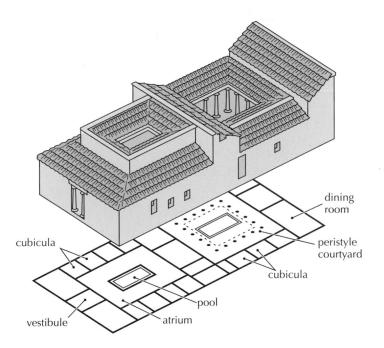

7.49 Reconstruction of Pompeiian house

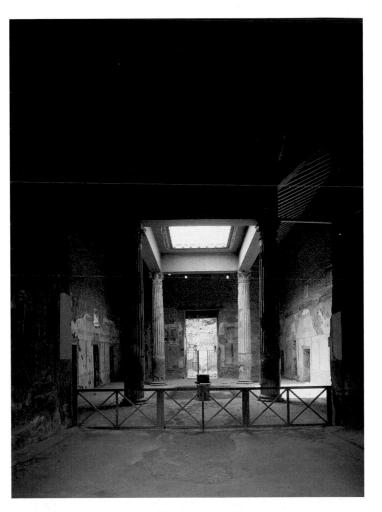

7.50 Atrium of the House of the Silver Wedding, Pompeii. 2nd century BCE-79 CE

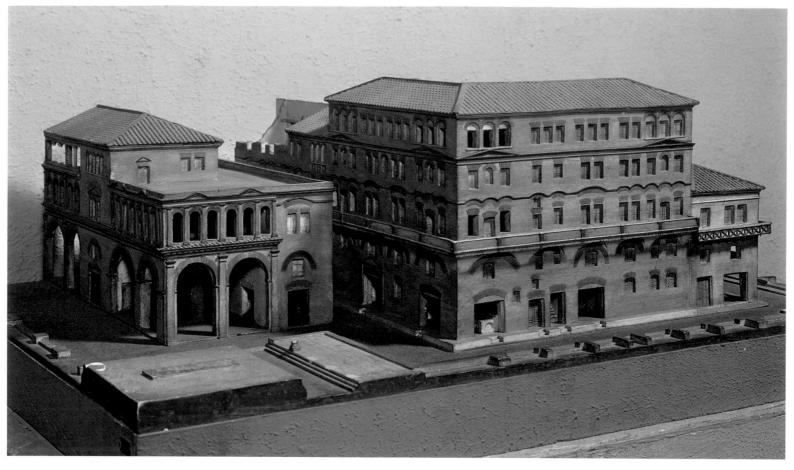

7.51 Model of apartment block

(cubicula), group around the atrium, which often leads to a tablinum, a reception room, where the family kept its archives. Beyond the tablinum, a colonnade (the *peristyle*) surrounds a garden, where the owner could display sculpture and take fresh air. There might be additional rooms at the back of the house. The chief light source was the atrium and the peristyle; walls facing the street did not typically have windows, but one should not be misled into believing that these houses were therefore particularly private. Romans routinely used rooms flanking the entryway as shops, and the front door often stood open. At the heart of Roman society was a client-patron relationship, and clients routinely visited their patrons in their homes, in a morning ritual known as the salutatio. The householder also conducted business in his home, even in the bedrooms. A visitor's access to the different parts of the house depended on his relationship with the owner, who would greet most visitors in the large central rooms.

In any given region of the Empire, there were huge discrepancies between the houses of the rich and the dwellings of the poor. Abandoned in the Middle Ages, Rome's port city, Ostia, preserves many examples of high-occupancy dwellings, known as **insulae** (literally "islands") (fig. 7.51). An **insula** was generally a substantial concrete-and-brick building (or chain of buildings) around a small central court, with many features of a present-day apartment block. On the ground floor, shops and taverns opened to the street; above lived numerous families in cramped quarters. Some

insulae had as many as five stories, with balconies above the second floor. Wealthy property owners often made a handsome income from these buildings.

MAU'S FOUR STYLES OF PAINTING Compared with Greek painting, Roman domestic painting—mostly wall painting—survives in great abundance. It comes mainly from Pompeii and Herculaneum, and also from Rome and its environs, and it dates mostly to a span of less than 200 years, from the end of the second century BCE to the late first century CE. Given the public character of a domus, these paintings were more than mere decoration: They also testified to a family's wealth and status.

Basing his analysis partly on Vitruvius' discussion of painting, the late nineteenth-century German art historian August Mau distinguished four styles of Roman wall painting (fig. 7.52), which are useful as general guidelines. (See www.myartslab.com.) In the First Style, dating to the late second century BCE, artists used paint and stucco to imitate expensive colored marble paneling. Starting about 100 BCE, Second Style painters sought to open up the flat expanse of the wall by including architectural features and figures. In a room in the Villa of the Mysteries just outside Pompeii, dating from about 60 to 50 BCE, the lower part of the wall (the dado) and the upper section above the cornice level are painted in rich mottled colors to resemble exotic stone (fig. 7.53). Figures interact as if on a narrow ledge set against a deep

August Mau (1840–1909 produced what remains the scheme that underpins all stylistic analysis of Pompeian decor: he divided the wall painting into four 'Styles,' each representing a phase in the chronology of Pompeian painting, from the second century BCE to the final eruption in 79 CE.

7.52 August Mau's Four Styles of Pompeiian wall painting

1. 'The First, or Incrustation, style': the wall is painted (and moulded in stucco) to imitate masonry blocks, no figured scenes. Second century BCE.

2. 'The Second, or Architectural, style': characteristically featuring illusionistic architectural vistas. c.100—15 BCE.

3. 'The Third, or Ornate, style': the vistas here give way to a delicate decorative scheme, concentrating on formal ornament. c.15 BCE.—50 CE.

4. 'The Fourth, or Intricate, style': a more extravagant painterly style, parading the whole range of decorative idioms. c.50 CE.

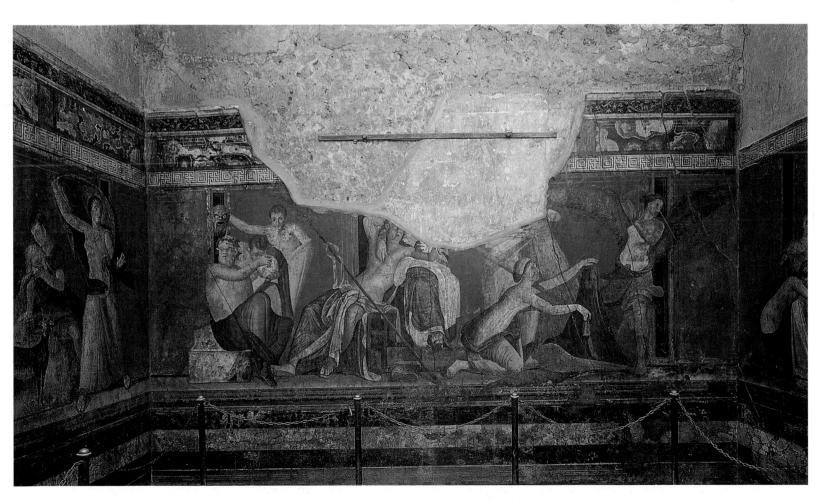

7.53 Scenes of Dionysiac Mystery Cult, from the Villa of the Mysteries, Pompeii. Second Style wall painting. ca. 60-50 BCE

7.54 Second Style wall painting, from the Villa of Publius Fannius Synistor at Boscoreale, near Pompeii. Mid-1st century BCE. Fresco on lime plaster, $8'8\frac{1}{2}" \times 19'7\frac{1}{8}" \times 10'11\frac{1}{2}"$ (2.65 \times 5.84 \times 3.34 m). Metropolitan Museum of Art, New York, Rogers Fund, 1903 (03.14.13)

7.55 Second Style wall painting of garden, from the Villa of Livia at Primaporta. ca. 20 BCE. Museo delle Terme, Rome

red background, articulated by upright strips of black resembling stylized columns. They are engaged in rites associated with the Dionysiac mysteries, one of the so-called mystery religions originating in Greece. The scene may represent an initiation into womanhood or marriage, in the presence of Dionysos and Ariadne with a train of satyrs. The solidity of the near-life-size figures, the bold modeling of their bodies, and their calm but varied poses lend a quiet power and vivid drama to the room.

In some cases, Second Style artists employed architectural vistas to open the wall into a fantasy realm, suggesting another world beyond the room. This movement may reflect architectural backdrops in contemporaneous theaters. In an example from the Villa of Publius Fannius Synistor at Boscoreale, near Pompeii, now reconstructed in the Metropolitan Museum of Art in New York (fig. 7.54), there is a foreground of architectural features: A painted parapet wall runs around the lower part of the surface, and resting on it are columns, which support a cornice. Receding away from the foreground, in a range of different perspectives, stoas and tholoi and scenic gazebos mingle with

one another in a maze of architectural fantasy, flooded with light to convey a sense of open space. A viewer struggles to disentangle the structures from one other; their size and spatial relationships are hard to determine. The world of the painting is a world inaccessible to those who view it, hovering out of reach. In the Villa of Livia at Primaporta, the garden beyond the trellis fence and low wall is an idyll of nature, filled with flowers, fruit trees, and birds (fig. 7.55). Although its lushness beckons, this fantasy garden is only for looking. Here the artist employed atmospheric perspective: Plants and animals become less distinct as they recede into the background.

The Third Style dominated wall decoration from about 20 BCE until at least the middle of the first century CE. In this phase, artists abandoned illusionism in favor of solid planes of intense colors like black and red, which they often articulated with attenuated architectural features and imitation panel paintings. The Fourth Style, which prevailed at the time of Vesuvius' eruption, was the most intricate of the four, uniting aspects of all three preceding styles to create an extravagant effect. The Ixion Room in the House of the Vettii (fig. 7.56) combines imitation

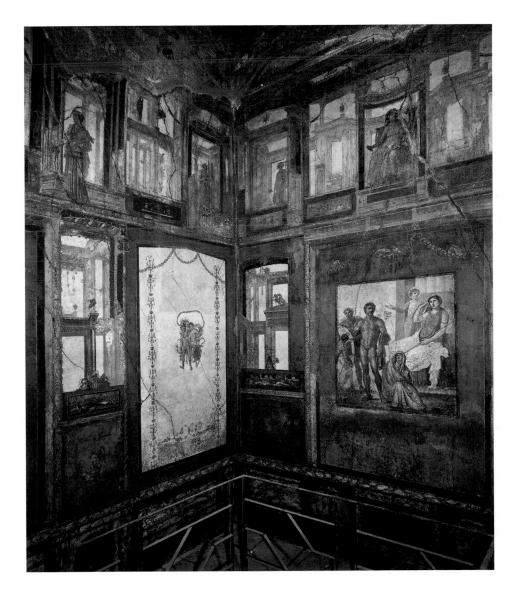

7.56 Fourth Style wall painting, Ixion Room, House of the Vettii, Pompeii. 63–79 CE

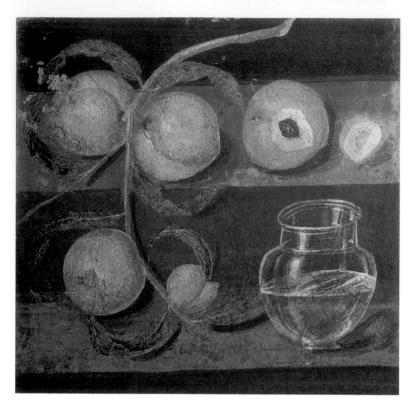

7.57 Still-life painting of peaches and water jar, from Herculaneum. ca. 50 ce. Museo Archaeologico Nazionale, Naples

marble paneling, framed mythological scenes resembling panel pictures set into the wall, and fantastic architectural vistas receding into space.

Within these Fourth Style designs, the artist might insert still life panels, which usually took the form of trompe-l'oeil (intended to trick the eye) niches or cupboards, with objects on shelves. A twenty-first-century viewer finds little unusual about this, yet these are the only visual studies of mundane, inanimate objects until the early modern period. The driving force in these paintings was not a narrative, as in many Roman paintings, but a close analysis of life. The example illustrated here depicts green peaches and a jar half-filled with water (fig. 7.57). Touches of white paint capture the effect of light playing on the surface of the jar and the water within. Shadows fall in different directions around the peaches, suggesting that the artist was more interested in forging a spatial relationship between the peaches and their surroundings than in indicating a single light source. It is possible, too, that the painting reflects the shadow's movement as the artist worked.

As in the Ixion Room in the House of the Vettii (see fig. 7.56), many Roman paintings depicted Greek themes. The few painters' names on record show that at least some of them were of Greek origin. There are also sufficient cases of paintings (or elements of paintings) closely resembling one another to indicate that artists used copybooks; in some cases, they may have been working from a Greek original, adapting the image to their own purposes. The *Alexander Mosaic* in the House of the Faun is a possible

instance of an artist copying a famous Greek painting, albeit into a different medium (see fig. 5.78). Given the scarcity of Greek mural paintings, however, it is rarely possible to demonstrate a clear connection between Greek original and Roman copy. Given the evident innovation in Roman painting, there is no reason to suppose that Roman artists were not capable of creating their own compositions and narratives when they chose. In recent years, scholarship has become less preoccupied with tracing Greek influences, and more focused on ways in which painting ensembles affected experience or dictated movement through a house, and expressed the owner's status. In fact, a genre of ancient literature known as ekphrasis is a learned exposition on a real or imagined painting. (See www.myartslab.com.) On the basis of these writings, scholars believe that homeowners sometimes conceived paintings as conversation pieces for their guests, who might discuss them as they dined. A painting program, then, takes on a new level of importance for what it might disclose about the patron's erudition, status, or aspirations.

THE LATE EMPIRE

During Marcus Aurelius' reign, incursions at the Empire's German and Danubian borders were a constant threat. His son Commodus succeeded him in 180 ce, and was assassinated in 192 CE. The imperial administration then hit an all-time low when, in 193 CE, the throne was auctioned off to the highest bidder. After a brief respite under the Severan dynasty, Rome entered a half-century of civil war, when a succession of emperors came to power and quickly fell through violence. Diocletian (r. 284–305 ce) finally restored imperial authority. His approach was to impose rigid order on all aspects of civil as well as military life. Recognizing the emperor's vulnerability, he also chose to divide authority among four rulers, known as the tetrarchs. Two were senior emperors, the Augusti; and two juniors, the Caesars. Terms of power were to be limited, and the Caesars were to succeed the Augusti. The tetrarchy dissolved in the early fourth century CE, and Constantine the Great, the first emperor to embrace Christianity, rose to power, overcoming his chief rival, Maxentius, at the Battle of the Milvian Bridge in Rome in 312 ce. Art forms are distinctly abstract in late antiquity, and scholars sometimes associate the change with the militaristic mood of the time. Sculptural forms are less naturalistic than before, and architects focus on simple but powerful geometric shapes.

Architecture

By the Late Empire, architects in Rome had more or less abandoned the straightforward use of post-and-lintel construction. Their interests appear to have focused instead on exploring the interior spaces that concrete made possible. Column, architrave, and pediment took on decorative roles, superimposed on vaulted brick-and-concrete cores.

Painted Stone in Greece and Rome

or many people, the prevailing image of Greek and Roman architecture and sculpture is white marble. There is good reason for this: As ancient works emerge from the ground, white is the dominant color. White columns still gleam majestically against the blues skies of lands once Greek or Roman, and white sculptures line the halls of European and American museums. Moreover, architects and sculptors such as Michelangelo drew their inspiration from these colorless pieces, and their pristine classicizing works have helped to perpetuate the impression.

Yet art historians have long noted traces of paint on Greek and Roman works of all kinds. As early as 1812, when German archaeologists unearthed the pedimental sculptures from the Temple of Aphaia at Aegina (see fig. 5.22), vestiges of paint fueled a lasting debate about color on ancient stone. Initially, attention focused on architecture, but with the discovery of the portrait of Augustus from Primaporta in 1863 (see fig. 7.29), scholars intensified their analysis of sculpture as well. Still, as the debate gained strength between the twentieth-century world wars, researchers discovered that their labors encountered ideological and aesthetic resistance.

In recent decades, researchers have profited from advances in technology to attempt convincing reconstructions of well-known ancient

works as they might once have appeared, including two examples shown here: an archer from Aegina and a portrait of the Roman emperor Caligula. They use improved ultraviolet light techniques (first pioneered by P. de la Coste-Messelière to examine the frieze of the Treasury of the Siphnians at Delphi, see fig. 5.21), and analysis by raking light and microscope to find traces of paint that are invisible to the naked eye. Other techniques include X-ray diffractometry and infrared spectography, which identify specific organic and mineral compounds. From these analyses, and from literary evidence such as the writings of Pliny the Elder, Vinzenz Brinkmann and others conclude that ancient artists employed a rich array of pigments that sometimes originated far from their use. Among them were cinnabar for red (from Istria and Andalusia), widely available ocher for yellow, azurite for blue (from Sinai as well as Italy and Spain), green malachite (from Laurion, near Athens), and arsenic for a luminous yellow and orange (from Anatolia). To make black paint, they collected smoke from burning bones or green wood. Artists also added gold and silver leaf to their sculptures. Recent analyses indicate that ancient artists often used strong, vibrant colors, a far cry from the muted tones that archaeologists first envisioned.

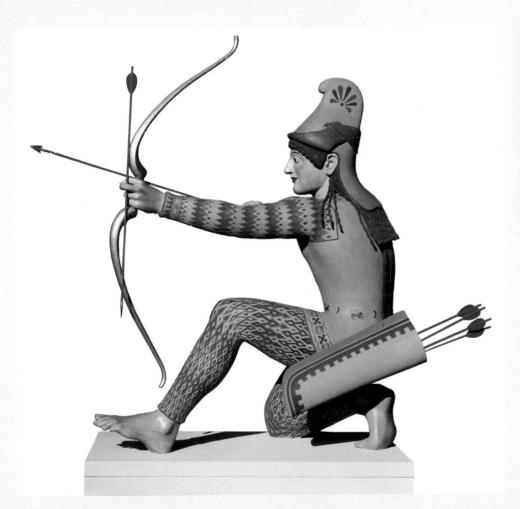

Trojan archer from the west pediment of the Temple of Aphaia on Aegina, color reconstruction

Head of Caligula, color reconstruction

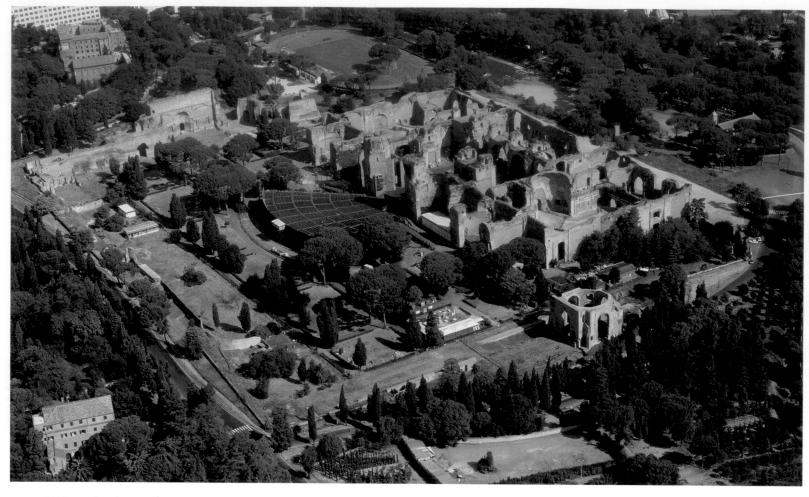

7.58 Baths of Caracalla, Rome. ca. 211-16 CE

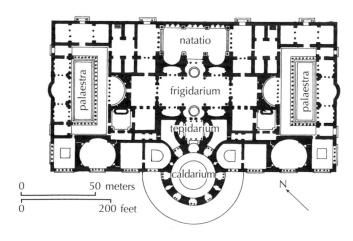

7.59 Plan of Baths of Caracalla

THE BATHS OF CARACALLA Imperial bath buildings demonstrate the new Late Empire architectural interests very clearly. By the beginning of the third century CE, public baths were a long-established tradition in Roman life. Emperors had routinely embellished the city with baths as an act of benefaction. Romans who did not own private baths expected to bathe

publicly most days, but the baths served other functions as well. They became a place of social interaction, where Romans conducted business and the wealthy flaunted troops of slaves. The Baths of Caracalla, built between 211 and 216 CE, were the most extensive and lavish of their kind (figs. 7.58 and 7.59). Set within a rectangular perimeter wall, they included the essential bathing facilities, arranged in a standardized layout: a cold room (frigidarium), a circular hot room (caldarium), and a warm room (tepidarium), as well as a vast swimming pool (natatio), changing rooms (apodyteria), and exercise areas (palaestrae). Lecture halls, libraries, and temples made for a multifaceted experience within its walls. Engineers had long mastered the technology for heating the warm rooms: They raised the floors on brick piers, and directed hot air from a furnace into the open space below. This is known as a hypocaust system. The sheer scale of Caracalla's complex must have been astounding: The principal block of buildings measured an immense 656 by 374 feet. Three vast groin vaults roofed the largest room, the frigidarium. Luscious marble panels revetted the walls, and sculptures animated the halls.

THE BASILICA OF MAXENTIUS When Maxentius commissioned a vast basilica for the center of Rome, the architects looked to the massive uninterrupted spaces of bath buildings for

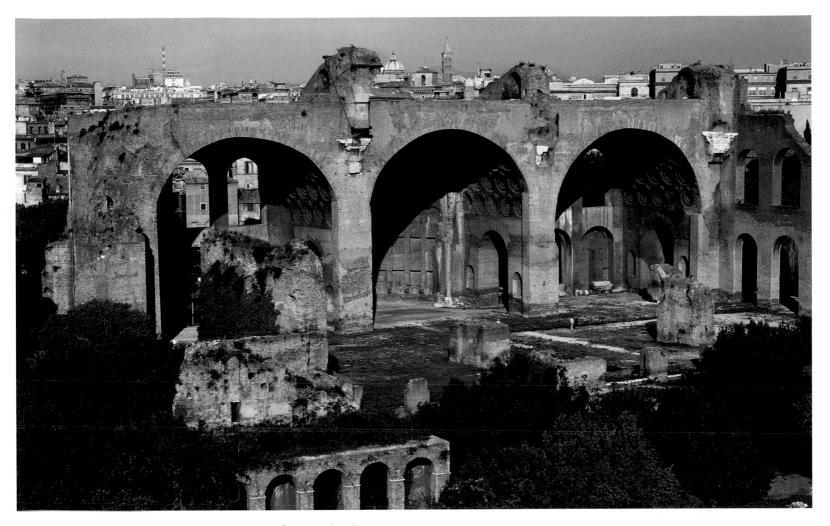

7.60 Basilica of Maxentius, renamed Basilica of Constantine, Rome. ca. 307 CE

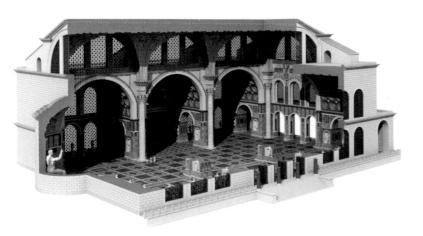

7.61 Basilica of Maxentius, renamed Basilica of Constantine. Reconstruction (after Huelsen)

inspiration. Basilicas (from the Greek basileus, meaning "king") had a long history in Rome. Since the Republic, they had served as civic halls, and they became a standard feature of Roman

towns. One of their chief functions was to provide a dignified setting for the courts of law that dispensed justice in the name of the emperor. Vitruvius prescribed principles for their placement and proportions, but in practice they never conformed to a single type and varied from region to region. The Basilica of Maxentius (figs. 7.60 and 7.61) was built on an even grander scale than the Baths of Caracalla and was probably the largest roofed interior in Rome. It had three aisles, of which only the north one still stands. Transverse barrel vaults covered the lateral aisles, and the wider, taller central aisle or nave was covered with three massive groin vaults. Since a groin vault concentrates its weight and thrust at the four corners (see fig. 7.3), the architect could pierce the nave's upper walls with a large clerestory (window in the topmost wall zone). As a result, the interior of the basilica must have had a light and airy quality. The building had two entrances, each faced by an apse: through a transverse vestibule at the east end, and through a stepped doorway on the south, leading from the Roman Forum. On overcoming Maxentius, Constantine expropriated the basilica. He gave it his own name, and placed his colossal portrait in the western apse (see fig. 7.68). Expropriations of this kind were not uncommon in Rome, and show how critical it was to have a physical presence in the city.

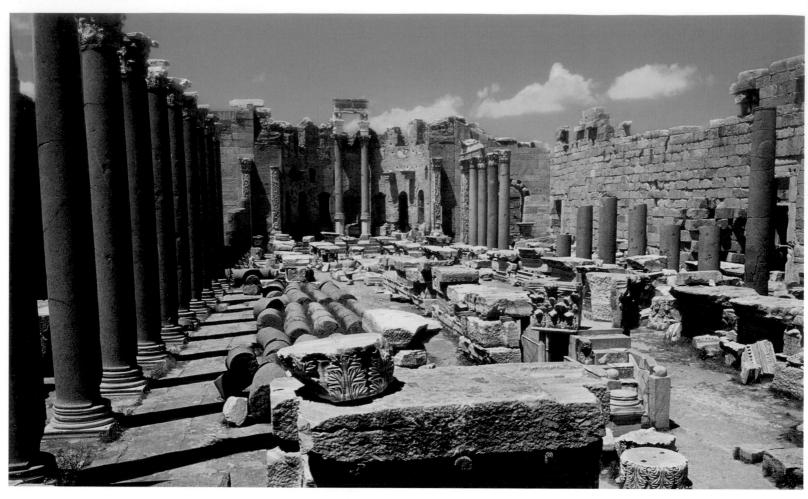

7.62 Basilica,Lepcis Magna, Libya.Early 3rd century CE

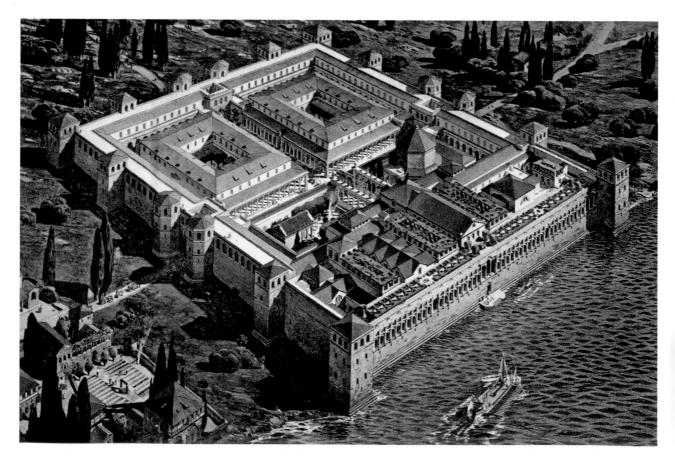

7.63 Palace of Diocletian, Spalato (Split), Croatia. Restored view. са. 300 се

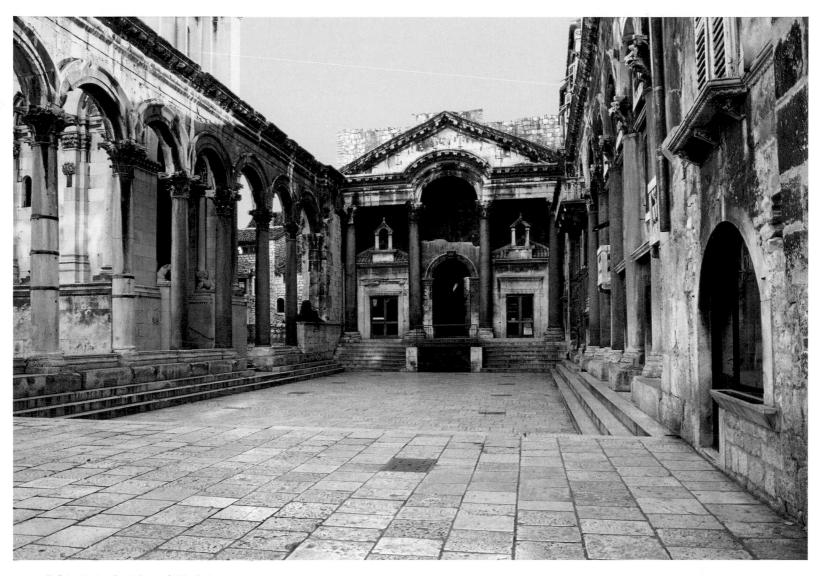

7.64 Peristyle, Palace of Diocletian

Architecture in the Provinces

By the early second century CE, Roman emperors were no longer exclusively from Italy; Trajan came from Spain and Septimius Severus was from North Africa. Both emperors embellished their native cities with new construction. Severus' home, Lepcis Magna, in present-day Libya, remains remarkably well preserved. The emperor was responsible for a grand new forum there, and a magnificent basilica with a long central aisle closed by an apse at either end (fig. 7.62). Colonnades in two stories provide access to the side aisles, which were lower than the nave to permit clerestory windows in the upper part of the wall. The wooden ceiling has long since perished.

DIOCLETIAN'S PALACE, SPLIT Developments in Roman architecture after Diocletian came to power appear to go hand-in-hand with the profound changes he made to society. This is clear in his palace at Split (ancient Spalato, in Croatia) overlooking the Adriatic Sea, which he commissioned for his abdication in 305 CE (figs. **7.63** and **7.64**). Although intended as a residence, it is

essentially a military fort, with defensive walls, gates, and towers. As in a military camp, two intersecting colonnaded streets stretched between the gates and divided the rectangular space within the walls, measuring about 650 by 500 feet, into four blocks. The street from the main gate led to a sunken peristyle court. Columns on two sides support arcuated (arched) lintels, used only sporadically since the early Empire and popular in late antiquity. They direct a visitor's gaze to the far end of the court, where an arcuated lintel set between the two central columns within a pediment creates a frame. It was here that the former emperor made public appearances. Behind this grand entrance was a vestibule, opening onto the audience hall. To the left of the peristyle court stood a large octagonal mausoleum, now used as a cathedral. Loosely based upon the Pantheon (see figs. 7.23-7.27), this type of imperial mausoleum would be one of the prototypes for Christian martyria, burial places of martyred saints. To the right of the court Diocletian dedicated a small temple to Jupiter, his patron god. The topographical relationship between mausoleum and temple implied an equivalency between emperor and god.

7.65 Basilica of Constantius Chlorus, Trier, Germany. Early 4th century CE

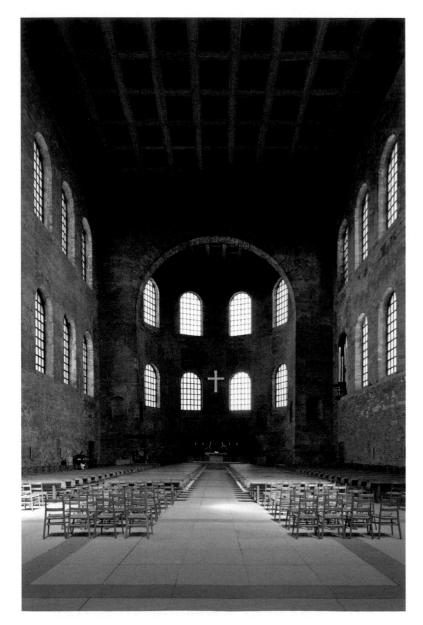

7.66 Interior of Basilica of Constantius Chlorus

THE BASILICA OF CONSTANTIUS, TRIER Diocletian divided authority between the tetrarchs, each of them established a capital in a different region of the empire and embellished it with appropriate grandeur. Constantius Chlorus, father of Constantine the Great, made his seat at Trier, in present-day Germany. There he constructed a basilica, which now functions as a church (figs. 7.65 and 7.66). In its design, Classical forms have dissolved entirely, leaving vast abstract expanses of solid and void. Elongated arches break the great mass of its walls, and serve as visual buttresses to frame the windows, beneath which were balconies. As vast as the interior was, the architect aspired to achieving an illusion of even greater dimensions. The windows in the apse are significantly smaller than those in the side walls, and the apse ceiling is lower than the ceiling over the main hall. Both devices make it appear that the apse recedes farther into the distance than it does. Not only did this make the building appear grander, but the apse was where the emperor—or his image would hold sway, and the altered dimensions would have made him appear significantly larger than life. The vocabulary of Roman building had changed, in other words, but it remained an architecture of power.

Portrait Sculpture

During the tetrarchy, portraiture took on a radically abstract quality. Two porphyry sculptural groups now immured in the Basilica of San Marco in Venice were probably originally mounted on columns (fig. 7.67). Each group shows two tetrarchs in elaborate military dress, with bird-headed sword hilts and flat Pannonian caps that probably represent the powerful Illyrian officer class from which they came. The figures are all but indistinguishable from one another (except that in each group, one is bearded, the other close-shaven). Their proportions are squat and nonnaturalistic, their facial features abstract rather than individualized. The portraits suggest that authority resides in the office of emperor, not in the individual who holds the office. The sameness of the portraits underlines the tetrarchs' equality, while their close embrace stresses unanimity and solidarity. The choice of material speaks volumes too: Porphyry, a hard Egyptian stone of deep purple color, had long been reserved for imperial use.

The severe abstraction abates only a little under Constantine, whose portraitist combined it with an Augustan classicism to create the colossal head of figure 7.68. The head is one fragment of a vast seated portrait that once occupied an apse in the basilica Constantine expropriated from Maxentius (see figs. 7.60 and 7.61). The head alone is 8 feet tall, and its dominant feature is the disproportionately large and deeply carved eyes. Combined with the stiff frontality of the face, they give the image an iconic quality. Some scholars associate changes like these with the spirituality of the later Empire, exemplified by Constantine's adherence to Christianity. Perhaps the eyes gaze at something beyond this world; perhaps they are a window to the soul. At the same time, a soft modeling to the cheeks and mouth renders the portrait more naturalistic than its tetrarchic predecessors. Moreover, the

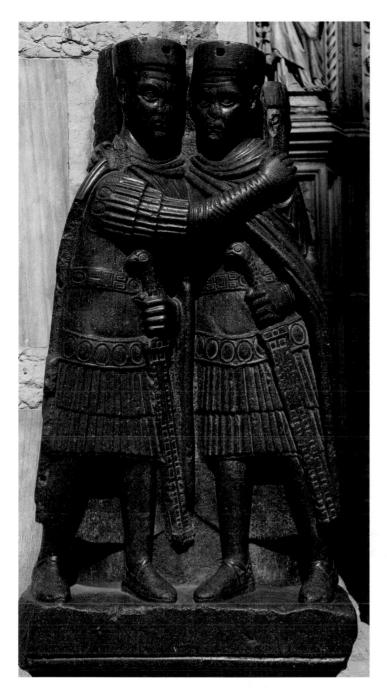

7.67 Portrait group of the tetrarchs. ca. 305 CE. Porphyry, height 51" (129.5 cm). Basilica of San Marco, Venice

full cap of hair, and the absence of a beard, appear to be direct references to Trajan and Augustus, great emperors of the past whose achievements still gave the office its authority.

Relief Sculpture

The second century CE witnessed a shift in Roman funerary customs. Inhumation gradually took the place of cremation for all but the imperial family. This led to a demand for marble sarcophagi in place of cinerary urns, and sculptors decorated them with a profusion of designs, which they passed from shop to shop,

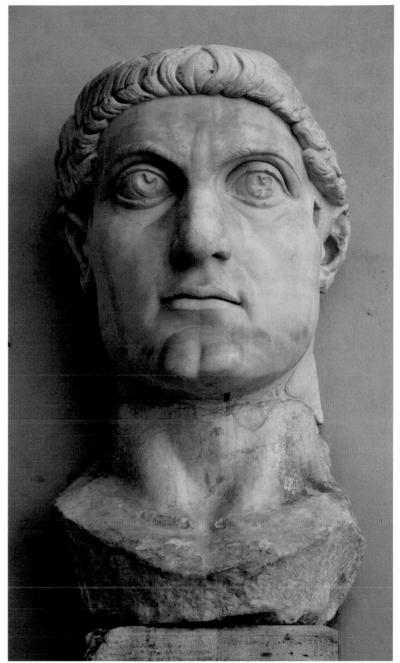

7.68 Portrait of Constantine the Great. Early 4th century CE. Marble, height 8' (2.4 m). Museo del Palazzo dei Conservatori, Rome

probably in pattern books of some kind. Preferences changed over time. For example, under Marcus Aurelius, patrons favored battle sarcophagi. In the third century CE, biographical and historical scenes preserved aspects of the deceased's life. Most popular were scenes taken from Greek mythology. Their purpose may have been to glorify the deceased through analogy to the legendary heroes of the past; they may equally have expressed the owner's erudition. Figure 7.69 illustrates a moment from the myth of Meleager. In Homer's account, Meleager saved Calydon from a ferocious boar, which Artemis had sent to ravage his father's land; he then died in a battle over its pelt. For the Romans, Meleager

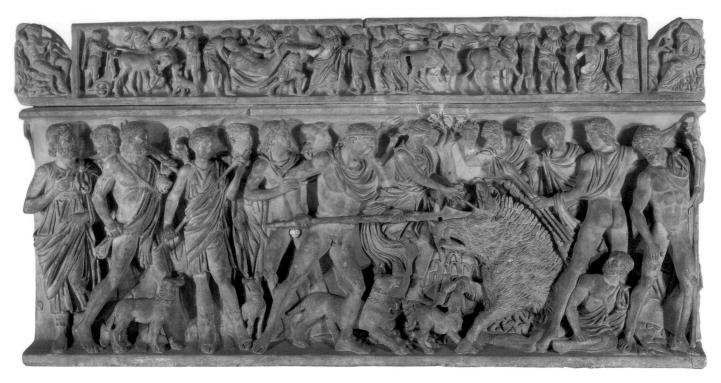

7.69 Meleager Sarcophagus. ca. 180 CE. Marble. Galleria Doria Pamphilj, Rome

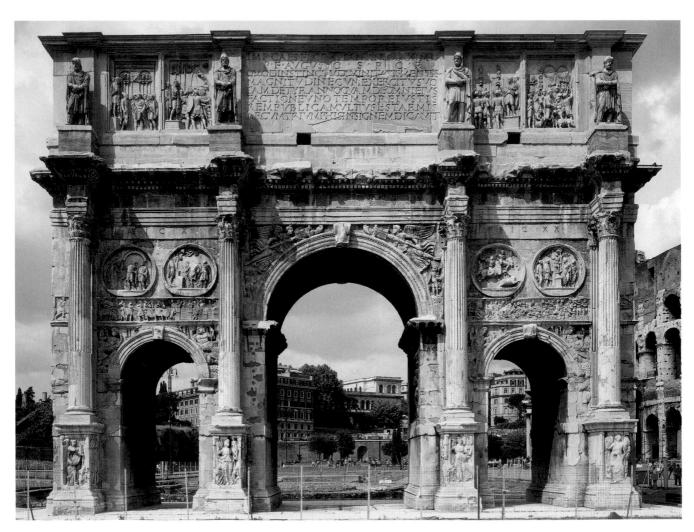

7.70 Arch of Constantine, Rome. 312–15 CE

was an example of noble *virtus*, or manly prowess. For his heroism and death in the service of his city, he earned immortality. The relief's style owes much to Greek sculpture, but crowding the entire surface with figures (known as *horror vacui*) is an entirely Roman practice.

People of Rome dedicated a triple-bayed arch to Constantine near the Colosseum to celebrate his ten-year anniversary and his conquest of Maxentius (fig. 7.70). It is one of the largest imperial arches, but what makes it unusual is that so little of the sculptural relief on its surface was specifically designed for this monument (fig. 7.71). The free-standing Dacian captives on the attic (upper portion) probably originated in Trajan's Forum, as did the Great Trajanic Frieze on the ends of the attic and inside the central bay. Eight hunting and sacrifice tondi above the lateral bays once belonged to a Hadrianic monument, and eight Aurelian panels on the attic may have decorated an arch to Marcus Aurelius. When the arch was constructed, sculptors recarved the heads of earlier

emperors to resemble Constantine and his coemperor, Licinius. A modern restoration replaced some of them with heads of Trajan.

Scholars describe sculptural and architectural borrowings of this kind by the modern term spolia, from the Latin spolium, meaning "hide stripped from an animal," a term primarily used for spoils taken in war. No ancient testimony acknowledges or explains the practice, and the spolia raise all manner of questions—such as how Romans perceived the stripping of one monument in favor of another, and what became of the original monument if it was still standing. In a renowned assault on late antique sculpture in the 1950s, art historian Bernard Berenson condemned the use of spolia as evidence of a pervasive artistic decline in the period, which he attributed to a mass exodus of artists from a city on the brink of destruction. Other scholars, assuming that Romans recognized style differences, see the spolia as part of a legitimation ideology, expressing qualities of "emperorness." By leaning on "good" rulers of the past, Constantine may have hoped to harness the reputations that they had earned during their lifetimes, as well as the nostalgic idealization that had

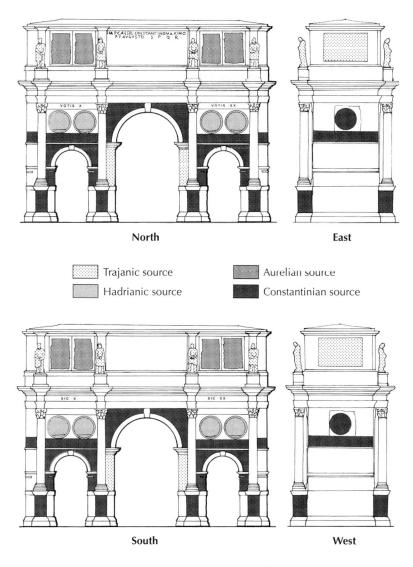

7.71 Schematic drawing of Arch of Constantine showing reused sculpture

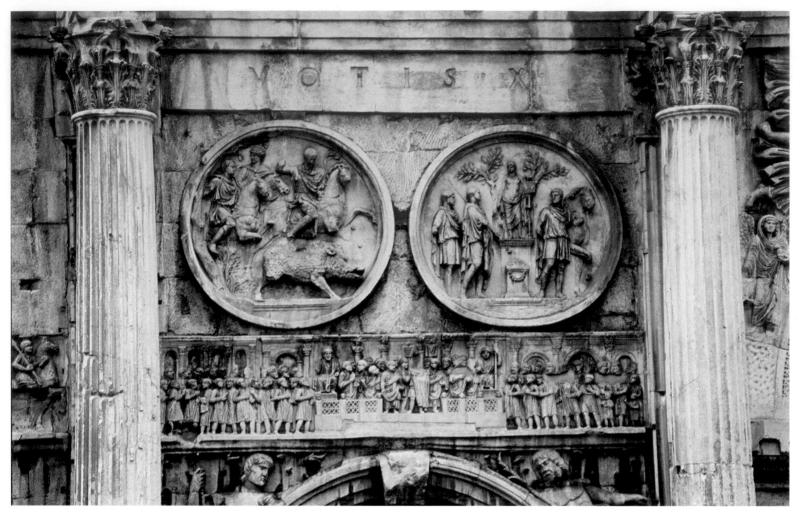

7.72 Constantinian relief from Arch of Constantine

accrued to those reputations through the intervening years. Constantine had reason to legitimize his authority: Maxentius had been a formidable opponent, with his efforts to reposition Rome at the Empire's center through a policy of revivalism. Moreover, as the first openly Christian emperor, Constantine risked alienating a pagan Senate. If this interpretation is correct, it is not dissimilar from readings of the Republican statue base, partly made up of Greek reliefs, as seen in figure 7.10.

To complement the borrowed pieces, Constantinian artists carved bases for the columns that flank the bays, a continuous relief to encircle the arch above the lateral bays, and roundels for the sides of the arch. One scene depicts Constantine addressing the Senate and people of Rome from the speaker's platform, or rostrum, in the Forum, after entering Rome in 312 CE (fig. 7.72). Figures crowd the scene. Their heads are disproportionately large, their bodies stocky, and their poses unnaturally rigid. Lines carved on the flat surface render anatomical details in place of modeling. The artist eschewed devices used on the Arch of Titus panels to give an illusion of depth; a second row of heads arranged above the first indicates recession (see figs. 7.37 and 7.38). Berenson judged the Constantinian reliefs just as harshly as the act of spoliation. Yet their abstract quality makes them unusually

legible from a distance, which is how viewers would have seen them. A careful order governs the composition, with the frontal emperor occupying the center; other figures turn and focus attention on him. Buildings in the background are sufficiently distinct to make the setting recognizable even today as the Roman Forum. The artists privileged the reliefs' message-bearing potential over illusionism or naturalism.

During the course of about a millennium, Rome grew from a small city to the capital of a massive, culturally diverse empire. Those years witnessed huge developments in architecture, due as much to changes in technology as to political motivations. Postand-lintel construction combined with free forms made possible by concrete, and then dissolved in favor of new abstract concepts of space. In the provinces, architecture brought some improvements in standards of living, but also helped to secure Roman control, exerting a constant Roman presence far from the center of administration. Sculpture and painting abounded within public and private buildings. Often sculpture carried a strong political message, its style chosen to best reinforce its content. As with architecture, an abstract style came to dominate sculpture in late antiquity, due perhaps to a change in concepts of rulership and an increased spirituality.

200-150 BCE Navalia in Rome, earliest known building constructed entirely of concrete

ca. 60-50 BCE Paintings from the Villa of the Mysteries, outside Pompeii

late 1st century ce Portrait of Domitia Longina

13–9 BCE Dedication of the *Ara Pacis* Augustae, the Altar of Augustan Peace

early 100s ce El Khasneh in Petra, Jordan

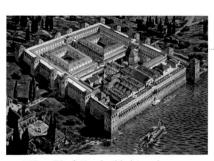

ca. 300 ce Diocletian builds his palace in Spalato, Croatia

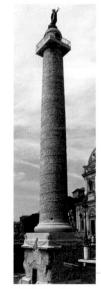

106-13 CE The Column of Trajan is erected in Rome

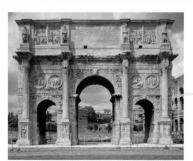

315 CE Dedication of the Arch of Constantine in Rome

Roman Art

1000 BCE

500 BCE

400

 ca. 509 BCE Elite Romans turn against the monarchy, expelling the last king

ca. 447 BCE Perikles orders the construction of the Parthenon

300

340–330 BCE *The Abduction of Persephone* tomb painting at Vergina ca. 279 BCE Ptolemy I commissions the Pharos

at Alexandria

■ by 275 BCE Rome controls all of Italy

200 BCE

100

0

все

106 BCE Birth of the Roman orator and statesman Cicero

■ 100s BCE Rome controls Greece and Asia Minor

 46-44 BCE Julius Caesar becomes perpetual dictator of Rome and is assassinated

27 BCE The Roman Senate names Octavian Augustus Caesar

 19 BCE The poet Vergil dies, leaving The Aeneid unfinished

■ 23/24-79 ce Pliny the Elder; wrote Natural History

■ 79 ce Vesuvius erupts

at Ctesiphon

100s ce The earliest painted portraits from the Fayum, Lower Egypt

200 CE

100

300

400

■ ca. 284 ce Diocletian establishes the tetrarchy

242-72 cE Shapur I's Sassanian palace

Glossary

ABACUS. A slab of stone at the top of a Classical capital just beneath the architrave.

ABBEY. (1) A religious community headed by an abbot or abbess. (2) The buildings that house the community. An abbey church often has an especially large choir to provide space for the monks or nuns.

ACROTERION (pl. **ACROTERIA**). Decorative ornaments placed at the apex and the corners of a pediment.

ACTION PAINTING. In Abstract art, the spontaneous and uninhibited application of paint, as practiced by the avant-garde from the 1930s through the 1950s.

AEDICULA. A small shrine or altar that dates to ancient Rome.

AEOLIC. An early style of Greek architecture, found in northwestern Asia Minor. The Aeolic style is often considered a precursor to the Ionic style.

AISLE. The passageway or corridor of a church that runs parallel to the length of the building. It often flanks the nave of the church but is sometimes set off from it by rows of piers or columns.

ALABASTRON. A perfume container, similar to an aryballos, crafted by Greek vase-painters and often imported into Etruria.

ALBUMEN PRINT. A process in photography that uses the proteins found in eggs to produce a photographic plate.

ALLEGORY. A representation in which figures or events stand for ideas beyond themselves as symbols or metaphors, to create a moral or message for the viewer.

ALLOVER PAINTING. A painting in which the texture tends to be consistent throughout and which has no traditional compositional structure with a dominant focus of interest but, rather, even stresses throughout the image, as in Jackson Pollock's Abstract Expressionist action paintings.

ALTAR. A mound or structure on which sacrifices or offerings are made in the worship of a deity. In a Catholic church, a tablelike structure used in celebrating the Mass.

ALTARPIECE. A painted or carved work of art placed behind and above the altar of a Christian church. It may be a single panel or a *triptych* or a *polytych*, both having hinged wings painted on both sides. Also called a reredos or retablo.

AMBULATORY. A covered walkway. (1) In a basilican church, the semicircular passage around the apse. (2) In a central-plan church, the ring-shaped aisle around the central space. (3) In a cloister, the covered colonnaded or arcaded walk around the open courtyard.

ANAMORPHIC. Refers to a special form of perspective, which represents an object from an unusual or extreme viewpoint, so that it can only be understood from that viewpoint, or with the aid of a special device or mirror.

ANDACHTSBILD. German for "devotional image." A picture or sculpture with imagery intended for private devotion. It was first developed in Northern Europe.

ANIMAL STYLE. A style that appears to have originated in ancient Iran and is characterized by stylized or abstracted images of animals.

ANNULAR. From the Latin word for "ring." Signifies a ring-shaped form, especially an annular barrel vault.

APOTROPAIC DEVICE. An object deployed as a means of warding off evil. Often a figural image (such as a Medusa head) or a composite image (like a Near Eastern lamassu), inserted into an architectural setting.

APSE. A semicircular or polygonal niche terminating one or both ends of the nave in a Roman basilica. In a Christian church, it is usually placed at the east end of the nave beyond the transept or choir. It is also sometimes used at the end of transept arms.

APSIDIOLE. A small apse or chapel connected to the main apse of a church.

ARCADE. A series of arches supported by piers or columns. When attached to a wall, these form a blind arrade.

ARCH. A curved structure used to span an opening. Masonry arches are generally built of wedge-shaped blocks, called *voussoirs*, set with their narrow sides toward the opening so that they lock together. The topmost *voussoir* is called the *keystone*. Arches may take different shapes, such as the pointed Gothic arch or the rounded Classical arch.

ARCHAIC SMILE. A fixed, unnaturalistic smile characteristic of many archaic Greek sculpted images. Artists ceased to depict figures smiling in this way once they began to explore greater naturalism.

ARCHITRAVE. The lowermost member of a classical entablature, such as a series of stone blocks that rest directly on the columns.

ARCHIVOLT. A molded band framing an arch, or a series of such bands framing a tympanum, often decorated with sculpture.

ARCUATION. The use of arches or a series of arches in building.

ART BRUT. Meaning "raw art" in French, art brut is the direct and highly emotional art of children and the mentally ill that served as an inspiration for some artistic movements in Modern art.

ARYBALLOS. A perfume jar, generally small in size, and often minutely decorated. This was a favorite type of vessel for Corinthian vase-painters.

ASHLAR MASONRY. Carefully finished stone that is set in fine joints to create an even surface.

ASSOCIATIONISM. A 20th-century art historical term that refers to the concept that architecture and landscape design can have motifs or aspects that associate them with earlier architecture, art, history, or literature.

ATMOSPHERIC PERSPECTIVE. Creates the illusion of depth by reducing the local color and clarity of objects in the distance, to imply a layer of atmosphere between the viewer and the horizon.

ATRIUM. (1) The central court or open entrance court of a Roman house. (2) An open court, sometimes colonnaded or arcaded, in front of a church.

AVANT-GARDE. Meaning "advance force" in French, the artists of the avant-garde in 19th- and 20th-century Europe led the way in innovation in both subject matter and technique, rebelling against the established conventions of the art world.

BALDACCHINO. A canopy usually built over an altar. The most important one is Bernini's construction for St. Peter's in Rome.

BAROQUE. A style of Hellenistic Greek sculpture, characterized by extreme emotions and extravagant gestures, as seen on the Great Altar of Zeus at Pergamon. The term is usually used to describe a style of 17th-century CE art, and scholars of ancient art coin it in recognition of similarities of style.

BARREL VAULT. A vault formed by a continuous semicircular arch so that it is shaped like a half-cylinder.

BAR TRACERY. A style of tracery in which glass is held in place by relatively thin membranes.

BAS-DE-PAGE. Literally "bottom of the page." An illustration or decoration that is placed below a block of text in an illuminated manuscript.

BASILICA. (1) In ancient Roman architecture, a large, oblong building used as a public meeting place and hall of justice. It generally includes a nave, side aisles, and one or more apses. (2) In Christian architecture, a longitudinal church derived from the Roman basilica and having a nave, an apse, two or four side aisles or side chapels, and sometimes a narthex. (3) Any one of the seven original churches of Rome or other churches accorded the same religious privileges.

BATTLEMENT. A parapet consisting of alternating solid parts and open spaces designed originally for defense and later used for decoration. See *crenelated*.

BAY. A subdivision of the interior space of a building. Usually a series of bays is formed by consecutive architectural supports.

BELVEDERE. A structure made for the purpose of viewing the surroundings, either above the roof of a building or free-standing in a garden or other natural setting.

BLACK-FIGURED. A style of ancient Greek pottery decoration characterized by black figures against a red background. The black-figured style preceded the red-figured style.

BLIND ARCADE. An arcade with no openings. The arches and supports are attached decoratively to the surface of a wall.

BLOCK BOOKS. Books, often religious, of the 15th century containing woodcut prints in which picture and text were usually cut into the same block.

BOOK OF HOURS. A private prayer book containing the devotions for the seven canonical hours of the Roman Catholic church (matins, vespers, etc.), liturgies for local saints, and sometimes a calendar. They were often elaborately illuminated for persons of high rank, whose names are attached to certain extant examples.

BUON FRESCO. See fresco.

BURIN. A pointed metal tool with a wedgedshaped tip used for engraving.

BUTTRESS. A projecting support built against an external wall, usually to counteract the lateral thrust of a vault or arch within. In Gothic church architecture, a flying buttress is an arched bridge above the aisle roof that extends from the upper nave wall, where the lateral thrust of the main vault is greatest, down to a solid pier.

CALOTYPE. Invented in the 1830s, calotype was the first photographic process to use negatives and positive prints on paper.

CAMEO. A low relief carving made on agate, seashell, or other multilayered material in which the subject, often in profile view, is rendered in one color while the background appears in another, darker color.

CAMES. Strips of lead in stained-glass windows that hold the pieces of glass together.

CAMPANILE. From the Italian word *campana*, meaning "bell." A bell tower that is either round or square and is sometimes free-standing.

CANON. A law, rule, or standard.

CAPITAL. The uppermost member of a column or pillar supporting the architrave.

CARAVANSARAY. A wayside inn along the main caravan routes linking the cities of Asia Minor, usually containing a warehouse, stables, and a courtyard.

CARTE-DE-VISITE. A photographic mounted on thicker card stock measuring 2½ x 4 inches (6 x 10 cm) that people commissioned and distributed to friends and acquaintances. They were developed in 1854 by the French photographer Adolphe-Eugène Disdéri, and by the end of the decade were so popular that they were widely collected in Europe and America, a phenomenon called "cardomania.

CARTOON. From the Italian word cartone, meaning "large paper." (1) A full-scale drawing for a picture or design intended to be transferred to a wall, panel, tapestry, etc. (2) A drawing or print, usually humorous or satirical, calling attention to some action or person of popular interest.

CARYATID. A sculptured female figure used in place of a column as an architectural support. A similar male figure is an atlas (pl. atlantes).

CASEMATE. A chamber or compartment within a fortified wall, usually used for the storage of artillery and munitions.

CASSONE (pl. CASSONI). An Italian dowry chest often highly decorated with carvings, paintings, inlaid designs, and gilt embellishments.

CATACOMBS. The underground burial places of the early Christians, consisting of passages with niches for tombs and small chapels for commemorative services.

CATALOGUE RAISONNÉ. A complete list of an artist's works of art, with a comprehensive chronology and a discussion of the artist's style.

CATHEDRAL. The church of a bishop; his administrative headquarters. The location of his cathedra or

CAVEA. The seating area in an ancient theater. In a Greek theater, it was just over semicircular; in a Roman theater, it was semicircular. Access corridors divided the seating into wedges (cunei).

CELLA. (1) The principal enclosed room of a temple used to house an image. Also called the naos. (2) The entire body of a temple as distinct from its external parts.

CENOTAPH. A memorial monument to honor a person or persons whose remains lie elsewhere.

CENTERING. A wooden framework built to support an arch, vault, or dome during its construction.

CHAMPLEVÉ. An enameling method in which hollows are etched into a metal surface and filled with enamel.

CHANCEL. The area of a church around the altar, sometimes set off by a screen. It is used by the clergy and the choir.

CHIAROSCURO. Italian word for "light and dark." In painting, a method of modeling form primarily by the use of light and shade.

CHIASTIC POSE. From the Greek letter chi: an asymmetrical stance, where the body carries the weight on one leg (and often bears a weight with the opposite arm). Also described as contrapposto.

CHINOISERIE. Objects, usually in the decorative arts (screens, furniture, lacquerware) made in a Chinese or pseudo-Chinese style, most popular in the 18th century.

CHITON. A woman's garment made out of a rectangle of fabric draped and fastened at the shoulders by pins. The garment is worn by some Archaic Greek korai, where it provides a decorative effect.

CHRYSELEPHANTINE. Usually refering to a sculpture in Classical Greece, signifying that it is made of gold and ivory. Pheidias' cult statues of Athena in the Parthenon, and Zeus at Olympia, were chryselephantine.

CLASSICISM. Art or architecture that harkens back to and relies upon the style and canons of the art and architecture of ancient Greece or Rome, which emphasize certain standards of balance, order, and beauty.

CLASSICIZING. To refer to the forms and ideals of the Classical world, principally Greece and Rome.

CLERESTORY. A row of windows in the upper part of a wall that rises above an adjoining roof. Its purpose is to provide direct lighting, as in a basilica or

CLOISONNÉ. An enameling method in which the hollows created by wires joined to a metal plate are filled with enamel to create a design.

CLOISTER. (1) A place of religious seclusion such as a monastery or nunnery. (2) An open court attached to a church or monastery and surrounded by an ambulatory. Used for study, meditation, and exercise.

COFFER. (1) A small chest or casket. (2) A recessed, geometrically shaped panel in a ceiling. A ceiling decorated with these panels is said to be coffered.

COLONNETTE. A small, often decorative, column that is connected to a wall or pier.

COLOPHON. (1) The production information given at the end of a book. (2) The printed emblem of a book's publisher.

COLOR-FIELD PAINTING. A technique of Abstract painting in which thinned paints are spread onto an unprimed canvas and allowed to soak in with minimal control by the artist.

COLOSSAL ORDER. Columns, piers, or pilasters in the shape of the Greek or Roman orders but that extend through two or more stories rather than following the Classical proportions.

COMBINES. The label the American artist Robert Rauschenberg gave to his paintings of the mid-1950s that combined painting, sculpture, collage, and found COMPOSITE CAPITAL. A capital that combines the volutes of an Ionic capital with the acanthus leaves of the Corinthian capital. Roman architects developed the style as a substitute for the Ionic style, for use on secular buildings.

COMPOSITE IMAGE. An image formed by combining different images or different views of the subject.

COMPOUND PIER. A pier with attached pilasters or shafts.

CONSTRUCTION. A type of sculpture, developed by Picasso and Braque toward 1912, and popularized by the Russian Constructivists later in the decade. It is made by assembling such materials as metal or

CONTINUOUS NARRATION. Portrayal of the same figure or character at different stages in a story that is depicted in a single artistic space.

CONTRAPPOSTO. Italian word for "set against." A composition developed by the Greeks to represent movement in a figure. The parts of the body are placed asymmetrically in opposition to each other around a central axis, and careful attention is paid to the distribution of weight.

CORBEL. (1) A bracket that projects from a wall to aid in supporting weight. (2) The projection of one course, or horizontal row, of a building material beyond the course below it.

CORBEL VAULT. A vault formed by progressively projecting courses of stone or brick, which eventually meet to form the highest point of the vault.

CORINTHIAN CAPITAL. A column capital ornamented with acanthus leaves, introduced in Greece in the late fifth century BCE, and used by Roman architeets throughout the Empire.

CORNICE. (1) The projecting, framing members of a classical pediment, including the horizontal one beneath and the two sloping or "raking" ones above. (2) Any projecting, horizontal element surmounting a wall or other structure or dividing it horizontally for decorative purposes.

CORPUS. In carved medieval altarpieces, the corpus is the central section which usually holds a sculpted figure or design.

COURT STYLE. See Rayonnant.

CRENELATIONS. A sequence of solid parts, and the intervals between them, along the top of a parapet, allowing for defense and to facilitate firing weapons. The effect is of a notched termination of a wall. Generally used in military architecture.

CROSSING. The area in a church where the transept crosses the nave, frequently emphasized by a dome or crossing tower.

CRYPT. A space, usually vaulted, in a church that sometimes causes the floor of the choir to be raised above that of the nave; often used as a place for tombs and small chapels.

CUBICULUM (pl. CUBICULA) A bedroom in a Roman house. A cubiculum usually opened onto the atrium. Most were small; some contained wall-paint-

CUNEUS (pl. CUNEI). A wedgelike group of seats in a Greek or Roman theater.

CUNEIFORM. The wedge-shaped characters made in clay by the ancient Mesopotamians as a writing system.

CURTAIN WALL. A wall of a modern building that does not support the building; the building is supported by an underlying steel structure rather than by the wall itself, which serves the purpose of a façade.

DADO. The lower part of an interior wall. In a Roman house, the dado was often decorated with paintings imitating costly marbles.

DAGUERREOTYPE. Originally, a photograph on a silver-plated sheet of copper, which had been treated with fumes of iodine to form silver iodide on its surface and then after exposure developed by fumes of mercury. The process, invented by L. J. M. Daguerre and made public in 1839, was modified and accelerated as daguerreotypes gained popularity.

DEËSIS. From the Greek word for "entreaty." The representation of Christ enthroned between the Virgin Mary and St. John the Baptist, frequent in Byzantine mosaics and depictions of the Last Judgment. It refers to the roles of the Virgin Mary and St. John the Baptist as intercessors for humankind.

DIKKA. An elevated, flat-topped platform in a mosque used by the muezzin or cantor.

DIPTERAL. Term used to describe a Greek or Roman building-often a temple or a stoa-with a double colonnade.

DIPTYCH. (1) Originally a hinged, two-leaved tablet used for writing. (2) A pair of ivory carvings or panel paintings, usually hinged together.

DOLMEN. A structure formed by two or more large, upright stones capped by a horizontal slab. Thought to be a prehistoric tomb.

DOME. A true dome is a vaulted roof of circular, polygonal, or elliptical plan, formed with hemispherical or ovoidal curvature. May be supported by a circular wall or drum and by pendentives or related constructions. Domical coverings of many other sorts have been devised.

DOMUS. Latin word for "house." A detached, onefamily Roman house with rooms frequently grouped around two open courts. The first court, called the atrium, was used for entertaining and conducting business. The second court, usually with a garden and surrounded by a peristyle or colonnade, was for the private use of the family.

DORIC COLUMN. A column characterized by a simple cushionlike abacus and the absence of a base. One of three styles of column consistently used by Greek and Roman architects.

DRÔLERIES. French word for "jests." Used to describe the lively animals and small figures in the margins of late medieval manuscripts and in wood carvings on furniture.

DROMOS. A pathway, found, for instance, in Bronze Age, Aegean and Etruscan tomb structures.

DRUM. (1) A section of the shaft of a column. (2) A circular-shaped wall supporting a dome.

DRYPOINT. A type of intaglio printmaking in which a sharp metal needle is use to carve lines and a design into a (usually) copper plate. The act of drawing pushes up a burr of metal filings, and so, when the plate is inked, ink will be retained by the burr to create a soft and deep tone that will be unique to each print. The burr can only last for a few printings. Both the print and the process are called drypoint.

EARLY ENGLISH STYLE. A term used to describe Gothic architecture in England during the early- and mid-13th century. The style demonstrates the influence of architectural features developed during the Early Gothic period in France, which are combined with Anglo-Norman Romanesque features.

EARTHWORKS. Usually very large scale, outdoor artwork that is produced by altering the natural environment.

ECHINUS. In the Doric or Tuscan Order, the round, cushionlike element between the top of the shaft and the abacus.

ENCAUSTIC. A technique of painting with pigments dissolved in hot wax.

ENGAGED COLUMN. A column that is joined to a wall, usually appearing as a half-rounded vertical shape.

ENGRAVING. (1) A means of embellishing metal surfaces or gemstones by incising a design on the surface. (2) A print made by cutting a design into a metal plate (usually copper) with a pointed steel tool known as a burin. The burr raised on either side of the incised line is removed. Ink is then rubbed into the V-shaped grooves and wiped off the surface. The plate, covered with a damp sheet of paper, is run through a heavy press. The image on the paper is the reverse of that on the plate. When a fine steel needle is used instead of a burin and the burr is retained, a drypoint engraving results, characterized by a softer line. These techniques are called, respectively, engraving and drypoint.

ENNEASTYLE. A term used to describe the façade of a Greek or Roman temple, meaning that it has nine

ENTABLATURE. (1) In a classical order, the entire structure above the columns; this usually includes architrave, frieze, and cornice. (2) The same structure in any building of a classical style.

ENTASIS. A swelling of the shaft of a column.

ENVIRONMENT. In art, environment refers to the Earth itself as a stage for Environmental art, works that can be enormously large yet very minimal and abstract. These works can be permanent or transitory. The term Earth art is also used to describe these art-

EVENTS. A term first used by John Cage in the early 1950s to refer to his multimedia events at Black Mount College in North Carolina that included dance, painting, music, and sculpture. The term was appropriated by the conceptual artist George Brecht in 1959 for his performance projects, and shortly thereafter by the conceptual and performance group Fluxus, which included Brecht.

EXEDRA (pl. EXEDRAE). In Classical architecture, an alcove, often semicircular, and often defined with columns. Sometimes, exedrae framed sculptures.

FAIENCE. (1) A glass paste fired to a shiny opaque finish, used in Egypt and the Aegean. (2) A type of earthenware that is covered with a colorful opaque glaze and is often decorated with elaborate designs.

FIBULA. A clasp, buckle, or brooch, often ornamented

FILIGREE. Delicate decorative work made of intertwining wires.

FLAMBOYANT. Literally meaning "flamelike" in French, describes a late phase of Gothic architecture where undulating curves and reverse curves were a main feature.

FLUTES. The vertical channels or grooves in Classical column shafts, sometimes thought to imitate the faceting of a hewn log.

FLYING BUTTRESS. An arch or series of arches on the exterior of a building, connecting the building to detached pier buttresses so that the thrust from the roof vaults is offset. See also Buttress

FOLIO. A leaf of a manuscript or a book, identified so that the front and the back have the same number, the front being labeled recto and the back verso.

FORESHORTENING. A method of reducing or distorting the parts of a represented object that are not parallel to the picture plane in order to convey the impression of three dimensions as perceived by the human eye.

FRESCO. Italian word for "fresh." Fresco is the technique of painting on plaster with pigments ground in water so that the paint is absorbed by the plaster and becomes part of the wall itself. Buon fresco is the technique of painting on wet plaster; fresco secco is the technique of painting on dry plaster.

FRIEZE. (1) A continuous band of painted or sculptured decoration. (2) In a Classical building, the part of the entablature between the architrave and the cornice. A Doric frieze consists of alternating triglyphs and metopes, the latter often sculptured. An Ionic frieze is usually decorated with continuous relief sculpture.

FRONTALITY. Representation of a subject in a full frontal view.

FROTTAGE. The technique of rubbing a drawing medium, such as a crayon, over paper that is placed over a textured surface in order to transfer the underlying pattern to the paper.

GABLE. (1) The triangular area framed by the cornice or eaves of a building and the sloping sides of a pitched roof. In Classical architecture, it is called a pediment. (2) A decorative element of similar shape, such as the triangular structures above the portals of a Gothic church and sometimes at the top of a Gothic picture frame.

GALLERY. A second story placed over the side aisles of a church and below the clerestory. In a church with a four-part elevation, it is placed below the triforium and above the nave arcade.

GEISON. A projecting horizontal cornice. On a Greek or Roman temple, the geison will often be dec-

GENRE PAINTING. Based on the French word for type or kind, the term sometimes refers to a category of style or subject matter. But it usually refers to depictions of common activities performed by contemporary people, often of the lower or middle classes. This contrasts with grand historical themes or mythologies, narratives or portraits.

GEOMETRIC ARABESQUE. Complex patterns and designs usually composed of polygonal geometric forms, rather than organic flowing shapes; often used as ornamentation in Islamic art.

GESTURE PAINTING. A technique in painting and drawing where the actual physical movement of the artist is reflected in the brushstroke or line as it is seen in the artwork. The artist Jackson Pollock is particularly associated with this technique.

GISANT. In a tomb sculpture, a recumbent effigy or representation of the deceased. At times, the gisant may be represented in a state of decay.

GLAZE. (1) A thin layer of translucent oil color applied to a painted surface or to parts of it in order to modify the tone. (2) A glassy coating applied to a piece of ceramic work before firing in the kiln as a protective seal and often as decoration.

GLAZED BRICK. Brick that is baked in a kiln after being painted.

GOTHIC. A style of art developed in France during the 12th century that spread throughout Europe. The style is characterized by daring architectural achievements, for example, the opening up of wall surfaces and the reaching of great heights, particularly in cathedral construction. Pointed arches and ribbed groin vaults allow for a lightness of construction that permits maximum light to enter buildings through stained-glass windows. Increasing naturalism and elegance characterize Gothic sculpture and painting.

GRANULATION. A technique of decoration in which metal granules, or tiny metal balls, are fused to a metal surface.

GRATTAGE. A technique in painting whereby an image is produced by scraping off paint from a canvas that has been placed over a textured surface.

GREEK CROSS. A cross with four arms of equal length arranged at right angles.

GRISAILLE. A monochrome drawing or painting in which only values of black, gray, and white are

GRISAILLE GLASS. White glass painted with gray

GROIN VAULT. A vault formed by the intersection of two barrel vaults at right angles to each other. A groin is the ridge resulting from the intersection of two

GUILLOCHE PATTERN. A repeating pattern made up of two ribbons spiraling around a series of central points. A guilloche pattern is often used as a decorative device in Classical vase-painting.

GUILDS. Economic and social organizations that control the making and marketing of given products in a medieval city. To work as a painter or sculptor in a city, an individual had to belong to a guild, which established standards for the craft. First mentioned on p.211. Emboldened entry on p.258

GUTTAE. In a Doric entablature, small peglike projections above the frieze; possibly derived from pegs originally used in wooden construction.

HALL CHURCH. See hallenkirche.

HALLENKIRCHE. German word for "hall church." A church in which the nave and the side aisles are of the same height. The type was developed in Romanesque architecture and occurs especially frequently in German Gothic churches.

HAN. In Turkish, an establishment where travelers can procure lodging, food, and drink. Also called a caravansaray.

HAPPENING. A type of art that involves visual images, audience participation, and improvised performance, usually in a public setting and under the loose direction of an artist.

HARMONY. In medieval architecture, the perfect relationship among parts in terms of mathematical proportions or ratios. Thought to be the source of all beauty, since it exemplifies the laws by which divine reason made the universe.

HATAYI. A style of ornament originated by the Ottomans and characterized by curved leaves and complex floral palmettes linked by vines, sometimes embellished with birds or animals.

HATCHING. A series of parallel lines used as shad ing in prints and drawings. When two sets of crossing parallel lines are used, it is called *crosshatching*.

HERALDIC POSE. A pose where two figures are mirror images of one another, sometimes flanking a central object, as in the relieving triangle above the Lioness Gate at Mycenae.

HEROÖN. The center of a hero cult, where Classical Greeks venerated mythological or historical

HEXASTYLE. A term used to describe the façade of a Greek or Roman temple, meaning that it has six

HIERATIC SCALE. An artistic technique in which the importance of figures is indicated by size, so that the most important figure is depicted as the largest.

HIEROGLYPH. A symbol, often based on a figure, animal, or object, standing for a word, syllable, or sound. These symbols form the early Egyptian writing system, and are found on ancient Egyptian monuments as well as in Egyptian written records.

HOUSE CHURCH. A place for private worship within a house; the first Christian churches were located in private homes that were modified for religious ceremonies.

HUMANISM. A philosophy emphasizing the worth of the individual, the rational abilities of humankind, and the human potential for good. During the Italian Renaissance, humanism was part of a movement that encouraged study of the classical cultures of Greece and Rome; often it came into conflict with the doctrines of the Catholic church.

HYDRIA. A type of jar used by ancient Greeks to carry water. Some examples were highly decorated. HYPOSTYLE. A hall whose roof is supported by

ICON. From the Greek word for "image." A panel painting of one or more sacred personages, such as Christ, the Virgin, or a saint, particularly venerated in the Orthodox Christian church.

ICONOCLASM. The doctrine of the Christian church in the 8th and 9th centuries that forbade the worship or production of religious images. This doctrine led to the destruction of many works of art. The iconoclastic controversy over the validity of this doctrine led to a division of the church. Protestant churches of the 16th and 17th centuries also practiced iconoclasm.

ICONOGRAPHY. (1) The depicting of images in art in order to convey certain meanings. (2) The study of the meaning of images depicted in art, whether they be inanimate objects, events, or personages. (3) The content or subject matter of a work of art.

IMPASTO. From the Italian word meaning "to make into a paste"; it describes paint, usually oil paint, applied very thickly.

IMPLUVIUM. A shallow pool in a Roman house, for collecting rain water. The impluvium was usually in the atrium, and stood beneath a large opening in the roof, known as a compluvium.

INFRARED LIGHT. Light on the spectrum beyond the comprehension of the naked eye is referred to as infrared. Special filters are needed to perceive it.

INFRARED REFLECTOGRAPHY. A technique for scientifically examining works of art. Special cameras equipped with infrared filters can look below the top layer of paintings to record the darker materials, such as carbon, which artists used to create drawings on panels or other supports.

INLAID NIELLO. See niello.

INSULA (pl. INSULAE). Latin word for "island." (1) An ancient Roman city block. (2) A Roman "apartment house": a concrete and brick building or chain of buildings around a central court, up to five stories high. The ground floor had shops, and above were living quarters.

INTAGLIO. A printing technique in which the design is formed from ink-filled lines cut into a surface. Engraving, etching, and drypoint are examples of intaglio.

INTERCOLUMNIATION. The space between two columns, measured from the edge of the column shafts. The term is often used in describing Greek and Roman temples.

INVERTED PERSPECTIVE. The technique, in some 16th- and 17th-century paintings, of placing the main theme or narrative of a work in the background and placing a still life or other representation in the

IONIC COLUMN. A column characterized by a base and a capital with two volutes. One of three styles of column consistently used by Greek and Roman architects.

IWAN. A vaulted chamber in a mosque or other Islamic structure, open on one side and usually opening onto an interior courtyard.

JAMBS. The vertical sides of an opening. In Romanesque and Gothic churches, the jambs of doors and windows are often cut on a slant outward, or "splayed," thus providing a broader surface for sculptural decoration.

JAPONISME. In 19th-century French and American art, a style of painting and drawing that reflected the influence of the Japanese artworks, particularly prints, that were then reaching the West.

JASPERWARE. A durable, unglazed porcelain developed by the firm of Josiah Wedgwood in the 18th century. It is decorated with Classically inspired

bas relief or cameo figures, and ornamented in white relief on a colored ground, especially blue and sage

KORE (pl. KORAI). Greek word for "maiden." An Archaic Greek statue of a standing, draped female.

KOUROS (pl. KOUROI). Greek word for "male youth." An Archaic Greek statue of a standing, nude

KRATER. A Greek vessel, of assorted shapes, in which wine and water are mixed. A calyx krater is a bell-shaped vessel with handles near the base; a volute krater is a vessel with handles shaped like scrolls.

KUFIC. One of the first general forms of Arabic script to be developed, distinguished by its angularity; distinctive variants occur in various parts of the Islamic worlds.

KYLIX. In Greek and Roman antiquity, a shallow drinking cup with two horizontal handles, often set on a stem terminating in a foot.

LAMASSU. An ancient Near Eastern guardian of a palace; often shown in sculpture as a human-headed bull or lion with wings.

LANCET. A tall, pointed window common in Gothic architecture.

LANTERN. A relatively small structure crowning a dome, roof, or tower, frequently open to admit light to an enclosed area below.

LATIN CROSS. A cross in which three arms are of equal length and one arm is longer.

LEKYTHOS (pl. LEKYTHOI). A Greek oil jug with an ellipsoidal body, a narrow neck, a flanged mouth, a curved handle extending from below the lip to the shoulder, and a narrow base terminating in a foot. It was used chiefly for ointments and funerary offerings.

LIGHT WELLS. Open shafts that allow light to penetrate into a building from the roof. These were a major source of light and ventilation in Minoan "palaces."

LIMINAL SPACE. A transitional area, such as a doorway or archway. In Roman architecture, liminal spaces were often decorated with apotropaic devices.

LINEARITY. A term used to refer to images that have a strong sense of line that provides sharp contours to figures and objects.

LITURGY. A body of rites or rituals prescribed for public worship.

LOGGIA. A covered gallery or arcade open to the air on at least one side. It may stand alone or be part of a building.

LUNETTE. (1) A semicircular or pointed wall area, as under a vault, or above a door or window. When it is above the portal of a medieval church, it is called a tympanum. (2) A painting, relief sculpture, or window of the same shape.

LUSTER. A metallic pigment fired over glazed ceramic, which creates an iridescent effect.

MACHICOLATIONS. A gallery projecting from the walls of a castle or tower with holes in the floor in order to allow liquid, stones, or other projectiles to be dropped on an enemy.

MAIDAN. In parts of the Near East and Asia a large open space or square.

MANDORLA. A representation of light surrounding the body of a holy figure.

MANUSCRIPT ILLUMINATION. Decoration of handwritten documents, scrolls, or books with drawings or paintings. Illuminated manuscripts were often produced during the Middle Ages.

MAQSURA. A screened enclosure, reserved for the ruler, often located before the mihrab in certain important royal Islamic mosques.

MARTYRIUM (pl. MARTYRIA). A church, chapel, or shrine built over the grave of a Christian martyr or at the site of an important miracle.

MASTABA. An ancient Egyptian tomb, rectangular in shape, with sloping sides and a flat roof. It covered a chapel for offerings and a shaft to the burial chamber.

MATRIX. (1) A mold or die used for shaping a ceramic object before casting. (2) In printmaking, any surface on which an image is incised, carved, or applied and from which a print may be pulled.

MEANDER PATTERN. A decorative motif of intricate, rectilinear character applied to architecture and sculpture.

MEGALITH. From the Greek mega, meaning "big," and lithos, meaning "stone." A huge stone such as those used in cromlechs and dolmens.

MEGARON (pl. MEGARONS or MEGARA). From the Greek word for "large." The central audience hall in a Minoan or Mycenaean palace or home.

MENHIR. A megalithic upright slab of stone, sometimes placed in rows by prehistoric peoples.

METOPE. The element of a Doric frieze between two consecutive triglyphs, sometimes left plain but often decorated with paint or relief sculpture.

MEZZOTINT. Printmaking technique developed in the late 17th century where the plate is roughened or "rocked" to better retain the ink and create dark images.

MIHRAB. A niche, often highly decorated, usually found in the center of the qibla wall of a mosque, indicating the direction of prayer toward Mecca.

MINA'I. From the Persian meaning "enameled," polychrome overglaze-decorated ceramic ware produced in Iran.

MINARET. A tower on or near a mosque, varying extensively in form throughout the Islamic world, from which the faithful are called to prayer five times a day.

MINBAR. A type of staircase pulpit, found in more important mosques to the right of the mihrab, from which the Sabbath sermon is given on Fridays after the noonday prayer.

MINIATURIST. An artist trained in the painting of miniature figures or scenes to decorate manuscripts.

MODULE. (1) A segment of a pattern. (2) A basic unit, such as the measure of an architectural member. Multiples of the basic unit are used to determine proportionate construction of other parts of a building.

MONOTYPE. A unique print made from a copper plate or other type of plate from which no other copies of the artwork are made.

MOSQUE. A building used as a center for community prayers in Islamic worship; it often serves other functions including religious education and public assembly.

MOZARAB. Term used for the Spanish Christian culture of the Middle Ages that developed while Muslims were the dominant culture and political power on the Iberian peninsula.

MUQARNAS. A distinctive type of Islamic decoration consisting of multiple nichelike forms usually arranged in superimposed rows, often used in zones of architectural transition.

NAOS. See cella.

NARTHEX. The transverse entrance hall of a church, sometimes enclosed but often open on one side to a preceding atrium.

NATURALISM. A style of art that aims to depict the natural world as it appears.

NAVE. (1) The central aisle of a Roman basilica, as distinguished from the side aisles. (2) The same section of a Christian basilican church extending from the entrance to the apse or transept.

NECROPOLIS. Greek for "city of the dead." A burial ground or cemetery.

NEMES HEADDRESS. The striped cloth headdress worn by Egyptian kings, and frequently represented in their sculpted and painted images.

NEOCLASSICISM. An 18th-century style that emphasizes Classical themes, sometimes with strong moral overtones, executed in a way that places a strong emphasis on line, with figures and objects running parallel to the picture plane. Paintings and drawings are typically executed with sharp clarity, by way of tight handling of paint and clearly defined line and light.

NIELLO. Dark metal alloys applied to the engraved lines in a precious metal plate (usually made of gold or silver) to create a design.

NIKE. The ancient Greek goddess of victory, often identified with Athena and by the Romans with Victoria. She is usually represented as a winged woman with windblown draperies.

NOCTURNE. A painting that depicts a nighttime scene, often emphasizing the effects of artificial light.

NOMAD'S GEAR. Portable objects, including weaponry, tackle for horses, jewelry and vessels, crafted by nomadic groups such as the tribes of early Iran, and sometimes buried with their dead.

OBELISK. A tall, tapering, four-sided stone shaft with a pyramidal top. First constructed as megaliths in ancient Egypt, certain examples have since been exported to other countries.

OCTASTYLE. A term used to describe the façade of a Greek or Roman temple, meaning that it has eight columns.

OCULUS. The Latin word for "eye." (1) A circular opening at the top of a dome used to admit light. (2) A round window.

OPISTHONAOS. A rear chamber in a Greek temple, often mirroring the porch at the front. The opisthonaos was sometimes used to house valuable objects. Access to the chamber was usually from the peristyle rather than the cella.

OPTICAL IMAGES. An image created from what the eye sees, rather than from memory.

ORANT. A standing figure with arms upraised in a gesture of prayer.

ORCHESTRA. (1) In an ancient Greek theater, the round space in front of the stage and below the tiers of seats, reserved for the chorus. (2) In a Roman theater, a similar space reserved for important guests.

ORIEL. A bay window that projects from a wall.

ORIENTALISM. The fascination of Western culture, especially as expressed in art and literature, with Eastern cultures. In the 19th-century, this fascination was especially focused on North Africa and the Near East, that is, the Arab world.

ORTHOGONAL. In a perspective construction, an imagined line in a painting that runs perpendicular to the picture plane and recedes to a vanishing point.

ORTHOSTATS. Upright slabs of stone constituting or lining the lowest courses of a wall, often in order to protect a vulnerable material such as mud-

POUSSINISTES. Those artists of the French Academy at the end of the 17th century and the beginning of the 18th century who favored "drawing," which they believed appealed to the mind rather than the senses. The term derived from admiration for the French artist Nicolas Poussin. See Rubénistes.

PALETTE. (1) A thin, usually oval or oblong board with a thumbhole at one end, used by painters to hold and mix their colors. (2) The range of colors used by a particular painter. (3) In Egyptian art, a slate slab, usually decorated with sculpture in low relief. The

small ones with a recessed circular area on one side are thought to have been used for eve makeup. The larger ones were commemorative objects.

PARCHMENT. From Pergamon, the name of a Greek city in Asia Minor where parchment was invented in the 2nd century BCE. (1) A paperlike material made from bleached animal hides used extensively in the Middle Ages for manuscripts. Vellum is a superior type of parchment made from calfskin. (2) A document or miniature on this

PEDIMENT. (1) In Classical architecture, a low gable, typically triangular, framed by a horizontal cornice below and two raking cornices above; frequently filled with sculpture. (2) A similar architectural member used over a door, window, or niche. When pieces of the cornice are either turned at an angle or interrupted, it is called a broken pediment.

PENDENTIVE. One of the concave triangles that achieves the transition from a square or polygonal opening to the round base of a dome or the supporting drum.

PERFORMANCE ART. A type of art in which performance by actors or artists, often interacting with the audience in an improvisational manner, is the primary aim over a certain time period. These artworks are transitory, perhaps with only a photographic record of some of the events.

PERIPTERAL TEMPLE. In Classical architecture, a temple with a single colonnade on all sides, providing shelter.

PERISTYLE. (1) In a Roman house or domus, an open garden court surrounded by a colonnade. (2) A colonnade around a building or court.

PERPENDICULAR GOTHIC STYLE. Describes Late Gothic architecture in England, characterized by dominant vertical accents.

PERSPECTIVE. A system for representing spatial relationships and three-dimensional objects on a flat two-dimensional surface so as to produce an effect similar to that perceived by the human eye. In atmospheric or aerial perspective, this is accomplished by a gradual decrease in the intensity of color and value and in the contrast of light and dark as objects are depicted as farther and farther away in the picture. In color artwork, as objects recede into the distance, all colors tend toward a light bluish-gray tone. In scientific or linear perspective, developed in Italy in the 15th century, a mathematical system is used based on orthogonals receding to vanishing points on the horizon. Transversals intersect the orthogonals at right angles at distances derived mathematically. Since this presupposes an absolutely stationary viewer and imposes rigid restrictions on the artist, it is seldom applied with complete consistency. Although traditionally ascribed to Brunelleschi, the first theoretical text on perspective was Leon Battista Alberti's On Painting (1435).

PHOTOGRAM. A shadowlike photograph made without a camera by placing objects on light-sensitive paper and exposing them to a light source.

PHOTOMONTAGE. A photograph in which prints in whole or in part are combined to form a new image. A technique much practiced by the Dada group in the 1920s.

PICTOGRAPH. A pictorial representation of a concept or object, frequently used by Egyptian artists, sometimes in conjunction with hieroglyphs.

PICTURESQUE. Visually interesting or pleasing, as if resembling a picture.

PIER. An upright architectural support, usually rectangular and sometimes with capital and base. When columns, pilasters, or shafts are attached to it, as in many Romanesque and Gothic churches, it is called a compound pier.

- PIETA. Italian word for both "pity" and "piety." A representation of the Virgin grieving over the dead Christ. When used in a scene recording a specific moment after the Crucifixion, it is usually called a Lamentation.
- **PILE CARPET.** A weaving made on a loom in which rows of individual knots of colored wool are tied so that the ends of each knot protrude to form a thick pile surface.
- **PILGRIMAGE PLAN**. The general design used in Christian churches that were stops on the pilgrimage routes throughout medieval Europe, characterized by having side aisles that allowed pilgrims to ambulate around the church. See *pilgrimage choir*.
- **PILOTIS.** Pillars that are constructed from reinforced concrete (ferroconcrete).
- **PINAKOTHEKE.** A museum for paintings. The first known example may have been in the Propylaia on the Athenian Akropolis.
- **PINNACLE.** A small, decorative structure capping a tower, pier, buttress, or other architectural member. It is used especially in Gothic buildings.
- PISÉ. A construction material consisting of packed earth, similar to wattle and daub. Etruscan architects used pisé for houses, with the result that little survives of them.
- **PLANARITY**. A term used to described a composition where figures and objects are arranged parallel to the picture plane.
- **PLATE TRACERY.** A style of tracery in which pierced openings in an otherwise solid wall of stonework are filled with glass.
- PLEIN-AIR. Sketching outdoors, often using paints, in order to capture the immediate effects of light on landscape and other subjects. Much encouraged by the Impressionists, their *plein-air* sketches were often taken back to the studio to produce finished paintings, but many *plein-air* sketches are considered masterworks.
- POCHADES. Small outdoor oil paintings made by landscape painters, serving as models for large-scale pictures that would be developed in the artist's studio.
- **POLIS.** A city-state, in the Classical Greek world. City-states began to develop in the course of the 7th and 6th centuries BCE, and were governed in a variety of different ways, including monarchy and oligarchy.
- **POLYPTYCH.** An altarpiece or devotional work of art made of several panels joined together, often hinged.
- PORTRAIT BUST. A sculpted representation of an individual which includes not only the head but some portion of the upper torso. Popular during the Roman period, it was revived during the Renaissance.
- **POST AND LINTEL**. A basic system of construction in which two or more uprights, the posts, support a horizontal member, the lintel. The lintel may be the topmost element or support a wall or roof.
- **POUNCING.** A technique for transferring a drawing from a cartoon to a wall or other surface by pricking holes along the principal lines of the drawing and forcing fine charcoal powder through them onto the surface of the wall, thus reproducing the design on the wall.
- **PREDELLA**. The base of an altarpiece, often decorated with small scenes that are related in subject to that of the main panel or panels.
- **PREFIGURATION.** The representation of Old Testament figures and stories as forerunners and foreshadowers of those in the New Testament.
- **PRIMITIVISM**. The appropriation of non-Western (e.g., African, tribal, Polynesian) art styles, forms, and techniques by Modern era artists as part of innovative

- and avant-garde artistic movements; other sources were also used, including the work of children and the mentally ill.
- **PROCESS ART.** Art in which the process is the art, as when Richard Serra hurled molten lead where a wall meets the floor, or Hans Haacke put water in a hermetic acrylic cube, which resulted in condensation forming on it.
- **PRONAOS**. In a Greek or Roman temple, an open vestibule in front of the *cella*.
- **PRONK**. A word meaning ostentatious or sumptuous; it is used to refer to a still life of luxurious objects.
- **PROPYLON**. A monumental gateway, often leading into a citadel or a precinct, such as the Akropolis of Mycenae or Athens.
- **PROTOME**. A decorative, protruding attachment, often on a vessel. Greek bronze-workers attached griffin-shaped protomes to tripod cauldrons in the 7th century BCE.
- **PROVENANCE.** The place of origin of a work of art and related information.
- **PSALTER**. (1) The book of Psalms in the Old Testament, thought to have been written in part by David, king of ancient Israel. (2) A copy of the Psalms, sometimes arranged for liturgical or devotional use and often richly illuminated.
- **PYLON.** Greek word for "gateway." (1) The monumental entrance building to an Egyptian temple or forecourt consisting either of a massive wall with sloping sides pierced by a doorway or of two such walls flanking a central gateway. (2) A tall structure at either side of a gate, bridge, or avenue marking an approach or entrance.
- **PYXIS.** A lidded box, often made of ivory, to hold jewelry or cosmetics in daily life, and, in the context of the Christian church, used on altars to contain the Host (Communion wafer).
- QIBLA. The direction toward Mecca, which Muslims face during prayer. The qibla wall in a mosque identifies this direction.
- QUADRANT VAULT. Λ half-barrel vault designed so that instead of being semicircular in cross-section, the arch is one-quarter of a circle.
- **QUATREFOIL.** An ornamental element composed of four lobes radiating from a common center.
- **RAYONNANT**. The style of Gothic architecture, described as "radiant," developed at the Parisian court of Louis IX in the mid-13th century. Also referred to as *court style*.
- **READYMADE.** An ordinary object that, when an artist gives it a new context and title, is transformed into an art object. Readymades were important features of the Dada and Surrealism movements of the early 20th century.
- **RED-FIGURED.** A style of ancient Greek ceramic decoration characterized by red figures against a black background. This style of decoration developed toward the end of the 6th century BCE and replaced the earlier *black-figured* style.
- REGISTER. A horizontal band containing decoration, such as a relief sculpture or a fresco painting. When multiple horizontal layers are used, registers are useful in distinguishing between different visual planes and different time periods in visual narration.
- **RELIEF.** (1) The projection of a figure or part of a design from the background or plane on which it is carved or modeled. Sculpture done in this manner is described as "high relief" or "low relief" depending on the height of the projection. When it is very shallow, it is called *schiacciato*, the Italian word for "flatened out." (2) The apparent projection of forms represented in a painting or drawing. (3) A category of printmaking in which lines raised from the surface are inked and printed.

- **RELIEVING TRIANGLE.** A space left open above a lintel to relieve it of the weight of masonry. This device was used by Bronze Age architects in gate and tomb construction.
- **RELIQUARY**. A container used for storing or displaying relics.
- **RENAISSANCE**. Literally, rebirth. During the 14th and 15th centuries, Italian writers, artists, and intellectuals aimed to revive the arts of the ancient world. From their accomplishments, the term has been applied to the period, and is used generally to refer to a cultural flowering.
- **REPOUSSÉ.** A metalworking technique where a design is hammered onto an object from the wrong side. Sasanian craftsmen used this techniques for silver vessels.
- RESPOND. (1) A half-pier, pilaster, or similar element projecting from a wall to support a lintel or an arch whose other side is supported by a free-standing column or pier, as at the end of an arcade. (2) One of several pilasters on a wall behind a colonnade that echoes or "responds to" the columns but is largely decorative. (3) One of the slender shafts of a compound pier in a medieval church that seems to carry the weight of the vault.
- **RHYTON**. An ancient drinking or pouring vessel made from pottery, metal, or stone, and sometimes designed in a human or animal form.
- RIBBED GROIN VAULTS. A vault is a stone or brick roof. Groin vaults result from the intersection of two barrel vaults; the places where the arched surfaces meet is called the groin. Adding ribs or thickenings of the groins increases the strength of the roof.
- RIBBED VAULT. A style of vault in which projecting surface arches, known as ribs, are raised along the intersections of segments of the vault. Ribs may provide architectural support as well as decoration to the vault's surface.
- ROCOCO. The ornate, elegant style most associated with the early-18th-century in France, and which later spread throughout Europe, generally using pastel colors and the decorative arts to emphasize the notion of fantasy.
- ROMANESQUE. (1) The style of medieval architecture from the 11th to the 13th centuries that was based upon the Roman model and that used the Roman rounded arch, thick walls for structural support, and relatively small windows. (2) Any culture or its artifacts that are "Roman-like."
- ROMANTICISM. A cultural movement that surfaced in the second half of the 18th century and peaked in the first half of the 19th century. The movement was based on a belief in individual genius and originality and the expression of powerful emotions, as well as preference for exotic themes and the omnipotent force of nature, often viewed as manifestation of God.
- ROSE WINDOW. A large, circular window with stained glass and stone tracery, frequently used on façades and at the ends of transepts in Gothic churches.
- ROSTRUM (pl. ROSTRA). (1) A beaklike projection from the prow of an ancient warship used for ramming the enemy. (2) In the Roman forum, the raised platform decorated with the beaks of captured ships from which speeches were delivered. (3) A platform, stage, or the like used for public speaking.
- ROTULUS (pl. ROTULI). The Latin word for scroll, a rolled written text.
- **RUBÉNISTES**. Those artists of the French Academy at the end of the 17th century and the beginning of the 18th century who favored "color" in painting because it appealed to the senses and was thought to be true to nature. The term derived from admiration for the work of the Flemish artist Peter Paul Rubens. See *Poussinistes*.

RUSTICATION. A masonry technique of laying rough-faced stones with sharply indented joints.

SALON. (1) A large, elegant drawing or reception room in a palace or a private house. (2) Official government-sponsored exhibition of paintings and sculpture by living artists held at the Louvre in Paris, first biennially, then annually. (3) Any large public exhibition patterned after the Paris Salon.

SARCOPHAGUS (pl. **SARCOPHAGI**). A large coffin, generally of stone, and often decorated with sculpture or inscriptions. The term is derived from two Greek words meaning "flesh" and "eating."

SAZ. Meaning literally "enchanted forest," this term describes the sinuous leaves and twining stems that are a major component of the *hatayi* style under the Ottoman Turks.

SCHIACCIATO. Italian for "flattened out." Describes low relief sculpture used by Donatello and some of his contemporaries.

SCHOLASTICISM. A school of medieval thought that tries to reconcile faith and reason by combining ancient philosophy with Christian theology.

SCIENTIFIC PERSPECTIVE. See perspective.

SCRIPTORIUM (pl. **SCRIPTORIA**). A workroom in a monastery reserved for copying and illustrating manuscripts.

SECTION. An architectural drawing presenting a building as if cut across the vertical plane at right angles to the horizontal plane. A *cross section* is a cut along the transverse axis. A *longitudinal section* is a cut along the longitudinal axis.

SELECTIVE WIPING. The planned removal of certain areas of ink during the etching process to produce changes in value on the finished print.

SEPTPARTITE VAULT. A type of vault divided into seven sections.

SERDAB. In Egyptian architecture, an enclosed room without an entrance, often found in a funerary context. A sculpture of the dead king might be enclosed within it, as at Saqqara.

SEXPARTITE VAULT. See vault.

SFUMATO. Italian word meaning "smoky." Used to describe very delicate gradations of light and shade in the modeling of figures. It is applied especially to the work of Leonardo da Vinci.

SGRAFFITO ORNAMENT. A decorative technique in which a design is made by scratching away the surface layer of a material to produce a form in contrasting colors.

SHADING. The modulation of volume by means of contrasting light and shade. Prehistoric cave-painters used this device, as did Greek tomb-painters in the Hellenistic period.

SILKSCREEN PRINTING. A technique of printing in which paint or ink is pressed through a stencil and specially prepared cloth to produce a previously designed image. Also called serigraphy.

SILVERPOINT. A drawing instrument (stylus) of the 14th and 15th centuries made from silver; it produced a fine line and maintained a sharp point.

SIMULTANEOUS CONTRAST. The theory, first expressed by Michel-Eugène Chevreul (1786–1889), that complementary colors, when placed next to one another, increase the intensity of each other (e.g., red becoming more red and green more green.)

SITE-SPECIFIC ART. Art that is produced in only one location, a location that is an integral part of the work and essential to its production and meaning.

SKENE. A building erected on a Greek or Roman stage, as a backdrop against which some of the action took place. It usually consisted of a screen of columns, arranged in several storeys.

SOCLE. A portion of the foundation of a building that projects outward as a base for a column or some other device.

SPANDREL. The area between the exterior curves of two adjoining arches or, in the case of a single arch, the area around its outside curve from its springing to its keystone.

SPATIAL PERSPECTIVE. The exploration of the spatial relationships between objects. Painters were especially interested in spatial perspective in the Hellenistic period in Greece.

SPIRE. A tall tower that rises high above a roof. Spires are commonly associated with church architecture and are frequently found on Gothic structures.

SPOLIA. Latin for "hide stripped from an animal." Term used for (1) spoils of war and (2) fragments of architecture or sculpture reused in a secondary context.

SPRINGING. The part of an arch in contact with its base.

SQUINCHES. Arches set diagonally at the corners of a square or rectangle to establish a transition to the round shape of the dome above.

STAIN PAINTING. A type of painting where the artist works on unprimed canvas, allowing the paint to seep into the canvas, thus staining it.

STELE. From the Greek word for "standing block." An upright stone slab or pillar, sometimes with a carved design or inscription.

STEREOBATE. The substructure of a Classical building, especially a Greek temple.

STEREOCARDS. Side-by-side photographs of the same image taken by a camera with two lenses, replicating human binocular vision. When put into a special viewer, the twin flat pictures appear as a single three-dimensional image.

STILL LIFE. A term used to describe paintings (and sometimes sculpture) that depict familiar objects such as household items and food.

STIPPLES. In drawing or printmaking, stippling is a technique to create tone or shading in an image with small dots rather than lines.

STREET PHOTOGRAPHY. A term applied to American documentary photographers such as Walker Evans, who emerged in the 1930s, and Robert Frank, who surfaced in the 1950s, who took to the streets to find their subject matter, often traveling extensively.

STYLOBATE. A platform or masonry floor above the stereobate forming the foundation for the columns of a Greek temple.

SUBLIME. In 19th-century art, the ideal and goal that art should inspire awe in a viewer and engender feelings of high religious, moral, ethical, and intellectual purpose.

SUNKEN RELIEF. Relief sculpture in which the figures or designs are modeled beneath the surface of the stone, within a sharp outline.

SYMPOSIUM. In ancient Greece, a gathering, sometimes of intellectuals and philosophers to discuss ideas, often in an informal social setting, such as at a dinner party.

SYNCRETISM. The act of bringing together disparate customs or beliefs. Historians usually describe Roman culture as syncretistic, because Romans embraced many of the the practices of those they conquered.

SYNOPTIC NARRATIVE. A narrative with different moments presented simultaneously, in order to encapsulate the entire story in a single scene. The device appears in early Greek pediment sculpture.

TEMPERA. Medium for painting in which pigments are suspended in egg yolk tempered with water or chemicals; this mixture dries quickly, reducing the possibility of changes in the finished painting.

TENEBRISM. The intense contrast of light and dark in painting.

TESSERA (pl. TESSERAE). A small piece of colored stone, marble, glass, or gold-backed glass used in a mosaic.

THOLOS. A building with a circular plan, often with a sacred nature.

TONDO. A circular painting or relief sculpture.

TRANSEPT. A cross arm in a basilican church placed at right angles to the nave and usually separating it from the choir or apse.

TRANSVERSALS. In a perspective construction, transversals are the lines parallel to the picture plane (horizontally) that denote distances. They intersect orthogonals to make a grid that guides the arrangement of elements to suggest space.

TRIBUNE. A platform or walkway in a church constructed overlooking the *aisle* and above the *nave*.

TRIFORIUM. The section of a nave wall above the arcade and below the clerestory. It frequently consists of a blind arcade with three openings in each bay. When the gallery is also present, a four-story elevation results, the triforium being between the gallery and clerestory. It may also occur in the transept and the choir walls.

TRIGLYPH. The element of a Doric frieze separating two consecutive metopes and divided by grooves into three sections.

TRILITHIC. A form of construction using three stones—two uprights and a lintel—found frequently in Neolithic tomb and ritual architecture.

TRIPTYCH. An altarpiece or devotional picture, either carved or painted, with one central panel and two hinged wings.

TRIUMPHAL ARCH. (1) A monumental arch, sometimes a combination of three arches, erected by a Roman emperor in commemoration of his military exploits and usually decorated with scenes of these deeds in relief sculpture. (2) The great transverse arch at the eastern end of a church that frames altar and apse and separates them from the main body of the church. It is frequently decorated with mosaics or mural paintings.

TROIS CRAYONS. The use of three colors, usually red, black, and white, in a drawing; a technique popular in the 17th and 18th centuries.

TROMPE L'OEIL. Meaning "trick of the eye" in French, it is a work of art designed to deceive a viewer into believing that the work of art is reality, an actual three-dimensional object or scene in space.

TRUMEAU. A central post supporting the lintel of a large doorway, as in a Romanesque or Gothic portal, where it is frequently decorated with sculpture.

TRUSS. A triangular wooden or metal support for a roof that may be left exposed in the interior or be covered by a ceiling.

TUMULUS (pl. TUMULI) A monumental earth mound, often raised over a tomb. Etruscan builders constructed tumuli with internal chambers for burials.

TURRET. (1) A small tower that is part of a larger structure. (2) A small tower at a corner of a building, often beginning some distance from the ground.

TUSCAN STYLE. An architectural style typical of ancient Italy. The style is similar to the Doric style, but the column shafts have bases.

TUSCHE. An inklike liquid containing crayon that is used to produce solid black (or solid color) areas in prints.

TYMPANUM. (1) In Classical architecture, a recessed, usually triangular area often decorated with sculpture. Also called a pediment. (2) In medieval architecture, an arched area between an arch and the lintel of a door or window, frequently carved with relief sculpture.

TYPOLOGY. The matching or pairing of pre-Christian figures, persons, and symbols with their Christian counterparts.

VANISHING POINT. The point at which the orthogonals meet and disappear in a composition done with scientific perspective.

VANITAS. The term derives from the book of Ecclesiastes I:2 ("Vanities of vanities, ...") that refers to the passing of time and the notion of life's brevity and the inevitability of death. The vanitas theme found expression especially in the Northern European art of the 17th century.

VAULT. An arched roof or ceiling usually made of stone, brick, or concrete. Several distinct varieties have been developed; all need buttressing at the point where the lateral thrust is concentrated. (1) A barrel vault is a semicircular structure made up of successive arches. It may be straight or annular in plan. (2) A groin vault is the result of the intersection of two barrel vaults of equal size that produces a bay of four compartments with sharp edges, or groins, where the two meet. (3) A ribbed groin vault is one in which ribs are added to the groins for structural strength and for decoration. When the diagonal ribs are constructed as half-circles, the resulting form is a domical ribbed vault. (4) A sexpartite vault is a ribbed groin

vault in which each bay is divided into six compartments by the addition of a transverse rib across the center. (5) The normal Gothic vault is quadripartite with all the arches pointed to some degree. (6) A fan vault is an elaboration of a ribbed groin vault, with elements of tracery using conelike forms. It was developed by the English in the 15th century and was employed for decorative purposes.

VELLUM. See parchment.

VERISTIC. From the Latin verus, meaning "true." Describes a hyperrealistic style of portraiture that emphasizes individual characteristics.

VIGNETTE. A decorative design often used in manuscripts or books to separate sections or to decorate borders.

VOLUTE. A spiraling architectural element found notably on Ionic and Composite capitals but also used decoratively on building façades and interiors.

VOUSSOIR. A wedge-shaped piece of stone used in arch construction.

WARP. The vertical threads used in a weaver's loom through which the weft is woven.

WEBS. Masonry construction of brick, concrete, stone, etc. that is used to fill in the spaces between groin vault ribs.

WEFT. The horizontal threads that are interlaced through the vertical threads (the warp) in a woven fabric. Weft yarns run perpendicular to the warp.

WESTWORK. From the German word Westwerk. In Carolingian, Ottonian, and German Romanesque architecture, a monumental western front of a church, treated as a tower or combination of towers and containing an entrance and vestibule below and a chapel and galleries above. Later examples often added a transept and a crossing tower.

WET-COLLODION PROCESS. A 19th-century photographic technique that uses a very sensitive emulsion called collodion (gun-cotton dissolved in alcohol ether), that reduces exposure time to under a second and produces a sharp, easily reproducible negative.

WHITE-GROUND. Vase-painting technique in which artists painted a wide range of colors onto a white background. This was a favorite technique for decorating lekythoi (vases used in a funerary context in ancient Greece.)

WOODCUT. A print made by carving out a design on a wooden block cut along the grain, applying ink to the raised surfaces that remain, and printing from

X-RADIOGRAPHIC. Using a form of electromagnetic radiation called X-rays, researchers can examine the layers of paint or other materials used by artists to construct works of art.

ZIGGURAT. From the Assyrian word zigguratu, meaning "mountaintop" or "height." In ancient Assyria and Babylonia, a pyramidal mound or tower built of mud-brick forming the base for a temple. It was often either stepped or had a broad ascent winding around it, which gave it the appearance of being stepped.

Books for Further Reading

This list is intended to be as practical as possible. It is therefore limited to books of general interest that were printed over the past 20 years or have been generally available recently. However, certain indispensable volumes that have yet to be superseded are retained. This restriction means omitting numerous classics long out of print, as well as much specialized material of interest to the serious student. The reader is thus referred to the many specialized bibliographies noted below.

REFERENCE RESOURCES IN ART HISTORY

1. BIBLIOGRAPHIES AND RESEARCH GUIDES

Arntzen, E., and R. Rainwater. *Guide to the Literature* of Art History. Chicago: American Library, 1980. Barnet, S. A Short Guide to Writing About Art. 8th ed.

New York: Longman, 2005.

Ehresmann, D. Architecture: A Bibliographical Guide to Basic Reference Works, Histories, and Handbooks. Littleton, CO: Libraries Unlimited, 1984.

— Fine Arts: A Bibliographical Guide to Basic Reference Works, Histories, and Handbooks. 3d ed. Littleton, CO: Libraries Unlimited, 1990.

Freitag, W. Art Books: A Basic Bibliography of Monographs on Artists. 2d ed. New York: Garland, 1997.

Goldman, B. Reading and Writing in the Arts: A Handbook. Detroit, MI: Wayne State Press, 1972.

Kleinbauer, W., and T. Slavens. Research Guide to the History of Western Art. Chicago: American Library, 1982.

Marmor, M., and A. Ross, eds. *Guide to the Literature* of Art History 2. Chicago: American Library, 2005. Sayre, H. M. Writing About Art. New ed. Upper Saddle

Sayre, H. M. Writing About Art. New ed. Upper S River, NJ: Pearson Prentice Hall, 2000.

2. DICTIONARIES AND ENCYCLOPEDIAS

Aghion, I. Gods and Heroes of Classical Antiquity. Flammarion Iconographic Guides. New York: Flammarion, 1996.

Boström, A., ed. Encyclopedia of Sculpture. 3 vols. New York: Fitzroy Dearborn, 2004.

Brigstocke, H., ed. *The Oxford Companion to Western Art*. New York: Oxford University Press, 2001.

Burden, E. *Illustrated Dictionary of Architecture*. New York: McGraw-Hill, 2002.

Carr-Gomm, S. The Hutchinson Dictionary of Symbols in Art. Oxford: Helicon, 1995.

Chilvers, I., et al., eds. *The Oxford Dictionary of Art.* 3d ed. New York: Oxford University Press, 2004.

Congdon, K. G. Artists from Latin American Cultures: A Biographical Dictionary. Westport, CT: Greenwood Press, 2002.

Cumming, R. Art: A Field Guide. New York: Alfred A. Knopf, 2001.

Curl, J. A Dictionary of Architecture. New York: Oxford University Press, 1999.

The Dictionary of Art. 34 vols. New York: Grove's Dictionaries, 1996.

Duchet-Suchaux, G., and M. Pastoureau. *The Bible and the Saints*. Flammarion Iconographic Guides. New York: Flammarion, 1994.

Encyclopedia of World Art. 14 vols., with index and supplements. New York: McGraw-Hill, 1959–1968.

Fleming, J., and H. Honour. The Penguin Dictionary of Architecture and Landscape Architecture. 5th ed. New York: Penguin, 1998. ——. The Penguin Dictionary of Decorative Arts. New ed. London: Viking, 1989.

Gascoigne, B. How to Identify Prints: A Complete Guide to Manual and Mechanical Processes from Woodcut to Inkjet. New York: Thames & Hudson, 2004.

Hall, J. Dictionary of Subjects and Symbols in Art. Rev. ed. London: J. Murray, 1996.

— . Illustrated Dictionary of Symbols in Eastern and Western Art. New York: HarperCollins, 1995. International Dictionary of Architects and Architecture. 2 vols. Detroit, MI: St. James Press, 1993.

Langmuir, E. Yale Dictionary of Art and Artists. New Haven: Yale University Press, 2000.

Lever, J., and J. Harris. *Illustrated Dictionary of Architecture*, 800–1914. 2d ed. Boston: Faber & Faber, 1993.

Lucie-Smith, E. The Thames & Hudson Dictionary of Art Terms. New York: Thames & Hudson, 2004. Mayer, R. The Artist's Handbook of Materials and

Techniques. 5th ed. New York: Viking, 1991.

——. The HarperCollins Dictionary of Art Terms & Techniques. 2d ed. New York: HarperCollins, 1991.

Murray, P., and L. Murray. A Dictionary of Art and Artists. 7th ed. New York: Penguin, 1998.

— A Dictionary of Christian Art. New York: Oxford University Press, 2004, © 1996.
Nelson, R. S., and R. Shiff, eds. Critical Terms for Art

Nelson, R. S., and R. Shiff, eds. Critical Terms for Art History. Chicago: University of Chicago Press, 2003. Pierce, J. S. From Abacus to Zeus: A Handbook of Art

Pierce, J. S. From Abacus to Zeus: A Handbook of A History. 7th ed. Englewood Cliffs, NJ: Pearson Prentice Hall, 2004.

Reid, J. D., ed. *The Oxford Guide to Classical Mythology in the Arts 1300–1990*. 2 vols. New York: Oxford University Press, 1993.

Shoemaker, C., ed. Encyclopedia of Gardens: History and Design. Chicago: Fitzroy Dearborn, 2001.

Steer, J. Atlas of Western Art History: Artists, Sites, and Movements from Ancient Greece to the Modern Age. New York: Facts on File, 1994.

West, S., ed. The Bulfinch Guide to Art History. Boston: Little, Brown, 1996.

——. Portraiture. Oxford History of Art. New York: Oxford University Press, 2004.

3. INDEXES, PRINTED AND ELECTRONIC

ARTbibliographies Modern. 1969 to present. A semiannual publication indexing and annotating more than 300 art periodicals, as well as books, exhibition catalogues, and dissertations. Data since 1974 also available electronically.

Art Index. 1929 to present. A standard quarterly index to more than 200 art periodicals. Also available

electronically.

Avery Index to Architectural Periodicals. 1934 to present. 15 vols., with supplementary vols. Boston: G. K. Hall, 1973. Also available electronically.

BHA: Bibliography of the History of Art. 1991 to present. The merger of two standard indexes: RILA (Répertoire International de la Littérature de l'Art! International Repertory of the Literature of Art, vol. 1. 1975) and Répertoire d'Art et d'Archéologie (vol. 1. 1910). Data since 1973 also available electronically.

Index Islamicus. 1665 to present. Multiple publishers.

Data since 1994 also available electronically.

The Perseus Project: An Evolving Digital Library on Ancient Greece and Rome. Medford, MA: Tufts University, Classics Department, 1994.

4. WORLDWIDE WERSITES

Visit the following websites for reproductions and information regarding artists, periods, movements, and many more subjects. The art history departments and libraries of many universities and colleges also maintain websites where you can get reading lists and links to other websites, such as those of museums, libraries, and periodicals.

http://www.aah.org.uk/welcome.html Association of Art Historians

http://www.amico.org Art Museum Image Consortium http://www.archaeological.org Archaeological Institute of America

http://archnet.asu.edu/archnet Virtual Library for Archaeology

http://www.artchive.com

http://www.art-design.umich.edu/mother/ Mother of all Art History links pages, maintained by the Department of the History of Art at the University of Michigan

http://www.arthistory.net Art History Network http://artlibrary.vassar.edu/ifla-idal International Directory of Art Libraries

http://www.bbk.ac.uk/lib/hasubject.html Collection of resources maintained by the History of Art Department of Birkbeck College, University of London

http://classics.mit.edu The Internet Classics Archive http://www.collegeart.org College Art Association http://www.constable.net

http://www.cr.nps.gov/habshaer Historic American Buildings Survey

http://www.getty.edu Including museum, five institutes, and library

http://www.harmsen.net/ahrc/ Art History Research Centre

http://icom.museum/ International Council of Museums http://www.icomos.org International Council on Monuments and Sites

http://www.ilpi.com/artsource

http://www.siris.si.edu Smithsonian Institution Research Information System

http://whc.unesco.org/ World Heritage Center

5. GENERAL SOURCES ON ART HISTORY, METHOD, AND THEORY

Andrews, M. Landscape and Western Art. Oxford History of Art. New York: Oxford University Press, 1999.

Barasch, M. Modern Theories of Art: Vol. 1, From Winckelmann to Baudelaire. Vol. 2, From Impressionism to Kandinsky. New York: 1990–1998.

. Theories of Art: From Plato to Winckelmann.
New York: Routledge, 2000.

Battistini, M. Symbols and Allegories in Art. Los Angeles: J. Paul Getty Museum, 2005.

Baxandall, M. Patterns of Intention: On the Historical Explanation of Pictures. New Haven: Yale University Press, 1985.

Bois, Y.-A. *Painting as Model*. Cambridge, MA: MIT Press, 1993.

Broude, N., and M. Garrard. *The Expanding Discourse: Feminism and Art History*. New York: Harper & Row, 1992.

——., eds. Feminism and Art History: Questioning the Litany. New York: Harper & Row, 1982.

Bryson, N., ed. Vision and Painting: The Logic of the Gaze. New Haven: Yale University Press, 1983.

- ., et al., eds. Visual Theory: Painting and Interpretation. New York: Cambridge University Press, 1991.
- Chadwick, W. Women, Art, and Society. 3d ed. New York: Thames & Hudson, 2002.

D'Alleva, A. Methods & Theories of Art History. London: Laurence King, 2005. Freedberg, D. The Power of Images: Studies in the

History and Theory of Response. Chicago: University of Chicago Press, 1989.

Gage, J. Color and Culture: Practice and Meaning from Antiquity to Abstraction. Berkeley: University of California Press, 1999.

Garland Library of the History of Art. New York: Garland, 1976. Collections of essays on specific periods.

Goldwater, R., and M. Treves, eds. Artists on Art, from the Fourteenth to the Twentieth Century. 3d ed. New York: Pantheon, 1974.

Gombrich, E. H. Art and Illusion. 6th ed. New York: Phaidon, 2002.

Harris, A. S., and L. Nochlin. Women Artists, 1550-1950. New York: Random House, 1999.

Holly, M. A. Panofsky and the Foundations of Art History. Ithaca, NY: Cornell University Press, 1984. Holt, E. G., ed. A Documentary History of Art: Vol. 1,

The Middle Ages and the Renaissance. Vol. 2, Michelangelo and the Mannerists. The Baroque and the Eighteenth Century. Vol. 3, From the Classicists to the Impressionists. 2d ed. Princeton, NJ: Princeton University Press, 1981. Anthologies of primary sources on specific periods.

Johnson, P. Art: A New History. New York: HarperCollins, 2003.

Kemal, S., and I. Gaskell. The Language of Art History. Cambridge Studies in Philosophy and the Arts. New York: Cambridge University Press, 1991.

Kemp, M., ed. The Oxford History of Western Art. New York: Oxford University Press, 2000.

Kleinbauer, W. E. Modern Perspectives in Western Art History: An Anthology of Twentieth Century Writings on the Visual Arts. Reprint of 1971 ed. Toronto: University of Toronto Press, 1989.

Kostof, S. A. History of Architecture: Settings and Rituals. 2d ed. New York: Oxford University Press,

Kruft, H. W. A History of Architectural Theory from Vitruvius to the Present. Princeton, NJ: Princeton Architectural Press, 1991.

Kultermann, U. The History of Art History. New York: Abaris Books, 1993.

Langer, C. Feminist Art Criticism: An Annotated Bibliography. Boston: G. K. Hall, 1993.

Laver, J. Costume and Fashion: A Concise History. 4th ed. The World of Art. London: Thames & Hudson,

Lavin, I., ed. Meaning in the Visual Arts: Views from the Outside: A Centennial Commemoration of Erwin Panofsky (1892-1968). Princeton, NJ: Institute for Advanced Study, 1995.

Minor, V. H. Art History's History. Upper Saddle River, NJ: Pearson Prentice Hall, 2001.

Nochlin, L. Women, Art, and Power, and Other Essays. New York: HarperCollins, 1989.

Pächt, O. The Practice of Art History: Reflections on Method. London: Harvey Miller, 1999.

Panofsky, E. Meaning in the Visual Arts. Reprint of 1955 ed. Chicago: University of Chicago Press, 1982.

Penny, N. The Materials of Sculpture. New Haven: Yale University Press, 1993.

Pevsner, N. A History of Building Types. Princeton, NJ: Princeton University Press, 1976.

Podro, M. The Critical Historians of Art. New Haven: Yale University Press, 1982.

Pollock, G. Differencing the Canon: Feminist Desire and the Writing of Art's Histories. New York: Routledge,

Vision and Difference: Femininity, Feminism, and the Histories of Art. New York: Routledge, 1988. Prettejohn, E. Beauty and Art 1750-2000. New York: Oxford University Press, 2005.

Preziosi, D., ed. The Art of Art History: A Critical Anthology. New York: Oxford University Press,

Rees, A. L., and F. Borzello. The New Art History. Atlantic Highlands, NJ: Humanities Press International, 1986.

Roth, L. Understanding Architecture: Its Elements, History, and Meaning. New York: Harper & Row,

Sedlmayr, H. Framing Formalism: Riegl's Work. Amsterdam: G+B Arts International, © 2001.

Smith, P., and C. Wilde, eds. A Companion to Art Theory. Oxford: Blackwell, 2002.

Sources and Documents in the History of Art Series. General ed. H. W. Janson. Englewood Cliffs, NJ: Prentice Hall. Anthologies of primary sources on specific periods.

Sutton, I. Western Architecture. New York: Thames & Hudson, 1999.

Tagg, J. Grounds of Dispute: Art History, Cultural Politics, and the Discursive Field. Minneapolis: University of Minnesota Press, 1992.

Trachtenberg, M., and I. Hyman. Architecture: From Prehistory to Post-Modernism. 2d ed. New York: Harry N. Abrams, 2002.

Watkin, D. The Rise of Architectural History. Chicago: University of Chicago Press, 1980.

Wolff, J. The Social Production of Art. 2d ed. New York: New York University Press, 1993.

Wölfflin, H. Principles of Art History: The Problem of the Development of Style in Later Art. Various eds. New York: Dover.

Wollheim, R. Art and Its Objects. 2d ed. New York: Cambridge University Press, 1992.

PART ONE: THE ANCIENT WORLD

GENERAL REFERENCES

Baines, J., ed. Civilizations of the Ancient Near East. 4 vols. New York: Scribner, 1995.

Boardman, J., ed. The Oxford History of Classical Art. New York: Oxford University Press, 2001.

De Grummond, N., ed. An Encyclopedia of the History of Classical Archaeology. Westport, CT: Greenwood,

Fine, S. Art and Judaism in the Greco-Roman World: Toward a New Jewish Archaeology. New York: Cambridge University Press, 2005.

Holliday, P. J. Narrative and Event in Ancient Art. New York: Cambridge University Press, 1993.

Redford, D. B., ed. The Oxford Encyclopedia of Ancient Egypt. 3 vols. New York: Oxford University Press,

Stillwell, R. The Princeton Encyclopedia of Classical Sites. Princeton, NJ: Princeton University Press,

Tadgell, C. Origins: Egypt, West Asia and the Aegean. New York: Whitney Library of Design, 1998.

Van Keuren, F. Guide to Research in Classical Art and Mythology. Chicago: American Library Association,

Wharton, A. J. Refiguring the Post-Classical City: Dura Europos, Jerash, Jerusalem, and Ravenna. New York: Cambridge University Press, 1995.

Winckelmann, J. J. Essays on the Philosophy and History of Art. 3 vols. Bristol, England: Thoemmes, 2001. Wolf, W. The Origins of Western Art: Egypt,

Mesopotamia, the Aegean. New York: Universe Books, 1989.

Yegül, F. K. Baths and Bathing in Classical Antiquity. Architectural History Foundation. Cambridge, MA: MIT Press, 1992.

CHAPTER 1. PREHISTORIC ART

Bahn, P. G. The Cambridge Illustrated History of Prehistoric Art. New York: Cambridge University

Chauvet, J.-M., É. B. Deschamps, and C. Hilaire. Dawn of Art: The Chauvet Cave. New York: Harry N. Ábrams, 1995.

Clottes, J. Chauvet Cave. Salt Lake City: University of Utah Press, 2003.

The Shamans of Prehistory: Trance and Magic in the Painted Caves. New York: Harry N. Abrams,

Cunliffe, B., ed. The Oxford Illustrated Prehistory of Europe. New York: Oxford University Press, 1994. Fitton, J. L. Cycladic Art. London: British Museum Press,

Fowler, P. Images of Prehistory. New York: Cambridge University Press, 1990.

Leroi-Gourhan, A. The Dawn of European Art: An Introduction to Paleolithic Cave Painting. New York: Cambridge University Press, 1982.

McCold, C. H., and L. D. McDermott. Toward Decolonizing Gender: Female Vision in the Upper Palaeolithic. American Anthropologist 98, 1996. Ruspoli, M. The Cave of Lascaux: The Final

Photographs. New York: Harry N. Abrams, 1987. Sandars, N. Prehistoric Art in Europe. 2d ed. New

Haven: Yale University Press, 1992. Saura Ramos, P. A. The Cave of Altamira. New York:

Harry N. Abrams, 1999.

Twohig, E. S. The Megalithic Art of Western Europe. New York: Oxford University Press, 1981. White, R. Prehistoric Art: The Symbolic Journey of

Mankind. New York: Harry N. Abrams, 2003. CHAPTER 2. ANCIENT NEAR EASTERN ART

Amiet, P. Art of the Ancient Near East. New York: Harry N. Abrams, 1980.

Aruz, J., ed. Art of the First Cities: The Third Millennium B.C. from the Mediterranean to the Indus. Exh. cat. New York: Metropolitan Museum of Art; Yale University Press, 2003

Collon, D. Ancient Near Eastern Art. Berkeley: University of California Press, 1995.

-. First Impressions: Cylinder Seals in the Ancient Near East. Chicago: University of Chicago Press, 1987.

Crawford, H. The Architecture of Iraq in the Third Millennium B.C. Copenhagen: Akademisk Forlag,

Curtis, J., and N. Tallis. Forgotten Empire: The World of Ancient Persia. Exh. cat. London: British Museum, 2005.

Frankfort, H. The Art and Architecture of the Ancient Orient. 5th ed. Pelican History of Art. New Haven: Yale University Press, 1997.

Goldman, B. The Ancient Arts of Western and Central Asia: A Guide to the Literature. Ames: Iowa State University Press, 1991.

Harper, P. O., ed. The Royal City of Susa: Ancient Near Eastern Treasures in the Louvre. New York: Metropolitan Museum of Art; Dist. by Harry N. Abrams, 1992.

Leick, G. A Dictionary of Ancient Near Eastern Architecture. New York: Routledge, 1988.

Lloyd, S. The Archaeology of Mesopotamia: From the Old Stone Age to the Persian Conquest. Rev. ed. New York: Thames & Hudson, 1984.

Moscati, S. The Phoenicians. New York: Abbeville Press, 1988.

Oates, J. Babylon. Rev. ed. London: Thames & Hudson, 1986.

Reade, J. Mesopotamia. 2d ed. London: Published for the Trustees of the British Museum by the British Museum Press, 2000.

Zettler, R., and L. Horne, eds. Treasures from the Royal Tombs of Ur. Exh. cat. Philadelphia: University of Pennsylvania, Museum of Archaeology and Anthropology, 1998.

CHAPTER 3. EGYPTIAN ART

Aldred, C. The Development of Ancient Egyptian Art, from 3200 to 1315 B.C. 3 vols. in 1. London: Academy Editions, 1972.

Egyptian Art. London: Thames & Hudson, 1985.

Arnold, D., and C. Ziegler. Building in Egypt: Pharaonic Stone Masonry. New York: Oxford University Press,

Egyptian Art in the Age of the Pyramids. New York: Harry N. Abrams, 1999.

Bothmer, B. V. Egyptian Art: Selected Writings of Bernard V. Bothmer. New York: Oxford University Press, 2004.

Davis, W. The Canonical Tradition in Ancient Egyptian

Art. New York: Cambridge University Press, 1989. Edwards, I. E. S. *The Pyramids of Egypt.* Rev. ed. Harmondsworth, England: Penguin, 1991.

Egyptian Art in the Age of the Pyramids. New York: Metropolitan Museum of Art; Dist. by Harry N. Abrams, 1999.

Grimal, N. A History of Ancient Egypt. London: Blackwell, 1992.

- Mahdy, C., ed. The World of the Pharaohs: A Complete Guide to Ancient Egypt. London: Thames & Hudson, 1990.
- Malek, J. Egypt: 4000 Years of Art. London: Phaidon, 2003
- -. Egyptian Art. Art & Ideas. London: Phaidon, 1999.
- Mendelssohn, K. The Riddle of the Pyramids. New York: Thames & Hudson, 1986.
- Parry, D. Engineering the Pyramids. Stroud, England: Sutton, 2004.
- Robins, G. *The Art of Ancient Egypt*. Cambridge, MA: Harvard University Press, 1997.
- Schaefer, H. Principles of Egyptian Art. Oxford: Clarendon Press, 1986.
- Schulz, R., and M. Seidel. Egypt: The World of the Pharaohs. Cologne: Könemann, 1998.
- Smith, W., and W. Simpson. The Art and Architecture of Ancient Egypt. Rev. ed. Pelican History of Art. New Haven: Yale University Press, 1999.
- Tiradritti, F. Ancient Egypt: Art, Architecture and History. London: British Museum Press, 2002.
- Walker, S. and P. Higgs, eds. Cleopatra of Egypt: From History to Myth. Exh. cat. Princeton, NJ: Princeton University Press, 2001.
- Wilkinson, R. Reading Egyptian Art: A Hieroglyphic Guide to Ancient Egyptian Painting and Sculpture. New York: Thames & Hudson, 1992.

CHAPTER 4. AEGEAN ART

- Akurgal, E. The Aegean, Birthplace of Western Civilization: History of East Greek Art and Culture, 1050–333 B.C. Izmir, Turkey: Metropolitan Municipality of Izmir, 2000.
- Barber, R. The Cyclades in the Bronze Age. Iowa City: University of Iowa Press, 1987.
- Dickinson, O. T. P. K. The Aegean Bronze Age. New York: Cambridge University Press, 1994.
- Elytis, O. The Aegean: The Epicenter of Greek Civilization. Athens: Melissa, 1997.
- German, S. C. Performance, Power and the Art of the Aegean Bronze Age. Oxford: Archaeopress, 2005. Getz-Preziosi, P. Sculptors of the Cyclades. Ann Arbor:
- University of Michigan Press, 1987.
- Graham, J. The Palaces of Crete. Rev. ed. Princeton, NJ: Princeton University Press, 1987.
- Hampe, R., and E. Simon. The Birth of Greek Art from the Mycenean to the Archaic Period. New York: Oxford University Press, 1981.
- Higgins, R. Minoan and Mycenaean Art. Rev. ed. The World of Art. New York: Oxford University Press, 1981.
- Hood, S. The Arts in Prehistoric Greece. Pelican History of Art. New Haven: Yale University Press,
- The Minoans: The Story of Bronze Age Crete. New York: Praeger, 1981.
- Hurwit, J. The Art and Culture of Early Greece, 1100-480 B.C. Ithaca, NY: Cornell University Press,
- McDonald, W. Progress into the Past: The Rediscovery of Mycenaean Civilization. 2d ed. Bloomington: Indiana University Press, 1990.
- Preziosi, D., and L. Hitchcock. Aegean Art and Architecture. New York: Oxford University Press,
- Renfrew, C. The Cycladic Spirit: Masterpieces from the Nicholas P. Goulandris Collection. London: Thames & Hudson, 1991.
- Vermeule, E. Greece in the Bronze Age. Chicago: University of Chicago Press, 1972.

CHAPTER 5. GREEK ART

- Beard, M. The Parthenon. Cambridge, MA: Harvard University Press, 2003.
- Beazley, J. D. Athenian Red Figure Vases: The Archaic Period: A Handbook. The World of Art. New York: Thames & Hudson, 1991.
- Athenian Red Figure Vases: The Classical Period: A Handbook. The World of Art. New York: Thames & Hudson, 1989.
- The Development of Attic Black-Figure. Rev. ed. Berkeley: University of California Press, 1986.
- Greek Vases: Lectures. Oxford and New York: Clarendon Press and Oxford University Press, 1989.

- Boardman, J. The Archaeology of Nostalgia: How the Greeks Re-created Their Mythical Past. London: Thames & Hudson, 2002.
- & Hudson, 1991.
- Early Greek Vase Painting: 11th-6th Centuries B.C.: A Handbook. The World of Art. New York: Thames & Hudson, 1998.
- —. Greek Art. 4th ed., rev. and expanded. The World of Art. New York: Thames & Hudson, 1996. —. Greek Sculpture: The Archaic Period: A Handbook. Corrected ed. The World of Art. New
- York: Thames & Hudson, 1991.

 —. Greek Sculpture: The Classical Period: A Handbook. Corrected ed. New York: Thames & Hudson, 1991.
- Burn, L. Hellenistic Art: From Alexander the Great to Augustus. London: The British Museum, 2004. Carpenter, T. H. Art and Myth in Ancient Greece: A
- Handbook. The World of Art. New York: Thames & Hudson, 1991.
- Carratelli, G. P., ed. The Greek World: Art and Civilization in Magna Graecia and Sicily. Exh. cat. New York: Rizzoli, 1996.
- Fullerton, M. D. Greek Art. New York: Cambridge University Press, 2000.
- Hampe, R., and E. Simon. The Birth of Greek Art. Oxford: Oxford University Press, 1981.
- Haynes, D. E. L. The Technique of Greek Bronze Statuary. Mainz am Rhein: P. von Zabern, 1992.
- Himmelmann, N. Reading Greek Art: Essays. Princeton, NJ: Princeton University Press, 1998.
- Hurwit, J. M. The Acropolis in the Age of Pericles. New York: Cambridge University Press, 2004.

 —. The Art & Culture of Early Greece,
- 1100-480 B.C. Ithaca, NY: Cornell University Press, 1985.
- Lawrence, A. *Greek Architecture.* Rev. 5th ed. Pelican History of Art. New Haven: Yale University Press,
- L'Empereur, J. Alexandria Rediscovered. London: British Museum Press, 1998.
- Osborne, R. Archaic and Classical Greek Art. New York: Oxford University Press, 1998.
- Papaioannou, K. The Art of Greece. New York: Harry N. Abrams, 1989.
- Pedley, J. Greek Art and Archaeology. 2d ed. New York: Harry N. Abrams, 1997.
- Pollitt, J. The Ancient View of Greek Art: Criticism, History, and Terminology. New Haven: Yale University Press, 1974.
- Art in the Hellenistic Age. New York: Cambridge University Press, 1986.
- ., ed. Art of Ancient Greece: Sources and Documents. New York: Cambridge University Press,
- Potts, A. Flesh and the Ideal: Winckelmann and the Origins of Art History. New Haven: Yale University Press, 1994.
- Rhodes, R. F. Architecture and Meaning on the Athenian Acropolis. New York: Cambridge University Press, 1995.
- ed. The Acquisition and Exhibition of Classical Antiquities: Professional, Legal, and Ethical Perspectives. Notre Dame, IN: University of Notre Dame Press, 2007.
- Richter, G. M. A. A Handbook of Greek Art. 9th ed. New York: Da Capo, 1987.
- Portraits of the Greeks. Ed. R. Smith. New York: Oxford University Press, 1984.
- Ridgway, B. S. Hellenistic Sculpture: Vol. 1, The Styles of ca. 331-200 B.C. Bristol, England: Bristol Classical Press, 1990.
- Robertson, M. The Art of Vase Painting in Classical Athens. New York: Cambridge University Press,
- Rolley, C. Greek Bronzes. New York: Philip Wilson for Sotheby's Publications; Dist. by Harper & Row,
- Schefold, K. Gods and Heroes in Late Archaic Greek Art. New York: Cambridge University Press, 1992. Smith, R. Hellenistic Sculpture. The World of Art. New
- York: Thames & Hudson, 1991. Spivey, N. Greek Art. London: Phaidon, 1997.

- Stafford, E. Life, Myth, and Art in Ancient Greece. Los
- Angeles: J. Paul Getty Museum, 2004. Stansbury-O'Donnell, M. Pictorial Narrative in Ancient Greek Art. New York: Cambridge University Press,
- Stewart, A. F. Greek Sculpture: An Exploration. New Haven: Yale University Press, 1990.
- Whitley, J. The Archaeology of Ancient Greece. New York: Cambridge University Press, 2001.

CHAPTER 6. ETRUSCAN ART

- Boethius, A. Etruscan and Early Roman Architecture. 2d ed. Pelican History of Art. New Haven: Yale University Press, 1992.
- Bonfante, L., ed. Etruscan Life and Afterlife: A Handbook of Etruscan Studies. Detroit, MI: Wayne State University, 1986.
- Borrelli, F. The Etruscans: Art, Architecture, and History. Los Angeles: J. Paul Getty Museum, 2004.
- Brendel, O. Etruscan Art. Pelican History of Art. New Haven: Yale University Press, 1995.
- Hall, J. F., ed. Etruscan Italy: Etruscan Influences on the Civilizations of Italy from Antiquity to the Modern Era. Provo, UT: Museum of Art, Brigham Young University, 1996.
- Haynes, Sybille. Etruscan Civilization: A Cultural History. Los Angeles: J. Paul Getty Museum, 2000.
- Richardson, E. The Etruscans: Their Art and Civilization. Reprint of 1964 ed., with corrections. Chicago: University of Chicago Press, 1976.
- Spivey, N. Etruscan Art. The World of Art. New York: Thames & Hudson, 1997.
- Sprenger, M., G. Bartoloni, and M. Hirmer. The Etruscans: Their History, Art, and Architecture. New York: Harry N. Abrams, 1983.
- Steingräber, S., ed. Etruscan Painting: Catalogue Raisonné of Etruscan Wall Paintings. New York:
- Johnson Reprint, 1986. Torelli, M., ed. *The Etruscans*. Exh. cat. Milan: Bompiani, 2000.

CHAPTER 7. ROMAN ART

- Allan, T. Life, Myth and Art in Ancient Rome. Los Angeles: J. Paul Getty Museum, 2005.
- Andreae, B. The Art of Rome. New York: Harry N. Abrams, 1977
- Beard, M., and J. Henderson. Classical Art: From Greece to Rome. New York: Oxford University Press, 2001.
- Bowe, P. Gardens of the Roman World. Los Angeles: J. Paul Getty Museum, 2004.
- Brilliant, R. Commentaries on Roman Art: Selected Studies. London: Pindar Press, 1994.
- -. My Laocoon: Alternative Claims in the Interpretation of Artworks. University of California Press, 2000.
- Claridge, A. Rome: An Oxford Archaeological Guide. New York: Oxford University Press, 1998.
- D'Ambra, E. Roman Art. New York: Cambridge University Press, 1998.
- , comp. Roman Art in Context: An Anthology. Englewood Cliffs, NJ: Prentice Hall, 1993.
- Davies, P. Death and the Emperor: Roman Imperial Funerary Monuments from Augustus to Marcus Aurelius. Austin: University of Texas Press, 2004.
- Dunbabin, K. M. D. Mosaics of the Greek and Roman World. New York: Cambridge University Press,
- Elsner, J. Imperial Rome and Christian Triumph: The Art of the Roman Empire, A.D. 100-450. New York: Oxford University Press, 1998.
- Gazda, E. K. Roman Art in the Private Sphere: New Perspectives on the Architecture and Decor of the Domus, Villa, and Insula. Ann Arbor: University of Michigan Press, 1991.
- Jenkyns, R., ed. The Legacy of Rome: A New Appraisal. New York: Oxford University Press, 1992.
- Kleiner, D. Roman Sculpture. New Haven: Yale University Press, 1992.
- ., and S. B. Matheson, eds. I, Claudia: Women in Ancient Rome. New Haven: Yale University Art Gallery, 1996
- Ling, R. Ancient Mosaics. London: British Museum Press, 1998.
- . Roman Painting. New York: Cambridge University Press, 1991.

- Nash, E. Pictorial Dictionary of Ancient Rome. 2 vols. Reprint of 1968 2d ed. New York: Hacker, 1981.
- Pollitt, J. J. The Art of Rome, c. 753 B.C.- A.D. 337: Sources and Documents. New York: Cambridge University Press, 1983.
- Ramage, N., and A. Ramage. *The Cambridge Illustrated History of Roman Art.* Cambridge: Cambridge University Press, 1991.
- ——. Roman Art: Romulus to Constantine. 4th ed. Upper Saddle River, NJ: Pearson Prentice Hall, 2005.
- Richardson, L. A New Topographical Dictionary of Ancient Rome. Baltimore, MD: Johns Hopkins University Press, 1992.
- Rockwell, P. The Art of Stoneworking: A Reference Guide. Cambridge: Cambridge University Press, 1993.
- Strong, D. E. Roman Art. 2d ed. Pelican History of Art. New Haven: Yale University Press, 1992.
- Vitruvius. The Ten Books on Architecture. Trans. I. Rowland. Cambridge: Cambridge University Press, 1999.
- Ward-Perkins, J. B. Roman Imperial Architecture. Reprint of 1981 ed. Pelican History of Art. New York: Penguin, 1992.
- Zanker, P. The Power of Images in the Age of Augustus. Ann Arbor: University of Michigan Press, 1988.

PART TWO: THE MIDDLE AGES

GENERAL REFERENCES

- Alexander, J. J. G. Medieval Illuminators and Their Methods of Work. New Haven: Yale University Press, 1992.
- , ed. A Survey of Manuscripts Illuminated in the British Isles. 6 vols. London: Harvey Miller, 1975–1996.
- Avril, F., and J. J. G. Alexander, eds. A Survey of Manuscripts Illuminated in France. London: Harvey Miller, 1996.
- Bartlett, R., ed. Medieval Panorama I os Angeles: J. Paul Getty Museum, 2001.
- Cahn, W. Studies in Medieval Art and Interpretation. London: Pindar Press, 2000.
- Calkins, R. G. Medieval Architecture in Western Europe: From A.D. 300 to 1500. New York: Oxford University Press, 1998.
- Cassidy, B., ed. *Iconography at the Crossroads*.
 Princeton, NJ: Princeton University Press, 1993
 Coldstream, N. *Medieval Architecture*. Oxford History
- of Art. New York: Oxford University Press, 2002.

 De Hamel, C. *The British Library Guide to Manuscript Illumination: History and Techniques.* Toronto: University of Toronto Press, 2001.
- . A History of Illuminated Manuscripts. Rev. and enl. 2d ed. London: Phaidon Press, 1994.
- Duby, G. Art and Society in the Middle Ages. Polity Press; Malden, MA: Blackwell Publishers, 2000.
- Hamburger, J. Nuns as Artists: The Visual Culture of a Medieval Convent. Berkeley: University of California Press, 1997.
- Katzenellenbogen, A. Allegories of the Virtues and Vices in Medieval Art. Reprint of 1939 ed. Toronto: University of Toronto Press, 1989.
- Kazhdan, A. P. *The Oxford Dictionary of Byzantium*. 3 vols. New York: Oxford University Press, 1991.
- Kessler, H. L. Seeing Medieval Art. Peterborough, Ont. and Orchard Park, NY: Broadview Press, 2004.
- Luttikhuizen, H., and D. Verkerk. Snyder's Medieval Art. 2d ed. Upper Saddle River, NJ: Prentice Hall, 2006.
- Pächt, O. Book Illumination in the Middle Ages: An Introduction. London: Harvey Miller, 1986.
- Pelikan, J. Mary Through the Centuries: Her Place in the History of Culture. New Haven: Yale University Press, 1996.
- Ross, L. Artists of the Middle Ages. Westport, CT: Greenwood Press, 2003.
- . Medieval Art: A Topical Dictionary. Westport, CT: Greenwood Press, 1996.
- Schütz, B. *Great Cathedrals*. New York: Harry N. Abrams, 2002.
- Sears, E., and T. K. Thomas, eds. *Reading Medieval Images: The Art Historian and the Object.* Ann Arbor: University of Michigan Press, 2002.
- Sekules, V. *Medieval Art*. New York: Oxford University Press, 2001.

- Stokstad, M. Medieval Art. Boulder, CO: Westview Press, 2004.
- Tasker, E. Encyclopedia of Medieval Church Art. London: Batsford, 1993.
- Watson, R. Illuminated Manuscripts and Their Makers: An Account Based on the Collection of the Victoria and Albert Museum. London and New York: V & A Publications; Dist. by Harry N. Abrams, 2003
- Wieck, R. S. Painted Prayers: The Book of Hours in Medieval and Renaissance Art. New York: George Braziller in association with the Pierpont Morgan Library, 1997.
- Wixom, W. D. Mirror of the Medieval World. Exh. cat. New York: Metropolitan Museum of Art; Dist. by Harry N. Abrams, 1999.

CHAPTER 8. EARLY JEWISH, EARLY CHRISTIAN, AND BYZANTINE ART

- Beckwith, J. Studies in Byzantine and Medieval Western Art. London: Pindar Press, 1989.
- Bowersock, G. W., ed. *Late Antiquity: A Guide to the Postclassical World*. Cambridge, MA: Belknap Press of Harvard University Press, 1999.
- Cormack, R. Icons. London: British Museum Press, 2007.
- Demus, O. Studies in Byzantium, Venice and the West. 2 vols. London: Pindar Press, 1998.
- Drury, J. Painting the Word: Christian Pictures and Their Meanings. New Haven and London: Yale University Press in association with National Gallery Publications, 1999.
- Durand, J. *Byzantine Art.* Paris: Terrail, 1999. Evans, H. C., ed. *Byzantium: Faith and Power,* 1261–1557. Exh. cat. New York: Metropolitan Museum of Art; New Haven: Yale University Press,
- Evans, H. C., and W. D. Wixom, eds. *The Glory of Byzantium: Art and Culture of the Middle Byzantine Era*, A. D. 843–1261. Exh. cat. New York: Metropolitan Museum of Art; New Haven: Yale University Press, 1997.
- Galavaris, G. Colours, Symbols, Worship: The Mission of the Byzantine Artist. London: Pindar, 2005.
- Grabar, A. Christian Iconography: A Study of Its Origins. Princeton, NJ: Princeton University Press, 1968.
- Henderson, G. Vision and Image in Early Christian England. New York: Cambridge University Press, 1999.
- Kalavrezou, I. Byzantine Women and Their World. Exh. cat. Cambridge, MA and New Haven: Harvard University Art Museums; Yale University Press, © 2003.
- Kleinbauer, W. Early Christian and Byzantine Architecture: An Annotated Bibliography and Historiography. Boston: G. K. Hall, 1993.
- Krautheimer, R., and S. Curcic. *Early Christian and Byzantine Architecture*. 4th ed. Pelican History of Art. New Haven: Yale University Press, 1992.
- Lowden, J. Early Christian and Byzantine Art. London: Phaidon Press, 1997.
- Maguire, II. Art and Eloquence in Byzantium.

 Princeton, NJ: Princeton University Press, 1981.

 Mango, C. The Art of the Byzantine Empire, 312–145.
- Mango, C. The Art of the Byzantine Empire, 312–1453: Sources and Documents. Reprint of 1972 ed. Toronto: University of Toronto Press, 1986.
- Mark, R., and A. S. Çakmak, eds. *Hagia Sophia from the Age of Justinian to the Present*. New York: Cambridge University Press, 1992.
- Matthews, T. Byzantium from Antiquity to the Renaissance. New York: Harry N. Abrams, 1998. ———. The Clash of Gods: A Reinterpretation of Early
- Christian Art. Princeton, NJ: Princeton University Press, 1993.
- Milburn, R. Early Christian Art and Architecture. Berkeley: University of California Press, 1988.
- Rodley, L. Byzantine Art and Architecture: An Introduction. New York: Cambridge University Press, 1994.
- Simson, O. G. von. Sacred Fortress: Byzantine Art and Statecraft in Ravenna. Reprint of 1948 ed. Princeton, NJ: Princeton University Press, 1987.
- Webster, L., and M. Brown, eds. The Transformation of the Roman World A.D. 400–900. Berkeley: University of California Press. 1997.

Weitzmann, K. Late Antique and Early Christian Book Illumination. New York: Braziller, 1977.

CHAPTER 9. ISLAMIC ART

- Asher, C. E. B. Architecture of Mughal India. New Cambridge History of India, Cambridge, England. New York: Cambridge University Press, 1992.
- Atil, E. The Age of Sultan Süleyman the Magnificent. Exh. cat. Washington, DC: National Gallery of Art; New York: Harry N. Abrams, 1987.
- ——. Renaissance of Islam: Art of the Mamluks. Exh. cat. Washington, DC: Smithsonian Institution Press, 1981.
- Behrens-Abouseif, D. Beauty in Arabic Culture. Princeton, NJ: Markus Wiener, 1998.
- Bierman, I., ed. The Experience of Islamic Art on the Margins of Islam. Reading, England: Ithaca Press, 2005.
- Blair, S., and J. Bloom. *The Art and Architecture of Islam 1250–1800*. Pelican History of Art. New Haven: Yale University Press, 1996.
- Brookes, J. Gardens of Paradise: The History and Design of the Great Islamic Gardens. New York: New Amsterdam, 1987.
- Burckhardt, T. Art of Islam: Language and Meaning. London: World of Islam Festival, 1976.
- Creswell, K. A. C. A Bibliography of the Architecture, Arts, and Crafts of Islam. Cairo: American University in Cairo Press, 1984.
- Denny, W. B. *The Classical Tradition in Anatolian Carpets*. Washington, DC: Textile Museum, 2002.
- Dodds, J. D., ed. al-Andalus: The Art of Islamic Spain. Exh. cat. New York: Metropolitan Museum of Art; Dist. by Harry N. Abrams, 1992.
- Erdmann, K. Oriental Carpets: An Essay on Their History. Fishguard, Wales: Crosby Press, 1976, © 1960.
- Ettinghausen, R., O. Grabar, and M. Jenkins-Madina. *Islamic Art and Architecture*, 650–1250. 2d ed. Pelican History of Art. New Haven: Yale University Press, 2002.
- Frishman, M., and H. Khan. *The Mosque: History, Architectural Development and Regional Diversity*. London: Thames & Hudson, 2002, © 1994.
- Goodwin, G. A History of Ottoman Architecture. New York: Thames & Hudson, 2003, © 1971.
- Grabar, O. *The Formation of Islamic Art.* Rev. and enl. ed. New Haven: Yale University Press, 1987.
- Hillenbrand, R. Islamic Architecture: Form, Function, and Meaning. New ed. New York: Columbia University Press, 2004.
- Komaroff, L., and S. Carboni, eds. The Legacy of Genghis Khan: Countly Art and Culture in Western Asia, 1256–1353. Exh. cat. New York: Metropolitan Museum of Art; New Haven: Yale University Press, 2002.
- Lentz, T., and G. Lowry. Timur and the Princely Vision: Persian Art and Culture in the Fifteenth Century. Exh. cat. Los Angeles: Los Angeles County Museum of Art; Washington, DC: Arthur M. Sackler Gallery; Smithsonian Institution Press, 1989.
- Lings, M. The Quranic Art of Calligraphy and Illumination. 1st American ed. New York: Interlink Books, 1987, © 1976.
- Necipolu, G. The Age of Sinan: Architectural Culture in the Ottoman Empire. Princeton, NJ: Princeton University Press, 2005.
- The Topkapi Scroll: Geometry and Ornament in Islamic Architecture. Topkapi Palace Museum Library MS H. 1956. Santa Monica, CA: Getty Center for the History of Art and the Humanities, 1995.
- Pope, A. U. Persian Architecture: The Triumph of Form and Color. New York: Braziller, 1965.
- Robinson, F. Atlas of the Islamic World Since 1500. New York: Facts on File, 1982.
- Ruggles, D. F. Gardens, Landscape, and Vision in the Palaces of Islamic Spain. University Park: Pennsylvania State University Press, 2000.
- ——, ed. Women, Patronage, and Self-Representation in Islamic Societies. Albany: State University of New York Press, 2000.
- Tabbaa, Y. The Transformation of Islamic Art During the Sunni Revival. Seattle: University of Washington Press, 2001.

- Thompson, J., ed. *Hunt for Paradise: Court Arts of Safavid Iran, 1501–1576.* Milan: Skira; New York: Dist. in North America and Latin America by Rizzoli, 2003.
- Oriental Carpets from the Tents, Cottages, and Workshops of Asia. New York: Dutton, 1988.
- Vernoit, S., ed. Discovering Islamic Art: Scholars, Collectors and Collections, 1850–1950. London and New York: I. B. Tauris; Dist. by St. Martin's Press, 2000.
- Welch, S. C. *Imperial Mughal Painting*. New York: Braziller, 1978.
- ——. A King's Book of Kings: The Shah-nameh of Shah Tahmasp. New York: Metropolitan Museum of Art; Dist. by New York Graphic Society, 1972.

CHAPTER 10. EARLY MEDIEVAL ART

- Backhouse, J. *The Golden Age of Anglo-Saxon Art*, 966–1066. Bloomington: Indiana University Press, 1984.
- ——. The Lindisfarne Gospels: A Masterpiece of Book Painting. London: British Library, 1995.
- Barral i Altet, X. *The Early Middle Ages: From Late Antiquity to A.D. 1000.* Taschen's World Architecture. Köln and New York: Taschen, © 1997.
- Conant, K. Carolingian and Romanesque Architecture, 800–1200. 4th ed. Pelican History of Art. New Haven: Yale University Press, 1992.
- Davis-Weyer, C. Early Medieval Art, 300–1150: Sources and Documents. Reprint of 1971 ed. Toronto: University of Toronto Press, 1986.
- Diebold, W. J. Word and Image: An Introduction to Early Medieval Art. Boulder, CO: Westview Press, 2000.
- The Pictorial Arts of the West, 800–1200. New ed. Pelican History of Art. New Haven: Yale University Press, 1993.
- Graham-Campbell, J. *The Viking-age Gold and Silver of Scotland*, A.D. 850–1100. Exh. cat. Edinburgh: National Museums of Scotland, 1995.
- Harbison, P. *The Golden Age of Irish Art: The Medieval Achievement*, 600–1200. New York: Thames & Hudson, 1999.
- Henderson, G. The Art of the Picts: Sculpture and Metalwork in Early Medieval Scotland. New York: Thames & Hudson, 2004.
- Kitzinger, E. Early Medieval Art, with Illustrations from the British Museum. Rev. ed. Bloomington: Indiana University Press, 1983.
- Lasko, P. Ars Sacra, 800–1200. 2d ed. Pelican History of Art. New Haven: Yale University Press, 1995.
- Mayr-Harting, M. Ottonian Book Illumination: An Historical Study. 2 vols. London: Harvey Miller, 1991–1993.
- Megaw, M. R. Celtic Art: From Its Beginnings to the Book of Kells. New York: Thames & Hudson, 2001. Mosacati, S., ed. The Celts. Exh. cat. New York: Rizzoli,
- 1999. Nees, L. Early Medieval Art. Oxford History of Art.
- New York: Oxford University Press, 2002.
 Ohlgren, T. H., comp. Insular and Anglo-Saxon
 Illuminated Manuscripts: An Iconographic Catalogue,
 c. A.D. 625 to 1100. New York: Garland, 1986.
- Rickert, M. *Painting in Britain: The Middle Ages.* 2d ed. Pelican History of Art. Harmondsworth, England: Penguin, 1965.
- Stalley, R. A. Early Medieval Architecture. Oxford History of Art. New York: Oxford University Press, 1999.
- Stone, L. Sculpture in Britain: The Middle Ages. 2d ed. Pelican History of Art. Harmondsworth, England: Penguin, 1972.
- Webster, L., and J. Backhouse, eds. *The Making of England: Anglo-Saxon Art and Culture, A.D. 600–900.* Exh. cat. London: Published for the Trustees of the British Museum and the British Library Board by British Museum Press, 1991.

CHAPTER 11. ROMANESQUE ART

- Barral i. Altet, X. The Romanesque: Towns, Cathedrals, and Monasteries. Cologne: Taschen, 1998.
- Bizzarro, T. Romanesque Architectural Criticism: A Prehistory. New York: Cambridge University Press, 1992.

- Boase, T. S. R. English Art, 1100–1216. Oxford History of English Art. Oxford: Clarendon Press, 1953.
- Cahn, W. Romanesque Bible Illumination. Ithaca, NY: Cornell University Press, 1982.
- Davies, M. Romanesque Architecture: A Bibliography. Boston: G. K. Hall, 1993.
- Focillon, H. *The Art of the West in the Middle Ages*. Ed. J. Bony. 2 vols. Reprint of 1963 ed. Ithaca, NY: Cornell University Press, 1980.
- Hearn, M. F. Romanesque Sculpture: The Revival of Monumental Stone Sculpture. Ithaca, NY: Cornell University Press, 1981.
- Mâle, E. Religious Art in France, the Twelfth Century: A Study of the Origins of Medieval Iconography. Bollingen series, 90:1. Princeton, NJ: Princeton University Press, 1978.
- Minne-Sève, V. Romanesque and Gothic France: Architecture and Sculpture. New York: Harry N. Abrams, 2000.
- Nichols, S. Romanesque Signs: Early Medieval Narrative and Iconography. New Haven: Yale University Press, 1983.
- O'Keeffe, T. Romanesque Ireland: Architecture and Ideology in the Twelfth Century. Dublin and Portland, OR: Four Courts, 2003.
- Petzold, A. Romanesque Art. Perspectives. Upper Saddle River, NJ: Prentice Hall, 1996.
- Platt, C. The Architecture of Medieval Britain: A Social History. New Haven: Yale University Press, 1990.
- Sauerländer, W. Romanesque Art: Problems and Monuments. 2 vols. London: Pindar, 2004. Schapiro, M. Romanesque Art. New York: Braziller, 1977.
- Schapiro, M. Romanesque Art. New York: Braziller, 1975. Stoddard, W. Art and Architecture in Medieval France. New York: Harper & Row, 1972, © 1966.
- Stones, A., J. Krochalis, P. Gerson, and A. Shaver-Crandell. The Pilgrim's Guide to Santiago de Compostela: A Critical Edition. 2 vols. London: Harvey Miller, 1998.
- Toman, R., and A. Bednorz. Romanesque Architecture, Sculpture, Painting. Cologne: Könemann, 2008.
- Zarnecki, G. Further Studies in Romanesque Sculpture. London: Pindar, 1992.

CHAPTER 12. GOTHIC ART

- Barnes, C. F. Villard de Honnecourt, the Artist and His Drawings: A Critical Bibliography. Boston: G. K. Hall. 1982.
- Belting, H. The Image and Its Public: Form and Function of Early Paintings of the Passion. New Rochelle, NY: Caratzas, 1990.
- Blum, P. Early Gothic Saint-Denis: Restorations and Survivals. Berkeley: University of California Press, 1992.
- Bony, J. French Gothic Architecture of the Twelfth and Thirteenth Centuries. Berkeley: University of California Press, 1983.
- Camille, M. Gothic Art: Glorious Visions. Perspectives. New York: Harry N. Abrams, 1997.
- The Gothic Idol: Ideology and Image Making in Medieval Art. New York: Cambridge University Press, 1989.
- Sumptuous Arts at the Royal Abbeys of Reims and Braine. Princeton, NJ: Princeton University Press, 1990.
- Cennini, C. The Craftsman's Handbook (Il Libro dell'Arte). New York: Dover, 1954.
- Coldstream, N. Medieval Architecture. Oxford History of Art. New York: Oxford University Press, 2002.
- Erlande-Brandenburg, A. *Gothic Art.* New York: Harry N. Abrams, 1989.
- Frankl, P. Gothic Architecture. Rev. by P. Crossley. Pelican History of Art. New Haven, CT: Yale University Press, 2001.
- Frisch, T. G. Gothic Art, 1140-c. 1450: Sources and Documents. Reprint of 1971 ed. Toronto: University of Toronto Press, 1987.
- Grodecki, L. *Gothic Architecture*. New York: Electa/Rizzoli, 1985.
- ——. Gothic Stained Glass, 1200–1300. Ithaca, NY: Cornell University Press, 1985.
- Hamburger, J. F. The Visual and the Visionary: Art and Female Spirituality in Late Medieval Germany. Zone Books. Cambridge, MA: MIT Press, 1998.
- Jantzen, H. High Gothic: The Classic Cathedrals of Chartres, Reims, Amiens. Reprint of 1962 ed. Princeton, NJ: Princeton University Press, 1984.

- Kemp, W. The Narratives of Gothic Stained Glass. New York: Cambridge University Press, 1997.
- Limentani Virdis, C. Great Altarpieces: Gothic and Renaissance. New York: Vendome Press; Dist. by Rizzoli, 2002.
- Mâle, E. Religious Art in France, the Thirteenth Century: A Study of Medieval Iconography and Its Sources. Ed. H. Bober. Princeton, NJ: Princeton University Press, 1984.
- Marks, R., and P. Williamson, eds. Gothic: Art for England 1400–1547. Exh. cat. London and New York: Victoria & Albert Museum; Dist. by Harry N. Abrams, 2003.
- Murray, S. Beauvais Cathedral: Architecture of Transcendence. Princeton, NJ: Princeton University Press, 1989.
- Panofsky, E. ed. and trans. Abbot Suger on the Abbey Church of Saint-Denis and Its Art Treasures. 2d ed. Princeton, NJ: Princeton University Press, 1979.
- Gothic Architecture and Scholasticism. Reprint of 1951 ed. New York: New American Library, 1985.
 Parnet, P., ed. Images in Ivory: Precious Objects of the
- Gothic Age. Exh. cat. Detroit, MI: Detroit Institute of Arts, © 1997.
- Sandler, L. Gothic Manuscripts, 1285–1385. Survey of Manuscripts Illuminated in the British Isles. London: Harvey Miller, 1986.
- Scott, R. A. The Gothic Enterprise: A Guide to Understanding the Medieval Cathedral. Berkeley: University of California Press, 2003.
- Simson, O. von. The Gothic Cathedral: Origins of Gothic Architecture and the Medieval Concept of Order. 3d ed. Princeton, NJ: Princeton University Press, 1988.
- Toman, R., and A. Bednorz. *The Art of Gothic: Architecture, Sculpture, Painting.* Cologne: Könemann, 1999.
- Williamson, P. *Gothic Sculpture*, 1140–1300. New Haven: Yale University Press, 1995.
- Wilson, C. The Gothic Cathedral: The Architecture of the Great Church, 1130–1530. 2d rev. ed. London: Thames & Hudson, 2005.

PART THREE: THE RENAISSANCE THROUGH

GENERAL REFERENCES AND SOURCES

- Campbell, L. Renaissance Portraits: European Portrait-Painting in the 14th, 15th, and 16th Centuries. New Haven: Yale University Press, 1990.
- Chastel, A., et al. *The Renaissance: Essays in Interpretation*. London: Methuen, 1982.
- Cloulas, I. Treasures of the French Renaissance. New York: Harry N. Abrams, 1998.
- Cole, A. Art of the Italian Renaissance Courts: Virtue and Magnificence. London: Weidenfeld & Nicolson, 1995.
- Gascoigne, B. How to Identify Prints: A Complete Guide to Manual and Mechanical Processes from Woodcut to Inkjet. New York: Thames & Hudson, 2004.
- Grendler, P. F., ed. *Encyclopedia of the Renaissance*. 6 vols. New York: Scribner's, published in association with the Renaissance Society of America, 1999.
- Gruber, A., ed. The History of Decorative Arts: Vol. 1, The Renaissance and Mannerism in Europe. Vol. 2, Classicism and the Baroque in Europe. New York: Abbeville Press, 1994.
- Harbison, C. The Mirror of the Artist: Northern Renaissance Art in its Historical Context. New York: Harry N. Abrams, 1995.
- Harris, A. S. Seventeenth-Century Art and Architecture. 2d ed. Upper Saddle River, NJ: Pearson Education,
- Hartt, F., and D. Wilkins. History of Italian Renaissance Art. 6th ed. Upper Saddle River, NJ: Pearson Prentice Hall, 2007.
- Hopkins, A. Italian Architecture: from Michelangelo to Borromini. World of Art. New York: Thames & Hudson, 2002.
- Hults, L. The Print in the Western World. Madison: University of Wisconsin Press, 1996.
- Impey, O., and A. MacGregor, eds. The Origins of Museums: The Cabinet of Curiosities in Sixteenthand Seventeenth-Century Europe. New York: Clarendon Press, 1985.

- Ivins, W. M., Jr. How Prints Look: Photographs with a Commentary. Boston: Beacon Press, 1987.
- Landau, D., and P. Parshall. *The Renaissance Print*. New Haven: Yale University Press, 1994.
- Lincoln, E. The Invention of the Italian Renaissance Printmaker. New Haven: Yale University Press, 2000.
- Martin, J. R. *Baroque*. Harmondsworth, England: Penguin, 1989.
- Millon, H. A., ed. *The Triumph of the Baroque:*Architecture in Europe, 1600–1750. New York:
 Rizzoli, 1999.
- Minor, V. H. Baroque & Rococo: Art & Culture. New York: Harry N. Abrams, 1999.
- Norberg-Schultz, C. Late Baroque and Rococo Architecture. New York: Harry N. Abrams, 1983. Olson, R. J. M. Italian Renaissance Sculpture. The
- World of Art. New York: Thames & Hudson, 1992 Paoletti, J., and G. Radke. *Art in Renaissance Italy*. 3d ed. Upper Saddle River, NJ: Pearson Prentice Hall,
- Payne, A. Antiquity and Its Interpreters. New York: Cambridge University Press, 2000.

2006

- Pope-Hennessy, J. An Introduction to Italian Sculpture: Vol. 1, Italian Gothic Sculpture. Vol. 2, Italian Renaissance Sculpture. Vol. 3, Italian High Renaissance and Baroque Sculpture. 4th ed. London: Phaidon Press, 1996.
- Richardson, C. M., K. W. Woods, and M. W. Franklin, eds. Renaissance Art Reconsidered: An Anthology of Primary Sources. Wiley-Blackwell, 2007.
- Smith, J. C. *The Northern Renaissance*. Art & Ideas. London: Phaidon Press, 2004.
- Snyder, J. Northern Renaissance Art: Painting, Sculpture, the Graphic Arts, from 1350–1575. 2d ed. New York: Harry N. Abrams, 2005.
- Strinati, E., and J. Pomeroy. Italian Women Artists of the Renaissance and Baroque. Exh. cat. Washington, DC: National Museum of Women in the Arts; New York: Rizzoli, 2007.
- Tomlinson, J. From Fl Greco to Goya: Painting in Spain 1561–1828. Perspectives. New York: Harry N. Abrams, 1997.
- Turner, J. Éncyclopedia of Italian Renaissance & Mannerist Art. 2 vols. New York: Grove's Dictionaries, 2000.
- Vasari, G. *The Lives of the Artists*. Trans. with an introduction and notes by J. C. Bondanella and P. Bondanella. New York: Oxford University Press, 1998.
- Welch, E. Art in Renaissance Italy, 1350–1500. New ed. Oxford: Oxford University Press, 2000.
- Wiebenson, D., ed. Architectural Theory and Practice from Alberti to Ledoux. 2d ed. Chicago: University of Chicago Press, 1983.
- Wittkower, R. Architectural Principles in the Age of Humanism. 5th ed. New York: St. Martin's Press, 1998

CHAPTER 13. ART IN THIRTEENTH-AND FOURTEENTH-CENTURY ITALY

- Bellosi, L. Duccio, the Maestà. New York: Thames & Hudson, 1999.
- Bomford, D. Art in the Making: Italian Painting Before 1400. Exh. cat. London: National Gallery of Art, 1989.
- Christiansen, K. *Duccio and the Origins of Western Painting*. New York: Metropolitan Museum of Art and Yale University Press, 2009.
- Derbes, A. The Cambridge Companion to Giotto. New York: Cambridge University Press, 2004.
- ., and M. Sandona. The Usurer's Heart: Giotto, Enrico Scrovegni, and the Arena Chapel in Padua. University Park: Pennsylvania State University Press, 2008.
- Kemp, M. Behind the Picture: Art and Evidence in the Italian Renaissance. New Haven: Yale University Press, 1997.
- Maginnis, H. B. J. *The World of the Early Sienese Painter*. With a translation of the Sienese Breve dell'Arte del pittori by Gabriele Erasmi. University Park: Pennsylvania State University Press, 2001.
- Meiss, M. Painting in Florence and Siena after the Black Death: The Arts, Religion, and Society in the Mid-Fourteenth Century. Princeton, NJ: Princeton University Press, 1978, © 1951.

- Nevola, F. Siena: Constructing the Renaissance City. New Haven and London: Yale University Press, 2008.
- Norman, D., ed. Siena, Florence, and Padua: Art, Society, and Religion 1280–1400. New Haven: Yale University Press in association with the Open University, 1995.
- Schmidt, V., ed. *Italian Panel Painting of the Duecento* and *Trecento*. Washington, DC: National Gallery of Art; New Haven: Dist. by Yale University Press, 2002.
- Stubblebine, J. H. Assisi and the Rise of Vernacular Art. New York: Harper & Row, 1985.
- Dugento Painting: An Annotated Bibliography. Boston: G. K. Hall, 1983.
- Trachtenberg, M. Dominion of the Eye: Urbanism, Art, and Power in Early Modern Florence. New York: Cambridge University Press, 2008.
- White, J. Art and Architecture in Italy, 1250–1400. 3d ed. Pelican History of Art. New Haven: Yale University Press, 1993.

CHAPTER 14. ARTISTIC INNOVATIONS IN FIFTEENTH-CENTURY NORTHERN EUROPE

- Ainsworth, M. W., and K. Christiansen. From Van Eyck to Bruegel: Early Netherlandish Painting in the Metropolitan Museum of Art. New York: Metropolitan Museum of Art, 1998.
- Borchert, T., ed. The Age of van Eyck: the Mediterranean World and Early Netherlandish Painting, 1430–1530. New York: Thames & Hudson, 2002.
- Chapuis, J., ed. Tilman Riemenschneider, Master Sculptor of the Late Middle Ages. Washington, DC: National Gallery of Art; New York: Metropolitan Museum of Art; New Haven: Dist. by Yale University Press, 1999.
- Cuttler, C. Northern Painting from Pucelle to Bruegel. Fort Worth: Holt, Rinehart & Winston, 1991,
- De Vos, D. Rogier van der Weyden: The Complete Works. New York: Harry N. Abrams, 1999.
- Dhanens, E. *Hubert and Jan van Eyck*. New York: Alpine Fine Arts Collection, 1980.
- Dixon, L. Bosch. Art & Ideas. London: Phaidon Press, 2003.
- Friedländer, M. Early Netherlandish Painting. 14 vols. New York: Praeger, 1967–1973.
- IIand, J. O., C. Mctzger, and R. Spronk. Prayers and Portraits: Unfolding the Netherlandish Diptych. Exh. cat. Washington DC, National Gallery of Art; New Haven: Yale University Press, 2006.
- Koldeweij, J., ed. Hieronymus Bosch: New Insights into His Life and Work. Rotterdam: Museum Boijmans Van Beuningen: NAi; Ghent: Ludion, 2001.
- Muller, T. Sculpture in the Netherlands, Germany, France, and Spain, 1400–1500. Pelican History of Art. Harmondsworth, England: Penguin, 1966.
- Nuttall, P. From Flanders to Florence: The Impact of Netherlandish Painting, 1400–1500. New Haven: Yale University Press, 2004.
- Pächt, O. Van Eyck and the Founders of Early Netherlandish Painting. London: Harvey Miller, 1994.
- Panofsky, E. Early Netherlandish Painting. 2 vols. New York: Harper & Row, 1971. Orig. published Cambridge, MA: Harvard University Press, 1958.
- Rothstein, B. L. Sight and Spirituality in Early Netherlandish Painting. Cambridge: Cambridge University Press, 2005.
- Van der Velden, H. The Donor's Image: Gérard Loyet and the Votive Portraits of Charles the Bold. Turnhout: Brepols, 2000.
- Williamson, P. Netherlandish Sculpture 1450–1550. London: V & A; New York: Dist. by Harry N. Abrams, 2002.

CHAPTER 15. THE EARLY RENAISSANCE IN ITALY

- Ahl, D. C. *The Cambridge Companion to Masaccio*. New York: Cambridge University Press, 2002.
- Aikema, B. Renaissance Venice and the North: Crosscurrents in the Time of Bellini, Dürer and Titian. Exh. cat. Milan: Bompiani, 2000.
- Ajmar-Wollheim, M., and F. Dennis, eds. At Home in Renaissance Italy. Exh. cat. London: Victoria & Albert Museum; V&A Publications, 2006.

- Alberti, L. B. On Painting. Trans. C. Grayson, introduction and notes M. Kemp. New York: Penguin, 1991.
- On the Art of Building, in Ten Books. Trans. J. Rykwert, et al. Cambridge, MA: MIT Press, 1991. Ames-Lewis, F. Drawing in Early Renaissance Italy. 2d ed. New Haven: Yale University Press, 2000.
- Baxandall, M. Painting and Experience in Fifteenth-Century Italy: A Primer in the Social History of Pictorial Style. 2d ed. New York: Oxford University Press, 1988.
- Blunt, A. Artistic Theory in Italy, 1450-1600. Reprint of 1940 ed. New York: Oxford University Press, 1983.
- Bober, P., and R. Rubinstein. Renaissance Artists and Antique Sculpture: A Handbook of Sources. New York: Oxford University Press, 1986.
- Borsook, E. The Mural Painters of Tuscany: From Cimabue to Andrea del Sarto. 2d ed. New York: Oxford University Press, 1980.
- Cole, B. The Renaissance Artist at Work: From Pisano to Titian. New York: Harper & Row, © 1983.
- Fejfer, J. The Rediscovery of Antiquity: The Role of the Artist. Copenhagen: Museum Tusculanum Press, University of Copenhagen, 2003.
- Gilbert, C. E. Italian Art, 1400–1500: Sources and Documents. Englewood Cliffs, NJ: Prentice Hall, 1980.
- Goldthwaite, R. Wealth and the Demand for Art in Italy, 1300–1600. Baltimore, MD: Johns Hopkins University Press, 1993.
- Gombrich, E. H. New Light on Old Masters. New ed. London: Phaidon Press, 1994.
- Heydenreich, L., and W. Lotz. *Architecture in Italy,* 1400–1500: Rev. ed. Pelican History of Art. New Haven: Yale University Press, 1996.
- Humfreys, P., and M. Kemp, eds. *The Altarpiece in the Renaissance*. New York: Cambridge University Press, 1990
- ., ed. The Cambridge Companion to Giovanni Bellini. New York: Cambridge University Press, 2004.
- Huse, N., and W. Wolters. The Art of Renaissance Venice: Architecture, Sculpture, and Painting, 1460–1590. Chicago: University of Chicago Press, 1990.
- Janson, H. W. *The Sculpture of Donatello*. 2 vols. Princeton, NJ: Princeton University Press, 1979.
- Kempers, B. Painting, Power, and Patronage: The Rise of the Professional Artist in the Italian Renaissance. New York: Penguin, 1992.
- Kent, D. V. Cosimo de' Medici and the Florentine Renaissance: The Patron's Oeuvre. New Haven: Yale University Press, © 2000.
- Krautheimer, R., and T. Krautheimer-Hess. *Lorenzo Ghiberti*. Princeton, NJ: Princeton University Press,
 1982
- Lavin, M. A. Piero della Francesca. Art & Ideas. New York: Phaidon Press, 2002.
- Murray, P. *The Architecture of the Italian Renaissance*. New rev. ed. The World of Art. New York: Random House, 1997.
- Musacchio, J. M. Art, Marriage, and Family in the Florentine Renaissance Palace. New Haven: Yale University Press, 2009.
- Pächt, O. Venetian Painting in the 15th Century: Jacopo, Gentile and Giovanni Bellini and Andrea Mantegna. London: Harvey Miller, 2003.
- Panofsky, E. *Perspective as Symbolic Form*. New York: Zone Books, 1997.
- Renaissance and Renascences in Western Art.

 Trans. C. S. Wood. New York: Humanities Press, 1970.
 Pope-Hennessy, J. Italian Renaissance Sculpture. 4th ed.
- London: Phaidon Press, 2000.

 Randolph, A. Engaging Symbols: Gender, Politics, and Public Art in Fifteenth-Century Florence. New Haven: Yale University Press, 2002.
- Saalman, H. Filippo Brunelleschi: The Buildings. University Park: Pennsylvania State University Press, 1993.
- Seymour, C. Sculpture in Italy, 1400–1500. Pelican History of Art. Harmondsworth, England: Penguin, 1966.
- Turner, A. R. Renaissance Florence. Perspectives. New York: Harry N. Abrams, 1997.
- Wackernagel, M. The World of the Florentine Renaissance Artist: Projects and Patrons, Workshop and Art Market. Princeton, NJ: Princeton University Press, 1981.

Wood, J. M., ed. The Cambridge Companion to Piero della Francesca. New York: Cambridge University Press, 2002.

CHAPTER 16. THE HIGH RENAISSANCE IN ITALY, 1495-1520

Ackerman, J., The Architecture of Michelangelo. 2d ed. Chicago: University of Chicago Press, 1986. Beck, J. H. *Three Worlds of Michelangelo*. New York:

W. W. Norton, 1999.

Boase, T. S. R. Giorgio Vasari: The Man and the Book Princeton, NJ: Princeton University Press, 1979.

Brown, P. F. Art and Life in Renaissance Venice Perspectives. New York: Harry N. Abrams, 1997.

Venice and Antiquity: The Venetian Sense

of the Past. New Haven: Yale University Press,

1997

- Chapman, H. Raphael: From Urbino to Rome. London: National Gallery; New Haven: Dist. by Yale University Press, 2004.
- Clark, K. Leonardo da Vinci. Rev. and introduced by M. Kemp. New York: Penguin, 1993, © 1988.
- Cole, A. Virtue and Magnificence: Art of the Italian Renaissance Courts. Perspectives. New York: Harry N. Abrams, 1995.
- De Tolnay, C. Michelangelo. 5 vols. Some vols. rev. Princeton, NJ: Princeton University Press,
- Freedberg, S. Painting in Italy, 1500-1600. 3d ed. Pelican History of Art. New Haven: Yale University Press, 1993.
- -. Painting of the High Renaissance in Rome and Florence. 2 vols. New rev. ed. New York: Hacker Art Books, 1985.
- Goffen, R. Renaissance Rivals: Michelangelo, Leonardo, Raphael, Titian. New Haven: Yale University Press,
- Hall, M. B. The Cambridge Companion to Raphael. New York: Cambridge University Press, 2005.
- Hersey, G. L. High Renaissance Art in St. Peter's and the Vatican: An Interpretive Guide. Chicago: University of Chicago Press, 1993.
- Hibbard, H. Michelangelo. 2d ed. Boulder, CO: Westview Press, 1998, © 1974.
- Kemp, M. Leonardo. New York: Oxford University Press, 2004.
- ., ed. Leonardo on Painting: An Anthology of Writings. New Haven: Yale University Press, 1989. Nicholl, C. Leonardo da Vinci: Flights of the Mind.

New York: Viking Penguin, 2004.

- Panofsky, E. Studies in Iconology: Humanist Themes in the Art of the Renaissance. New York: Harper & Row, 1972.
- Partridge, L. *The Art of Renaissance Rome*. Perspectives. New York: Harry N. Abrams, 1996.
- Rowland, I. The Culture of the High Renaissance: Ancients and Moderns in Sixteenth Century Rome. Cambridge: 1998.
- Rubin, P. L. Giorgio Vasari: Art and History. New Haven: Yale University Press, 1995.
- Steinberg, L. Leonardo's Incessant Last Supper. New York: Zone Books, 2001.
- Wallace, W. Michelangelo: The Complete Sculpture, Painting, Architecture. Southport, CT: Hugh Lauter
- Wölfflin, H. Classic Art: An Introduction to the High Renaissance. 5th ed. London: Phaidon Press, 1994.

CHAPTER 17. THE LATE RENAISSANCE AND MANNERISM

- Ackerman, J. Palladio. Reprint of the 2d ed. Harmondsworth, England: Penguin, 1991, © 1966.
- Barkan, L. Unearthing the Past: Archaeology and Aesthetics in the Making of Renaissance Culture. New Haven: Yale University Press, 1999.
- Beltramini, G., and A. Padoan. Andrea Palladio: The Complete Illustrated Works. New York: Universe; Dist. by St. Martin's Press, 2001.
- Cole, M., ed. Sixteenth-Century Italian Art. Oxford: Blackwell, 2006.
- Ekserdjian, D. Correggio. New Haven: Yale University Press, 1997.
- Fortini Bown, P. Private Lives in Renaissance Venice: Art, Architecture, and the Family. New Haven: Yale University Press, 2004.

- Friedlaender, W. Mannerism and Anti-Mannerism in Italian Painting. Reprint of 1957 ed. Interpretations in Art. New York: Columbia University Press, 1990.
- Furlotti, B., and G. Rebecchini. The Art and Architecture of Mantua: Eight Centuries of Patronage and Collecting. London: Thames & Hudson, 2008.

Goffen, R. Titian's Women. New Haven: Yale University Press, 1997.

- Jacobs, F. H. Defining the Renaissance "Virtuosa": Women Artists and the Language of Art History and Criticism. New York: Cambridge University Press, 1997.
- Klein, R., and H. Zerner. Italian Art, 1500-1600: Sources and Documents. Reprint of 1966 ed. Evanston, IL: Northwestern University Press, 1989.
- Kliemann, J., and M. Rohlmann. Italian Frescoes: High Renaissance and Mannerism, 1510-1600. New York: Abbeville Press, 2004.
- Partridge, L. Michelangelo-The Last Judgment: A Glorious Restoration. New York: Harry N. Abrams,
- Rearick, W. R. The Art of Paolo Veronese, 1528-1588. Cambridge: Cambridge University Press, 1988.
- Rosand, D. Painting in Sixteenth-Century Venice: Titian, Veronese, Tintoretto. New York: Cambridge University Press, 1997.
- Shearman, J. K. G. Mannerism. New York: Penguin Books, 1990, © 1967.
- Smyth, C. H. Mannerism and Maniera. 2d ed. Bibliotheca artibus et historiae. Vienna: IRSA, 1992.
- Tavernor, R. Palladio and Palladianism. The World of Art. New York: Thames & Hudson, 1991. Valcanover, F., and T. Pignatti. Tintoretto. New York:
- Harry N. Abrams, 1984. Wundram, M. Palladio: The Complete Buildings. Köln and London: Taschen, 2004.

CHAPTER 18. EUROPEAN ART OF THE SIXTEENTH CENTURY: RENAISSANCE AND REFORMATION

- Bartrum, G. Albrecht Dürer and His Legacy: The Graphic Work of a Renaissance Artist. Princeton, NJ: Princeton University Press, 2002.
- Baxandall, M. The Limewood Sculptors of Renaissance Germany. New Haven: Yale University Press, 1980.
- Campbell, T. P. Tapestry in the Renaissance: Art and Magnificence. Exh. cat. New York: Metropolitan Museum of Art; New Haven: Yale University Press,
- Eichberger, D., ed. Durer and His Culture. New York: Cambridge University Press, 1998.
- Hayum, A. The Isenheim Altarpiece: God's Medicine and the Painter's Vision. Princeton, NJ: Princeton University Press, 1989.
- Hitchcock, H.-R. German Renaissance Architecture. Princeton, NJ: Princeton University Press, 1981.
- Honig, E. A. Painting and the Market in Early Modern Antwerp. New Haven: Yale University Press, 1998.
- Hulse, C. Elizabeth I: Ruler and Legend. Urbana: Published for the Newberry Library by the University of Illinois Press, 2003.
- Hutchison, J. C. Albrecht Dürer: A Biography. Princeton, NJ: Princeton University Press, 1990.
- Jopek, N. German Sculpture, 1430-1540: A Catalogue of the Collection in the Victoria and Albert Museum. London: V & A, 2002.
- Kavaler, E. M. Pieter Bruegel: Parables of Order and Enterprise. New York: Cambridge University Press,
- Koerner, J. The Moment of Self-Portraiture in German Renaissance Art. Chicago: University of Chicago Press, 1993.
- The Reformation of the Image. Chicago: University of Chicago Press, 2004. Mann, R. El Greco and His Patrons: Three Major
- Projects. New York: Cambridge University Press, 1986.
- Melion, W. Shaping the Netherlandish Canon: Karel van Mander's Schilder-Boeck. Chicago: University of Chicago Press, 1991.
- Moxey, K. Peasants, Warriors, and Wives: Popular Imagery in the Reformation. Chicago: University of Chicago Press, 1989.
- Osten, G. von der, and H. Vey. Painting and Sculpture in Germany and the Netherlands, 1500-1600. Pelican History of Art. Harmondsworth, England: Penguin, 1969.

- Panofsky, E. The Life and Art of Albrecht Dürer. 4th ed. Princeton, NJ: Princeton University Press, 1971.
- Smith, J. C. Nuremberg: A Renaissance City, 1500-1618. Austin: Published for the Archer M. Huntington Art Gallery by the University of Texas Press, 1983
- Stechow, W. Northern Renaissance Art, 1400-1600: Sources and Documents. Evanston, IL: Northwestern University Press, 1989, © 1966.
- Van Mander, K. Lives of the Illustrious Netherlandish and German Painters. Ed. H. Miedema. 6 vols. Doornspijk, Netherlands: Davaco, 1993–1999.
- Wood, C. Albrecht Altdorfer and the Origins of Landscape. Chicago: University of Chicago Press, 1993.
- Zerner, H. Renaissance Art in France: The Invention of Classicism. Paris: Flammarion; London: Thames & Hudson, 2003

CHAPTER 19. THE BAROQUE IN ITALY AND SPAIN

- Avery, C. Bernini: Genius of the Baroque. London: Thames & Hudson, 1997
- Bissell, R. W. Masters of Italian Baroque Painting: The Detroit Institute of Arts. Detroit, MI: Detroit Institute of Arts in association with D. Giles Ltd.,
- Brown, B. L., ed. The Genius of Rome, 1592-1623. Exh. cat. London: Royal Academy of Arts; New York: Dist. in the United States and Canada by Harry N. Abrams, 2001.
- Brown, J. Francisco de Zurbaran. New York: Harry N. Abrams, 1991.
- . Painting in Spain, 1500-1700. Pelican History of Art. New Haven: Yale University Press, 1998.

 ——. Velázquez: The Technique of Genius. New Haven: Yale University Press, 1998.
- Dempsey, C. Annibale Carracci and the Beginnings of Baroque Style. 2d ed. Fiesole, Italy: Cadmo, 2000.
- Enggass, R., and J. Brown. Italy and Spain, 1600-1750: Sources and Documents. Reprint of 1970 ed. Evanston, IL: Northwestern University Press, 1992.
- Freedberg, S. Circa 1600: A Revolution of Style in Italian Painting. Cambridge, MA: Harvard University Press, 1983.
- Garrard, M. D. Artemisia Gentileschi: The Image of the Female Hero in Italian Baroque Art. Princeton, NJ: Princeton University Press, 1989.
- Marder, T. A. Bernini and the Art of Architecture. New York: Abbeville Press, 1998.
- Montagu, J. Roman Baroque Sculpture: The Industry of Art. New Haven: Yale University Press, 1989.
- Nicolson, B. Caravaggism in Europe. Ed. L. Vertova. 3 vols. 2d ed., rev. and enl. Turin, Italy: Allemandi,
- Schroth, S., R. Baer, et al. El Greco to Velázquez: Art During the Reign of Philip III. Exh. cat. Boston: Museum of Fine Arts; MFA Publications, 2008.
- Smith, G. Architectural Diplomacy: Rome and Paris in the Late Baroque. Cambridge, MA: MIT Press, 1993.
- Spear, R. E. From Caravaggio to Artemisia: Essays on Painting in Seventeenth-Century Italy and France. London: Pindar Press, 2002.
- Spike, J. T. Caravaggio. Includes CD-ROM of all the known paintings of Caravaggio, including attributed and lost works. New York: Abbeville Press, @ 2001.
- Varriano, J. Italian Baroque and Rococo Architecture. New York: Oxford University Press, 1986. Wittkower, R. Art and Architecture in Italy, 1600-1750.
- 4th ed. Pelican History of Art. New Haven: Yale University Press, 2000
- . Bernini: The Sculptor of the Roman Baroque. 4th ed. London: Phaidon Press, 1997.

CHAPTER 20. THE BAROQUE IN FLANDERS AND HOLLAND

- Alpers, S. The Art of Describing: Dutch Art in the Seventeenth Century. Chicago: University of Chicago Press, 1983.
- Chapman, H. P. Rembrandt's Self-Portraits: A Study in Seventeenth-Century Identity. Princeton, NJ: Princeton University Press, 1990.
- Fleischer, R., ed. Rembrandt, Rubens, and the Art of Their Time: Recent Perspectives. University Park: Pennsylvania State University, 1997.

- Franits, W. E. Dutch Seventeenth-Century Genre Painting: Its Stylistic and Thematic Evolution. New Haven: Yale University Press, 2004.
- Grijzenhout, F., ed. The Golden Age of Dutch Painting in Historical Perspective. New York: Cambridge University Press, 1999.
- Kiers, J. and E. Runia, eds. The Glory of the Golden Age: Dutch Art of the 17th Century. 2 vols. Exh. cat. Rijksmuseum, Amsterdam: Waanders: 2000.

Logan, A. S. Peter Paul Rubens: The Drawings. Exh. cat. New York: Metropolitan Museum of Art; New Haven: Yale University Press, 2004.

Salvesen, S., ed. Rembrandt: The Master and His Workshop. 2 vols. Exh. cat. New Haven: Yale University Press, 1991.

Schama, S. The Embarrassment of Riches: An Interpretation of Dutch Culture in the Golden Age. New York: Alfred A. Knopf, 1987.

Schwartz, G. Rembrandt: His Life, His Paintings. New

York: Viking, 1985.

- Slive, S. Dutch Painting, 1600-1800. Pelican History of Art. New Haven: Yale University Press, 1995. Frans Hals. Exh. cat. Munich: Prestel-Verlag,
- Jacob van Ruisdael: Master of Landscape.
- London: Royal Academy of Arts, 2005.
- Sluiter, E. I. Rembrandt and the Female Nude. Amsterdam University Press, 2006.
- Sutton, P. The Age of Rubens. Exh. cat. Boston: Museum of Fine Arts, 1993.
- Vlieghe, H. Flemish Art and Architecture, 1585-1700. Pelican History of Art. New Haven: Yale University Press, © 1998.
- Westermann, M. Art and Home: Dutch Interiors in the Age of Rembrandt. Exh. cat. Zwolle: Waanders, 2001. Rembrandt. Art & Ideas. London: Phaidon Press, 2000.
- A Worldly Art: The Dutch Republic 1585-1718. Perspectives. New York: Harry N. Abrams, 1996.

Wheelock, A. K., ed. Johannes Vermeer. Exh. cat. New Haven: Yale University Press, 1995.

., et al. Anthony van Dyck. Exh. cat. New York: Harry N. Abrams, 1990.

White, C. Peter Paul Rubens. New Haven: Yale University Press, 1987.

CHAPTER 21. THE BAROQUE IN FRANCE AND **ENGLAND**

- Blunt, A. Art and Architecture in France, 1500-1700. 5th ed. Pelican History of Art. New Haven: Yale University Press, 1999.
- Brusatin, M., et al. The Baroque in Central Europe: Places, Architecture, and Art. Venice: Marsilio, 1992. Donovan, F. Ruhens and England. New Haven:
- Published for The Paul Mellon Centre for Studies in British Art by Yale University Press, 2004. Downes, K. *The Architecture of Wren*. Rev. ed. Reading,
- England: Redhedge, 1988.
- Garreau, M. Charles Le Brun: First Painter to King Louis XIV. New York: Harry N. Abrams, 1992.
- Kitson, M. Studies on Claude and Poussin. London: Pindar, 2000.
- Lagerlöf, M. R. Ideal Landscape: Annibale Carracci, Nicolas Poussin, and Claude Lorrain. New Haven: Yale University Press, 1990.
- Mérot, A. French Painting in the Seventeenth Century. New Haven: Yale University Press, 1995
- . Nicolas Poussin. New York: Abbeville Press,
- Porter, R. London: A Social History. Cambridge, MA: Harvard University Press, 1995.
- Rosenberg, P., and K. Christiansen, eds. Poussin and Nature: Arcadian Visions. Exh. cat. New York: Metropolitan Museum of Art; New Haven: Yale University Press, 2008.
- Summerson, J. Architecture in Britain, 1530-1830. Rev. 9th ed. Pelican History of Art. New Haven: Yale University Press, 1993.
- Tinniswood, A. His Invention So Fertile: A Life of Christopher Wren. New York: Oxford University Press, 2001.
- Verdi, R. Nicolas Poussin 1594-1665. London: Zwemmer in association with the Royal Academy of Arts, 1995.
- Vlnas, V., ed. The Glory of the Baroque in Bohemia: Essays on Art, Culture and Society in the 17th and 18th Centuries. Prague: National Gallery, 2001.

- Waterhouse, E. K. The Dictionary of Sixteenth and Seventeenth Century British Painters. Woodbridge, Suffolk, England: Antique Collectors' Club, 1988
- . Painting in Britain, 1530-1790. 5th ed. Pelican History of Art. New Haven: Yale University Press,
- Whinney, M. D. Wren. World of Art. New York: Thames & Hudson, 1998.

CHAPTER 22. THE ROCOCO

- Bailey, C. B. The Age of Watteau, Chardin, and Fragonard: Masterpieces of French Genre Painting. New Haven: Yale University Press in association with the National Gallery of Canada, 2003.
- Brunel, G. Boucher. New York: Vendome, 1986. Painting in Eighteenth-Century France. Ithaca, NY: Cornell University Press, 1981.
- Cuzin, J. P. Jean-Honoré Fragonard: Life and Work: Complete Catalogue of the Oil Paintings. New York: Harry N. Abrams, 1988.
- François Boucher, 1703-1770. Exh. cat. New York: Metropolitan Museum of Art, © 1986.
- Gaunt, W. The Great Century of British Painting. Hogarth to Turner. 2d ed. London: Phaidon Press, 1978.
- Kalnein, W. von. Architecture in France in the Eighteenth Century. Pelican History of Art. New Haven: Yale University Press, 1995.
- Levey, M. Giambattista Tiepolo: His Life and Art. New Haven: Yale University Press, 1986.
- Painting and Sculpture in France, 1700–1789. New ed. Pelican History of Art. New Haven: Yale University Press, 1993.
- Painting in Eighteenth-Century Venice. 3d ed. Pelican History of Art. New Haven: Yale University Press, 1993.
- Rococo to Revolution: Major Trends in Eighteenth-Century Painting. Reprint of 1966 ed. The World of Art. New York: Thames & Hudson, 1985
- Links, J. G. Canaletto. Completely rev., updated, and enl. ed. London: Phaidon Press, 1994.
- Paulson, R. Hogarth. 3 vols. New Brunswick: Rutgers University Press, 1991-1993.
- Pointon, M. Hanging the Head: Portraiture and Social Formation in Eighteenth-Century England. New Haven: Yale University Press, 1993.
- Posner, D. Antoine Watteun. Ithaca, NY: Cornell University Press, 1984.
- Rococo to Romanticism: Art and Architecture, 1700-1850. Garland Library of the History of Art. New York: Garland, 1976.
- Rosenberg, P. Chardin. Exh. cat. London: Royal Academy of Art; New York: Metropolitan Museum of Art, 2000.
- —. From Drawing to Painting: Poussin, Watteau, Fragonard, David & Ingres. Princeton, NJ: Princeton University Press, 2000.
- Scott, K. The Rococo Interior: Decoration and Social Spaces in Early Eighteenth-Century Paris. New Haven: Yale University Press, 1995.
- Sheriff, M. D. The Exceptional Woman: Elisabeth Vigée-Lebrun and the Cultural Politics of Art. Chicago: University of Chicago Press, 1996
- Wintermute, A. Watteau and His World: French Drawing from 1700 to 1750. Exh. cat. London: Merrell Holberton; New York: American Federation of Arts, 1999.

PART FOUR: THE MODERN WORLD

GENERAL REFERENCES

- Arnason, H. H. History of Modern Art: Painting, Sculpture, Architecture, Photography. 5th ed. Upper Saddle River, NJ: Pearson Prentice Hall, 2004
- Atkins, R. Artspoke: A Guide to Modern Ideas, Movements, and Buzzwords, 1848-1944. New York: Abbeville Press, 1993.
- Baigell, M. A Concise History of American Painting and Sculpture. Rev. ed. New York: Icon Editions, 1996. Banham, R. Theory and Design in the First Machine Age.
- 2d ed. Cambridge, MA: MIT Press, 1980, © 1960. Bearden, R., and H. Henderson. A History of African-
- American Artists from 1792 to the Present. New York: Pantheon, 1993.

- Bergdoll, B. European Architecture 1750-1890. Oxford History of Art. New York: Oxford University Press, 2000.
- Bjelajac, D. American Art: A Cultural History. Upper Saddle River, NJ: Pearson Prentice Hall, 2005
- Boime, A. A Social History of Modern Art. Vol. 1, Art in the Age of Revolution, 1750-1800. Vol. 2, Art in the Age of Bonapartism, 1800-1815. Vol. 3, Art in the Age of Counterrevolution, 1815-1848. Chicago: University of Chicago Press, 1987-2004.
- Bown, M. C. A Dictionary of Twentieth Century Russian and Soviet Painters 1900-1980s. London: Izomar, 1998.
- Campany, D., ed. Art and Photography. Themes and Movements. London: Phaidon Press, 2003.
- Castelman, R. Prints of the Twentieth Century: A History. Rev. ed. London: Thames & Hudson, 1988.
- Chiarmonte, P. Women Artists in the United States: A Selective Bibliography and Resource Guide to the Fine and Decorative Arts, 1750-1986. Boston: G. K. Hall, 1990.
- Chilvers, I. A Dictionary of Twentieth-Century Art. New York: Oxford University Press, 1998.
- Chipp, H., ed. Theories of Modern Art: A Source Book by Artists and Critics. Berkeley: University of California Press, 1968.
- Colquhoun, A. Modern Architecture. New York: Oxford University Press, 2002.
- Crary, J. Techniques of the Observer: On Vision and Modernity in the Nineteenth Century. Cambridge, MA: MIT Press, 1990.
- Craven, W. American Art: History and Culture. New York: Harry N. Abrams, 1994.
- Crook, J. The Dilemma of Style: Architectural Ideas from the Picturesque to the Post Modern. Chicago: University of Chicago Press, 1987.
- Crow, T. Modern Art in the Common Culture. New Haven: Yale University Press, 1996.
- Cummings, P. Dictionary of Contemporary American Artists. New York: St. Martin's Press, 1988.
- Documents of Modern Art. 14 vols. New York: Wittenborn, 1944-1961. Anthologies of primary source material. Selected titles listed individually, below.
- The Documents of Twentieth-Century Art. Boston: G. K. Hall, Anthologies of primary source material. Selected titles listed individually, below.
- Doss, E. Twentieth-Century American Art. Oxford History of Art. New York: Oxford University Press,
- Drucker, J. The Century of Artists' Books. New York: Granary Books, 2004
- Eisenman, S. Nineteenth Century Art: A Critical History. New York: Thames & Hudson, 2002.
- Eitner, L. An Outline of Nineteenth-Century European Painting: From David Through Cézanne. 2 vole. New York: Harper & Row, 1986.
- Elderfield, J., ed. Modern Painting and Sculpture: 1880 to the Present at the Museum of Modern Art. New York: Museum of Modern Art; Dist. by D.A.P./Distributed Art Publishers, 2004.
- Evans, M. M., ed. Contemporary Photographers. 3d ed. New York: St. James Press, 1995.
- Farrington, L. E. Creating Their Own Image: The History of African-American Women Artists. New York: Oxford University Press, 2005.
- Frampton, K. Modern Architecture: A Critical History. 3d ed. New York: Thames & Hudson, 1992.
- Frascina, F. and J. Harris, eds. Art in Modern Culture: An Anthology of Critical Texts. New York: Harper & Row, 1992.
- Gaiger, J., ed. Art of the Twentieth Century: A Reader. New Haven: Yale University Press in association with the Open University, 2003.
- . Frameworks for Modern Art. New Haven: Yale University Press in association with the Open University, 2003.
- Goldberg, R. Performance Art: From Futurism to the Present. Rev. and exp. ed. The World of Art. New York: Thames & Hudson, 2001.
- Goldwater, R. Primitivism in Modern Art. Enl. ed. Cambridge: Harvard University Press, 1986.
- Gray, J. Action Art: A Bibliography of Artists' Performance from Futurism to Fluxus and Beyond. Westport, CT: Greenwood Press, 1993.
- Harrison, C., and P. Wood, eds. Art in Theory 1815-1900: An Anthology of Changing Ideas. Malden, MA: Blackwell, 1998.

——. Art in Theory, 1900–2000: An Anthology of Changing Ideas. New ed. Malden, MA: Blackwell, 2003.

Heller, N. Women Artists: An Illustrated History. New York: Abbeville Press. 2003.

York: Abbeville Press, 2003. Hertz, R., ed. *Theories of Contemporary Art.* 2d ed. Englewood Cliffs, NJ: Prentice Hall, 1993.

., and N. Klein, eds. Twentieth-Century Art Theory: Urbanism, Politics, and Mass Culture. Englewood Cliffs, NJ: Prentice Hall, 1990.

Hitchcock, H. R. Architecture: Nineteenth and Twentieth Centuries. 4th rev. ed. Pelican History of Art. New Haven: Yale University Press, 1987, © 1977.

Hughes, R. American Visions: The Epic History of Art in America. New York: Alfred A. Knopf, 1997.

Hunter, S., and J. Jacobus. *Modern Art: Painting, Sculpture, Architecture*. 3d rev. ed. New York: Harry N. Abrams, 2000.

Igoe, L. 250 Years of Afro-American Art: An Annotated Bibliography. New York: Bowker, 1981.

Joachimides, C., et al. American Art in the Twentieth Century: Painting and Sculpture, 1913–1933. Exh. cat. Munich: Prestel, 1993.

Johnson, W. Nineteenth-Century Photography: An Annotated Bibliography, 1839–1879. Boston: G. K. Hall, 1990.

Kostelanetz, R. A Dictionary of the Avant-Gardes. New York: Routledge, 2001.

Lewis, S. African American Art and Artists. Berkeley: University of California Press, 1990.

Marien, M. *Photography: A Cultural History*. Upper Saddle River, NJ: Pearson Prentice Hall, 2002.

McCoubrey, J. American Art, 1700–1960: Sources and Documents. Englewood Cliffs, NJ: Prentice Hall, 1965.

Meikle, J. L. *Design in the USA*. Oxford History of Art. New York: Oxford University Press, 2005.

Modern Arts Criticism. 4 vols. Detroit, MI: Gale Research, 1991–1994.

Newhall, B. *The History of Photography from 1830 to the Present*. Rev. and enl. 5th ed. New York: Museum of Modern Art; Dist. by Bulfinch Press/Little, Brown, 1999.

Nochlin, L. The Politics of Vision: Essays on Nineteenth-Century Art and Society. New York: Harper & Row, 1989.

Osborne, H., ed. Oxford Companion to Twentieth-Century Art. Reprint. New York: Oxford University Press, 1990.

Patton, S. F. African-American Art. Oxford History of Art. New York: Oxford University Press,

Pevsner, N. Pioneers of Modern Design: From William Morris to Walter Gropius. 4th ed. New Haven: Yale University Press, 2005.

Piland, S. Women Artists: An Historical, Contemporary, and Feminist Bibliography. Metuchen, NJ: Scarecrow Press, 1994.

Powell, R. J. Black Art and Culture in the 20th Century. New York: Thames & Hudson, 1997.

Robinson, Hilary. Feminism-Art-Theory: An Anthology, 1968–2000. Oxford and Malden, MA: Blackwell, 2001.

Rose, B. American Art Since 1900. Rev. ed. New York: Praeger, 1975.

— . American Painting: The Twentieth Century. New updated ed. New York: Rizzoli, 1986.

Rosenblum, N. A World History of Photography. 3rd ed. New York: Abbeville Press, 1997.

Rosenblum, R., and H. W. Janson. 19th Century Art. Rev. and updated ed. Upper Saddle River, NJ: Pearson Prentice Hall, 2005.

Schapiro, M. Modern Art: Nineteenth and Twentieth Centuries. New York: Braziller, 1982.

Scharf, A. Art and Photography. Reprint. Harmondsworth, England: Penguin, 1995

Sennott, S., ed. *Encyclopedia of 20th Century Architecture*. 3 vols. New York: Fitzroy Dearborn, 2004.

Stiles, K., and P. Selz. Theories and Documents of Contemporary Art. Berkeley: University of California Press, 1996.

Tafuri, M. Modern Architecture. 2 vols. New York: Rizzoli, 1986.

Taylor, J. The Fine Arts in America. Chicago: University of Chicago Press, 1979. ., ed. Nineteenth-Century Theories of Art. California Studies in the History of Art. Berkeley: University of California Press, 1987.

Tomlinson, J. Readings in Nineteenth-Century Art.
Upper Saddle River, NJ: Prentice Hall, 1995.

Upton, D. Architecture in the United States. New York: Oxford University Press, 1998.

Varnedoe, K., and A. Gopnik, eds. Modern Art and Popular Culture: Readings in High and Low. New York: Harry N. Abrams, 1990.

Waldman, D. Collage, Assemblage, and the Found Object. New York: Harry N. Abrams, 1992. Weaver, M. The Art of Photography, 1839–1989. Exh.

cat. New Haven: Yale University Press, 1989. Wilmerding, J. American Views: Essays on American Art. Princeton, NJ: Princeton University Press, 1991.

Witzling, M., ed. Voicing Our Visions: Writings by Women Artists. New York: Universe, 1991.

CHAPTER 23. ART IN THE AGE OF THE ENLIGHTENMENT, 1750-1789

Bryson, N. Tradition and Desire: From David to Delacroix. Cambridge: Cambridge University Press, 1984.

— Word and Image: French Painting in the Ancient Régime. Cambridge: Cambridge University Press, 1981.

Crow, T. Painters and Public Life in Eighteenth-Century Paris. New Haven: Yale University Press, 1985.

Eitner, L. E. A. Neoclassicism and Romanticism, 1750–1850: Sources and Documents. Reprint of 1970 ed. New York: Harper & Row, 1989. Fried, M. Absorption and Theatricality: Painting and

Fried, M. Absorption and Theatricality: Painting and Beholder in the Age of Diderot. Chicago: University of Chicago Press, 1980.

Friedlaender, W. *David to Delacroix*. Reprint of 1952 ed. New York: Schocken Books, 1968.

Goncourt, E. de, and J. de Goncourt. French Eighteenth-Century Painters. Reprint of 1948 ed. Ithaca, NY: Cornell University Press, 1981.

Honour, H. Neoclassicism. Reprint of 1968 ed. London: Penguin, 1991.

Irwin, D. G. *Neoclassicism*. Art & Ideas. London: Phaidon Press, 1997.

 Licht, F. Canova. New York: Abbeville Press, 1983.
 Miles, E. G., ed. The Portrait in Eighteenth-Century America. Newark: University of Delaware Press, 1993.

Ottani Cavina, A. Geometries of Silence: Three Approaches to Neoclassical Art. New York: Columbia University Press, 2004.

Picon, A. French Architects and Engineers in the Age of Enlightenment. New York: Cambridge University Press, 1992.

Rebora, C., et al. *John Singleton Copley in America*. Exh. cat. New York: The Metropolitan Museum of Art. 1995.

Rosenblum, R. Transformations in Late Eighteenth Century Art. Princeton, NJ: Princeton University Press, 1967.

Rosenthal, M., ed. Prospects for the Nation: Recent Essays in British Landscape, 1750–1880. Studies in British Art. New Haven: Yale University Press, © 1997.

Saisselin, R. G. The Enlightenment Against the Baroque: Economics and Aesthetics in the Eighteenth Century. Berkeley: University of California Press, 1992.

Solkin, D. Painting for Money: The Visual Arts and the Public Sphere in Eighteenth-Century England. New Haven: Yale University Press, 1993.

Vidler, A. The Writing of the Walls: Architectural Theory in the Late Enlightenment. Princeton, NJ: Princeton Architectural Press, 1987.

Watkin, D., and T. Mellinghoff. German Architecture and the Classical Ideal. Cambridge: MIT Press, 1987.

CHAPTER 24. ART IN THE AGE OF ROMANTICISM, 1789-1848

Boime, A. *The Academy and French Painting in the Nineteenth Century*. New ed. New Haven: Yale University Press, 1986.

Brown, D. B. *Romanticism*. Art & Ideas. New York: Phaidon Press, 2001.

Chu, P. Nineteenth-Century European Art. Upper Saddle River, NJ: Pearson Prentice Hall, 2002.

Eitner, L. E. A. Géricault: His Life and Work. Ithaca, NY: Cornell University Press, 1982.

Hartley, K. *The Romantic Spirit in German Art*, 1790–1990. Exh. cat. London: South Bank Centre, © 1994.

Herrmann, L. Nineteenth Century British Painting. London: Giles de la Mare, 2000.

Honour, H. Romanticism. New York: Harper & Row, 1979.

Johnson, E. The Paintings of Eugène Delacroix: A Critical Catalogue, 1816–1863. 6 vols. Oxford: Clarendon Press, 1981–1989.

— The Paintings of Eugène Delacroix: A Critical Catalogue. 4th supp. and reprint of 3d supp. New York: Oxford University Press, 2002.

Joll, E. The Oxford Companion to J. M. W. Turner. Oxford: Oxford University Press, 2001.

Koerner, J. Caspar David Friedrich and the Subject of Landscape. New Haven: Yale University Press, 1990.

Licht, F. Goya: The Origins of the Modern Temper in Art. New York: Harper & Row, 1983.

Middleton, R. Architecture of the Nineteenth Century. Milan: Electa, © 2003.

Noon, P. J. Crossing the Channel: British and French Painting in the Age of Romanticism. Exh. cat. London: Tate, 2003.

Novak, B. Nature and Culture: American Landscape and Painting, 1825–1875. Rev. ed. New York: Oxford University Press, 1995.

Novotny, F. Painting and Sculpture in Europe, 1780–1880. 3d ed. Pelican History of Art. New Haven: Yale University Press, 1992.

Pérez Sánchez, A., and E. A. Sayre. Goya and the Spirit of Enlightenment. Exh. cat. Boston: Bulfinch Press, 1989

Rosenblum, R. Jean-Auguste-Dominique Ingres. New York: Harry N. Abrams, 1990.

Tomlinson, J. Goya in the Twilight of Enlightenment. New Haven: Yale University Press, 1992.

Vaughn, W. *Romanticism and Art*. World of Art. London: Thames & Hudson, © 1994.

CHAPTER 25. THE AGE OF POSITIVISM: REALISM, IMPRESSIONISM, AND THE PRE-RAPHAELITES, 1848-1885

Adriani, G. *Renoir*. Cologne: Dumont; Dist. by Yale University Press, 1999.

Broude, N. *Impressionism: A Feminist Reading*. New York: Rizzoli, 1991.

Cachin, F., et al. *Cézanne*. Exh. cat. New York: Harry N. Abrams, 1995.

Cikovsky, N., and F. Kelly. Winslow Homer. Exh. cat. New Haven: Yale University Press, 1995.

Clark, T. J. The Absolute Bourgeois: Artists and Politics in France, 1848–1851. Berkeley: University of California Press, 1999, © 1973.

Denvir, B. The Chronicle of Impressionism: A Timeline History of Impressionist Art. London: Thames & Hudson, 2000, © 1993.

— The Thames & Hudson Encyclopaedia of Impressionism. New York: Thames & Hudson, 1990. Elsen, A. Origins of Modern Sculpture. New York: Braziller, 1974.

Fried, M. Courbet's Realism. Chicago: University of Chicago Press, 1990.

— Manet's Modernism, or, The Face of Painting in the 1860s. Chicago: University of Chicago Press, 1996. Goodrich, L. Thomas Eakins. 2 vols. Exh. cat.

Cambridge, MA: Harvard University Press, 1982. Gray, C. *The Russian Experiment in Art, 1863–1922.* Rev. ed. The World of Art. New York: Thames &

Rev. ed. The World of Art. New York: Thames & Hudson, 1986. Hamilton, G. H. *Manet and His Critics*. Reprint of 1954

ed. New Haven, CT: Yale University Press, 1986. Hares-Stryker, C., ed. *An Anthology of Pre-Raphaelite*

Writings. New York: New York University Press, 1997.

Herbert, R. Impressionism: Art, Leisure, and Parisian Society. New Haven: Yale University Press, 1988. Higonnet, A. Berthe Morisot. New York: Harper & Row. 1990.

House, J. *Impressionism: Paint and Politics*. New Haven: Yale University Press, 2004.

Monet: Nature into Art. New Haven: Yale University Press, 1986.

Jenkyns, R. Dignity and Decadence: Victorian Art and the Classical Inheritance. Cambridge, MA: Harvard University Press, 1991.

Kendall, R., and G. Pollock, eds. Dealing with Degas: Representations of Women and the Politics of Vision. New York: Universe, 1992.

Degas: Beyond Impressionism. Exh. cat. London: National Gallery; Chicago: Art Institute of Chicago; New Haven: Dist. by Yale University Press, 1996.

Krell, A. Manet and the Painters of Contemporary Life. The World of Art. New York: Thames & Hudson,

Lipton, E. Looking into Degas. Berkeley: University of California Press, 1986.

Mainardi, P. Art and Politics of the Second Empire: The Universal Expositions of 1855 and 1867. New Haven: Yale University Press, 1987.

The End of the Salon: Art and the State in the Early Third Republic. Cambridge: Cambridge University Press, 1993.

Miller, D., ed. American Iconology: New Approaches to Nineteenth-Century Art and Literature. New Haven: Yale University Press, 1993.

Needham, G. Nineteenth-Century Realist Art. New York: Harper & Row, 1988.

Nochlin, L., ed. Impressionism and Post-Impressionism, 1874-1904: Sources and Documents. Englewood Cliffs, NJ: Prentice Hall, 1976.

Realism and Tradition in Art, 1848-1900: Sources and Documents. Englewood Cliffs, NJ: Prentice Hall, 1966.

Novak, B. American Painting of the Nineteenth Century: Realism and the American Experience. 2d ed. New York: Harper & Row, 1979.

Nature and Culture: American Landscape and Painting, 1825 1875. New York: Oxford University Press, 1995.

Pollock, G. Mary Cassatt: Painter of Modern Women. New York: Thames & Hudson, 1998.

Prettejohn, E. *The Art of the Pre Rappaelites*. Princeton, NJ: Princeton University Press, 2000.
Reff, T. *Manet and Modern Paris*. Exh. cat. Washington,

DC: National Gallery of Art, 1982.

Rewald, J. Studies in Impressionism. New York: Harry N. Abrams, 1986, © 1985.

Rubin, J. H. Impressionism. Art & Ideas. London: Phaidon Press, 1999.

Spate, V. Claude Monet: Life and Work. New York: Rizzoli, 1992.

Tucker, P. H. Claude Monet: Life and Art. New Haven:

Yale University Press, 1995. The Impressionists at Argenteuil. Washington, DC: National Gallery of Art; Hartford, CT:

Wadsworth Atheneum Museum of Art, 2000. Monet in the '90s: The Series Paintings. Exh. cat. New Haven: Yale University Press, 1989.

Walther, I., ed. Impressionist Art, 1860-1920. 2 vols. Cologne: Taschen, 1996.

Weisberg, G. Beyond Impressionism: The Naturalist Impulse. New York: Harry N. Abrams, 1992.

Werner, M. Pre-Raphaelite Painting and Nineteenth-Century Realism. New York: Cambridge University Press, 2005.

CHAPTER 26. PROGRESS AND ITS DISCONTENTS: POST-IMPRESSIONISM, SYMBOLISM, AND ART NOUVEAU, 1880-1905

Brettell, R., et al. The Art of Paul Gauguin. Exh. cat. Boston: Little, Brown, 1988.

Broude, N. Georges Seurat. New York: Rizzoli, 1992.

Denvir, B. Post-Impressionism. The World of Art. New York: Thames & Hudson, 1992.

Dorra, H., ed. Symbolist Art Theories: A Critical Anthology. Berkeley: University of California Press,

Gibson, M. The Symbolists. New York: Harry N. Abrams, 1988.

Hamilton, G. H. Painting and Sculpture in Europe, 1880–1940. 6th ed. Pelican History of Art. New Haven: Yale University Press, 1993.

Herbert, R. L. Georges Seurat, 1859-1891. New York: Metropolitan Museum of Art; Dist. by Harry N. Abrams, 1991.

Hulsker, J. The New Complete Van Gogh: Paintings, Drawings, Sketches: Revised and Enlarged Edition of the Catalogue Raisonné of the Works of Vincent van Gogh. Amsterdam: J. M. Meulenhoff, 1996.

Mosby, D. Henry Ossawa Tanner. Exh. cat. New York: Rizzoli, 1991.

Schapiro, M. Paul Cézanne. New York: Harry N. Abrams, 1988.

-. Vincent Van Gogh. New York: Harry N. Abrams, 2000, © 1983.

Shiff, R. Cézanne and the End of Impressionism: A Study of the Theory, Technique, and Critical Evaluation of Modern Art. Chicago: University of Chicago Press, 1984.

Silverman, D. Art Nouveau in Fin-de-Siècle France.

Berkeley: University of California Press, 1989. Théberge, P. Lost Paradise, Symbolist Europe. Exh. cat. Montreal: Montreal Museum of Fine Arts, 1995.

Troy, N. J. Modernism and the Decorative Arts in France: Art Nouveau to Le Corbusier. New Haven: Yale University Press, 1991.

Varnedoe, K. Vienna 1900: Art, Architecture, and Design. Exh. cat. New York: Museum of Modern Art, 1986.

CHAPTER 27. TOWARD ABSTRACTION: THE **MODERNIST REVOLUTION, 1904-1914**

Bach, F., T. Bach, and A. Temkin. Constantin Brancusi. Exh. cat. Cambridge: MIT Press, 1995.

Behr, S. Expressionism. Movements in Modern Art. Cambridge: Cambridge University Press, 1999.

Bowlt, J. E., ed. Russian Art of the Avant-Garde: Theory and Criticism, 1902-1934. New York: Thames & Hudson, 1988.

Brown, M. The Story of the Armory Show. 2d ed. New York: Abbeville Press, 1988.

Duchamp, M. Marcel Duchamp, Notes. The Documents of Twentieth-Century Art. Boston: G. K. Hall, 1983.

Edwards, S. Art of the Avant-Gardes. New Haven: Yale University Press in association with the Open University, 2004.

Elderfield, J. Henri Matisse: A Retrospective. Exh. cat. New York: Museum of Modern Art; Dist. by Harry N. Abrams, 1992.

Golding, J. Cubism: A History and an Analysis, 1907-1914. 3d ed. Cambridge, MA: Harvard University Press, 1988.

Goldwater, R. Primitivism in Modern Art. Enl. cd. Cambridge, MA: Belknap Press, 1986.

Gordon, D. Expressionism: Art and Idea. New Haven: Yale University Press, 1987.

Green, C. Cubism and Its Enemies. New Haven: Yale University Press, 1987.

Herbert, J. Fauve Painting: The Making of Cultural Politics. New Haven: Yale University Press, 1992.

Hoffman, K., ed. Collage: Critical Views. Ann Arbor, MI: UMI Research Press, 1989.

Kallir, J. Egon Schiele: The Complete Works. Exp. cd. New York: Harry N. Abrams, 1998.

Krauss, R. The Originality of the Avant-Garde and Other Modernist Myths. Cambridge: MIT Press,

Kuspit, D. The Cult of the Avant-Garde Artist. New York: Cambridge University Press, 1993.

Rosenblum, R. Cubism and Twentieth-Century Art. New York: Harry N. Abrams, 2001.

Rubin, W. S. Picasso and Braque: Pioneering Cubism. Exh. cat. New York: Museum of Modern Art, 1989.

Taylor, B. Collage: The Making of Modern Art. London: Thames & Hudson, 2004.

Washton, R.-C., ed. German Expressionism: Documents from the End of the Wilhelmine Empire to the Rise of National Socialism. The Documents of Twentieth-Century Art. Boston: G. K. Hall, 1993.

Weiss, J. The Popular Culture of Modern Art: Picasso, Duchamp and Avant Gardism. New Haven: Yale University Press, 1994.

CHAPTER 28. ART BETWEEN THE WARS, 1914-1940

Ades, D. Photomontage. Rev. and enl. ed. London: Thames & Hudson, 1986.

Arbaïzar, P. Henri Cartier-Bresson: The Man, the Image and the World: A Retrospective. New York: Thames & Hudson, 2003.

Bayer, H., et al., eds. Bauhaus, 1919-1928. Reprint of 1938 ed. Boston: New York Graphic Society, 1986. Blaser, W. Mies van der Rohe. 6th exp. and rev. ed.

Boston: Birkhauser Verlag, 1997. Campbell, M., et al. *Harlem Renaissance: Art of Black*

America. New York: Harry N. Abrams, 1987. Chadwick, W., ed. Mirror Images: Women, Surrealism, and Self-Representation. Cambridge, MA: MIT Press,

Corn, W. The Great American Thing: Modern Art and National Identity, 1915-1935. Berkeley: University

of California Press, 2001. Curtis, W. Modern Architecture Since 1900. 3rd ed. New

York: Phaidon Press, 1996. Durozoi, G. History of the Surrealist Movement.

Chicago: University of Chicago Press, 2002.

Fer, B., et al. Realism, Rationalism, Surrealism: Art Between the Wars. Modern Art-Practices and Debates. New Haven: Yale University Press, 1993.

Fiedler, J., ed. Photography at the Bauhaus. Cambridge, MA: MIT Press, 1990.

Foster, S. C., ed. Crisis and the Arts: The History of Dada. 10 vols. New York: G. K. Hall, 1996–2005.

Gale, M. Dada & Surrealism. Art & Ideas. London: Phaidon Press, 1997.

Gössel, P., and G. Leuthäuser. Architecture in the Twentieth Century. Cologne: Taschen, 1991.

Greenough, S., and J. Hamilton. Alfred Stieglitz: Photographs and Writings. New York: Little, Brown, 1999.

Haskell, B. The American Century: Art & Culture, 1900–1950. New York: W. W. Norton, 1999.

Hight, E. M. Picturing Modernism: Moholy-Nagy and Photography in Weimar Germany. Cambridge, MA: MIT Press, 1995.

Hitchcock, H. R., and P. Johnson. The International Style. With a new forward. New York: W. W. Norton, 1996.

Hochman, F. S. Bauhaus: Crucible of Modernism. New York: Fromm International, © 1997

Hopkins, D. Dada and Surrealism: A Very Short Introduction. New York: Oxford University Press,

Kandinsky, W. Kandinsky: Complete Writings on Art. Orig. pub. in The Documents of Twentieth-Century Art. New York: Da Capo Press, 1994.

Krauss, R. L'Amour Fou: Photography and Surrealism. New York: Abbeville Press, 1985.

Kultermann, U. Architecture in the Twentieth Century. New York: Van Nostrand Reinhold, 1993.

Lane, B. Architecture and Politics in Germany, 1918-1945. New ed. Cambridge, MA: Harvard University Press, 1985.

Le Corbusier. Towards a New Architecture. Oxford: Architectural Press, 1997, © 1989.

Lodder, C. Russian Constructivism. New Haven: Yale University Press, 1983.

McEuen, M. A. Seeing America: Women Photographers Between the Wars. Lexington, KY: University Press of Kentucky, 2000.

Miró, J. Joan Miró: Selected Writings and Interviews. The Documents of Twentieth-Century Art. Boston: G. K. Hall, 1986.

Mondrian, P. The New Art, the New Life: The Complete Writings. Eds. and trans. H. Holtzmann and M. James. Orig. pub. in The Documents of Twentieth-Century Art. New York: Da Capo, 1993.

Motherwell, R., ed. The Dada Painters and Poets: An Anthology. 2d ed. Cambridge, MA: Harvard University Press, 1989.

Nadeau, M. History of Surrealism. Cambridge, MA: Harvard University Press, 1989.

Phillips, C., ed. Photography in the Modern Era: European Documents and Critical Writings, 1913-1940. New York: Metropolitan Museum of Art; Aperture, 1989.

Roskill, M. Klee, Kandinsky, and the Thought of Their Time: A Critical Perspective. Urbana: University of Illinois Press, 1992.

Silver, K. E. Esprit de Corps: The Art of the Parisian Avant-Garde and the First World War, 1914–1925. Princeton, NJ: Princeton University Press, 1989.

Spiteri, R., ed. Surrealism, Politics and Culture. Aldershot, Hants., England and Burlington, VT: Ashgate, 2003.

Wood, P., ed. Varieties of Modernism. New Haven: Yale University Press in association with the Open University, 2004.

Wright, F. L. Frank Lloyd Wright, Collected Writings. 5 vols. New York: Rizzoli, 1992–1995.

CHAPTER 29. POST-WORLD WAR II TO POSTMODERN, 1945-1980

Archer, M. Art Since 1960. World of Art. New York: Thames & Hudson, 2002.

Ashton, D. American Art Since 1945. New York: Oxford University Press, 1982.

Atkins, R. Artspeak: A Guide to Contemporary Ideas, Movements, and Buzzwords, 1945 to the Present. New York: Abbeville Press, 1997.

Baker, K. *Minimalism: Art of Circumstance*. New York: Abbeville Press, 1989.

Battcock, G., comp. *Idea Art: A Critical Anthology*. New ed. New York: Dutton, 1973.

—., ed. Minimal Art: A Critical Anthology.

Berkeley: University of California Press, 1995.

——, and R. Nickas, eds. The Art of Performance: A Critical Anthology. New York: Dutton, 1984. Beardsley, J. Earthworks and Beyond: Contemporary

Beardsley, J. Earthworks and Beyond: Contemporary Art in the Landscape. 3d ed. New York: Abbeville Press, 1998.

——, and J. Livingston. Hispanic Art in the United States: Thirty Contemporary Painters and Sculptors. Exh. cat. New York: Abbeville Press, 1987.

Burgin, V., ed. *Thinking Photography*. Communications and Culture. Houndsmills, England: Macmillan Education, 1990.

Carlson, M. A. Performance: A Critical Introduction. 2d ed. New York: Routledge, 2004.

Causey, A. Sculpture Since 1945. Oxford History of Art. New York: Oxford University Press, 1998.

Crane, D. The Transformation of the Avant-Garde: The New York Art World, 1940–1985. Chicago: University of Chicago Press, 1987.

Crow, T. The Rise of the Sixties: American and European Art in the Era of Dissent. London: Laurence King, 2005, © 1996.

Frascina, F. Pollock and After: The Critical Debate. 2d ed. New York: Routledge, 2001.

Gilbaut, S. How New York Stole the Idea of Modern Art. Chicago: University of Chicago Press, 1983.

——., ed. Reconstructing Modernism: Art in New York, Paris, and Montreal, 1945–1964. Cambridge: MIT Press, 1990.

Greenberg, C. Clement Greenberg: The Collected Essays and Criticism. 4 vols. Chicago: University of Chicago Press, 1986–1993.

Griswold del Castillo, R., ed. Chicano Art: Resistance and Affirmation, 1965–1985. Exh. cat. Los Angeles: Wight Art Gallery, University of California, 1991.

Hopkins, D. *After Modern Art: 1945–2000*. New York: Oxford University Press, 2000.

Joselit, D. American Art Since 1945. The World of Art. London: Thames & Hudson, 2003.

Landau, E. G., ed. Reading Abstract Expressionism: Context and Critique. New Haven: Yale University Press, 2005. Leggio, J., and S. Weiley, eds. American Art of the 1960s. Studies in Modern Art, 1. New York: Museum of Modern Art, 1991.

Leja, M. Reframing Abstract Expressionism: Subjectivity and Painting in the 1940s. New Haven: Yale University Press, 1993.

Linder, M. Nothing Less Than Literal: Architecture After Minimalism. Cambridge, MA: MIT Press, 2004.

Lippard, L. R, ed. From the Center: Feminist Essays on Women's Art. New York: Dutton, 1976.

Prehistory. New York: Pantheon, 1983.

Livingstone, M. Pop Art: A Continuing History. New York: Thames & Hudson, 2000.

Lucie-Smith, E. Movements in Art Since 1945. The World of Art. New York: Thames & Hudson, 2001.

McEvilley, T. Sculpture in the Age of Doubt. New York: School of Visual Arts; Allworth Press, 1999. Meisel, L. K. Photorealism at the Millennium. New

York: Harry N. Abrams, 2002.

Ockman, J., ed. Architecture Culture, 1943–1968: A Documentary Anthology. New York: Rizzoli, 1993. Orvell, M. American Photography. The World of Art. New York: Oxford University Press, 2003.

Pincus-Witten, R. Postminimalism into Maximalism: American Art, 1966–1986. Ann Arbor, MI: UMI Research Press, 1987.

Polcari, S. Abstract Expressionism and the Modern Experience. New York: Cambridge University Press, 1991.

Rosen, R., and C. Brawer, eds. Making Their Mark: Women Artists Move into the Mainstream, 1970–85. Exh. cat. New York: Abbeville Press, 1989.

Ross, C. Abstract Expressionism: Creators and Critics: An Anthology. New York: Harry N. Abrams, 1990. Sandler, I. Art of the Postmodern Era: From the Late

1960s to the Early 1990s. New York: Icon Editions, 1996. ———. The New York School: The Painters and

Sculptors of the Fifties. New York: Harper & Row, 1978.

—. The Triumph of American Painting: A History of Abstract Expressionism. New York: Praeger, 1970. Sayre, H. The Object of Performance: The American Avant-Garde Since 1970. Chicago: University of Chicago Press, 1990.

Seitz, W. Abstract Expressionist Painting in America.

Cambridge, MA: Harvard University Press, 1983.
Self-Taught Artists of the 20th Century: An American

Self-Taught Artists of the 20th Century: An American Anthology. Exh. cat. San Franciso: Chronicle Books, 1998.

Sontag, S. On Photography. New York: Picador; Farrar, Straus & Giroux, 2001, © 1977.

Weintraub, L. Art on the Edge and Over. Litchfield, CT: Art Insights; Dist. by D.A.P., 1997.

Wood, P., et al. Modernism in Dispute: Art Since the Forties. New Haven: Yale University Press, 1993.

CHAPTER 30. THE POSTMODERN ERA: ART SINCE 1980

Barthes, R. The Pleasure of the Text. Oxford: Blackwell, 1990.

Belting, H. Art History After Modernism. Chicago: University of Chicago Press, 2003.

Broude, N., and M. Garrad., eds. Reclaiming Female Agency: Feminist Art History After Postmodernism. Berkeley: University of California Press, 2005.

Brunette, P., and D. Wills, eds. *Deconstruction and the Visual Arts: Art, Media, Architecture.* New York: Cambridge University Press, 1994.

Capozzi, R., ed. Reading Eco: An Anthology.

Bloomington: Indiana University Press, © 1997.

Derrida, J. Writing and Difference. London: Routledge Classics, 2001.

Eco, U. A Theory of Semiotics. Bloomington: Indiana University Press, 1976.

Foster, H., ed. *The Anti-Aesthetic: Essays on Postmodern Culture*. New York: New Press; Dist. by W. W. Norton, 1998.

Ghirardo, D. Architecture After Modernism. New York: Thames & Hudson, 1996.

Harris, J. P. The New Art History: A Critical Introduction. New York: Routledge, 2001.

Jencks, C. New Paradigm in Architecture: The Language of Post-Modernism. New Haven: Yale University Press, 2002.

., ed. *The Post-Modern Reader*. London: Academy Editions; New York: St. Martin's Press, 1992.

Lucie-Smith, E. *Art Today*. London: Phaidon Press, 1995.

Mitchell, W. J. T. The Reconfigured Eye: Visual Truth in the Post-Photographic Era. Cambridge, MA: MIT Press. 1992.

Norris, C., and A. Benjamin. What Is Deconstruction? New York: St. Martin's Press, 1988.

Papadakes, A., et al., eds. *Deconstruction: The Omnibus Volume.* New York: Rizzoli, 1989.

Paul, C. Digital Art. New York: Thames & Hudson, © 2003.

Pearman, H. Contemporary World Architecture. London: Phaidon Press, © 1998.

Risatti, H., ed. *Postmodern Perspectives*. Englewood Cliffs, NJ: Prentice Hall, 1990.

Senie, H. Contemporary Public Sculpture: Tradition, Transformation, and Controversy. New York: Oxford University Press, 1992.

Steele, J. Architecture Today. New York: Phaidon Press, 2001.

Thody, P. Introducing Barthes. New York: Totem Books; Lanham, MD: National Book Network, 1997.

Tomkins, C. *Post to Neo: The Art World of the 1980s.* New York: Holt, 1988.

Wallis, B., ed. Art After Modernism: Rethinking Representation. Documentary Sources in Contemporary Art, 1. Boston: Godine, 1984.

Index

Aaron the Priest, 239 Abacus, 110 Abbas I, Royal Mosque, Isfahan, 307, 307 Abbasid dynasty, 285 Abbasid Qur'an, 281 Abbey church of Saint-Riquier, France, 330-331, 330 Abbey church, Corvey, Germany, 331-332, Abd al-Malik, 280 Abduction of Persephone, Tomb I, Vergina, 161-162, 161 Abu Simbel, Temple of Ramasses II, 69-70, 69-70 Abu Temple, statues, 25-26, 26 Abul Hasan, Ceremonial Audience of Jahangir, 308, 309 Abulafia, Samuel Halevy, 290 Accusation and Judgment of Adam and Eve, bronze doors of Bishop Bernward, Hildesheim, 338–339, 338 Achaemenids, 42–43 Achilles and Ajax Playing Dice (Exekias), 121, 121 Acropolis. See Akropolis Acroteria, 116 Bronze Age, 81–82 Cycladic art, 82–84, *83* map of, 82 Minoan art, 84-93 Mycenaean art, 93-100 writing, 84, 94, 99 Aegina, Temple of Aphaia, 112, 112, 118–119, 118–119, 120 Aeneid (Virgil), 183, 195 Aeolic, 112 Aeschylus, 123 Agathias, 263 Ageladas of Argos, 129 Agrippa, 199 Ain Ghazal, Jordan, figurines, 13, *13* Aisles, 439 Aït Ben Haddou, Morocco, 23, 23 Ajax Painter, The, 108 Akbar the Great, 308 Akhenaten and His Family, 73 Akhenaten, Karnak, Thebes, 72, 73 Akkad (Akkadians), 30–32 Akropolis, Athens development of 130, 131, 131 Erechtheion, 140, 140 Parthenon (Itkinos, Kallikrates, and Karpion), 131–138, *132*, *134–135* Propylaia (Mneskiles), 139, *139* Temple of Athena Nike, *130*, 140, *140* Alabastron, 172 Al-Aqmar mosque, Cairo, 291, 291 Al-Aqsa mosque, Jerusalem, 282 Alba Madonna (Raphael), xv Albuquerque (Friedlander), xxi, xxi Alcuin of York, 324 Alexander Mosaic, 222 Alexander the Great, 45, 78, 147, 154 Alexandria, Pharos (lighthouse), 153–154, 153 Alhambra, Granada, Spain, 290, 299–300, 300 Allegory of Good Government (A. Lorenzetti), 459-461, 460, 461 Allegory of Worldly and Otherworldly Drunkenness (Sultan-Muhammad), from the Divan of Hafiz, Tabriz, 304-306, 305 Almohads, 287, 290

Almoravids, 290

Altamira, Spain, cave paintings, 1, 2, 3, 4 Altar, 245 Altarpieces, 441 See also Maestà Altarpiece Altarpiece of St. Clare, Convent of Santa Chiara, Assisi, 440-441, 440 Birth of the Virgin (P. Lorenzetti), 458-459, 459 Ambulatory, 247 Amenhotep III, 71, 72, 73 Amenhotep IV, 71 American Gothic (Wood), xv-xvi, xvi Amien Cathedral (Luzarches, de Cormont and de Cormont), 408, 409 sculpture, relief, 412, 412 Amphora, 105, 106–107, 106 Amun-ra, temple of, 67-68, 68 Anastasis, fresco, Kariye Camii (Church of the Savior), Constantinople, 276, 276 Andachtsbild, 434 Andrea da Firenze/Andrea Bonaiuti, The Way of Salvation, Santa Maria Novella, Florence, 463, 463 Angilbert, Saint, 330, 332 Anglo-Saxon art, 314-318, 315, 316, 317 Animal Head, from Oseberg burial ship, 323, 323 Animal Hunt, Çatal Hüyük, 14 Animals in art Anglo-Saxon, 316-318, 316, 317 Augro-saxon, 316–318, 316, 317 Assyrian, 36–37, 36–37 Babylonian, 38, 38 Fgyprian, 50, 51, 52–53, 61–62, 61, 64, 64, 65 Etruscan, 167, 168-169, 168, 169 Greek, Orientalizing style, 108 Minoan, 88, 89, 91, 91, 92, 92 Mycenaean, 95-96, 95, 99, 100 Neolithic, 13, 14 Paleolithic cave painting, 1 (facing), 1-7, Paleolithic sculpture, 7–11, 8–11 Persian, 41, 41 Romanesque, 361, 361 Sumerian, 26, 28–28, 27, 28, 29 Viking, 322, 323, 323 Annunciation (Jean Pucelle), from the Hours of Jeanne d'Évreux, 419-420, 419 Annunciation (Simone Martini), 458, 458 Annunciation to the Virgin, Byzantine icon, tempera on panel, 274, 275 Annunciation, Reims Cathedral, 411, 411 Anthemius of Tralles, Hagia Sophia, Constantinople (Istanbul), 257–260, 257–258, 260 Antoninus Pius and Faustina, column base of, 211-212, 211 Aphaia, Temple of (Aegina), 112, 112, 118–119, 118–119, 120 Aphaia, Temple of, 112, 112 painted sculpture, 223, 223 Aphrodite of Knidos, (Praxiteles), 143-144, Aphrodite, 104, 135 Aphrodite, Pan, and Eros, 159, 160 Aplu (Apollo), (Vulca of Veii), 175–176, 175 Apollo Belvedere, 157, 157 Apollo, 104, 105, 116, 127, 128, 128, 129

Sanctuary of (Delphi), 116, *117* Temple of, at Didyma, 148–150, *149* Apollodorus, 199, 202, 211

Apoxyomenos (Scraper) (Lysippos), xvii,

xviii, xix, 144-145, 145

Apotropaic device, 26

Apse, 225, 441 Apsidioles, 351 Aqueduct, Segovia, Spain, 213-214, 213 Ara Pacis Augustae, 207-208, 207-208 Arabesque, geometric, 286 Arcades, 259 blind, 45 Arch of Constantine, 230, 231-232, 231-232 Arch of Titus, Forum Romanum, Rome, xv, Archaic smile, 115 Archangel Michael, ivory diptych, Byzantine, 261-262, 261 Arches See also under Vaults Corbel, 94, 95 Roman, 185-186, 185 triumphal, xv, 208, 209-210, 230, 231–232, 231–232 voussoirs, 173, 173, 185, 185, 286, 286 Architect, medieval use of term, 393 Architecture as art, xxi xxiii Assyrian, 34-37, 35, 36 Babylonian, 37-38, 38 Byzantine, carly, 251 260, 254–260 Byzantine, middle, 269–273, 269–272 Carolingian, 328–333, 329–332 Christian early, 244-247, 245-247 Cistercian, 366-367, 366, 367 Cluniac, 356–365, 357–365 Egyptian, Middle Kingdom, 63, 63, 64 Egyptian, Old Kingdom, 53–58, 53–58 English Gothic, 426–429, 427–429 English Romanesque, 382-384, 383 Etruscan, 173-175, 173-175 French, Early Gothic, 391-399, 392, 394-399 French, High Gothic, 399–413, 401–403, 407–410 French, Romanesque, 357-364, 357, 358, 360-364, 372-375, 373, 375 German Gothic, 430-432, 431, 432 German Romanesque, 378–379, 378, 379 Gothic, English, 426–429, 427–429 Gothic, French, Early, 391-399, 392, 394–399 Gothic, French, Flamboyant, 422-423, 423 Gothic, English, 426-429, 427-429 Gothic, German, 430-432, 431, 432 Gothic, Italian, 438-439, 439 Gothic, Spanish, 423-426, 424-426 Greek Archaic, 109–113, 109–113 Greek Classical, 18, 141–142, 141–142 Hellenistic, 148-154, 149, 152, 153 Indian, 310, 310 Islamic, 280-284, 282, 284, 285-286, 285, 286, 287–288, 288, 291, 291, 293, 293, 294, 295, 295, 296, 296 298, 299–300, 300, 302–303, 302, 303, 307, 307, 310, Italian Gothic, 438-439, 439 Italian Romanesque, 375–378, 376–378 Jewish synagogues, 237–240, 237–239 Minoan, 84–86, 85, 86 modules and proportions, 406 Mycenaean, 93-98, 93-98 Neolithic, 11-12, 12, 13-14, 15-16, 16, 17-18. 18 Norman, 382-385, 383-385 Ottoman, 302-303, 302, 303 Ottonian, 333-336, 334-336 Paleolithic, 11 Persian, 41-45, 42, 43, 45

proportions and modules, 406 restoration of, 369 Roman domestic, 216-218, 217-218 Roman Empire, 196-203, 196-203 Roman Empire, late, 222-228, 224-228 Romanesque, Cistercian, 366–367, 366, 367 Romanesque, early, 349–350, 349 Romanesque, English, 382-384, 383 Romanesque, French, 357-364, 357, 358, 360-364, 372-375, 373, 375 Romanesque, German, 378–379, 378, 379 Romanesque, Italian, 375–378, 376–378 Romanesque Norman, 382-385, 383-385 Romanesque pilgrimage churches, 351–354, 352–353 Romanesque secular, 355-356, 356 Roman provinces, 213-215, 213-215, 216-218, 217–218, 226, 227–228, 227–228 Roman Republic, 183–188, 183–188 Spanish Gothic, 423–426, 424–426 Sumerian, 23–24, 23, 24, 32–33, 32 Architrave, 110 Archivolt, 362 Arcuated, 227 Arcuation, 380 Ardashir (Artaxerxes), 45 Arena (Scrovegni) Chapel, Padua, 450–453, 450-452 Aristophanes, 123 Aristotle, 123, 133 Armi, C. Edson, 369 Arnolofo di Cambio Santa Croce, Florence, 441-441, 442 Florence Cathedral, 445-446, 445, 446 Palazzo della Signoria (Palzzo Vecchio), Florence, 448, 448 Art aesthetics and, xx architecture as, xxi-xxiii context, changing, xvii context, impact of, xv-xvii defining, xvii-xix, xxiii illusionism in, xx meaning in, xx photography as, xxi power of, xv-xvii Artemis, 104, 135 Temple of (Corfu), 115-116, 115, 116 Temple of (Ephesos), 112, 112 Aryballos (perfume jar), 108, 108 Ashlar masonry, 84 Ashurbanipal, 37 Ashurnasirpal II, 37 Ashur-uballit, 34 San Francesco basilica, 438-440, 439, 440 Santa Chiara (St. Clare) convent, 440, 440 Assur, 34 Assyria (Assyrians), 34-37 Athena and Alkyoneus, Great Altar of Zeus, Pergamon, 156 Athena Parthenos (Pheidias), 132, 133 Athena, 104 Athendorus of Rhodes, 183 Atlas Bringing Herakles the Apples of the Hesperides, 129, 129 Atmospheric perspective, 195 Atrium, 217 Attalos II, 151 Audience Hall of Darius and Xerxes, 43, 43 Augustus (Caesar), 195, 199, 203 Altar of Augustan Peace, 208-208, 207-208

forum of, 196

Augustus of Primaporta, 204-205, 204 Cavallini, Pietro, 440 Cicero, 188 Aurignacian period, 9 Ayyubids, 291, 292, 296, 299 mud, 23, 23, 54, 55 Letters to Atticus, 192 Cave paintings, Paleolithic, 1, 1 (facing), glazed, 38 2-7, 3-7 Cimabue, Madonna Enthroned, 449, 449 Bridge, Puente La Reina, Spain, 355–356, techniques, 5 Cinerary urns, Etruscan, 171-173, 171, 172 Cavea, 151 Cistercian architecture and art, 366-367, 366, 367 Babylon (Babylonians), 33-34, 37-38 British Museum, 134, 135 Celestial beings, 273 Bronze work alloy bucket, inlaid, Iran, 289 Babylonian deed of sale, 22 Cella, 23 Citadels, Mycenaean, 93-96, 93-96 City planning Etruscan, 174–175 Baghdad, 285 Baldacchino, 246 Greek, 109, 109 Carolingian, 324, 324 doors, San Giovanni baptistery, Florence, Sumerian, 25 Celts, 313, 314 Banditaccia Cemetery, Cerveteri, 167 Hellenistic, 150–151, 150, 151 Islamic, 307 Baptism of Christ (A. Pisano), bronze 446-448, 447, 448 Centering, 380 head from Delos, 154, 155 Ottonian doors, 336–339, 337–339 She-Wolf, Etruscan/Roman, 176–177, 176 doors, baptistery of San Giovanni, Florence, 447–448, 448 Central-plan churches, 246-247, 247 City-state, Greek Archaic, 109 Ceramics, Islamic, 288–289, 289
Ceremonial Audience of Jahangir (Manohar and Abul Hasan), illuminated manuscript, 308, 309 Clerestory, 225, 446 Baptismal font (Renier of Huy), 379-381, Cloak of Roger II, 292, 292 tripods, 108, 109 Cloisonné, 64, 65 Baptistery of San Giovanni, Florence, Italy, 377, 377 Brutus, bronze bust, Rome, 190-192, 191 Cloister, 331 Bubonic Plague, 299, 462, 463
map of spread in Europe, 464
Building of the Tower of Babel, abbey
church of Saint-Savin-sur-Gartempe, Cernavoda, Romania, ceramic figures, 15, Bar tracery, 406 Baroque, use of term, 159 15 architecture and sculpture, 356-365, Champlevé, 354 357-365 Barrel vaults, 185, 186 manuscripts, 368–370, 368, 369 Sarcophagus of Doña Sancha, 364–365, 365 wall painting, 365–366, 366 Cluny Lectionary, 368, 369–70 Chancel, 350 Chapel of Henry VII, Westminster Abbey, London, 429, 429 annular, 186 France, 367-368, 368 Bas-de-page (bottom of the page), 420 Basilica at Lepcis, Magna, Libya, 226, 227 Basilica of Constantius Chlorus, Trier, 227, Bukhara Tomb of the Samanids, 288, 288 Bull head, rhyton vessel, Minoan, 91, 91 Bull Lyre, tomb of Queen Pu-abi, 28, 28 Charioteer from Motya (Sicily), 124, 124 Charlemagne, 324, 325, 348, 391
Palace Chapel of, 328–330, 329, 330
Charles Martel, 391 Cluny, abbey church of (Cluny III) (Gunzo), France, 357–358, 357, 358 Code of Hammurabi, 34, 34, 35 228 Basilica of Maxentius and Constantine, Buon fresco, 86, 87 Rome, 225, 225 Burial customs. See Funerary customs Codex Colbertinus, Mossiac monastery, Charles the Bald, 391 Burial ships Basilica of San Marco, See St. Mark's, Chartres Cathedral 370-371, 370 Oseberg, Norway, 322–324, *323* Sutton Hoo, England, 315, 316–318, *316*, Venice buttresses, 402, 403, 403 Codex, 252 Basilica, 186, 441 nave, 400, 401, 401 Coffers, 201 rebuilding of, 400–408, 400 sculpture, 388, 395–396, 396, 397 sculpture and transepts, 404–408, 407, 408 stained glass, 403–404, 403, 404, 405, 406 Basilica-plan churches, Early Christian, 317 Colonettes, 353 245–246, 245–246, 247 Buttresses, 32 Colosseum, Rome, 198-199, 198, 199 Baths of Caracalla, Rome, 224, 224 flying, 403, 403 Column of Trajan, 211-212, 211 Battle of Hastings, detail of Bayeux Buttressing technique, Egyptian, 56, 56 Columns Tapestry, 382, 382 Byzantine art, early west façade, 388, 395-396, 395 composite style, 198, 198 Battle of Issos or Battle of Alexander and the Persians, 162, 162 Battle of the Gods and Giants, Treasury of architecture and decoration, 254-260, Charun and Vanth, Tomb of the Anina Doric, 110-112, 110-112 254-260 Family, 170-171, 170 Egyptian 54, 55 Chauvet, France, cave paintings, 2–3, 3, 5, 5 Chi Rho Iota page from *Book of Kells*, 321–322, 322 icons, 263-265, 263, 264 Ionic, 110-113, 110, 112 the Siphnians, Delphi, 118 manuscripts, 262–263, 262 mosaics, 256, 257, 259 Minoan, 84, 86 Battle of the Lapiths and Centaurs, Temple Tuscan style, 198, 198 Chiastic pose, 124 Chinese Horse, Lascaux Cave, 4, 4, 6 of Zeus, 128, 129 sculpture, 260-262, 261 Composite images, 5 Battlements, 448 Byzantine art, late Compound piers, 350 Bayeux Tapestry, 381–382, 381, 382 Bays, 349 icons, 273-274, 274, 275 Chios, kore from, 114, 115 Concrete, early use of, 186-188, 198, 202 ivory diptychs, 261-262, 261 Chiton, 115 Consecration of the Tabernacle and Its Baysunghur, 296 Christ and Apostles, apse painting, Berzé-la-Ville, 365–366, 366 Christ Blessing Emperor Otto II and Empress Theophano, ivory, 340, 340 mosaics and murals, 274-276, 276 Priests, Dura-Europos synagogue, 238, Bear, Chauvet Cave, 3 Byzantine art, middle 239 Constantine the Great, 228 Arch of, 230, 231–232, 231–232 Behzad, 304 architecture and decoration, 269-273, Poor Man Refused Admittance to a 269-272 Mosque, A, from Bostan of Sa'di, 296, Iconoclastic Controversy, 265-266, 270 Christ Crowning Romanos and Eudokia Basilica of Maxentius and Constantine, 297 ivory triptychs, 268, 268 ("Romanos Ivory"), Byzantine, 268, 225, 225 Belvedere, 211 manuscripts, 265, 265, 266–268, 266, 267 mosaics, 269–273, 269–272 268 conversion to Christianity, 235-236 Benedict of Nursia, St., Rules of, 330-331, portrait of, 228–229, 229
Constantine VII, 267
Constantius Chlorus, Basilica of, 227, 228 Christ Entering Jerusalem (Giotto di Bondone), Arena (Scrovegni) Chapel, Padua, 451–452, 451 332, 333 sculpture, 268, 268 Benedictines, 330 Byzantine Empire, map of 236 architecture and wall painting, 367-368, Copley, John Singleton, Mrs Joseph Scott, Christ Enthroned, from the Godescalc 368 Cairo, Al-Aqmar mosque, 291, 291 Gospels, 325, 325 xiii-xiv, xiv Beni Hasan, rock-cut tombs, 63, 63, 64 Berbers, 279, 287, 290 Christ in Majesty (Maiestas Domini), Saint-Sernin, Toulouse, 355, 355 Caligula, painted sculpture, 223 Corbel arch, 94, 95 Cames, 405 Corbeled casemate, 94, 95 Berenson, Bernard, 231 Campanile, 375, 446 Christ Pantocrator, mosaic, Church of the Dormition, Daphni, 269, 269 Christ, encaustic on panel, Monastery of St. detail, 80 Bernard of Clairvaux, Saint, 359, 362, 374, Corbie Gospel book, 370, 371 Canon 393 Cycladic, 82, 84 Córdoba, Spain, Great Mosque, 278, Bernini, Gianlorenzo, xxi-xxii, xxii Egyptian, 61-62 Catherine, 263-264, 263 286-287, 286 Bernward, bishop of Hildesheim, 335 bronze doors of, 336–339, 337–339 Greek, 127 Christian art, early Corfu, 109, 115-116 architecture, 244-247, 245-247 Capitals, 110 Corinth, 109, 116 Berzé-la-Ville, apse painting, 365–366, 366 Betrayal of Christ (Jean Pucelle), from the Âeolic, 112 catacombs, 240-243, 242 Corinthian capital, 142, 142 Byzantine use of, 259, 260 composite, 198, 198 illuminated manuscripts, 252–253, 252 Jesus, scenes of life most frequently depicted, 241 Corinthian style, 109, 142 Cormont, Renaud de, Amiens Cathedral, Hours of Jeanne d'Évreux, 419-420, 419 Bible Corinthian, 142, 142 408, 409, 412, 412 illuminated, 252, 252 Doric, 110, 110, mosaics, 248-251, 248-251 Cormont, Thomas de, Amiens Cathedral, moralized (moralisée), 416-417, 417 Egyptian, 54, 55 painting, 240-243, 242, 244-245, 244 408, 409, 412, 412 Vienna Genesis, 262–263, 262 Biblical and celestial beings, 273 Birth of the Virgin (P. Lorenzetti), 458–459, Ionic, 110, 110, 112 sculpture, 243, 243, 253-254, 253 Cornice, 132 Minoan, 84, 86 symbolic representation, 237 Coronation Gospels (Gospel Book of Persian, 43, 43 Christianity Charlemagne), 325, 326 Caracalla, baths of, 224, 224 biblical and celestial beings, 273 Coronation of the Virgin (tympanum), Chartres Cathedral, 407, 407 Black Death, 299, 462, 463 Caravansaray, 293, 293 early 235-237 map of spread in Europe, 464 Cardona, Church of Sant Vincenç, 349-350, influence on Early Medieval art, 313-314, Corvey, Abbey church of, Germany, Black-figure pottery style, 119-120, 121, 318 331-332, 331 Carolingian art architecture, 328–333, 329–332 illuminated books, 325–327, 325–327 122 map of, 236 Court of the Lions, Alhambra, Granada, Blanche of Castile, psalter of 416, 416 as a patron of art, 313-314 Spain, 299–300, 300 Court style, 413–418, 413–417 Blind arcades, 45 in Roman Empire, 235–237 schism, 236, 271 Bloch, Herbert, 202 sculpture, 324-325, 324 use of term, 416 Crac des Chevaliers, castle, Homs Pass, Boccaccio, Giovanni, 438 Carrey, Jacques, 135 Chryselephantine, 132 Decameron, 462 Drawings of east pediment of the Churches Syria, 374-375, 375 Bone, in house construction, 11, 11, 15 Parthenon, 134 See also under name of Crenelations, 374 basilica plan, 245–246, 245–246, 247 central plan, 246–247, 247 Bonino da Campione, Tomb of Bernabò Carter, Howard, 75 Crossing, 446 Visconti, 465–466, 465 Book of Hours of Giangaleazzo Visconti Carvatids, 116 Crowds Gaze in Awe at a Comet as Harold Casemates, 94, 95 Greek-cross plan, 248, 272 Is Told of an Omen, detail of Bayeux (Giovannino dei Grassi), 466, 466 Book of hours, 419–420, 419 Book of Kells, 321–322, 322 Castles, Romanesque Crusader, in Holy hall, 367-368, 367, 430-432, 431 Tapestry, 381-382, 381 Land, 374–375, *375* Çatal Hüyük, Turkey, 13, *13*, 14, *14* house, 243-245, 244 Crucifixion (Grünewald) xx Latin cross-plan, 375–376 Orthodox and Catholic, comparison of, Crucifixion and Deposition, from the Psalter of Blanche of Castile, 416, 416 Crucifixion and Iconoclasts, from the Book of the Dead of Hunefer, 77, 78 Cathedral, 271 Book of the Dead, 77, 77 And see under name/location Bostan (Poetic Garden) of Sa'di, 296, 297 pilgrimage plan, 353 Khludov Psalter, 265, 265

Crucifixion, choir screen, Naumburg Dying Warrior, pediment of Temple of Italian fourteenth-century sea trade inscriptions on, Palazzo Pubblico, Siena, Cathedral, 432, 432 Aphaia, 118, 119, 119, 120 routes, 438 Italian, Gothic, 439-441, 440 Crucifixion, mosaic, Church of the prehistoric, 2 Romanesque period, 348 Euthymides, Dancing Revelers, 121–122, Minoan, 86-89, 87-89 Dormition, Daphni, 270, 270 Early English style, 426 Palazzo Pubblico (Lorenzetti), Siena, Crusades, 347, 348 Echinus, 110 Edward II, king of England, 430 Crypt, 334 459-461, 460, 461 Cunei, 152 Evans, Sir Arthur, 81, 84, 86, 87 Friedlander, Lee, Albuquerque, xxi, xxi Amarna style, 72–75, 73, 74 Cuneiform Eve (Gislebertus), cathedral of Saint-Frieze, 110 Frontality, 30, 38
"Frying pan", Cycladic, 82, 83
Fugitives Crossing River, Palace of Sumerian, 21, 22, 22 architecture, Middle Kingdom, 63-64, Lazare, Autun, France, 362, 364, 364 Cycladic art, 82-84, 83 63-64 Exedra, 177 Cylinder seals, 29, 29, 52 Exekias, Achilles and Ajax Playing Dice, architecture, New Kingdom, 65-70, 66, 121, 121 Ashurnasirpal II, 36 Cyrus the Great, 41 architecture, Old Kingdom, 53-58, 53-58 Funerary architecture. See Tombs Factory, The, xviii Dado, 218 Book of the Dead, 77, 77 Funerary customs
See also Burial ships Dancing Revelers (Euthymides), 121–122, 122 early art, 50-53 Faience, 63 Fatimids, 290–292 Fatimids, artistic revival under, 290–292, cemetery at Ur, 26-27 291, 292 Female Figurine, Thebes, 63, 65 Cycladic, 82 Dante Alighieri, 438 Divine Comedy, excerpt from, 453

Daphnis of Miletos, Temple of Apollo,
Didyma, 148–150, 149

Darius and Xerxes Giving Audience, 44, 44 Etruscan, 165-173, 165-173 geography of, 49 Female Head, Uruk, 25 gods and goddesses, 52 Great Sphinx, 56, 57, 58 Greek amphora vessels, 105, 106-107, Feminist art history, 11 Feminist movement, role of, xvii Fibulae, 41, 166, 166 106 Neolithic, 12, 15-16 human form, representation of, 57, 59-63, Darius I, 41, 42, 44, 45 59-63, 65 Roman Empire, 212 Figurines Cycladic, 82-84, 83 Roman sculpture portraits, 193, 193 Dating jewelry, 64, 65 of cave paintings, 4-5 major periods in, 54 Egypt, 63, 65 Funerary masks of Agamemnon, 98, 99 Greek Archaic dating based on map of ancient, 50 faience, 63, 65 Greek kore (korai), 113–114, *113*, *114* Greek, kouros (kouroi), 113–114, *113*, *114* Minoan, 91–92, *91–92* Middle Kingdom, 62-5 naturalism, 115 Mycenaean, 98, 99 New Kingdom, 65–71 Old Kingdom, 53–62 Paleolithic labels and periods, 9 radiocarbon, 5 Gable, 373 painting, Middle Kingdom, 63, 64 painting, New Kingdom, 66, 71, 71, 77, Neolithic, 13, 13, 14-15, 15 works of art, techniques for, 17 Galla Placidia, Mausoleum of, 248-250, David and Goliath (Master Honoré), from Paleolithic, 8, 8, 10-11, 10, 11 248-250 the Prayer Book of Philip IV the Fair, Venus, 10 Gallery, 247 painting, Old Kingdom, 50, 51, 61, 61, 62 418-419, 418 Woman from Brassempouy, Grotte du Geison, 110 David Composing the Psalms, from the Paris Psalter, 267, 267 Davies, Paul, 202 predynastic art, 50–53 pyramids at Giza, 55–61, *55–61* religous belief, 49, 52, 53–57 Pape, 10, 10 Woman of Willendorf, Austria, 10, 11, 11 Filigree, 169, 315 Gentileschi, Artemisia, xvii Geometric arabesque, 286 Germany Decameron (Boccaccio), 462 sculpture, Middle Kingdom, 62-63, 62, Findspot, 50 architecture, Gothic, 430-432, 431, 432 Delos, bronze head from, 154, 155 Flamboyant, 422-423, 423 architecture, Romanesque, 378-379, 378, Delphi, 109, 116-118, 117, 118 sculpture, New Kingdom, 66-67, 67, Florence 69–70, 69, 70 sculpture, Old Kingdom, 59–62, 59–62 tombs, 49, 50, 51, 53–62, 53–62, 65–71, 65–71 sculpture, Gothic, 432–434, 432–434 sculpture, Paleolithic, 7–8, 8 Demus, Otto, 270 Baptistery of San Giovanni, 377, 377, 445, Dietrich II, bishop of Naumburg, 433 Gernrode, nunnery church of St. Cyriakus, 333–334, 334 Dikka, 284 bronze doors (A. Pisano), San Giovanni Diocletian, Palace of (Split), 226, 227 baptistery, 446-448, 447, 448 Dionysius the Areopagite, 392 writing, 49, 50, 51 Cathedral (Arnolfo di Cambio), 445-446, Gero Crucifix, Ottonian, 343-344, 343 Dionysos, 104, 135, 144, 151 **Diotisalvi**, Pisa baptistery, 375, 376 Ekkehard and Uta, Naumburg Cathedral, 445, 446 Gessii, funerary relief of, 193, 193 433-434, 433 Palazzo della Signoria (Palzzo Vecchio) Getty Museum, 188 El Khasneh, Petra, Jordan, 214–215, 215 Elgin Marbles, 134 Ghiberti, Lorenzo, 449 Gilgamesh, 24 Dipteral, 113 Dipylon Vase, 106, 106 (Arnolfo di Cambio), 448, 448 San Miniato al Monte, 377–378, 378 Epic of Gilgamesh, 25 Diskobolos (Discus Thrower) (Myron), 126, Elgin, (Lord) Thomas Bruce, 134–135 Santa Croce (Arnolfo di Cambio), Emperor Justinian and His Attendants, San Florence, 441-441, 442 Giotto di Bondone, 440, 449, 453 126 Dit du Lion, Le, Guillaume de Machaut, Vitale church, Ravenna, 256, 257 Santa Maria Novella, 463, 463 Christ Entering Jerusalem, 451-452, 451 Empress Theodora and Her Attendants, San Vitale church, Ravenna, 256, 25/ Enchanted Garden, The, from Le Dit du Lion, Guillaume de Machaut, 420, 420 Florence Cathedral (Arnolfo di Cambio), 445–446, 115, 116 420, 420 Florence Cathedral campanile, 445, 446 Divine Comedy (Dante Alighieri), 453 Djehutihopte, 56 Djoser, funerary complex of, 53–55, 53–54, Lamentation, 452, 452 Last Judgment, 436, 451 Madonna Enthroned, 450, 450 Flotilla Fresco, Akrotiri, 89, 89 Flutes, 110 England Flying buttresses, 403, 403 Gislebertus Doge's Palace, Venice, 464, 465 architecture, Gothic, 426-429, 427-429 Folio, 252 Eve, cathedral of Saint-Lazare, Autun, Dolmen, 16 architecture, Romanesque, 382-384, 383 Fontenay Abbey, France, 366-357, 367 France, 362, 364, 364 Foreshortening, 456
Fortitude pulpit (N. Pisano), 443, 443
Forum (fora), Rome, 196–198, 196–198
Fountain (Duchamp), xix Dome of the Rock, Jerusalem, 280-283, illuminated manuscripts, 429-430, 430 Last Judgment, cathedral of Saint-Lazare, Stonehenge, 16, 18, *18* Sutton Hoo burial ship, 315, 316–318, 282 Autun, France, 362, 363 Giuliani, Rudolph, xvi Domes, 380 Giza, pyramids at, 55-61, 55-61 pendentive, 259, 259 316, 317 Romanesque, 380, 380 Glaber, Raoul, 349 Enneastyle, 112 Four-iwan mosque, 288, 288 Domitia Longina, portrait of, 205-206, 205 Entablature, 110 Glasswork Domus, 217 Entasis, 112 architecture, Early Gothic, 391-399, 392, colored glass, use of, 405 Doric style, 109–112, *110*, *111*, *112*, 136 Dormition, church of, Daphni, Greece, Eos and Memnon (Douris), 122–123, 122 Epidauros, Theater at, 151–152, 152 394-399 grisaille, 405 394–399 architecture, High Gothic, 399–413, 401–403, 407–410 architecture, Romanesque, 357–361, 357, 358, 360–364, 372–375, 373, 375, Islamic enameled, 299, 299 stained glass, French Gothic, 403–404, 405, 403, 404, 405 Epigonos (of Pergamon), Dying Trumpeter, 269-271, 269, 270 Dormitrion and Assumption of the Virgin 155, 155 (lintel), Chartres Cathedral, 407, 407 Equestrian statue of a Carolingian Ruler, Theophilus on, 402 Doryphoros (Spear Bearer) (Polykleitos), bronze, 324-325, 324 384-385, *384-385* Glaze, 41 126–127, 126, 144 Equestrian Statue of Marcus Aurelius, 206, Chauvet cave paintings, 2-3, 3, 5, 5 Glazed brick, 38 Douris, Eos and Memnon, 122-123, 122 207 illuminated manuscripts, Gothic, Gloucester Cathedral, England, 428, 428 Erechtheion, Akropolis, 140, 140 Erechtheus, King, 136 Esquiline tomb painting, 194, 194 Goat in thicket (Ram and Tree) Royal Cemetery at Ur, 26 Godescalc Gospels, Christ Enthroned, from 416-420, 416-420 Drôleries, 420 Lascaux cave paintings, 1, 1 (facing), 4, 4, Drums, 111 Drunken Old Woman (Mryron of Thebes), 6, 6, 7 Les Trois Frères cave paintings, 4, 7 Ménec, menhirs, 16, 17 Etruria, map of, 166 the, 325, 325 Gods and goddesses, Egyptian, 52 Gold Marilyn Monroe (Warhol), xii, xiii, Duccio di Buoninsegna, 453 Maestà Altarpiece, Annunciation of the Death of the Virgin, 456, 456 Maestà Altarpiece, Christ Entering architecture, 173-175, 173-175 Pech-Merle cave paintings, 5, 6, 6 sculpture, Early Gothic, 388, 395–396, 396, 397 city planning, 174–175 civilization, 165, 178 xiv, xvii, xviii Gold work Jerusalem, 456, 457 gold work, 166, 167, 169, 169 sculpture, High Gothic, 404-408, 407, Anglo-Saxon/Celtic, 315, 315, 316-318 Maestà Altarpiece, Madonna Enthroned, periods of, 165 408, 420–422, 421, 422 Egypt, 76, 77 454-456, 454-455 sculpture, 174, 174, 175, 177-178, 177 stained glass, Gothic, 403-404, 405, 403, Etruscan, 166, 167, 169, 169 Duchamp, Marcel Bicycle Wheel, xix 404, 405 Tuc d'Audoubert cave engravings, 8, 9 tombs and decoration, 164, 165–173, 165–173 Persian, 42-43, 42 Sumerian, 26, 27 Good Shepherd, Mausoleum of Galla Francis of Assisi, saint, 438, 439 Fountain, xix Eumenes II 151 Mona Lisa, xviii-xix, xix Euripides, 137 Franciscans, 438–441 Placidia, 248, 250, 250 Dur Sharrukin, 35-36, 35, 36 Europe, maps of Franks, 313 Gospel Book of Abbot Wedricus, 371-372, Frescoes Dura-Europos Bubonic Plague spread, 464 372 Christian Meeting House, 244, 245 synagogue, 237–239, 237–238 Arena Chapel (Giotto), Padua, 450–453, early Christian and Byzantine periods, Gospel Book of Archbishop Ebbo of Reims, 450-452 326, 326 236 early Middle Ages, 314 Durham Cathedral, England, 382-384, 383 Gospel Book of Charlemagne, 325, 326 conservation and techniques, 441 Gothic, 390 Dying Trumpeter (Epigonos), 155, 155 defined, 441 Gospel Book of Otto III, 340-342, 341, 342

Gothic art architecture, English, 426–429, 427–429	Guggenheim Museum, Solomon R. (Wright), New York City, xxii-xxiii,	Horse, Vogelherd Cave, 7, 8	cultural influences, 437–438, 449
architecture, English, 426–429, 427–429 architecture, Flamboyant, 422–423, 423	(wright), New York City, xxii–xxiii,	Hours of Jeanne d'Évreux (Jean Pucelle), 419–420, 419	frescoes, 439–441, 440, 450–453, 450–452 459–461, 460, 461
architecture, French, Early Gothic,	Guidalotti, Buonamico, 463	House church, 243-245, 244	geography, effects of, 437
391–399, 392, 394–399	Guilloche pattern, 108, 108	House of the Silver Wedding, Pompeii, 217,	illuminated manuscripts, 466, 466
architecture, French, High Gothic, 399–413, 401–403, 407–410	Gunzo , abbey church of Cluny, 357–358, 357, 358	217 House of the Vettii, Pompeii, 221–222, 221	map of trade routes, 438 map of Bubonic Plague spread, 464
architecture, German, 430-432, 431, 432	Guti, 32	Human form, representation, Egypt, 57,	mendicant orders, growth of, 439
architecture, Italian, 438-439, 439,	Guttae, 111	59–63, 59–63	painting, 439-441, 440, 449-453, 450-45
441–442, 442, 445–448, 445, 446,	Hades, 104	Humanism, 438	459–461, 460, 461
453–454, <i>453</i> , <i>464</i> , 465 architecture, Spanish, 423–426, <i>424–426</i>	Hadrian, 199	Hunting Scene, from the Queen Mary Psalter, 429–430, 430	sculpture, Gothic, 442–444, <i>443–444</i> , 46. <i>465</i>
Flamboyant phase, 422–423, 423	portrait of, 205, 205	Hydria, 121, 122	secular power, 437, 448
illuminated manuscripts, English,	villa of, Tivoli, 203, 203	Hypostyle hall, Temple of Amun-ra, 67-68,	trade routes, 437, 438
429–430, <i>430</i> illuminated manuscripts, French,	Hafiz, 304	68	Ivory
416–420, <i>416–420</i>	Hagesandros of Rhodes, 183 Hagia Sophia (Anthemius of Tralles and	Hypostyle mosques, 283–284, 284, 286	casket, Islamic, 287, 287 diptychs, Byzantine, 261–262, 261
metalwork, 420–421, 421	Isidorus of Miletus), Constantinople	Ice Age, 2	frame, Fatimid, Egypt. 292, 292
perpendicular style, 428, 428	(Istanbul), 257-260, 257-258, 260	Iconoclasm, 265–266	Ottonian, 340, 340
Rayonnant or Court style, 413–418, 413–417	Hall church, 367–368, 367, 430–432, 431	Iconoclastic Controversy, 265–266, 270	Paleolithic carvings, 7, 8, 8
sculpture, French, 388, 395–396, 396, 397,	Hall of the Bulls, Lascaux Cave, 1, 1 (facing), 6, 7	lcons Byzantine, early, 263–265, 263, 264	plaque, Phoenician, 38, 39 Siege of the Castle of Love, mirror back,
404–408, 407, 408, 420–422, 421,	Hallenkirche, 430	Byzantine, late, 273–274, 274, 275	422, 422
422	Hammath Tiberias synagogue, 239–240, 239	Iliad, The (Homer), 81, 84, 106, 118	Three Deities, Mycenae, 100, 100
sculpture, German, 432–434, 432–434 sculpture, Spanish, 424–426, 425, 426	Hammurabi, 33	Imhotep, 53, 55	triptychs, Byzantine, 268, 268
spread of, 423	code of, 34, 34, 35 Hand dots, Chauvet Cave, 5	India architecture, 310, <i>310</i>	Iwan, 287 Persian, 45
stained glass, French, 403-404, 405, 403,	Hanging Gardens of Babylon, 37	decorative art, 309–310, 309	1 Cisiali, 43
404, 405, 406	Hanson, Duane, Man on a Mower, xx, xx	illuminated manuscripts, 308, 309	Jacob Wrestling the Angel, from the Vienn.
Gothic era	Harbaville Triptych, ivory, 268, 268	Mughal period, 300, 308-310	Genesis, 262–263, 262
development of, 389–391 map of, <i>390</i>	Harel, Ambroise, Saint-Maclou, Rouen, 423, 423	Inlay panel, Royal Cemetery At Ur, 28, 28	Jahan, shah, 309
use of term, 389	Hariulf, History of the Monastery of Saint-	Inlay, Sumerian, 25–27, 26–27 Insula (insulae) (apartment block), 218, 218	Taj Mahal, 310, <i>310</i> wine cup, 309, <i>309</i>
Granada, Spain, Alhambra, 290, 299-300,	Riquier, 331	Intercolumniation, 133	Jahangir, 309
300	Harmony, 392	Interior of Old Saint Peter's, Rome	Jambs, 360, 361, 361
Grandstand Fresco, Knossos, 86, 87 Granulation, 169, 169	Harpist, Cycladic, 82, 83	(Grimaldi), 246	statues, 388, 396, 396, 397, 408, 408, 424,
Grassi, Giovannino dei, Book of Hours of	Harvester Vase, Hagia Triada, 90–91, 91 Hatayi style, 304, 304	Ionic style, 109–111, 112–113, <i>110</i> , <i>112</i> Iranian art	<i>426</i> Jeanne d'Évreux, 419–420, <i>419</i> , 420, 421
Giangaleazzo Visconti, 466, 466	Hatshepsut, 56	See also Islamic art	Jericho, Jordan, 11–12, 12
Grave Stele of Hegeso, 138, 139	Kneeling Figure of King Hatshepsut, 67, 67	early, 41, 41	Jerusalem, 40–41, 235
Gravettian culture, 9	temple of, 65–66, 66	figural art forms, 288–289, 289	Dome of the Rock, 280-283, 282
Great Altar of Zeus, Pergamon, 156, <i>156</i> , <i>158</i> , 159	Hattusilis I, 38 Head of Herakles or Telephos, Temple of	Isabella of France, queen, 430 Isfahan, mosque of Abbas I, 307, <i>307</i>	sack of, 40–41, 209–210, 210
Great Pyramids, Giza, 55–61, 55–61	Athena Alea, 143, 143	Ishtar Gate, Babylon, 38, 38	Temple of Solomon, 40, 40, 235 Jesus Teaching in the Temple, from the
Great Sphinx, 56, 57, 58	Heel Stone, 16, 18	Isidorus of Miletus, Hagia Sophia,	Queen Mary Psalter, 429-430, 430
Greece	Heiligenkreuz (Parler and Parler),	Constantinople (Istanbul), 257–260,	Jesus Washing the Feet of St. Peter, from the
brief history, 104, 123 culture, emergence of, 103, 104	Schwäbish-Gmünd, Germany, 430–432, 431	257–258, 260 Islam, 279, 283	Gospel Book of Otto III, 341–342, 341
gods and goddesses, 105	Helen of Alexandria, 162	figural images, mistrust of, 57, 279	Jesus, scenes of life most frequently depicted, 241
homosexuality, 121	Helladic, use of term, 81	impact on visual arts, 279, 280	Jewelry, Egypt, 64, 65
map of Archaic and Classical, 104	Hellenistic art	Shi'ites versus Sunni, 290–291	Jewish art, early
map of Hellenistic, <i>147</i> myth, role of, 127, 135, 136, 157	architecture, 148–154, 149, 152, 153	Sufism, 288	Christian art, influence of, 239
problems with studying, 103–104	city planning, 150–151, <i>150</i> , <i>151</i> painting, 161–162, <i>161–162</i>	Islamic art architecture, 280–284, 282, 284, 285–286,	Consecration of the Tabernacle and Its Priests, Dura-Europos, 238, 239
women's lives, 106, 108, 120, 121, 122,	realism, 160, <i>160</i>	285, 286, 287–288, 288, 291, 291, 293,	Graeco-Roman content, 239, 240
<i>138</i> , 139, 160, <i>160</i>	sculpture, 154-160, 154-160, 183	293, 294, 295, 295, 296, 296 298,	in Late Roman Empire, 237
Greek art, Archaic	Hemsoll, David, 202	299–300, 300, 302–303, 302, 303, 307,	synagogue decoration, 237-240, 237-239
architecture, 109–113, <i>109–113</i> dating based on naturalism, 115	Henry of Blois, bishop of Winchester, 386 Hera, 104	307, 310, 310 carpets, 299, 301, 301, 306, 306	Jordan, El Khasneh, Petra, 214–215, <i>215</i> Josephus Flavius, 209, 210
sculpture, freestanding stone, 113–114,	Hera I, Temple of 111–112, 111	ceramics, 288–289, 289, 304, 304	Joshua and the Emissaries from Gibeon,
113–114, 116	Hera II, Temple of 112, 112	Fatimids, 290–292	from the Joshua Roll, 266, 266
sculpture, pediment, 115–119, 115,	Herakles, 107, 108	figural art forms in Iran, 288-289, 289	Joshua Roll, 266, 266
118–119, 120 Symposium 119, 123, 121, 122	Heraldic pose, 94	glass, enameled, 299, 299	Judaism
Symposium, 119–123, <i>121</i> , <i>122</i> vases, 119–122, <i>121</i> , <i>122</i>	Herat, 296 Herculaneum	ivory products, 287, 287 manuscripts, illuminated, 293, 293, 296,	influence on early Christian art, 240, 242 in Late Roman Empire, 235
Greek art, Classical	architecture and painting, 216–22, 222	297, 304–306, <i>305</i> , <i>308</i> , 309	See also Jewish art
architecture, 131-141, 130-1, 132, 137,	Villa of the Papyri, 188	Mamluk patronage, 295, 297-299	Julius Caesar, 182, 195, 196
139, 140	Herland, Hugh, Westminster Hall,	metalwork, 299	Junius Bassus, sarcophagus of, 253-254,
architecture, in late, 141–142, <i>141–142</i> painting, in late, 146–147, <i>146</i>	London, 429–430, <i>430</i> <i>Hermes</i> (Praxiteles), 144, <i>144</i>	Mongol patronage, 295 mosaics, 282–283, 282, 296, 296	Jupiter Optimus Maximus, Temple of 184,
and philosophy, 127	Hermes, 104	Mudejares, 287, 290	184
sculpture, freestanding, 123-127,	Hermodorus, 185	Mughal period, 300, 308–310	Justinian as Conqueror, 260, 261
123–127	Herodotus, 75, 165	Nasrids, 290, 299-300	Justinian, 254, 256, 256, 257, 259, 260, 261
sculpture, pediment, 128, 129, 129 sculptures, Parthenon, 134–138, 134–138	Heroön, 151	Ottomans, 300, 302–304	K 6 - 1 - 6 50 50
Greek art, Hellenistic. See Hellenistic art	Hesy-ra, 60, 60, 61 Hetland, Lise, 202	Persian influence, 287–289 Safavids, 300, 304–307	Kafra, sculpture of, 59, 59 Kairouan, Tunisia, Great Mosque, 285, 285
Greek art, styles/periods	Hexastyle, 112	Seljuks, 288, 289, 290	Kallimachos, 142
Archaic, 109–122, 109–122	Hieratic scale, 28	Spanish, Middle Ages, 290, 290	Kamares ware, 90, 90
Classical, 123–137, <i>123–13</i> 8, 141–147, <i>141–146</i>	Hieroglyphs, 50–52	style, development of, 285–287	Kariye Camii (Church of the Savior),
Geometric, 104–107, <i>105–107</i>	Hippodamos of Miletos, 150 Hittites, 34, 38	textiles, 291–292, 292 Timurid patronage, 295–296	Constantinople, 275–276, <i>276</i> Kasbahs, 23, <i>23</i>
Orientalizing, 107-109, 107, 108	Holy Land, Romanesque castles, 374–375,	writing, 279, 281, 281, 283	Kassites, 34
Pheidian, 138-141, 138-141	375	Islamic world	Khafra, pyramid of, 55-58, 55-57
Greek cross, 248 Greek-cross plan churches, 272	Holy Virgin Mary (Ofili), xvi, xvi	cultural complexity, 279	Khludov Psalter, 265, 265
Gregory I (Gregory the Great), pope, 371	Homer, 81, 82, 84, 106 Homosexuality in Greek culture, 121	and literacy, 283 map of, 280	Khnum-hotep, tomb of, 63, <i>64</i> Khufu, pyramid of, 55, <i>55</i> , 56
Grimaldi, Jacopo, Interior of Old Saint	Honnecourt, Villard de, Wheel of Fortune,	Italy	Kiss of Judas, choir screen, Naumburg
Peter's, Rome, 246	404, 406	architecture, of city government, 448,	Cathedral, 433, 433
Grisaille glass, 405 Grisaille, 419	Honoré, Master, David and Goliath, from	<i>448</i> , 453–454, <i>453</i>	Kneeling Figure of King Hatshepsut, 67
Groin vaults, 185, 376, 376, 379	the <i>Prayer Book of Philip IV the Fair</i> , 418–419, <i>418</i>	architecture, Gothic, 438–439, 439 architecture, Romanesque, 375–378,	Knossos, Palace at, 84–90, <i>84–89</i> Kore (korai) statues, 113–114, <i>113</i> , <i>114</i>
Grünewald, Matthias, The Crucifixion, xx	Honorious, 248	376–378	Kore (Maiden), 113, 113
Gudea, 32–33, <i>32</i> , <i>33</i>	Horace, 188, 195	art, importance to society, 455	Kouros (kourai) statues, 113-114, 113, 114

Krater, 146 Man and Centaur, 107, 107 Mesopotamia. See Near East Muhammad Ibn Mahmud Al-Amuli, 281 Athenian, 106 Man on a Mower (Hanson), xx, xx Metalwork Muhammad, 279 Anglo-Saxon/Celtic, 314–318, *315–317* Gothic, French, 420–421, *421* Krates of Mallos, 156 Kritios, Kritios Boy, 123–125, 123 Kroisos (Kouros from Anavysos), 114, 115 Mandorla, 276 Manohar, Ceremonial Audience of God's Messenger, 283 Muqarnas, 291 Jahangir, 308, 309 Islamic, 299 Murad III, 303 Kufic alphabet, 279, 281, 283 Manuscript illumination, 252 Mycenaean, 98, 99 Murals Byzantine, late, 276, 276
Byzantine, late, 276, 276
Egyptian, New Kingdom, 71, 71, 77, 78
Egyptian, Old Kingdom, 48, 50, 51,
61–62, 61, 63, 64 Manuscripts, illuminated Byzantine, early, 262–263, 262 Byzantine, middle, 265, 265, 266–268, Ottonian, 336-339, 337-339 Kylix, 122, 122 Persian, 46, 46 Vaphio cups, 99, 100 L'Arringatore (the Orator), Etruscan bronze, 177–178, 177 266, 267 Metope, 110 266, 267 Carolingian, 325–327, 325–327 Christian, Early, 252–253, 252 English Gothic, 429–430, 430 French Gothic, 416–420, 416–420 Hellenistic, 161–162, 161 Labors of the Month, Amiens Cathedral, Parthenon, 135-136, 136 Minoan, 86–89, 87–89, 92–93, 92 Roman domestic, 218–221, 219–221 Roman provincial, 216, 216 Meung, Jean de, 422 Mezhirich, Ukraine, bone house, 11, *11* 412, 412 Lady Sennuwy, sculpture of, 62, 63 Lagash, 32–33 Middle Ages Anglo-Saxon art, 314–318 Lamassu (Dur Sharrukin), 36, 36 Indian, 308, 309 Roman Republic, 194, 194 Lamentation (Giotto di Bondone), Arena Islamic, 293, 293, 296, 297, 304–306, 305, Carolingian art, 324–333 Musicians and Dancers, Tomb of Nebamun, 71 Muslims, 283 See also Islamic art (Scrovegni) Chapel, Padua, 452, 452 308, 309 Christianity, influence on art, 313-314 Italian Gothic, 466, 466 Ottonian, 340–342, 341, 342 Romanesque, 368–372, 368, 370–372, 386, Landscape painting earliest image, 14, 14 Minoan, 88, 89, 89 description of, 313–314 map of Europe in, 314 medieval, use of term, 237, 313 Mycenae, reconstruction of, 93, 93 Lanterns, 272 Ottonian art, 333-344 Mycenaean art architecture, 93–98, *93–98* Laon, France, cathedral of Notre-Dame, scriptoria, 313 Viking art, 322-324 metalwork, 98, 99, 99 sculpture, 99–100, 100 tombs, 96–100, 96–100 397-398, 397 Maps Mihrab, 284 Aegean world, Bronze Age, 82 Lapith and Centaur, Parthenon, 136 Milan Lapiths, 128, 129, 136
Lascaux, France, cave paintings, 1, 1 (facing), Egypt, Ancient, 50 Europe, Bubonic Plague spread, 464 Europe, early Middle Ages, 314 in fourteenth century, 465–466 Visconti, Bernabò, tomb of, 465–466, 465 Vaphio cups, 99, 100 Myron (of Thebes) 4, 4, 6, 6, 7 Milon of Athens, 146 Europe, Gothic period, 390 Europe and the Near East, prehistoric, 2 Last Judgment (Giotto di Bondone), Arena Mina'i dish, Iran, 288-289, 289 Diskobolos (Discus Thrower), 125-126, (Scrovegni) Chapel, Padua, 436, 451 Minaret, 284 126 Europe and the Near Last, premstor Europe, Romanesque period, 348 Greece, Archaic and Classical, 104 Greece, Hellenistic, 147 Italian fourteenth-century sea trade Last Judgment (Gislebertus), cathedral of Minbar, 284 Nafâ'is al-Funûn (The Beauty of Knowledge) (Al-Amuli), 281 Saint-Lazare, Autun, France, 362, 363 Latin cross-plan churches, 375–376 Le Tuc d'Audoubert, France, cave Miniatures, xv Minoan art and civilization architecture, 84–86, 85, 86 Naos, 109 engravings, 8, 9 Leaning Tower of Pisa (Pisano), 375, 376 routes, 438 development of, 84 Napoleon, 49 Italian peninsula, Etruscan period, 166 painting, 86-89, 87-89, 92-93, 92 Naqada II/III, 50 Naram-Sin, 30–32, 30, 31 Naram-Sin, 50–53, 51, 52–53 Narrative, visual development, Sumcrian, 27–28, 27, 28 Lekythos, 146-147, 146 of Islamic world, 280 pottery, 89-91, 90-91 sculpture, 91-92, 91-92 Lcs Trois Frères, France, cave paintings, 4, 7 Near East, Ancient, 22 pilgrimage routes, 354 Roman Empire, early second century, 182 Roman Empire, early Christian and Minos, King, 84 Minos, Palace of, 84–90, 84–89 Leto, 135 Leyster, Judith, Self-Portrait xvii, xvii Libon of Elis, 129, 133 Minotaur, legend of, 84 Narthex, 246 Light wells, 84, 86 Byzantine period, 236 Nasir ad-Din al-Hasan, 299 Liminal space, 209 Magamat manuscript, Scene in an Arab engraved Etruscan, 178, 178 Nasrids, 290, 299-300 Village (Yahya ibn Mahamud al-Wasiti), 293, 293 Maqsura, 285 Nativity pulpit (G. Pisano), 444, 444 Nativity pulpit (N. Pisano), 113 111, 111 Naturalism, 5, 10 Lindau Gospels, 327, 328 Siege of the Castle of Love, mirror back, ivory, 422, 422 Linear A, 84 Linear B, 94 Modeling, 4 Module, 333 Marcus Atonius, statue base of, 189–190, 190 Naumburg Cathedral, Germany, 432–434, Lion Gate (Hittite), 38, 39 Lion Hunt relief, Palace of Ashurbanipal, Marcus Aurelius, 212, 222, 229, 231 Mona Lisa (Duchamp), xviii-xix, xix 432, 433 equestrian statue of, 206, 207 Navalia, Rome, 186, 186 Monasteries Lioness Gate, Mycenae, 94, 95 See also under name of order and name of Mars, Field of, 187, 213 Nave, 245, 439 Liturgy, 238 Looting of art, 29, 29 Lorenzetti, Ambrogio monastery development of, 439–41 and illuminated manuscripts, 318, 319, Martini, Simone, Annunciation, 458, 458 Naves Martyria, 227 Amiens Cathedral, 408, 409 Mary Tudor, queen of England, 130 Chartres Cathedral, 400, 401, 401, 409 Good Government in the City and Good Mask of Agamemnon, 98, 99 320, 321 comparison of, 409 Government in the Country, Mastaba, 53, 53, 54 in Ireland, 318-319 Notre-Dame, Paris, 398, 399, 409 Near East Akkadia, 30–32 Assyria, 34–37 459-461, 460, 461 Masud ibn Ahmad al-Naqqash, cast Monasticism, 269 and spread of Christianity, 319 Mongols, 295 Lorenzetti, Pietro, Birth of the Virgin, 458-459, 459 bronze bucket, 289 Mau, August Lorris, Guillaume de, 422 four styles of Pompeiian wall painting Babylon, 33–34, 37–38 Monreale Cathedral, Italy, 272, 273 Lost-wax process, 127, 128, 338 218-222, 219 Moralia in Job, Gregory the Great, 371, 371 geography of, 21 Mausoleum at Halikarnassos, 141-142, 141, Hebrews, 40–41 Byzantine, early, 256, 257
Byzantine, late, 274–276
Byzantine, middle, 269–273, 269–272
Christian, early, 248–251, 248–251
Hatayi style, 304, 304 Louis IX, king of France, 390, 413, 416 Louis VI, king, 391 Hittites, 39 142 Iran 41 map of Ancient, 22 Persia, 41–46 Mausoleums See also under Tombs of Galla Placidia, 248–250, 248–250 at Halikarnassos, 141–142, 141, 142 of Santa Costanza, Rome, 246–247, 247 Louvre, East front, xxii Lunettes, 240 Luster, 288 Phoenicians, 39-40 Luzarches, Robert de, Amiens Cathedral, Hellenistic, 248 Sumer (Sumerian), 21-29, 32-33 408, 409, 412, 412 Mausolos, 141 Islamic, 282-283, 282, 296, 296 Nebamun, tomb of 71, 71 Maxentius, 222, 228, 231, 232
Basilica of Maxentius and Constantine, Lysippos, Apoxyomenos (Scraper), xviii, xix, Jewish synagogues, 239-40, 239 Nebuchadnezzar I, 34 144–145, 145 materials and techniques, 248 Nebuchadnezzar II, 26, 37, 40, 47 Necropolis, 53 Nefertiti, Queen, 72, 74 Nemes headdress, 67 Portrait of Alexander the Great, 154, 154 225, 225 Ottoman, 303, 303 at Pompeii (copy of Hellenistic painting) 162, 162 Meander pattern, Greek Geometric, 106 Medes, the, 30, 37, 41, 47 Machaut, Guillaume de, The Enchanted Garden, from Le Dit du Lion, 420, 420 Roman, 162, 162, 180, 194, 195, 248 Neolithic art Medieval Machicolations, 374 importance of images in European Sumerian, 24 architecture, 11-12, 12, 13-14, 15-16, 16, use of term, 248 Mosan style, 379–381, 379 Madonna Enthroned (Cimabue), 449, 449 society, 455 17-18, 18 use of term, 237, 313 and see Middle Ages Medina al-Zahra, 287 Madonna Enthroned (Giotto di Bondone), in Egypt, 50 painting, 13–14, 14 pottery, 14, 15, 15 sculpture, 12, 12, 13, 13, 14–15, 14–15 Mosques, 283 See also under name of 450, 450 Madonna Enthroned, Byzantine icon, tempera on panel, 273–274, 274 Madrasas, 288, 291, 293, 302 Medusa, 115–116 hypostyle, 283–284, 284 Megaliths, 16 Mossiac, monastery of, France, 358-362, time periods, 9 Megaron, 96, 96
"Queen's Megaron", Knossos, 88, 89
Melchizedek and Abraham, from the
Psalter of St. Louis, 417–418, 417
Melchizedek and Abraham, Reims of Sultan Hasan, 298, 299 358, 360-362 New Stone Age, 11 Mouth of Hell, from the Winchester Psalter, 386, 386 New York city
Guggenheim Museum, Solomon R.
(Wright), xxii–xxiii, xxiii of Ulugh Beg, 296, 296 Maestà Altarpiece (Duccio) Annunciation of the Death of the Virgin, Mozarab style, 290 New York Kouros, 113, 113, 115 456, 456 Mrs Joseph Scott (Copley), xiii-xiv, xiv Niello, 99 Nike (Nikai), 138–139 Nike of Samothrace (Pyhthokritos), 158, Christ Entering Jerusalem, 456, 457 Cathedral, 411-412, 411 Mryron (of Thebes), Drunken Old Meleager Sarcophagus, 229–230, 231 Madonna Enthroned, 454–456, 454–455 Magdalenian period, 9 Mai and His Wife, Urel, 71, 72 Woman, 160, 160 Mud brick, 23, 23, 54, 55 Menhirs, 16, 17 Mudejares, 287, 290 Mughal period, 300, 302 Menkaure and His Wife, Queen 159 Maidan, 307 Khamerernebty II, 59, 59-60 Nike, Temple of Athena, 138 Maison Carrée (Square House), Nîmes, 214, Menkaure, pyramids of 55-61, 55-61 in India, 308-310 Nile Mosaic, Sanctuary of Fortuna Muhammad ibn abd al-Wahid, cast bronze Primiginia, 162, 162, 180, 194, 195 Mentohotep II, 62, 66, 66 Mamluks, 295, 297-299 Mesolithic period, 9 bucket, 289 Nineveh, 30, 32

Niobid Painter, Red-figured calyx krater,	Paionios of Ephesos, Temple of Apollo, Didyma, 148–150, 149	Philoxenos of Eretria, 162 Phoenicians, 38, 39, 40	Priene plan of, 150, <i>150</i>
146, <i>146</i> Nomad's gear, 41	Palaces	Photography as art, xxi	Temple of Athena, 148, <i>148</i>
Notre-Dame de la Belle Verrière, stained	Alhambra, 290, 299–300, 300	Pictograms, 21	Priest-King Feeding Sacred Sheep, Uruk, 29
glass, Notre-Dame cathedral, Chartres,	Ashurbanipal, 37, 37 Ashurnasirpal II, 36, 37	pictographs, 52–43 Piers, 259, 446	Prince Rahotep and His Wife, Nofret, 60, 6
404, 404, 405 Notre-Dame, Amiens (Luzarches, de	Babylon, 38, 38	Pilgrim's Guide to Santiago de Compostela,	Procopius of Caesarea, 259, 260
Cormont and de Cormont), 408, 409	Chapel of Charlemagne, 328-330, 329,	excerpts from, 352, 353, 356	Pronaos, 109
sculpture, relief, 412, 412	330 of Diocletian, 226, 227	Pilgrimage churches, 351–354, 352–353 Pilgrimage routes, map of, 354	Propylaia (Mneskiles), 139, 139 Propylons, 94
Notre-Dame, Chartres buttresses, 402, 403, 403	Doge's, 464, 465	Pilgrimage-plan church, 353	Protomes, 102, 108, 109
nave, 400, 401, 401, 409	at Knossos, 84–90, 84–89	Pinakotheke, 139	Provenance, 83
rebuilding of, 400–408, 400 sculpture, 388, 395–396, 396, 397	Medina al-Zahra, 287 of Minos, 84–90, <i>84</i> –89	Pisa, Italy cathedral complex, 375–377, 376	Psalters Blanche of Castile, 416, 416
sculpture and transepts, 404–408, 407, 408	at Persepolis (Darius I and Xerxes),	Leaning Tower of, 375, 376	defined, 265, 326–327
stained glass, 403–404, 403, 404, 405, 406	42–44, 42, 43	Pisano, Andrea, Bronze doors, baptistery	Khludov, 265, 265
west façade, 388, 395–396, 395 Notre-Dame, Laon, France, 397–398, 397	Persian, 41–45, <i>42–45</i> Sargon II, 35–36, <i>35</i> , <i>36</i>	of San Giovanni, Florence, 446–448, 447, 448	Paris, 267, 267 Queen Mary, 429–430, 430
Notre-Dame, Paris, 398–399, 398	of Shapur I, 45, 45	Pisano, Bonanno, Leaning Tower of Pisa,	St. Louis, 417–418, 417
nave, 398, 399, 409	Topkapi, 302	375, <i>376</i> Pisano, Giovanni, 442, 455	Utrecht, 326–327, 327 Winchester, 386, 386
sculpture, 421–422, <i>421</i> west façade, 399, <i>399</i>	Palazzo della Signoria (Palzzo Vecchio) (Arnolfo di Cambio), Florence, 448, 448	<i>Nativity</i> , pulpit, Pisa, 444, 444	Ptolemy xiv, 78
Notre-Dame, Reims, 408, 410	Palazzo Pubblico, Siena, 453-454, 453	Pisano, Nicola, 442, 445	Ptolemy, 78
sculpture, relief, 411–413, <i>411</i> , <i>412</i> sculpture, west portal, 410–411, <i>411</i>	Paleolithic art cave paintings, 1–7	Fortitude, pulpit, Pisa, 443, 443 Nativity, pulpit, Pisa, 443–444, 444	Pucelle, Jean, Hours of Jeanne d'Évreux, 419–420, 419
west façade, 410, 410	sculpture, 7–11	pulpit, Pisa, 443, 443	Puente La Reina, bridge, Spain, 355–356,
Notre-Dame-la-Grande, Poitiers, France,	time periods, 9	Plate tracery, 406	356
372–373, 373	Palette of King Narmer, xv, 50–53, 51, 52–53, 59	Plato, 49, 123 Play of Adam, 372	Pyhthokritos (of Rhodes), Nike of Samothrace, 158, 159
Obelisks, 67	Pantheon, 199–203, 200–202	Pliny the Elder, 142, 143, 155, 162, 183	Pylons, 67
Octastyle, 132	problems and dating of, 202	Plutarch, 131, 136, 138	Pyramid Text of Unis, 58
Octopus Vase, Crete, 90, 90 Oculus, 201	Pantocrator, 269, 270, 272 Parchment, 252	Pointilliste effect, 5 Polis, 109	Pyramids building techniques, 56, 56
Odo of Metz, Palace Chapel of	Paris Psalter, David Composing the Psalms,	Polybius, 192, 194	Djoser, funerary complex of, 53–55, 53–5
Charlemagne, 328–330, 329, 330	from the, 267, 267	Polydorus of Rhodes, 183	at Giza, 55–61, 55–61
Odyssey, The (Homer), 81, 82, 84, 106 Ofili, Chris, The Holy Virgin Mary, xvi,	Paris Notre-Dame, 398–399, <i>398</i> , 399, <i>409</i>	Polygnotos of Athens, 146 Polykleitos the Younger, Corinthian	Senwosret III, complex at Dahshur, 62, 62, 64, 65
xvi	Sainte-Chapelle, 413–415, 413, 414	capital, 142, 142	Pytheos (of Priene)
Old Saint Peter's basilica, Rome, 245–246,	Parler, Heinrich, Heiligenkreuz,	Polykleitos, Doryphoros (Spear Bearer),	Mausoleum at Halikarnassos, 141–142,
245–246 Oljeytu, tomb of, Sultaniya, Iran, 294, 295,	Schwäbish-Gmünd, Germany, 430–432, 431	126–127, <i>126</i> Polyptych, 454	<i>141</i> , 142 Temple of Athena, 148, <i>148</i>
295	Parler, Peter, Heiligenkreuz, Schwäbish-	Pompeii	Pyxix, 287, 287
Opisthanaos, 132	Gmünd, Germany, 430–432, 431	architecture, 216–218, 217	Occural Have france from 284 284
Optical images, 5 Orants, 242	Parthenon (Itkinos, Kallikrates, and Karpion), 131–138, <i>132</i> , <i>134–135</i>	four styles of wall painting 218–222, 219–221	Qasr al-Hayr, fresco from, 284, 284 Qibla, 283
Orchestra, 151	Parthenon, east frieze, 136-137, 137	mosaic (copy of Hellenistic painting) 162,	Quatrefoil, 412
Orthostats, 37	western entrance frieze, 137 Parthians, 45	162 Pompey, theatre complex, 186–188, 188,	Quedlinburg Itala, 252, 252, 253 Queen Mary Psalter, 429–430, 430
Osman, 300, 302 Ostrogoths, 313	Parting of Lot and Abraham, Santa Maria	196	Queen Nefertiti, sculpture of, 74, 74
Otto I, 333	Maggiore, 250, 251	Poor Man Refused Admittance to a Mosque,	Queen Pu-abi, 28
Otto II, 333, 340 Otto III Between Church and State, from	Patrons of art See also under name of	A (Behzad), from Bostan of Sa'di, 296, 297	Queen Tiy, sculpture of, 73–74, 74 "Queen's Megaron", Knossos, 88, 89
the Gospel Book of Otto III, 340, 341	Black Death, effects of, 299, 462	Porch of the Maidens, 140–141, 140	Qur'an, 279, 281, 281, 283
Otto III Receiving the Homage of the Four	Christianity as, 313–314	Porta Marzia (Gate of Mars), Perugia, 173,	D : W : 4 127 127
Parts of the Empire, from the Gospel Book of Otto III, 340, 341	women, Romanesque Spain, 364–365 Pech-Merle, France, cave paintings, 5, 6, 6	173 Porticus Aemilia, See Navalia	Raice Warrior A, 127, 127 Ramesses II, 78
Otto III, 333, 334, 340	Pectoral of Mereret, 64, 65	Portrait Head, bronze from Delos, 154,	temple of, 69–70, 69–70
Ottomans, 300, 302–304	Pediment, 110	155	Ramasses III, 78
Ottonian art architecture, 333–336, <i>334–336</i>	sculpture, Greek Archaic, 115–119, <i>115</i> , 118–119, 120	Portrait of a Man, Etruscan terra cotta, 177,	Ramose, tomb of 71, 72 Raphael, <i>The Alba Madonna, xv</i>
ivory, 340, <i>340</i>	sculpture, Greek Classical, 128, 129, 129,	Portrait of a Woman, Fayum, Egypt, 216,	Ravenna
manuscripts, 340–342, 341, 342	134–138, <i>134–138</i>	216 Remark of Alexander the Creat (Lysings)	Mausoleum of Galla Placidia, 248–250, 248–250
metalwork, 336–339, <i>337–339</i> sculpture, 336–339, <i>337–339</i> , 343–344,	Pegasus, 116 Pendentives, 259, 259	Portrait of Alexander the Great (Lysippos), 154, <i>154</i>	San Vitale church, 254, 255–257, 255–256
343, 344	Pentecost, from the Cluny Lectionary, 368,	Portrait sculpture. See Sculpture, portrait	Rayonnant or Court style, 413-418,
Ovid, 195	369–70	Portunus, Temple of, Rome, 184, <i>184</i> Poseidon, 104, 116	413–417 use of term, 415
Paestum, Italy, Temples of Hera I and Hera	People, boats, and animals, tomb chamber, Hierakonpolis, 50, 51	Post-and-lintel-construction, 16	Red-figure pottery style, 121–123, 122
11, 111–112, 111, 112	Pepin, Carolingian king, 391	Pottery	Red-figured calyx krater (Niobid Painter),
Painting See also Frescoes; Landscape painting;	Pepy II, 62 Pergamon, 148	black-figure style, 119–121, <i>121</i> , <i>122</i> Cycladic, 82, <i>83</i>	146, 146 Reed Painter, White-ground lekythos,
Mosaics; Murals	Great Altar of Zeus, 156, 156, 158, 159	Etruscan, 171, <i>171</i>	146–147, <i>146</i>
Christian, early, 240-243, 242, 244-245,	plan of, 151, 151, 183	Greek painted archaic, 119-123, 121, 122	Registers, 28
244 Cluniac, 365–366, <i>366</i>	Perikles, 123, 131 Peripteral temple, 109, 110	Greek painted, Geometric, 105–106, 105–106	Regolini-Galassi tomb, Cerveteri, 166–167
Egyptian, New Kingdom, 71, 71, 77, 78	Peristyle, 110	Greek painted Orientalizing, 108, 108	Reims Cathedral, 408, 410
Egyptian, Old Kingdom, 48, 50, 51,	Peroz I or Kavad I hunting rams, 20, 46	Iranian, early, 41, 41	sculpture, relief, 411–413, 411, 412
61–62, <i>61</i> , 63, <i>64</i> Etruscan, <i>164</i> , 168–171, <i>169</i> , <i>170</i>	Peroz I, 46, 46 Perpendicular Gothic style, 428, 428	Minoan, 89–91, <i>90–91</i> Neolithic, 14, 15, <i>15</i>	sculpture, west portal, 410–411, <i>411</i> west façade, 410, <i>410</i>
Gothic, Italian, 439-441, 440, 450-453,	Perrault, Claude, Louvre, xxii, xxii	ref-figure style, 121-123, 122	Relics, 351, 353, 355, 359
450–452, 459–461, 460, 461 Greek Classical, 146–147, 146	Persephone, 104	Praeneste, Sanctuary of Fortuna Primigenia, 186, 187	Relief Panel of Hesy-ra, 60, 60 Relief, 22, 443
Hellenistic, 161–162, 161, 162	Persepolis, 42–44, <i>42</i> , <i>43</i> Perseus, 116	Praxiteles	Relieving triangle, 94
Italian, Gothic, 439-441, 440, 450-453,	Persia (Persians), 41-46	Aphrodite of Knidos, 143-144, 143	Religious beliefs
450–452, 459–461, 460, 461 Jewish synagogues, 237–239, 237, 238	influence on Islamic art, 287–289 Petrie, William Flinders, 56	Hermes, 144, 144 Prayer Book of Philip IV the Fair, 418–419,	Egyptian, 49, 52, 53–57 Greek, 103
Minoan, 86-89, 87-89	Pharos at Alexandria, 153–154, 153	418	Jewish, 40, 238
Neolithic, 13-14, 14	Pheidian style, 138–139, <i>138</i>	Prefiguration, 242	Minoan, 91–92
Paleolithic cave, <i>xxiv</i> , 1–7, 2–7 Roman domestic, 218–222, 219–222	Pheidias, 135 Pheidias , <i>Athena Parthenos</i> , 132, <i>133</i>	Prehistoric art, 1 feminist interpretation, 11	Mycenaean, 93–96, <i>93–96</i> Paleolithic, 5–6
Romanesque Cluniac, 365-366, 366	Philip II, king of Macedon, 147	interpreting, 5–6	Persian, 41–42
Roman Provinces, 216, 216	Philip IV the Fair, prayer book of, 418–419, 418	Neolithic, 11–18 Paleolithic, 2–11	Sumerian, 22, 23, 24, 27 Reliquaries, 348, 353, 354–355, <i>354</i>
Roman Republic, 194, 194	720	i meeting, will	

Assyrian, 36, 36 Babylonian, 36, 36 Remus, 177, 181, 207 Rotuli, 212 Seven Wonders of the World, 153 Renier of Huy, baptismal font, 379-381, Royal Standard of Ur, 27-28, 27 Severus, Septimius, 227 Christian, early, 243, 243, 253-254, 253 Rubens, Peter Paul, xviii Sexpartite groin vaults, 385 Repatriation of cultural heritage, 134, 135 Rule, the, of monastic life, 263 Carolingian, 324-325, 324 Shading, 4, 162 Repoussé, 46 Responds, 393 Rusticated, 448 Cluniac, 359-365, 360-365 Shah Kulu, tile in hatayi with saz design, Cycladic, 82–84, 83 Egypt, block sculpture, 70, 70 Egypt, Middle Kingdom, 62–63, 62, 63, 304, 304 Restoration of architecture, 369 Safavids, 300, 304-307 Shamanism, 6, 7 Saint-Denis, abbey church, France ambulatory and choir, 391–393, 392 Revetments, Etruscan, terra cotta, 174, 174, Shapur I Triumphing over the Roman Emperors Philip the Arab and Valerian, Rhinoceros, Wounded Man, and Bison, Lascaux Cave, 4, 6 construction of, 394-395 Egypt, New Kingdom, 68–70, 69, 70, 72–74, 72–74 Nash-i-Rustan, 44, 45 rebuilding of, 391 Suger of Saint-Denis, role of, 391, 392, Shapur I, 45, 45 Shepherds in a Landscape, Santa Maria Rhyton cup Minoan, 90–91, 91 Persian, 42–43, 42 Egypt, Old Kingdom, 59-62, 59-62 393, 394, 395 Etruscan, 171-173, 171-173, 175-178, Maggiore, 250, 251 west façade, 395, 394 174-177 She-Wolf, Etruscan/Roman, 176-177, 176 Ribbed groin vaults, 446 Ritual cup (Persian), 42, 42 Robin, Pierre, Saint-Maclou, Rouen, 423, Sainte-Chapelle, Paris, 413–415, 413, 414 Saint-Étienne, abbey church, Caen, France, 384–385, 384–385 Gothic, French, 388, 395–396, 396, 397, 404–408, 407, 408, 420–422, 421, 422 Gothic, Italian, 442–444, 443–444, Siege of the Castle of Love, mirror back, ivory, 422, 422 Siena, Palazzo Pubblico, 453-454, 453 Signs of the Zodiac, Amiens Cathedral, 412, Saint-Genis-des-Fontaines, Church, lintel 446-448, 447, 448 Rococo, use of term, 159 of, France, 346, 350-351, 350 Gothic, Spanish, 424-426, 425, 426 Roettgen Pietà, 434, 434 Saint-Gilles-du-Gard, abbey church of, Greek Geometric, 107, 107 Silkscreen, xiii Sinan, Mosque of Selim II (Selimiye), 302–303, 302, 303 Greek kore (korai), 113-114, 113, 114 Roger II, 292 France, 373-374, 373 Roman art and culture Saint-Lazare cathedral, Autun, France, Greek, kouros (kouroi), 113-114, 113, architecture in the provinces, 213–215, 213–215, 216–218, 217–218, 226, 362-364, 363 Siphnian Treasury, Delphi, 116-117, 117, 114 Saint-Maclou, Rouen (Robin and Harel), Greek late Classical, 142-145, 143-145 118 227-228, 227-228 Greek pediment (Archaic), 115-119, 115, Sippar, 30 423, 423 gods and goddesses, 105 Saint-Riquier, Abbey church of, France, 118-119, 120 Skara Brae, Orkney, Scotland, stone house, Greek influence, 181, 183, 189, 193, 222 330-331, 330 Greek pediment (Classical) 128, 129, 129, 15, 16 134-138, 134-138 Hellenistic, 154-160, 154-160 human form, Egypt, 57, 59-63, 59-63, 65 Italian, Gothic, 442-444, 443-444, Skene, 152 Greek mythology, use of, 229-230, 230 Saint-Savin-sur-Gartempe, France, abbey church, 367–368, 368 painting in the provinces, 216, 216, 218–222, 219–222 Skopas of Paros, 142, 143 Snake Goddess, Knossos, 92, 92 Saint-Urbain, Troyes, 415–416, 415, 416 Salah ad-Din (Saladin), 292 sculpture in the provinces, 215–216, 215 Sneferu, 55 syncretism, 181 Salisbury Cathedral, England, 426, 427 446-448, 447, 448 Socrates, 123 Sophocles, 123, lost-wax process, 127, 128, 338 Minoan, 91–92, 91–92 Roman de la Rose (Romance of the Rose), Samanids, tomb of the, 288, 288 422 Samarkand, 295 Roman Empire madrasa of Ulugh Beg, 296, 296 Mycenaean, 99–100, 100 Neolithic, 12, 12, 13, 13, 14–15, 14–15 Ottonian, 343–344, 343, 344 Alhambra, 299-300, 300 architecture, 196–203, *196–203* Christianity in, 235–237 Samarra, 285 Altamira, cave paintings, 1, 2, 3, 4 Bridge, Puente La Reina, 355–356, 356 Great Mosque, Córdoba, 278, 286–287, San Francesco, basilica, Assisi, 438-440, map of, 182 painted, Greek and Roman, 223, 223 sculpture, portrait, 203-207, 204-206 San Giovanni baptistery, Florence, 445, 446 Paleolithic, 7–11, 8–11 sculpture, relief, 207-213, 207-213 bronze doors (A. Pisano), 446-148, 447, Roman copies of Greek, 193, 193 Islamic art, 290, 290 Roman Empire, Late architecture, 222–228, 224–228 Judaism in, 235 Romanesque architecture, 319 350, 349 Roman Empire, 196 Romanesque Cluniac, 359–365, 360–365 in the round, 61 San Giovanni, baptistery, Florence, 377, 377 San Miniato al Monte, church of, Florence, Santiago de Compostela, cathedral of, 351–354, 352, 353 Spanish, Gothic, 424–426, 425, 426 Sumerian, 25–27, 25–27, 32–33, 32–33 map of, 236 377-378, 378 sculpture, Goilie, 424-126, 125, 126 sculpture, portrait, 228, 229 San Vitale church, Ravenna, 254, 255-257, Spandrels, 355, 444 sculpture, relief, 229-232, 230-232 255-256, 329-330 Sculpture, freestanding Spatial perspective, 162 Greek Archaic, 113–114, 113, 114, 116 Greek Classical, 123–127, 123–127 Roman Republic, 189 Sanctuary of Apollo, Delphi, 116, 117
Sanctuary of Fortuna Primigenia Roman Republic Spear Thrower with Interlocking Ibexes, architecture, 183–188, 183–188 Greek influence, 181, 183, 189, 193, 222 Grotte d'Enlène, 8, 8 Speyer cathedral, Germany, 378–379, (Praeneste), 186, *187* Sangallo, Antonio da 173 origins of, 181-183 Sculpture, portrait Egypt, Royal portraiture, 62–63, *62–63* Etruscan, 177–170, *177* Hellenistic, 154–155, *154–155* Spolia, 231 painting, 194, 194 Sanguszko carpet, Tabriz, 306, 306 sculpture, freestanding, 189 sculpture, portrait, 190–193, 190–193 sculpture, relief, 188–190, 189–190 Romanesque art and culture Sant Vincenç, church of, Cardona, Spain Spotted Horses and Human hands, Pech-Santa Costanza, Mausoleum of, 246–247, 247 Santa Croce (Arnolfo di Cambio), Florence, 441–441, 442 Merle Cave, 5, 6, 6 Roman Empire, 203–207, 204–206 Roman Empire, late, 228, 229 Roman Republic, 190–193, 190–193 Sculpture, relief Spring Fresco, Akrotiri, 88, 89 Springing, 378 Squinches, 270 architecture, Cistercian, 366–367, 366–367 Santa Maria Antiqua, sarcophagus, 243, 243 architecture, early, 349-350, 349 Santa María cathedral, León, Spain, St. Catherine, monastery of, Mount Sinai, architecture, French, 372-375, 373, 375 424-426, 421-426 Akkadian, 30, 31 263-265, 263, 264 Assyrian, 36–37, 36, 37 Byzantine, early, 260–262, 261 Byzantine, middle, 268, 268 Egyptian, 50–53, 51, 60, 60, 61, 62, 66, architecture, German, 378-379, 378-379 Santa Maria Maggiore, basilica of, 250-251, St. Cyriakus, nunnery church of, Gernrode, architecture, Italian, 375–378, 376–378 architecture, Norman, 382–385, 383–385 architecture, pilgrimage churches, 351–354, 352–353 333-334, 334 251 St. Francis Preaching to the Birds, Basilica of San Francesco, Assisi, 439–440, 440 Santa Maria Novella church, Florence, 463, 463 St. Gall, monastery plan of, 332–333, 332 St. John the Evangelist, from the Gospel Book of Abbot Wedricus, 371–372, 372 Santiago de Compostela, cathedral of, 72-74 architecture, restoration of, 369 Spain, 351–354, 352, 353 Etruscan, 174, 174, 175 architecture, secular, 355-356, 356 historical, 189 Sarcophagi Ottonian, 336-339, 337-339 Bayeux Tapestry, 381-382, 381, 382 Christian, early, 243, 243 St. Louis, psalter of, 417-418, 417 Egyptian, 53 Etruscan, 171–173, 171, 173 Meleager Sarcophagus, 229–230, 231 Sarcophagus of Doña Sancha, 364–365, 365 Benedictine architecture and painting, 367–368, 368 St. Luke, from the Gospel Book of Otto III, Persian, 44, 44 Roman Empire, 207–213, 207–213 Roman Empire, late, 229–232, 230–232 342, 342 castles, French, Holy Land, 374–375, *375* Cistercian, 366–367, *366*, *367* St. Mark, from the Corbie Gospel book, Romanesque, monumental stone, 346, 370, 371 Cluniac architecture and sculpture, Sarcophagus of Junius Bassus, 253-254, 253 350-351, 350, 355, 355 St. Mark's, Venice, 271-272, 271 356-365, 357-365 Sargon I, 30 Roman Republic, 188-190, 189-190 sculpture 228, 229 Sargon II, palace of, 35, 35, 36, 36 Sasanian dynasty, 45–46 Cluniac painting, 365-366, 366 sunken, 68, 69, 69, 72, 72 St. Matthew, from the Codex Colbertinus, Seals, cylinder, 29, 29, 52
Seated Scribe, Saqqara, 61, 61
Second Coming of Christ, portal, church of
Saint-Pierre, Mossiac, 359–360, 360 Cluniac Sarcophagus of Doña Sancha, 364–365, 365 Mossiac monastery, 370–371, 370 St. Matthew, from the Gospel Book of Archbishop Ebbo of Reims, 326, 326 Saxons, 313 history of, 347-349 Saz design, 304, 304 Scene in an Arab Village (Yahya ibn Mahamud al-Wasiti), Maqamat Islamic influence, 347, 358, 361 St. Matthew, from the Gospel Book of manuscripts, 368-372, 368, 370-372, 386, Section (sculpture), 135 Charlemagne, 325, 326 386 manuscript, 293, 293 Sed-festival, 54, 54 St. Michael's abbey church at Hildesheim, Scenes from the Apocalypse, from a Bible moralisée, 417, 417 Segovia, Roman aqueduct, 213–214, 213 Seleucids, 45 335–336, 335–336 bronze doors, 336–339, 337–339 St. Peter's, Rome, Nave and façade, *xxii* St. Pierre church, Mossiac, France, 359–362, Mosan style, 379-381, 379 sculpture, monumental stone, 346, 350-351, 350, 355, 355 Scenes of Dionysiac Mystery Cult, Pompeii, Seleukas, 45 use of term, 347 women, 362, 364–365 218–219, 218 Self-Portrait (Leyster), xvii, xvii Selim II (Selimiye), 300, 303 mosque of (Sinan), 302–303, 302, 303 Seljuks, 288, 289, 290, 292–293 Schliemann, Heinrich, 81, 87, 98 360-362 Rome Scholasticism, 391 Scriptoria, 313 St. Theodore the Studite, 266 Arch of Titus, Forum Romanum, xv Stained glass French Gothic, 403–404, 405, 403, 404, Scriptorium, 252 Seneca, 178 Old St. Peter's basilica, 245-246, 245-246 Scrovegni Chapel, Padua, 450-453, 450-452 Senenmut with Nefrua, Thebes, 70, 70 St. Peter's, nave and façade, *xxii* Santa Maria Maggiore basilica, 250–251, *251* Scrovegni, Enrico, 451 Senwosret III, sculpture of, 62, 62 technique of, 402, 405 Septpartite groin vaults, 383 Serdab, 54, 55 Stele, 30 See also Sculpture, freestanding; Code of Hammurabi, 34, 34, 35 Romulus, 177, 181, 207 Sculpture, portrait; Sculpture, relief Akkadian, 30–32, 30, 31 Seti I's Campaigns, Temple of Amun-ra, 68, of Naram-Sin, 30, 31 Rostrum, 232 Stereobate, 110

Still-li	fe paintings nan, 222, 222	Pergamon, plan of, 151, 151 Temple of Apollo, Didyma, 148–150,	painting in, 449–463, <i>449–452</i> , <i>454–463</i> Tutankhamun, 43	Vitruvius, 109, 110, 141, 142, 148 Vogelherd, Germany, carvings, 7, 8
seve	enteenth century, xv	149	tomb of 75–77, 75, 76	Volute, 110
	Age, 9 henge, Salisbury Plain, England, 16,	Theodorus of Samos, 113, 115 Theophilus, <i>De diversis artibus (The Various</i>	Tuthmosis, 74 Two Bison, Le Tuc d'Audubert Cave, 8, 9	Voussoirs, 173, 173, 185, 185, 286, 286 Vulca (of Veii), 184
18	3, 18	Ârts/On Divers Arts), 315, 402, 405	Tympanum, 359, 360, 361	Aplu (Apollo), 175–176, 175
	oate, 110 of Saint-Denis, abbot, 391, 392, 393,	Thomas Aquinas, saint, 391 Three Deities, Mycenae, 100, 100	Typology, 242, 339	Wall painting
	94, 395	Three Goddesses, Parthenon, 135, 135	Ulugh Beg, madrasa of, Samarkand, 296,	See also Murals
	man I, 303	Thutmose I, 65, 67	296	Neolithic, 13–14, 14
	Han, turkey, 293, 293 Hasan, madrasa and tomb of, Cairo,	Thutmose II, 65, 70 Thutmose III, 65, 66, 70	Umayyad dynasty, 283, 287, 290 Unis, Pyramid Text, 58	Paleolithic, 1–7, <i>1–7</i> Warhol, Andy, Gold Marilyn Monroe, xii,
29	98, 299	Ti Watching a Hippopotamus Hunt, 61-62,	Ur, 22, 23, 26–28	xiii, xiv, xvii, xviii
	n-Muhammad, Allegory of Worldly nd Otherworldly Drunkenness, from	61 Tibnan, funerary relief of, Palmyra,	Urban II, pope, 348 Urnammu, 32	Way of Salvation (Andrea da Firenze/Andrea Bonaiuti), 463, 463
	ne Divan of Hafiz, Tabriz, 304–306,	215–216, <i>215</i>	Uruk, 22, 23–24, 24	Webs, 380
30		Timur (Tamerlane), 295	Utrecht Psalter, 326-327, 327	Weighing of the Heart and Judgment by
	r (Sumerians) nder seals, 29, 29	Timurids, 295–296 Tiryns, 94, 95, 96	Valadier, Guiseppe, 209	Osiris, from the Book of the Dead of Hunefer, 78
geog	graphy of, 21	Titus, 198	Valley of the Kings, 65	detail, 48
	y, 25–27, 26–27 saic, 24	Arch of, <i>xv</i> , <i>208</i> , 209–210, <i>210</i> Tiy, Queen, 73–74, <i>74</i>	Vaphio Cups, 99, 100 Vasari, Giorgio, 449	Westminster Abbey, Chapel of Henry VII, 429, 429
	-Sumerian revival, 32–33	Tomb 100, Hierakonpolis, 50, 51	Vases and vessels	Westminster Hall (Yevele and Herland),
	gion, 22, 23, 24, 27	Tomb paintings, Egyptian, 50, 51	early Iranian beaker, 41, 41	London, 429–430, <i>430</i> Westwork, 330, <i>331</i>
	val Cemetery at Ur, 26–27 val Standard of Ur, 27–28, 27	Tombs See also Burial ships	Greek forms for, 105, <i>105</i> Greek ornamental motifs, 106, <i>106</i>	Wheel of Fortune (de Honnecourt), 404,
scul	pture, 25–27, 25–27	of the Anina Family, 170–171, 170	Greek painted, Archaic, 119-122, 121,	406
	ple architecture, 23–24, 24, 32–33, 32 al narratives, 27–28, 27, 28	cist graves, 82 Cycladic, 82	122 Greek painted, Geometric, 105–107,	White Temple, Uruk, 23–24, 24 White-ground lekythos (Reed Painter),
	ting, 21	Djoser, funerary complex of, 53–55,	105–107	146–147, <i>146</i>
	en relief, 68	53-54	Greek painted, Orientalizing, 108–109,	William II of Normandy, 381
	n Hoo burial ship, England, 315, 16–318, <i>316, 317</i>	Egypt, Middle Kingdom, 63–65, <i>63</i> , <i>64</i> Egypt, Old Kingdom, 50, <i>51</i> , 53–62,	108 Kamares ware, 90, 90	William the Conqueror, 381 Wilson Jones, Mark, 202
	osium, art of (Greek Archaic),	53–62	marine motifs, 90, 90	Winchester Psalter, 386, 386
	19–123, 121, 122	Egypt, New Kingdom, 65–78, 66, 71–78	Minoan, 89–91, 90–91	Winckelmann, Johann Joachim, 157, 181, 183
Synag at D	Oura-Europos, 237–239, 237–238	Etruscan, 164, 165–173, 165–173 of Hatshepsut, 65–66, 66	stone, 90–91, <i>91</i> Vaphio cups, 99, <i>100</i>	Woman from Brassempouy, Grotte du Pape,
at H	Hammath Tiberias, 239–240, 239	of Halikarnassos, 141-142, 141	Vatican Vergil, 252, 253	10, 10
	nsito, Toledo, 290, <i>290</i> etism, 181	of Hunting and Fishing, 168, <i>169</i> Mycenaean tholos, 97	Vaults barrel, 148, <i>185</i> , 186, 380	Woman of Willendorf, Austria, 10, 11, 11 Women artists
	mic, 280	of Nebamun, 71, 71	corbel, 95, 95	Gentileschi, Artemisia, xvii
Synop	otic narrative, 116	Neolithic, 15–16	groin, 185, 376, 376	Helen of Alexandria, 162
Tabriz	z, 295, 304	Oljeytu, Sultaniya, Iran, 294, 295, 295 pyramids at Giza, 55–61, 55–61	quadrant, 380 quadripartite, 401, <i>401</i>	Leyster, Judith, xvii, <i>xvii</i> Vigée-Lebrun, Marie-Louise Élizabeth,
	nuscript illumination and carpets in,	of Ramose, 72, 72	ribbed, 380, 383-384, 446	xvii
Tai M	304–306, <i>305</i> , <i>306</i> ahal, Agra, India, 310, <i>310</i>	Ramesses II, 69–70, 69–70 of the Reliefs, 168, 168	septpartite, 383 sexpartite, 385, 401	Women at a fountain house (Priam Painter), black-figured hydria, 121,
	ti, Francesco, Florence Cathedral,	rock-cut, 63, 63, 64	Vellum, 252	122
	45–446, 445, 446	of the Samanids, 288, 288	Venice	Women
	rlane, 295 inius the Ancient, 184	Sultan Hasan, <i>298</i> , 299 Taj Mahal, 310, <i>310</i>	Doge's Palace, 464, 465 in fourteenth century, 465	in Ancient Greece, 106, 108, 120, 121, 122, 138, 139, 160, 160
Tarqu	inius the Proud, 184	Treasury of Atreus, 96, 97-98, 97	St. Mark's, 271-272, 271	Cycladic, 82-84, 83
	smar, 25–26, 26	of Bernabò Visconti, 465–466, 465	Venus, 105	feminist movement, role of, xvii in nunneries, 440–441
Templ	era paints, 441 le(s)	Topkapi Palace, Istanbul, 302 Toreador Fresco, Knossos, 92–93, 92	figurines, 10 Veristic male portrait, 192, <i>192</i>	in prehistoric art, 10–11, <i>10–11</i>
Abb	bu Temple, statues from 26, 26	Tower of Babel, 37	Vespasian, 196, 198	in Roman provincial art, 215-216, 215
	un-ra, 67–68, <i>68</i> Aphaia, 112, <i>112</i> , 118–119, <i>118–119</i> ,	Tracery, bar and plate, 406 Traini, Francesco	portrait of, <i>204</i> , 205 Via di San Gregorio pedimental sculptures	Romanesque Spain, 364–365 Sumerian, 25
01 1	120, 223, 223	sinopia drawing for The Triumph of	(Rome), 189, 189	Wood, Grant, American Gothic, xv-xvi, xvi
	Apollo, at Didyma, 148–150, <i>149</i>	Death, 441, 441	Victimarius, Via di San Gregorio pediment,	Wounded Bison, Altamira Cave, 3
	Artemis (Corfu), 115–116, <i>115</i> , <i>116</i> Artemis (Ephesos),112, <i>112</i>	The Triumph of Death, 462, 462 Trajan, 45, 199, 202	189, 189 Vienna Genesis, 262–263, 262	Wright, Frank Lloyd Guggenheim Museum, Solomon R.,
of A	Athena Alea, 143, <i>143</i>	column of 211-212, 211	View of Town and Volcano, Çatal Hüyük,	New York City, xxii-xxiii,
	Athena Nike, 140, 140	forum of, 196–197, <i>196</i> Transept, 246, 442	14 Vigée-Lebrun, Marie-Louise Élizabeth,	xxiii Robie House, xxiii
	Athena, Priene, 148, <i>148</i> chtheion, 140, <i>140</i>	Transito Synagogue, Spain, 290, 290	xvii	Writing
Etri	uscan, 174–175, 175	Treasury of Atreus, Mycenae, 96, 97-98, 97,	Vignettes, 419	Cuneiform, 21, 22, 22
	eek Archaic, 109–113, 109–113 eek Classical, 127–140, <i>127–139</i>	98, 100 Treasury of the Siphnians, Delphi, 116–117,	Viking art, 322–324, <i>323</i> Villa of Hadrian, 203, <i>203</i>	hierolglyphs, 50–52 kufic, 279, 281, <i>281</i> , 283
	Hatshepsut, 65–66, 66	117, 118	Villa of Livia, Primaporta, 220, 221	Linear A, 84
	Hera I, 111–112, 111	Tribune, 330	Villa of Publius Fannius Synistor,	Linear B, 94
	Hera II, 112, <i>112</i> Jupiter Optimus Maximus, 184, <i>184</i>	Triforium, 358 Triglyph, 110	Boscoreale, 220, 221 Villa of the Mysteries, Pompeii, 218–219,	pictograms, 21 pictographs, 52–53, 73
Mai	ison Carrée, 214, 214	Trilithic construction, 16	219	
	Portunus, 184, <i>184</i> messes II, 69–70, <i>69–70</i>	Tripods, bronze, <i>102</i> , <i>108</i> , 109 Triptych, 458	Virgil, the Aeneid, 183 Virgin and Child Enthroned Between Saints	Xerxes, 41, 42, 44
	Solomon, 40, 40	Birth of the Virgin (P. Lorenzetti),	and Angels, encaustic on panel,	Yahya ibn Mahamud al-Wasiti, Scene in
	merian, 23–24, 24, 32–33, 32	458–459, <i>459</i>	Monastery of St. Catherine, 264–265,	an Arab Village, Maqamat manuscript,
	okapi, 302 nite Temple, 23–24, 24	Triumph of Death (Traini), 441, 441, 462, 462	264 Virgin of Essen, Ottonian, 344, 344	293, 293 Yevele, Henry, Westminster Hall, London,
of Z	Zeus, 127–129, <i>127–129</i>	Triumphal arch, 246	Virgin of Jeanne d'Évreux, 420–421, 421	429–430, <i>430</i>
	tation and Fall, bronze doors of Bishop Bernward, Hildesheim, 339, 339	Troy 118 Troyes Saint-Urbain 415-416 415 416	Virgin of Paris, Notre-Dame, Paris, 421–422, 421	Youth and Female Demon, Etruscan, 172, 172
	rae, 194	Troyes, Saint-Urbain, 415–416, <i>415</i> , <i>416</i> Trumeau, 361, <i>361</i>	Visconti family 465–466	1/2
Tetrar	rchs, portrait group of, 228, 229	Tumuli, 166	Visconti, Bernabò, tomb of (Bonino da	Zeus (Bronze nude), 125, 125, 128
	les, Islamic, 291–292, 292 pets, 299, 301, <i>301</i>	Tunisia, Great Mosque of Kairouan, 285, 285	Campione), 465–466, <i>465</i> Visconti, Giangaleazzo, 465	Zeus, 104, 116 Great Altar of, 156, <i>156</i> , <i>158</i> , 159
Thang	gmar of Heidelberg, 338	Tura del Grasso, Agnolo di, Chronicle,	Book of Hours (Giovannino dei Grassi),	temple of, 127-129, 127-129
	ter at Epidauros, 151–152, <i>152</i> ter complex of Pompey, 186–188, <i>188</i> ,	454 Turrets, 327	466, <i>466</i> Visigoths, 313, 314	Ziggurats Sumerian, 23–24, 24
1	96	Tuscany	Visitation, Reims Cathedral, 411, 411	Ur, 23, 32, 32
Theat	tricality	architecture, Romanesque, 375-378,	Visual narrative, Sumerian art, 27-28, 27,	Zoroaster, 41
ın (Great Altar of Zeus, 159	376–378	28	

Credits

CREDITS AND COPYRIGHTS

The Authors and Publisher wish to thank the libraries, museums, galleries, and private collections for permitting the reproduction of works of art in their collections. Sources not included in the captions are gratefully acknowledged below.

INTRODUCTION

I.1 © 2009. Digital Image, The Museum of Modern Art, New York/Scala, Florence, © The Andy Warhol Foundation for the Visual Arts / Artists Rights Society (ARS), New York / DACS, London 2009; I.2 © 2005. Photo The Newark Museum/Art Resource/Scala, Florence; I.3 Image © The Board of Trustees, National Gallery of Art, Washington I.4 akg-images / Erich Lessing; I.5 Werner Forman Archive; I.6 © Grant Wood/ Licensed by VAGA, New York. Photography © The Art Institute of Chicago; I.8 Photograph by Lorene Emerson/Images © The Board of Trustees, National Gallery of Art, Washington; I.9 © 1990. Photo Scala, Florence; I.10 Photograph by Lynn Rosenthal, Philadelphia Museum of Art, © Succession Marcel Duchamp/ADAGP, Paris and DACS, London 2009; I.11 Photo by O. Zimmermann, © Musée d'Unterlinden, Colmar; I.12 © Estate of Duane Hanson/VAGA, New York/DACS, London 2009; I.13 © Lee Friedlander, courtesy Fraenkel Gallery, San Francisco; I.14 © Aerocentro; I.15 akg-images / Erich Lessing; I.16 Ezra Stoller © Esto, © ARS, NY and DACS, London 2009; I.17 Ben Mangor / SuperStock, © ARS, NY and DACS, London 2009.

CHAPTER 1

1.0 © Centre des Monuments Nationaux, Paris; 1.1 National Geographic / Getty Images; 1.2 Joan Clottes, Ministère de la Culture et des Communications; 1.3 Jean Vertut; 1.4 Jean Vertut; Box p5 Ministère de la Culture et des Communications; 1.6 Jean Vertut; 1.8 © Centre des Monuments Nationaux, Paris; 1.9 Thomas Stephan, © Ulmer Museum; 1.10 Kunsthalle Tubingen; 1.11 Photo by Max Begouen; 1.12 Jean Vertut; 1.13 © Jean-Gilles Berizzi/Reunion des Musees Nationaux; 1.14 akg-images/Erich Lessing; 1.15 Harry N. Abrams; 1.16 akg-images / © Erich Lessing; 1.17 Zev Radovan; 1.18 R. Sheridan, The Ancient Art & Architecture Collection; 1.19 Dr. Gary/Prof. Nasser D Khalili; 1.20 Courtesy McDonald Institute for Archaeological Research; 1.22 akg-images / Frich Lessing; 1.23 Alamy; 1.24 © Yan Arthus-Bertrand / Corbis; 1.25 © English Heritage, NMR.

CHAPTER 2

2.0 © 2007. Image The Metropolitan Museum of Art/Art Resource/Scala, Florence; 2.1 © The Trustees of the British Museum; Box images Penelope Davies; 2.3 World Tourism Organization: Iraq; 2.4 © 2008. Photo Scala, Florence/BPK, Bildagentur fuer Kunst, Kultur und Geschichte, Berlin; 2.5 Courtesy of The Oriental Institute of the University of Chicago; 2.6 University of Pennsylvania Museum of Archaeology and Anthropology; 2.7 © The Trustees of the British Museum; 2.8 University of Pennsylvania Museum of Archaeology and Anthropology; 2.9 University of Pennsylvania Museum of Archaeology and Anthropology; 2.10 © 2005. Photo Scala, Florence/BPK, Bildagentur fuer Kunst, Kultur und Geschichte, Berlin; 2.11 © 1990. Photo Scala, Florence; 2.12 C Chuzeville/Réunion des Musécs Nationaux; 2.13 The Ancient Art & Architecture Collection Ltd; 2.14 Photograph © 2010, Museum of Fine Arts, Boston; 2.15 © Réunion des Musées Nationaux; 2.16 © Herve Lewandowski / Réunion des Musées Nationaux; 2.17 Courtesy of The Oriental Institute of the University of Chicago; 2.18 World Tourism Organization: Iraq; 2.19 © The Trustees of the Br itish Museum; 2.20 © The Trustees of the British Museum; 2.21 © 2005. Photo Scala, Florence/BPK, Bildagentur fuer Kunst, Kultur und Geschichte, Berlin; 2.22 The Art Archive / Alfredo Dagli Ort; 2.23 © The Trustees of the British Museum; 2.24 PhotoEdit Inc; 2.25 © Réunion des Musées Nationaux; 2.26 © Kurt Scholz SuperStock; 2.27 © 1990. Photo Scala, Florence; 2.28 © Gerard Degeorge, Corbis; 2.29 akgimages / Erich Lessing; 2.30 Courtesy of The Oriental Institute of the University of Chicago; 2.31 Corbis; 2.32 @ Robert Harding/Getty Images; 2.33 @ 2007. Image The Metropolitan Museum of Art/Art Resource/Scala, Florence.

CHAPTER 3

3.0 © The Trustees of the British Museum; 3.1 The Art Archive / Egyptian Museum Cairo / Dagli Orti; 3.2 Werner Forman Archive; 3.4 The Art Archive / Gianni Dagli Ort; 3.5 © The Trustees of the British Museum; 3.6 Peter A. Clayton; 3.7 Nature Picture Library; 3.8 Photo by Carl Andres, © President and fellows of Harvard College for the Semitic Museum; 3.9 Roger Wood/Corbis; 3.10 Araldo de Luca/Index, Florence; 3.11 Photograph © 2010, Museum of Fine Arts, Boston; 3.12 The Art Archive / Egyptian Museum Cairo / Alfredo Dagli Orti; 3.13 akgimages / Andrea Jemolo; 3.15 © Herve LewandowskiRéunion des Musées Nationaux; 3.16 © Araldo de Luca; 3.17 © 2007. Image copyright The Metropolitan Museum of Art/Art Resource/Scala, Florence; 3.18 Photograph © 2010, Museum of Fine Arts, Boston; 3.19 Jean Vertut; 3.20 © Graham Harrison; 3.21 Peter A. Clayton; 3.22 © The Trustees of the British Museum; 3.23 © Jurgen Liepe; 3.24 Robert Frerck, Woodfin Camp & Associates, Inc; 3.26 Photograph Schecter Lee/© 1986 The Metropolitan Museum of Art; 3.27 Dorling Kindersy Media Library; 3.28 Jean Vertut; 3.29 The Art Archive / Gianni Dagli Orti; 3.30 Gianni Dagli Orti; The Art Archive/Picture Desk; 3.31 Hervé Champollion / akg-images; 3.32 © 2008. Photo Scala, Florence/BPK, Bildagentur fuer Kunst, Kultur und Geschichte, British Museum; 3.34 © 1997. Photo Scala, Florence; 3.35 Araldo De Luca, Index, Florence; 3.36 © 2005. Photo Scala, Florence/BPK, Bildagentur fuer Kunst, Kultur und Geschichte,

Berlin; 3.37 © 2005. Photo Scala, Florence/BPK, Bildagentur fuer Kunst, Kultur und Geschichte, Berlin; 3.38 © 2005. Photo Scala, Florence/BPK, Bildagentur fuer Kunst, Kultur und Geschichte, Berlin; 3.39 The Stapleton Collection / Art Resource, NY; 3.40 Jurgen Liepe Photo Archive; 3.41 © The Trustees of the British Museum.

CHAPTER 4

4.0 © 1990. Photo Scala, Florence; 4.1 © Studio Kontos/Photostock; 4.2 John Bigelow Taylor; 4.3 © 1990. Photo Scala, Florence; 4.4 From John Griffiths Padley, *Greek Art and Archaeology*, 2/e, Prentice Hall 1988, fig 3.1, p.65; 4.5 Courtesy McRae Books Srl, Florence; 4.6 © Roger Wood, Corbis; 4.7 From: Donald Preziosi and Louise, A. Hitchcock, *Aegean Art and Architecture*, Oxford University Press, Oxford, 1999, fig 54, pg. 96; 4.8 © Studio Kontos/ Photostock; 4.9 © Studio Kontos/ Photostock; 4.10 akg-images / Nimatallah; 4.11 © Studio Kontos/ Photostock; 4.12 © 1990. Photo Scala, Florence; 4.13 akg-images / Nimatallah; 4.15 akg-images / Frich Lessing; 4.16 akg-images / Nimatallah; 4.17 © Studio Kontos/ Photostock; 4.19 From John Griffiths Pedley, *Greek Art and Archaeology*, 2/e, Prentice Hall 1988, fig 3.40, p.95; 4.20 © 1990. Photo Scala, Florence; 4.22 © Studio Kontos/ Photostock; 4.23 © Studio Kontos/ Photostock; 4.24 © Vanni Archive, Corbis; 4.26 The Art Archive / Gianni Dagli Ort; 4.27 Hirmer Verlag, Munich; 4.28 akg-images / Nimatallah; 4.29 akg-images / Nimatallah; 4.30 akg-images / Nimatal

CHAPTER 5

5.0 @ The Trustees of the British Muscum; 5.2 akg-images / Nimatallah; 5.4 @ 2007. Image copyright The Metropolitan Museum of Art/Art Resource/Scala, Florence; 5.5 Photograph © 2010, Museum of Fine Arts, Boston; 5.6 © The Trustees of the British Museum; 5.9 © Marco Cristofori, Corbis; 5.10 © John Heseltine, Corbis; 5.12 © The Trustees of the British Museum; 5.13 © Hervé Lewandowski/Réunion des Musées Nationaux; 5.14 © 2007. Image copyright The Metropolitan Museum of Art/Art Resource/Scala, Florence; 5.15 © 1990. Photo Scala, Florence; 5.16 The Art Archive / Acropolis Museum Athens / Gianni Dagli Orti; 5.17 The Art Archive / Archaeological Museum Corfu / Gianni Dagli Orti; 5.21 Penelope Davies; 5.22 Vanni, Art Resource, NY; 5.23 Staatliche Antikensammlungen und Glypthothek Munich; 5.24 Staatliche Antikensammlungen und Glypthothek Munich; 5.25 A. Bracchetti, © Photo Vatican Museums; 5.26 Photograph © 2010, Museum of Fine Arts, Boston; 5.27 Staatliche Antikensammlungen und Glypthothek Munich; 5.28 Giraudon, Art Resource, NY; 5.29 akg-images / Nimatallah; 5.30 Pubbliphoto; 5.31 National Archaeological Museum, Athens, Greece; 5.32 Foto Vasari/Index, Firenze; 5.33 © 2003, Photo Scala, Florence, courtesy of the Ministero Beni e Att. Culturali; 5.34 Soprintendenza per i Beni Archeologici della Calabria; 5.35 © Studio Kontos/Photostock; 5.36 © Studio Kontos/Photostock; 5.38 © Studio Kontos/Photostock; 5.40 © Studio Kontos/Photostock; 5.41 Box p134 © The Trustees of the British Museum; 5.43 © The Trustees of the British Museum; 5.44 © The Trustees of the British Museum; 5.45 © Studio Kontos/Photostock; 5.46 @ The Trustees of the British Museum; 5.47 akg-images / Nimatallah; 5.48 akg-images / Nimatallah; 5.49 © Studio Kontos/Photostock, 5.50 © Studio Kontos/Photostock; 5.51 Bettmann, Corbis; 5.52 From Howard Colvin, Architecture and the After Life, Yale University Press, 1991, fig. 31, p.35; 5.54 John Decopoulos; 5.55 Hirmer Verlag, Munich; 5.56 © Photo Vatican Museums; 5.57 © Studio Kontos/Photostock; 5.58 © 1990. Photo Scala, Florence; 5.59 © Réunion des Musées Nationaux; 5.60 akg-images / Nimatallah; 5.61 Reprinted with permission from Cambridge University Press. From Jerome Politt, Art in the Hellenistic Age, 1986, fig.31, p.35; 5.62 ZUMA Press - Gamma; 5.63 Reprinted with permission from Cambridge University Press. From Jerome Politt, Art in the Hellenistic Age, 1986, fig.31, p.35; 5.64 © 2005 Photo Scala, Florence/BPK, Bildagentur fuer Kunst, Kultur und Geschichte, Berlin; 5.65 Advance Illustration Ltd, Congleton, Cheshire, UK; 5.66 © Bednorz-Images; 5.68 akg-images; 5.69 © Réunion des Musées Nationaux/Musee du Louvre; 5.71 © Araldo de Luca/CORBIS; 5.72 © 2009. Photo Scala, Florence/BPK, Bildagentur fuer Kunst, Kultur und Geschichte, Berlin; 5.73 Staatliche Museen, Berlin, Germany / Photo © AISA / The Bridgeman Art Library; Box p157 © 1990. Photo Scala, Florence; 5.74 © Réunion des Musées Nationaux; 5.75 akg-images / Nimatallah; 5.76 Staatliche Antikensammlungen und Glypthothek Munich; 5.77 © Studio Kontos/Photostock; 5.78 © Fotografica Foglia, Naples.

CHAPTER 6

6.0 Soprintendenza Beni Archeologici Etruria Meridionale, Roma; 6.1 INDEX/Ricciarini; 6.2 O Louis Mazzatenta, National Georgraphic/Getty Images; 6.3 Etruscan Life and Afterlife: A Handbook of Etruscan Studies, © 1986 Wayne State University Press, with the permission of Wayne State University Press; 6.4 © 1990. Photo Scala, Florence − courtesy of the Ministero Beni e Att. Culturali; Box p6 © G. Blot/C. Jean/Réunion des Musées Nationaux; 6.5 © Soprintendenza Etruria Meridionale; 6.6 Soprintendenza Beni Archeologici Etruria Meridionale, Roma; 6.7 Canali Photobank, Milan Italy; 6.9 © 1990, Photo Scala, Florence − courtesy of the Ministero Beni e Att. Culturali; 6.10 © Nicolo Orsi Battaglini; 6.11 Photograph © 2010, Museum of Fine Arts, Boston; 6.12 © 1990. Photo Scala, Florence; 6.13 Etruscan Life and Afterlife: A Handbook of Etruscan Studies, Copyright © 1986 Wayne State University Press, with the permission of Wayne State University Press, 6.14 © 2005, Photo Scala, Florence − courtesy of the Ministero Beni e Att. Culturali; 6.15 Penelope Davies; 6.16 Canali Photobank, Milan Italy; 6.17 © 1990. Photo Scala, Florence; 6.18 © Vincenzo Pirozzi, Rome fotopirozzi@inwind.it; 6.19 Canali Photobank, Milan Italy; 6.20 Canali Photobank, Milan Ita

CHAPTER 7

7.0 akg-images / Nimatallah; Box p7 © 1996. Photo Scala, Florence - courtesy of the Ministero Beni e Att. Culturali; 7.1 from "La Grande Roma dei Tarquini. Alterne civvende di un felice intuizione", Bullcom (2000), fig. 7-26, p.25; 7.2 Canali Photobank, Milan Italy; 7.4 From Amanda Claridge, An Archaeological Guide, Oxford University Press, 1988, fig. 188, p.389; 7.5 Gianni Vanni / Art Resource, NY; 7.8 © Archivio Fotografico Musei Capitolini; 7.9 Penelope Davies; ni vanni / Ari Resource, N1; 7.8 © Archivo Fotogranco Musel Capitolini, 7.5 renerope Davies, 7.10 Foto Marburg, Art Resource, NY (top), Photo: Chuzeville. Louvre, Paris, France, © Réunion des Musées Nationaux (bottom); 7.11 © Araldo de Luca, Corbis; 7.12 Penelope Davies; Box p193 Reprinted with permission from Cambridge University Press. From Peter Rockwell, The Art of Stoneworking, 1993, diagram 43; 7.13 Photograph © 2010, Museum of Fine Arts, Bostonn; 7.14 Canali Photobank, Milan Italy; 7.15 © 1990. Photo Scala, Florence – courtesy of the Ministero Beni e Att. Culturali; 7.18 Gilbert Gorski; 7.20 Canali Photobank; 7.21 @ Alinari Archives/CORBIS; 7.22 Reprinted from Frank Sear, Roman Architecture, © 1982 by Frank Sear. Used by permission of the publisher, Cornell University Press; 7.23 Canali Photobank, Milan Italy; 7.24 From William L. McDonald, Architecture of the Roman Empire, An Introductory Study, Volume I, Yale University Press, p.96; 7.25 Alamy; 7.28 © 1990. Photo Scala, Florence; 7.29 SuperStock; 7.30 © Soprintendenza di Roma-Pal. Massimo; 7.31 Soprintendenza di Roma; 7.33 Canali Photobank, Milan Italy; 7.34 akg-images / Andrea Jemolo; 7.35 © 1990. Photo Scala, Florence - courtesy of the Ministero Beni e Att. Culturali; 7.36 Canali Photobank, Milan Italy; 7.37 Werner Forman Archive; 7.38 © 1990. Photo Scala, Florence – courtesy of the Ministero Beni e Att. Culturali; 7.39 Robert Frerck, Woodfin Camp & Associates, Inc; 7.40 © 1991. Photo Scala, Florence - courtesy of the Ministero Beni e Att. Culturali; 7.41 Penelope Davies; 7.42 Photograph by Elke Estel, 2V44; 7.43 Archivio Oronoz; 7.44 © Archivo Iconografico, SA, Corbis; 7.45 Penelope Davies; 7.46 © Réunion des Musées Nationaux; 7.47 © Trustees of the National Museums of Scotland; 7.48 NOT 7.49 Photo Researchers, Inc; 7.50 © Fotografica Foglio; 7.51 © 1990. Photo Scala, Florence - courtesy of the Ministero Beni e Att. Culturali; 7.52 From Mary Beard and John Henderson, Classical Art: From Mero Greece to Rome, Oxford History of Art, Oxford University Press, 2001, p.39; 7.53 Canali Photobank, Milan Italy; 7.54 Photo: Schecter Lee. © 2007. Image copyright The Metropolitan Museum of Art/Art Resource/Scala, Florence; 7.55 Canali Photobank, Milan Italy; 7.56 Canali Photobank, Milan Italy; 7.57 Canali Photobank, Milan Italy; 7.58 @ Alinari Archives, Corbis; 7.60 @ 1990. Photo Scala, Florence - courtesy of the Ministero Beni e Att. Culturali; 7.62 @ Peter M. Wilson, Corbis; 7.63 akg-images; 7.64 © 2008, DeAgostini Picture Library/Scala, Florence; 7.65 From Jas bis; 7.63 akg-images; 7.64 © 2008, DeAgostini Picture Library/Scala, Florence; 7.65 from Jas Elsner, Imperial Rome and Christian Triumph: The Art of the Roman Empire AD100–400, Oxford University Press, 1998, fig. 90, p. 131; 7.66 © Bednorz-images; 7.67 Penelope Davies; 7.69 Canali Photobank, Milan Italy; 7.70 © Araldo de Luca Archives, Index, Florence; 7.71 From Jas Elsner, Imperial Rome and Christian Triumph: The Art of the Roman Empire AD100-400, Oxford University Press, 1998, fig. 126, p. 188; 7.72 From Jas Elsner, Imperial Rome and Christian Triumph: The Art of the Roman Empire AD100-400, Oxford University Press, 1998, fig. 90, p. 131; 7.72 © Foto Vasari, Roma.

CHAPTER 8

8.0 © The Trustees of the British Museum; 8.1 Art Resource, NY; 8.2 Z Radovan / www.Bible.LandPictures; 8.4 Canali Photobank, Milan Italy; 8.5 Soprintendenza Archeologica di Roma; 8.8 From Krautheimer, Early Christian and Byyzantine Architecture, Yale University Press, 1984. Image 34; 8.9 © Vatican Apostolic Library; 8.11 © 1990. Photo Scala, Florence; 8.12 From Kenneth J. Conant, Carolignian and Romanesque Architecture, Yale University Press, 1959, image 78(a); 8.13 Canali Photobank, Milan Italy; 8.14 Canali Photobank, Milan Italy; 8.15 Canali Photobank, Milan Italy; 8.16 Canali Photobank, Milan Italy; 8.17 Canali Photobank, Milan Italy; 8.17 Canali Photobank, Milan Italy; 8.18 © 2007. Photo Scala, Florence/BPK, Bildagentur fuer Kunst, Kultur und Geschichte, Berlin; 8.19 © Vatican Apostolic Library; 8.20 © Fabbrica di San Pietro; 8.23 Archivio e Studio Folco Quilici, Rome; 8.24 © 1990, Photo Scala, Florence; 8.25 © CAMERAPHOTO Arte, Venice; 8.26 CAMERAPHOTO Arte, Venice; 8.26 Bednorz-images; 8.29 akg-images / Erich Lessing; 8.31 Hagia Sophia Museum; 8.32 © Bednorz-images; 8.33 © The Trustees of the British Museum; 8.34 © Austrian National Library/Picture Archive, Vienna, E 4586-C; 8.35 © Studio Kontos Photostock; 8.36 © Studio Kontos Photostock; 8.38 © Vatican Apostolic Library; 8.39 Bibliothèque Nationale, Paris; 8.42 From John Lowden, Early Christian & Byzantine Art, Phaidon, 1997, fig. 149, p. 260; 8.44 akg-images / Erich Lessing; 8.45 © Studio Kontos Photostock; 8.46 © Pubbli Aer Foto; 8.47 © 1998, Photo Scala, Florence; 8.48 © 1990. Photo Scala, Florence; 8.49 © The National Gallery of Art, Washington; 8.50 The Art Archive / Icon Gallery Ohrid Macedonia / Gianni Dagli Orti; 8.51 The Art Archive / Alfredo Dagli Orti.

CHAPTER 9

9.0 © Bednorz-images; 9.1 © President and Fellows of Harvard College, 9.2 Corbis; 9.4 © 1992 Said Nuseibeh; 9.6 © Bednorz-images; 9.7 © Roger Wood, Corbis; 9.8 © Bednorz-images; 9.9 Werner Forman Archive; 9.10 © Réunion des Musées Nationaux / Hervé Lemadowski; 9.12 Jonathan Bloom; 9.13 © 1980 The Metropolitan Museum of Art; 9.14 Walter. B. Denny; Box p11 Walter. B. Denny; 9.15 Walter. B. Denny; 9.16 Erich Lessing / Art Resource, NY; 9.17 © 2005. Photo Scala, Florence/BPK, Bildagentur fuer Kunst, Kultur und Geschichte, Berlin; 9.19 Walter. B. Denny; 9.21 Walter. B. Denny; 9.24 akg-images / Bildarchiv Steffens; 9.26 © 2007. Image copyright The Metropolitan Museum of Art/Art Resource/Scala, Florence; 9.27 © Bednorz-images; 9.28 From Gulru Necipo, *The Age of Sinan, Architectural Culture and the Ottoman Empire*, Reaktion Books, 2005; 9.29 akg-images / Bildarchiv Steffens; 9.31 Photograph © 1989 The Metropolitan Museum of Art / Harvard University Art Museums; 9.32 Imperial Embassy of Iran; 9.33 akg-images / Bildarchiv Steffens; 9.34 Photograph © 2010, Museum of Fine Arts, Boston; 9.35 V & A Images, Victoria & Albert Museum, London; 9.36 © 1990. Photo Scala, Florence.

CHAPTER 10

10.0 © 2009 The British Library, London; Box p10 Photo: National Museum of Ireland; 10.1 © The Trustees of the British Museum, London; © The Trustees of the British Museum, London; 10.3 © The Trustees of the British Library, London; 10.6 © The British Library, London; 10.7 © 1991. Photo Scala, Florence − courtesy of the Ministero Beni e Att. Culturali; 10.10 Eriik Irgens Johnsen; 10.11 akg-images / Erich Lessing; 10.12 Bibliothèque Nationale, Paris; 10.13 Kunsthistorisches Museum. Vienna; 10.14 akg-images / Erich Lessing; 10.16 © 2004. Photo Pierpont Morgan Library/Art Resource/Scala, Florence; 10.18 © Bednorz-images; 10.20 Bibliothèque Nationale, Paris; 10.21 © Bednorz-images; 10.23 © Bednorz-images; 10.25 © Bednorz-images; 10.26 © Bednorz-images; 10.27 © Frank Tomio,

Dom-Museum Hildesheim; 10.29 akg-images / Erich Lessing; 10.30 © Frank Tomio, Dom-Museum Hildesheim; 10.31 © Réunion des Musées Nationaux; 10.35 Rheinisches Bildarchiv, Museen Der Stadt Koln; 10.36 Foto Marburg , Art Resource, NY.

CHAPTER 11

11.0 © Bednorz-images; 11.1 Oronoz Fotografia Digital Madrid; 11.2 © Bednorz-images; 11.4 From K J Conant Carolingian and Romanesque Architecture, 800–1200, Yale University Press 1959; 11.5 akg-images / Andrea Jemolo; 11.6 © 2007. Image The Metropolitan Museum of Art/Art Resource/Scala, Florence; 11.7 © 1995. Photo Scala, Florence, 11.8 © Phillip Augustavo / Alamy; 11.10 From Kenneth John Conant, Carolingian and Romanesque Architecture, Yale University Press, 1959, plate 65; 11.11 From Kenneth John Conant, Carolingian and Romanesque Architecture 800–1200. The Pelican History of Art. Penguin, Middlesex, 1959; Plate 60; 11.12 David Peter Adams; 11.13 © Bednorz-images; 11.15 © Bednorz-images; 11.16 © Bednorz-images; 11.17 © Bednorz-images; 11.18 © Bednorz-images; 11.20 Oronoz; 11.22 © Bednorz-images; 11.30 © Bednorz-images; 11.31 © Bednorz-images; 11.32 Superstock; 11.33 © 2002. Photo Scala, Florence; 11.34 Bridgeman Art Library; 11.35 © 2002. Photo Scala, Florence; 11.34 Bridgeman Art Library; 11.35 © 2002. Photo Scala, Florence; 11.36 akg-images / Erich Lessing; 11.37 From Kenneth John Conant, Carolingian and Romanesque Architecture, Yale University Press; 11.38 © Bednorz-images; 11.39 © Bednorz-images; 80x p11 From Spiro Kostof, A History of Architecture: Settings and Rituals, 1985, fig. 9.4, p.195; 11.40 Musee de la Tapisserie, Bayeux, France / With special authorisation of the city of Bayeux / The Bridgeman Art Library; 11.41 Foto Marburg; 11.42 From Kenneth John Conant, Carolingian and Romanesque Architecture, Yale University Press, 1959, fig. 78; 11.43 From Kenneth John Conant, Carolingian and Romanesque Architecture, Yale University Press, 1959, fig. 75; 11.46 © Bednorz-images; 11.47 © Bednorz-images; 11.48 British Library, London.

CHAPTER 12

12.0 © Bednorz-imageS; 2.1 Peter Kidson; 12.2 © Bednorz-images; 12.3 © Bednorz-images; 12.4 © Bednorz-images; 12.5 © Bednorz-images; 12.6 © Bednorz-images; 12.7 © Bednorz-imageS; 12.9 Hirmer Fotoarchive, Munich, Germany; 12.10 © Bednorz-images; 12.12 © Bednorz-images; 12.14 From James Snyder, Medieval Art, Prentice Hall, fig. 453, p. 354; 12.15 © Bednorz-images; 12.17 © Bednorz-images; 12.18 © Photo Josse. Paris; Box p12 © Bednorz-images; 12.19 Bibliotheque Nationale de France; 12.20 © Bednorz-images; 12.21 © Bednorz-images; 12.24 © Bednorz-images; 12.27 © Paul Almasy, Corbis; 12.28 © Bednorz-images; 12.29 © 1990. Photo Scala, Florence; 12.30 © Bednorz-images; 12.31 © 1990. Photo Scala, Florence, 12.32 © Bednorz-images; 12.33 © Bednorz-images; 12.34; © Bednorz-images; 12.36 © 2004. Photo Pierpont Morgan Library/Art Resource/Scala, Florence; 12.39 Photograph © 1985 The Metropolitan Museum of Art; 12.41 © M. Beck-Copolla/Réunion des Musées Nationaux; 12.42 Notre Dame, Paris, France/ The Bridgeman Art Library; 12.43 Photograph by Paul Macapia; 12.44 © Bednorz-images; 12.45 From Alain Erlande-Brandenburg, Gothic Art, Abrams, 1989, fig. 75; 12.46 © Bednorz-image; 12.47 Instituto Amatller de Arte Hispanico, Barcelona, Spain; 12.48 Oronox; 12.49 akg-images / A.F.Kersting; 12.51 akg-images / A.F.Kersting; 12.54 akg-images / A.F.Kersting; 12.55 © Bednorz-images; 12.57 © Bednorz-images; 12.58 © Bednorz-images; 12.59 © Bednorz-images.

CHAPTER 13

13.0 © 1990, Photo Scala, Florence; 13.1 © 1995. Photo Scala, Florence; 13.2 Canali Photobank, Milan Italy; 13.3 © 2004, Photo Scala, Florence; Box p441 akg-images; 13.4 © 1991. Photo Scala, Florence/Fondo Edifici di Culto − Min. dell'Interno; 13.6 © Quattrone, Florence; 13.7 © 1990, Photo Scala, Florence; 13.8 & Alinari Archives / Florence; 13.9 © 1990, Photo Scala, Florence; 13.10 © Bednorz-images; 13.11 © Bednorz-images; 13.13 Tosi, Index, Florence; 13.14 © 1990. Photo Scala, Florence; 13.15 © 2006, Photo Scala, Florence; 13.16 Tosi, Index, Florence; 13.17 © Quattrone, Florence; 13.21 © Photoservice Electa/Arnaldo Vescovo; 13.22 Canali Photobank, Quattrone, Florence; 13.21 © Photoservice Electa/Arnaldo Vescovo; 13.22 Canali Photobank, Milan Italy; 13.25 Canali Photobank, Milan Italy; 13.25 Canali Photobank, Milan Italy; 13.26 Canali Photobank, Milan Italy; 13.27 Canali Photobank, Milan Italy; 13.28 © 1990. Photo Scala, Florence; 13.20 © 1990. Photo Scala, Florence; 13.30 Canali Photobank, Milan Italy; 13.31 Canali Photobank, Milan Italy; 13.32 © Dorling Kindersley, John Heseltine; 13.33 © 2002. Photo Scala, Florence, 13.34 Biblioteca Nazionale, Firenze/Microfoto.

TEXT CREDITS

Page 25 From The Epic of Gilgamesh, translated by Maureen Gallery Kovacs with an Introduction and Notes (California: Stanford University Press, 1989), copyright © 1985, 1989 by the Board of Trustees of the Leland Stanford Junior University. All rights reserved. Used with the permission of Stanford University Press, www.sup.org. Page 33 Henri Frankfort. From The Art and Architecture of the Ancient Orient, 4th edition (New Haven: Yale University Press, 1970). Reprinted by permission of the publisher. Page 58 "The Resurrection of King Unis" from Ancient Egyptian Literature: Anthology, translated by John L. Foster (Austin, TX: University of Texas Press, 2001). By permission of the University of Texas Press. Page 266 St. Theodore the Studite. From "Second and Third Refutations of the Iconoclasts" from On the Holy Icons, translated by Catherine P. Roth (Crestwood, NY: St. Vladimir's Seminary Press, 1981). Reprinted by permission of the publisher. Page 309 Abd al-Hamid Lahori. From "Padshah Nama" from *Taj Mahal: The Illumined Tomb*, compiled and translated by W.E. Begley and Z.A. Desai (Cambridge, Mass: Aga Kahn Program for Islamic, Architecture 1989). Reprinted by permission of the Aga Khan Program Publications. Pages 352, 353 From The Pilgrim's Guide to Santiago de Campostela, edited and translated by William Melczer (New York: Italica Press, 1993). Copyright 1993 by William Melczer. Used by permission of Italica Press. Page 359 St. Bernard of Clairvaux. From "Apologia to Abbot William of Saint-Thierry" from The "Things of Greater Importance": Bernard of Clairvaux's Apologia and the Medieval Attitude Towards Art, edited by Conrad Rudolph (Philadelphia: University of Pennsylvania Press, 1990). Reprinted by permission of the publisher. Page 369 C. Edson Armi. "Report on the Destruction of Romanesque Architecture in Burgundy" from Journal of the Society of Architectural Historians, volume 55 (1996). Reprinted by permission of the publisher. Page 393 Suger of Saint-Denis. From "On the Consecration of the Church of Saint-Denis" from Abbot Suger on the Abbey Church of Saint-Denis and Its Art Treasures, edited and translated by Erwin Panofsky (Princeton, NJ: Princeton University Press, 1946), © 1947, 1958, 1982 Princeton University Press. Reprinted by permission of Princeton University Press. Page 461 Inscriptions on the Frescoes in the Palazzo Pubblico, Siena from Arts of Power: Three Halls of State in Italy, 1300-1600, edited by Randolph Starn and Loren Partridge (Berkeley: University California Press, 1992), copyright © 1992 The Regents of the University of California. Reprinted by permission of the University of California Press

Notes

Notes